Joanna Cannon and André Vauchez

Margherita of Cortona
and the
Lorenzetti

Sienese Art and the Cult of a Holy Woman
in
Medieval Tuscany

The Pennsylvania State University Press
University Park, Pennsylvania

Library of Congress Cataloging-in-Publication Data

Cannon, Joanna.
 Margherita of Cortona and the Lorenzetti : Sienese art and the
cult of a holy woman in medieval Tuscany / Joanna Cannon and André
Vauchez.

 p. cm.
 Includes bibliographical references and index.
 ISBN 0-271-01756-2 (alk. paper)
 1. Mural painting and decoration, Italian—Italy—Cortona.
2. Mural painting and decoration, Medieval—Italy—Cortona. 3. Lost
works of art—Italy—Cortona. 4. Margherita, da Cortona, Saint,
1247–1297—Art. 5. Lorenzetti, Ambrogio, 1285–ca. 1348.
6. Lorenzetti, Pietro, fl. 1320–1348. I. Vauchez, André.
II. Title.
ND2757.C68C36 1999
751.7′3′094559—dc21 97-48436
 CIP

It is the policy of The Pennsylvania State University Press to use acid-free
paper for the first printing of all clothbound books. Publications on uncoated
stock satisfy the minimum requirements of American National Standard for
Information Sciences—Permanence of Paper for Printed Library Materials,
ANSI Z39.48-1992.

Faite prieghiera, o Sancta Margarita,
a Iesu Cristo per li cortonesi,
ché le mantenga en pace e in buona vita,
e per li vostri meriti sieno defesi,
e sieno acesi de l'amore divino,
ché al punto stremo agiono consolança.

(The people of Cortona ask you
Margherita—pray to Jesu.
For them may peace and life entwine
Through your merits they're defended
May they be lit by love divine
And solace find, this world being ended.)
—From the *lauda* "Allegramente e
de buon core," first recorded in
the early fourteenth century, in the
Laudario of Cortona

". . . a solemn and public feast, with the ceremonies which communes generally organise in such circumstances, is celebrated at Cortona. For the celebration of this feast not only the people of Cortona but also the inhabitants of the neighboring towns, lands, and castles are seen to flock there in great numbers. Nevertheless, since no mention of Margherita herself is made in the masses and offices celebrated on that day, because she is neither canonised nor inscribed in the catalogue of saints, many of those who go there are filled with astonishment."
—6 February 1516, Leo X, *Regimen universalis*

A part of the mountain-top is occupied by the church of St. Margaret, and this was St. Margaret's day. The houses pause roundabout it and leave a grassy slope, planted here and there with lean black cypresses. The contadini from near and far had congregated in force and were crowding into the church or winding up the slope. When I arrived they were all kneeling or uncovered; a be-dizened procession, with banners and censers, bearing abroad, I believe, the relics of the saint, was re-entering the church. The scene made one of those pictures that Italy still brushes in for you with an incomparable hand and from an inexhaustible palette when you find her in the mood.
—Henry James, recording a visit made in 1873, in his *Italian Hours*

Contents

Maps

Acknowledgments

My first and greatest debt is to André Vauchez, my co-author and the originator of this project. In the winter of 1976 he was kind enough to suggest that with the support of a bursary from the Ecole Française de Rome, and the use of their magnificent facilities in Palazzo Farnese and Piazza Navona, I might spend one month studying the watercolors in the records of the canonization process of Margherita of Cortona, *Archivio Segreto Vaticano, fondo Riti* 552. Its evidence proved to be intriguing and in 1982 I was able to gather further material in Cortona, but it was not until the winter of 1986 that we both had the opportunity to return to the subject. At that stage we decided on a joint publication, which was to take the form of an article but eventually developed into this more wide-ranging study. The majority of the writing has, in the event, been mine; as the typescript grew in length, André Vauchez has been content to restrict himself to contributing the two opening chapters and a conclusion. His support and participation throughout the project, however, have been unfailing. Undertaking a collaborative endeavor when the material is found in Italy, the authors live in England and France, and the publisher is in the United States, has been taxing at times. Our occasional meetings to review the progress of work, made delightful by the hospitality of Mme. Vauchez, have been vital to keeping the project alive over an extended period. In the final stages of preparing the text and illustrations for publication it was a great pleasure to return for a few days in 1996 to the starting point—the Ecole Française de Rome—where André Vauchez is now director.

In the twenty years since we first took an interest in the watercolors of ASV, *Riti* 552 a substantial amount of new research has been published on the issues of late medieval sanctity, the Franciscan Third Order, female spirituality and, more specifically, about Margherita and Cortona. This work has helped to place the visual material relating to Margherita more firmly and fully in its context and to make this context more familiar to a wider

group of scholars and students. Writing in the rather curious capacity of one voice out of a pair of authors, I believe that it is only fair to point to the major contributions made by my co-author during this time, notably in his fundamental study *La Sainteté en Occident aux derniers siècles du Moyen Age* (Bibliothèque des Ecoles françaises d'Athènes et de Rome, 241, Rome, 1981, reprinted in 1988 and 1994 and available in English as *Sainthood in the Later Middle Ages*, trans. J. Birrell, Cambridge, 1997). This monumental work took as its starting point the evidence of canonization processes—the church hierarchy's official mechanism for measuring sanctity—within and beyond the later Middle Ages. (Out of that research came the initial interest in the existence of the watercolors in ASV, *Riti*,552, and the plan to ask for an art historian's view of their significance.) Many of the ideas and issues raised in *La Sainteté en Occident* are fundamental to the present study. I should also like to single out for mention here a short essay by André Vauchez, "Patronage des saints et religion civique dans l'Italie communale à la fin du Moyen Age" (in *Patronage and Public in the Trecento*, Proceedings of the St. Lambrecht Symposium, Abtei St. Lambrecht, Styria, 16–19 July 1984, ed. V. Moleta, Florence, 1986, 59–80; available in translation in *The Laity in the Middle Ages: Religious Beliefs and Devotional Practices*, trans. M. J. Schneider, Notre Dame, 1993, 153–68). The discussion of civic cults given there sets the scene for what follows in this study.

A long if interrupted project such as this one incurs many debts and I hope not to have forgotten too many of them in the following acknowledgments. Financial help for brief and intensive spurts of essential travel came twice from the Ecole Française de Rome and once from the British Academy. These I acknowledge with great gratitude. The University of Paris X–Nanterre and the Courtauld Institute of Art also made contributions to travel costs. Among institutions abroad I was particularly fortunate to have access, in Rome, to the indispensable facilities of the Archivio Segreto Vaticano, the Biblioteca Apostolica Vaticana, the Bibliotheca Hertziana, and the Ecole Française de Rome, and in Florence to the Kunsthistorisches Institut. I am also grateful for the help of the staff at the Biblioteca Laurenziana in Florence; the Museo Francescano in Rome, with particular thanks to Father Servus Gieben; and the Brera in Milan (where it proved impossible to find any trace of the set of watercolors mentioned by Kaftal). In Cortona I have received much kindness at different times: notably, in the Biblioteca Comunale e dell'Accademia Etrusca, from the late Celestino Bruschetti, vice-lucumone and secretary of the Accademia Etrusca, and I have benefited—as have many others studying medieval matters Cortonese—from the enthusiasm of Bruno Gialluca. I also thank Monsignor Giovanni Materazzi, director of the Museo Diocesano in Cortona, and the staff of the Museo dell'Accademia Etrusca for their assistance. Paolo Mori was kind enough to respond to an inquiry for information. I am also grateful to the Franciscan guardians of the sanctuary of S. Margherita for permission to study in their archive and museum, under the aegis of Father Fortunato Iozzelli. For access to books that would have been hard to find outside Cortona I thank Edoardo Mori, Beth Williamson, the Libreria Nocentini of Cortona, and Loredana Polezzi of the University of Warwick, by birth a Cortonese.

Much of my work had to be done in England rather than in Italy. The British Library

was an important resource, particularly since it holds a copy of da Pelago's edition of Margherita's *Legenda;* the library of the Institute of Historical Research, University of London, also proved essential on several occasions. But tackling this sort of project in England was, in the end, only possible because of the remarkable resources of the library of the Warburg Institute. The interdisciplinary approach taken in this book would have been unthinkable without free access to the Warburg treasure-trove. This study would also have been impossible without the extensive photographic material needed for research and illustration. I have been extremely fortunate in benefiting from the facilities and support of the Conway Library in the Courtauld Institute, and of the holdings of the Garrison Collection. The Courtauld slide library has given practical assistance; the Witt Library at the Courtauld has also been a valuable resource, as has the Courtauld Book Library, which has come to my rescue on several occasions. Many of the photographs used in this project were taken specially for it by "photo-team Cannon/Lowden" and printed with the help of the Conway Library. Others were obtained from a wide variety of sources, acknowledged at the end of this book. Among those photo-archives I single out for special thanks the Fototeca of the Kunsthistorisches Institut in Florenz for providing a high-quality, wide-ranging, efficient and low-priced service of the type that is so vital to a project such as this. My thanks also to Father Gerhard Ruf for taking the trouble to provide various details of frescoes from S. Francesco, Assisi.

A short foretaste of our conclusions has recently been published in the proceedings of the conference *"La Religion Civique,"* organized by André Vauchez and held at the University of Paris X–Nanterre in 1993 ("Marguerite et les Cortonais: Iconographie d'un 'culte civique' au XIVe siècle," in *La religion civique à l'époque médiévale et moderne (Chrétienté et Islam),* ed. A. Vauchez, Collection de l'École française de Rome, 213, Paris, 1995, 403–13). I am also grateful for other opportunities I have had, since 1982, to publicize different aspects of this material in lectures, seminars, and conferences, and for the discussions that ensued, organized under the auspices of the following institutions and organizations: Columbia University (Robert Branner Forum); University of Leeds International Medieval Congress; University of London (Courtauld Institute of Art, Institute of Historical Research—Later-Medieval and Renaissance Italy Seminar, Anglo-American Conference of Historians, London Society for Medieval Studies, Accordia Research Centre); University of Sussex; University of Warwick; University of York.

It is a privilege to be able to teach in an academic institution with all the stimuli and facilities that, despite financial cuts and other pressures, such an establishment, and the wider world of the University of London, is still able to provide. Generations of students (so it seems) have been obliged to listen to various formulations of parts of this work. They have proved to be a most enthusiastic and supportive audience and I thank them all, particularly the members of the M.A. groups of 1990–91 and 1991–92.

A number of people have given help on specific points of information and this is recorded in the relevant footnotes. Here I particularly thank Father Fortunato Iozzelli, whom I met when we were both studying Margherita in Cortona, for his enthusiasm and, together with his colleague at the Antonianum Father Cacciotti, for securing the Italian-language publication of this study. I also thank Gianna Mina, particularly for discussing the Lorenzetti; Jane

Bridgeman, for wrestling over details of medieval dress and undergarments; Tom Henry, for sharing his local knowledge of Cortona and Arezzo; Rupert Hodge, for unfailing courtesy and for steering me in the right direction concerning Andrea del Sarto and Pietro da Cortona; Giovanni Freni, Catherine Manley, and Beth Williamson, for reporting back on travels in Tuscany; Andy Williamson for redrawing the diagrams and ground plans; Mike Tyler of Mapstyle for redrawing the maps; John Lowden for taking on the arduous task of compiling the index; Iain Grey for recovering the text of Appendix III when my hard disk failed; Laura Corti and Riccardo Spinelli for inviting me to contribute to the catalogue of the forthcoming exhibition on the iconography of Margherita in Cortona; Patricia Rubin, for putting me in touch with Laura Corti and for organizing a "giornata margheritiana" at I Tatti; and Miri Rubin, Evelyn Welch, and Susan Haskins for encouragement along the way.

My debt to Céline Perol is of a very particular kind. At an earlier stage in this project she drew on her knowledge of postmedieval Cortona to contribute a chapter on the evidence for late medieval and postmedieval devotion to Margherita in her adopted town. Pressure of space has meant that unfortunately this contribution will now be found only in the Italian-language version of this book. I am grateful to her specifically for certain information that appears toward the end of Chapters 4 and 14, and more generally for her valiant labors in making accesible to me primary material not available in England.

Several people have read all or parts of this text. I am most grateful to Patricia Rubin for her advice on Vasari, and to Julian Gardner for responding to what I had to say on burials and tombs. Over the years Dillian Gordon has read more than one draft with patience and care. Vital encouragement has also came from David d'Avray who has heard me speak on the topic of Margherita on more than one occasion. I am particularly indebted to four people who read the complete text at an advanced stage and gave valuable, incisive, and sympathetic advice as to how it could be improved: Annemarie Carr, Anne Derbes, Liz James, and John Lowden. As this long-drawn-out project came to a close, they provided the essential mixture of enthusiasm, encouragement, and a measure of provocation that provided the impetus to make those final changes and revisions which, I hope, will make this book more accessible and palatable to the reader.

If this book is not only palatable but also attractive to look at and clearly produced, it is thanks to the skill and efforts of Cherene Holland and Steven Kress at Penn State Press. I owe a great debt to Philip Winsor and his colleagues at the Press for their ready acceptance of a detailed interdisciplinary project and for being prepared to do justice to the art-historical content, despite the cost and complexity of production.

* * *

My share in this book is dedicated to three generations of my family. The arrival of the youngest generation initially made work on this project impossible, but help from the other two generations gradually gave me opportunities to return to the library, the sanctuary of the study, and eventually to brief forays abroad. I thank my mother for babysitting on a regular basis; Gregory and Caroline for tolerance and cheerfulness during my occasional absences and for vital assistance preparing the paste-up of the illustrations and in printing out the final typescript; and John for very many reasons not merely academic.

Note on Abbreviations

ACC Archivio Storico del Comune di Cortona

ASV Archivio Segreto Vaticano

BC/AE Biblioteca Comunale e dell'Accademia Etrusca, Cortona

Da Pelago, I; Da Pelago, II L. da Pelago, *Antica leggenda della vita e dei miracoli di S. Margherita da Cortona*, 2 vols., Lucca, 1793. Volume I contains the text of Fra Giunta's *Legenda*. Volume II contains the *Registro di documenti spettanti alla leggenda di S. Margherita* and other material.

Da Pelago, *Sommario* L. da Pelago, *Sommario della storia della chiesa e convento di Santa Margherita di Cortona, compilato e disposto per ordine cronologico dal P. Fra Lodovico da Pelago* . . . , 1781. Unpublished manuscript in the Archivio conventuale of S. Margherita in Cortona; manuscript copy in the Archivio provinciale of the Friars Minor, Florence. Pagination of the two manuscripts differs, so references are given here *ad annum*.

Legenda References to the text of the *Legenda* of Margherita, compiled by Fra Giunta Bevegnati, are given in accordance with the chapter and paragraph divisions given in da Pelago, I. Where F. Iozzelli's new edition of the text diverges from da Pelago's numbering system, the Iozzelli numbering is given as well (F. Iozzelli, *Iunctae Bevegnatis. Legenda de Vita et Miraculis Beatae Margaritae de Cortona*, Bibliotheca franciscana ascetica medii aevi 13, Grottaferrata, 1997).

CM *Capitulum de miraculis*, the last chapter of the *Legenda*. In da Pelago's edition this is numbered as chapter XII. Iozzelli's new edition of this chapter numbers it as chapter XI and also includes twenty-one paragraphs lost from the only surviving fourteenth-century version of this chapter and not previously known. To avoid confusion, reference to da Pelago's edition is given first, followed by reference to Iozzelli's new numbering, with the abbreviation CM.

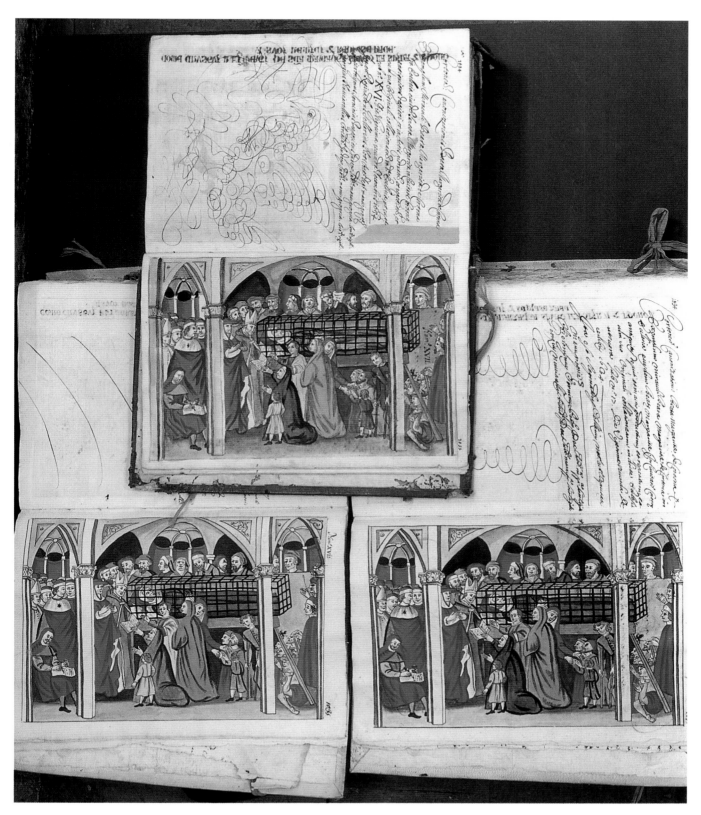

Color Plate I. Three copies of the Canonization Process of Margherita of Cortona, 1629–40, Archivio Storico del Comune di Cortona, MSS H 27, H 28, H 29, openings showing watercolor no. xvii, by Adriano Zabarelli, and copies of signatures on reverse of watercolor no. xvi.

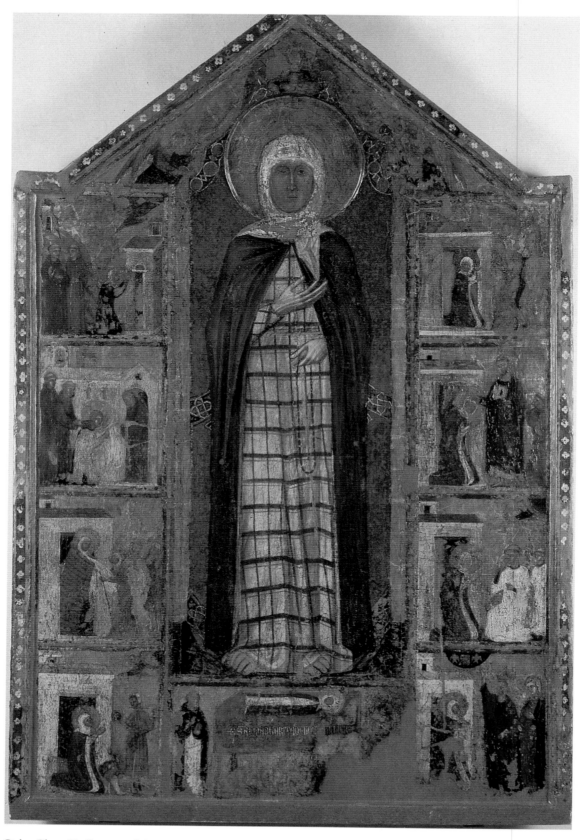

Color Plate II. Cortona, Museo Diocesano, *Beata Margherita with Eight Scenes from Her Life,* panel (maximum dimensions: 197.5 x 131 cm), Tuscan (or Umbrian), within the decade following 1297.

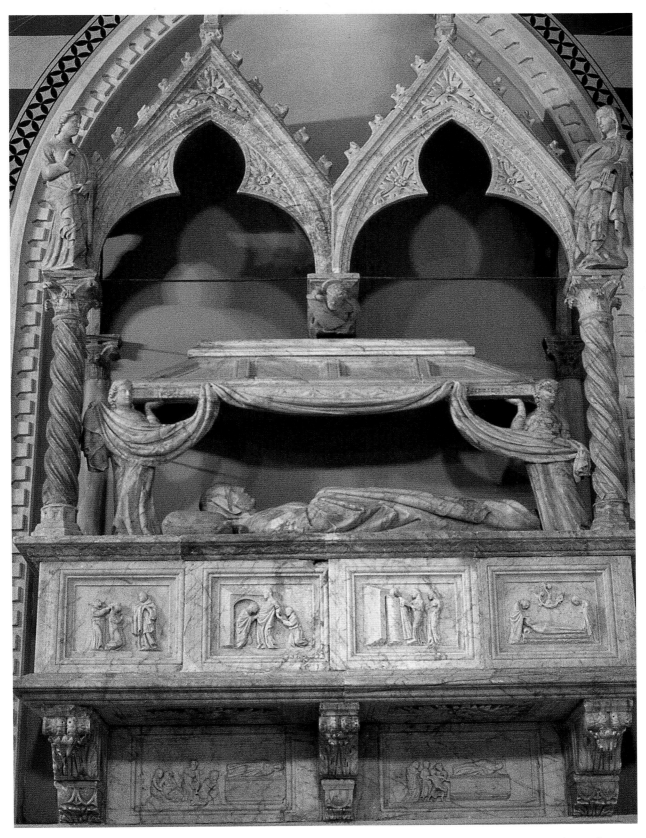

Color Plate III. Cortona, S. Margherita, funerary monument of Beata Margherita (maximum width of base of monument: 229 cm), Sienese sculptor (Gano di Fazio?), second or third decade of the fourteenth century.

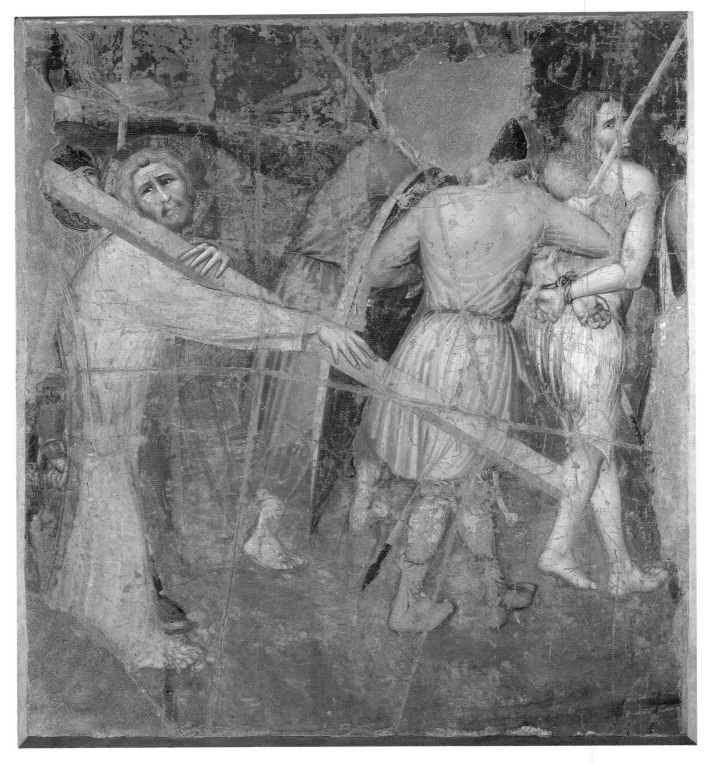

Color Plate IV. Cortona, Museo Diocesano, *The Way to Calvary*, fragment A (approx. maximum dimensions of painted surface: 166 x 146 cm), fragment of fresco, formerly nave of S. Margherita, here attributed to Pietro Lorenzetti working with a member of the Lorenzetti workshop who may also have worked with Ambrogio Lorenzetti, c. 1335.

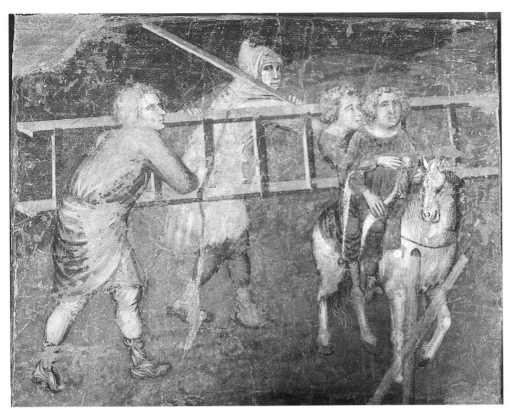

Color Plate V. Cortona, Museo Diocesano, *The Way to Calvary*, fragment B (77 x 84.5 cm), fragment of fresco, formerly nave of S. Margherita, here attributed to Pietro Lorenzetti and a member of the Lorenzetti workshop who may also have worked with Ambrogio Lorenzetti, c. 1335.

Color Plate VI. Cortona, Museo Diocesano, *The Way to Calvary*, fragment C (32 x 30.5 cm), fragment of fresco, formerly nave of S. Margherita, here attributed to Pietro Lorenzetti and a member of the Lorenzetti workshop who may also have worked with Ambrogio Lorenzetti, c. 1335.

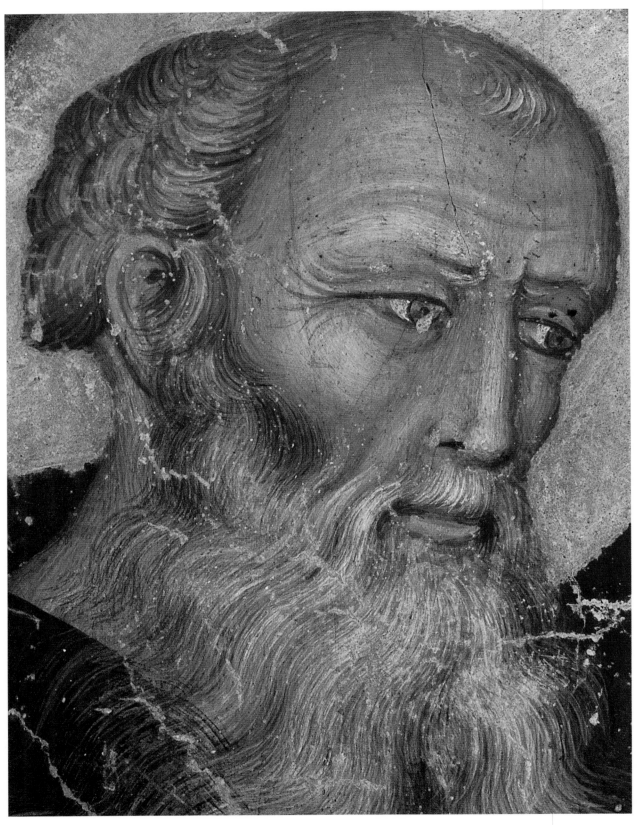

Color Plate VII. Cortona, Museo Diocesano, *Head of a Hermit Saint (Egidio?)*, fresco fragment (maximum dimensions: 39 x 33.5 cm), here attributed to Pietro Lorenzetti, detail.

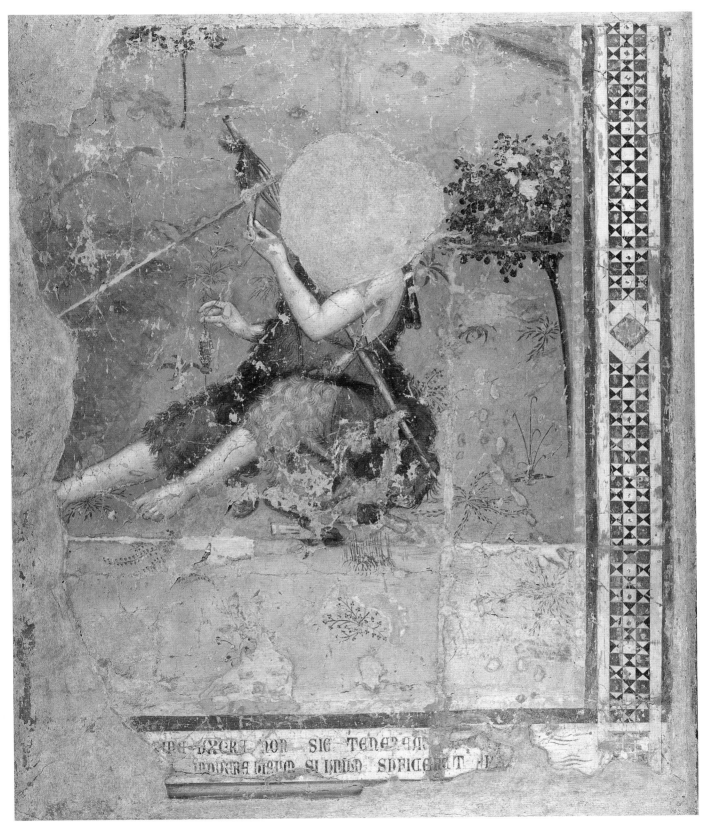

Color Plate VIII. Cortona, Museo dell'Accademia Etrusca, *Eve Spinning* (approx. maximum dimensions of painted surface: 200 x 161 cm), fragment of the fresco *Labor of Adam and Eve*, formerly nave of S. Margherita, Tuscan (Sienese?) artist, first half of the fourteenth century (c. 1335?).

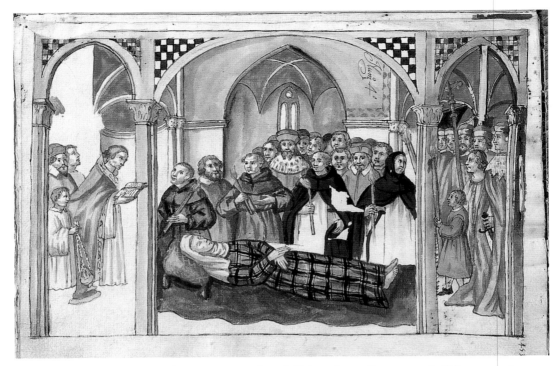

Color Plate IX. Cortona, Biblioteca Comunale e dell'Accademia Etrusca, cod. 429, watercolor no. iv, copy of the mural *The Funeral of Margherita*, formerly on the north wall of the *cappella maggiore* of S. Margherita.

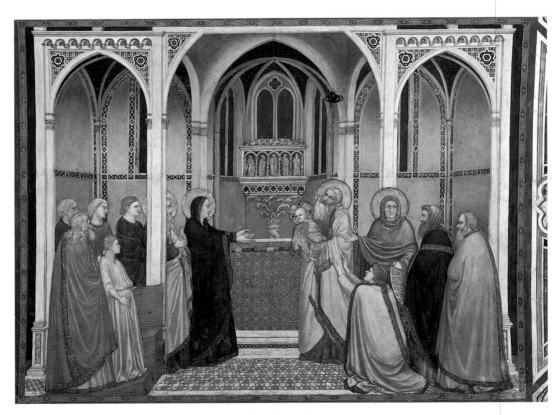

Color Plate X. Assisi, S. Francesco, Lower Church, right transept, *Presentation in the Temple*, fresco, attributed to the school of Giotto.

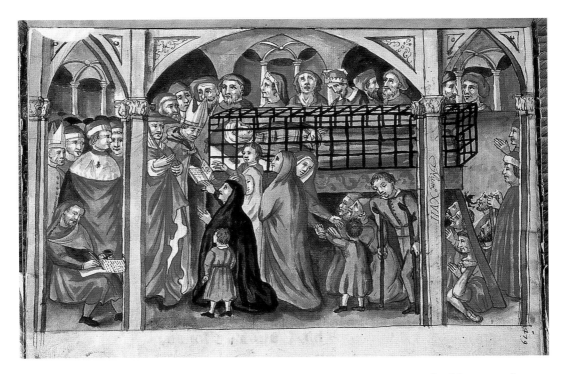

Color Plate XI. Cortona, Biblioteca Comunale e dell'Accademia Etrusca, cod. 429, watercolor no. xvii, copy of the mural *The Visitation of Cardinal Napoleone Orsini*, formerly on the south nave wall of S. Margherita.

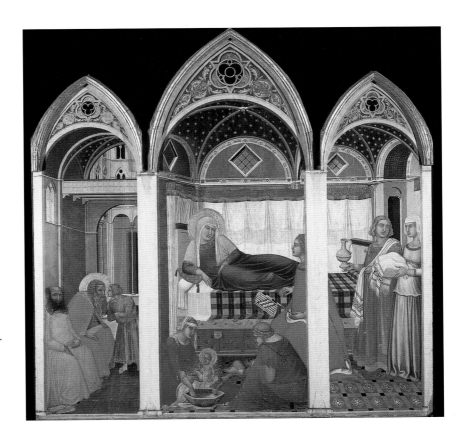

Color Plate XII. Siena, Museo dell'Opera del Duomo, *Birth of the Virgin*, panel (187 x 182 cm), formerly *Cappella di S. Savino*, Duomo, Siena, Pietro Lorenzetti, 1335–42.

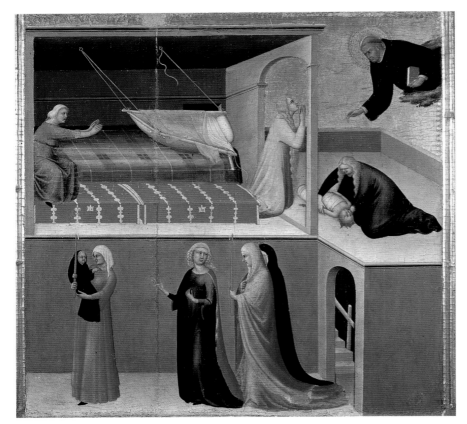

Color Plate XIII. Siena, Pinacoteca Nazionale (on deposit), *Beato Agostino Novello and Four Miracles*, panel (200 x 256 cm), from S. Agostino, Siena, Simone Martini (attrib.), before 1329, detail, *Miraculous Cure of an Infant Which Fell from Its Cradle*.

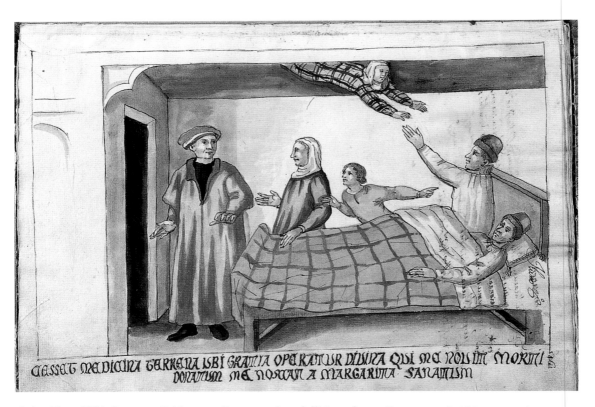

Color Plate XIV. Cortona, Biblioteca Communale e dell'Accademia Etrusca, cod. 429, watercolor scene viii, copy of the mural *The Cure of Simonello di Angeluccio*, formerly on the south wall of the the *cappella maggiore* of S. Margherita.

Color Plate XV. Florence, Galleria degli Uffizi, *Four Scenes from the Life and Miracles of Saint Nicholas*, panel, from S. Procolo, Florence, Ambrogio Lorenzetti (attrib.), c. 1332, *Resuscitation of the Merchant's Son* (width, including frame, 52.5 cm).

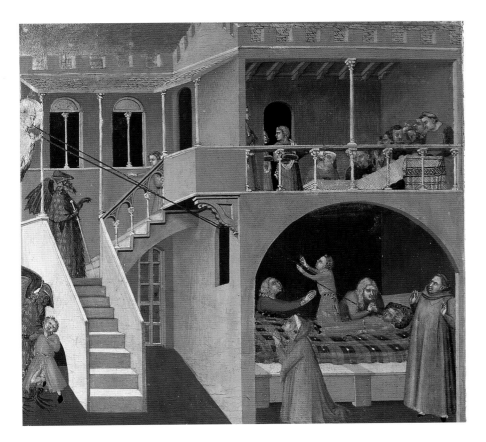

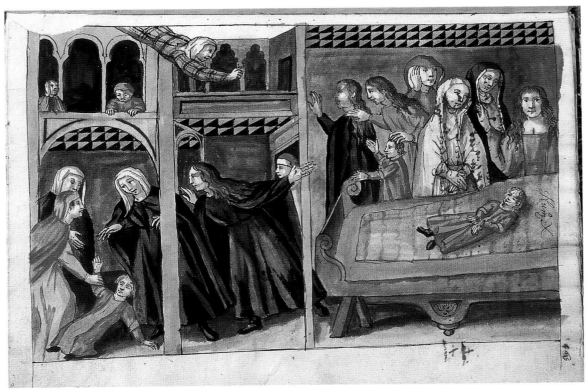

Color Plate XVI. Cortona, Biblioteca Comunale e dell'Accademia Etrusca, cod. 429, watercolor no. x, copy of the mural *The Resuscitation and Healing of Suppolino*, formerly on the south wall of the *cappella maggiore* of S. Margherita.

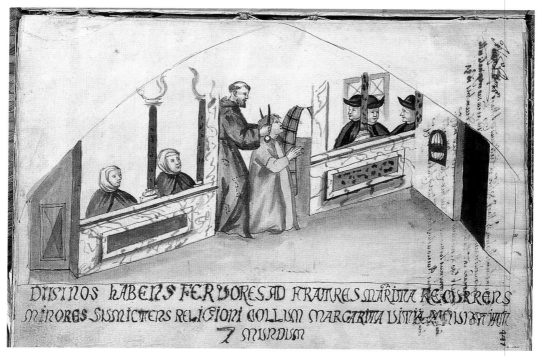

Color Plate XVII. Cortona, Biblioteca Comunale e dell'Accademia Etrusca, cod. 429, watercolor scene i, copy of the mural *The Profession and Investiture of Margherita as a Member of the Franciscan Third Order*, formerly in the lunette of the north wall of the *cappella maggiore* of S. Margherita.

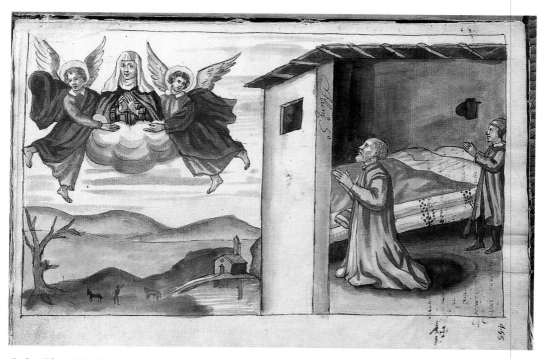

Color Plate XVIII. Cortona, Biblioteca Comunale e dell'Accademia Etrusca, cod. 429, watercolor scene v, copy of the mural *The Man of Città di Castello Witnesses the Ascent of Margherita's Soul*, formerly on the north wall of the *cappella maggiore* of S. Margherita.

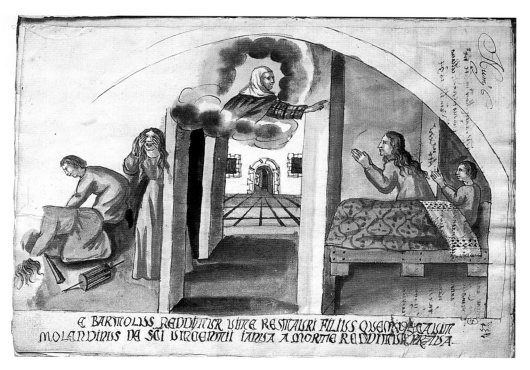

Color Plate XIX. Cortona, Biblioteca Comunale e dell'Accademia Etrusca, cod. 429, watercolor no. vi, copy of the mural *The Revival and Healing of Bartoluccio of Cortona*, formerly in the lunette of the south wall of the *cappella maggiore* of S. Margherita.

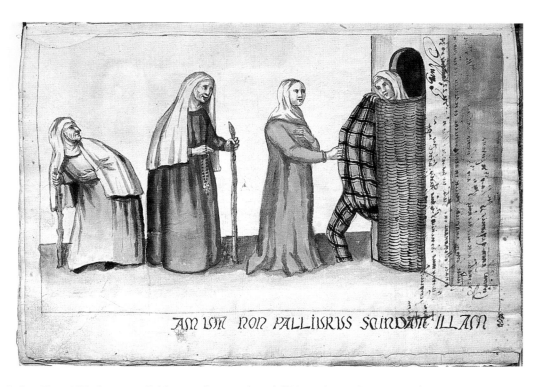

Color Plate XX. Cortona, Bibloteca Comunale e dell'Accademia Etrusca, cod. 429, watercolor no. iii, copy of the mural *Margherita Gives Her Possessions to the Poor and Wraps Herself in the Mat of Woven Reeds on Which She Slept*, formerly on the north wall of the *cappella maggiore* of S. Margherita.

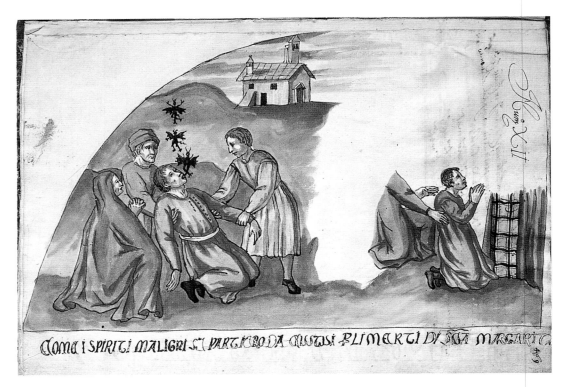

COME I SPIRITI MALIGRI SI PARTIRO DA QUESTI PUMERTI DI STA MARGARIT

Color Plate XXI. Cortona, Biblioteca Comunale e dell'Accademia Etrusca, cod. 429, watercolor no. xii, copy of the mural *Liberation from Devils of the Boy of Borgo Sansepolcro*, formerly in the lunette of the south nave wall of S. Margherita.

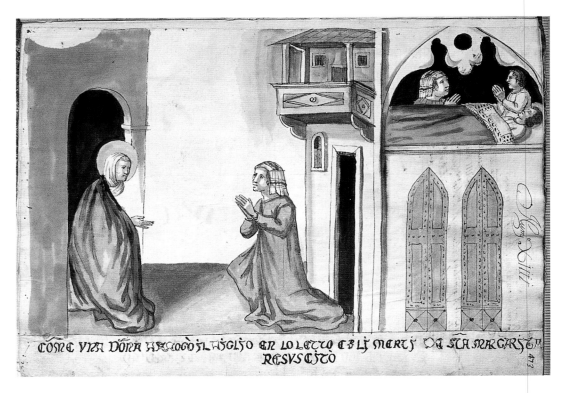

CŌME VNA DŌNA ARECOÒ IL TIGLIO EN LO LETTO E PLI MERTI DA STA MARGARITĒ RESVSCITO

Color Plate XXII. Cortona, Biblioteca Comunale e dell'Accademia Etrusca, cod. 429, watercolor no. xiv, copy of the mural *Margherita Resuscitates a Dead Child in Cortona*, formerly on the south nave wall of S. Margherita.

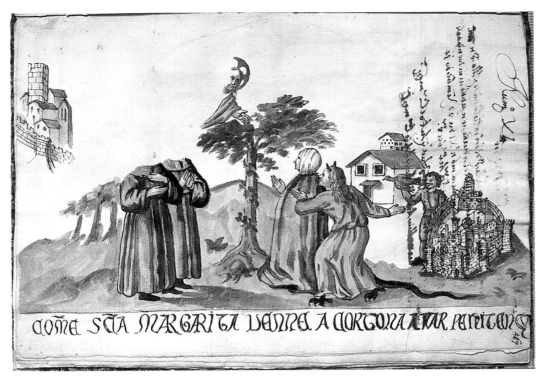

Color Plate XXIII. Cortona, Biblioteca Comunale e dell'Accademia Etrusca, cod. 429, water-color no. xi, copy of the mural *Christ Calls Margherita to Go to Cortona to Do Penance*, formerly in the lunette of the south nave wall of S. Margherita.

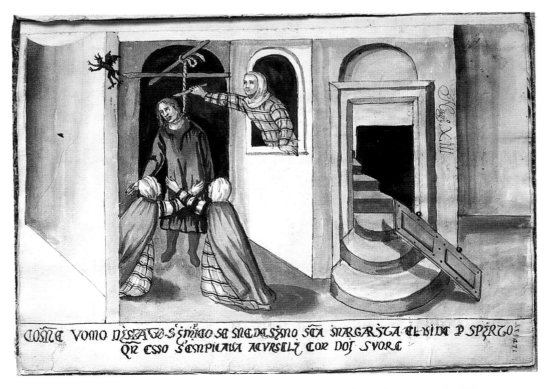

Color Plate XXIV. Cortona, Biblioteca Comunale e dell'Accademia Etrusca, cod. 429, water-color no. xiii, copy of the mural *The Saving of the Suicide*, formerly on the south nave wall of S. Margherita.

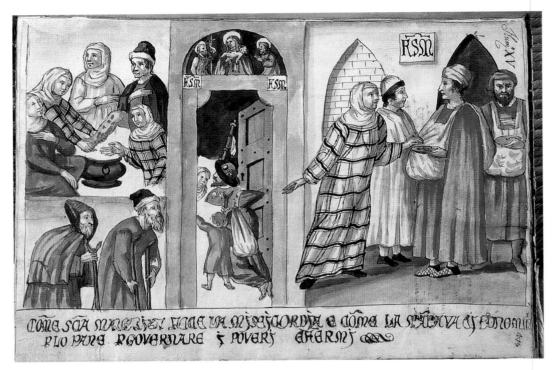

Color Plate XXV. Cortona, Biblioteca Comunale e dell'Accademia Etrusca, cod. 429, watercolor no. xv, copy of the mural *The Ospedale della Misercordia*, formerly on the south nave wall of S. Margherita.

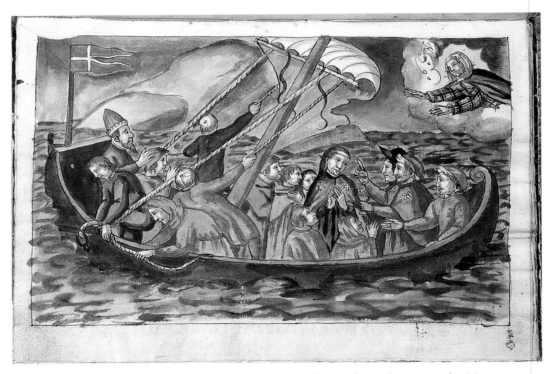

Color Plate XXVI. Cortona, Biblioteca Comunale e dell'Accademia Etrusca, cod. 429, watercolor no. ix, copy of the mural *The Calming of the Sea of Ancona*, formerly on the south wall of the *cappella maggiore* of S. Margherita.

Margherita of Cortona
and the
Lorenzetti

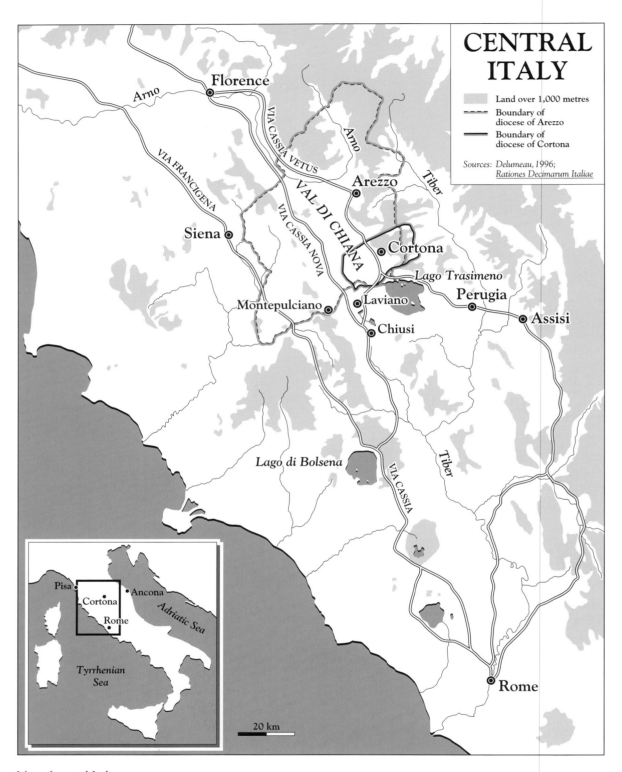

CENTRAL ITALY

- Land over 1,000 metres
- - - - Boundary of diocese of Arezzo
- ——— Boundary of diocese of Cortona

Sources: Delumeau, 1996;
Rationes Decimarum Italiae

Florence

Arno

VIA CASSIA VETUS

Arno

VIA FRANCIGENA

Arezzo

Tiber

Siena

VIA CASSIA NOVA

VAL DI CHIANA

Cortona

Lago Trasimeno

Montepulciano

Laviano

Perugia

Assisi

Chiusi

Lago di Bolsena

Tiber

VIA CASSIA

Pisa

Cortona

Ancona

Adriatic Sea

Rome

Tyrrhenian Sea

Rome

20 km

Map of central Italy

Introduction

In Cortona at the beginning of the fourteenth century work was under way on a church that, it seems, was bidding to emulate S. Francesco and S. Chiara at Assisi as a center of devotion and pilgrimage. The focus was to be the cult of the miracle-working body of Margherita of Cortona. Margherita had been hailed by her biographer as the light of the Third Order of the Franciscans, to be ranked together with Saint Francis and Saint Clare, the lights of the First and Second Orders. Margherita's burial church, like those of Francis and Clare, was an imposing, fully vaulted stone structure; like theirs, it was decorated with an extensive and coherent scheme of murals that told the saint's story in apposition to the Scriptures of both the Old and New Testaments. Those frescoes, which there is good reason to believe were commissioned from the workshop of two of the leading artists of the day, together with Margherita's splendid funerary monument, must have presented a setting worthy of the anticipated attention of multitudes of the faithful. And yet the Church of S. Margherita at Cortona is not a monument that is now familiar, even to most specialists. The wholesale rebuilding of its structure and the loss of much of its decoration have obscured both its former significance and the aspirations that accompanied its construction. The present study will reintroduce this important monument so that it can play its part in future studies of later medieval Italy.

Whereas the Church of S. Margherita in Cortona is not well known today, awareness of its dedicatee Margherita of Cortona (born c. 1247, died 1297) has grown in recent years. As the study of the spirituality of medieval women gains momentum, Margherita's colorful story has been retold on several occasions. The substantial volume of information contained in the lengthy *Legenda* compiled by her Franciscan confessor has proved a rich

source for the consideration of her spirituality[1] and, more briefly, of her relations with her contemporaries in Cortona,[2] with the Franciscan friars,[3] and with the activities of the religious movement to which she belonged.[4] This grouping, known at the time when Margherita joined it as the Order of Penitence, was reconstituted, in 1289, as the Franciscan Third Order.[5] Its members were primarily lay people, who generally remained within the

1. The distinctive spirituality of a number of women in thirteenth- and fourteenth-century Italy has been studied by Italian and French scholars and, more recently, has also attracted the interest of English-speaking scholars investigating the lives of later medieval women. See the fundamental study by G. Petrocchi, "Correnti e linee della spiritualità umbra ed italiana nel Duecento," *Atti del IV Convegno di studi umbri (Gubbio 1966)*, Perugia, 1967, 133–76; and, for a lucid and stimulating introduction to the topic, see the essays gathered together in A. Vauchez, *Les laïcs au Moyen Age: Pratiques et expériences religieuses*, Paris, 1987 (available in English as *The Laity in the Middle Ages: Religious Beliefs and Devotional Practices*, trans. M. J. Schneider, with a preface and additional annotation by D. Bornstein, Notre Dame, 1993). A number of conferences held in Italy in the past two decades have concentrated on specific personalities or themes, producing much valuable material and analysis. See, as a starting point, the informative *état de question* provided in the introduction to the valuable collection of papers reprinted in A. Benvenuti Papi *"In Castro Poenitentiae": Santità e società femminile nell'Italia medievale*, Italia sacra 45, Rome, 1990, esp. xv–xxix. An interesting selection of Italian conference papers, prefaced by a helpful survey of the literature, is available in English in *Women and Religion in Medieval and Renaissance Italy*, ed. D. Bornstein and R. Rusconi, trans. M. J. Schneider, Chicago, 1996 (revised version of *Mistiche e devote nell'Italia tardomedievale*, Naples, 1992.) Two studies dealing specifically with Margherita's spirituality, as portrayed by the *Legenda*, are E. Menestò, "La mistica di Margherita di Cortona," in *Temi e problemi nella mistica femminile trecentesca: Convegni del Centro di studi sulla spiritualità medievale, 20, Todi, 1979*, Todi, 1983, 181–206; and the stimulating analysis given by A. Benvenuti Papi, "Margarita filia Jerusalem. Santa Margherita da Cortona e il superamento mistico della crociata," in *Toscana e Terrasanta nel Medioevo*, ed. F. Cardini, Florence, 1982, 117–57 (now reprinted as "Cristomimesi al femminile," in Benvenuti Papi, 1990, 141–68. Margherita's spirituality is touched on, among many other examples, in C. Walker Bynum, *Holy Feast and Holy Fast: The Religious Significance of Food to Medieval Women*, Berkeley and Los Angeles, 1987, and a collection of papers by the same author, *Fragmentation and Redemption: Essays on Gender and the Human Body in Medieval Religion*, New York, 1991. Margherita is also one of the examples considered in R. M. Bell, *Holy Anorexia*, Chicago, 1985, where the cited source of information—the *Legenda*—is sometimes embroidered on. A short study devoted specifically

to Margherita, drawing on previously unpublished archival material, in addition to the *Legenda*, is D. Bornstein, "The Uses of the Body: The Church and the Cult of Santa Margherita da Cortona," *Church History*, 62, 1993, 163–77. For further references to Margherita in synthetic works addressed primarily to an English-speaking audience, see notes 8 and 11.

For guides to the earlier bibliography concerning Margherita, often of a devotional nature, see the Bibliography of Cited Works.

2. A. Benvenuti Papi, "Marguerite de Cortone," in *Une Eglise éclatée, 1275–1545*, Histoire des saints et de la sainteté chrétienne 7, ed. A. Vauchez, Paris, 1986, 178–83; R. Rusconi, "Margherita da Cortona, Peccatrice redenta e patrona cittadina," in *Umbria sacra e civile*, ed. E. Menestò and R. Rusconi, Turin, 1989, 89–104 (subsequently republished as *Umbria. La strada delle sante medievali*, Rome, 1991, 56–73, 200–201.) See also F. Iozzelli, "I miracoli nella "legenda" di Santa Margherita da Cortona," *Archivum Franciscanum Historicum* 86 (1993), 217–76, which draws on the evidence of Margherita's posthumous miracles. Iozzelli's new edition of the *Legenda*, which appeared when this book was in the press, has been consulted for references to the *Legenda* text; unfortunately it was not possible to incorporate reference to Iozzelli's extended introductory essay in the present study.

3. See A. Benvenuti Papi, "Velut in sepulchro: Cellane e recluse nella tradizione agiografica italiana," in *Culto dei santi, istituzioni e classi sociali in età preindustriale*, ed. S. Boesch-Gajano and L. Sebastiani, Rome-L'Aquila, 1984, 367–455, esp. 413–27; reprinted in Benvenuti Papi, 1990, 305–402, esp. 375–96.

4. F. Casolini, "I Penitenti francescani in "Leggende" e Cronache del Trecento," in *I Frati penitenti di San Francesco nella società del due e trecento: Atti del 2° Convegno di studi francescani, Rome 1976*, ed. M. d'Alatri, Rome, 1977, 69–86; M. d'Alatri, "L'ordine della Penitenza nella Leggenda di Margherita da Cortona," in *Prime manifestazioni di vita comunitaria, maschile e femminile, nel movimento francescano della Penitenza (1215–1447): Atti del 4° Convegno di studi francescani, Assisi 1981*, ed. R. Pazzelli and L. Temperini, Rome, 1982, 67–80.

5. Although, as d'Alatri (1982, 67–68) points out, the designation "Third Order of St. Francis" was not generally used before the close of the thirteenth century. The terms *continenti*, *penitenti*, and *mantellati* were all current at this time.

The pioneering study on the Order of Penitence is G. G. Meersseman, *Dossier de l'Ordre de la pénitence au*

secular world: at the same time, however, they wore distinctive clothing; followed a very simplified version of the daily Office observed by a friar, monk, or nun; held regular assemblies in church to hear sermons; observed certain fasts; attended confession and the mass a prescribed number of times each year; and were absolved from bearing arms. The opportunity this way of life offered for the mingling of the earthly and the spiritual was open to both men and women. Married men and women could become members of the Third Order provided they observed conjugal chastity on certain days of the year.[6] Thus husband and wife could continue to live in their community while, at the same time, keeping in view the heavenly community of the hereafter.

Thanks to a number of recent studies we now know considerably more about this striking product of late medieval piety. But we still have much to learn, and Margherita's story, set at the very moment when the Order was being established, is an important source of information. Membership of the Order did not require a high degree of literacy and membership was not—as far as we can tell—restricted to a narrow social band.[7] When Margherita came to Cortona as a penitent, in about 1272, she came as an unmarried woman accompanied by her son—the visible proof of the irregularity of her former life. The death of the nobleman who had fathered her son had left her in "unofficial" widowhood.[8] Her father and stepmother, probably tenant-farmers,[9] had rejected her, but she was taken in by two gentlewomen—presumably members of the Order of Penitence—and a year or two later, in 1275, was considered ready to become a member of the Order herself. Like many of her fellows, she undertook charitable work, ministering to the sick and poor, while earning her own living as a birth-assistant to the noblewomen of the town. What distinguished her from the majority of her fellows was the growing austerity of her life, her ever-increasing devotion to the Eucharist, and the number and the intensity of the visions she began to receive.

The rigor of Margherita's penance, and the fervor of her spirituality, although far removed from the daily lives of many members of the Order, were not unique. The relative latitude of life within the Order—lived under the spiritual supervision of clerics, but not lived communally—allowed for such intense and personal expressions of religious feeling. There is, of course, an element of paradox in the enclosed life of an anchoress led by

XIIIe siècle, Fribourg, 1961, 2d ed. Fribourg, 1982. For a brief but illuminating discussion, see A. Vauchez, s.v. "Pénitents au Moyen Age," *Dictionnaire de Spiritualité*, xII, Paris, 1984, cols. 1010–23, and 'Medieval Penitents' in *Vauchez*, 1993, 119–27. See also *I Frati penitenti di San Francesco nella società del due e trecento: Atti del 2° Convegno di studi francescani, Rome 1976*, ed. M. d'Alatri, Rome, 1977. The Order of Penitence also gave birth to the Dominican Third Order, whose rule was drawn up in 1285.

6. This practice led to the frequent use of the sobriquet *continenti* (the chaste ones) for members of the Order.

7. For the problems inherent in defining membership see G. Casagrande, "Un tentativo d'indagine sullo 'status' economico e sociale dei 'Frati della Penitenza' a Perugia,"

in *I Frati penitenti di San Francesco nella società del due e trecento: Atti del 2° Convegno di studi francescani, Rome 1976*, ed. M. d'Alatri, Rome, 1977, 325–45.

8. Although Margherita came to be regarded as a "second Magdalen," this was in relation to the quality of her penitence rather than to the nature of her sin. Margherita is sometimes characterized, in the secondary literature, as a prostitute rather than as a concubine, but there is no contemporary evidence to support this assertion. (See, e.g., M. Goodich, *Vita Perfecta: The Ideal of Sainthood in the Thirteenth Century*, Monographien zur Geschichte des Mittelalters 25, Stuttgart, 1982, 182, where Margherita is described as a "former courtesan.")

9. There is no evidence for Goodich's claim that she was the "scion of a noble family" (90).

Margherita and others at this time. Margherita's existence, marked by reclusion and privacy, acted as a beacon for the members of the Order gathered around her cell and, more widely, for the citizens of Cortona. She was hidden from their sight, but her cell—in a location that dominated the town—was constantly in view. This may be an obvious point, but it is one not always borne in mind when evaluating Margherita's case and what it has to tell us about the religious life of the later Middle Ages. In using the evidence of Margherita's *Legenda* to elucidate female spirituality, some authors have chosen to concentrate almost exclusively on selected aspects of the text. Thus Margherita's ascetic and penitential practices, and the more lurid of her many visions, have been presented—particularly to an English-language readership—as paradigmatic, at the expense of their wider context. These elements form only a part of a long and detailed text, and we should treat with due caution the wider conclusions based on such selective readings. We should also turn to another source of information that has so far been virtually untapped: the visual evidence concerning Margherita. The lost fresco cycle, the tomb, and the panel painting of her life have been used, on occasion, for the illustration of her story, but scarcely for its elucidation.[10] These works have never received any extended examination or analysis. This is not entirely surprising, given the difficulties of reconstructing the lost material, of interpreting what survives,[11] and of establishing a sequence—let alone specific dates—for the works in question. Despite the lengthy detective work such material requires these efforts find their reward. If we seek a better understanding of the spirituality and wider preoccupations not only of Margherita but also of her contemporaries, we should not regard visual evidence as intrinsically less informative than written evidence. On the contrary, we should remember that an image of Christ played a central part in Margherita's devotions. Fra Giunta Bevegnati, compiler of the *Legenda,* considered the crucifix in the Church of S. Francesco in Cortona so central to Margherita's story that he introduced it in the first paragraph of his opening chapter. There he presented a dramatic scene, taken, in fact, from later in Margherita's life: as Margherita was praying in S. Francesco one day before the image she heard Christ asking her, "What do you want, little poor one?" to which she replied, "I neither seek nor want anything but you, my Lord Jesus."[12] In the presence of this crucifix Margher-

10. See, for example, pl. 4 in Bell, 1985, which illustrates the relief on Margherita's funerary monument, which shows Margherita giving her possessions to the poor and wrapping herself in the mat of woven reeds on which she slept (my Fig. 164). Bell provides the caption: "Margherita of Cortona emerges from her tiny cell and accepts the advice of townswomen to change her filthy dress." This misunderstanding appears to derive from a remarkably free interpretation of two separate sections of *Legenda,* III, 2 (Bell, 100).

11. Kaftal, in his indispensable *Iconography of the Saints in Tuscan Painting,* Florence, 1952, notes that the damaged condition of the panel painting of Margherita makes the interpretation of a number of scenes very doubtful. However, a number of authors have subsequently repeated his tentative identifications without any indication that they were provisional (e.g., D. Weinstein and R. M. Bell, *Saints and Society: The Two Worlds of Western Christendom, 1000–1700,* Chicago, 1982, caption to fig. 14, pp. 106–7, which reproduces the Margherita panel. Three out of nine scenes are misidentified, and two others probably misinterpreted, so that the perception of Margherita presented in the panel is substantially misunderstood). See below, Chapter 11, for proposed revisions to Kaftal's tentative identifications, and the consequent reinterpretation of the panel.

12. *Legenda,* I, 1; "in oratione coram Ymagine Christi que nunc est in Altari dictorum Fratrum." Christ asked Margherita: "Quid vis paupercula?" to which she replied, "Non quero, nec volo aliud, nisi vos, Domine mi Jhesu."

ita experienced her fullest mystical reliving of the Passion.[13] The *Legenda* text tells us, in vivid terms, that the people of Cortona ran to see Margherita's sufferings, culminating, at the ninth hour, with a collapse that apparently rendered her virtually lifeless: "as if she herself were placed on the cross."[14] When Margherita's mystical journey was over, and she had returned to her cell, we may envisage how the crucifix remained on view in the church of S. Francesco, as a constant reminder to the people of Cortona of the intense example of spirituality they had witnessed.[15]

A carved and painted wooden crucifix that is now displayed in the Church of S. Margherita (Figs. 3, 5, and 6) is traditionally thought to be the image before which Margherita prayed.[16] A thorough and careful restoration has revealed this sculpture to be a powerful and disturbing work. It is not difficult to imagine how prayer and meditation before such an object might produce intense religious experiences. The anonymous artist who carved and painted it is not thought to have been an Italian. The work has most recently been tentatively attributed to an itinerant artist, possibly of Spanish origin[17]—and a much older tradition considered the work to have been brought back to Cortona from the East by Brother Elias, third minister general of the Franciscan Order.[18] In either case it is interesting to note that this work was—and is—regarded as alien to the culture of southern Tuscany; this may help to explain the strong reactions it may have engendered. But before being tempted to read too much into this sculpture we should bear in mind that its precise dating is unknown and that we cannot therefore be absolutely certain that this crucifix

13. For a stimulating discussion of the importance of images in promoting and shaping the visions of female mystics in duecento and trecento Italy, see C. Frugoni, "Le mistiche, le visioni e l'iconografia: rapporti ed influssi," in *Temi e problemi nella mistica femminile trecentesca: Convegni del Centro di studi sulla spiritualità medievale, 20, Todi, 1979*, Todi, 1983, 139–79 (available in translation as "Female Mystics, Visions, and Iconography," in Bornstein and Rusconi, eds., 1996, 130–64).

14. *Legenda*, v, 3–5. The people of Cortona "videbant namque non iuxta crucem, sed quasi in cruce positam."

15. Fra Giunta is emphatic about the continued location of the image in question, "Ymagine Christi que nunc est in Altari dictorum Fratrum," *Legenda*, i, 1.

16. It belongs to the type characterized by De Francovich as "il crocifisso gotico doloroso," initially carved by German sculptors, which rapidly became popular in southern Europe, particularly in connection with mendicant piety. G. De Francovich, "L'Origine e la diffusione del crocifisso gotico doloroso," *Römisches Jahrbuch für Kunstgeschichte*, 2, 1938, 143–261. For an account of the restoration of the crucifix, a consequent reassessment of style and dating, and further bibliography, see the exhibition catalogue *Arte nell'Aretino, seconda mostra di restauri dal 1975 al 1979*, ed. A.M. Maetzke, Florence, 1979, 21–26, figs. 21–31.

17. Maetzke, 1979, passim. Another possible origin that deserves further consideration is Scandinavia. A Norwegian work, the wood and polychrome Crucifix no. 1 from Tretten, now in the Oldsaksamlingen, University of Oslo (Fig. 4), shows notable similarities in the overall position and form of the body, in the treatment of Christ's loincloth, and in the polychrome representation of blood and wounded flesh. The crucifix is tentatively dated to the thirteenth century. I am grateful to Nigel Morgan for pointing to a possible Norwegian connection, to Kirsten Seaver for suggesting comparisons from before 1300, and to Erla Hohler for answering my enquiries about the Tretten crucifix. There is also an intriguing resemblance between the Cortona crucifix and the somewhat more schematic crucifix from the cathedral of Split. De Francovich, 171–76, dated the Split crucifix to 1280–90. Belamarić, writing after the recent restoration of the crucifix, preferred to date it to the second half of the fourteenth century and considered it to have been carved by a Venetian sculptor active on the east coast of the Adriatic. J. Belamarić, "Un intagliatore gotico ignoto sulla sponda orientale dell'Adriatico," in *Gotika v Sloveniji. Nastajanje kulturnega prostora med Alpami, Panonijo in Jadranom. Akti mednarodnega simpozija Ljubljana, Narodna galerija, 1994*, ed. J. Höfler, Ljubljana, 1995, 147–57, figs. 4, 7, and 9.

18. Fra Giunta Bevegnati, *Leggenda della vita e dei miracoli di Santa Margherita da Cortona*, trans E. Mariani, Vicenza, 1978, 2 n. 2.

was indeed visible in the Church of S. Francesco during the last quarter of the thirteenth century when Margherita came to Cortona.[19]

Although there is no confirmation that the image that Fra Giunta knew remained in the Church of S. Francesco throughout the intervening centuries, the existing crucifix is certainly the one that was carried from S. Francesco to S. Margherita at the head of a solemn procession with the participation, so it is said, of all the people of Cortona, in 1602.[20] Later in the seventeenth century a drawing of this crucifix (Fig. 191), confirmed by witnesses as an accurate record of the sculpture, was included in the evidence considered during the inquiry that eventually led to Margherita's canonization.[21] It was during the same legal proceedings that the watercolor copies of the mural paintings of Margherita's life and miracles that form the core of this study were made. It is salutary to recall that in the seventeenth century the visual material related to or relating Margherita's story was treated by those charged with inquiring scrupulously into the details of that story as a valued source of historical information.

The *Legenda* text presents one version of Margherita, an amalgam of Margherita's own dictation and Fra Giunta's presentation of the material he knew at first hand and had gathered together from others.[22] But it is not the only view. The images to be considered in this book present a sequence of three versions of Margherita's life and significance. Undoubtedly they tell us as much, or more, about those who commissioned and viewed these works—and about the conventions within which they were produced—as they do about Margherita herself. This is valuable information that increases our understanding of the world that Margherita inhabited and influenced. Margherita's story did not, of course, end with her death. On the contrary, her death was the beginning of a new chapter. Within Cortona there was more than one group that wished to use her memory for their own purposes. The *Legenda* presents one such attempt, but its value as a historical source is enhanced if we test it against the other perceptions of Margherita, presented by the visual sources. Thus while the *Legenda* text takes us within the private world of Margherita's cell,

19. If the S. Margherita crucifix is the work to which Fra Giunta referred it would constitute a rare example of the survival of a work of art that once formed the stimulus for the visions of a female Italian mystic. One other surviving example is the stained-glass window in the Upper Church of S. Francesco at Assisi before which Angela of Foligno experienced an ecstatic vision. For this work see, in addition to Frugoni, 1983/1996, J. Poulenc, "Saint François dans le "vitrail des anges" de l'église supérieure de la basilique d'Assise," *Archivum Franciscanum Historicum* 76 (1983), 701–13.

For an introduction to the relation of vision and image in northern Europe, with copious bibliographic reference, see J. Hamburger, "The Visual and the Visionary: The Image in Late Medieval Monastic Devotions," *Viator* 20 (1989), 161–82; for a detailed study of these issues in relation to a single north European manuscript, see Hamburger, *The Rothschild Canticles: Art and Mysticism in Flanders and the Rhineland circa 1300*, New Haven, 1990.

20. ". . . con processione di tutto il Clero e concorso di tutta la Città," in G. Lauro, *Dell'Origine della Città di Cortona in Toscana e sue Antichità*, Rome, 1639; reprinted in the series Historiae Urbium et Regionum Italiae Rariores, n.s., 79, Sala Bolognese, 1981, part II, gathering F; Domenico Tartaglini, *Nuova Descrizione dell'antichissima città di Cortona*, Perugia, 1700; reprinted in the series Historiae Urbium et Regionum Italiae Rariores, n.s., 86, Sala Bolognese, 1986, 130–31; da Pelago, I, 18 n.4.

21. For the various stages in the official recognition of Margherita's holiness, and also for the unofficial terminology used to express her status, see Chapter 2.

22. For a sympathetic and nuanced account of the relation between a hagiographical text, its compiler and its female subject, see J. Dalarun, *"Lapsus linguae": La Légende de Claire de Rimini*, S.I.S.M.E.L., Biblioteca di Medioevo Latino 6, Spoleto, 1994, esp. 445–53.

and speaks to us of a Franciscan viewpoint, the sources presented here place us among the Cortonese gathered outside that cell, looking toward it in curiosity, in awe, and in expectation, and making their own interpretations of the phenomenon in their midst.

The form of this book—the result of a project that developed in unexpected ways—may require a few words of introduction. It began as a study of a set of intriguing seventeenth-century watercolors unexpectedly bound into one of the many records of canonization processes kept in the Archivio Segreto Vaticano, *fondo Riti*.[23] The watercolors were made as copies of a cycle of mural paintings concerning the story of Beata Margherita of Cortona that decorated her burial church in that town and have long since disappeared from view. Our initial plan was to make a comparison between the content of this lost—apparently medieval—cycle of paintings and the written life of the saint. While this comparison has remained at the heart of our study, it has been joined by several related concerns. The relatively straightforward task of comparing a single text with a single series of images has been extended, on the one hand, by considering two earlier series of images of the saint's life, on a panel painting and on her funerary monument, and on the other hand by looking more widely at the scattered evidence for the development of Margherita's cult and the pursuit of her canonization.

At the same time a growing appreciation of the significance of the lost mural cycle, and of the quality of the few fragments that have survived from other frescoes that once deco-

23. The set of watercolors bound into *ASV, Riti* 552, is by no means the only set that survives. A total of seven other sets of watercolors have been located, and are discussed in detail in Appendix II. In addition Kaftal, 1952, col. 672, mentioned a set in the Brera, Milan, that I have not been able to trace. Kaftal did not list any other set of watercolors, nor did he list the scenes shown in the watercolors in his entry on Beata Margherita. The eight sets have not previously been gathered together for comparison, or studied in depth, but individual sets, or scenes from sets, have occasionally been referred to in the literature. Reference has generally been to the two sets now in the Biblioteca Comunale e dell' Accademia Etrusca. Scenes from BC/AE 390 and 429 were reproduced, in black and white, in D. Bacci, *Il Santuario di S. Margherita in Cortona*, Arezzo, 1921. Eleven scenes from BC/AE 429 were reproduced xerographically (and thus, sadly, illegibly) in E. B. Nightlinger, "The Iconography of Saint Margaret of Cortona," Ph.D. diss., George Washington University, 1982, figs. 20–30 (this study unfortunately contains inaccuracies and misinterpretations). Six scenes from BC/AE 390 (although referred to in the text as BC/AE 429) reproduced on small scale in black and white, accompany the entry on Beata Margherita by A. Gianni in the exhibition catalogue *Sante e beate umbre tra il XIII e il XIV secolo: Mostra iconografica*, Foligno, 1986, 112–13. Scenes selected principally from BC/AE 390 have recently been reproduced in color in a guidebook by E.

Mori and P. Mori, *Guida storico artistica al Santuario di Santa Margherita in Cortona*, Cortona, 1996. Selected scenes from BC/AE 429 have also been used to illustrate books and articles concerning Margherita; for example, G. Guerrieri, *Santa Margherita da Cortona nella pietà, nella letteratura e nell'arte*, Cortona, 1977, fig. e; illustration to Fra Giunta Bevegnati, *Leggenda della vita e dei miracoli di Santa Margherita da Cortona*, trans. E. Mariani, Vicenza, 1978, 231; Benvenuti Papi, 1986, 179; S. Pagnotti, *Margherita, 1247–1297*, Turin, 1993.

The location of four further sets has also been noted: M. Salmi, "Postille alla Mostra di Arezzo," *Commentari* 2 (1951), 170 n. 3, mentioned the existence of the Laurenziana set, which he described as a replica of BC/AE 429, without further comment. D. Bornstein, "Pittori sconosciuti e pitture perdute nella Cortona tardo-medioevale," *Rivista d'arte* 42 (1990), 227–28, substantially increased the number of known images by drawing attention to the existence of the three sets in ACC H27, H28, and H29, publishing illustrations of three watercolours from ACC H27. The existence of the set in ASV 552 has not previously been noted, and the set in the Museo Francescano has not, to our knowledge, been discussed (but see the catalogue being prepared by Laura Corti and Riccardo Spinelli for the exhibition *Margherita da Cortona: Una storia emblematica di devozione narrata per testi e immagini* to be held in Cortona in 1998, in which it is planned to include the Museo Francescano watercolors.)

rated the church, encouraged a much fuller art-historical discussion of the works associated with Margherita than had originally been envisaged. Vasari's admiration for frescoes in the church that he reported had been painted by Ambrogio Lorenzetti in 1335, has generally been dismissed or passed over without comment. But we believe that Vasari's evidence deserves to be taken seriously, and that the testimony of the watercolors and fresco fragments, if read with care and attention, constitute a significant addition to our knowledge of early Sienese painting. Accordingly the surviving fragments and the lost frescoes are here presented in detail, in the hope that others—whether students of artistic style, narrative painting, hagiographical iconography, workshop organization among fourteenth-century painters, or of the history of civic cults, of female sanctity or of the spirituality of late medieval women—will have full access to this rich material, previously little known and largely unpublished.

Having been content to follow where the material led us, and in seeking to uncover as much of the evidence as possible, we have produced a book that has in mind a number of audiences. While the reader is invited to examine all the avenues opened by a study of the art, cult, and hoped-for canonization of Margherita of Cortona, in the half-century following her death, the organization of the book allows for a division of interests. Parts III and IV, which set out in detail the arguments for the art-historical importance of the lost decoration of the church, may be primarily of interest to students of that particular discipline. The remaining sections offer a more synthetic view of various historical sources, illustrating our belief that the visual—whether extant or recorded, whether a work of art, a procession, or the body of a saint—is an essential primary source for the historian. In this study, through our consideration of certain aspects of the spirituality and preoccupations of the occupants of a single late medieval Italian town, we hope to have demonstrated the contribution such sources can make to an understanding of the Middle Ages.[24]

24. Among recent stimulating contributions in this field that consider various aspects of late medieval Italian material see the collection of essays in *Malerei und Stadtkultur in der Dantezeit: Die Argumentation der Bilder*, ed. H. Belting and D. Blume, Munich, 1989; for the use of images in dating hagiographical texts, and the role of images in the story of Beata Chiara of Rimini, see Dalarun, 1994; for three fifteenth-century examples of the role of images in both expressing and contributing to a female spirituality and/or sanctity, see D. Russo, "Jeanne de Signa ou l'iconographie au féminin, étude sur les fresques de l'église paroissiale de Signa," *Mélanges de l'Ecole française de Rome, Moyen Age-Temps Modernes* 98 (1986), 201–18; D. Rigaux, "The Franciscan Tertiaries at the Convent of Sant'Anna at Foligno," *Gesta* 31 (1992), 92–98; and, for the remarkable case of the iconographic manipulation of Beata Colomba of Rieti on her deathbed, see the contributions by F. Bisogni and R. Argenziano in the conference proceedings *Una santa, una città*, ed. G. Casagrande and E. Menestò, Perugia, 1990, 239–90.

Part I

Margherita and Cortona

by André Vauchez

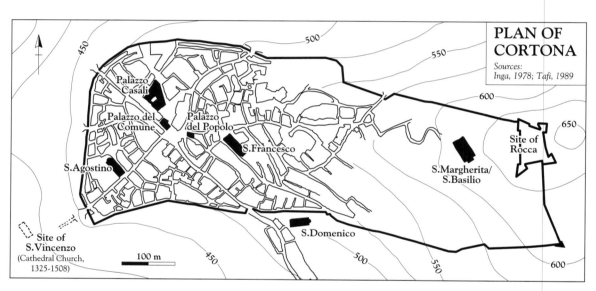

Town plan of Cortona

1

Cortona in the Time of Margherita: Politics and Religion

Cortona's site and buildings make it one of the most picturesque of all the towns of central Italy. And yet a curious fate seems to weigh upon it. Even today its history remains very little known. Admittedly it is not, and never has been, one of the great Italian cities. It would not be unfair to define it as an urban center of middling importance, both now and in the past, with a population that can never have exceeded five or six thousand souls. Yet there are in Tuscany and Umbria a good number of other minor centers whose histories have been far more studied, and which have retained much clearer traces of the luster with which they shone in the time of the communes.

A History That Is Not Easily Accessible

Today a visitor to Cortona is particularly struck by the "cyclopean" walls that formed the enclosure of this Etruscan and subsequently Roman town, situated on the western slope of the Alta di S. Egidio, which rises behind to a height of 1056 meters. The medieval town

is elevated in tiers on steep terraces that stretch from the Church of San Vincenzo, on the lower level, up to the *Rocca*, a fortress situated at a height of 650 meters, which dominates the site. But nothing is known of the history of Cortona between the end of antiquity and the very end of the twelfth century—an obscurity unprecedented among the towns of the area. It is possible, although not certain, that Cortona was the seat of a bishopric between the fourth and the seventh centuries. Weakened, if not ruined, by the Gothic Wars and the Lombard invasions, the town was only able to survive these dark centuries by virtue of its strategic position. It overlooked and effectively dominated the Via Cassia, not far from the place where it was joined by the Perugia to Arezzo road, which skirted Lake Trasimeno and crossed the lower slopes of the Monti Cortonesi. But in the Middle Ages the plain that spread out from the foot of the town scarcely resembled the pleasant landscape of fertile countryside that is seen today. The Val di Chiana and a good part of the *contado* to the northeast of Chiusi were then, and remained until the *bonifica* (land reclamation) of modern times, damp and poorly drained expanses, unhealthy and sparsely populated. Nothing in these lowlands could help promote the rise of a great town. Moreover even in later times Cortona always suffered from its marginal position on the frontier lands between the southeastern edge of Tuscany and the borders of Umbria, which belonged to different political groupings, while its proximity to great episcopal cities such as Arezzo, Perugia, and Siena, undoubtedly also prevented its development.

Various specific misfortunes, accumulating over the centuries, have conspired to make the task of the historians of medieval Cortona particularly difficult: a fire destroyed a good part of the communal archives in 1569; subsequently the main part of what had survived was transferred to Florence; and finally, as far as the monuments are concerned, between the seventeenth and nineteenth centuries many buildings from the time of the commune were destroyed or remodeled, not least the Church of S. Margherita (situated in the upper part of the town and dedicated in the Middle Ages to Saint Basil), which was in large part replaced, between 1858 and 1896, by the neo-Gothic construction that is to be seen today.

At the time when Cortona first appears in the documentary sources it formed part of the county of Arezzo and thus depended politically on the bishop of that town who, in 1052, had received from Emperor Henry III the rights of public jurisdiction within the borders of the diocese.[1] To judge from the evidence, we are dealing at this period with a *castrum* of middling importance that guarded the southern reaches of the Aretine *contado*, extending from Lake Trasimeno to Bacialla near Terontola. A document of 1165 reveals only the existence at Cortona of a parish church, S. Maria, and a suburban church, S. Vincenzo, which belonged, in part, to the Benedictine monastery of SS. Flora e Lucilla near Arezzo. During the eleventh and twelfth centuries the region seems to have been dominated by a number of great aristocratic families who were settled in the countryside, particularly those of the *Marchiones*, or marquises "del Monte S. Maria." There is also mention around Cortona of the Benedictine monasteries of Farneta, in the Val di Chiana, of Petroio and of Mon-

1. On this document and its importance for the history of Arezzo and its *contado*, see J.-P. Delumeau, *Arezzo, espace et sociétés, 715–1230*, Ecole française de Rome, 1996, 264–303. I should like to thank my colleague J.-P. Delumeau for having allowed me to use various maps taken from his doctoral thesis.

temaggio toward Città di Castello, and of the Camaldolese foundation of S. Giovanni di Villamagna, or "de' Fieri," on Monte Sant'Egidio.[2]

From the Commune to the Signoria: The Troubled Origins of Cortona's Political and Ecclesiastical Autonomy

Cortona enjoyed a certain flowering during the first half of the thirteenth century without, however, being able to shake off its status as a "quasi-city," due to its being the seat of neither a bishop nor a count. This in large part explains the delays and difficulties that were experienced in achieving municipal autonomy. Nevertheless at this period, thanks to economic growth and to an alliance with Perugia that lessened the domination of Arezzo, Cortona increased its prosperity and developed following a process common to the majority of central Italian towns. Behaving in the manner of the great autonomous communes, from the early thirteenth century the civic powers of Cortona launched themselves on a vigorous policy of subduing the neighbouring countryside: as a result the rural lords were obliged to establish themselves within the town. This, however, allowed them to become integrated with the civic oligarchy whose economic and political dominance had not yet been challenged. From among these "magnates" were recruited the membership of the councils and other administrative and judicial bodies that governed Cortona and made the annual choice of a foreign *podestà* to ensure order and justice. But two factors soon disturbed this harmonious scene. One was internal, and consisted of the appearance and affirmation, in the very heart of the town, of the *Popolo*, a grouping formed, as elsewhere, out of the new social strata that had been enriched by economic activity but excluded from power, and who, from 1230 to 1240 onward, asserted their right to participate in the exercise of that power. The other disruption was external and took the form of a renewal of antagonism with Arezzo, whose bishop had every intention of preventing Cortona achieving political autonomy. In about 1250 the *Popolo* succeeded in having its rights recognized and was included by the magnates in the government of the town; the *Popolo* built a palace for themselves and divided the town into three *terzieri*. But this did not prevent further conflicts from growing between various parties; those who were excluded from power, and sometimes from the town, did not hesitate to call for external intervention so as to take their revenge on their political opponents.[3]

These appeals became a dangerous game once Guglielmino degli Ubertini became bishop of Arezzo (1248–89). He was a political opportunist and veritable warlord—against

2. For the formation of the *contado* of Cortona and the origins of the communal regime, see B. Gialluca, "La formazione del comune medioevale di Cortona," in *Cortona, Struttura e storia: Materiali per una conoscenza operante della città e del territorio*, G. Cataldi et al., Cortona, 1987, 239–73.

3. The only general work on the history of Cortona in the medieval period is that of G. Mancini, *Cortona nel Medio Evo*, Cortona, 1897 (2d ed., reprint, Rome, 1969). This work is well informed but often confused and difficult to use.

whom Beata Margherita directed terrible curses shortly before his death—and he put into effect the threats his predecessors had leveled against Cortona.[4] Since at least 1230 the bishops of Arezzo had been trying to reclaim from the town, by virtue of their dual privilege as counts, a half share in Cortona's *regalia*, that is to say, in all the rights of public origin (*dazi*, fines, profits of justice, grain tax)—income that had been appropriated by the town. Cortona was struck with excommunication by Gregory IX in 1235 for this diversion of funds, and subsequently placed under interdict; it then became passionately Ghibelline (that is, antipapal) and remained so until the beginning of the fourteenth century. Emperor Frederick II was received within the walls of Cortona in 1240, at a time when Arezzo had a Guelph (that is, anti-imperial and pro-papal) bishop. Frederick II had him assassinated in 1248, but his successor—the terrible Guglielmino—pursued a pro-papal and pro-Florentine policy at the beginning of his career. With the support of exiled Cortonese magnates who had taken refuge in Arezzo, and of the commune of Arezzo, Bishop Guglielmino's troops succeeded in entering Cortona in 1258: the town was pillaged and partially razed to the ground. A good part of the population fled, taking with them the relics of Beato Guido (d. 1247), a holy companion of Saint Francis and native of the town. Among the exiles were to be found numerous members of the *Popolo*, but also some aristocratic families, such as the Casali, who appear here for the first time in the history of the region in the person of the first Uguccio, whom a deep-rooted but unverifiable local tradition has wanted to see as the protector and benefactor of Margherita.[5] Having taken refuge at Castiglion del Lago, these Cortonese, several hundred in number, fought beside the victorious Sienese at the battle of Montaperti (1261). The victory of the Ghibellines, which altered the political balance of central Italy, persuaded Arezzo to change camps and demonstrate goodwill toward Cortona. The exiles were allowed to return to their homes in that year, and a reconciliation took place between the two rival factions in the town as it rose from its ruins. Yet it was still necessary to accept the harsh rule of the bishop, relayed by the commune of Arezzo, which imposed on Cortona the payment of a heavy tax. In this period Uguccio Casali seems to have been one of the principal architects of a policy of reconciliation toward Bishop Guglielmino, and to have guided the commune in receiving the fugitive Sienese Ghibellines in 1270. Yet the internal conflict in Cortona was rekindled when the commune, perceiving the situation to be turning decisively in favor of Charles of Anjou and the Guelphs, expelled those same exiles from its walls in 1273. The bishop of Arezzo, who had become the chief champion of the Ghibelline cause in eastern Tuscany, was embittered by this act and relaunched hostilities against Cortona. It is within this troubled and turbulent setting that Margherita played a role as mediator between the bishop and the town which, in 1277, resulted in a peace agreement.[6]

4. Giovanni Villani said of him that he was "più uomo d'arme che d'onestà di chiericia" (VIII, cx, in the *Nuova Cronica*, ed. G. Porta, Parma, 1990 I, 575 and VIII, cxxxi, 602.) This is confirmed by the strong reproofs which Margherita directed at him, *Legenda*, IX, 43–45.

5. On the links between Margherita and the Casali, both during her lifetime and after her death, see F. Cardini, "Una signoria cittadina 'minore' in Toscana: I Casali di Cortona," *Archivio storico italiano*, 131 (1973), 241–55.

6. *Legenda*, IV, 4.

During the last decades of the thirteenth century the internal history of Cortona was marked by two concurrent phenomena: the growth of conflict between the magnates and the *Popolo*, and the rise of the Casali, an aristocratic family that had been able to maintain good relations with the "popular" party. Uguccio Casali, "prior of consuls and guilds," was at that time one of the most influential people in the town and his reputation passed to his son Guglielmino Casali, who may be the person to whom, according to a local chronicler, Margherita addressed the words "Ecco il cavaliere santo!" (Behold the holy knight!). No doubt it was also to him that Margherita is said to have predicted that soon Cortona would no longer be under the domination of foreigners and that it would become a "new Jerusalem."[7] After the death of Bishop Guglielmino degli Ubertini, killed by the Florentines on the battlefield at Campaldino in 1289, his successor to the see of Arezzo, Ildebrandino (1289–1312), was a less political individual, who took care to maintain good relations with Cortona. It was he who granted in 1290, at Margherita's request, an indulgence to those assisting in the reconstruction of the Church of S. Basilio, beside which Margherita had just established her cell.[8] But the real architect of the rise of the Casali family was Ranieri, son of Guglielmino, who knew how to achieve power by exploiting both the tensions between the magnates and the *Popolo*, and the Cortonese aspirations for independence from Arezzo. An alliance with the Florentine *Bianchi* and the Holy See—the papal legates Cardinals Niccolò da Prato, O.P. and Napoleone Orsini came to Cortona several times between 1305 and 1308—strengthened the diplomatic standing of the small town. It is within this context that the *Legenda* of Margherita, compiled by the Franciscan Giunta Bevegnati, was officially approved at a meeting that took place at the Casali palazzo, on 15 February 1308, in the presence of the highest civil and religious authorities of the region.[9]

The descent of the Emperor Henry VII into Italy, in 1312, did not put an end to this period of reconciliation even if Cortona, remembering opportunely its Ghibelline traditions, gained recognition from the young emperor as a direct dependency of the empire,

7. "Di meser Uguccio rimase meser Guglielmino, che medesimamente fu un savio cavaliere et da bene et saggia persona, il quale, quando santa Margherita stava nel Poggio di Cortona a fare penitenza, l'andava spesso a visitare et lei, come lo vedeva, diceva: "Ecco il cavaliere Santo." Onde lui gli fece chiedere grazia a Dio che Cortona non venisse più alle mani de forestieri, il che Iddio gli concesse. Santa Margherita diceva: 'Ella sarà Gerusalem novella'; e cosi confermò santa Margherita a meser Guglielmino," *Cronache cortonesi di Boncitolo e di altri cronisti*, ed. G. Mancini, Cortona, 1896, 19. L. da Pelago maintained that this prediction was addressed to Uguccio, not to Guglielmino Casali.

8. L. da Pelago, *Registro di documenti spettanti alla leggenda di S. Margherita* in *Antica leggenda della vita e dei miracoli di S. Margherita da Cortona*, Lucca, 1793, II, no. 3, 160. Father Lodovico Bargili da Pelago (1724–95), lecturer in theology and Franciscan scholar formed in the tradition of Muratori, applied himself to the collection of

all the material available at that time on the life and cult of Santa Margherita in Cortona. In addition to the above-mentioned work, published without the author's name, we also owe to him an important compilation of documents arranged and discussed in chronological order, entitled *Sommario della storia della chiesa e convento di Santa Margherita di Cortona, compilato e disposto per ordine cronologico dal P. Fra Lodovico da Pelago . . .* , 1781 (hereafter cited as da Pelago, *Sommario*). This work remains unpublished but two manuscript copies exist, one in the convent of S. Margherita in Cortona and another in the Archivio provinciale of the Friars Minor in Florence. (Since the page numbering of these two versions does not agree, references are given here *ad annum*, rather than to specific pages.) It was possible for me to have access to this work thanks to the kind and productive intervention of Céline Perol. For the work of Father Bargili da Pelago, see Iozzelli, 1993, 217–19.

9. This text has been edited by da Pelago, I, 340; Iozzelli, 1997, 477–78.

while Ranieri Casali received the title of imperial vicar, and the surrender imposed on the town by the bishop of Arezzo in 1261 was declared null and void. During the years 1319–25 the "popular" party exercised power in Cortona and drew up a set of communal statutes. But the expulsions of the magnates that Ranieri Casali carried out, and the population's fear of seeing the city fall into further internal crises enabled Ranieri to have himself recognised as *Dominus generalis* for life of the fledgling commune.[10] At exactly the same time the ambitions of Guido Tarlati, bishop of Arezzo (1312–26), who became lord of Arezzo in 1321, and the policy of territorial expansion on which he embarked under the most ardent Ghibelline banner, encouraged a new rapprochement between Cortona and Perugia, Florence, and Pope John XXII. When the pope excommunicated the bishop of Arezzo in 1324 Cortona took the opportunity to declare its independence, gaining support from the Ubertini, an important Aretine family who were enemies of the Tarlati and allies of the Casali. On 18 May 1325, John XXII in turn annulled the agreements that had bound Cortona to the bishop of Arezzo and released it from any obligation toward him, starting with the tax of one thousand gold florins that the town had been obliged to pay him each year. On the following day another papal bull, issued from Avignon, created a new diocese with Cortona as its chief town, and the Church of S. Vincenzo in Cortona as its cathedral (an arrangement that applied from 1325 to 1508, at which date the Pieve of S. Maria took over this function).[11] Its territory, which virtually coincided with that of the contado of Cortona, was composed of parishes taken from the dioceses of Arezzo, Chiusi, and Città di Castello. Its first bishop was Ranieri, papal chaplain and member of the Ubertini family, whose support had enabled Cortona to break the ties that had previously bound it to Arezzo.

These momentous events constituted a success also for the Casali, whose definitive assumption of power coincided with the recognition of Cortona's complete autonomy. They were to maintain this power until 1409, when the last of them, Aloigi Casali, was taken prisoner by King Ladislas of Naples. But from 1387 onward Cortona entered the orbit of Florence, to be eventually absorbed, together with her territory, in 1411. From then on the history of Beata Margherita's town merges first with that of the Medicean city-state, and then with that of the grand duchy of Tuscany.

Under the Sign of Saint Francis

Before it found itself provided with a bishop and a cathedral chapter Cortona had already become, during the course of the thirteenth century, an important religious center under the influence of the mendicant orders. By around 1300 they had established at least four convents in the town: that of the Dominicans, outside the walls (only constructed in c.

10. See F. Cardini, "Agiografia e politica: Margherita da Cortona e le vicende di una città inquieta," *Studi francescani* 76 (1979), 127–36.

11. The bull establishing the diocese of Cortona (*Vigilis speculatoris*), of 19 June 1325, is published in da Pelago, II, *Registro*, no. 14, 169–70.

1290), and, within the walls, those of the Augustinian Hermits, the Servites (in existence in 1288), and the Friars Minor.[12] Of all the new orders, these last seem to have taken root most strongly in this town where their influence was considerable and of long standing. Saint Francis of Assisi had come himself to Cortona in 1211, and among his first disciples are numbered two friars, both called Guido, natives of the town, of whom the more famous was the Beato Guido who died in about 1247 in the odor of sanctity. This last soon became a highly venerated local saint, as is shown by the mention of his feast in the calendar of celebrations solemnized by the commune, in the communal statutes of 1325.[13] During one of his visits to Cortona, Saint Francis had received a piece of land in the woods some four kilometers from the town. On this mountainside site he built, with his companions, a dozen huts. This hermitage of the Celle, where the cell of Saint Francis can still be seen today, was the third fixed foundation of the newly formed fraternity, following Rivotorto and the Porziuncola in the environs of Assisi. Francis stayed there for the last time in May and June 1226, after the "cure" the papal physicians had inflicted on him at Rieti had succeeded only in ruining his health. It was from there that he set out, under escort, to reach Assisi some weeks before his death. After he had passed away, Brother Elias (called "of Cortona" even if he does not seem to have been a native of the town, and minister general of the Friars Minor from 1232) had a large convent built at the Celle where he liked to reside and which his enemies were later to reproach him with having made too comfortable.[14] Deposed by the General Chapter in 1239, and excommunicated by Pope Gregory IX after he rallied to the cause of Emperor Frederick II, Elias only reconciled himself with the church on the eve of his death. After having made confession and received communion from the hands of the archpriest of Cortona, he died on 22 April 1253. Some years earlier, between 1245 and 1250, he had instigated the foundation of another Franciscan convent at the very heart of the town dedicated, as was proper, to Saint Francis. This was where the majority of the friars settled. Elias deposited there a fragment of the True Cross, which had been given to him during a diplomatic mission that he had undertaken to Constantinople on behalf of the emperor.[15] Nonetheless a certain number of friars, opposed to this *inurbamento*, remained in the convent at the Celle, which was to become, at the end of the thirteenth century, one of the main centers of the Spiritual movement within the Franciscan Order, bound to the original ideals of complete poverty and the eremitical life. A community of Clare Nuns was also established, between 1225 and 1237, in the monastery of Targia, or Targe, situated near the town cemetery, outside the walls;

12. See the plan of medieval Cortona (page 10).

13. For this individual, see G. Odoardi, *s.v.* "Guido da Cortona, beato," *Bibliotheca Sanctorum*, VII, Rome, 1966, cols. 505–8. His fourteenth-century *"Leggenda volgare"* is edited in B. Frescucci's "L'eremo delle Celle," in *Le Celle di Cortona eremo francescano del 1211, aa.vv.*, Cortona, 1977, 20–30. On his cult, see A. I. Galletti, "I francescani e il culto dei santi nell'Italia centrale," *Francescanesimo e vita religiosa dei laici nel 200, Assisi*, 1981, 353–59. For Guido's tomb, see Chapter 6, note 58, and Figs. 89–91.

14. Salimbene de Adam, *Cronica,* ed. G. Scalia, I, Bari, 1966, 147.

15. This cross, which is in fact a staurotheke, and the inscription it bears have recently been very precisely analyzed by A. Guillou, *Recueil des inscriptions grecques médiévales d'Italie*, Ecole française de Rome, 1996, 16–18 and pl. 5.

this existed until 1581, the date at which the community was transferred inside the town walls, into the monastery, which took the name of S. Chiara.[16]

But the greatest originality of Cortona, in the Franciscan domain, was undoubtedly to be found in the importance that lay religious movements enjoyed there, particularly the Order of Penitence, which became officially, from 1289 onward, the Third Order of Saint Francis. The penitential ideal and the lay penitents' form of life were not, it is now well known, an invention of Saint Francis or of the mendicant orders. Indeed, from the end of the twelfth century, penitents—either isolated or in communities—had increased rapidly, especially in Italy. These penitents aspired to lead an authentically religious life while at the same time remaining within the secular world.[17] The majority of them were married people who, without renouncing the conjugal life, committed themselves voluntarily to privations and devotional exercises and also to the practice of sexual continence during certain periods or important moments in the liturgical year. Contemporary texts often called them "the continent ones." They formed confraternities of men and women, living according to a rule entitled *Propositum fratrum et sororum de Poenitentia in domibus propriis existentium*, of which the earliest known version—that which was adopted by the Penitents of Romagna—dates from the years 1215 to 1221 and was subsequently enriched with various additions.[18] Local fraternities were at that time autonomous and administered themselves under the direction of a priest and lay officials. But it is undeniable that with the advent of Saint Francis and of the mendicant orders the penitential movement received a decisive impetus: had not the *Poverello* himself begun by creating a confraternity of penitents, at Assisi, in the years 1207–8? At all events, his itinerant preaching and that of his companions was entirely orientated toward penitence, understood as a type of Christian behavior appropriate to all walks of life. "Let us therefore have charity and humility; and let us give alms, for these wash the soul of the stains of sin. . . . We must also fast and abstain from vice and sin, and from excess in food and drink, and be catholics," he wrote in his *Letter to the Faithful*.[19] This letter gathers together a number of exhortations that certainly seem to be directed at the laypeople who had joined the *ordo poenitentiae*. Besides the communal penitents who took part in the activities of a confraternity there were also private forms of penitence, from enclosure in a cell adjoining a church or cemetery (the *cellane* or *incarcerate* often mentioned in Italian communal statutes), to the very flexible forms of urban eremiticism, which combined a life of retreat dedicated to prayer and penitential practices in the setting of a private house, with acts of charity to the poor and sick

16. See G. Inga, "Gli insediamenti mendicanti a Cortona," *Storia della città*, 9 (1978), 42–52; and, in particular, F. Iozzelli, "I Francescani ad Arezzo e a Cortona nel Duecento," *Quaderni di vita e di cultura francescana*, Florence (1991), 121–42. For the problems that settlement within urban centers posed for the Franciscans, see A. Vauchez, *Ordini Mendicanti e società italiana, XIII–XV secolo*, Milan, 1990, 279–82. For the Clares, see S. Mencherini, "Le Clarisse in Cortona. Documenti inediti del sec. XIII," *La Verna* 10 (1912–13), 330ff.

17. For the penitents in Italy and their history, see

Meersseman, 1961/1982, and for a brief introduction Vauchez, 1984 (see also Vauchez, 1993; 119–27).

18. This text was published and discussed by Meersseman, 1982, 91–112.

19. *Epistola ad Fideles II*, 30 and 32, "Habemus itaque caritatem et humilitatem; et faciamus eleemosynas, quia ipsa lavat animas a sordibus peccatorum. . . . Debemus etiam ieiunare et abstinere a vitiis et peccatis et a superfluitate ciborum et potus et esse catholici," *Opuscula sancti Patris Francisci Assisiensis*, Bibliotheca franciscana ascetica medii aevi, 12, ed. C. Esser, Grottaferrata, 1978, 119.

outside. A very representative example of this second form of penitential life is provided by the life of Beata Umiliana dei Cerchi (d. 1246) who, having been widowed, lived in this condition, under the spiritual direction of the Franciscans of Florence.[20] But the most famous personality of the female pentitential movement of the Franciscan obedience in Italy was without doubt Margherita of Cortona (d. 1297), whose biographer did not hesitate to designate her "the third light of the Order of Saint Francis," after the *Poverello* himself and Saint Clare of Assisi.[21]

20. See A. Benvenuti Papi, "Umiliana dei Cerchi: Nascita di un culto nella Firenze del Duencento," *Studi francescani* 77 (1980), 87–117, reprinted in Benvenuti Papi, 1990, 59–98.

21. *Legenda,* ix 61; Iozzelli x, 9. See Benvenuti Papi, 1990, 141–68, and Rusconi, 1991. On the close links that Margherita maintained during her lifetime, with the Franciscans of Cortona, see E. Magrini, "Margherita in ambiente francescano," *Cortona a Santa Margherita nel settimo centenario della "conversione" (1272–1972),* Cortona, 1973, 77–85. See also d'Alatri, 1982.

2

The Life and Cult of Margherita of Cortona

The Story of a Soul and of a Body

As far as written documents are concerned, we would know virtually nothing about Margherita of Cortona if we did not possess her *Legenda*. This was composed by one of her Franciscan confessors, Fra Giunta Bevegnati, between 1297 and 1307, on the basis of notes he had made following conversations that he himself had with the saint or that other friars or members of the clergy transmitted to him. The original text, which comprised eleven chapters, was publicly approved by Cardinal Napoleone Orsini on 15 February 1308, in the Casali palazzo in Cortona, after it had previously been revised and approved by several local and provincial superiors of the Franciscans of Tuscany.[1] It was then "preached"—doubtless in an abbreviated form—by various Franciscans, among whom is mentioned Ubertino da Casale, at that time a chaplain and member of the household of Cardinal

1. As shown by the record of the approval of the *Legenda*, which is found in the smaller and more complete of the two manuscripts skill kept in the Convent of S. Margherita (cod. 61); see da Pelago, I, 340–42.

Napoleone.[2] This text was subsequently augmented, between 1308 and 1311, by the addition of a further chapter, containing only accounts of miracles—material that had been virtually absent from the original *Vita* text. Doubtless this addition was made in order to facilitate the canonization of Margherita, a goal to which the civil authorities of Cortona aspired just as much as the Franciscan Order.

The Life of Margherita compiled by Giunta Bevegnati seems to have enjoyed a strictly limited diffusion: only three medieval copies of the text are now known to exist, all of them still in Cortona. Only one of these—a manuscript of small format that is to be found in the Franciscan convent attached to the Church of S. Margherita (cod. 61)—contains the last chapter, concerning the miracles. This chapter does not appear in the printed text prepared by the Bollandists in the third volume for February of the *Acta Sanctorum*.[3] The *Legenda* takes the form of a very lengthy spiritual biography. It is divided into chapters following a scheme that combines an account of certain events of Margherita's life with a relation of the principal stages in her spiritual itinerary. The author evokes, in turn, her dissipated and worldly youth, and then her spectacular conversion, following her arrival in Cortona. This made of her a "new Magdalene," in other words a penitent drawn into the Franciscan orbit and marking herself out through the austerity of her way of life, her humility and self-disdain, as well as through a vehement and passionate devotion to the Passion of Christ. The author then describes her zeal for prayer and the importance that she attached to preaching, the intensity of her sacramental life, her active pity for the underprivileged and her care for the salvation of souls. The last part of the account is dedicated to the description of her supernatural gifts: clairvoyance and the ability to see into people's souls; mystical phenomena that accompanied her ecstatic visions; and lastly her death at the end of a final battle against the devil who, right up to the end, tried to make her renounce the sufferings and privations she had voluntarily inflicted upon herself.

Fra Giunta's work takes the form of a series of conversations between Christ and Margherita, reported in direct speech, whose essential purpose is to show Margherita's progress in the love of Jesus, who spoke to her in the form of a crucifix, appeared to her in the Eucharist, and filled her with supernatural grace. Chronological indications appear only fortuitously and tangentially: the author's aim was clearly not to write a piece of history. These

2. Ibid., 340, "frater Ubertinus de Janua etiam eam predicavit." Ubertino da Casale had certainly known Margherita and had encountered her several times during her lifetime.

3. The Life of Margherita by Fra Giunta (*Bibliotheca hagiographica latina antiquae e mediae aetatis*, 2 vols., Brussels, 1898–1901, 5314) was edited, rather poorly, in the *Acta Sanctorum* (*AA.SS Febr.*, III, 300–356, Paris ed.). The eleventh chapter, concerning miracles accomplished by Margherita, is missing from this edition. This chapter is found in an incomplete version, in only one fourteenth-century manuscript: Cortona, *Archivio del convento di S. Margherita*, 61. In later manuscripts, chapter x was divided into two parts (x and xi), so that the miracle chapter consequently became chapter XII of the *Legenda*. See Iozzelli,

1993, with critical edition of the miracle chapter, 261–76. The full text of the *Legenda* was published by da Pelago, I, 15–339. The *Legenda* text was republished without changes, under the same title, by E. Crivelli, in Siena, in 1897. A critical edition of the Latin text of the *Legenda* has recently been completed by Father Fortunato Iozzelli Iuncta Bevegnatis, *Legenda de vita et miraculis beatae Margaritae de Cortona*, Bibliotheca franciscana ascetica medii aevi 13, Rome, 1997. The miracles recorded during the inquiry held with a view to Margherita's canonization (Cortona, 1629–40), which testify to the influence of an oral tradition, were published by O. Montenovesi, "I Fioretti di Santa Margherita di Cortona," *Miscellanea francescana* 56 (1946), 234–93.

indications are, nevertheless, very valuable since they alone allow us occasionally to anchor the ascetic and mystic itinerary of Margherita within the local political and religious context, and to establish an approximate chronology.

The first part of the life of Margherita is that about which we are the least well informed, since it constituted, in the eyes of her biographer, the scandalous part of her existence, on which it was not suitable to dwell. We do, however, learn that Margherita was born in the village of Laviano, in the diocese of Chiusi, not far from Lake Trasimeno, in about 1247. She came from a family of relatively prosperous peasants. We know, through the account of a miracle, that she had a brother called Bartolo who left for the Holy Land in about 1307 or 1308 and only survived a violent storm thanks to the intercession of his late sister. Margherita's mother died when she was eight years old. Brought up, subsequently, by a stepmother who took no interest in her, she seems to have had an unhappy family life. An attractive young woman, she was very soon courted and fled one night from the paternal home in order to join a young noble, to whom an unconfirmable tradition has given the name Arsenio del Monte, lord of Valiano. After Margherita's conversion, Christ was to remind her of that tragic night when she almost lost her life, crossing the marsh of Chiana, in order to rejoin her seducer. She then lived with him for nine years in Montepulciano, in wealth and luxury, and had a son by him. But this liaison ended tragically one day when—if a later tradition is to be believed—she discovered the blood-soaked body of her lover, who had been murdered by his enemies. Expelled from his palazzo, for she was only a concubine and could not lay claim to any rights, she returned to her father's house with her son, then about six or seven years old. But her stepmother soon drove her out and it was then that she took the decision to make her way to Cortona, some dozens of miles away. Entering the town through the Porta Berarda, she was taken in, together with her child, by two pious women, Marinaria and Raineria, who established the pair in a small room in their house. Margherita began to earn a living as a midwife.

This moment, evoked so often in the *Legenda*, which must have occurred at some point between 1272 and 1274, marked the start of a new existence, set beneath the sign of repentance and conversion: until her death, indeed, the former sinner lived in the fear and even the anguish of being unable to atone for a past that she had striven in vain to forget, but that clung both to her body and to her memory. She soon went to see the Franciscans of the Convent of S. Francesco, established *intra muros* since 1247–50, where she was received and supervised first by brother Giovanni da Castiglion Aretino, who later became head of the Arezzo custody, and subsequently by several other friars, including Fra Giunta. A devotee of Saint Francis, she asked to be admitted to the Order of Penitents, but the friars seem to have been, at least initially, unwilling to grant this request in view of her checkered past and no doubt also her excitable character, which made some of them uneasy. Eventually, in 1275 she was authorized to take the habit of the Franciscan Third Order while her son, who had reached the age of twelve, entered the Franciscan house in Arezzo as a novice.

From then on she was to divide her life between prayer (not knowing Latin, she recited the Pater Noster, Ave Maria and Gloria Patri many dozens of times at each of the hours),

the adoration of the cross in the Church of San Francesco, and works of charity toward the needy. Thanks to the help of an anonymous benefactor, she was able to transform a private house into a hospice, or *domus misericordiae*, for the poor and sick. According to a document of 1421, she was the founder, in 1286, of the *Fraternitas Sanctae Mariae de Misericordia*. This charitable lay confraternity met at the Church of Sant' Andrea and initially had as its prior the priest Ser Badia, who was to be the saint's last spiritual director.[4] Although no documentation survives, Margherita must certainly have had close links with the *Fraternitas*, which was later associated with the cult accorded to her in the sanctuary of San Basilio.[5]

During these years she lived in a *cella*, a modest habitation or retreat situated close to the house of her benefactors and to the Convent of S. Francesco which she frequently attended. She often gave food to poor beggars who came to her. From this time on she was evidently joined by several other pious women, mentioned in the *Vita* by the title *sorores*, who must have followed a way of life similar to hers.[6] But her reputation for sanctity, which continued to grow both in Cortona and in the surrounding area, impelled her to leave the lower town so as to find some solitude—albeit relative—elsewhere.[7] Many people did indeed seek her out in order to ask her to effect cures or to be godmother to their children. This disturbed her daily existence, which she wished increasingly to devote to prayer and contemplation. Thus in about 1288 she moved to another cell, situated in the upper part of the town, just at the foot of the ramparts of the fortress, or "Rocca," built by the Aretines in 1258, next to a small, ruined, church dedicated to Saints Basil, Giles (Egidio), and Catherine.[8] Margherita's Franciscan confessors seem to have long opposed her desire for isolation, but since the Franciscan provincial chapter which met in Siena in 1288 had, it seems, criticized the closeness of the relations that existed between the Friars Minor of Cortona and this exceptional penitent, the friars must have yielded to and granted her wish. They did, however, make her promise that after her death her body would be buried in the church or cemetery of San Francesco.

4. The statutes of the *Fraternitas Sanctae Mariae de Misericordia* have been published in da Pelago, II, *Registro*, no. 2, 150–54.

5. The association between Margherita, the activities of the hospice, and of the confraternity were forcefully illustrated in the mural recorded in watercolor no. XV (Pl. XXV). See Chapter 14.

6. This was the case, in particular, for Sister Margherita of Siena: see *Legenda*, XI, 8; Iozzelli x, 8.

7. Christ was to declare to her (*Legenda*, III, 2): "Et quamvis te in desertum non destinem, cum deserta non sint his apta temporibus, ita silvestris maneas intra terram, sicut si in vasts deserta maneres."

8. For the history of this church from its origins to the present day, see D. Mirri, *Cronaca dei lavori edilizi della nuova chiesa di S. Margherita in Cortona*, rev. E. Mori, Cortona, 1989, as well as Mori and Mori, 1996, a brief survey that unfortunately lacks any reference to sources. For many additions and some corrections to the information contained there concerning S. Basilio and the construction and decoration of the new church in the fourteenth century, see below, esp. Chapters 3 and 4. See also M. Bertagna, "Intorno all'origine del convento di Santa Margherita in Cortona," *Studi francescani* 72 (1975), 125–32. The Church of S. Basilio, probably built at the end of the episcopate of Jerome of Arezzo (1142–75) was in ruins after 1258, as is shown by the agreement concluded in 1269 between Bishop Guglielmino degli Ubertini and the prior general of the Camaldolese ("restituit [episcopus] situm ecclesiae Sancti Basilii et jus mortuarium et parocciam ipsius"). See *Annales Camaldulenses*, Venice, 1765 v, Appendix, 106–13. One must suppose that the Camaldolese subsequently ceded it to the Commune of Cortona, who were the owners in 1290, as is shown by a document cited by da Pelago, *Sommario, ad annum* 1636. I thank Cécile Caby for having kindly supplied me with this information.

In 1290 Margaret obtained from the new bishop of Arezzo, Ildebrandino, the concession of an indulgence of forty days for those who helped in the rebuilding of the Church of San Basilio.[9] The church was at this time under the patronage of the commune, which did not have sufficient funds to repair the considerable damage it had suffered during the siege and the capture of Cortona by the Aretine troops in 1258. But the restoration work must already have been underway by 1290 since in September of the same year a rector was charged with serving in the little church which, in the absence of parochial status—it was a simple *oratorium*—constituted a benefice *sine cura*. This rector was a member of the secular clergy, Ser Badia, who knew Margherita well. He became her spiritual director in place of Fra Giunta who had been sent to the convent of Siena in 1289 or 1290 and did not return to Cortona until the saint's death was imminent. But the two men seem to have had no difficulty in collaborating; Fra Giunta tells us in the *Legenda* that the priest sent him letters that kept him informed about his conversations on spiritual matters with Margherita and about the doubts that assailed his penitent. She died finally at about fifty years of age on 22 February 1297. The commune and the rector had her remains placed in San Basilio, not in the church of the Franciscans—a circumstance to which the friars were never reconciled.[10] From a certain point of view Margherita's *Legenda* by Fra Giunta could be considered an exercise in the spiritual reconquest of her sanctity and a demonstration of her Franciscan allegiances, put forward at the very moment when her body had just eluded the friars.[11]

Mirror of Sinners and Glory of the Franciscan Order

Whereas the plan of the *Legenda* is complex and not always clear in its detail, the general intention of the work is perfectly obvious. God chose Margherita, Giunta writes, to be a mirror for sinners (*Speculum peccatorum*), so as to show his infinite mercy.[12] The biographer places the emphasis both on her moral downfall—her wanton youth is evoked in the blackest terms, as in Thomas of Celano's *Vita Prima* of Francis of Assisi seventy years earlier—and at the same time on the wonders worked in her through divine grace. Indeed, despite her unworthiness, Jesus Christ has not only pardoned her sins, but has chosen her as "daughter" and "spouse," so as to show to her male and, in particular, to her female contemporaries that repentance is always fruitful and that, however deep in sin one may be, it is always possible to wrest oneself from its grasp.

But another intention also appears on every page of the work: that of exalting the Franciscan Order and its providential function in the history of salvation. Thus Margherita's biographer does not hesitate to make Christ say: "The Friars Minor are the most useful

9. da Pelago, II, *Registro*, no. 4, 160.

10. For detailed discussion of the location and form of this burial, see Chapter 4.

11. As is clearly shown in Benvenuti Papi, 1986.

12. *Legenda*, V, 15: "Ego (= Christ) enim in speculum peccatorum vocavi te ad poenitentiam, sicut Beatum Matthaeum publicum peccatorem," and VII, 20: "scalam peccatorum te feci, ut per exempla vitae tuae pergant ad me."

fishers of souls in the world today. Their zeal makes their Order more pleasing to me than any other in my Church. I have founded it and planted it. May they thus strengthen themselves through the bonds of mutual love! No one may come to me except by the way of love. There is in the world no better school of love than this Order."[13] Among the cases of moral debate on which the friars asked Margherita to ascertain the opinion of her master appears the problem of recruitment: Ought one to recruit widely or to be restrictive? Here again the reply is very simple: "The friars should not be afraid to receive favorably those who wish to join them. If postulants intend to remain chaste and to chant the Divine Office, the convent doors should be opened to them; and even if they dream only of fleeing the crimes of the world, its treacheries, its scandals and its vices, they should still be admitted."[14] Francis himself is not only a very great saint: Christ reaffirms to Margherita that he has taken the place left empty in heaven by Satan and that he is seated there on the highest throne;[15] Christ even says that he finds no fault in the declaration that "Francis is like a new God," the "restorer of the faith and of my Church," for, he says, "I have made him like me as to certain privileges, and his disciples are more numerous than mine were."[16] Claims made with such assurance are reminiscent of a Franciscan milieu that might be characterised as "Bonaventurian." In this work the emphasis is certainly not placed predominantly on poverty. Fra Giunta says that he forbade Margherita to beg or to return to those places where she had lived in opulence so as to call to conversion those who had formerly known her. Emphasis is given instead to the providential and at the same time eschatological function of the seraphic family: the Order is like a Noah's ark and all those who enter it and bind themselves to it will be saved. In these circumstances it is understandable that Ubertino da Casale, who had in fact met Margherita and had no doubt discussed with her the problems of the Order (as had, moreover, Conrad of Offida, another leader of the Italian Spirituals) does not mention her in his *Arbor vitae,* composed at La Verna in 1305, although he gives a great deal of space to her contemporary and neighbor Angela of Foligno, who was much closer to the antiestablishment currents. Margherita, supporting the unity of the Friars Minor, was the spiritual daughter of the Franciscans of the local convent who favored the apostolic mission and in particular the preaching of which she ceaselessly speaks, not of the Franciscans of the Celle, who several years later, in 1311–12, were to be the first to rebel against the hierarchy of the Order and against the papacy.[17] This did not prevent her, if her biographer is to be believed, from announcing on Christ's behalf to the friars the imminence of terrible tribulations for the Order and for the Church: in May 1288—one of the few precise dates that is to be found in this text—she saw the precursor of the Antichrist emerging from Hell and loosing himself on the earth; but she immediately received assurances that the Franciscan Order would stand fast and

13. *Legenda,* VIII, 22.
14. *Legenda,* VI, 17.
15. *Legenda,* VI, 17.
16. *Legenda,* IV, 12.
17. On the Fraticelli of the Celle who were in a state of rebellion against the hierarchy of the Order between 1285 and 1318, the date of the closure of the convent and dispersal of the friars, see L. Oliger, "Documenta inedita ad historiam fraticellorum spectantia," *Archivum Franciscanum Historicum* 6 (1913), 721–30. Pope John XXII eventually imposed an interdict on the convent: *Bullarium Franciscanum,* V, 378–79.

that once the crisis had passed those who had apostasized would return, thanks to her, to the true faith.[18]

The *Legenda* of Margherita also provides valuable information about the fortunes of the Order of Penitents, which during her lifetime was transformed into the Third Order. It was in 1289 that the Franciscan pope Nicholas IV, through his bull *Supra montem*, put an end to the autonomy of lay penitents, who were firmly invited to choose their spiritual directors and their visitors from among the friars, matters in which their lay ministers had previously had great freedom. Not only were the penitents constrained to attach themselves, institutionally, to one of the two great mendicant orders, but they were forbidden to return to secular life after having joined one of the Third Orders. Lay religious movements were thus taken in hand and at the same time an attempt was made to "regularize" them into a more monastic way of life.[19]

The documents we have from Cortona provide us with very little information on the situation of the Franciscan Third Order in this town and no rule or statute of a local congregation of this type has survived, although we know by other means that the *Mantellati* were numerous there and that the *Laudesi* met in the crypt of the church of San Francesco to sing hymns in the vernacular to the glory of God and the saints.[20] The *Legenda* of Margherita is thus even more valuable in that it sheds interesting light on the changes that were shaking these movements at the time. The saint herself seems to have belonged, initially, to a confraternity of penitents whose ascetic and religious obligations were relatively light, since the devil was later to suggest to her, on several occasions, that she should return to these practices.[21] But in fact she chose to impose on herself a more severe dietary asceticism (her daily food, which excluded oil and, generally, meat, consisted of water mixed with a little wine, a few almonds or hazelnuts, some bread, and raw greens) and she lived in relative isolation, in the manner of a recluse, accompanied only by a servant and some companions (Adriana, Egidia, and Ghisla) who died before she did.[22] It seems certain that her example in this matter was directed, above all, at other tertiaries living in the

18. *Legenda*, VIII, 18; IX, 19, 23. At this time there were numerous eschatological interpretations of the Book of Daniel that led to the dating of the appearance of Antichrist—or that of his precursor—around the year 1290.

19. Text in da Pelago, II, *Registro*, no. 3, 155–60, and Meersseman, 1961/1982, 128–38 and 156. On the bull *Supra montem* and its repercussions, see Meersseman, 1982, 25–38, and *La "Supra montem" di Niccolò IV (1289), Genesi e diffusione di una regola*, Atti del 5° convegno di studi francescani, Ascoli Piceno, 1987, ed. R. Pazzelli and L. Temperini, Rome, 1988 (= Analecta TOR 20, 1988).

20. We know this from the references to Tertiaries found in the Life of Margherita, as well as through documentation of the commune and testamentary donations in favor of the community that served the Church of S. Basilio from 1297 onward. See da Pelago, II, *Registro*, no. 11, 166, and da Pelago, *Sommario, ad annum* 1304, 1330, 1351, 1360, 1363. For the *Laudesi* of Cortona see G. Vara-

nini, L. Banfi, and A. Ceruti Burgio, *Laude cortonesi dal secolo XIII al XV*, 4 vols., Florence, 1981–85, who publish (I, 2, 386–87) a fine *lauda* in honor of Margherita (*Allegramente e di bon core*), first recorded in the early fourteenth century in the *Laudario* of Cortona (Biblioteca Comunale e dell'Accademia Etrusca, Cortona, cod. 91), which belonged to the *fraternità di Santa Maria delle laude*, which met at S. Francesco in Cortona. Longer versions of the same *lauda*, recorded in the *laudario* (now cod. 180 in the Fraternità dei Laici, Biblioteca Comunale, Arezzo [principally compiled in the fourteenth century] and in the *laudario* of the Fraternità di Santa Maria della Laude de San Francesco [dated 1425] are printed in Varanini et al., 2:254–56 and 3:175–77). See also *Laudario di Cortona, Temi musicali e poetici contenuti nel cod.91 della Biblioteca comunale di Cortona*, ed. C. Terni, Spoleto, 1992.

21. *Legenda*, III, 5.

22. *Leggenda*, III, 4, 6; IX, 31, 50; XI, 8 (Iozelli X, 8).

secular world. In the *Legenda* Christ, through the mouth of his intermediary, asked the Friars Minor to admit into their Third Order only steadfast people who were prepared to place themselves irreversibly under the Franciscans' obedience, keeping their doctrine. The friars were meanwhile reminded that it was up to them to make careful inquiries concerning lay postulants before admitting them into the fraternity.[23] One could hardly find language closer in both letter and spirit to the bull *Supra montem*, whose specific requirements the Franciscan Cardinal Matthew of Acquasparta reaffirmed in Cortona itself in 1298, some months after the death of the saint.[24]

In the same year, at all events, a community of Franciscan Tertiaries or *Mantellati*, which included priests, other members of the clergy, and lay brothers and sisters, was established beside the Church of S. Basilio.[25] By 1308 they were in the course of constructing a house for themselves and to this end the bishop of Arezzo conceded an indulgence to those who came to their assistance.[26] The second rector of the church, Ser Felice (c. 1306–c. 1343) and probably also the first rector, Ser Badia, belonged to the Order of *Continenti* or *Mantellati*. The clergy seem to have officiated in the church and in the chapels that were soon created within it, while the laity took charge of the hospices that, thanks to testamentary donations, were built around the sanctuary to accommodate the crowds of pilgrims who thronged to Margherita's tomb in search of cures.[27] As far as their participation in the cult was concerned the *Mantellati* were governed by the rector who was appointed by the commune, but in other spheres they had their own superiors: a minister directed them in spiritual concerns and a chamberlain in temporal matters.[28] A type of joint management of the sanctuary was thus established (at least by 1385) under the protection of the commune of Cortona, which had supreme control over the body of Santa Margherita and over the finances of the church through the agency of three lay representatives. In this context, the *Mantellati* certainly appear to have been the tenants of a "civic religion," whose focus was the Church of S. Basilio, with at its heart the saint's tomb and the pilgrimage that attracted such crowds.[29]

The contradiction apparent in this evidence leaves the historian somewhat perplexed: Why did the Franciscans persist in trying to regain Margherita's body and the church in which it rested throughout the fourteenth century, given that both were in the hands of members of their own Third Order? It seems to me that the case of Cortona reveals a phenomenon that is also to be found elsewhere at this time, demonstrating the autonomy of the secular clergy and laity of the Third Order, who claimed to be a part of the Franciscan movement but who in reality depended on the commune and the bishops, rather than on the Friars Minor. In fact, through wishing to impose strict control and an ascetic way of life on their Penitents the mendicant orders saw, after 1300, the ranks of their followers

23. *Legenda*, v, 14.

24. Text in da Pelago, II, *Registro*, no. 7, 163, and Meersseman, 1982, 157–58.

25. Da Pelago, *Sommario*, ad annum 1298.

26. The text is given in da Pelago, II, 166.

27. Da Pelago, *Sommario*, ad annum 1298, 1304.

28. This can be deduced from various documents from 1360 onward; see da Pelago, *Sommario*, ad annum 1360, 1374, 1385.

29. On this subject, see the study by J. Cannon, "Marguerite et les Cortonais: Iconographie d'un 'culte civique' au XIVe siècle," in *La religion civique à l'époque médiévale et moderne (Chrétienté et Islam)*, Ecole française de Rome, ed. A. Vauchez, Rome, 1995, 403–13.

becoming sparser and their lay associations being restricted to certain groups of pious women known by the name of *Mantellate*, like those who, in about 1300, congregated around a figure such as Beata Vanna of Orvieto (d. 1307) or, later, Saint Catherine of Siena.[30] The case of Cortona does not, of course, allow us to resolve all the complex problems raised by the relations among lay religious movements, the ecclesiastical hierarchy, and the religious orders, in the fourteenth century. But it does open, in this connection, some new perspectives, by revealing the separation that was established in this particular case between the friars and the *Mantellati*: although attached to the same patron saint, the two groups were obviously not on the same side when, after 1297, it was necessary to organize the cult that was to be paid to the miracle-working body of Margherita and the preservation of her memory.

A Saint for Cortona: The Changing Fortunes of the Cult and of the Sanctuary in the Fourteenth and Early Fifteenth Centuries

The Growth of the Civic Cult

The *Legenda* of Margherita by Giunta Bevegnati places more emphasis on the penitent's membership of the Franciscan family than on her role within the local context. Nevertheless certain scattered remarks enable us to glimpse the reasons why her popularity was established and her cult took root in the town that had received her and to which she left her remains. Her biographer tells us that she strove constantly to reinstate peace within Cortona, torn by conflicts between clans and parties. We also learn that the terrible Bishop Guglielmino of Arezzo agreed at her insistence to be reconciled with the rebel town in 1277.[31] At all events, she often implored God to protect the town and on many occasions she received assurances that it would be rewarded for having welcomed her so well. According to a local chronicler, God even promised her to make of Cortona a "New Jerusalem."[32]

Margherita very soon became the saint par excellence of the commune of Cortona, while the Church of S. Basilio where her body rested came to serve, in due course, as a "pantheon" for the Casali dynasty, in power throughout the fourteenth century, many of whose members were buried there, at least from the later fourteenth century. From the day following the saint's death, the commune undertook the construction of a new church, much more important than the previous one, which was to become the center of a pilgrimage that attained fame and popularity throughout the region. In order to accelerate the

30. For this development see *Il B. Tomasuccio da Foligno terziario francescano ed i movimenti religiosi popolari umbri nel Trecento*, ed. R. Pazzelli, Rome, 1979.

31. For Margherita's interventions in the political and social domains, see B. Frescucci, "Attività sociale di S. Margherita," in *Cortona a Santa Margherita*, 51–59.

32. See Chapter 1, note 7; this theme has been well studied by Anna Benvenuti Papi, "*In castro poenitentiae*," 143–47.

work, the assistance of the ecclesiastical authorities was sought in the form of the conces-
sion of indulgences. As early as 28 November 1297 Bishop Peter of Chiusi, the diocese in
which Laviano (the village in which Margherita was born) was situated, granted an indul-
gence of forty days to those who promoted, through their donations, the progress of build-
ing works.[33] It is particularly noteworthy that in this text the prelate designates Margherita,
who had died only months before, as *beatissima* and that he mentions the very numerous
miracles that had taken place at her sanctuary—a topic that does not feature again in later
documents of this type. The papal legates who visited Cortona at the beginning of the
fourteenth century appear to have been distinctly more cautious on this point: in 1304 the
cardinal of Ostia, the Dominican Niccolò da Prato, granted a full hundred days' indulgence
to those who visited the Church of S. Basilio on certain feast days, but the text of the
letter contains no mention of Margherita, so that in reading it one would have no idea
that a cult was accorded to her there.[34] More subtly, in September 1306, Cardinal Napo-
leone Orsini conceded a year and one hundred and forty days' indulgence to pilgrims
visiting the church in question for the feasts of its patrons (Basil, Giles/Egidio, and Cather-
ine), as well as for that of *Cathedra Petri*.[35] The inclusion of this last feast does not appear
to be fortuitous once it is recognized that it falls on 22 February, anniversary of the *dies
natalis*—that is to say, of the death—of Margherita. Thus, without mentioning the name
of the latter and so pronouncing officially on her degree of sanctity, a high dignitary of the
Church of Rome, evidently favorable to her cause since he approved her *Legenda* in 1308,
encouraged the celebration of her feast. The same prelate moreover completed these dispo-
sitions several weeks later by according an indulgence of one hundred and forty days to all
those visiting the sanctuary, confessed and penitent, on any day of the year.[36] In 1318 a
collective letter was issued from Avignon by twelve prelates of the Curia, according to a
usage then fairly common for the uncanonized, which granted forty days' indulgence to
those who visited S. Basilio during certain liturgical feasts. This text is important because
it mentions for the first time in a curial document the presence of "corpus beate Margarite"
in the church and because it specifies that the prelates in question—mostly Franciscan
bishops *in partibus infidelium*—had acted at the request of a certain Master Accursio, native
of Cortona and doctor to Cardinals Napoleone Orsini and Giovanni Caetani.[37] But the
estimation of Margherita's sanctity was left to everyone's goodwill and when, in 1320,
Bishop Guido of Arezzo in his turn granted an indulgence to the Church of S. Basilio
which was, at that time, still within his diocese, he contented himself with evoking the
"bone memorie corpus sororis Margarite."[38] In order to try to put an end to this—from the
canonical point of view—ill-defined situation, the commune of Cortona then decided to
make an approach to the Holy See with a view to, in the words of a clause of the communal
statutes of 1325, "having the body of the blessed Margherita canonized."[39] The rector of S.

33. da Pelago, II, *Registro*, no. 6, 162. The bull is incor-
rectly dated by da Pelago as 1290, but it must relate to
1297 since there is reference in it to the recent death of
Margherita.
 34. da Pelago, II, *Registro*, no. 8, 165.

35. Ibid., no. 9, 165–66.
36. Ibid., no. 10, 166.
37. Ibid., no. 12, 167–68.
38. Ibid., no. 13, 168.
39. Statutes of 1325, IV, 75, para. 18; see Appendix I.

Basilio was charged with making contacts and taking initiatives useful to this end, but whether the expenses involved were too great for a town of only middling importance, or whether the request was not favorably received by the Avignon Curia, nothing was to be achieved in this area before the sixteenth century.[40]

Given these conditions, the commune and the Casali were moved to organize for themselves the cult of Santa Margherita. The communal statutes of 1325—the first drawn up for the town, which was to be autonomous from them on—are, in this respect, of exceptional interest. Because of their late date, in comparison with the majority of such statutes, and of the concomitance between the development of Margherita's cult and Cortona's attainment of recognized independence, they give much space to the ceremonies organized by the commune in her honor: the list of the public feasts honored by the authorities shows us at once Margherita's inclusion among the recognized protectors of the town. Cortona's earliest patron saint seems to have been the Archangel Michael. In the second half of the thirteenth century Saint Mark was added, by virtue of the fact that the Cortonese who had been exiled after Arezzo captured the town had returned home on 25 April 1261, the feast day of Saint Mark. With the creation of the diocese of Cortona in 1325 Saint Vincent, titular of the cathedral church, became the patron of the ecclesiastical sphere: the statutes of 1325 accord him little space but his prestige was to grow in the course of the fourteenth century.[41]

In short, Margherita asserted herself among this company as the figurehead of the town. Various rubrics of the communal statutes bear witness to this: those who spoke ill of her were to be severely punished; a solemn procession was to be organized every year on the eve of her feast by the commune in which not only the civic authorities but also the trades participated, bearing wax and tallow candles; on this occasion, as for Saint Mark, representatives of the *masserizie* of the *contado* came to Cortona to bring the offerings of each community. Very strict measures were put in place for the organization of the feast of Margherita, which drew to Cortona crowds of pilgrims needing food and lodging.[42] Thanks to a register of communal deliberations for 1324 (unfortunately the only one of its kind to have survived for this period), we know that one or two prisoners were freed each year by the commune on this occasion, just as happened on the feast of Saint Mark, Christmas, and Good Friday.[43]

These Cortonese festivities in honor of a saint on whose account the Church of Rome had not officially pronounced were nothing out of the ordinary at this time, at least in Italy. They must however have been decked out with particular finery since several sources

In 1324 the commune decided to offer presents to the nephews of Cardinal Napoleone Orsini, perhaps in order to encourage them to look favorably on Margherita's cause: ACC, Q.1, f.90v.

40. On the slowness and difficulties of the canonization procedure in the fourteenth century, see Vauchez, 1981/1988, 71–80.

41. In a peace treaty signed for Cortona by Bartolomeo Casali in 1358 (da Pelago, II, *Registro*, no. 17, 173), the patron saints of the city are, in order, the Virgin Mary, Saint Michael Archangel, Saint Mark, Saint Vincent and Saint Margherita.

42. See the extracts from the communal statutes published in Appendix I, and Mancini, 1897, 174–77.

43. ACC, Q.1, ff.38v and 39r. For the respective roles of the communal and ecclesiastical authorities in the management of Margherita's body in the fourteenth and fifteen centuries, see Bornstein, 1993.

external to the town mention them during the fifteenth century. Thus in 1445 the arch-bishop of Florence, Antonio Pierozzi (Saint Antoninus), noted in his work in the vernacu-lar addressed to the lower clergy: "Le feste di quelli santi che non sono canonizzati, datto che la terra ne facci festa grande, come a Siena del beato Ambrosio nostro e della beata Margherita del Terz'Ordine a Cortona, nessuno è obbligato a guardale, ne di tali santi si debbe fare alcuno uffizio o messa propria."[44]

Eventually the papacy was so troubled by this situation (which was, from a canonical point of view, abnormal) that in 1516 the Florentine Pope Leo X officially authorized the observance of a cult in Margherita's honor within the diocese of Cortona. As far as the commemoration of her feast, held each year on 22 February, was concerned, the pontiff indicated in the bull that on that occasion

> a solemn and public feast, with the ceremonies which communes generally orga-nize in such circumstances, is celebrated at Cortona. For the celebration of this feast not only the people of Cortona but also the inhabitants of the neighboring towns, lands, and castles are seen to flock there in great numbers. Nevertheless, since no mention of Margherita herself is made in the masses and offices cele-brated on that day, because she is neither canonized nor inscribed in the catalogue of saints, many of those who go there are filled with astonishment.[45]

So as to put an end to the gap between the pomp and ceremony of the civic cult and the lacunae in the liturgical cult, the pope conceded Margherita her own office for use in Cortona. But it was not until 1623 that its use was extended to the whole Franciscan Order by Urban VIII, and it was only in 1728, with the much-desired and belatedly obtained canonization that the sanctity of Margherita emerged from the bounds of the strictly local setting that had been its context since the later centuries of the Middle Ages. Far from lamenting this delay, however, the modern historian may take pleasure in the special cir-cumstances that have made the medieval cult of Margherita in Cortona a remarkable look-out post from which to observe and study civic religion.

The Friars Minor Attain the Sanctuary

By the end of the fourteenth century the system for administering the Church of S. Basilio, which had functioned since 1297, was in crisis. The surviving sources do not unfortunately indicate precisely the reasons for the change in attitude on the part of the commune and the Casali family toward the community which, as we have seen, comprised a rector assisted by chaplains, and the *Mantellati* who belonged to the Franciscan Third Order. These latter

44. (Concerning the feasts of those saints who are not canonized, given that the world makes a great feast for them, as at Siena for our beato Ambrogio [Sansedoni] and for beata Margherita of the Third Order in Cortona, no one is obliged to observe them, nor does one have to cele-brate for such saints their own office or mass), da Pelago,

II, *Registro*, no. 18, 174. The text in question is the *Curam illius habe*, Florence, 1565, 38.

45. Leo X, *Regimen universalis*, 6 February 1516 (= 1515 *stile dell'Incarnazione*) in da Pelago, II, *Registro*, no. 25, 182–83.

had certainly been viewed favorably by both the civic authorities and the local population at the beginning of the century; the commune of Cortona had written to John XXII to defend them, as had indeed the majority of Tuscan communes, soon after the pope had launched serious charges of heresy against the Beguines and other "lay religious" suspected of being in sympathy with the Franciscan Spirituals.[46] But their popularity must have declined in the course of the following decades; in 1385 Uguccio Casali made a request to the Olivetan monks to ensure the proper religious functioning of the sanctuary.[47]

In fact, the report of the pastoral visits of the bishops of Cortona, of which a certain number survive, show clearly that the priests serving the Church of S. Basilio were not entirely above suspicion. Thus in 1337 the rector and Franciscan tertiary Ser Felice was accused by a chaplain, in front of the Visitor, of trafficking in the movable and immovable goods of the church, selling an old missal in order to buy a worse one of lesser value, as well as a chalice worth twenty florins, without anyone knowing what had become of this money, and of having acquired a house by irregular means with a certain "suora Amatucia."[48] In 1356, when the church was visited by Bishop Gregorio Nucciarelli, the situation seems to have been somewhat better. The new rector was not reproached for any irregularity except, perhaps, on the question of ecclesiastical dress: asked if he wore a black habit, he replied that he did not, but that he wore the beige (bigio) habit of the Third Order.[49] But in 1361 and 1365 the Visitors again reported that S. Basilio was poorly served for both the diurnal and nocturnal offices, and that the requirements of the founders of chapels—who had increased over the years—were not being respected. Moreover, two of the chaplains were keeping concubines in the houses next to the sanctuary. Another chaplain admitted that he knew neither the articles of faith nor the sacraments, that he did not celebrate the Office regularly, and that, moreover, he did not own a breviary.[50] These documents would certainly seem to indicate widespread laxity, perhaps due to the great proliferation of chaplaincies.

In this context the agreement made between the Casali and the austere monks of Monte Oliveto is no doubt to be explained, in the first instance, by the wish of the "lords" of Cortona to see a minimum of order and regularity reestablished in the cult offered to Margherita and in the prayers for the dead. But this attempt was without sequel, and it does not seem that the White Monks ever took possession of the Church of S. Basilio.[51] In November 1392, on the other hand, in a long deliberation whose text has been preserved, the commune of Cortona decided to hand over to the Observant Franciscans the sanctuary

46. See A. M. Ini, "Nuovi documenti sugli spirituali in Toscana," *Archivum Franciscanum Historicum* 66 (1973), 366–67. In the years 1361–63 Giovanni, bishop of Teano, bequeathed several houses which he owned in Cortona to the "Pauperes Fraticelli," but it is not possible to say whether this term refers to the Tertiaries of the sanctuary of Santa Margherita.

47. Da Pelago, *Sommario, ad annum* 1385, 1387, 1389, 1390.

48. N. Meoni, "Visite pastorali a Cortona nel Trecento," *Archivio storico italiano* 129 (1971), 181–256, esp. 197. See also D. Bornstein, "Parish Priests in Late Medieval Cortona: The Urban and Rural Clergy," *Preti nel Medievo*, Quaderni di storia religiosa 4, Verona, 1997, 165–93.

49. Meoni, 201.

50. Ibid., 214, 223.

51. Da Pelago, *Sommario, ad annum* 1385, 1387, 1389, 1390.

together with the adjoining buildings ("chapels, houses, cloisters, cemetery, and gardens"), while retaining its patronage rights over the church.[52] Plainly the Franciscan Order would have considered this decision as fair recompense, since in justifying the transfer the document underlined the fact that "it appeared evident, according to public rumor [ex fama], that Margherita herself had prophesied with her own mouth that the said church would eventually pass one day into the control of this Order, at the end of a long period of time."[53] Moreover, in the same document the "lords" of Cortona expressed their intention to create near S. Pietro in Marzano, not far from S. Basilio, a monastery of Clares who must "in their dress and in their way of life, imitate and follow as far as possible in the steps of the late blessed Sister Margherita."[54] Pope Boniface IX, who was asked to approve the new administration of the church and the foundation of the monastery, gave his assent in the bull *Piis devotorum,* issued from Perugia, 2 December 1392, to three members of the Casali family: Uguccio, Francesco, and the young Aloigi.[55]

This decision gave rise to numerous problems that were not easy to solve. Although it is not difficult to imagine the reasons that drove the Casali to put an end to the ministry of secular clergy in the prestigious sanctuary of S. Basilio and S. Margherita, the originality of the solution envisaged for replacing these secular clergy was nevertheless striking. The idea of building, near the church, a monastery of Clares associated with a convent of Friars Minor seems even more strange; such double communities are not recorded elsewhere in the Franciscan Order. But here this was indeed to be the case: the bull of Boniface IX specifies that all the goods and rights of the Church of S. Basilio and S. Margherita were to devolve upon the female monastery and its abbess, on condition that they provide for the upkeep of the friars.

Institutions of this type were not unknown at the end of the fourteenth century and no doubt one sees in this text an echo of the influence of Saint Bridget (d. 1373). Brigittine circles were in fact very influential in central Italy and well regarded by Pope Boniface IX, who had just canonized the Swedish prophetess in the previous year.[56] In the Order of the Holy Savior, which she founded and whose motherhouse was the abbey of Vadstena, in Sweden, are to be found monasteries combining a rather large number of women with a smaller group of monks under the direction of an abbess.[57] In the case that concerns us here, certain indications fortunately allow us to do more than draw a purely institutional parallel. As Cardini has clearly shown, the decision of 1392 was no doubt due, in large measure, to the influence of Allegrezza Casali, a relative of Uguccio Casali, who exercised

52. Da Pelago, II, *Registro,* no. 21, 175–78.

53. Ibid., no. 21, 176.

54. Da Pelago, II, *Registro,* no. 21, 177: "Quae quidem moniales debeant in vestibus et in vita sequi et renovare vestigia ejusdem beate quondam sororis Margarite."

55. The text has been published by Bertagna, 1975, 128–29. I thank Isabelle Heullant-Donat who kindly obtained for me a photocopy of this bull (ASV, *Reg. Lat.* 30, f.261–62) in the Vatican Archives.

56. The canonization of Saint Bridget by Boniface IX took place in Rome, 7 October 1391. The bull of canonization *Ab origine mundi* is published in the *AA.SS* (Paris ed.), *October,* IV, 468–72. The process was opened in December 1373 at Montefalco, with the bishop of Spoleto presiding, in the presence of many ecclesiastics and religious of the area; cf. I. Collijn, *Acta et processus beate Birgitte,* Stockholm, 1931, 71–73.

57. Cf. T. Nyberg, *Birgittinische Klostergründungen des Mittelalters,* Lund, 1965, and Nyberg, s.v. "Brigidini-Brigidine," *Dizionario degli Istituti di Perfezione,* ed. G. Pelliccia and G. Rocca, I, Rome, 1974, cols. 1578–93.

real power in Cortona at that time.[58] Born in 1350, widowed without children in 1387, she withdrew from the world and elected to be buried in due course in the Church of S. Basilio, in favor of which she provided donations in her will. Under the influence of her paternal cousin Linora Casali, abbess of the Monastery of Targia in Cortona, she took the veil as a Clare nun in 1392 under the name of Sister Martha. In the same year the first Italian Brigittine monastery, "Paradiso," was founded on the outskirts of Florence, established by Antonio di Nicolo degli Alberti in his villa at Bagno a Ripoli. Sister Martha—Allegrezza Casali—was chosen in March 1395 to be the first abbess of the new foundation. This house encountered serious problems, however, and Allegrezza subsequently returned to Cortona where she was elected abbess of the Monastery of Targia in 1408 on the death of her cousin Linora. She remained there until her own death in 1412 or 1413.

What is important in the present context is the role that Martha-Allegrezza must have played in devising the constitution for a community of a new type, inspired by the Brigittine model, linking the Franciscan First and Second Orders in the management of Margherita's memory. In fact this great project rapidly miscarried. Work was undertaken with a view to the construction of the new Clare monastery, as is shown by a lapidary inscription of 1400 in which, after the names of the three Casali "lords" then in power, appear the words: "Hoc est monasterium sancte Margarite."[59] But work was abandoned shortly afterward and the sisters who had begun to settle there had to return to the communities from which they came. War had begun again in the region and, above all, the Casali dynasty underwent a rapid decline after the death of Uguccio in 1400. In 1407 the young Aloigi Casali, who had for many years been champing at the bit, had his uncle, the popular Francesco, assassinated. The inhabitants of Cortona, infuriated by his actions, rose up against him and delivered him up to Ladislas of Hungary, king of Naples, who took the town in 1409 while he was waging war against Florence. Finally Ladislas sold Cortona to the Florentines in 1411: the little town was never thereafter to regain its independence and the last of the Casali died a prisoner in Naples. In these unfavorable circumstances there was evidently no question of realizing the innovative and complex project that had been set in motion in 1392. The Franciscan Observants of the Tuscan Province established themselves in the buildings abandoned by the Tertiaries and established there a purely male convent of the standard type.[60] In 1433 they were relieved by Pope Eugenius IV of the censure they might have incurred in contravening the provisions of the bull of Boniface IX.[61] But the benevolent tone of this document clearly shows that in high places there was no grievance even though the wishes of the founders had not been respected. From then onward the Friars Minor laid hands on the Convent and Church of S. Basilio. The body and the fame of the lay saint, Margherita, both passed at the same moment into the man-

58. This question has been thoroughly studied by F. Cardini, "Allegrezza Casali devota di S. Margherita, figura poco nota della devozione cortonese," *Studi francescani* 72 (1975), 335–44.

59. The inscription is reproduced in full in da Pelago, *Sommario, ad annum* 1400.

60. Bertagna, 1975, 130–31, has published a Florentine document of 1412 that shows unambiguously that the Friars Minor in question were Observants.

61. Eugenius IV, *Ad ea ex*, 11 April 1433, in da Pelago, II, *Registro*, no. 23, 179–80.

agement of the Franciscans, after an interlude of almost a century, and soon the process of the normalization of her cult by the Roman Church, which was to lead by stages to the canonization of 1728, would be able to begin. But the inhabitants of Cortona had not lost everything, for the agreement with the friars stipulated very specifically that the body of the saint was the property of the commune, would remain perpetually in the church above the town, and could not be removed from there;[62] an agreement that throughout subsequent centuries and even to the present day has always been respected.

62. See the instrument of concession of the Church and Convent of S. Basilio and S. Margherita to the Friars Minor (25 November 1392) in da Pelago, II, *Registro*, no. 21, 177: "quod beatum et sanctum corpus sancte Margarite predicte semper et in perpetuo stet in dicta ecclesia sub clavibus et custodia suprastantium positorum et po-nendorum per comune Cortone et generales dominos eiusdem civitatis." The text clearly says that the commune and rulers of Cortona retained the ownership of the property represented by the body of the saint, while the friars had only the usufruct and "management" of it.

Part II

"Ecclesia et Corpus Tumulatum"

Three visual sequences of the life and miracles of Margherita of Cortona stand at the heart of this study. Before we can give proper consideration to the evidence they provide, however, we must first understand something of their physical and artistic context. Before attempting to reconstruct a series of lost wall-paintings we need to reconstruct, in as far as this is possible, the walls on which they were painted. And before discussing the varied representations of the saint within her burial church we should give some thought to how her actual remains were presented to those visiting the sanctuary. Thus the two following chapters seek to determine the original appearance of the Churches of S. Basilio and S. Margherita, and the changing ways in which Margherita was entombed within them. As we have already seen, medieval Cortona does not yield up its secrets easily to the inquiring historian. But a careful examination of the varied sources of information will enable us to picture for ourselves, with some degree of confidence, the buildings that contained the murals and the tomb, and to consider the aspirations that may have prompted the choices that were made.

3

The Churches of S. Basilio and S. Margherita

The Church of S. Margherita Since the Middle Ages

Approaching on foot the Church of S. Margherita, the present-day visitor climbs the path from Porta Berarda to Piazza S. Margherita. This is the route followed by the citizens of Cortona as they participate in the annual reenactment of the medieval ceremony of the offering of candles to S. Margherita. The steady ascent is punctuated by fourteen mosaic scenes that flank the route. These form a *Via Crucis*, designed by Gino Severini, a native of Cortona, at the instigation of the last resident bishop of Cortona in 1945.[1] At the top of the *Via Crucis*, the visitor rounds the south side of the convent and church and arrives in the piazza facing the facade of S. Margherita. The walk may well have been inspiring, and the view through the trees to the Val di Chiana is impressive and atmospheric,[2] but

1. A Tafi, *Immagine di Cortona*, Cortona, 1989, 330. For further discussion of the introductory mosaic of this series in the context of Margherita's civic cult, see Cannon, 1995, 403–5.

2. Compare the description given by Giacomo Lauro, writing in the seventeenth century: "e fuori del Convento vi è un boschetto di cipressi, che nede insieme vaghezza di vista al luogo, e devotione." G. Lauro, *Dell'Origine della Città di Cortona in Toscana e sue Antichità*, Rome, 1639, reprinted in the series Historiae Urbium et Regionum Italiae Rariores, n.s., 79, Sala Bolognese, 1981, part II, gathering G (pages unnumbered).

visitors with a particular interest in the Middle Ages may be somewhat disconcerted by what awaits them. The Church of S. Margherita and its contents, with a few notable exceptions, appear to be entirely postmedieval (Figs. 8, 12, and 15). Only the masonry of the rose window, visible from the piazza, and, as we shall see, the underlying fabric of two of the nave vaults and of the *cappella maggiore*, survive from the Middle Ages. Within the oppressively dark interior of the church the only medieval contents still preserved are Margherita's imposing marble funerary monument, erected in the fourteenth century; the carved crucifix that is said to have addressed her in the church of S. Francesco; some marble relief slabs; and Margherita's own mummified remains, displayed in a baroque silver and glass coffin on the high altar.

Before embarking on our study of the medieval structures of S. Basilio and S. Margherita, we must pause here and consider briefly the complex cycle of construction, piecemeal demolition, and reconstruction that has taken place on the site over the centuries. In times of crisis through seven centuries the Cortonese have called on Margherita, and their gratitude for her protection has found visible expression, most notably in the construction, decoration, restoration and remodeling of the Church of S. Margherita. The new church begun after Margherita's death in 1297 was a fully vaulted structure of impressive scale and was probably completed in the first quarter of the fourteenth century. The walls of the choir and nave of this new church were covered with the medieval mural paintings that are of particular importance to this study. By the early seventeenth century the attitude of the Cortonese to these medieval paintings was ambivalent. On the one hand, the murals of the choir and the eastern nave bay, which represented scenes from the life and miracles of Margherita, were diligently recorded in a series of signed and witnessed copies, and used as crucial evidence in Margherita's canonization process. Yet a number of large altarpieces were installed against the nave walls, above family altars, between 1601 and 1610, without any apparent concern for the areas of medieval mural painting they covered. Perhaps the nave paintings were by then so damaged and fragmentary that they were considered to have outlived their usefulness. This was certainly the case by the middle of the seventeenth century, when a coat of whitewash was applied throughout the church to tidy its appearance. This finally obliterated the surviving scenes of Margherita's life in the *cappella maggiore*, and all remaining visible areas of painting in the nave.

 Margherita's canonization, when it was finally achieved, prompted further alterations to the church. In 1738 the north and south walls of the eastern nave bay were demolished to make way for a transept extending for one bay to either side (Fig. 14).[3] The removal of this bay of the south nave wall would have destroyed the frescoes of Margherita's life that had been painted there and that, until then, had presumably been preserved, in some form, under the whitewash. The wall demolished on the north side of the same bay was the one

3. This rebuilding was financed, in large part, by John V of Portugal. See D. Mirri, *Cronaca dei lavori edilizi della nuova chiesa di S. Margherita in Cortona*, rev. E. Mori, Cortona, 1989, 37–38; M. Brancia Apricena, "La chiesa di S.

Margherita a Cortona," in *Giovanni V di Portogallo (1707–1750) e la cultura romana del suo tempo*, ed. S. Vasco Rocca and G. Borghini, Rome, 1995, 197–99.

in which Margherita's remains had been placed in the fourteenth century, and on which her funerary monument had continued to be displayed. The choir was modernized in 1767, decorated with stucco, and illuminated by three new large windows (visible in Fig. 22). These must have cut into any medieval painting still surviving beneath the whitewash there.

Less than a century later the church was again being rebuilt and enlarged, this time in fulfilment of a vow made to S. Margherita during the cholera epidemic that ravaged Tuscany in 1855.[4] The campaign continued, fitfully, until 1896. The idea of demolishing the nave walls, and extending the building to the north and south, used in 1736 to make the transepts, was now applied to the remaining two nave bays (Figs. 14 and 16) and a third bay was added to the west. Comparison of a watercolor of the church, seen from the southwest, made before the nineteenth-century changes (Fig. 9), with a photograph taken about 1875, from the same direction (Fig. 10), provides an intriguing insight into the progress of work. The facade and nave of the church have already been enclosed in the new masonry that was to extend its dimensions, but the existing original nave walls have not yet been demolished to make the connection between the original nave and its nineteenth-century aisles. (The present state of the interior, with nave and aisles connected, is shown in Fig. 15.) As the large baroque altarpieces were moved from the nave walls in preparation for their demolition, some fragments of medieval painting were revealed. The fragments were removed for conservation (and still exist), and the opening up of the nave walls proceeded. To the north of the church this involved the total loss of the original Church of S. Basilio, and of the structure believed to have been Margherita's cell, and the site of her death. Although the function and appearance of these two buildings had altered over the centuries, their basic medieval structure had presumably survived until that moment.

The Church of S. Basilio

S. Basilio may initially have been a Camaldolese foundation. It had been established at some date before 1175.[5] The church was probably damaged in the Aretine sack of Cortona in 1258, and seems to have been abandoned until Margherita moved to a cell nearby and instigated its repair. A bull permitting this rebuilding and a refoundation of the church, with a joint dedication to Saints Basilio, Egidio (Giles), and Catherine of Alexandria, was issued by the bishop of Arezzo on 27 August 1290.[6] This was followed swiftly, on 6 September of the same year, by the appointment of Ser Badia as first rector of the church.[7] Ser Badia took possession of the altar cloths of S. Basilio immediately; an indication, as da Pelago pointed out, that the church had already been repaired before episcopal support was

4. For a detailed and vivid account of the nineteenth-century campaigns, see Mirri, rev. Mori, passim.

5. See Chapter 2 and, for the fullest account of the original church see Mirri, rev. Mori, 9–27. This makes

some corrections and additions to the information in da Pelago, ii, 47–48.

6. Da Pelago, ii, 160.

7. Ibid., 161–62.

secured.[8] The cost of the rebuilding was borne by the commune of Cortona, which had also acquired the land on which S. Basilio stood, and the adjoining piazza.[9] The commune thus assumed the possession and patronage of the church, which they retained in full until the end of the fourteenth century.[10]

The most detailed discussion of the original appearance of the first Church of S. Basilio, and of the church that superseded it, was provided by Lodovico da Pelago in one of the *dissertazioni* that follow his 1793 edition and translation of the *Legenda* of Margherita, and in the accompanying plan and elevation of the medieval buildings that he provided (Figs. 13 and 21).[11] These reconstructions, and the annotation given with them, have since been accepted as an accurate record of the early history and appearance of these churches. Da Pelago based much of his reconstruction on a careful examination of the church fabric, already altered in his day, and now, in large part, demolished. Although these observations cannot now be verified, his descriptions of the traces of medieval structures visible in the late eighteenth century are clear and convincing. Da Pelago was also familiar with a wealth of documentary material concerning the history of the church and convent. In 1781 he assembled a *Sommario* of the history of the Church and Convent of S. Margherita, from its inception to his day. This work, which remains unpublished, presented a chronology of events, and a documentary appendix containing many transcriptions.[12] Some of this material was repeated in the *dissertazioni* published with the *Legenda* text in 1793, with occasional emendations.[13] Many of da Pelago's statements can thus be tested against documentary evidence, but when his conclusions are unsupported they have to be treated with caution, as we shall see.

Da Pelago identified the buildings to the north of the nave of the main church, which had served in his day as the sacristy, as the original Church of S. Basilio (marked D on the plan; see Fig. 13).[14] Using a document of 1332, he was able to identify the structure contig-

8. Ibid., 49–50.

9. *"Terrenum sive platea"*; instrument of 6 September 1290, printed in da Pelago, II, 161–62.

10. See Chapter 2. The agreement of 1392 with the Franciscan First Order only left the commune with a degree of control over the body of the saint; da Pelago, II, 133–34, 177.

11. Da Pelago, II, diss. III, 47–50, and tav. 2 and 3 (bound in at end of book). Da Pelago's late eighteenth-century publication remains a fundamental basis for the study of the life and cult of Margherita. Volume I contains a preface and the text of the *Legenda* (now superseded by Iozzelli's edition) with valuable annotation and a parallel translation into Italian. Volume II begins with a summary of the *Legenda*, followed by the twelve lengthy *dissertazioni* concerning the *Legenda* and related matters, the *Registro* of relevant documents, and a group of plans and elevations of S. Basilio, S. Margherita, and S. Francesco in Cortona.

12. *Sommario della storia della chiesa e del convento di S. Margherita di Cortona, compilato e disposto per ordine crono-*

logico dal P. Fra Lodovico da Pelago . . . , 1781. The original MS is in the conventual library of S. Margherita. A transcription exists in the Franciscan *archivio provinciale* in Florence. Since the page numbering of these two versions does not agree, references are given here *ad annum*, rather than to specific pages. Some of the original documents have recently reemerged in Florence, Archivio di Stato, Diplomatico, *Unione dei Luoghi Pii di Cortona*.

For a summary of da Pelago's career, see M. Bertagna, "Sviluppo edilizio del convento di S. Margherita a Cortona nel sec. XV," *Annuario dell'Accademia Etrusca di Cortona* 18, n.s., 11 (1979), 63 n. 2, and Iozzelli, 1993, 218 n. 4.

13. For example, the notes accompanying the ground plan in the *Sommario* give the date for the completion of the new church and for Margherita's translation as *certamente prima del 1343*. In the published engraving of 1793 the date for the translation is given as c. 1330 and the completion date of the building is not mentioned.

14. Da Pelago, II, tav. 2.

uous with this building, to the east (marked E on the plan; see Fig. 13), as Margherita's third cell, which she inhabited at the time of her death.[15] In da Pelago's 1793 ground plan (Fig. 13), S. Basilio is shown as a rectangular, aisleless structure with three square bays. But the sketch-plan in his *Sommario* shows rectangular bays of differing dimensions, and a rib vault is indicated. These features are confirmed in a valuable source of information that has only recently been published by Edoardo Mori. The first architect of the nineteenth-century rebuilding of S. Margherita, Enrico Presenti, produced a series of project drawings that included measured tinted plans, elevations, and sections of the current state of the church, made in 1856.[16] Presenti's measured plan (Fig. 14) confirms the dimensions given by da Pelago, 15 × 5 m (= 26 × 8 braccia fiorentina),[17] and one of Presenti's measured sections (Fig. 18) shows that by the nineteenth century the height of the building that da Pelago had identified as the original church was 7.4 m to the top of the vault. The approximate maximum dimensions of the site of Margherita's cell were 4.2 × 2.1 m. We should be cautious, however, in accepting that the structures that da Pelago and Presenti recorded were precisely those inhabited by Margherita and restored at her instigation. The variation in bay size shown in the plans of old S. Basilio (Fig. 14) raises the possibility that the oratory had been added to in stages and, as da Pelago recognized, the provision of doorways and access must have changed after the new church was built against the old church and cell.[18]

The New Church

In the November following Margherita's death a bull was issued by the bishop of Chiusi in favor of those contributing to the building of a new church, on which work had apparently already begun, in honor of Margherita.[19] The date of 1297 is also given in a fragmentary inscription, now displayed in the Convent of S. Margherita, whose full text is preserved in a replacement stone.[20] The inscription records that the church was begun at the time when a certain Francesco was prior of the consuls of Cortona.[21]

15. The document records the establishment of a chaplaincy in the Cappella del Salvatore, which it specifies was formerly Margherita's cell, situated halfway down the north side of the nave of the church: "quedam Cappella quasi in medio dicte Ecclesie ex parte montis [i.e., north] in loco ubi olim B. Margarita contraxit residentiam," da Pelago, II, 172.

16. The complete set are illustrated and discussed in Mirri, rev. Mori, passim, and a selection of the most important drawings are now also available in Mori and Mori, 1996.

17. Da Pelago, II, 48.

18. An engraving suggesting the original access, published in Mirri, rev. Mori, 26, as by da Pelago, but not in the 1793 edition of the *Legenda*, shows an entrance at the west, an altar at the east, and immediately to the left of

it an entranceway leading to the Cappella del Salvatore, formerly Margherita's cell, with its own altar on the north wall. (Margherita is believed to have had an altar in the cell during her lifetime.) See da Pelago, II, 37–38. A doorway is also indicated in the east wall of the cell.

19. 28 November 1297. "Cum igitur in Cortona ad honorem Dei et Beate Margarite nova construatur Ecclesia, qua compleri non potest, nisi a Christi fidelibus, et devotis subsidium porrigatur." Da Pelago, II, 162–63, where the bull is incorrectly dated to 27 August 1290.

20. For illustrations of both stones see Mirri, rev. Mori, 29, 30.

21. ANO DNI M.CC.LXXXXVII. TEMPORE. DNI. FRANCISCI. PRIORIS. CONSULUM. COMUNIS. CORTONE. INCEPTA. FUIT. HEC. ECCLESIA

Da Pelago implied that work on this new church was probably completed around 1330.[22] This date has since been repeated by Della Cella, and others.[23] On the other hand Bacci, in his book on the *Santuario di S. Margherita*, gave a date of c. 1304 for the building of the new church (without supporting evidence), and this has recently been repeated by Tafi, Bornstein, and Mori.[24] This early completion date cannot be correct; a bull issued by Cardinal Niccolò da Prato in Cortona on 13 July 1304 offers an indulgence to all those assisting or giving money toward the continuation of the new church.[25] Work was thus clearly under way, but not yet complete, in that year. Two years later, on 2 September 1306, Cardinal Napoleone Orsini was in Cortona and granted further indulgences for those visiting, on certain feast days, the Church of S. Basilio "de novo constructa."[26] This phrase can mean either "recently built" or "built anew." Here it appears to have been used to distinguish the new church, begun in 1297, from the original building. Since the bull assumes that the faithful were able to visit this new church on feast days we can deduce that enough of the structure had been completed by 1306—presumably at the east end—for it to be open to the cult. But a bull issued by Ildebrandino, bishop of Arezzo, on 21 June 1308, shows that work on the fabric was still continuing. The faithful were urged to contribute both to the day-to-day necessities of the members of the Order of Penitence (that is, Tertiaries) living at S. Basilio and to building work on both the church and on the living quarters being constructed for the Tertiaries.[27]

If the completion date of 1304 mentioned by Bacci, Tafi, and others is incorrect, what of the later date given by da Pelago? He proposed a date of c. 1330 for the translation of Margherita's remains to the new church and, by implication, a terminus ante quem of c. 1330 for the completion of that church, without any explanation.[28] Elsewhere, he used a document of 1343, which provided for the establishment of a chaplaincy at an altar below Margherita's remains, to establish a terminus ante quem for the translation.[29] Perhaps it was the instrument of 1332, establishing a chaplaincy in the Cappella del Salvatore, which provided da Pelago with his terminus ante quem of "c. 1330" for the new church. As mentioned above, the chapel is described as situated halfway down the church, on the

22. Da Pelago, II, 127.

23. A. Della Cella, *Cortona antica*, Cortona, 1900, 135. A number of writers follow the c. 1330 date that da Pelago gave for Margherita's translation to the new church without necessarily tying the completion of the church to this apparent terminus ante quem (e.g., Mirri, rev. Mori, 31; Bornstein, 1993, 172).

24. D. Bacci, *Il Santuario di S. Margherita in Cortona*, Arezzo, 1921, 22; Tafi, 284; Bornstein, 1993, 172; Mori and Mori, 1996, 34.

25. Summary given, without full text, in da Pelago, *Sommario*, ad annum 1304.

26. Da Pelago, II, 165.

27. Da Pelago, II, 166. The wording of the document is not immediately clear since it refers both to construction work in progress on the new church (*Ecclesia*) and on the living quarters that were to be provided for the Tertiaries

(*dicta domus fratres*). In his *Sommario* da Pelago summarized the bull as an appeal for help in completing the construction of the new church, but in his published *Registro*, where the text is given in full, da Pelago's heading refers only to the construction of new living accommodation for the members of the Third Order at S. Basilio.

28. Da Pelago, II, annotations to tav. 2 and 3 and 50, 127, and 128.

29. Da Pelago, II, 128. Da Pelago summarized the text in the *Sommario* but it has not been printed in full. An extract from the document (17 January 1343; now in Florence, Archivio di Stato, Diplomatico, *Unione di Cortona*) is given in G. Bardotti Biasion, "Gano di Fazio e la tomba-altare di Santa Margherita da Cortona," *Prospettiva* 37 (1984), 18 n. 41. I am most grateful to Dillian Gordon for having obtained a microfilm of this document for me.

north side, a description that only makes sense if it refers to the new church.[30] But the main structure of the new church was probably completed significantly earlier than this. As we have seen, the east end seems to have been functioning by 1306, and a bull issued from the Curia at Avignon by twelve prelates on 30 January 1318, which was clearly intended to be of assistance to the expenses incurred by S. Basilio, makes no mention of building work.[31] Instead it is the provision of instruments of the cult and liturgical furnishings—books, a chalice, a chasuble, and other ornaments for priests and altars—that will secure an indulgence for the faithful. It seems reasonable to assume that no further major building work was envisaged for the church at that point, and that the main structure of the new church had been completed at some time between 1308 and 1318.[32]

One further document that refers, in some form, to the fabric of the church should be mentioned. In 1324 an unknown sum of money was voted by the commune *pro ecclesia Sancti Basilii augmentanda*.[33] This is the only year for which a register of communal deliberations survives, but since the decision seems to have been taken not to increase the amount given in that year to S. Basilio, the implication must be that this is the only surviving trace of a regular subvention. The form of these intended additions or improvements to the church is not known, but taken together with the elaborate arrangements made for the civic celebration of the day of Margherita's death in the following year (which coincided with Cortona's elevation to an independent diocese), it may be supposed that the commune's general aim was to encourage the cult, embellish the church, and perhaps also to provide more space for the circulation of pilgrims between the old and new churches, and the site of the cell in which Margherita had died.[34]

The Dedication of the Two Churches and the Function of the Original Church

As we have seen, the new S. Basilio *de novo constructa* was distinguished from the original one in the documents of 1304–8. But by 1392 the text of an agreement in which the church and convent were transferred to Franciscan supervision makes it clear that the church had, for some time, been popularly known by a joint dedication, "oratorium vulgar-

30. In the Italian summary of the document given in the *Sommario*, *ad annum* 1332, da Pelago refers to the "nuova chiesa di S. Basilio," although the original Latin says simply "Ecclesia S. Basilii" (da Pelago, II, 172).

31. Da Pelago, II, 167–68.

32. Two other elements that tend to confirm that the main construction of the new church was complete by that time and that no further major building work was envisaged in the immediate future are the dating of a bell, cast in 1322 by Vannes Pisanus, which still exists in the church (Mirri, rev. Mori, 142) and a bull of Guido Tarlati, bishop of Arezzo, 10 May 1320 (da Pelago, II, 168) which grants an indulgence for those contributing to the building work for the habitation of those serving the church but makes no mention of work on the fabric of the church itself.

33. ACC, Q.1, f.29r.

34. The possibility of additions to the structure of the old church has been raised above. The contiguity of the three buildings, forming a single unit in da Pelago's plan (Fig. 13), is surprisingly convenient. No medieval source specifies that Margherita's cell was contiguous with old S. Basilio. Perhaps it was at this time that the structures were linked together by inserting an extra bay to the east of the old church that may originally have consisted of only one or two bays. At the same time new openings between the new church and the original church and cell could have helped those two structures to function as side chapels, as the documentary mention of the Cappella del Salvatore in 1332 indicates.

iter nominatur Ecclesia S. Basilii et Sancte Margarite de Cortona."[35] This raises the question of what became of the original church and of its dedication. Da Pelago's translation of a document of 1390, rescinding an agreement previously made with the monks of Monte Oliveto Maggiore, is more specific about the joint dedication, "La chiesa di S. Basilio coll'altro ad essa unita di S. Margherita."[36] In other words the principal dedication of the large church was to S. Basilio, and the smaller oratory on its north side was dedicated to S. Margherita. Confusingly, this situation is precisely the reverse of that existing by da Pelago's time (and in general use today). When da Pelago referred to the Church of S. Margherita, he meant the large church, on whose high altar the remains of S. Margherita had been displayed since 1580. He referred to the smaller church, restored to use as a chapel in 1771, as S. Basilio.[37]

It may be that the dedication of the original church changed, as might perhaps be expected, once the new one was sufficiently advanced to be used for liturgical functions. A document of 25 April 1306 records that Ser Felice, second rector of S. Basilio, requested permission from the commune to draw funds for the repair of the roofs of the "Cappella di S. Margherita" and the sacristy.[38] This presumably indicates essential repairs to existing older structures, once work on the new church was well advanced. It seems reasonable to suppose further that the Cappella di S. Margherita—not mentioned in any earlier documents—was the name now applied to the original Church of S. Basilio. This title would be particularly appropriate for the building in which Margherita's remains were kept. Although it seems that the eastern part of the new church was ready for use by 1306, we cannot be sure of the date of completion of the nave bay to which Margherita's remains were in due course translated. Indeed, it is possible that the initial plan was to leave the body in the smaller original church, which would act as a burial chapel.[39] There would have been good reasons for leaving Margherita, at least initially, in the sacred space that had already been the site of so many miracles.[40] As we shall see, the written accounts of a few of these miracles stress a connection with proximity to the tomb at the time of cure, while many more describe visits to the tomb as a votive act following healing.[41] Around 1306 the catalogue of Margherita's miracles was still growing, and the process of obtaining official approval from the Curia for the *Legenda* was not yet complete.[42] It may thus have

35. Da Pelago, ii, 176.

36. Da Pelago, *Sommario, ad annum* 1390.

37. See da Pelago, *Sommario*, ground plan of S. Margherita in 1781.

38. Da Pelago, *Sommario, ad annum* 1306.

39. Da Pelago (ii, 127–28) assumed that the translation would have occurred soon after the completion of the new church.

40. Compare the bishop of Treviso's insistence, against the wishes of the commune of Treviso, that the miracle-working remains of Beato Enrico da Bolzano (d. 1315) should be left in their original site when a permanent tomb was provided (Vauchez, 1981/1988, 278–79). For re-

cent stimulating discussions of holy spaces see *Luoghi sacri e spazi della santità*, ed. S. Boesch Gajano and L. Scaraffia, Turin, 1990.

41. For further discussion of this point, see Chapter 4, esp. notes 12 and 14.

42. Approval was obtained from Cardinal Legate Napoleone Orsini in 1308, and miracles continued to be added to the initial list until 1311 (see the introduction to Part V). It may also be worth noting that in describing miracles connected with the tomb the *Legenda* text never indicates any change in burial place, or potential doubt over its location.

been prudent to preserve Margherita's remains in an oratory freshly named for her, until an appropriate stage in the quest for her canonization was marked by a translation.[43]

The Architecture of the New Church

Whereas the building history of the new church is uncertain, the basic form of its architecture can be established with some confidence. Da Pelago's reconstruction of the ground plan (Fig. 13) shows an aisleless building, consisting of three square rib-vaulted nave bays, terminating in a choir composed of a single rectangular rib-vaulted bay. With the help of Presenti's project drawings, and the contemporary account of the nineteenth-century rebuilding given by Domenico Mirri, it is possible to confirm the main lines of da Pelago's reconstruction and to supplement what he tells us about the appearance of the new church.

As described above, the building has undergone many postmedieval alterations, but it is still possible to gain some idea of the original scale and design of the fourteenth-century church from a visit to the present, largely postmedieval building (Figs. 12 and 15). Two of Presenti's project drawings, one of which is adapted here in diagrammatic form (Fig. 16), show clearly the relation between the fourteenth- and nineteenth-century churches.[44] The nave of the church was enlarged to the north and south by the addition of side aisles, and an extra nave bay was added at the west. These areas are shown unshaded in Figure 16. The existing walls, surviving elements of the medieval fabric, were opened up to form arcades leading to the new side aisles. This plan necessitated the demolition of large parts of these walls (shown in gray on Fig. 16), but some sections were retained to form the piers supporting the vaults (shown in solid black on Fig. 16).[45] The two surviving fourteenth-century nave vaults were thus preserved (Figs. 10 and 15), and a third one of the same dimensions was added to the west. The fourteenth-century nave had consisted of three bays (Fig. 13), the easternmost of which had been demolished when the transept was constructed in 1738 (Fig. 14).[46] The dimensions of the central transept bay and the first two nave bays thus correspond to the dimensions of the original nave.

It can be appreciated that the original nave would have formed an impressive structure. Each bay measured approximately 9×9 m[47] and Presenti's measured sections show that the height of the nave to the top of the vaults was approximately 13.20 m (Figs. 18 and 22).[48] A fully vaulted nave was the exception rather than the rule in Tuscany and Umbria at that time. Only the most ambitious churches built for the mendicant orders were treated

43. See the remarks on the significance of translations in Vauchez, 1981/1988, 504 and n. 19.

44. Mirri, rev. Mori, ps. III bis, III ter. The elevation proposed by Presenti is not as finally built, but the ground plan represents that of the present church.

45. Mirri, rev. Mori, 124. Postmedieval walls that were retained are shown in dark gray in Figure 16; postmedieval walls that were demolished are shown in gray hatching.

46. The north and south walls of the bay were demol-

ished and a bay was added to the north and south to form transepts. Mirri, rev. Mori, 37.

47. Della Cella, 133, and Tafi, 284, give the dimensions as 10×10m, but the internal dimensions of 9×9 m given in Mirri, rev. Mori, 31, are confirmed both by consulting Presenti's measured plans and by measuring the present structure.

48. The height to the springing was approximately 6.90 m.

in this way. Vaulting was normally reserved for the east end, with wooden roofs for the nave.[49] Wooden-roofed naves were, for example, used in S. Francesco and S. Domenico in Cortona. It is interesting to compare the size of the nave bays of the new church with those of two churches with fully vaulted naves (both four, rather than three bays long): S. Francesco and S. Chiara in Assisi. The nave bays of the Upper Church at S. Francesco measure approximately 13.50 × 12.30 m, those of S. Chiara 10.80 × 10.60 m. The nave of the church in Cortona was conceived on a somewhat smaller scale, but still deserves to be considered in the context of those ambitious structures.[50]

The incorporation of an earlier building into the new Church of S. Basilio also has associations with the example of Saint Francis. The preservation of Margherita's cell, in which she died, brings to mind the Cappella del Transito of Saint Francis in S. Maria degli Angeli.[51] As mentioned above, da Pelago used a document of 1332 establishing a chaplaincy, to identify a structure situated halfway down the north side of the nave of the new church as Margherita's third cell, which she inhabited at the time of her death.[52] In his reconstruction of the elevation of the north nave wall of the new church (Fig. 21), da Pelago indicated that in addition to the door that gave access from the nave to this chapel (marked B on da Pelago's elevation), a window to the left of Margherita's tomb (marked C on da Pelago's elevation) permitted those in the nave to look into the chapel that marked the place of Margherita's death.[53] This sight would surely have stimulated the interest and devotion of pilgrims visiting the church. The document of 1332 explains that the chapel was called the *cappella Salvatoris* because within it "stood a carved wooden figure of our savior Jesus Christ" (presumably a crucifix).[54] Thus through the chapel window the

49. The fundamental studies are K. Biebrach, *Die Holzgedeckten Franziskaner- und Dominikanerkirchen in Umbrien und Toskana,* Berlin, 1908, and W. Krönig, "Caratteri dell'architettura degli Ordini Mendicanti in Umbria," in *Storia e Arte nell'età communale: Atti del sesto convegno di studi umbri,* Perugia, 1971, I, 165–98. For a survey of Franciscan churches in central Italy, particularly Umbria, and further bibliography, see the exhibition catalogue *Francesco d'Assisi, Chiese e Conventi,* Comitato regionale umbro per le celebrazioni dell'VIII centenario della nascita di san Francesco di Assisi, Milan, 1982. For a survey of Dominican churches in Tuscany, Umbria and Lazio, and further bibliography, see J. Cannon, "Dominican Patronage of the Arts in Central Italy: The "Provincia Romana," c. 1220–c. 1320, Ph.D. diss., University of London, 1980.

50. The height of the Upper Church vaults in S. Francesco, Assisi, is approx. 18.60 m to apex, compared with the Cortona measurement of approximately 13.20 m. For the ways in which the architecture of S. Chiara, Assisi can be said to have "copied" or emulated the example of S. Francesco see the interesting comments in H.-R. Meier, "Santa Chiara in Assisi. Architektur und Funktion im Schatten von San Francesco," *Arte medievale,* 2d ser., 4, ii (1990), 151–78, esp. 164–65.

51. See J. Garms, "Gräber von Heiligen und Seligen," in *Skulptur und Grabmal des spätmittelalters in Rom und Italien: Akten des Kongress, "Scultura e Monumento Sepolcrale del tardo medioevo a Roma e in Italia"* (Rome 1985), ed. J. Garms and A. M. Romanini, Vienna, 1990, 93, for the significance of the site of Saint Francis's death. Meier, 156–57, argued convincingly against the previously held view that the small church of S. Giorgio, the original burial place of both Saint Francis and, later, Saint Clare, was incorporated into the new church of S. Chiara built beside it. The reuse of old S. Basilio as a chapel flanking the new church had appeared to offer a parallel to the use of S. Giorgio at Assisi. (For the previous view of the reuse of S. Giorgio, see M. Bartoli, *Chiara d'Assisi,* Bibliotheca Seraphico-Capuccina, 37, Rome, 1989, 220, 237–38, 248–49, with further bibliography.)

52. ". . . quedam Cappella quasi in medio dicte Ecclesie ex parte montis [i.e. North] in loco ubi olim B. Margarita contraxit residentiam"; da Pelago, II, 172.

53. Da Pelago, II, 128 and tav. 3.

54. ". . . in qua quidem Cappella Salvatoris nostri Jesu Christi figura lignea opere relevato consistit"; da Pelago, II, 172. The fate of this work is not known.

faithful would also have seen a carved wooden crucifix—although not, it seems, the image through which Christ had addressed Margherita in S. Francesco, Cortona[55]—that might remind visitors to the church of Margherita's visions of Christ's Passion.[56]

The ground plan of the east end of the new S. Basilio did not, however, resemble either of the two Assisi churches. There was no transept, and the *cappella maggiore* was a simple rectangle (Figs. 13 and 14). The underlying fabric of the *cappella maggiore* appears to have survived from the Middle Ages (Figs. 13, 16, and 62). Its internal dimensions are approximately 6 × 7 m, and the height to the apex of the vault (replaced in the eighteenth century with a cupola)[57] would have been approximately 11.10 m (Fig. 22).[58] On the exterior, the original gable end above the *cappella maggiore* can still be seen from the path leading up to the Rocca (Fig. 17).[59] The squared stones are cut from the yellowish-grey, friable sandstone on which Cortona stands and which is typical of buildings in the area.[60] The appearance of the exterior of the upper part of the *cappella maggiore* is comparable to that of S. Francesco in Cortona.

Presenti's drawings give further information about the exterior of the church. The entire fabric seems to have been faced in the same roughly squared local stone as the east end.[61] The lower half of the facade was masked by a portico, initially constructed in the early fifteenth century (Fig. 20).[62] Above this was set a rose window, later dismantled and replaced in the present facade.[63] The facade terminated in a simple, low-pitched gable, containing a much smaller oculus, and was flanked by two rectangular buttresses. The general composition of gable and rose again invites comparison with the two Churches of S. Francesco and S. Chiara in Assisi.[64] The west door of the church was presumably always the principal entrance. Da Pelago's ground plan (Fig. 13) also shows a door leading into the easternmost nave bay, situated at the east end of the south nave wall. The existence of this door is confirmed in topographical views of Cortona such as that drawn by Pietro da Cor-

55. For discussion of that image see the Introduction.

56. The image of Christ in S. Francesco, with which Fra Giunta opened the *Legenda* text, was certainly still in that church at the time when the *Legenda* was approved and completed (1308–11). The document of 1332 specifies that the existing Cappella del Salvatore was known by this name because of the carved wooden image of Christ, presumably a crucifix, it already contained. Thus it seems unlikely that a crucifix that had been displayed in the *Cappella del Salvatore* for some time before 1332 can be the same object as that described so emphatically by Fra Giunta as belonging in the Franciscan church in Cortona.

57. Mirri, rev. Mori, 38.

58. Bay measurement taken in situ and from Presenti's plan (Mirri, rev. Mori, 31, gives 6 × 7.50 m, which includes the crossing buttresses). The vault height is estimated from the top of the lunette on the north wall of the *cappella maggiore* in Presenti's measured drawing. The surviving medieval gable end (Fig. 17) confirms that the height of the *cappella maggiore* has not changed substantially.

59. The buttress at the junction of the northwest corner of the *cappella maggiore* with the original nave, with a roofing of stone slabs which may be original, is also visible (Fig. 19).

60. Compare, for example, S. Francesco, S. Domenico, and the Duomo (Pieve di S. Maria) in Cortona.

61. A drawing including the south side of the two surviving nave bays shows simple, rectangular-plan, attached buttresses (also indicated on the ground plan). Mirri, rev. Mori, tav. 2.

62. D. Bornstein, "Pittori sconosciuti e pitture perdute nella Cortona tardo-medioevale," *Rivista d'arte* 42 (1990), 234.

63. Mirri, rev. Mori, 119–20.

64. The design of the rose relates, in reduced form, to that of S. Chiara. For the relation between the facade of S. Francesco and the simplified version at S. Chiara, see Meier, 160–61.

tona in 1634 before the construction of the transepts in this part of the church.[65] Da Pelago's ground plan also indicates the location of other doorways within the church.[66]

The interior elevation of the fourteenth-century nave was relatively plain. A section by Presenti (Fig. 22), and an elevation by da Pelago (Fig. 21), both show the north nave wall. The division into bays seems to have been marked by simple pilasters, with molded capitals (possibly of postmedieval design) supporting the broad diaphragm arches and the springing of the vault ribs. No windows are shown, and this presumably reflects the original arrangement, since the roofs of old S. Basilio, the Cappella del Salvatore and the old sacristy all abutted the north nave wall (Fig. 18). Lighting only from the south side was a common procedure.[67] An anonymous antiquarian (connected, in some capacity, with the convent) who compiled a manuscript guide to Cortona in 1774, noted that at the end of 1773 two windows above the first two altars to the right of the entrance (that is, on the south side of the nave) were replaced. Their previous form, shown in a rough sketch in the manuscript of the guide, was a two-light lancet, set in a square embrasure.[68] The original interior elevation of the cappella maggiore was presumably equally plain. No record of the original fenestration remains. In 1766 large baroque windows were placed high on the north and south walls (Fig. 22) (now replaced by smaller oculi; Fig. 62).[69]

Despite many vicissitudes, enough is still known about the original form of the new Church of S. Basilio to show that it was conceived on an ambitious scale.[70] Although only the seat of a rector, and not intended to accommodate the liturgical needs of a house of friars, it merits comparison with S. Francesco and S. Chiara at Assisi. The scale and form of its vaulted nave might lead one to expect a more ambitious design for its east end. But the disparity has a certain logic: the cappella maggiore was presumably initially intended

65. The engraving forms the frontispiece to G. Lauro, Dell'Origine della Città di Cortona in Toscana e sue Antichità, Rome, 1639, reprinted in the series Historiae Urbium et Regionum Italiae Rariores, n.s., 79, Sala Bolognese, 1981. The doorway is visible above the figure 2 on the engraving.

66. The plan (Fig. 13) shows entranceways connecting the original sacristy (F) to the easternmost nave bay, old S. Basilio (D) to the middle nave bay, and the west wall of the sacristy to the east wall of the Cappella del Salvatore (E). Since the original sacristy had been demolished more than half a century before da Pelago was writing, to make way for the transept, and the Cappella del Salvatore had been turned into a vestibule to old S. Basilio (Fig. 14), most of these elements of da Pelago's plan are presumably conjectural. But he had clearly looked carefully at the surviving fabric of the north nave wall and saw the walled-up opening that had previously led from the central bay of the nave (A) to the Cappella del Salvatore (E). Da Pelago, ii, p. 38.

67. Compare, for example, S. Francesco, Cortona.

68. L'Antiquario Sacro che conduce alcuni suoi amici forestieri a vedere, e visitare le Chiese, e pitture che sono tanto negli Altari, che nei Conventi della Città di Cortona . . . fatto

l'anno 1774 da un dilettante, Cortona, Biblioteca Comunale, Cod. 501, f. 10v. The text of the manuscript remains unpublished.

69. Da Pelago, Sommario, ad annum 1766; Mirri, rev. Mori, tav. 4. The east wall of the cappella maggiore is now obstructed by conventual buildings for much of its height.

70. This need not, however, imply that it was the work of an architect whose name is known to us. Vasari (ed. Bettarini and Barocchi, text vol. 2:63) asserted that the church was designed by Nicola Pisano, which cannot be the case since Nicola was dead by 1284, long before construction began. A desire to correct and build on Vasari's information may well have been the basis for the long-lived traditional ascription of the church to his son, Giovanni. This ascription is presumably also linked to a longstanding but equally erroneous attribution of Margherita's tomb to Giovanni Pisano which reaches back at least to the eighteenth century (see Bardotti Biasion, 1984, 9 and n. 25). Since there is no documentary or pressing stylistic evidence to support these attributions it would seem safer to assume that, as in the vast majority of cases in this period, the name of the person who designed the church remains unknown to us.

primarily for the liturgical duties only of the rector. In general the broad space of the nave would have provided more suitable accommodation for the devotions of the members of the Third Order.[71] When the friars of the Franciscan First Order took over the church in 1392, it appears that a remodeling of the choir was necessary in order to provide for the needs of a group of regular clergy.[72]

Additional choir chapels, so often a feature of central Italian churches at this time, were not constructed in the initial building campaign. As already discussed, the Cappella del Salvatore and presumably also the original S. Basilio (or Cappella di S. Margherita) fulfilled these functions. And a number of side altars were set up against the nave walls, during the course of the later fourteenth century.[73]

The simple nature of the east end, without flanking chapels, transepts, or a polygonal apse, may also indicate, as discussed above, that it was not originally intended to transfer Margherita's remains there. This consideration brings us to the question of how Margherita's remains were to be housed, honored, and displayed within both the original and new Churches of S. Basilio.

71. The liturgical practices expected of members of the Franciscan Third Order are set out in Nicholas IV's bull of 17 August 1289. See G. G. Meersseman, *Ordo Fraternitatis: Confraternite e pietà dei laici nel Medioevo*, Rome, 1977, 397, 400. Margherita's desire to have an altar in her own cell (da Pelago, II, p. 37) was a rarity among Tertiaries.

72. Bornstein, 1990, 231 n. 12, 243–44.

73. See, for example, da Pelago, *Sommario, ad annum* 1363.

4

The Burial Places of Margherita

The rapid increase in the local cults of contemporary saints and would-be saints in later medieval Italy provided a curious challenge for those in charge of their mortal remains.[1] These bodies often attracted an initially intense period of popular attention and votive activity as rumors of miraculous cures spread rapidly. In this respect the bodily remains functioned—and if carefully managed could continue to function—as potent relics that the guardians of the cult had to make accessible to the faithful while, at the same time, needing to protect their precious property from harm. The varying demands of visibility, instruction, access, protection, liturgical celebration, and pilgrimage, had all to be met within the overall necessity for a dignified and decorous entombment. Thaumaturgic relics such as these were not, it must be remembered, the desiccated remains of a single finger or of an arm; they were, at least initially, the complete bodies of recently deceased persons who, in life, may well have been familiar presences to those within their communities. One result was that burials of important contemporary (non-holy) figures could influence the

1. For an introduction to the issues raised by the veneration of the bodies of these holy persons, with many examples, see Vauchez, 1981/1988, esp. 495–518.

choice of burial type for new saints if sufficient funds were available (and no preexisting Roman sarcophagus was conveniently to hand).[2] From the later thirteenth century onward considerable resources had been devoted in Italy to the development of splendid tombs for members of the ecclesiastical and, subsequently, the secular hierarchies.[3] As sculptors and their clients familiarized themselves with these new designs we can begin to observe the use of various new strategies for the presentation of the remains of near-contemporary holy people. In due course long-dead saints, especially those that formed the object of a civic cult, were also re-presented through new tombs.[4]

This focus of artistic experiment and change, which embraced painting as well as sculpture and three-dimensional works in other media, has much to reveal about how the people of late medieval Italy regarded their saintly contemporaries and near contemporaries. It is within this context of varied burial types that we shall seek to reconstruct the different ways in which Margherita's remains were preserved and displayed. We shall see that in the decades following her death there were significant changes in the manner of her presentation, with a move toward commemorations of a markedly civic character. And we shall see the growing influence of Sienese artists on such tombs, with Margherita's splendid monument as a key work in this development. But we shall also observe how changing artistic models and enduring local requirements both had roles to play in the choices that were made.

The First Burial

The *Legenda* records that immediately after her death Margherita's body was embalmed and wrapped in purple garments.[5] Embalming, an expensive procedure that ensured the preservation of honored remains, was not uncommon at the time.[6] The *Legenda* does not mention that Margherita's remains were publicly displayed before being placed in a coffin, but the testimony of a witness at the seventeenth-century canonization process indicates a

2. As, among many other examples, for Beato Guido of Cortona (Figs. 89–91). See below, Chapter 6, note 58.

3. For major ecclesiastical tombs see J. Gardner, *The Tomb and the Tiara: Curial Tomb Sculpture in Rome and Avignon in the Later Middle Ages*, Oxford, 1992. For discussion of the development and significance of such monuments see also I. Herklotz, *"Sepulcra" e "Monumenta" del Medioevo: Studi sull'arte sepolcrale in Italia*, Rome, 1985, esp. chaps. 4 and 5.

4. The variety of tomb-types used for saints and *beati* in later medieval Italy are outlined in the very valuable introductory survey by J. Garms, "Gräber von Heiligen und Seligen," in *Skulptur und Grabmal des spätmittelalters in Rom und Italien: Akten des Kongress, "Scultura e Monumento Sepolcrale del tardo medioevo a Roma e in Italia"*

(*Rome 1985*), ed. J. Garms and A. M. Romanini, Vienna, 1990, 83–105.

5. *Legenda*, xi, 20; Iozzelli, x, 19. The embalming is mentioned again in the account of a miracle in which the distant sight of the Church of S. Basilio, "in qua est beate Margarite corpus balsamo conditum" led a certain Franciscan Tertiary to make a vow to Beata Margherita. *Legenda*, xii, 9; CM, 10.

6. Chiara of Montefalco (d. 1308) and Margherita of Città di Castello (d. 1320) were among those whose bodies were embalmed. In the latter's case the civic rectors paid for the purchase of balsam and aromatics. For these and further examples see Vauchez, 1981/1988, 274 and 504.

delay between death and burial, during which the embalmed body was accesible, and began to manifest its thaumaturgic qualities:

> I affirm that when the people of Cortona heard of the most glorious passing of this blessed woman, the Public and General Council assembled to the honor and glory of God . . . [and] went to the oratory of S. Basilio where the Beata's body, dressed in crimson, was kept unburied for several days because of the sweet perfume that issued from it and because of the miracles it radiated, and eventually she was buried in the presence of members of the clergy in that oratory, which she had built with charitable donations.[7]

Although the reliability of this oral tradition cannot be tested, its evidence should not be dismissed out of hand. Delay before burial, and the associated commencement of miraculous cures, is described in other cases: the burial of Ambrogio Sansedoni (d. 1287) was delayed for two days; that of Enrico da Bolzano (d. 1315) for eight days.[8]

The first contemporary indication of the miraculous powers of Margherita's remains is found in the bull issued by the bishop of Chiusi in 1297, nine months after Margherita's death. According to this text a number of miraculous cures (the blind made to see, the deaf to hear, the weak and sick healed, and a boy who was mortally injured brought back to life) had already taken place.[9] The efficacy of a visit to Margherita's remains is also shown in the final chapter of the *Legenda*, which details all Margherita's posthumous miracles that had been reported and approved by 1311.[10] Yet it is striking that only three of the cures described there took place at the tomb itself.[11] Accounts of miracles associated with shrines had previously been characterized by the physical contact made by the supplicant, who often spent the night in close proximity to the tomb before being granted a cure. But in common with other collections of posthumous miracles being recorded at this time, Margherita's postmortem thaumaturgic powers reached beyond the immediate vicinity of her tomb,[12] permitting those unable to journey there, or unwilling to entrust themselves

7. "Io so che il popolo di Cortona sentendo il gloriosissimo transito di questa Beata, ad honore e gloria di Dio congregato il pubblico e generale Consiglio . . . andò all'oratorio di San Basilio dove il corpo della Beata, vestito di remesion rosso antico fu tenuto più giorni insepolto per il soave odore che usciva da quello e per i miracoli de'quali risplendeva, e finalmente in detto oratorio, da lei edificato d'elemosine, fu sepolto con intervento dell'uno e dell'altro clero"; O. Montenovesi, "I Fioretti di Santa Margherita da Cortona," *Miscellanea francescana* 46 (1946), 271.

Remesion should presumably read *cremisi* (crimson-colored silk or other textile) or *cremisino* (crimson-colored). Compare the *tunica cremisi broccata d'oro* in which Beata Zita (d. 1278) was buried in S. Frediano, Lucca, for which see R. Silva, "Una cintura trecentesca di argento dorato con smalti," *Arte medievale*, 2d ser., 5, ii (1991), 149.

8. The Life of Ambrogio Sansedoni, composed by four of his Dominican contemporaries, reports that "dilata est autem sacri corporis sepultura per biduum, propter maximam populi frequentiam," AASS, March, iii, para. 68, p. 194 (Antwerp, 1643ff. edition). An eyewitness account of the death of Enrico da Bolzano, which was marked by an extraordinary eruption of popular devotion, shows that his body, placed on a litter and covered in a blanket, was displayed for eight days within the protection of a wooden cage before temporary burial in a stone sarcophagus sent from Venice. AASS, June, ii, 373–74 (Antwerp ed.)

9. Da Pelago, ii, 162–63.

10. For this dating see the introduction to Part V.

11. *Legenda*, xii, 7, 30, and 33; CM, 8, 31, and 34.

12. For a detailed analysis of the place of origin of those benefiting from Margherita's miracles see Iozzelli, 1993, 238–44, and fig. B, from which is derived the information given in the sketch map provided here.

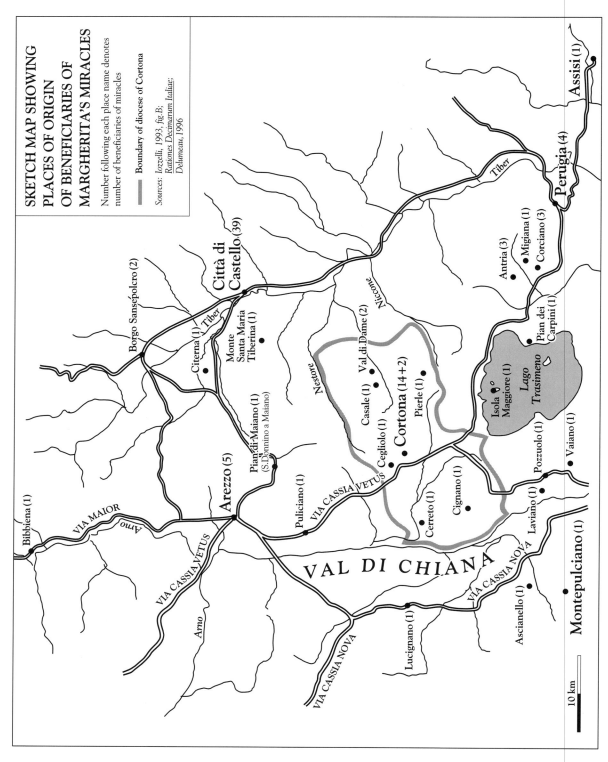

SKETCH MAP SHOWING
PLACES OF ORIGIN
OF BENEFICIARIES OF
MARGHERITA'S MIRACLES

Number following each place name denotes
number of beneficiaries of miracles

—— Boundary of diocese of Cortona

Sources: Iozzelli, 1993, fig.B;
Rationes Decimarum Italiae;
Delumeau, 1996

Bibbiena (1)

VIA MAIOR

Arno

VIA CASSIA VETUS

Arno

Arezzo (5)

Borgo Sansepolcro (2)

Città di
Castello (39)

Citerna (1) Tiber

Monte
Santa Maria
Tiberina (1)

Pian di Maiano (1)
(S.Donnino a Maiano)

Puliciano (1)

VIA CASSIA VETUS

Nestore

Niccone

Val di Dame (2)

Casale (1)

Cegliolo (1) Cortona (14+2)

Pierle (1)

Cerreto (1)

Cignano (1)

VAL DI CHIANA

Lucignano (1)

VIA CASSIA NOVA

Ascianello (1)

Montepulciano (1)

VIA CASSIA NOVA

Laviano (1)

Pozzuolo (1)

Vaiano (1)

Isola
Maggiore (1)

Lago
Trasimeno

Pian dei
Carpini (1)

Antria (3)

Migiana (1)
Corciano (3)

Tiber

Perugia (4)

Assisi (1)

10 km

Sketch map showing the places of origin of beneficiaries of Margherita's miracles

entirely to the efficacy of a single saint, to benefit from Margherita's assistance in their own homes, villages, and towns.[13] In the majority of cases a vow to visit the tomb was sufficient to ensure a swift recovery. Only then was the vow honored, and the miracle reported at the church.[14] It therefore seems that visits to the shrine were often marked by a celebratory character, and the fulfilment of these vows was accompanied, in many cases, by ex-voto offerings. These donations must once have formed a notable element in the appearance of Margherita's burial place,[15] and the references to them in the *Legenda* broaden our knowledge of nonliturgical rites connected with the church.[16]

The ex-voto might take the form of an image: Baldacchino of Cortona presented a wax image to Margherita's tomb—although whether of the saint herself, or of his leg that had been healed, is not clear.[17] Candles were often presented: the mother of five-year-old Marcuccio of Cortona offered a candle that was the same height as her son, after his cure from kidney pain.[18] In several cases the grateful supplicant undertook to encircle (*cingere*) Margherita's tomb. Da Pelago took this to mean encircling the tomb with candles, or presenting as much wax as would reach round the tomb, made into candles, since in four cases a girdle of wax (*cingulum cereum*) is specified.[19] The true meaning of this phrase,

13. Vows made to a succession of saints until a cure was secured are a feature of many collections of miracles at this time.

14. Although the *Legenda* text is not always specific about what the fulfillment of a vow to Margherita entailed, it appears that the majority of miraculous cures (approximately 44 out of a total of 83 posthumous miracles) occurred after a vow to visit Margherita's tomb, generally with a donation. These figures fit with the trends shown in Vauchez, 1981/1988, table 30, 523, and discussed on 522 and 550, that postmortem miracles occurred, increasingly, at a distance from the tomb. In the case of Margherita the fulfillment of the vow to visit the tomb was of great importance: a certain Donna Bruna had a son called Cenne whose legs were covered in sores. These were cured following Donna Bruna's vow to visit Margherita's tomb, but she failed to carry this out, and the sores returned several times. It was not until the vow was finally carried out that the sores were completely cured (*Legenda*, XII, 60; CM, 82).

15. The record of the Visitation of 1629, made as part of the seventeenth-century canonization process, noted the existence, around the high altar and Margherita's *arca*, which by that date rested upon it, of many ex-voto offerings. These included images of people painted on canvas and paper, and votive panel paintings. Witnesses testified to the previous existence of many more such paintings that had disintegrated with age. Inside Margherita's *arca* were more than fifty silver votive offerings. ASV, *Riti*, Proc. 552, pp. 502–5.

16. The canonization process of Nicola da Tolentino (d. 1305, process 1325) provides a rich source of comparative material. For discussion of the evidence for nonliturgical rites and ex-voto donations found in that process,

see E. Pasztor, "Pietà e devozione popolare nel processo di canonizzazione di S. Nicola da Tolentino," in *San Nicola, Tolentino, le Marche: Contributi e ricerche sul processo (a. 1325) per la canonizzazione di San Nicola da Tolentino. Convegno internazionale di studi, Tolentino 4–7 Sett, 1985*, Tolentino, 1987, 219–41, esp. 233–40. For ex-voto paintings presented to the tomb, see F. Bisogni, "Gli inizi dell'iconografia di Nicola da Tolentino e gli affreschi del Cappellone," in ibid., 255–321, esp. 255–59.

17. *Legenda*, XII, 61, CM, 83. Two further references to wax images of unspecified form are found in CM, 59, 61. Wax ex-voto images of afflicted parts of the body were, of course, common at this time. For a representation of ex-votos hanging above a tomb see the *vita*-panel of c. 1400 of Saint Margaret of Antioch, attributed to the style of Turino Vanni, now in the Vatican Pinacoteca, illus. W. F. Volbach, *Catalogo della Pinacoteca Vaticana, vol. 2, Il Trecento: Firenze e Siena*, Vatican City, 1987, fig. 7. See also Figs. 25 and 26.

18. *Legenda*, XII, 14; CM, 15. Such practices are recorded from the seventh century onward. See D. R. Dendy, *The Use of Lights in Christian Worship*, London, 1959, 112–15; R. Büll, "Wachs und Kerzen im Brauch, Recht und Kult. Zur Typologie der Kerzen," in *Vom Wachs, Hoechster Beiträge zur Kentnis der Wachse*, I, 10–11, Frankfurt, 1970, 908–9. Simone Martini's representation of the fulfillment of a vow, in his Beato Agostino Novello panel (Pl. XIII and Fig. 24), in which the child is carried together with a child-sized candle, provides a fourteenth-century visualization of such an event.

19. *Legenda*, XII, 4, 55; CM, 4, 55, 72, 77. Da Pelago, I, 318 n. 4. Similarly, in the case of offerings to the tomb of Nicola da Tolentino, Pazstor, 239 n. 119, takes the phrase

however, becomes clearer when we consider two other miracles described in the *Legenda*. Magio of Villa d'Antria (cured of kidney stones) and an anonymous captive (released from prison) both vowed to encircle the whole church with a candle, "Ecclesiam cingere cum candela."[20] This activity resembles the rites described by Leopold Kretzenbacher in his study of pagan and Christian encircling of entire churches and other cult objects in various parts of Europe.[21] Girdles might be made of iron, gold, or silver chains; of cords or lengths of canvas, wool, or silk; or of wax. Their function could be votive, and although Kretzenbacher includes no Italian examples,[22] the description of Breton "ceintures de cire" and "cordons de cire" make it clear that, surprising as it may seem, a *cingulum cereum* consisted of a single, thin, flexible waxed taper.[23] A wax taper of such proportions would have represented a substantial investment. After the ceremony of encirclement the valuable candle was presumably presented to Margherita's shrine.[24] Although no fourteenth-century Italian painting appears to record this type of ex-voto, a Bavarian painting of about 1480, the High Altarpiece from the Church of Saint Wolfgang in Pipping, now a suburb of Munich, shows such an offering.[25] On the left wing (Fig. 25) we see a group of supplicants coming in search of, or thanks for, miraculous cures. They have been walking around the main church and are now approaching Saint Wolfgang's shrine, carrying wax ex-voto offerings. On the right wing of the altarpiece (Fig. 26) we see, among the objects placed on the saint's tomb, a bundle of thin wax wound like a bale of string (known in England as a trindle),[26] and presumably long enough to have been used to encircle the building.

Shorter lengths of wax taper (*Kerzenstränge/Wachsstränge*) are visible in another German painting of the fifteenth century, a Bavarian panel of Saints Marinus and Anianus (or Theclanus), dated 1483, from Neustift in Freising, now in the Bayerische Staatsgemälde-sammlungen.[27] Among the many votive objects shown suspended on an iron bar above the two saints are two loops of candle that may have been used to encircle a tomb or altar rather than a building, and perhaps show us what a *cingulum cereum* intended for Margherita's tomb could have looked like.[28] The Saints Marinus and Anianus painting, and the

cingere archam de cera to mean surrounding the tomb with candles.

20. *Legenda*, xii, 13 and 22; CM, 14 and 23.

21. L. Kretzenbacher, "Die Ketten um die Leonhards-kirchen im Ostalpenraume. Kulturhistorische Beiträge zur Frage der Gürtung von Kult-objekten in der religiösen Volkskultur Europas," in *Kultur und Volk: Festschrift für Gustav Gugitz*, ed. L. Schmidt, Vienna, 1954, 163–202. See also the earlier study by P. Saintyves, "Le tour et la ceinture de l'église," *Revue archéologique*, 5th ser., 15 (1922), 79–113, esp. 101–9 for the use of girdles of various materials, including wax, in different cultures.

22. In addition to the example of Cortona, discussed here, the *cintola* of Pisa Cathedral (see note 35) presumably belongs, in some sense, in Kretzenbacher's discussion.

23. Kretzenbacher, 177. For the use of candles encircling the walls of French cities, from the twelfth century onward, and the wider context of such activities, see P. Saintyves, *Essais de Folklore biblique*, Paris, 1922, 177–204; Büll, 909–10.

24. For the presentation of candles used to (or, in other cases, long enough to) encircle towns to the altar of the patron saint of the place see Saintyves, *Essais de Folklore*, 1922, 189–93.

25. Reproduced in color in L. Kriss-Rettenbeck, *Ex Voto*, Zürich, 1972, figs. 1 and 11.

26. See D. Rock, *The Church of our Fathers as Seen in St. Osmund's Rite for the Cathedral of Salisbury*, new ed. G. W. Hart and W. H. Frere, London, 1905, III, 191–97, 340–45. For illustration of coiled tapers in an English context see *La Estoire de Seint Aedward le Rei*, Cambridge, University Library, ms Ee.3.59, for example, f.33r. I am indebted to my son, Gregory, for this reference from a primary school history textbook.

27. Illustrated in Kriss-Rettenbeck, fig. 6.

28. Kriss-Rettenbeck, 84–85, seems to identify these as head-rings but they do not appear to form complete circles. She calls the bundles of wound-up candle here, and on the Pipping altarpiece, tapers (*Wachsstöcke*) without speculating on their particular function.

altarpiece from Pipping, may also offer further help in visualizing certain visits paid to Margherita's tomb. In both pictures a woman accompanying a child to the shrine has a thin wax taper wound round her hat band.[29] Presumably this is a wax *cingulum* of the appropriate length, ready for presentation to the shrine. In the Saint Wolfgang painting it seems that the candle was worn in this way while mother and child took part in a circumambulation.[30] These figures call to mind the story of the daughter-in-law of Signor Guidone della Cornia of Perugia who, when praying for the revival of her newborn child, vowed to encircle Margherita's tomb, bringing the infant with her, or Donna Mina of Porta San Vincenzo, Cortona, who carried her three-month-old baby to the tomb while wearing a wax *cingulum* round her neck.[31]

The *cingula* presented to Margherita's tomb were not always made of wax. Ugo of Val di Dame placed a silver thread around the tomb when seeking a cure for his son,[32] and the mother of Bartoluccio of Cortona made the same type of offering after the cure of her son who had fallen into the teeth of a mill wheel.[33] When the type of *cingulum* is not specified, as in the case of Buccio of Cortona, who promised to visit the church "cum cingulo,"[34] an actual girdle or belt may be intended. The 1369 inventory of the Cathedral of Pisa lists a number of *cintole*, made of silk and decorated with silver and enamel plaques, sometimes representing figures of saints, initially made to be worn by women, but then presented as ex-voto offerings.[35] When it is the verb *cingere* that is used, without any qualification, the meaning must remain uncertain, but the implication is that the tomb or altar could, in some sense, be encircled. While encircling a building involved actual circumambulation, it is less clear that this was the case for tombs. Belts, threads, and loops of candle of a

29. Noted, in the Marinus and Anianus painting, by Kriss-Rettenbeck, 84. In the Pipping altarpiece (Fig. 25) the woman in question stands directly behind the standing man with covered eyes.

30. For the votive aspects of circumambulation, especially in connection with the birth, health, and nurture of children, see Saintyves, "Le tour et la ceinture," 1922, 95–101.

31. ". . . cingere vovit tumulum, secum puerum deferendo"; *Legenda*, xii, 42; CM, 43. A similar description is found in the miracle of Suppolino, which took place in 1304 and was subsequently examined by Napoleone Orsini, in which his mother, Donna Muccia, prayed to Margherita thus: "voveo, et tibi promitto, ipsum [Suppolino] ad tuum deferre tumulum et cingere altare [sic] tuum"; *Legenda*, xii, 35; CM, 36. The words *tumulus* and *altare* may be being used interchangeably here, or may simply result from a slip of the pen, but the implication is that an altar was already established for Margherita by that date.

For Donna Mina, see CM, 55. In her case it is fascinating to note that the *Legenda* reports that she first tried pagan rites as a cure (etiam et per brevia et paganorum antiquum ritum, quem adhuc christianae imprudenter non cessant). Donna Mina's promise to visit Margherita's tomb barefoot, dressed in a hair shirt, and with a *cingulum*

round her neck, was evidently considered more appropriate behavior for a Christian.

32. ". . . vovit insimul cum uxore, ducere puerum ad sepulcrum sancte Margarite, et ipsum cingere cum filo argenti"; *Legenda*, xii, 11; CM, 12.

33. *Legenda*, xii, 38; CM, 39. The healing of Bartoluccio is shown in Scene vi of the watercolors (Pl. XIX). The gift of a silver thread is also mentioned in CM, 68. For the income generated by such silver threads, candle wax, and coins dropped into Margherita's wooden coffin, between 1369 and 1384, see Bornstein, 1993, 173–74.

34. *Legenda*, xii, 12; CM, 13.

35. R. Barsotti, *Gli antichi inventari della Cattedrale di Pisa*, Pisa, 1959, 5–6, 31, 64–65, and 67. These *cintole* presumably imitated the large *cintola*, already in existence in 1313, which was used to encircle the cathedral at Easter and on the feast of the Assumption. See Barsotti, 9–10; L. Tanfani Centofanti, *Notizie di artisti tratte dai documenti pisani*, Pisa, 1897, 212; illustrated A. F. Moskowitz, *The Sculpture of Andrea and Nino Pisano*, Cambridge, 1986, 96 and figs. 180 and 181.

For excellent color photographs of a well-preserved fourteenth-century bridal belt, presented to the tomb of Beata Zita (d. 1278) in S. Frediano, Lucca, see Silva, 149–55.

length sufficient to encircle the tomb may simply have been hung near the shrine.[36] On the other hand the action of circumambulation itself, a part of both pagan and Christian rites charged with magical meanings,[37] was an important aspect of encirclement, as Kretzenbacher has emphasised.[38] Although it cannot be proved, it seems reasonable to suppose that the rite of presenting a *cingulum* to the tomb, or of vowing to encircle (*cingere*) it, was marked either by the placing of the girdle around the *arca* containing the saint's body, or by circumambulation of the tomb.

This raises the issue of the initial location of Margherita's body within the church of S. Basilio. Was it locked away, perhaps within the thickness of the wall—as was later the case? Or was it made more accessible to the faithful, in a manner akin to the elevated and freestanding tombs favored for some venerated remains in the period?[39] Da Pelago believed that Margherita's first burial place was marked by a tomb niche in the south wall of the central bay of old S. Basilio (marked d on da Pelago's plan; see Fig. 13). The niche, still visible in da Pelago's day, was set approximately one *braccia* (c. 58.4 cm) above floor level.[40] Da Pelago cited a passage from the *Legenda* in support of this identification: a young girl who lived near Assisi was placed "sub beate Margarite tumulo" in order that a cure might be effected.[41] Da Pelago took this to mean literally below the tomb, but the precise meaning of *sub* in this context is open to question.[42] On the other hand da Pelago's belief that Margherita's remains were always elevated—and never buried beneath the pavement of S. Basilio—agrees with the evidence concerning other venerated persons at this time.[43] The use of a tomb niche, as proposed by da Pelago, would evidently preclude the possibility that encirclement of the tomb, discussed above, included actual circumambulation. But before pursuing the question of where Margherita's body was housed, it may first be useful to give further consideration to the question of how it was housed.

Turning to the watercolor copies of the mural cycle that were used as evidence in the canonization process of 1629–40, and that form a central part of this study, we find a piece of information concerning Margherita's remains that da Pelago did not discuss. Scene xvii (Pl. XI; Fig. 23) represents the approbation of the *Legenda* and miracles of Margherita by Cardinal Napoleone Orsini during his visit to Cortona as legate in 1308. Margherita's body is displayed in a box made of a metal grille, supported on a simple wooden trestle. The

36. As shown in the Bavarian panel of Saints Marianus and Anianus (Kriss-Rettenbeck, fig. 6)—but these may indicate the method of storing and displaying the ex-voto after the presentation and any accompanying ceremony. The representation of Saint Wolfgang's tomb, on the altarpiece from Pipping (Fig. 26), shows the tomb still covered with objects.

37. For circumambulation of holy buildings, altars, and tombs as a religious or magical rite see the entry, with further bibliography, by L. Gougaud in *Dictionnaire de Spiritualité*, Paris, 1937–95.

38. Kretzenbacher, 191, points to the significance of the girdle—of whatever material—as a permanent indication that a circumambulation had been carried out. See also Saintyves, "Le tour et la ceinture," 1922, esp. 109–13.

39. For example, the second and third burials of Saint Dominic, for which see Cannon, 1980, 169–82; the second burial of Beato Ambrogio Sansedoni, for which see below.

40. Da Pelago, ii, 125.

41. *Legenda*, xii, 7; CM, 8.

42. The word might mean "below" in a liturgical sense (i.e., "to the West of") or might simply indicate a general proximity to the tomb.

43. For example, see Vauchez, 1981/1988, 105–6. There were, however, exceptions to this rule, notably within the Franciscan Order.

fresco on which the watercolor was based cannot have been a direct record of the appearance of the first burial, for it was almost certainly painted after Margherita's body had been translated to the new church.[44] But it was probably painted at a time when a number of those who remembered the initial disposition were still alive. Confirmation that this iron box was not merely a product of the artist's imagination comes in the records of the canonization process. In 1634 judges for the process visited the church. Among other items they were shown an *arca* (tomb chest or coffin) composed of a grille of gilded iron in which, according to reliable witnesses reporting an ancient tradition, the body of the beata was kept for some years after her death.[45]

This curious cage was the product of two conflicting elements in the veneration of such earthly remains: access to the elevated body encouraged devotion and miraculous cures, but access also made the remains more vulnerable to pious theft. A raised stone tomb chest afforded both visibility and protection, but was expensive and could be slow to produce.[46] Another solution was to place the remains within a wooden chest in a wall niche whose entrance was protected by an iron grille.[47] The iron *arca* used for Margherita was a more expensive and unusual measure. Iron cages also enclosed the coffin of a particularly precious body: that of Saint Francis.[48] In the case of Saint Francis it is argued that this method was adopted in order to ensure access to, and sight of, the body within its undecorated stone sarcophagus.[49] In the case of Margherita, too, the cage may have been chosen to permit visibility and, at the same time, ensure access.

If the watercolor is to be trusted in its representation of the iron *arca*, what are we to make of the open display of Margherita's body within it, at a ceremony that took place several years after her death? It is certainly inaccurate in one respect, since we know from the *Legenda* that Margherita's body, shown here in the dress of a Tertiary and Penitent, was clothed in precious purple textiles.[50] The protection afforded by the iron *arca* (to judge by the very open construction shown in the watercolor) would seem to be negated by the ease with which portions of the remains might be stolen through the gaps in the grille. It seems,

44. For the dating of the frescoes, see Chapters 9 and 10.

45. When the visitors of 1634 saw it, it was kept near the site of the fourteenth-century tomb, on the north nave wall, "et iuxta dictum sepulcrum [i.e. the marble monument] adest Arca ferrea graticulata deaurata, in qua Corpus dicte Beate post eius dormitione per aliquot Annos conservatum fuit, prout a viris fide dignis ex antiquissima traditione fuit narratum"; ASV, *Riti,* Proc. 552, 513–14.

46. In the case of Beato Guido of Cortona (d. 1247) this problem was solved when a Roman Sarcophagus (Figs. 89–91) was miraculously found in a field near the city walls. See below, Chapter 6, note 58. For the stages in the entombment of Enrico da Bolzano see below, note 53.

47. For example, the niche containing the remains of five companions of St. Francis (Fig. 120), described below, note 75.

48. See I. Gatti, *La Tomba di S. Francesco nei secoli,* Assisi, 1983, 41–42, 154, figs. 3, 13, and 15.

49. Gatti, 40–43. Whether the cage was provided before or after Saint Francis's translation from the Church of S. Giorgio in Assisi to S. Francesco is not known, although Gatti considers that it was probably provided before the translation, soon after Francis's death.

50. The Latin text cited at the start of this chapter says purple, while the Italian text says crimson, but the same expensive dye-stuff is obviously intended in both languages. Margherita's body was re-dressed in 1456 (as noted, in a fifteenth-century hand, in the back cover of one of the fourteenth-century manuscripts of Margherita's *Legenda*). She was also reclothed in 1580 and 1774 (see Tafi, 289). The body was clothed in its present garments in 1804; see *Santuario di Santa Margherita, Cortona: Breve guida illustrata a cura dei Padri Minori del Santuario,* Cortona, n.d., 12.

indeed, unlikely that the body, wrapped in its precious textiles, would simply have been placed directly in the cage. The usual container for such a body was, in the first instance, a wooden chest.[51] The earliest reference to a *pinum* (pine coffin) containing Margherita's remains is found in the document of 1343,[52] but there is every reason to suppose that it was provided much earlier, presumably from the outset. This would mean that a wooden chest was enclosed within the iron cage, the combination providing adequate protection for the remains. Such a combination of tomb-chest and cage seems to have been used for Saint Francis, both for his permanent burial in S. Francesco, and possibly also in his temporary resting place in the Church of S. Giorgio. In Francis's case it is thought that the lid was left off the chest, permitting—to those allowed to approach the remains—sight of the corpse through the grille above, which was dense enough to ensure that no hands could reach through it.[53] It seems likely that Margherita's cage, too, would have formed a closely worked grid rather than the more open grille-work reflected in Scene xvii of the watercolors. (This was presumably a modification on the part of the trecento artist, to ensure that Margherita's body could be clearly seen in the mural.) The choice of the iron *arca* for Margherita may indicate that, at least initially, her body, wrapped in precious textiles, but with face, hands, and feet exposed, also remained visible. After a time, perhaps when the initial flow of supplicants slowed and those attached to the Church of S. Basilio would no longer spare the time to guard the tomb,[54] a lid was placed on the *pinum*.

We can now return to the question of where the iron *arca* was placed within the church. Da Pelago gives no indication of the length or depth of the tomb niche in the original Church of S. Basilio, but assuming that the recess was large enough to accommodate the coffin and cage it would have been possible for visitors to the tomb to reach in and tie *cingula* around the length of the *arca*. If what the sources describe as *cingere tumulum* was, on the other hand, an actual circumambulation, the coffin in its cage would have to have been, in some sense, freestanding. The evidence of the watercolor of Scene xvii may again be of relevance here. As already noted, the cage is shown resting on a wooden trestle. This encourages the speculation that on special occasions, notably when those who had benefited from Margherita's miraculous interventions came to report the event before witnesses,[55] and to fulfil the vow of a visit to her shrine, the cage may have been taken out of

51. The customary use of a wooden *arca*, often as a temporary measure until a stone monument could be provided, is noted in Vauchez, 1981/1988, 274.

52. See Chapter 3, especially note 29.

53. Gatti, 41–43, 100–101, fig. 15. Compare also the eyewitness account of the temporary burials of Enrico da Bolzano (d. 1315) in the days following his death. When his wooden coffin was virtually destroyed by the crush of people, he was hastily placed in a depression in the cathedral pavement, covered by a strong wooden grating, as a temporary measure, so that people could see the body without touching it. Next his body was covered with a blanket, and placed on a litter resting on the cathedral pavement, protected by a much stronger wooden cage,

with a door, above which was erected a platform on which the sick could lie. After eight days his body was placed within a stone sarcophagus sent from Venice, and a year later a permanent stone monument, financed by the commune of Treviso, was completed. AASS, June, II, 373–74 (Antwerp ed.). For the role played by the commune see Vauchez, 1981/1988, 277–79.

54. For the (non)payment of guards in the case of Enrico of Bolzano see Vauchez, 1981/1988, 278; for the representation of a guarded body see the Funeral of Saint Francis in the Upper Church of S. Francesco at Assisi (J. Poeschke, *Die Kirche San Francesco in Assisi und ihre Wandmalereien*, Munich, 1985, fig. 184).

55. See the introduction to Part V.

the niche for more open display. This would also be consistent with the evidence of the chapter of miracles in the *Legenda* concerning the encircling of the tomb, which all relates to such occasions. The representation of this arrangement in the scene of the Visitation of Napoleone Orsini (Pl. XI; Fig. 23) would thus have been a retrospective indication of how the early miracles had been reported, either to Orsini or to others, in the original Church of S. Basilio.[56] As for the open display of Margherita's body within the cage, this should not be taken merely as a piece of artistic license; it makes clear that even when enclosed within the pine coffin, the continued presence of the incorrupt body was crucial to the cult.[57]

Entombment in the New Church of S. Basilio

The first reference to the pine coffin is found in the will of Donna Niccoluccia, made in 1343, which provided, as discussed above, for the establishment of a chaplaincy at the altar existing below the site of Margherita's coffin.[58] By this date Margherita's remains had been translated from old S. Basilio—the Cappella di S. Margherita—to the north wall of the easternmost bay of the new church (marked C on da Pelago's ground plan; see Fig. 13). Da Pelago provided an engraving of his reconstruction of the fourteenth-century arrangement showing the altar, tomb niche and marble funerary monument (Fig. 21). By his time this wall had been demolished to make way for a transept; the monument had been relegated to a position above the sacristy door (see Fig. 18); and the altar had, according to da Pelago, been removed when Margherita's body was translated to the high altar of the main church in 1580.[59] The engraving thus needs to be treated not as an accurate record but as a speculative approximation.

For his reconstruction da Pelago probably drew on the account of the Visitation of 1634, mentioned above, which provides a meticulous record of the items shown to the judges for the canonization process. On the north wall of the nave, near the high altar, the judges saw the "old marble tomb."[60] Below it, opening a shutter (*fenestra*) (see Fig. 27), they saw a coffin (*capsa* or *arca*) in which, for more than two hundred years, Beata Margherita's body had been kept.[61] Da Pelago described the arrangement as a cavity in the wall, approximately

56. In reality, Napoleone Orsini's Visitation of 1308, during which he approved the *Legenda* text, took place in Palazzo Casali. Scene xvii of the mural cycle was evidently a conflation of various events. For further discussion of the significance of the Visitation scene, and of other possible anachronisms within it, see Chapter 14.

57. For general discussion of the importance of the incorrupt body in the cult and canonization of saints see Vauchez, 1981/1988, 499–507.

58. "unum capellanum altaris existentis in dicta eccle-

sia sancti baxilii sub pino in quo positus est corpus beate margarite in ecclesia supradicta." Cited in Bardotti Biasion, 1984, 18 n. 41.

59. Da Pelago, ii, 127.

60. ASV, *Riti*, Proc. 552, 512. The text says *latere dextero* but, as explained in Chapter 7, this should be interpreted as the left, or north, side of the nave.

61. This was a separate item from the iron *arca*, which they were also shown on the same visit. The coffin was made, in part, of glass. See below, note 158.

three *braccia* (c.1.75 m) above floor level, accessible both from the nave and, at the rear, from the sacristy, and enclosed on both faces by horizontal wooden doors.[62]

The door giving access from the sacristy was undecorated. The one facing the nave is not shown in da Pelago's reconstruction (Fig. 21), but he mentioned in his text that it survived in his day, kept in the convent, and was decorated with the following images: at the center, the Crucifixion with the Virgin, Saint John the Evangelist, and Saint Mary Magdalene at the foot of the cross; on the right Saint John the Baptist, Beata Margherita, and Saint Basil; on the left Saint Peter, Saint Catherine of Alexandria, and Saint Francis.[63] Da Pelago suggested a date of c. 1330 for the paintings.[64] He gave no reason for this statement,[65] but he probably linked the making of the shutter to the translation of Margherita's body to the new church which, as discussed above, he believed to have taken place c. 1330. Da Pelago noted that these paintings were in very poor condition,[66] and no such painted door now exists, but two plain wooden panels of strong construction, with large keyholes, are still kept in the convent museum.[67]

The painted door was seen during the Visitation of 1634.[68] At that time it formed part of the *sepulchrum*, which contained Margherita's body after the translation to the high altar in 1580.[69] The visitation records describe the paintings as *imagines antiquas*, a term that appears to have been used with some discrimination. During their visit to the church the judges were shown a number of images, principally in order to note those that showed Margherita with a halo, in the company of other saints, and in order to gauge the age of this tradition.[70] Paintings were categorized systematically as *antiquissima*, *antiqua*, or *satis moderna*. The visitation record would not have described a painting made at the time of Margherita's translation to the high altar in 1580 as *antiqua*. This confirms da Pelago's information that the painted door previously covered the niche on the north nave wall, and it seems probable that da Pelago was correct in assuming that the door was made at

62. Da Pelago, ii, 127. (It must be remembered that at the time da Pelago was noting such a precise measurement, the wall in question no longer existed.)

63. The inclusion of Saint Peter is appropriate since B. Margherita died on the feast of *Cathedra Petri*. The original church of S. Basilio was also dedicated to Saints Catherine of Alexandria (included here) and Egidio. The bearded figure identified as Saint John the Baptist by da Pelago may, in fact, have been the less familiar figure of Egidio, shown as a hermit. Napoleone Orsini's bull of 2 September 1306 offered an indulgence to all those visiting the church on the feasts of the *Cathedra Petri*, Saints Basilio, Catherine of Alexandria, and Egidio. Da Pelago, ii, 165.

64. Da Pelago, ii, 39.

65. The text simply says, "una tavola, che serviva di chiudenda all'antico deposito, o urna della Santa, dipinta, per quanto credesi, circa l'anno 1330."

66. ". . . benchè in gran parte scrostate . . ."

67. Maximum dimensions of each panel is approximately 64 × 205 cm. There is no remaining evidence that either was originally painted.

68. The description clearly refers to the same object, although the visitation record does not mention Saint John the Evangelist and Saint Mary Magdalene at the foot of the Cross, and seems to have mistaken Saint Francis for Saint Anthony of Padua.

69. ASV, *Riti*, Proc. 552, 501–3. The watercolor copy of the monument made a year or two before the Visitation of 1634 (Fig. 27) shows, in place of the painted door, two undecorated wooden doors enclosing the niche below the funerary monument.

70. For similar appeals to the visual evidence of halos in a canonization process see J. Osborne, "Lost Roman Images of Urban V (1362–1370)," *Zeitschrift für Kunstgeschichte* 57 (1991), 28 n. 36; and, for Gregory X, S. Ditchfield, "How Not to Be a Counter-Reformation Saint: The Attempted Canonization of Pope Gregory," *Papers of the British School at Rome* 60 (1992), 392.

the time when Margherita's body was translated to the new church, at some time during the first half of the fourteenth century.[71]

The scheme of placing an altar beneath a wooden coffin containing venerated remains, in the nave of a church, and the associated use of panel paintings, would not be unique. Butzek, Bagnoli, and Seidel have drawn attention to the original form of Beato Agostino Novello's burial in the nave of S. Agostino in Siena.[72] The remains were contained in a wooden *capsa* decorated with four panels showing scenes from Agostino Novello's life. These scenes were probably executed at the same time as the panel of Agostino Novello with four posthumous miracles, attributed to Simone Martini, now on deposit in the Pinacoteca in Siena (Fig. 24). Seidel argued that the ensemble must have been installed before 1329, and Bagnoli proposed a terminus ante quem of 1324, the year of the Sienese Commune's first substantial participation in Agostino Novello's feast day.[73] Seidel deduced that the *capsa* was situated above the altar and beneath the panel painting.[74]

There may have been a comparable arrangement in another Sienese church. The remains of Beato Andrea Gallerani (d. 1251), a lay penitent and founder of a hospital in Siena, were placed in a gilded wooden *capsa* in a niche in the nave wall of S. Domenico in Siena. Below the niche (which was protected by an iron grille) there was an altar above which was a panel painting representing Gallerani and various of his miracles.[75] Bossio's apostolic visitation of 1575, quoted in the discussion of the cult in the Acta Sanctorum, described the work as "painted panels most beautifully and delicately executed."[76] The information about this painting is supplemented by the evidence of Raimondo Barbi, whose *Vita* of Andrea Gallerani, composed in 1638, included a list of images of Gallerani to be seen in Siena,

71. Mancini, in discussing the setting of Signorelli's Deposition of 1502 on the high altar, referred to the record of the Visitation of 1634. He assumed that the paintings on the shutters were also executed by Signorelli, but at the time when Signorelli's altarpiece was first placed on the high altar, Margherita's body was still enclosed behind shutters in the tomb niche, and there is therefore no reason to connect the two works. G. Mancini, *Vita di Luca Signorelli*, Florence, 1903, 135 n.1.

72. M. Butzek in *Die Kirchen von Siena*, ed. P.A. Riedl and M. Seidel, Munich, 1985, I,1, 210, and 212; A. Bagnoli and M. Seidel in the exhibition catalogue *Simone Martini e "chompagni*," Florence, 1985, 56, 68–69. For further examples, discussed in the context of the development of panel painting function and design in Italy, see K. Krüger, *Der frühe Bildkult des Franziskus in Italien*, Berlin, 1992, esp. chap. 3.

73. M. Seidel, "Ikonographie und Historiographie," *Städel Jahrbuch*, n. s, 10 (1985), 129 n. 2; Bagnoli, 60.

74. Seidel, 1985, 81–85; Seidel, "Condizionamento iconografico e scelta semantica: Simone Martini e la tavola del Beato Agostino Novello," in *Simone Martini atti*

del convegno (Siena, 1985), ed. L. Bellosi, Florence, 1988, 75–76.

75. The comparison is made in H. van Os, "Due divagazioni intorno alla pala di Simone Martini per il Beato Agostino Novello," in *Simone Martini atti del convegno (Siena, 1985)*, ed. L. Bellosi, Florence, 1988, 85. Van Os did not pursue the identity of the artist beyond noting Avanzati's hypothesis, cited below, note 78.

A surviving example of a *capsa* in a niche behind an iron grille, associated with painted images of the deceased, is that containing the remains of five companions of Saint Francis, in the right transept of the Lower Church of S. Francesco at Assisi (Fig. 120). Directly above the images of the deceased is the mural of the Virgin and Child Enthroned with Angels, flanked by Saint Francis, attributed to Cimabue. See Fra' Ludovico da Pietralunga, *Descrizione della Basilica di S. Francesco e di altri santuari di Assisi*, ed. P. Scarpellini, Treviso, 1982, figs. 28 and 30, and pp. 70–72. Scarpellini puts the fresco of the *beati francescani* "close to the style of Pietro Lorenzetti."

76. "tabulis perpulchre et ornate depictis subtilissime"; AASS, Martii, III, 51, paras. 15 and 16 (Antwerp ed.).

but that which, above all, testifies to the devotion of the people and to his [Gallerani's] sanctity, is the [image] that was executed in about the year 1327 (as some people say) by Antonio Laurati, brother of Pietro of Siena, both of them painters, and that was placed in those days on the altar where his holy body still resides, in an elevated position; [an image] accompanied by representations of various miracles and charitable works of this blessed man, and many people maintain that this likeness was taken from the original, representing the appearance of this blessed man.[77]

"Antonio Laurati" is presumably a misreading for Ambrogio Laurati, the partially Latinized form of Ambrogio Lorenzetti.[78] Ambrogio and Pietro Lorenzetti, together with Simone Martini, were instrumental in a reformulation of Sienese hagiographical narrative in the third and fourth decades of the fourteenth century. We shall return to this subject, and to the question of the place of the Andrea Gallerani narratives within this development, in Chapter 10. In the present context it is interesting to note the physical proximity of the venerated remains, an altar, and a panel painting presenting an image of the *beato* flanked by scenes representing the *vita* or posthumous miracles. A panel painting of similar content (but somewhat earlier date) now in the Museo Diocesano of Cortona, shows Margherita, scenes from her life, and miraculous cures at her shrine (Pl. II; Fig. 56). As we shall see, this painting may have been closely connected with Margherita's remains.

The Marble Monument of Beata Margherita and the Development of the Sienese Tomb-Altar

In reconstructing the tomb of Beato Agostino Novello, Seidel made a comparison with the burial of San Ranieri of Pisa in the cathedral of his native city.[79] In one of the three scenes

77. "ma sopra al tutto dien pur credito alla devozione de popoli ed all santità sua, quella [pittura] fatta da Antonio Laurati fratello di Pietro sanese, amendue pittori, (come alcuni dicono) nell'anno 1327, in circa, posta in quei giorni nel proprio altare, dove al presente anco risiede il suo santo Corpo, in elevato luogo; [pittura] ornata attorno con diversi miracoli ed opere caritative di questo Beato, la quale effigie vogliono molti che sia cavata dal suo originale, che rapresentava la figura di questo Beato"; R. Barbi, *Vita del B. Andrea Gallerani*, Siena, 1638, 124–25, quoted in P. Bacci's *Dipinti inediti e sconosciuti di Pietro Lorenzetti, Bernardo Daddi, ecc, in Siena e nel contado*, Siena, 1939, 10. (Bacci, 9 and 11, notes that Barbi's sources included the fourteenth-century MS *Leggendario* now in the Biblioteca Comunale, Siena.)

78. Vasari called Pietro Lorenzetti "Pietro Laurati." E. Avanzati in the exhibition catalogue *Simone Martini e "chompagni,"* Florence, 1985, 78, preferred to connect the description tentatively with a Simonesque panel of Beato

Andrea Gallerani (without scenes) now in the Church of S. Pellegrino alla Sapienza in Siena. Van Os, 1988, 85, considered the painting to have been a fourteenth-century work (the date of 1427 which he cites is presumably a misprint for 1327.)

Previously Bossio's description had been connected with a pair of thirteenth-century painted shutters (now Siena Pinacoteca no. 5) (Figs. 174 and 176) by Bacci (3–32), and by J. H. Stubblebine, *Guido da Siena*, Princeton, 1964, 69–71. The subject matter of these shutters does not correspond to the scenes enumerated by Barbi (for which see Chapter 10). An indulgence issued in connection with Gallerani's tomb in 1274 (Bacci, 18–19) may relate to the dating of the shutters. These may have formed an earlier phase of decoration, later augmented or superseded by the fourteenth-century panel.

79. Seidel, 1985, 84–85; Seidel 1988, 76. For further discussion of the S. Ranieri tomb-altar, see M. Seidel, "Studien zu Giovanni di Balduccio und Tino di Ca-

of the predella-like section below the main gable area, there is a representation of Ranieri's body being placed in his tomb. This scene (Fig. 29), taken together with the scene of the Presentation of the Tomb to San Ranieri (Fig. 28), shows that the monument consisted of three distinct sections: the tomb chest in which the body was placed, decorated with rectangular reliefs and supported on consoles; the historiated gable above; and an altar below, which formed an integral part of the tomb.

The combination of tomb and altar found in the San Ranieri monument has provided the starting-point for several discussions of tombs for venerated remains made by Sienese artists in the fourteenth century. Studies by Bardotti Biasion, Kreytenberg, and Garms have drawn attention to the association of this type of monument with the cults of local *beati* often linked with the mendicant orders and enjoying civic support.[80] Seidel and Van Os, in particular, have addressed the art-historical implications of Vauchez' work on civic cults and the mendicant orders in Siena.[81]

The earliest of the group may be the tomb of Ambrogio Sansedoni (d. 1287), a member both of the Dominican Order and of a prominent aristocratic Sienese family, and closely associated with lay piety through his establishment of one of the first *laudesi* confraternities in S. Domenico, Siena.[82] The chapel constructed in his honor (*capella opere suntuoso*) contained a tomb-chest (*archa*) raised on four marble columns, and was enclosed by an ironwork screen.[83] The chapel stood near the middle (*nel bel mezzo*) of S. Domenico.[84] This situation clearly drew popular attention to the cult but probably caused congestion in the church.[85] As we shall see, Sienese sculptors of the early fourteenth century seem to have addressed this problem by the use of the wall tomb, supported on consoles.[86] Communal financial support for Sansedoni's chapel was forthcoming in 1287; two years later, in S. Francesco, Siena, a *sepulchrum nobile cum ciborio et altare* was constructed for Pietro Pettinaio of the Franciscan Third Order (d. 1289), again with financial help from the com-

maino," *Städel Jahrbuch*, n.s., 5 (1975), 71–78; and for an illuminating account of the monument in the context of Ranieri's cult and *Legenda*, see L. Richards, "The Cult of San Ranieri and Its Importance in Pisa from the Twelfth to the Fourteenth Centuries; The Evidence of Text and Image," M.A. thesis, Courtauld Institute of Art, University of London, 1991 (to be published in the series Courtauld Research Papers, vol. 1, ed. J. Cannon and B. Williamson, forthcoming).

80. Bardotti Biasion, 1984; G. Kreytenberg, "Zum gotischen Grabmal des heiligen Bartolus von Tino di Camaino in der Augustinerkirche von San Gimignano," *Pantheon* 46 (1988), 13–25; Garms, passim.

81. A. Vauchez, "La commune de Sienne, les Ordres Mendiants et le culte des saints. Histoire et enseignements d'une crise (novembre 1328–avril 1329)," *Mélanges de l'Ecole française de Rome, Moyen Age-Temps Modernes* 89 (1977), 757–67; Seidel, 1985, 86–101; Seidel, 1988, 78–80; van Os, 1988, 84–86.

82. G. G. Meersseman, "Les confréries de Saint-Dominique," *Archivum Fratrum Praedicatorum* 20 (1950), 19,

34–35, 39–41, 46–47; Meersseman, "Nota sull'origine delle compagnie dei Laudesi, (Siena 1267)," *Rivista di storia della chiesa in Italia* 17 (1963), 395–405; Vauchez, 1977, 758 n. 5.

83. Seidel, 1985, 137–38; Garms, 88–89.

84. G. Sansedoni, *Vita del Beato Ambrogio Sansedoni da Siena*, Rome, 1611, 149–51. The chapel was destroyed in the fire of 1533, but the site was still visible to Sansedoni, "per la differenza dei mattoni dello spino del pavimento in un gran quadro . . . per contro all'organo, ed all'altare hoggi del Rosario."

85. Sansedoni, 257, reports a tradition that when Beato Ambrogio died (1287) so many people came to S. Domenico and made offerings that the Dominicans built a new, large transept for their church.

86. For a discussion of the genesis of this type see Bardotti Biasion, 1984, esp. 2–3. For a list of early examples, in commemoration of prelates, laymen, and saints, see R. Bartalini, "Goro di Gregorio e la tomba del giurista Guglielmo di Ciliano," *Prospettiva* 41 (1985), 35 n. 23.

mune.[87] Since neither of these works has survived, it is impossible to know whether they resembled one another. Nor do we know the form of the monument with which the Carmelites of Siena honoured their local *beato*, Franco da Grotti, but Ugurgieri noted that an altar and an image of the saint were associated with his remains.[88]

In the case of the fifth major mendicant order in Siena, Bardotti Biasion was able to point to an existing monument. Three reliefs now in the Pinacoteca in Siena (Fig. 31) were shown by dal Pino to represent scenes from the life of Beato Gioacchino, a member of the Siena house of the Servite Order, who died in 1305.[89] The first miracles associated with his cult occurred in 1310 and his tomb, like that of Margherita, was soon festooned with ex-voto offerings.[90] Dal Pino suggested that the surviving reliefs formed the front of the chest of a wall tomb, placed above an altar, and Bardotti Biasion has drawn attention to the similarity between this proposal and the original form of San Ranieri of Pisa's tomb-altar (Figs. 28, 29, and 31).[91] The decoration of the sacrophagus with scenes from the life of the deceased (rather than with posthumous miracles) would provide a parallel with the description of the *arca* of Beato Agostino Novello.

The key monument in Bardotti Biasion's study is the funerary monument of Beata Margherita (Figs. 32–37).[92] Although it no longer has an altar,[93] Donna Niccoluccia's will of 1343, referred to above, shows that an altar already existed below Margherita's coffin at that date.[94] The four reliefs on the sarcophagus-like area of the tomb show scenes from Margherita's life, and may give some indication of the original setting of the scenes from the life of Beato Gioacchino (Figs. 31 and 32).[95] The chest is supported on consoles,[96] and the whole monument is designed as a wall tomb, to be placed above an altar without obstructing circulation in the church.

Similarities between the monuments of Beata Margherita and Beato Gioacchino go beyond questions of general design; as Bardotti Biasion has shown, the reliefs of Margherita's monument, carved in an elegantly restrained and lucid manner, are clearly by the same hand as the Beato Gioacchino narratives (compare, for example, Figs. 30 and 31 with Figs. 149 and 161). Toesca had already noted this similarity but a mistaken connection made between the Margherita monument and a document of 1362 hampered his discussion of the sculptural style.[97] In common with several other scholars he connected the style of the tomb with the work of Sienese sculptors of the first half of the fourteenth century. But all those discussing the tomb accepted that a document of 1362 which named Angelo and

87. Vauchez, 1977, 759; Seidel, 1985, 137–38.

88. Cited by van Os, 1988, 85.

89. Overall dimensions 45 × 170 cm. Bardotti Biasion, 1984, 3–6; Vauchez, 1977, 758.

90. A. M. dal Pino, "Note iconografiche sul B. Giovacchino da Siene e la sua 'legenda,' " *Studi storici dell'Ordine dei Servi di Maria* 8 (1957–58), 156–61, esp. 158.

91. dal Pino, 160; Bardotti Biasion, 1984, 6.

92. For previous art-historical study of the tomb see Bardotti Biasion, 1984, esp. 18 n. 28. Virtually all of the monument's original polychrome, apart from small areas of gilding, has been lost. Fig. 32 shows the monument in

a pre-restoration state, in which some or all of the polychrome may be original.

93. Removed in 1580. See da Pelago, II, 127.

94. Bardotti Biasion, 1984, 8–9.

95. Two reliefs showing miracles accomplished at Margherita's tomb, set between the consoles supporting the marble monument, will be discussed in Chapter 11.

96. Seidel, 1985, 85, proposed that Beato Agostino Novello's wooden *arca* was similarly supported.

97. P. Toesca, *Il Trecento*, Storia dell'Arte italiana 2, Turin, 1951, 302 n. 69 (B. Gioacchino mistakenly identified as S. Filippo Benizzi).

Francesco di Pietro d'Assisi in connection with work on Margherita's burial place, referred to the carving of the marble monument.[98] Bardotti Biasion's careful reconsideration of the document showed that the connection was false: Angelo and Francesco were not sculptors, whose only known masterpiece was Margherita's tomb,[99] but local workmen engaged in some more humble form of activity. Bardotti Biasion thought that this was probably a repositioning of Margherita's body, without being more specific.[100] The document is rather loosely worded, but it appears that the coffin was to be replaced in the niche after work was completed. Presumably it was to be removed while work was in progress, and it thus seems probable that the *laborerium* and *opus* for which Angelo and Francesco were employed, was to knock through a hole from the sacristy side to the existing niche in the north nave wall of the church, and to provide a door, so that access to the body could be gained from the sacristy, as da Pelago described.[101]

Once the funerary monument had been freed from the date of 1362, Bardotti Biasion was able to pursue its stylistic links with Sienese sculpture of the first quarter of the fourteenth century. She argued for a connection with the wall tomb of Bishop Tommaso d'Andrea (d. 1303) in the Collegiata of Casole d'Elsa, the only signed work of the Sienese sculptor Gano di Fazio.[102] Gano died at some time between September 1316 and 1318.[103] Bardotti Biasion placed Margherita's monument toward the end of his career, with the tomb reliefs of Beato Gioacchino rather earlier, c. 1308–10.[104]

This terminus ante quem of 1318, based on stylistic attribution requires careful consideration; as we have seen, there is no documentary evidence establishing the date of either Margherita's translation, or the installation of the marble monument. It must be said that stylistic comparisons between the Margherita monument and the tomb of Tommaso d'Andrea present certain difficulties. The relief style is one of the most strikingly distinctive elements in the style of the Cortona work (and forms the links with the Beato Gioacchino reliefs), but the bishop's tomb has no narrative reliefs. Both monuments have recumbent effigies but, as Toesca noted, Margherita's face may have been remade; indeed a telltale

98. The document was published in P. Bologna, "Aneddoti artistici cortonesi," *Archivio storico italiano*, 5th ser., 17 (1896), 133–35; newly transcribed in Bardotti Biasion, 1984, 18 n. 37. For discussion of the various attributions proposed, and a list of those accepting the date of 1362, see Bardotti Biasion, 7 and 18 n. 28.

99. For their supposed careers see, for example, U. Thieme and F. Becker, *Allgemeines Lexikon der bildenden Künstler*, 1, Leipzig, 1907, s.v. "Angelo di Pietro"; E. Carli in *Dizionario biografico degli Italiani*, Rome, 1960, s.v. "Agnolo di Pietro."

100. Bardotti Biasion, 1984, 7–9.

101. Da Pelago, II, 127. The exhortation in the document that the work should be done legally and in good faith may simply represent a legal formula, but it might also indicate the commissioners' anxiety that Angelo and Francesco might be tempted to remove parts of the venerated body to sell as valuable relics, while the coffin was

out of its niche. This worry may also lie behind the insistence on the two masters' Cortonese origins: local men, of local background, were less likely to damage or disturb the coffin, either through carelessness or greed.

102. Illustrated Bardotti Biasion, 2, fig. 1.

103. Gano was alive in September 1316, and dead by the time a list of holdings in his *terziera* was drawn up at some time in 1318. P. Bacci, *Fonti e commenti per la storia dell'arte senese*, Siena, 1944, 106–8. Bardotti Biasion simply gives his death date as 1317.

104. Bardotti Biasion, 5 and 9–14. For a more precise dating, to shortly before the year of Gano's death, see Bardotti Biasion, "Il monumento di Gregorio X ad Arezzo," in *Skulptur und Grabmal des spätmittelalters in Rom und Italien: Akten des Kongress, "Scultura e Monumento Sepolcrale del tardo medioevo a Roma e in Italia" (Rome 1985)*, ed. J. Garms and A. M. Romanini, Vienna, 1990, 270.

crack extends from beneath Margherita's chin to the top of her head (Fig. 36).[105] We should therefore be cautious about any arguments based on this part of the monument.[106] Comparisons are thus restricted to the architecture of the tomb, which provides generic similarities but few precise comparisons, and to the smaller figures, particularly those of curtain-holding angels on both monuments, which present greater similarities but not, perhaps, identities.[107]

Although the specific attribution of Margherita's monument to Gano di Fazio may not be accepted without reserve, the connection that Bardotti Biasion has proposed between this work and Sienese sculpture of the first quarter of the fourteenth century gains support from consideration of some further pieces associated with the Church of S. Margherita that Bardotti Biasion argues were produced by the same artist and that other writers, notably Middeldorf Kosegarten, have also connected, more generally, with Sienese work of this period.[108] Two marble sculptures of the Virgin and Child Enthroned, now in the Museo Diocesano of Cortona, came from S. Margherita. Their original locations within—or outside—the church are uncertain. The more weathered group (Fig. 43)[109] was previously placed high up in a niche on the north buttress of the facade,[110] and its condition suggests that it had long occupied a position on the exterior of the church. Middeldorf Kosegarten considered this piece to be a Sienese work executed before c. 1320.[111] Salmi reported that

105. Toesca, 302. (Also suggested by Perkins, cited in A. Mezzetti, "Il sarcofago di Santa Margherita nell'omonima Chiesa cortonese," *Annuario dell'Accademia Etrusca di Cortona*, n.s., 11 [1979], 363. Mezzetti, on the other hand, cites Venturi to support the opinion that the face is original.) Bardotti Biasion does not specifically discuss the face of Margherita's effigy.

106. Because the tomb is set high on the wall, it is difficult to be certain whether the face has been either partly recut, or even entirely remade. Restoration could have been carried out when the tomb was placed in its present position in 1879, having languished in a storeroom in the convent since 1864 (Miri, rev. Mori, 136–37). A possible candidate for such recutting or restoration work is Amalia Dupré (1845–1928)—daughter of the sculptor Giovanni Dupré—who made four terracotta sculptures for the nave piers of the remodeled church in 1886–89 (Miri, rev. Mori, 139). I thank Nancy Proctor for giving me the benefit of her knowledge of Amalia Dupré's oeuvre. (For further questions raised by the problematic condition of the face, see note 153.)

107. See Bardotti Biasion, 1984, figs. 1, 2, 3, 4, 16, and 17. Bardotti Biasion's redating and reattribution of Margherita's tomb has generally gained acceptance: see, for example, G. Previtali, *Studi sulla scultura gotica in Italia*, Turin, 1991, 133 n. 7 and 142 n. 4; and L. Bellosi, "Gano a Massa Marittima," *Prospettiva* 37 (1984), 19–22; but the redating has been rejected in E. Carli, "Sculture senesi nel Trecento tra Gano, Tino e Goro," *Antichità viva* 29, ii–iii (1990), 26–39, esp. 28–33.

108. One consideration that points away from the attribution to Gano is the close stylistic relationship between the Annunciate Virgin and the angels on the tomb (and the related Virgin and Child from S. Margherita [Fig. 44]) and certain sculptures made for the Duomo and the Bapitstery of Siena. The sculptures in question, an Annunciate Virgin and a personificiation of the government of Siena, are dated by Middeldorf Kosegarten to c. 1315–25 (A. Middeldorf Kosegarten, *Sienesische Bildhauer am Duomo Vecchio: Studien zur Skulptur in Siena 1250–1330*, Italienische Forschungen herausgegeben vom Kunsthistorischen Institut in Florenz, 3d series, vol. 13, Munich, 1984, cat. nos. XXI; XXIII, 3, pp. 354–55, figs. 236–38, 256.) This dating bracket of c. 1315–25, and the fact that the baptistery foundation stone was not laid until 1317 (Middeldorf Kosegarten, 139) would militate against attributing these works to Gano, who is last heard of in September 1316.

109. Approx. 86 cm high. See M. Salmi, "Postille alla Mostra di Arezzo," *Commentari* 2 (1951), 173 n. 1, who dated it to c. 1340 and compared it to the work of Giovanni Pisano and Arnolfo di Cambio.

110. A photograph taken c. 1875, when the exterior walls of the new nave were in place but the old facade was still standing, shows the sculpture in situ (Fig. 10).

111. A. Kosegarten, "Einige sienesische Darstellungen der Muttergottes aus dem frühen Trecento," *Jahrbuch der Berliner Museen*, n.s., 8 (1966), 113–14, dated it to before c. 1320.

the other Virgin and Child group (Fig. 44),[112] which is considerably less damaged by weathering, but has lost the Child's head and the right arms of both Virgin and Child,[113] came from the facade portal.[114] The Visitation of 1634 mentions a marble sculpture of the Virgin placed near the west doorway of the church.[115] It is not clear which of the two existing sculptures the Visitation judges saw, but whichever it was, it may once have formed part of a larger group; a payment of 1403, published by Bornstein, mentions painting and gilding of a marble figure of Saint Basilio, which by that time had sustained some damage, and which stood above the doorway to the church.[116]

The difference in condition between the two Virgin and Child sculptures suggests that the group with the headless child (Fig. 44) occupied, at least initially, a position inside the church. Kosegarten argued that this sculpture was a Sienese work of c. 1310–20,[117] and Salmi and Bardotti Biasion attributed it to the author of Margherita's monument, seeing a clear stylistic connection with the Annunciation group that crowns the spiral columns framing Margherita's marble monument (Figs. 39 and 41).[118] Bardotti Biasion considered that the quality and vigor of the Annunciate Virgin and Gabriel almost put them outside the bounds of Gano's oeuvre.[119] It may not, in fact, be necessary to consider them as part of the funerary monument. Although standing figures do occupy comparable positions in contemporary tomb sculpture,[120] the presence of an Annunciation group makes no particular iconographic sense here. Moreover, the bases of these two figures have been turned through a right angle in relation to the capitals on which they stand, and the shape and dimensions of sculpture bases and supporting abaci do not match. The bases of the two figures thus extend well beyond the ledges on which they stand, making their present positions precarious (Figs. 40 and 42). This fine pair of sculptures may originally have formed a separate decoration in the church, either flanking the entrance to the *cappella maggiore* or, more likely, placed on an altar.

Five marble relief slabs, moved from the old portico in 1878, now decorate the base of an eighteenth-century sculpture of Beata Margherita in the south transept of the church.[121] Three of the slabs are decorated with busts of Christ and six saints, set in roundels (Figs. 45–51); the other two have foliate decoration (Figs. 52 and 53).[122] Toesca and Salmi both attributed the reliefs to the artist of the marble monument, and Bardotti Biasion, agreeing with this connection, attributed the works to Gano di Fazio.[123] To the left of Christ (Fig.

112. Approx. 94 cm high. For a wide-ranging discussion of the style of this work in relation to Sienese sculpture, see Kosegarten, 1966, 96–118.

113. A wooden sculpture in S. Biagio a Vaglialle, near Anghiari, which, as Salmi noted, copies closely this Virgin and Child, indicates the original form and pose of the missing elements. Illustrated in Salmi, tav. L, fig. 198.

114. Salmi, 172.

115. *ASV, Riti*, Proc. 552, p. 510.

116. D. Bornstein, "Pittori sconosciuti e pitture perdute nella Cortona tardo-medioevale," *Rivista d'arte* 42 (1990), 227–44, esp. 243–44. No trace of the S. Basilio figure remains.

117. Since Kosegarten accepted the date of 1362 for Margherita's funerary monument, she did not pursue the possible stylistic connections between that work and the Virgin and Child.

118. Salmi, 172; Badotti Biasion, 1984, 13–14.

119. Bardotti Biasion, 1984, 13–15.

120. For example, the angels on the tomb of Gregory X in the Duomo of Arezzo, Bardotti Biasion, 1984, fig. 24.

121. Mirri, rev. Mori, 133.

122. Overall dimensions of figured slabs approx 34 ×

45) are Saints John the Evangelist (Fig. 48), Catherine of Alexandria (Fig. 47), and Margherita (Fig. 46); to the right of Christ are Saints Egidio (Fig. 49), Francis (Fig. 50), and Basilio (Fig. 51). These marble reliefs correspond to those described in the report of the Visitation of 1634, decorating the front face of the high altar.[124] The identification is confirmed by an eighteenth-century drawing of the high altar, bound into the Vatican copy of the canonization process (Figs. 54 and 61).[125] The drawing shows the post-1580 arrangement of the high altar, with Margherita's body set above it, within a casket designed by Pietro da Cortona in 1651.[126] Above it we see the altarpiece of the Deposition painted by another successful artist who was a native of Cortona, Luca Signorelli, in 1502.[127]

This arrangement of the high altar, with its postmedieval features, clearly differs from that which existed in the fourteenth century. Nevertheless, were the marble reliefs originally made for the high altar? The choice of saints would be appropriate for this position, since it includes those to whom the church was originally dedicated: Basilio, Egidio, and Catherine of Alexandria.[128] On the other hand we have already encountered a similar group of saints in the descriptions of the painted wooden door made to enclose the burial niche,[129] and we know that an altar was in place beneath the niche before 1343. According to da Pelago, that altar was removed at the time of the 1580 translation.[130] It is impossible now to establish the original course of events, but it seems that either the reliefs always formed part of the high altar, or that they were incorporated with it in 1580, having previously belonged with Margherita's marble tomb-altar. If they did initially form a part of that monument, they could have functioned as a more durable version of the images painted on the shutters, forming a visual link between altar and niche.[131]

Consideration of the development of Margherita's civic cult lends further support to a dating within the second or third decades of the fourteenth century for her funerary monument and perhaps, also, its related altar reliefs. Vauchez and Seidel have drawn attention

231 cm. The irregular breaks between the three slabs indicate that they were always arranged in the present order. Overall dimensions of each foliate slab are approximately 34 × 66 cm. A new foliate roundel was added at the centre, for symmetry, when the reliefs were moved to their present position.

123. Toesca, 302 n. 69; Salmi, 173 n. 1; Bardotti Biasion, 1984, 14. Salmi believed that they had been partially recut in the eighteenth century.

124. ASV, Riti, Proc. 552, 502. The only variation is the identification of Saint Paul for the figure with the forked beard who presumably represents the hermit saint, Egidio.

125. ASV, Riti, Proc. 549 (copy of process of 1709, made in 1719). Drawn by Francesco Fabbrucci, a Cortonese sculptor (b. 1687, d. 1767). The drawing shows four polygonal columns supporting the altar. Two similar columns and capitals, made of a greyish marble, are preserved in the convent museum (approximate height 48.5 cm). Da Pelago, Sommario, ad annum 1766, mentions that these reliefs were immured under the portico when the high altar was dismantled.

126. See below, note 159.

127. Now in the Museo Diocesano, Cortona.

128. Da Pelago, II, 160.

129. The Saint Peter of the shutters seems to have been replaced by Saint John the Evangelist in the marble reliefs. The figure reported as Saint John the Baptist on the shutters is probably a misidentification of the less familiar bearded figure of the hermit saint, Egidio.

130. Da Pelago, II, 127.

131. The relevant dimensions are as follows (all measurements approximate): max. width of base of tomb 229 cm; max. width of wooden doors in convent museum 205 cm; overall width of reliefs with figures 231 cm. It is interesting to note the stylistic similarity between the foliate decoration on the end panels of the sarcophagus of the marble monument (Fig. 37; for location see Fig. 27) and the foliate panels that may have decorated the sides of the altar (e.g., Fig. 38). The postmedieval appearance of the altar marked F on da Pelago's reconstruction (Fig. 21) should be disregarded since, as discussed above, the engraving was not an accurate record of an existing arrangement.

to the links between the provision of an impressive burial place for a venerated person, and the establishment of communal donations for the celebration of their feast day in Siena.[132] Kreytenberg has pointed to a similar pattern in the case of Beato Bartolo of S. Gimignano.[133] In three cases out of four the commune is known to have contributed to the cost of the tomb, and in the fourth case, that of Beato Agostino Novello, Seidel has speculated that this may also have been the case.[134] Donations for feast and tomb were generally close in date.[135] We also have records of communal donations for the feasts of Beata Margherita and Beato Gioacchino. The Sienese Commune first gave candles for Gioacchino's feast in 1320,[136] and, as discussed in Chapter 2, the commune of Cortona made detailed arrangements, in 1325, for the celebration of the anniversary of Margherita's death. The years around these dates therefore seem the most likely time for the provision of splendid new monuments for each of these *beati*.[137]

Not only the timing and funding of Margherita's new entombment but also, as we have seen, the form and workmanship of her marble monument, can be placed in the context of recent civic practice. But this was not necessarily the obvious or only choice. In the previous chapter we considered the comparison between the burial churches of Saint Francis and Saint Clare, founders of the Franciscan First and Second Orders, and the church built to honor Margherita, the "light of the Third Order." We have also seen that the body of Saint Francis, like that of Margherita, was protected within an iron cage. When Francis was translated from S. Giorgio to the new church built as his permanent resting place, his remains were placed below pavement-level, in the crossing of the Lower Church.[138] Saint Clare, in turn, was translated from S. Giorgio to a permanent burial in S. Chiara, where she was placed below the pavement-level of her church.[139] Margherita's translation, on the

132. Vauchez, 1977, esp. 763; Seidel, 1985, 86–88.

133. Beato Bartolo (d. 1300) was buried in S. Agostino. Having paid for candles in the year of his death, the commune discussed the celebration of his feast in 1322, and provided money for it in 1325. In 1327 they contributed to the costs of his tomb, which remained incomplete. Kreytenberg has shown that this monument was a wall tomb, placed above an altar, probably in the nave of S. Agostino. Kreytenberg includes the document of 1327, but prefers to date the tomb 1317–18. G. Kreytenberg, "Zum gotischen Grabmal des heiligen Bartolus von Tino di Camaino in der Augustinerkirche von San Gimignano," *Pantheon* 46 (1988), 17–19, and 25.

134. For Ambrogio Sansedoni and Pietro Pettinaio, see above. For Bartolo, see above, note 133. For Agostino Novello, see Seidel, 1985, 88.

135.

	Contribution to tomb	Initial contribution to feast
A. Sansedoni (d. 1286)	1287	1306
P. Pettinaio (d. 1289)	1289	1296
Agostino Novello (d. 1309)	?	1324
Bartolo (d. 1300)	1327	1300, 1322, 1325

136. Vauchez, 1977, 760.

137. Bardotti Biasion (1984, 4–5) takes the mention of a miracle at Beato Gioacchino's tomb, shortly after 1310, as evidence for the existence of the marble monument by that date, and dates the monument to c. 1308–11. This dating seems unconvincingly early. The *Legenda*, composed c. 1330–35, specifically states that although Gioacchino died in 1305 no miracles occured before 1310. It would thus be surprising if a grand tomb had been supplied for an ordinary convent member. Moreover, the examples of Beato Agostino Novello and Beato Bartolo show a delay of several years between the start of a cult and provision of an impressive tomb. For further discussion of the dating of Margherita's funerary monument see Chapter 11.

138. Initially there was access to Francis's burial place from above, but the site was later permanently closed in. Gatti, chap. 2, esp. 101–5.

139. Gatti, 105. (For the ironwork screen that surrounded the altar below which Chiara was buried, see Meier, 165–68. For the visits of pilgrims to Chiara's burial place see Meier, 169–70.) Garms, 94, gives two further examples of venerated members of the Second Order buried beneath the pavement, under the high altar.

other hand, led to the raising up of her remains.[140] Rather than following the example of the mid-thirteenth-century burials of the founders of the First and Second Orders, the arrangement of Margherita's entombment after translation to the larger church belongs with ideas about the burials suitable for mendicant and civic saints current among Sienese artists of the late thirteenth and early fourteenth centuries. It shares with many of them the combination of altar and tomb in a vertical continuum that does not encroach excessively on the floor-space of the church.[141] These tombs were made accessible and visible, often within the nave of the church; narratives, either painted or carved, presented the life and miracles of the deceased; the qualities of a shrine were mixed with those of an important lay or ecclesiastical burial to present to onlookers a person who was both dedicated to the life of religion and remembered as a civic figure, both capable of miraculous acts and approachable as a familiar local presence.[142]

But in some respects Margherita's burial appears to have differed from the rest. Although the "tomb-chest" is comparable to those of San Ranieri, Beato Agostino Novello, and Beato Gioacchino, it did not contain the body.[143] This suggests that although an established type of marble wall tomb was provided, the pine coffin was already in place within a wall niche, perhaps enclosed behind painted doors, and that it was decided not to disturb this arrangement, but to set the marble monument above it.[144] Retaining the niche and the door—which made possible, on special occasions, access to the body—combined the shrine or reliquary element in the burial arrangement with the more sophisticated and elaborate qualities of the marble cenotaph.[145]

140. Compare the case of Saint Dominic, in which burial beneath the pavement was equated with the smothering of the nascent cult, while the decision to provide a raised tomb in 1233 was explained by the Master General Humbert of Romans as a means of placing his remains higher, in order to lead the devotion of the faithful in a worthy way. The third tomb, the *arca* in progress in 1265, was even more conspicuous. For the three burials and their significance see Cannon, 1980, 169–82.

141. An impression of the arrangement of a tomb-altar, and—in schematic form—the importance of the presence of the body of the holy person, may be gained from an early fifteenth-century painting of the shrine of Beata Fina (d. 1253) patron saint of S. Gimignano, whose remains were kept in the Collegiata. The scene (Fig. 55), from a pair of reliquary shutters by Lorenzo di Niccolò, dated 1402, now in the Museo Civico of S. Gimignano, shows a man being freed from devils in the presence of laymen and clergy. Fina's body is displayed on a chest supported on consoles above the altar. (The visibility of the body should not, presumably, be taken literally, but the position of the body above the altar is, it seems, significant.) G. Kaftal, *Iconography of the Saints in Tuscan Painting*, Florence, 1952, cols. 369–76.

142. See Bardotti Biasion, 1984, 2–3, for the first two examples of "pendant" wall tombs, one for a saint (Ranieri), the other for a prelate (Bishop Tommaso d'Andrea). An interesting contrast is presented by the *Arca* of S. Ottaviano and the *Arca* of S. Cerbone, both also made by Sienese sculptors in the first quarter of the fourteenth century. These two works, which both contain the remains of long-dead saints, have the form of free-standing shrines, not wall tombs. See G. Kreytenberg, "Drei gotische Grabmonumente von Heiligen in Volterra," *Mitteilungen des Kunsthistorischen Institutes in Florenz* 34 (1990), 69.

143. In contrast, the reliefs on S. Ranieri's tomb-chest emphasise the presence of the body within it (Fig. 29).

144. It may even be that the niche/coffin/shutter arrangement existed in the wall niche in old S. Basilio and was in due course transferred to the new position in the larger church. In this context it is interesting to note that Donna Niccoluccia's will of 1343 identifies the altar in question as being "sub pinum" but does not find it necessary to mention the marble monument.

145. A similar combination, in abbreviated form, was found in the Beato Agostino Novello and Beato Bartolo tomb-chests, which both included an opening at the center, to permit a closer approach to the relics. Seidel, 1985, 85; Kreytenberg, 1988, 17.

Presentations and Representations of Margherita's Body

Margherita's monument includes the earliest extant example of the full-scale tomb effigy of a saint in central Italy, perhaps the earliest anywhere in the peninsula.[146] Although this priority is presumably due to the chances of survival, it may still be significant that the unknown commissioners of the tomb chose this type. By the first quarter of the fourteenth century effigies were an expected part of the lavish tomb of a prelate or powerful layman but do not appear to have had any significant role to play in the shrine of a miracle-working saint.[147] The inclusion of Margherita's effigy forms one stage in the continuing relationship between the people of Cortona and the incorrupt body of their prospective patron saint.

At first Margherita's body seems to have been openly displayed, in its purple garments, within the custody of the coffin and the iron cage. In due course a lid was presumably placed on the coffin. The panel painting of Margherita, now in the Museo Diocesano in Cortona (Pl. II; Fig. 56), may have provided a visual substitute for the venerated remains at this time.[148] The large-scale image of Margherita at the center of the panel stands before an elaborately decorated red textile, held by three angels. Directly below, at the base of the panel, Margherita's body is shown lying on a bier raised on four columns, and covered with the same type of red textile. This scene represents, in a schematic fashion, Margherita's initial shrine, with embalmed body displayed. Beneath it the sick and crippled come to seek a cure. The textile is the purple garment mentioned in the *Legenda*, in which the

146. Depending on the dating of the effigy of Saint Simeon, in S. Simeone Grande, Venice, for which see W. Wolters, *La Scultura veneziana gotica (1300–1460)*, Venice, 1976, I, 152–53, II, figs. 34, 38, and 39; and subsequently, G. Previtali, "Alcune opere 'fuori contesto': Il caso di Marco Romano," in Previtali, 1991, 115–36 (reprinted from an article in *Bolletino d'arte*, 22 [1983], 43–68) where a date of 1318 is proposed for the effigy. Garms, 96, has raised the possibility that there may have been an intention to press for the canonization of Clement IV (d. 1268), whose full-scale tomb effigy is generally considered the earliest in Italy.

Seidel has recently proposed that the tomb of Margaret of Luxemburg, made by Giovanni Pisano, c. 1313–14, had a recumbent effigy, and has pointed to an attempt to encourage a cult for Margaret at the time when the tomb was erected. M. Seidel, "Das Grabmal der Kaiserin Margarethe von Giovanni Pisano," in *Skulptur und Grabmal des spätmittelalters in Rom und Italien: Akten des Kongress, "Scultura e Monumento Sepolcrale del tardo medioevo a Roma e in Italia (Rome 1985)*, ed. J. Garms and A. M. Romanini, Vienna, 1990, 307–16. Kreytenberg (1988, 19–22) reconstructed another early example of the full-scale effigy of a saint by a Sienese sculptor: the tomb of B. Bartolo (d. 1300) in S. Agostino, S. Gimignano. Kreytenberg associated two angels holding curtains, now in

Frankfurt, with the tomb, and thus assumed a lost "grave-chamber" with effigy. Kreytenberg proposed a date of 1317–18 for the tomb but it is documented as unfinished in 1327. Two saints' tombs of unknown date in Volterra, both attributed to Sienese sculptors, have recently been reconstructed by Kreytenberg (1990, figs. 13 and 24.). He attributed the tomb of S. Vittore to Agostino di Giovanni, c. 1325, and associated with it two angels holding curtains, in the Museo d'Arte Sacra, Volterra; he attributed the tomb of an unknown saint, whose effigy still exists, to Giovanni di Agostino, c. 1331.

147. For a brief but pioneering survey of later medieval burials of saints and *beati* in Italy see Garms, passim.

148. For discussion of the provenance of the panel see below, Chapter 11, note 2. A near-contemporary example of a painted image, placed above the burial site, functioning as a replacement for visibility of the person herself is found in the canonization process (1318–19) of Beata Chiara of Montefalco (d. 1308). After her death Chiara twice appeared to people who were able to identify her because of her resemblance to the painting of her above her tomb. See S. Nessi, "Primi appunti sull'iconografia clariana dei secoli XIV e XV," *La Spiritualità di S. Chiara da Montefalco: Atti del Convegno di studio, Montefalco, 1985*, ed. S. Nessi, Montefalco, 1986, 314.

embalmed body was wrapped.[149] In the large-scale image above, the textile has been held open to reveal Margherita's continued presence.[150]

Entombment in a pine coffin within a wall niche, probably initially in old S. Basilio and then in the new church, ensured an elevated position and consequent visibility of the site of the remains but, after a possible initial phase of display, kept the actual body locked away from view. Only on special occasions were the shutters opened, allowing sight of the body through a window set into the coffin.[151] In contrast the marble effigy set above the niche was permanently revealed by two angels who not only held back the curtains—a standard motif in elaborate Italian tombs of the time—but also supported the sarcophagus lid, as though in the act of raising it (Figs. 33, 34, and 58).[152] Thus the effigy may have functioned as a further visual substitute for the embalmed body. Two scenes showing miracles at Margherita's tomb, set between the consoles at the base of the monument, include, as in the panel painting, representations of Margherita's body set on a textile-covered bier (for example, Fig. 57).[153]

As long as the high altar and church remained dedicated to S. Basilio, Margherita's position on the north nave wall, not far from the high altar, signified a resting place of honor.[154] After her translation to the high altar in 1580 the dedication of the church to her cult, for long recognized in the popular name for the church, was visually established as an inescapable fact.[155] Margherita's body now occupied the most important position in

149. For the interchangeability of "red" and "purple" in this context, see note 50. For consideration of the type of textile represented (alla perugina), which was widely used in Umbria, see L. Corti, "Esercizio sulla mano destra: Gestualità e santi nel medioevo," in Annali della Scuola Normale Superiore di Pisa. Classe di Lettere e filosofia 26, forthcoming.

150. In the thirteenth-century panel of Saint Clare which, as will be discussed in Chapter 11, provided a model for the Beata Margherita panel, the large-scale image of the saint is set before a gold ground, without any textile (Fig. 153). Vita panels of Saint Francis also have a plain gold ground behind the central figure of the saint.

151. For example, the body was shown to the bishop of Narni in 1370, and to Niccolò Giovanni Casali in 1381 (Bornstein, 1993, 173–74). For the window in the coffin see below, note 158.

152. H. A. Ronan, "The Tuscan Wall Tomb, 1250–1400, Ph.D diss., Indiana University, 1982, 37, noted that the angels appear to be lifting the sacrophagus lid.

153. Although Margherita's eyes are closed in these two scenes they are, surprisingly, open in the effigy. This may simply be the result of a postmedieval restoration (see notes 105 and 106), but if this is an original feature, or a reflection of one, it would appear that Margherita was shown in eternal life. If the effigy's eyes were originally open, a specific relationship may always have been visible between Margherita's effigy and the haloed figure directly above the sarcophagus lid who holds a scroll (which no

longer bears any inscription) and whose mouth is opened in speech (Fig. 35). The absence of a cross in the nimbus makes it uncertain whether it is the Redeemer, or a prophet or apostle, who appears to be communicating directly with Margherita.

154. Compare the sites of, for example, the tombs of Beato Agostino Novello (north nave wall, immediately to west of choir screen), Butzek, 212, and ground plan, 146; Seidel, 1985, 85; Ranieri Ubertini (d. c. 1296 or c. 1300), in S. Domenico, Arezzo (left wall of cappella maggiore), Bardotti Biasion, 1990, 271–72; Margaret of Luxemburg (d. 1311), formerly in S. Francesco di Castelletto, Genoa (left wall of cappella maggiore), Seidel, 1990, 316; Archbishop Simone Saltarelli (d. 1342) in S. Caterina, Pisa (on the left side of the nave, near the high altar), Moskowitz, 80–82; and the Arca di S. Ottaviano of 1320, in the Duomo of Volterra (to the left, near the high altar), Kreytenberg, 1990, 69.

155. The move was partly motivated by concern for the condition of the body, which was suffering from the effects of damp. In 1575 a Cortonese councillor, calling for the transfer of the remains, stressed the importance of their preservation "in tal maniera che ciascuno ne possi sempre restare satisfatto e che anche i posteri nostri possino godere e participare di cosi gran tesoro e hornamento della città e per salute del anime e matenimento della pace e unione di tutto quello universale." I am indebted to Céline Perol for this passage from the deliberations of 1575, now in the Archivio di Stato, Florence.

the church, resting above the high altar, but it remained enclosed within a gilded wooden *sepulcrum*, guarded by the painted wooden door.[156] Here, as in the previous burial niche, access to the body was restricted to special occasions such as the arrival of a visiting dignitary at the church.[157] At such times it was evidently considered important that onlookers could see into the coffin. From at least the early fifteenth century, and probably earlier, the sides of the coffin were partly made of glass.[158] When the silver coffin-casing designed by Pietro da Cortona was installed on the high altar in 1651[159] the body continued to be hidden, but the distinction between visibility and invisibility was less sharply drawn.[160] In front of the body was displayed a life-sized embroidered silk image of Margherita, presented by Pietro da Cortona at his own expense in 1652, which showed the body dressed and arranged as in the coffin, wearing a silver wreath also presented by the artist (Fig. 59).[161] The iconography of S. Margherita *nell'urna*, which repeated Pietro da Cortona's image of the crowned body, often seemingly revealed behind parted curtains, became popular in and around Cortona in the seventeenth and eighteenth centuries (for example, the image from the church of S. Bartolomeo, Pergo, near Cortona; Fig. 60).[162] But the remains were still

For comparable cases of the movements of the remains of two female saints, Catherine and Monica, in response to various stages in their cults, and changing ideas about suitable commemoration, see L. Bianchi and D. Giunta, *Iconografia di Santa Caterina da Siena*, I, Rome, 1988, 16–62 and Garms, 102–3.

156. *ASV, Riti*, Proc. 552, pp. 501–3.

157. For example, the visit of General Piccolomini who, according to the seventeenth-century diarist Annibale Laparelli was amazed by the state of preservation of the body and "l'ha lodato il più bel corpo di santo che sia in Cristianità." A. Laparelli, *Memorie cortonesi dal 1642 al 1670*, Accademia Etrusca, Cortona, Fonti e Testi, 1, ed. N. Fruscoloni, Cortona, 1982, 37.

158. The judges for the canonization process were shown, in 1634, three *arcae* or *capsae*: the iron cage; an empty coffin kept behind shutters in the niche below the marble monument (said to have contained Margherita's body for more than two hundred years); and the coffin then in use within the *sepulcrum* on the high altar (*ASV, Riti*, Proc. 552, pp. 503, 512–14). The empty coffin was described as "capsam seu arcam vitream depictam stellis aureis, et variis coloribus." The glass referred to presumably consisted of a large panel, rather than a coffin entirely made of glass. The same pane of glass is probably referred to in the decision made by the council in 1524 to remove the glass panel from the coffin in order to counteract problems of damp and to allow the body to "breathe" (ASF, Q11, f.143v., deliberation of 8 June 1524; I owe this reference to Céline Perol). The coffin in use in the seventeenth century also had a glass panel in the side, covered by curtains. Tartaglini (91), describing the tomb in 1700, refers to a "cassa di finissimo cristallo" but here again the use of glass panels in the sides, rather than a coffin entirely made of glass, should probably be envis-

aged. For the transfer of Chiara of Montefalco's remains to a "cassa di cristallo" in 1577, see S. Nessi, "Un raro cimelio nel monastero di S. Chiara a Montefalco," *Commentari* 14 (1963), 5.

159. Annibale Laparelli records that in thanks for a peace treaty concluded, in 1644, between the Church and the grand duchy of Tuscany, the nobility of Cortona resolved to present an ornament to Margherita's tomb (Laparelli, 61, 64, and 83). The design for the silver casing was commissioned from Pietro Berettini—better known as Pietro da Cortona—one of the city's most famous sons, then resident in Rome. Pietro supervised the work, and the casing arrived in Cortona in 1651. Laparelli does not mention the artist's connection with this work but Della Cella publishes a letter of Berettini's, written in 1646, concerning the project and discusses the progress of work (A. Della Cella, *Cortona antica*, Cortona, 1900, 136–38).

160. The blurring of the distinction between the hidden and the seen is indicated in the eighteenth-century drawing of the high altar (Fig. 61) in which it is unclear whether what we see is Pietro da Cortona's silk embroidery or the body itself.

161. The image was designed by Pietro da Cortona and executed by a Flemish master. Both the image and the crown were presented by the artist in gratitude for having been raised to the nobility of his native town. Laparelli, 64, 83, 86, and 99.

162. For a survey of a number of examples of this unusual iconography, see E. B. Nightlinger, "The Iconography of Saint Margaret of Cortona," Ph.D diss., George Washington University, 1982, 229–40, figs. 112–20 (xerographic reproductions of poor quality). This iconography will also be discussed in the catalogue being prepared by Laura Corti and Riccardo Spinelli for the exhibition on the iconography of S. Margherita, *Margher-*

shown to the faithful only on special occasions, such as the day in January 1875 when work
on the new church was resumed.[163] Only during the present century has this restricted
visibility finally been abandoned. The wooden door enclosing the front face of the casket
has been replaced with a reinforced glass panel, protected by an iron grille (Fig. 62). Mar-
gherita's embalmed body is once more openly displayed, as in the days, weeks, or months
following her death. Throughout these changes one element has remained constant: the
commune of Cortona has retained, and still retains, possession of the keys that give access
to the body.[164]

*ita da Cortona: Una storia emblematica di devozione narrata
per testi e immagini*, ed. L. Corti and R. Spinelli, Milan,
1998.

 163. Mirri, rev. Mori, 107.

164. See, for example, agreement with the Franciscan
First Order in 1392, da Pelago, ii, 177; Visitation of 1634,
ASV, Riti, Proc. 552, pp. 501–3; for the nineteenth and
twentieth centuries, Mirri, rev. Mori, 107 n. 30.

Part III

"Prima era tutta dipinta": Reconstructing the Mural Decoration of S. Margherita

It is time to turn from consideration of the burial places of Margherita and the Churches of S. Basilio and S. Margherita in which they were set, and to investigate the decoration of the walls reconstructed in Chapter 3. What was the imagery with which they were painted, imagery that provided a setting for Margherita's tomb and for those tending and visiting it? We learn from the records of the seventeenth-century canonization process that the *cappella maggiore* of the new church, and the first bay of the south nave wall opposite Margherita's tomb, were painted with frescoes of Margherita's story. These works, subsequently lost, will be discussed in detail in Parts IV and V of this study. But it will be helpful first to consider what other paintings may once have completed the decoration of the new church. This investigation might seem, at first sight, to be taking us away from the main themes of this book; as we shall see, however, the careful analysis of surviving painting from the church will lead us to conclusions that significantly affect our assessment of the date and authorship—and thus our evaluation and interpretation—of the lost frescoes of the Margherita cycle.

It is possible to pinpoint with dismal accuracy the disappearance of much of our evidence. In his *Memorie cortonese*, the seventeenth-century diarist Annibale Laparelli noted among the entries for 1653: "In this same month of June the Church of S. Margherita was whitewashed at the expense of benefactors. Previously [the church] was completely painted, but since the paintings had been ruined by time it was decided to whitewash over them."[1] Less than twenty years earlier, in the Visitation of 1634, which formed part of the canonization process, the frescoes of Margherita's life and miracles had received detailed attention as records of historical importance. But now these damaged and untidy images were to be obliterated in order to neaten the appearance of the burial church of the woman who, it was hoped, would soon gain full official recognition as a saint. Moreover Laparelli's comments imply that in 1653 not only the *cappella maggiore* but also all the other walls of the church were decorated with murals—occasionally described in passing, but for the most part not mentioned at all in the records of the Visitation of 1634. Laparelli's words thus raise a number of questions: Is there any corroborative evidence for his statement that the church was "tutta dipinta," and if so, what were these other paintings? Were they contemporary with the Margherita cycle, forming part of a larger decorative program? Or did they constitute a second, independent, campaign? Or were they simply an assemblage of votive images—the accretions of a century or more? These questions can, to a certain extent, be answered by using the evidence of some surviving fresco fragments and by turning, before that, to Vasari.

1. "In questo medesimo mese di Giugno si è imbiancata la chiesa di S. Margherita a spese di benefattori, che prima era tutta dipinta, ma per esser le pitture rovvinate dal tempo si è risoluto d'imbiancarla," Annibale Laparelli, *Memorie cortonesi dal 1642 al 1670*, Accademia Etrusca, Cortona, Fonti e Testi, 1, ed. N. Fruscoloni, Cortona, 1982, 87.

5

The Testimony of Vasari

Vasari had made no reference to the trecento decoration of the Church of S. Margherita in the first edition of the *Vite*, published in 1550. But in the second edition, published in 1568, the church was mentioned in the lives of three separate artists: Ambrogio Lorenzetti, Berna, and Buonamico Buffalmacco. Ambrogio Lorenzetti was credited with some works (*alcune cose*), notably half of the vaults and walls (*la metà delle volte e le facciate*).[1] Berna was said to have painted the larger part of the vaults and walls of the church (*la maggior parte delle volte e delle facciate*).[2] Buffalmacco was also connected with certain paintings (*alcune pitture*) in S. Margherita.[3]

 The attribution of the lion's share of decoration in the church to two different artists in two different *vite* may be mere carelessness; Vasari was certainly less than accurate in attributing the architecture of the new church, only begun in 1297, to Nicola Pisano (who was dead by March 1284).[4] His evidence concerning Ambrogio Lorenzetti is dismissed out of hand by Rowley in his monograph on that artist: "Vasari's story of a call to Cortona is

1. Giorgio Vasari, *Le Vite de'più eccellenti Pittori, Scultori e Architettori*, ed. R. Bettarini and P. Barocchi, Florence, 1966–87, text vol. 2, 181.

2. Ibid., 254.
3. Ibid., 174.
4. Ibid., 63.

suspect, as are most of the additions in his second edition."[5] But there is a strong case to be made for treating Vasari's evidence more seriously.

Vasari had a good reason, unconnected with trecento frescoes, for visiting the church of S. Margherita. In the 1550 edition of the *Vite*, among the list of works by that famous native of Cortona Luca Signorelli, he praised the *Cristo morto* which stood on the high altar of that church:[6] "ch'è tenuto cosa bellissima e di gran lode non pure da'Cortonesi ma degli artefici ancora."[7] Vasari's comment implies that he owed his information about the painting to local artists, and, as Robert Williams has pointed out, the phrase "che è tenuta bella" was sometimes (but not exclusively) applied by Vasari to works he had not himself seen.[8] In the autumn of 1554 Vasari spent some time in Cortona, painting the vaults of the crypt of the confraternity of the Gesù, and preparing drawings and a model for the church of S. Maria Nuova.[9] Vasari's increasing interest in Signorelli was manifested in the 1568 edition of the *Vite* by the many additions to that artist's biography, which was moved to a prominent position at the end of the second part of the book.[10] It would appear that Vasari took advantage of the time he spent in Cortona to study Signorelli's works there, and obtain more information about the artist.[11] In the second edition of the *Vite* his revised description of the Signorelli *Cristo morto* is a briefer, but more personal one, "In S. Margherita di Cortona sua patria, luogo de' Frati del Zoccolo, un Cristo morto, opera delle sue rarissima."[12] Vasari's enthusiasm for Signorelli had presumably led him to look at the painting in 1554, and it seems likely that while he was in the Church of S. Margherita he also made brief notes on its earlier fresco decoration.[13] The description of Ambrogio Lorenzetti's work has the enthusiasm of an eyewitness report: "he painted . . . various works . . . so well that even though they are now almost destroyed by time, some very fine effects are still visible in the figures and one can tell that he was justly praised for this work."[14] On the other hand the lack of any description of subject matter, and the apparent contradiction in the apportioning of work in the church, may indicate a later working-up for the second edition of notes made in 1554 that Vasari had no opportunity to verify.[15]

5. G. Rowley, *Ambrogio Lorenzetti*, Princeton, 1958, 1:139.

6. Signorelli's Deposition, formerly signed and dated 1502, now in the Museo Diocesano, Cortona.

7. ". . . which is considered a very beautiful and most praiseworthy thing not only by the Cortonese but also by artists." Vasari, ed. Bettarini and Barocchi, text vol. 3, 635.

8. R. Williams, "Notes by Vincenzo Borghini on Works of Art in San Gimignano and Volterra: A Source for Vasari's 'Lives,' " *Burlington Magazine* 127 (1985), 19.

9. Vasari, ed. Bettarini and Barocchi, text vol. 6, 398–99; K. Frey and H.-W. Frey, *Der literarische Nachlass Giorgio Vasaris*, Munich, 1923–30, 1:427.

10. I am very grateful to Patricia Rubin for having discussed with me the question of Vasari's changing attitudes both to Signorelli and to the trecento during his preparation of the second edition, and for having helped me to find my way around the relevant bibliography.

11. Compare the two versions of Signorelli's *Vita* (Va-

sari, ed. Bettarini and Barocchi, text vol. 3, 633–40), esp. sections on Signorelli's works in the Gesù and the Duomo of Cortona, and the artist's later years in Cortona.

12. "In S. Margherita of Cortona, his native town, in the church of the *Frati del Zoccolo* [Franciscan Observants] a Dead Christ [Deposition] one of his most exceptional works"; Vasari, ed. Bettarini and Barocchi, text vol. 3, 635.

13. Vasari refers to his use of notes (*i ricordi e gli scritti*) in, for example, the epilogue to the *Vite*. Vasari, ed. Bettarini and Barocchi, text vol. 6, 411. For mention of Vasari carrying a sketchbook in his pocket see below, note 15.

14. ". . . lavorò . . . alcune cose . . . così bene che, ancora che oggi siano quasi consumate dal tempo, si vede ad ogni modo nelle figure affetti bellissimi e si conosce che egli ne fu meritamente comendato"; Vasari, ed. Bettarini and Barocchi, text vol. 2, 181.

15. Vasari passed by the walls of Cortona on 3 April 1566, in the course of a journey connected with the preparation of the second edition, but there is no indication

The other striking feature of the passage concerning Ambrogio Lorenzetti is the precision of the information that Vasari provides on the circumstances of the commission: "in the year 1335 he was brought to Cortona by order of Bishop Ubertini, then lord of that city, where he painted various works in the Church of S. Margherita, built a short time before for the friars of Saint Francis on the summit of the hill."[16]

The date may well have been taken from an inscription in the church. A fragmentary fresco inscription found in S. Margherita and now preserved in the Museo Diocesano in Cortona, bears the date 133— (Fig. 97).[17] But it is not common to find the name and status of a patron recorded in an inscription in a trecento fresco cycle. The closing remark of Vasari's description, "e si conosce che egli ne fu meritamente comendato" (and one acknowledges that he was justly praised for it) seems to imply awareness of a trecento written source. Vasari was assiduous in collecting new material on duecento and trencento artists for the 1568 edition.[18] He himself traveled to Assisi and elsewhere;[19] he used material supplied by Vincenzo Borghini;[20] and he solicited material concerning certain Sienese artists from a local goldsmith called Giuliano di Niccolò Morelli.[21] He used Giovanni Villani's chronicle in preparing the lives of, among others, Giotto and Simone Martini; and he consulted a number of other Florentine, Sienese, and Venetian chronicles, some of which no longer survive.[22] Perhaps a local chronicle, subsequently lost, was also the source that supplied dates, names, and a brief comment on Lorenzetti's work in S. Margherita. Vasari was in correspondence in 1564 with a man who might well have had access to such information: Girolamo de'Gaddi, bishop of Cortona.[23] Too perfunctory a consultation of this type of source, either by Vasari himself or a correspondent, might explain an error made in the description of Ambrogio Lorenzetti's call to Cortona. Vasari mentions the "vescovo degli Ubertini, allora signore di quella citta." The first bishop of Cortona was Ranieri degli Ubertini (1325–48), while the lord of Cortona at that time was Ranieri I Casali (1325–51). As we shall see, either man could have had good reason to organize the decoration of the church, and later confusion between the two (or a conflation of the two into one), given that they were contemporaries with the same first name, is easy to understand.[24]

that he was able to spend any time within the city. In a letter sent to Vincenzo Borghini from Perugia on 4 April 1566 he refers to a letter he suspects must have dropped from his pocket the day before: "che ieri mattina camminando sotto Cortona per veder una anticaglia, che la chiamano la grotta di piettagora o d'Archimede, nel cavar della tascha il libretto da disegnar su con lo stile, bisogno chella [the letter] mi cascassi." Frey and Frey, 2: 226–27. For Vasari's busy itinerary at that time see W. Kallab, *Vasaristudien*, Vienna, 1908, 123–24, and Frey and Frey, 2: 244–45.

16. ". . . l'anno 1335 fu condotto a Cortona per ordine del vescovo degli Ubertini, allora signore di quella città, dove lavoro alla chiesa di S. Francesco nella sommità del monte, alcune cose"; Vasari, ed. Bettarini and Barocchi, text vol. 2, 181.

17. See Chapter 6, for further discussion of the date in general and for the inscription in particular.

18. See the analysis of the differences between the 1550 and 1568 *vite* of Giotto in P. Rubin, *Giorgio Vasari: Art and History*, New Haven, 1995, chap. 7, esp. 313–20.

19. Kallab, 112, and 304–5; Frey and Frey, 2: 244–45.

20. Williams, 17–21.

21. See the entry by C. Davis and J. Kliemann in the exhibition catalogue *Giorgio Vasari (Arezzo 26 Settembre–29 Novembre 1981)*, Florence, 1981, 233–34; Frey and Frey, 2: 26–28.

22. Kallab, 308–42. Kallab (339) suggests that Giuliano di Niccolò Morelli may have sent Vasari information culled from Sienese chronicles. See Rubin, 287–99, for an analysis of the written sources used for Giotto's *vita*.

23. Frey and Frey, 2:69.

24. See Rubin, 313 n. 129, for a similar conflation and confusing of the names, careers, and dates of different popes in Vasari's *vita* of Giotto.

Episcopal tradition could also be the source of Vasari's statement that "Buonamico [i.e. Buonamico Buffalmacco] also painted many things in the bishop's palace in Cortona for messer Aldebrandino, bishop of that city,[25] especially the chapel and high altarpiece; but since this was demolished during the renovation of the palace and the church, it is not necessary to say anything more about it."[26] One further piece of information available to Vasari concerning the activities of trecento artists in Cortona was Ghiberti's comment that "Barna . . . painted many Old Testament scenes in San Gimignano, and many other works in Cortona."[27] Perhaps it was these two sources of information that made him reach for the names of Buffalmacco and Berna to attach to two of the areas of trecento fresco that he had seen in S. Margherita and that, for reasons he does not elucidate, he chose not to attribute to Ambrogio Lorenzetti.

25. This reference also appears to be confused. It could refer to Ildebrandino, bishop of Arezzo, 1289–1312, who had jurisdiction over the majority of Cortonese territory at that time, or, more likely, to Ubaldino Bonamici da Firenze, bishop of Cortona, 1391–93.

26. "In Cortona ancora dipinse Buonamico, per messer Aldobrandino vescovo di quella città, molte cose nel Vescovado, e particolarmente la cappella e tavola dell'altar maggiore; ma perché nel rinovare il palazzo e la chiesa andò ogni cosa per terra, non accade farne altra menzione"; Vasari, ed. Bettarini and Barocchi, text vol. 2, 174.

27. "Barna . . . A San Gimignano molte istorie del testamento vecchio, e ne a Cortona assai lavorò"; L. Ghiberti, *I Commentarii*, ed. J. von Schlosser, Berlin, 1912, 42.

6

The Fresco Fragments

The whitewashing of the walls of S. Margherita in 1653 meant that early editors of Vasari's *Vite* were unable to assess his attributions concerning painting in the church. They simply recorded that the works in question were now lost.[1] Milanesi's 1878 edition noted in the appropriate sections that the paintings by Ambrogio Lorenzetti and Berna had not survived,[2] but in the *Vita* of Buffalmacco, apparently annotated slightly later, he reported that some remains of paintings, thought to be by Ambrogio Lorenzetti or Berna, had recently been found in S. Margherita di Cortona.[3]

Mirri's account of the rebuilding of S. Margherita describes the rediscovery of these fragments.[4] In 1876 the altarpieces that belonged to a series of seventeenth-century side altars, installed against the nave walls (see Fig. 22), were removed in preparation for the

1. Vasari, ed. Bettarini and Barocchi, commentary vol. 2, 501, 644.

2. ". . . oggi non ne rimane più nulla." *Le Vite de' più eccellenti Pittori Scultori ed Architettori scritte da Giorgio Vasari . . .*, ed. G. Milanesi, 1, Florence, 1878, 524–648.

3. "In Santa Margherita di Cortona furono scoperti ul-timamente alcuni lavori, avanzi di antiche pitture giudicate di Ambrogio Lorenzetti o del Berna, i quali, secondo il Vasari, dipinsero, oltre Buffalmacco, in quella chiesa." Milanesi, 517.

4. Mirri, rev. Mori, 118 and 126.

demolition of large parts of the original nave (see Fig. 16).[5] Behind the altarpieces were discovered the remains of some frescoes that, during March and April of the following year, were removed from the walls, placed in metal supports, and stored above the loggia of the church.[6] In the 1885 edition of volume three of Crowe and Cavalcaselle's *Storia della Pittura in Italia* the subjects of the fragments were recorded as Eve Spinning, Joseph Sold by his Brothers, The Way to Calvary, one small fragment with one figure carrying a ladder, and two others riding a white horse, (tentatively identified as a piece from a Crucifixion), and a fictive cornice with an illegible inscription and the mutilated date M CCC xxx. . . .[7] In due course the two Old Testament scenes passed into the safekeeping of the Museo dell'Accademia Etrusca. The remaining pieces described by Crowe and Cavalcaselle, and two further fragments with a decorative border, are now displayed, together with the head of a bearded saint, in the Museo Diocesano of Cortona. These remains, although scattered and damaged, permit some reconstruction of the original fresco program of S. Margherita.

The Genesis Scenes

The first Old Testament fragment (200 × 161 cm)[8] (Pl. VIII; Fig. 63) consists of a figure of Eve, clothed in animal skins, seated in a rocky, flower- and plant-strewn landscape, and holding a distaff and spindle. The head of the figure has been removed, leaving a blank area approximately 40 cm high. The Labor of Adam and Eve did not generally appear as an isolated scene in Italian mural decoration. It was used at the end of a sequence of scenes representing Adam and Eve before and after the Fall.[9]

The second fragment (186 × 200 cms)[10] (Fig. 64) shows the well into which Joseph was cast. The surface of the painting is interrupted by many damages and losses, which make it difficult to interpret. To the right, one of Joseph's brothers kills the goat whose blood will be used to stain Joseph's many-colored coat. The head of this figure has been removed, leaving a blank space approximately 28 cm high. Behind the well two figures, each resting a hand upon its edge, stand together. One of them, perhaps Judah, extends his other hand in speech, and the other, probably Reuben, raises his right hand to his cheek in a gesture of sorrow. In front of the well are two further figures, one apparently receiving something from the other, perhaps indicating the sale of Joseph to the Ishmaelites.

5. See Chapter 3, for the rebuilding of the church.

6. The detachment was carried out by Prof. Filippo Fiscali, after a protracted correspondence with a commission set up by the authority for the conservation of monuments. Mirri, rev. Mori, 126.

7. G.-B. Cavalcaselle and J.-A. Crowe, *Storia della Pittura in Italia*, 3, Florence, 1885, 135 n. 2 and 205.

8. Approximate maximum dimensions of painted surface.

9. For example, Rome, S. Paolo fuori le Mura; Palermo, Cappella Palatina; Monreale; Venice, S. Marco, Atrium; Florence, Baptistry; Assisi, S. Francesco, Upper Church; Stimigliano, S. Maria in Vescovio; Pisa, Camposanto; Pistoia, ex-Convento del Tau. An exception is the Sala dei Notari in the Palazzo dei Priori, Perugia, in which only the Creation of Adam and Eve accompanies the Labor, in what is, according to Riess, "a political reformulation of Genesis." J. Riess, *Political Ideals in Medieval Italian Art: The Frescoes in the Palazzo dei Priori, Perugia*, Ann Arbor, 1981, chap. 5.

10. Approximate maximum dimensions of painted surface.

The scene of Joseph Sold by His Brothers was, like the Labor of Adam and Eve, generally found in the context of a substantial narrative cycle.[11] Adam and Eve scenes and Joseph scenes were often linked by further Genesis subjects selected from among the stories of Cain and Abel, Noah, or Abraham and Isaac. Thus these two fragments imply that there was once a substantial Genesis cycle in the Church of S. Margherita.

Mirri did not specify the precise positions in which the individual fragments were found, but since they evidently escaped being whitewashed in 1653 they must already have been hidden by altarpieces installed against the walls before that date. In the first half of the seventeenth century four side altars were set up in the nave of S. Margherita and three of these (Fig. 204) were supplied with large canvases at the time of their construction or shortly afterward: on the north wall was the Baldelli family altar of 1610, with an Ecstasy of Saint Catherine, attributed to Barocci; on the south wall was the Laparelli family altar of 1607, with a Virgin in Glory attributed to Empoli; and further east on the same wall was the Lucci family altar of 1602, with an Immaculate Conception attributed to Francesco Vanni.[12]

Since three substantial fragments were found behind the altarpieces it seems reasonable to assume that each of the three altarpieces concealed one of those three fragments. The fragment of Joseph Sold by His Brothers, which is at least 200 cm wide,[13] cannot have come from behind the Barocci Altarpiece of the Ecstasy of Saint Catherine, which itself measures only 199 cm across.[14] It must thus have been covered by one of the altarpieces on the south wall, which are both approximately 216 cms wide, and it seems probable that the other Genesis scene also came from the south nave wall, with the narrower Way to Calvary fragment (146 cm wide; see below) hidden behind the Barocci Ecstasy of Saint Catherine on the north wall.

Since the Adam and Eve scene would have come much earlier in the cycle than the Joseph scene, the question arises as to whether both scenes could have come from behind the same altarpiece, placed one above the other, in successive tiers of the cycle. It can easily be shown that this was not the case, for the combined heights of the two scenes (386 cm) is greater than that of either of the south nave altarpieces.[15] Thus each of the Genesis scenes was presumably concealed by one of the two seventeenth-century altarpieces on the south nave wall.

This deduction corresponds with a brief description which shows that certain murals had already been uncovered in the eighteenth century. The anonymous antiquarian of

11. For example, Rome, S. Paolo fuori le Mura; Venice, S. Marco, Atrium; Florence, Baptistry; Assisi, S. Francesco, Upper Church; San Gimignano, Collegiata.

12. Mirri, rev. Mori, 118 n. 59 (where in common with other sources, the Massacre of the Innocents from the Alticozzi altar by Pietro Zanotti da Bologna, is incorrectly dated 1636, instead of c. 1698), 126 and 136. See also Della Cella, 140. Presenti's longitudinal section of the church (Fig. 22) shows the Alticozzi and Baldelli altars on

the north nave wall. His ground plan (Fig. 14) also indicates the positions of the Lucci and Laparelli altars on the south nave wall.

13. The support has been extended beyond the painted surface and now measures approximately 207 cm wide.

14. Dimensions 287 × 199 cm given in the exhibition catalogue Arte nell'Aretino, ed. A.M. Maetzke, 73.

15. Immaculate Conception, height: 310 cm. Virgin in Glory, height also approximately 310 cm.

Cortona Biblioteca Comunale Cod. 501 describes how, at the end of 1773, the two windows above the first two altars to the right of the main entrance were replaced.[16] The paintings of the altars were temporarily removed, so as to avoid damage to them. Behind both were revealed murals in "vaghi colori" that were all rather ruined, but that had figures that were well executed (*con assai bene intese figure*). Disappointingly, the subject of the paintings is not recorded. But this eighteenth-century uncovering could explain a difference between the surviving Old and New Testament fragments. While the heads of the two Genesis fragments (Pl. VIII; Figs. 63 and 64) have been cut out, those of the Way to Calvary Fragment (Pl. IV; Fig. 65) remain untouched. It seems most unlikely that the damage was done at the time of the nineteenth-century discovery, when great care was taken to inform the proper authorities, and to ensure the preservation of the fragments.[17] It seems much more probable that the two Genesis fragments were revealed, behind the two altarpieces on the south wall of the nave, in the eighteenth century, and that the most attractive elements of the paintings were at that time cut from their surroundings. These heads may still, indeed, survive, awaiting recognition in some private collection.

We can go a little further in estimating the possible extent of this hypothetical Genesis cycle. The easternmost bay of the south nave wall was occupied, as we shall see (see Chapter 7) by scenes from the Margherita cycle. (By the time of the rediscovery of the fragments in 1876 this wall had, it will be remembered, been demolished to make way for the early eighteenth-century transepts, see Chapter 3 and Fig. 16). The remaining two bays of the south nave wall each contained one of the Genesis scenes described above. But there was room to accommodate a considerable number of further scenes at a similar scale in these bays. The Eve fragment (Pl. VIII; Fig. 63), whose painted surface has a maximum width of 161 cm, preserves its right border and appears to lack approximately half the scene since Adam is not visible delving. This suggests an original width of approximately 300 cm for the complete composition.[18] Each nave bay of the original church measured approximately 9 meters square, so in addition to the large lunette-shaped fields below the rib vaults there would have been room in each bay for up to three scenes, each with a maximum width of 300 cm, in each tier of the cycle. (It should, however, be borne in mind that the window we know to have existed in each of the south nave bays would have occupied some of the available space, and the width of scenes could, like those of the Old Testament cycle in the nave of the Collegiata at S. Gimignano, have varied.) The original height of the scenes is harder to estimate, but the lozenge in the right border of the Eve scene probably marks the halfway point of the framing decoration, in which case the overall height would have been approximately 240 cm.[19] The height of the nave wall to the springing of the vault and base of the lunette was approximately 6 m 90. The walls could easily have contained two tiers of scenes, with one or two further tiers in each lunette, which had a maximum

16. *L'Antiquario Sacro . . .*, f.10v. The windows in question are visible in one of Presenti's drawings (Fig. 9).

17. Mirri, rev. Mori, 126.

18. This suggestion is supported by the Joseph scene, which has been substantially trimmed at both edges and now has a maximum width of 200 cm.

19. The Joseph scene, including its lower border, now has an approximate maximum height of 186 cm.

height of approximately 6 m 30.[20] It is thus reasonable to conclude that the south nave wall of S. Margherita could comfortably have accommodated an extensive Genesis cycle.[21]

One further small point should be noted. The decorative framing of the two scenes is similar, but not identical. In both cases the main framing decoration is a geometric pattern based on squares and diagonals, picked out in red, white, and black (Pl. VIII; Figs. 63 and 64). In the Adam and Eve scene the interior border, between frame and scene, consists of two simple stripes of red and ocher, but in the Joseph scene a more substantial division, formed by a fictive stone molding topped by a frieze of dentils lit from the top left, stands in front of the red inner framing band, providing the transition into the painted world of the scene. This difference may be due to a distinction between the framing for the different tiers of the cycle, with the Joseph scene lower down the wall, and thus given a more solid base. A further puzzling diversity is to be found in the fragmentary inscriptions accompanying the two scenes: although there are no significant differences in the epigraphy, the inscription below Eve is in Latin, that below Joseph in the vernacular.[22] This divergence need not indicate a difference in date between the two scenes: the Latin inscription below Eve, which appears from its layout to have been versified, might have been copied from a text that did not extend to the whole book of Genesis.[23]

The Way to Calvary

The third large fragment discovered in S. Margherita in 1876 represents part of the foreground of a Way to Calvary composition (166 × 146 cm) (Pl. IV; Fig. 65). The surface of the mural is abraded, and much *a secco* painting has presumably been lost, leaving areas of underdrawing and *buon fresco* painting visible.[24]

On the left, Christ shoulders the cross Himself.[25] To the right, a large red shield presses in on Him, the shield-bearer's arm still visible, clenched within it, while behind Christ another soldier, his face partially obscured by the cross, appears to urge Him forward. The motif of the partially obscured face is repeated for the thief on the right of the composition, whose backward glance is glimpsed beyond the diagonal formed by the spear handle of the

20. These dimensions are based on Presenti's measured drawings, discussed in Chapter 3.

21. Compare the north nave wall of the Collegiata at San Gimignano, with twenty-nine scenes, arranged (with one exception) with five to each bay. See the diagram in S. Faison Jr., "Barna and Bartolo di Fredi," *Art Bulletin* 14 (1932), 286.

22. Eve: ... PE UXORA NON SIC TENEREM ...
 VERE VIRUM [?] SI UNUM SUFICE[R]ET ...
 JOSEPH: [COME IO]SEP FONE [*sic*]
 VENDUTO DAI FRATELLI
For discussion of a similar diversity within the Margherita cycle, see Chapter 12.

23. An example of a Latin text of the analogous length (in prose rather than verse) is the *Tractatus de creatione mundi*, Siena, Biblioteca Comunale degli Intronati, Cod. H.VI.31, illustrated by a Tuscan artist in the late thirteenth or early fourteenth century, which runs from the First Day of Creation to the Labor of Adam and Eve. See the exhibition catalogue *Il gotico a Siena: Siena, 1982*, Florence, 1982, 82–85.

24. The irregular area of loss at the upper right is presumably random damage rather than a section deliberately cut from the painting.

25. The lower end of the cross, painted *a secco*, which has now almost disappeared, overlapped the thief's right calf. The right arm of the cross is still visible above and to the right of Christ's head.

soldier in yellow. The soldier himself looks backward, peering over the protection of his large, pointed shield, and linking together the two groups of figures by the direction of his gaze. The shape of the shield is echoed in the outline of the soldier in red, who bends forward, maintaining the forward motion of the procession. His face has been destroyed, but to his right is preserved the face of another figure, apparently dressed in green, shown in full profile, with individualized features and, it seems, a glint in the fierce white of his eye. The remains of spear handles are still visible against the darker ground of the upper part of the fragment, forming a series of diagonals and verticals to compliment the main lines of the composition. Despite its battered condition, the finest passages of the painting, notably the richly colored drapery of the soldier in yellow, and the retreating figure of the thief, indicate that this was once a work of considerable power.

The Way to Calvary has only once received anything more than a passing mention in the art-historical literature.[26] In an entry for an exhibition catalogue Bellosi attributed the work to Pietro Lorenzetti and his shop, and noted that Longhi, Previtali, and Laclotte were in agreement.[27] Bellosi made no specific comparisons with other works by Pietro Lorenzetti, beyond pointing to the three panel paintings by Pietro that are now in the Museo Diocesano in Cortona: the signed panel of the Virgin and Child with Angels from the Duomo (Fig. 66), the large Crucifix from S. Marco, Cortona (Fig. 71), and the small "Cut-away" Crucifix, found in a cupboard in the crypt of the Gesù (Fig. 70).[28] Nor did he propose a date for the Way to Calvary. Before pursuing the questions of date and attribution, however, it will be helpful to consider in more detail some unusual features of the iconography and design of the composition in its original form.

Iconography of the Way to Calvary

As already noted, the most expressive figure in the surviving fragment is that of the thief. Despite being mentioned in Saint Luke's Gospel (23:32), the presence of the thieves in the Way to Calvary was virtually unknown in art before the fourteenth century. Wilk, in her study of representations of the Way to Calvary before 1300, found only two examples:

26. For the attributions made (without supporting argument) by Crowe and Cavalcaselle, and by Salmi, see below. The fragment is also mentioned in passing in C. Volpe, *Pietro Lorenzetti*, ed. M. Lucco, Milan, 1989, 77, as an example of a compositional echo of the Way to Calvary in the Lower Church at Assisi, but no attribution is suggested, although Volpe implies that the artist was not a Sienese.

27. Presumably these were verbal opinions, since Bellosi gives no references for them. *Arte in Valdichiana*, ed. L. Bellosi, G. Cantelli, and M. Lenzini Moriondo, Cortona, 1970, 10–11. Volpe, ed. Lucco, 77, cites Bellosi's entry without discussing the attribution. The attribution to Pietro Lorenzetti was supported by Boskovits who, in review-

ing Volpe's book, regretted that the Cortona Way to Calvary fragment had not been included there in the artist's oeuvre: M. Boskovits, "Un libro su Pietro Lorenzetti," *Arte cristiana* 79 (1991), 387–88. Bellosi's attribution has recently been upheld by Laura Speranza in a catalogue entry in *Il Museo diocesano Cortona*, ed. A. M. Maetzke, Florence, 1992, 51–53.

28. None of these three works is securely dated. The Virgin and Child is generally considered an early work, painted before the Arezzo polyptych of 1320–23, as is the large Crucifix. Suggestions for the "cut-away" Crucifix range from 1316–20 (Boskovits) to "after 1329" (Volpe). For the bibliography on these works see Volpe, ed. Lucco, 108–9, 119–21, and 149–50.

at S. Pietro, Ferentillo, and possibly also at S. Maria Antiqua in Rome.[29] In the early fourteenth century the presence of the thieves, described in somewhat more detail in the *Meditations on the Life of Christ*,[30] was still uncommon in art, but seems to have attracted the attention of more than one Sienese artist. The two thieves appear, stripped and bound, in the foreground of Pietro Lorenzetti's composition in the Lower Church of S. Francesco at Assisi (Fig. 74), and their presence is implied in the New Testament cycle in the Collegiata at S. Gimignano (previously attributed to "Barna" and now convincingly given to Lippo Memmi) by the inclusion of a second cross visible above the crowd.[31] The two figures also appear, labeled with their respective names, in a fourteenth-century composition in the Upper Church of the Sacro Speco at Subiaco (Fig. 76),[32] but Way to Calvary compositions were seldom sufficiently expansive to allow room for the thieves. Even in the Spanish Chapel in S. Maria Novella, where Andrea Bonaiuti painted an extensive Way to Calvary (Fig. 77), and the thieves were represented in the Crucifixion, they were not included in the accompanying procession.[33]

One of the smaller fragments from S. Margherita (77 × 84.5 cm) (Pl. V; Fig. 67, fragment B) provides further evidence for the original appearance of the Cortona Way to Calvary procession. The fragment shows, reading from left to right, a man carrying one end of a ladder, held horizontally; behind the ladder another man, carrying a piece of wood over his shoulder whose cross bar, just visible at the upper edge of the fragment, shows that this is a cross; and, in front of the ladder, two figures mounted on a horse. Crowe and Cavalcaselle thought that this fragment might have formed part of a Crucifixion scene,[34] but Bellosi identified it correctly as a small part of the Way to Calvary.[35] The inclusion of one of the thieves' crosses, in agreement with the description in the *Meditations on the Life of Christ*—which says that the thieves did not have to carry their own crosses—confirms this identification.[36] The inclusion of the ladder in the Way to Calvary is unusual, but not

29. B. Wilk, *Die Darstellung der Kreuztragung Christi und verwandter Szenen bis um 1300*, Ph.D. diss., Tübingen, 1969, 177.

30. *Meditations on the Life of Christ*, trans. and ed. I. Ragusa and R. Green, Princeton, 1961, 331. For the development of the theme in apocryphal and devotional literature, and in Passion plays, see Wilk, 4–18.

31. See E. Borsook, *The Mural Painters of Tuscany*, 2d ed., Oxford, 1980, 43–46, and fig. 55, where the date bracket c. 1335-c. 1350 is proposed and, subsequently, G. Freuler, "Lippo Memmi's New Testament Cycle in the Collegiata of San Gimignano," *Arte cristiana* 74 (1986), 93–102, who argues, on stylistic and documentary grounds, for the attribution to Lippo Memmi and a date of 1343.

32. See the essay by M. L. Cristiani Testi in *The Benedictine Monastery of Subiaco*, ed. C. Giumelli, Milan, 1982, 139–76, figs. 143 and 148. Cristiani Testi (132–38) attributes the frescoes to an anonymous "Maestro Trecentesco," a late follower of Meo da Siena, working in the Sienese tradition, c. 1362, but D. Gordon, "Art in Umbria, c. 1250–c. 1350," Ph.D. diss., University of London,

1979, 136–37, advances cogent arguments, based partly on the evidence of patronage, for a date "shortly after 1337, 1338, or 1339" for the commencement of work. For a thorough survey of recent dating proposals (which does not, however, mention Gordon's arguments), see S. Romano, *Eclissi di Roma: Pittura murale a Roma e nel Lazio da Bonifacio VIII a Martino V (1295–1431)*, Rome, 1992, 345–48. Romano herself favors a date of c. 1340, a moment of prosperity for the monastery.

33. For the links between Franciscan spirituality and the inclusion of the thieves in the Way to Calvary, the Ascent of the Cross, and the Crucifixion in late duecento and early trecento art, see A. Derbes, *Picturing the Passion in Late Medieval Italy: Narrative Painting, Franciscan Ideologies and the Levant*, Cambridge, 1996, 153–54, 235 n. 71. It is interesting to note that Margherita's lengthy vision of the Passion (*Legenda*, v, 3) specifically includes the good and bad thieves.

34. Cavalcaselle and Crowe, 3: 135 n. 2.

35. Bellosi, 1970, 10–11.

36. *Meditations*, ed. and trans. Ragusa and Green, 331.

unknown, before 1300,[37] and occurs in at least two fourteenth-century Sienese examples: the S. Gimignano cycle,[38] and the Reliquary of the Holy Corporal made by Ugolino di Vieri and associates for the Duomo of Orvieto in 1337–38 (Fig. 75).[39]

The Cortona Way to Calvary was thus an unusually detailed scene, whose iconography does not precisely repeat any existing scene, but that finds several comparisons in Sienese art of the second quarter of the fourteenth century.

The Way to Calvary: Figures in a Landscape Setting

In Pietro Lorenzetti's Way to Calvary at Assisi the protagonists are set in front of the walls of Jerusalem (Fig. 74), but the background at Cortona is an unspecific area of brown, with a darker area toward the top of the fragment, suggesting a rocky landscape (Pl. IV; Fig. 65). The figures in the fragment with the ladder (Pl. V; Fig. 67, fragment B) walk on a brown ground similar to that of the lower part of the main section; behind them, however, is an undulating horizon and a red sky, presumably originally covered with azurite applied *a secco*.[40] This, combined with the small scale of the figures, shows that the fragment belongs toward the top of the original composition, where these people inhabited an elevated part of the background. It is possible to be somewhat more specific about the original position of this fragment. In the bottom right corner can be seen the crossed shafts of two spears, one held vertically, the other at an angle of approximately 60 degrees. This is also the angle at which the soldier in yellow in the large fragment holds his spear, with the tip pointing downward. Presumably the angled shaft in the smaller fragment is the end of the handle of this weapon. This locates the smaller fragment above and to the right of the main fragment (Fig. 78).[41] The shaft of the vertical lance seen in the small fragment was presumably carried by a soldier who stood to the right of the surviving part of the main composition.

These figures from the upper right-hand part of the Way to Calvary presumably formed part of a subsidiary procession, separated from the foreground figures by a vertical rockface, executed in a darker tone of brown. It is not immediately clear whether they were ahead of the main procession, well advanced on the ascent to Calvary, or whether they were lagging behind Christ, and had not yet descended into the valley represented in the foreground of the main composition. Nor is the direction of this subsidiary procession clear. While the men carrying the cross and ladder move, like the foreground figures, from left

37. Wilk, 180. For the connection with the iconography of the Ascent of the Cross and its Franciscan associations, see Derbes, esp. 121–23, 142–57.

38. Illustrated in Borsook, 1980, fig. 55.

39. P. Dal Poggetto, *Ugolino di Vieri: Gli smalti di Orvieto*, Florence, 1965. The motif is also found in the Way to Calvary in Umbrian art at this time. See the double-sided dossal from the Church of Sant' Antonio di Padova, Paciano, now in the Galleria Nazionale dell'Umbria in Perugia. I am grateful to Dillian Gordon for pointing this out to me.

40. Compare the red ground for the sky in, for example, Pietro Lorenzetti's Crucifixion fresco for the Chapterhouse of S. Francesco, Siena, illustrated in color in C. Frugoni, *Pietro and Ambrogio Lorenzetti*, Florence, 1988, 32, figs. 39 and 40.

41. How far above is not certain, but since the height of the Barocci altarpiece which seems to have covered these fragments is 287 cm, the vertical distance between them would not have been more than 45 cm.

to right, the horse with the two riders moves forward and slightly to the right, but turns its head to the left.

Here it is necessary to consider one further fragment in the Museo Diocesano (Pl. VI; Fig. 68, fragment C). Bellosi described it as "il corpo vestito di un bambino,"[42] but on closer inspection this small piece (32 × 30.5 cm) can be seen to represent the torsos of two figures, one clothed in pink and the other in yellowy green, mounted on a horse.[43] The figures are facing toward the left, the figure in pink holding his arms out, presumably to control the reins, while the figure behind clasps him round the waist. This pose agrees with the mounted pair in the fragment with the ladder (Pl. V; Fig. 67, fragment B), but the figures in fragment C were originally significantly larger: they measure approximately 32 cm from shoulder to knee, in comparison with a measurement of approximately 18 cm for the same distance in the figures in the fragment with the ladder. The larger scale of the two mounted figures in pink and green shows that they must have been placed further forward in space, although still very clearly distinguished from the much larger foreground figures in the main fragment. Here again, one can probably be more precise about their original position, for the flowing tail of a horse, visible in the top left corner of the main fragment, seems to be part of the steed on which the two were mounted (Pls. IV and VI; Figs. 65 and 68). Unlike the foreground figures, or the men with the ladder and cross in the upper part of the background, this pair is traveling from right to left. In other words they occupy the middle ground of a procession that once snaked down the hill in a reversed S-curve, perhaps issuing from a representation of the city of Jerusalem at the top left of the composition, moving from left to right in the background (including the men with the ladder and cross) then from right to left, and finally, in the foreground section, from left to right again. The turning pose of the horse in the fragment with the ladder, may indicate that horse and riders are in the process of changing direction in order to join the group doubling back across the upper landscape.

It may be easier to picture the original form of the Cortona *Way to Calvary* if we turn to a later Sienese fresco of the same subject, executed by Vecchietta in the Baptistry of the Duomo in Siena, in 1450 (Fig. 80).[44] Here the S-curve of the procession runs in the opposite direction, but the main lines of the composition are clear: in the background a procession of tiny figures, set above a hilly landscape, issues from Jerusalem. As the procession moves forward in space, the figures gradually increase in size and the procession swings back across the picture plane. It runs briefly behind a conical hill and then emerges, in ever-increasing scale, turning back across the foreground of the painting, with the protagonists, in large scale, set in front of the rocky landscape through which the procession has

42. Bellosi, 1970, 10.

43. This fragment is not included in the catalogue of the Museo diocesano edited by Maetzke in 1992 and has not been on display with the other fragments in the museum in recent years.

44. G. Vigni, *Lorenzo di Pietro detto il Vecchietta*, Florence, 1937, 76. A simpler version of the type occurs in another of Vecchietta's works, the reliquary cupboard doors of the Ospedale of S. Maria della Scala, Siena, 1444. See H. W. van Os, *Vecchietta and the Sacristy of the Siena Hospital Church*, The Hague, 1974, pl. 11. It is interesting to note, in this connection that Feldges (among others) points to Vecchietta's use of Ambrogio Lorenzetti's landscape compositions. U. Feldges, *Landschaft als topographisches Porträt*, Bern, 1980, 114.

progressed. Looking back at the Cortona Way to Calvary (Fig. 78) it seems likely that there, as in the Vecchietta fresco—and many other post–Arena Chapel versions of the subject—Christ is turning his sorrowing gaze toward the Virgin, at the left of the composition. He is passing her at the crossroads below the city walls, as described in the *Meditations on the Life of Christ*,[45] while, to the right, the procession is taking the path that will lead it upward again, and toward Calvary.

Vecchietta's composition connects background, middle-ground, and foreground in a continuum not found in surviving fourteenth-century works. The illusion is achieved through the gradation of figure scale, the snaking shape of the procession, and the ambiguous size of the rocks in the landscape through which it passes. No earlier surviving Way to Calvary attempts such a thorough exploration of space, but Vecchietta's composition is not an isolated one. In the fifteenth century the motif of a cavalcade winding its way through a hilly landscape was found in a number of representations of the Journey of the Magi, of which the best known are probably the works of Gentile da Fabriano and Benozzo Gozzoli. In Gozzoli's work of 1459 in the Palazzo Medici-Riccardi in Florence, the procession forms a continuous line, increasing in figure-scale as it moves from background to foreground and back again,[46] while in Gentile's Adoration of the Magi of 1423 (Florence, Uffizi) the small-scale background figures snaking in and out of the upper part of the composition are quite separate from the large-scale foreground group.[47] A precursor of Gentile's composition is to be found in the lavish panel attributed to Bartolo di Fredi (first mentioned 1353, d.1410) now in the Pinacoteca in Siena (Fig. 81);[48] Bartolo also used a simplified version of this composition in a work now divided between the Lehman Collection in the Metropolitan Museum, New York, and the Musée des Beaux-Arts, Dijon.[49] The Dijon panel (Fig. 79) may give some indication of how the figures in the Cortona fragment B (Pl. V; Figs. 67 and 78) originally continued their journey but, as in Gentile's altarpiece, Bartolo's two versions of the Journey of the Magi are restricted to the background zone of the composition, firmly separated from the large-scale foreground figures by curving hillocks that occupy the middle ground.[50] On the other hand Bartolo's Old Testament cycle

45. *Meditations*, trans. and ed. Ragusa and Green, 331–32.

46. A. Padoa Rizzo, *Benozzo Gozzoli pittore fiorentino*, Florence, 1972, 123–24, figs. 107–12.

47. K. Christiansen, *Gentile da Fabriano*, London, 1982, 29–30. Christiansen observes, "Behind this foreground screen unfolds the first continuous landscape in Italian painting since Ambrogio Lorenzetti decorated the city hall of Siena."

48. Ibid., 29–30.

49. J. Pope-Hennessy and L. B. Kanter, *The Robert Lehman Collection. Vol. 1: Italian Paintings*, The Metropolitan Museum of Art, New York, 1987, 30–32, illus. p. 31; M. Guillaume, *Catalogue raisonné du Musée des Beaux-Arts de Dijon: Peintures italiennes*, Dijon, 1980, 6. I am grateful to Marguerite Guillaume for having answered my inquiry about the Dijon panel.

50. See also the curving procession of mounted and walking figures issuing from Jerusalem in the background of the Agony in the Garden on the left wing of a triptych in the Corcoran Gallery, Washington, D.C., signed by Andrea Vanni. Illustrated in E. Carli, *La Pittura senese del Trecento*, Milan, 1981, 247, fig. 284, who dates the painting to c. 1384–85.

A small panel of the Adoration of the Magi attributed to the workshop of Bartolo di Fredi, now in Polesden Lacey, suggests a tentative development from this type toward a more continuous link between background and foreground. The short road along which the Magi journey leads from the background toward the foreground although it does not explicitly reach it. The middle-ground is omitted in this abbreviated composition. See G. Freuler, *Bartolo di Fredi Cini*, Disentis, 1994, 201, fig. 185, and Cat. 57, p. 475.

in the Collegiata at San Gimignano, painted in 1367, contains a very tentative exploration of the placing of medium- or small-scale figures on the rocky ledges of the middle-ground or background. This can be seen in scenes such as the Parting of Abraham and Lot in the Land of Canaan (Fig. 82) or the Murder of Job's Servants and the Theft of His Flocks.[51] Since Bartolo's works are not generally noted for their compositional originality, his interest in situating figures within a landscape may have been indebted, like much else in the formation of his art, to the example of the Lorenzetti brothers.[52]

As it happens, Bartolo may have had the opportunity to visit the Church of S. Margherita, and see the Way to Calvary procession painted there. Bellosi has proposed that a fresco from S. Francesco, Cortona, of the Virgin and Child Enthroned with Saints, should be attributed to the early stage of Bartolo's career, before his first dated work of 1364.[53] This suggestion gains support from the evidence of a donation *inter vivos* made by Fra Orsino di Odile d'Anseta, a priest attached to the Church of S. Margherita, in 1374. The donation included an inventory of the *arredi sacri*—liturgical equipment and furnishings—of the Cappella dei SS. Vitale ed Orsina, which were to be given to S. Margherita. The altar, situated on the south wall of the westernmost nave bay, had been set up by Fra Orsino, with his own money, in 1363; among the items listed in an inventory of 1374 are a silver-gilt and enameled chalice, made in Siena, which cost seventeen florins, and "una tavola dipinta avanti l'Altare, con Tribuna pure dipinta dal Maestro Bartolo di Siena per 30 fiorini d'oro, coi veli di seta."[54]

Although the Procession of the Magi seems to have inspired the most lively experiments in central Italy in the fourteenth and fifteenth centuries, there is some evidence that the subject of the Way to Calvary procession also provided the opportunity for some noteworthy experiments in the setting of narrative within a landscape. In the Lower Church at Assisi the procession curves down from the city of Jerusalem, which occupies a large part of the upper half of the composition, and starts to move toward the distant hills, at the right edge of the scene, where the rearing horse of one of the soldiers is seen from behind moving almost directly into the picture space (Fig. 74). In the Subiaco version the movement upward and to the right is emphasized because of the practical necessity of raising the composition above an intervening embrasure (Fig. 76). In the Spanish Chapel, Andrea Bonaiuti expands the implications of both the Assisi Way to Calvary and the Betrayal in the same cycle (Fig. 86), by showing the procession crowding awkwardly up through a

51. Illustrated in Carli, 1981, 326, fig. 273.

52. For Bartolo's career and stylistic debts, see the concise and informative entry by E. Castelnuovo in *Dizionario Biografico degli Italiani*, 6, Rome, 1964, s.v. "Bartolo di Fredi." See also Freuder's very detailed and lavishly illustrated recent monograph on the artist 1994. For comparison of the Dijon Magi Procession with the work of Pietro Lorenzetti, see Guillaume, 6. For debts to the Lorenzetti in the Old Testament cycle see Faison, 303–15, and Carli, 1981, 236–38.

53. L. Bellosi, "Per l'attività giovanile di Bartolo di

Fredi," *Antichità viva* 24 (1985), 21–26. This attribution is rejected by Freuler (1994, 94 n. 47), but he accepts my argument that the inventory of 1374 cited below shows that the artist did visit Cortona in the early part of his career (Freuler, 19–20, 24 n. 38, and 60–61).

54. "A panel painting on top of the altar [? 'avanti l'Altare'], with a predella [? 'tribuna'] also painted by Maestro Bartolo di Siena for 30 gold florins, with their silk covers." The donation is summarized, and its circumstances are discussed in da Pelago, *Sommario, ad annum* 1363 and 1374.

rocky gap in order to move toward the left and merge with the crowds moving to the right in the Crucifixion scene above (Fig. 77).

These fourteenth-century Way to Calvary compositions share an interest in the depth-generating possibilities of a procession. Groups of figures are moved through a landscape on curving lines and orthogonals, ascending and descending, approaching and retreating, in order to explore and define depth in a landscape setting. In its original state the Cortona Way to Calvary may have been one of the most daring of these experiments.

Attribution and Dating of the Way to Calvary

With a clearer picture of the original form of the Way to Calvary in mind, we can now return to the questions of authorship and chronology raised by Bellosi's attribution of the fragments to Pietro Lorenzetti. The point of departure for any comparison must be the Way to Calvary in the Passion Cycle attributed to Pietro Lorenzetti in the Lower Church of S. Francesco at Assisi (Fig. 74).

We have already noted that the two works are linked by their unusual inclusion of the two thieves. In both cases one of the thieves is shown in rear view. At Assisi the soldier urging him on is seen from the side, but the rear view used at Cortona recalls the rear view and *profil perdu* of the soldier to the left of Christ at Assisi, who uses his pointed shield to bar the Virgin's path. The open-mouthed figure shown in full profile above the soldier in yellow at Cortona, resembles the figure to the left of the thieves' captor at Assisi.

Despite these similarities of composition and figure pose, the protagonists in the two scenes are by no means identical. The Assisi Christ is shown in three-quarter profile, facing the direction in which He walks, whereas at Cortona His head, resting on the cross, is turned toward the spectator, and is thus seen in full face. The facial proportions used at Cortona—low forehead framed by waving hair; broad cheekbones; closely set, elongated eyes; pronounced shading on both sides of the nose; lightly drawn beard—can be more readily found elsewhere in Pietro Lorenzetti's oeuvre, notably in the Saint John the Baptist of the polyptych for the Pieve at Arezzo (commissioned 1320, completed 1323) (Figs. 83 and 84). This facial type is adapted by means of the curving, upturned brows, to convey an expression of pathos foreshadowed, but not equaled, in what remains of the face of the Christ of the Flagellation in the Lower Church at Assisi and, more powerfully, in several of the figures of the framing medallions in the Assisi Passion cycle.[55] The thief—presumably the good thief, since he occupies a position analogous to that of the good thief at Assisi—wears a similarly sorrowful expression (Figs. 87). His features are not particularly close to those of the bad thief at Assisi (Fig. 85); the tangling strands of hair that fall over his shoulders give more life to the face, and his turned head and eyes give a special force to the three-quarter profile view.

The forms of the drapery in the Cortona fragment are quite unlike the sharp and rather

55. See, in particular, the Prophet (Volpe no. 42), the saints (Volpe nos. 65 and 69), and Isaiah (Volpe no. 70), illustrated in Volpe, ed. Lucco, 99, 103, and 105. See also the fleeing apostle who turns to face the spectator at the upper right of the Assisi Betrayal (Fig. 86).

mannered shapes that enliven many of the figures at Assisi. The regular, tubular folds and grooves of the tunic of the soldier in yellow are more akin to Pietro's later oeuvre, from Elijah and Elisha's cloaks in the Carmelite Altarpiece (completed 1329),[56] to the female visitor at the far right of Pietro's Birth of the Virgin (commissioned 1335, completed 1342) (Pl. XII).

In view of these divergences it might be argued that the works were not by the same artist or workshop, and that similarities of composition and pose merely resulted from the artist of the Cortona Way to Calvary studying the Assisi scene with sketchbook in hand.[57] But the Cortona mural was not simply a copy of the Assisi composition. As we have seen, elements from Assisi were rethought and rearranged, and placed in a very different setting, at Cortona. Moreover a comparison of the good thief in the two works shows that far from being a copy of the Assisi figure, the Cortona thief is a more skillful development of the pose explored at Assisi. In the Lower Church at Assisi the thief nearer to Christ is shown from the back, his face in *profil perdu*, stepping forward on legs whose positions would, in reality, be impossible (Fig. 85). His counterpart at Cortona, turns his face, partially obscured by the soldier's spear, toward the spectator (Fig. 87). At Assisi the soldier does not really seem to touch the thief's back, but at Cortona the soldier's skillfully foreshortened arm holds the slanting spear handle, blocking off any hope of retreat for the thief. At Assisi the thief's cupped hands are softly painted, suggesting resignation—almost repose, but at Cortona they are powerfully drawn, tensed in clawlike gestures, and vividly foreshortened, in a manner reminiscent of Christ's agonized hands on the cross in, for example, the large Crucifix now in the Museo Diocesano in Cortona attributed to Pietro Lorenzetti (Figs. 71 and 72). At Assisi the good thief's legs are turned in a different direction from his torso, making the relation between the torso shown above the loincloth, and the legs shown below it, irreconcilable. At Cortona the legs have been turned to align more convincingly with the hips and torso, and the thief and the two soldiers have fallen into step. The bare feet of the thief, which are beautifully observed, presumably derive from life studies that also supplied the pose for the feet of the two soldiers (Pl. IV; Fig. 65). The figure of the Cortona good thief, in its entirety, suggests careful study of a model placed in a pose in which the contrast between forward movement and backward glance would express forcefully the reluctance of the good thief to continue along the way.[58]

56. Illustrated in ibid., 138 and 139.

57. For discussion of drawings made from other frescoes in the Lower Church at Assisi, see below, Chapters 8 and 9. As noted above, Volpe (77) seems to have considered the Cortona Way to Calvary an "echo" of the Lower Church composition, and does not raise the possibility that the same artist was involved in the design of both compositions.

58. Another source for the musculature of the torso may be a piece of Roman sculpture. A sarcophagus of the Battle of Bacchus and his Retinue with Indians and an Amazon, c. A.D. 160 (Fig. 89), now in the Museo Diocesano, comes from the Duomo in Cortona, where it is said to have been used for the burial of Beato Guido (d. 1247), following its discovery in a nearby field. (Giacomo Lauro, *Dell'Origine della Città di Cortona in Toscana e sue Antichità*, Rome, 1639, reprinted in Historiae Urbium et Regionum Italiae Rariores, n.s., 79, Sala Bolognese, 1981, part II, gathering F; Della Cella, 38–40 [who mistakenly give 1240 instead of 1247 for the date of Guido's death.]) Vasari recounted how the sarcophagus excited great enthusiasm in Donatello and Brunelleschi, and the work may also have been studied earlier by Pietro Lorenzetti, whose Virgin and Child Enthroned (Fig. 66) also comes from the Duomo. The sarcophagus provides front and rear views of naked torsos and, on the lid, front and rear views of naked

The links between the Assisi and Cortona Way to Calvary murals concern design rather than execution, and while there may be certain difficulties in concluding that the same hand executed both sets of figures, it is less hard to accept that the design of the two scenes was conceived by the same man. Even within other parts of the Assisi cycle we can see figures that are closer in conception to Cortona, notably the soldier in the right foreground of the Betrayal whose rear view, *profil perdu*, and foreshortened shield-bearing arm appear to be precursors of the Cortona soldier's pose (Figs. 86 and 87). Although the decorative swirls of his drapery are quite unlike the garment of the Cortona soldier in yellow, the rich color and soft folds of Peter's cloak, immediately to his right, anticipate the drapery style of the Cortona figure.[59] The manner in which the fleeing apostle in the Assisi Betrayal turns to engage the spectator's eye with a sorrowful gaze, and the fierce full profile of Malchus, also relate to figures in the Cortona Way to Calvary fragment. Moreover the arrangement of the Betrayal as a procession, entering round a rock at the left, winding down through a gateway to the foreground, and departing upward into the middle ground behind another rocky *repoussoir* at the right, introduces some of the themes that were to be much more thoroughly explored, it appears, at Cortona.[60]

Thus although the Cortona Way to Calvary is not a close copy of Pietro Lorenzetti's composition in the Lower Church at Assisi, it develops elements of that composition—and other parts of the Assisi Passion cycle—with sufficient skill and imagination to suggest the possibility of an artist returning, with further thoughts, to a subject already treated some time earlier.[61] Pietro Lorenzetti's work at Assisi is now generally thought to have been completed before 1320, or, at the latest, a year or two later.[62] The notable difference in the Cortona figures may be attributed, in part, to the passage of several years between the two works, and comparisons have been made here with Pietro's post-Assisi drapery style. But the Cortona figures do not, on the other hand, display the bulky monumentality that characterizes many of the figures in Pietro's later works, such as the Birth of the Virgin

captives with bound hands (Figs. 90 and 91). Pietro would presumably have known—and perhaps made drawings from—these figures before designing the Assisi Way to Calvary thieves (Pl. IV; Figs. 65 and 87) were painted, since his Virgin and Child in the Duomo is generally dated before Assisi. He could have renewed his acquaintance with the work, to good effect, on his return to Cortona to work in S. Margherita. For the sarcophagus and Vasari's story, see A. Minto, "Il sarcofago romano del Duomo di Cortona," *Rivista d'arte* 26 (1950), 1–22, esp. 1–3; P. Bober and R. Rubinstein, *Renaissance Artists and Antique Sculpture*, London, 1986, 31–32 and 180–81; for a more detailed account, citing all the relevant texts in full (but also giving 1240 as Beato Guido's death date), see M. E. Micheli, "Aneddoti sul sarcofago del Museo Diocesano di Cortona," *Xenia* 5 (1983), 93–96 (I am indebted to Ruth Rubinstein for this reference.)

59. The magnificent yellow of the Cortona soldier's tunic can be even more closely paralleled within the Assisi Passion cycle in the medallion figure of a saint (Volpe

no. 39, "Joseph of Arimathea?") in the framing band to the right of the Crucifixion scene, with its soft tubular folds and its similarly vibrant combination of rich yellow with rusty orange shading. For an excellent color reproduction see Volpe, ed. Lucco, 97.

60. For an illustration of the complete scene in color, see Carli, 1981, 140.

61. The central predella panel of the Carmelite altarpiece includes a group of figures in the foreground, just to the right of center (illustrated in Volpe, ed. Lucco, 53), whose poses clearly derive from those of the Assisi thieves and the soldier to the left of them. This magnificent panel is universally attributed to Pietro himself, suggesting that the Assisi Way to Calvary procession was still, artistically, current in Pietro's shop in 1329. The Cortona Way to Calvary figures may thus have been conceived after this date.

62. For a recent summary of opinions, and further bibliography, see Volpe, ed. Lucco, 60–65.

altarpiece, commissioned in 1335 and completed by 1342 (Pl. XII; Fig. 96). On stylistic and compositional grounds a date in the late 1320s or early 1330s seems most appropriate.

External evidence points to a similar dating bracket. The Way to Calvary on the Reliquary of the Holy Corporal at Orvieto, commissioned in 1337 and completed in 1338 (Fig. 75), has clear affinities with the Assisi composition, particularly in the figure of the foreground soldier, as Dal Poggetto has noted.[63] But in other respects—the prominence of the tall spears, the ladder, and the rocky background—the reliquary indicates a knowledge of another version or versions of the scene, executed after Assisi and before the reliquary was made in 1337–38. The extensive interest shown by the artists of the reliquary in Lorenzetti compositions may indicate that one source of these new elements in the Way to Calvary was a Lorenzetti work. The other expanded Way to Calvary procession—which, like Assisi and Cortona, includes the two thieves, the fresco in the Sacro Speco at Subiaco attributed to a follower of Meo da Siena (Fig. 76)—has been convincingly dated by Gordon to the same years.[64] Meiss, discussing the Crucifixion in the Subiaco cycle, proposed that the method used there for setting numerous figures within an extensive landscape might have been derived from a composition by Ambrogio Lorenzetti, perhaps the lost Crucifixion from the Chapterhouse of S. Spirito in Florence, whose decoration was attributed to him by Ghiberti.[65] In the case of the Subiaco Way to Calvary, with its grandiose architectural backdrop, its lengthy procession, and its attempt to show both thieves seen from behind, the evidence again points to a Lorenzettian prototype, known to other artists by the later 1330s.[66] The Cortona Way to Calvary Fragment, and the information about its original form that has been pieced together here, may be our best surviving evidence for the form that such a post-Assisi Lorenzetti Way to Calvary composition once took.[67]

Mention of Pietro's brother Ambrogio in this context raises one further point concerning the possible authorship of the Cortona Way to Calvary. There is something in the powerful nature of the Cortona Way to Calvary, and in particular in the figure of the good thief (Fig. 87), that distinguishes it from much of Pietro Lorenzetti's more tranquil post-Assisi paintings. In some respects it recalls the harshness of certain works attributed to his brother, notably the Massacre of the Franciscans at Ceuta, formerly in the Chapterhouse

63. Dal Poggetto, introductory essay.

64. "Shortly after 1337, 1338, or 1339." Gordon, 1979, 136–37. For reference to other dating proposals, see above, note 32.

65. M. Meiss, " 'Highlands' in the Lowlands, Jan Van Eyck, the Master of Flemalle and the Franco-Italian Tradition," *Gazette des Beaux-Arts* 57 (1961), 290, and 312 n. 48.

66. It is not known whether the paintings in the Chapterhouse of S. Spirito included a Way to Calvary. Vasari, the only source to mention the subject matter (and who, unlike Ghiberti, attributed the work to Simone Martini) called the decoration "la storia della Passione di Cristo." Vasari, ed. Bettarini and Barocchi, text vol. 2, 194.

Steinweg has suggested the lost S. Spirito Crucifixion

as the "immediate prototype" for the Crucifixion in the Spanish Chapel; R. Offner and K. Steinweg, *A Critical and Historical Corpus of Florentine Painting*, iv, vi, New York, 1979, 46. The extensive Way to Calvary in the Spanish Chapel (Fig. 77), discussed above in the context of the Cortona composition, precedes that Crucifixion.

67. The only surviving thoroughgoing fourteenth-century essay in the exploration of continuous landscape is, of course, the setting of figures of varying scale in the landscape of Ambrogio Lorenzetti's *Buon Governo* (c. 1338–39). The sturdy men carrying the ladder and cross, and the broad-headed riders in the background of the Cortona Way to Calvary (Fig. 67), find many counterparts among the minor figures in the townscape and landscape of Ambrogio's *Buon Governo* (see, e.g., Fig. 69).

of S. Francesco, Siena (Fig. 88).[68] The executioner in the foreground, at the left, is shown in a turned and twisting pose as daringly conceived and accurately observed as that of the Cortona good thief.[69] The chilling effect of his pug-nosed profile may have been in the mind of the artist who drew the fierce profile of the man in green to the left of the Cortona thief (Pl. IV; Fig. 87).[70] The thief's protruding lower lip, not easily paralleled in Pietro's work, and the particularly emphatic curve of his brows, may be a quieter echo of the horrified expressions of the figures immediately to the left of the executioner, in the Massacre at Ceuta.[71]

It would not be entirely surprising to find elements from the manner of one brother in the work of the other. They worked side by side on the lost frescoes for the facade of S. Maria della Scala in Siena (1335)[72] and both participated in the decoration of the Chapterhouse of S. Francesco in Siena, where the Massacre at Ceuta was painted.[73] Borsook suggested a specific connection between the executioner in the Massacre and the work attributed to Pietro at Assisi, proposing that the executioner was painted by an assistant of Ambrogio's who was well acquainted with the figure of the soldier accompanying the two thieves in the Assisi Way to Calvary (Figs. 85 and 88).[74] But a closer comparison may be made between the pose and dress of the executioner and that of the soldier in yellow in the Cortona Way to Calvary (Figs. 87 and 88). Although the position of the limbs differs, the form of the torso, and the curved neck and hem of the tunic, gathered at the waist in narrow tubular folds, are sufficiently similar to suggest that a drawing of a turned pose—presumably initially based on a life-study—may have been adapted for use in both paintings. The closeness of these two figures also raises the possibility that both were painted by

68. Now displayed in the Bandini Piccolomini chapel. For a recent color reproduction of the whole composition, see Frugoni, 1988, 60, fig. 69.

69. Damage to the legs of the figure unfortunately obscures the treatment of foreshortened feet, seen from behind. The type is, of course, also indebted to the figures of the flagellants in a Flagellation scene. This may initially have suggested to the artists a careful study of the pose.

70. For an excellent color reproduction see Carli, 1981, 186, fig. 218. The profile of the man in green in the Cortona Way to Calvary, developed from his Assisi counterpart (Fig. 86), is also reminiscent of the prisoner whom Saint Leonard has freed, in the Abegg Stiftung panel attributed to Pietro (illustrated in Volpe, ed. Lucco, 117).

71. The tangled hair of the Cortona thief, picked out in black and white, and the rapid black and white brushstrokes used to describe his garment, recall the brushwork in certain of the Massacre of Ceuta figures (some of it underdrawing) notably the figures to the right of the Sultan.

72. As recorded in the lost inscription: HOC OPUS FECIT PETRUS LAURENTII ET AMBROSIUS EIUS FRATER M. CCC. XXX. V.

73. The datings suggested for the various Chapterhouse paintings oscillate between the early 1320s and the mid-1330s. For a summary and further bibliography see Volpe, ed. Lucco, 128–34. Seidel raised the possibility that all or part of the Chapterhouse decoration might have been executed at the same time as the cloister, c. 1336; M. Seidel, "Gli affreschi di Ambrogio Lorenzetti nel chiostro di San Francesco: ricostruzione e datazione," Prospettiva 18 (1979), 19. Subsequently he agreed with Volpe in dating the Pietro Lorenzetti Crucifixion from the Chapterhouse to the earlier 1320s. (Seidel, 1985, 141 n. 143.) Maginnis also saw the Chapterhouse decoration as a collaborative project, but preferred to date the works to the mid-1320s. H. B. J. Maginnis, "Pietro Lorenzetti: A Chronology," Art Bulletin 66 (1984), 199–200.

Several writers have noted the rapprochement between the styles of the two brothers from the 1330s onward; for example, Volpe, ed. Lucco, 50, "Si rammenti inoltre che nel 1335, come già si è detto, Pietro e Ambrogio lavoreranno insieme agli affreschi sopra citati dell'Ospedale, e che pertanto in quel tempo dovette verosimilmente attuarsi un avvicinamento mentale fra i due fratelli, in qualche modo rispecchiabile nelle altre opere dello stesso momento."

74. E. Borsook, Ambrogio Lorenzetti, Florence, 1966, 5–6. Borsook did not specify whether she considered that this assistant of Ambrogio's had previously worked in Pietro's shop.

the same artist. The question of the interaction between the two brothers and their assis-
tants during the 1330s will be raised again, in connection with the Margherita cycle, in
Chapter 10.

Position and Context of the Way to Calvary

If the south nave wall of S. Margherita was decorated with a Genesis cycle, does the sur-
vival of the fragmentary Way to Calvary from the north nave wall imply the existence of a
corresponding Passion cycle? The Way to Calvary was not generally used as an isolated
devotional image in mural painting of the time. An apparent exception to this rule is the
figure of Christ Carrying the Cross on the south wall of the former *cappella maggiore* of S.
Chiara, Montefalco (Fig. 180).[75] This painting, which forms part of the mural decoration
executed c. 1333 in the burial church of Beata Chiara of Montefalco (d. 1308), shows
Christ without any accompanying figure apart from the kneeling Beata Chiara. The subject
matter is not, in fact, the biblical event of the Way to Calvary but the representation of a
vision in which Christ appeared to Chiara and imprinted her heart with the cross. Even in
this case the image of Christ Carrying the Cross is not entirely isolated; a large and detailed
Crucifixion scene formed the focal point of the scheme, on what was then the east wall of
the *cappella maggiore*. The many-peopled form of the Way to Calvary always belonged to a
narrative ensemble, generally a cycle of considerable length. Even in more abbreviated
programs, such as that of the Spanish Chapel, the scene accompanied a Crucifixion.[76]

The Baldelli altar in S. Margherita, behind which the Way to Calvary appears to have
been found, was originally situated in the second bay of the north nave wall (Fig. 204).
Since the main procession in the foreground of the scene moves from left to right (Pl. IV;
Fig. 65), it can be proposed that any crucifixion scene would have been placed to the right
of the Way to Calvary. Presenti's watercolor of the elevation of the north nave wall (Fig.
22) shows a doorway immediately to the right of the Baldelli altar, and da Pelago's eleva-
tion of the same bay shows, in the same position (Fig. 21), an opening that permitted those
in the nave to look into the Cappella del Salvatore and see, within the chapel, a wooden
sculpture of Christ (which had been there since at least 1332).[77] It is conceivable that the
presence of this sculpture by itself provided the culmination of the Calvary procession. If,
on the other hand, a Crucifixion mural did exist, it could have been situated in the next
bay to the east. The inclusion of thief, ladder, and lengthy procession at Cortona raises the
possibility that if such a scene existed it may, like the Crucifixions in the Lower Church at

75. The chapel is called the Cappella di S. Croce. For
further detailed discussion of the chapel decoration, its
contents, dating, attribution, and the circumstances of its
patronage, see Gordon, 239–58. See also S. Nessi, "Primi
appunti sull'iconografia clariana dei secoli XIV e XV," in
*La Spiritualità di S. Chiara da Montefalco: Atti del I° Con-
vegno di studio, Montefalco, 1985*, ed. S. Nessi, Montefalco,
1986, 315–17; and see below, Chapters 12 and 14.

76. A later example is the Crucifixion attributed to

Taddeo Gaddi in the Sacristy of S. Croce, flanked by a
Way to Calvary (attrib. Spinello Aretino) and a Resurrec-
tion (attrib. Niccolò di Pietro Gerini). See M. Boskovits,
Pittura Fiorentina alla vigilia del Rinascimento, 1370–1400,
Florence, 1975, 99, 406, and 435.

77. For discussion of Presenti and da Pelago, see above,
Chapter 3. For the *Cappella del Salvatore* and the sculpture,
see above, pages 48–49.

Assisi, the Collegiata of S. Gimignano, and the Sacro Speco at Subiaco, have included the two thieves flanking the crucified Christ. The width of the wall (9 m) could have accommodated a large-scale fresco such as this, as well as the funerary monument of Beata Margherita (maximum width of base 2 m 29 cm), which we know to have been placed on that wall.[78] The inclusion of a large-scale Way to Calvary and, it is possible, Crucifixion close to Margherita's burial place would have been appropriate both to her own spirituality[79] and for those who were influenced by it. Margherita's frequent meditations on the Passion have been seen as a forerunner of the devotion to the *Via Crucis*.[80] Information given by Della Cella, writing just before 1900, appears, at first sight, to confirm this hypothesis concerning a Crucifixion mural,

> Round the niche where the body of S. Margherita was before 1580, a fourteenth-century painter (perhaps Lorenzetti) had painted the Crucifixion with the Virgin at the foot of the cross and with Saint John, Saint Mary Magdalene, Saint Francis, Saint Basil (Basilio), Saint Peter, and other saints. A fragment of these frescoes still exists and was placed in one of the galleries of the new church with some other fragments belonging to the frescoes that were on the side walls of the church and that were mutilated in the seventeenth century.[81]

It would be convenient to accept Della Cella's description at face value, but his somewhat uncritical use of sources should make us cautious. Disappointingly, he gives no source for his information concerning this supposed lost fourteenth-century Crucifixion fresco. But it seems possible that he mistakenly combined da Pelago's description of the subject matter of the painted doors from the tomb niche (discussed above, Chapter 4) with Crowe and Cavalcaselle's (incorrect) identification of the small fresco fragment with the ladder (Fig. 67) as a piece from a Crucifixion.[82]

As Demus long ago demonstrated, there was a long-lived tradition of combining Old and New Testament mural or mosaic cycles in central Italian churches that had its origins in the nave decoration of Old Saint Peter's.[83] Each cycle varied to fit its particular context, but recurrent features included the pairing of Old and New Testament cycles across a nave,

78. Da Pelago shows the tomb placed centrally in the bay but, as discussed in Chapter 3, his reconstruction drawing was made when that part of the nave wall no longer existed.

79. For Margherita's intense meditations on the Passion in the presence of an image of Christ, see the Introduction.

80. See A. Benvenuti Papi, "Margarita filia Jerusalem. Santa Margherita da Cortona e il superamento mistico della crociata," *Toscana e Terrasanta nel Medioevo*, ed. F. Cardini, Florence, 1982, 120–23, and 136; reprinted in Benvenuti Papi, 1990, 146–49 and 167–68. For further discussion of Margherita's meditations on the Passion, see the Introduction, Chapter 2, and Chapter 14.

81. "Attorno alla nicchia dove, prima del 1580, era il Corpo di S. Margherita un pittore del secolo XIV (forse il Lorenzetti) aveva dipinto la crocifissione colla Vergine a piedi della croce e con S. Giovanni, S. Maria Maddalena, S. Francesco, S. Basilio, S. Pietro ed altri santi. Un frammento di questi affreschi esiste ancora e fu collocato in una delle tribune della nova chiesa con qualche altro frammento appartenente agli affreschi che erano sui muri laterali della chiesa e che nel secolo XVII furono mutilati," Della Cella, 138.

82. Cavalcaselle and Crowe, 135 n. 2.

83. O. Demus, *The Mosaics of Norman Sicily*, London, 1950, 205–9.

and a larger area used for the Crucifixion than for the other scenes.[84] The Upper Church of S. Francesco at Assisi, which was among the churches cited by Demus, has parallel Genesis and New Testament cycles, and the decoration of Saint Clare's burial place, now severely damaged, also included scenes from both Genesis (Creation to Sacrifice of Isaac) in the left transept, and the Infancy of Christ, in the right transept.[85] Although the evidence is not conclusive, it is possible that the decoration of Margherita's burial church also belonged to this tradition.

The Head of a Hermit Saint

A fresco fragment showing the head of a bearded saint (Pl. VII; Fig. 92) (max. dimensions 39 × 33.5 cm) is now displayed in the Museo Diocesano together with the pieces from the Church of S. Margherita. The painting, which is a very fine and well-preserved piece, appears to be virtually unpublished.[86] Mori, in a recent guide to the Museo Diocesano, noted that the fragment came to the museum from Palazzo Tommasi in via Dardano, Cortona.[87] The head was evidently cut from its surroundings, much as Eve's head was removed, probably in the eighteenth century, from the Genesis fresco now in the Accademia Etrusca (compare Pls. VII and VIII). In the absence of any documentary evidence the original setting of this fragment cannot be established, but in view of the high quality of the piece it will be worth pausing, briefly, during our consideration of the other fresco fragments to consider whether it, too, may be associated with the decoration of the nave of S. Margherita by Sienese artists in the second quarter of the fourteenth century.

The type of saint represented may provide some links with our church. He wears a black monastic habit, the hood of which is just visible in the fragment, and the combination of this garment with his unkempt tonsure and his long forked beard indicates that he is a

84. The nave of the Upper Church of S. Francesco at Assisi, S. Maria in Vescovio at Stimigliano, and the nave of the Collegiata of S. Gimignano are all late examples of the tradition, and each varies in the choice and arrangement of scenes. Even the wall allotted to the cycles varies: at Assisi and Stimigliano the New Testament cycle is on the left nave wall, at S. Gimignano it is on the right, while the direction of the narrative might lead from east to west (Assisi) or might start at the west and zigzag down the walls (S. Gimignano).

85. E. Zocca, *Assisi*, Catalogo delle cose d'arte e di antichità d'Italia, 8, Rome, 1936, 191–94. The Chapel of S. Giorgio contains further Infancy and Passion scenes (Zocca, 195–98). For recent discussion, accompanied by excellent illustrations, see E. Lunghi, 'La decorazione pittorica della Chiesa,' in M. Bigaroni, H.-R. Meier, and E. Lunghi, *La basilica di S. Chiara in Assisi*, Perugia, 1994, 137–282, especially 195–230.

86. Apart from a passing mention in the catalogue entry by Bellosi, noting that, included with the other frag-

ments from S. Margherita now in the Museo Diocesano, is one "con una testa di vecchio" (Bellosi, Cantelli, and Lenzini Moriondo, 10) and the comment in Mori and Mori, 1995, cited below. The head was not included in the catalogue of the Museo Diocesano edited by Maetzke in 1992.

87. E. Mori and P. Mori, *Guida storico artistica al Museo diocesano di Cortona*, Cortona, 1995, 25, where the fragment is mentioned together with the pieces from S. Margherita, and identified as the head of an apostle, without illustration or further comment. Mori's source of information was the unpublished typescript *Inventario-Ricerca* by Monsignor Giovanni Basanieri, former director of the museum. Palazzo Tommasi, was acquired by the curia vescovile in 1938. I am grateful to Paolo Mori for responding to my enquiry concerning the provenance. Dott. Mori considers that the fragment probably came, originally, from S. Margherita, but no information survives concerning its location before it came to Palazzo Tommasi.

hermit saint. This conforms with representations of two of the saints to whom Margherita's church was originally dedicated: Basilio and Egidio.[88] Basilio could also be represented in an alternative form, as a bishop,[89] and it appears that this was the type chosen twice for him in the church, in the lost sculpture over the west doorway, and in the surviving marble altar reliefs (Fig. 51). The figure with a long forked beard in those reliefs is thought to represent Egidio (Fig. 49), and this is the name I propose to use here. It is possible that "Egidio" belonged with a group of saints recorded during the Visitation of 1634. When looking for visual evidence of the antiquity of Margherita's cult, the judges were shown paintings of various saints on the walls and vaults of the church.[90] Among these, on the north nave wall, they saw an "imaginem antiquissimam" of Margherita, with a halo like those used in the paintings of the other saints represented in that part of the wall.[91] The term *antiquissima* was used with discrimination in the Visitation records (as discussed in Chapter 4), and appears to have been applied only to works of, or earlier than, the four-teenth century. The same sentence in the Visitation record goes on to report that the judges were then shown Margherita's funerary monument, which was on the same side of the church. Thus the description in the Visitation indicates the existence of fourteenth-century murals that included a group of saints, not far from the funerary monument. It is thus conceivable that the bearded hermit saint came from a group painted on the north nave wall that included Margherita's image and may have been located near her resting place. This location could account for the chance preservation of the head, which might have been cut from the wall at the time when it was demolished, to make way for the addition of transepts, in 1738.

No attribution has previously been proposed for this superb fragment. A case will be made here for connecting the work with the name of Pietro Lorenzetti. Among Pietro's signed and documented works the closest comparisons are to be found in the polyptych for the Pieve at Arezzo (commissioned 1320, completed 1323). The "S. Egidio" relates to the heads of two apostles in the main tier of the polyptych. He shares with the Saint Matthew (Fig. 93) the three-quarter view, with the further eyelid sloping down toward the edge of the face. This feature combines with the furrowed forehead (whose folds rise, in a formulaic manner, from the inner corners of the puckered eyebrows), the shadowed corners of the mouth, and the drooping lines of the moustache, to give both figures a meditative and melancholic air. The silhouettes of the heads are similar, particularly the flattened top to the head, extended by the mass of hair expanding behind it, and the broad neck, rising from the shoulder in a gentle arc. The head of the Arezzo Saint John the Evangelist (Fig. 94) offers comparisons for "S. Egidio" 's waving, forked beard, and the arrangement of the hair, bushing out above the ears, but consisting of only a small tuft on top.[92] The "S.

88. Kaftal, 1952, cols. 143–44, 452–57. S. Basilio was, during his life, monk, hermit, and bishop; S. Egidio was a hermit who founded a monastery.

89. Kaftal, cols. 143–44.

90. ASV, *Riti*, Proc. 552, p. 512.

91. The text says *in pariete dextero* but, as explained below, Chapter 7, this should be taken to mean the north wall of the church.

92. The effect of combining the three-quarter view of the Saint Matthew head with the beard of the Evangelist can to some extent be gauged by looking at the small-scale figure of S. Agostino, at the righthand end of the second tier of the polyptych.

Egidio" can also be compared with later signed and dated works by Pietro Lorenzetti. The Saint Nicholas of Bari in the Carmelite Altarpiece (completed 1329)[93] and, in particular, the Joachim of the Birth of the Virgin (commissioned 1335, completed 1342) (Figs. 95 and 96) show that this method of constructing and painting a male bearded head in three-quarter profile remained a constant during Pietro's career.

These comparisons with panel paintings emphasise the remarkable surface detail of the Cortona fragment. Pietro Lorenzetti's frescoes are not always so well preserved, but consideration of the head of the Centurion in the Crucifixion from the Chapterhouse of S. Francesco, Siena, shows that the refinement of the "S. Egidio," which seems more akin to the brushwork of a panel painting, has parallels within Pietro's *buon fresco* works.[94] If the "S. Egidio" finds a place in Pietro's oeuvre, it should surely be placed later than the Pieve Polyptych in Arezzo (1320–23). The swifter painting of the head, required by the demanding medium of *buon fresco*, also suggests a more relaxed and assured approach. The type found at Arezzo is here mastered so thoroughly that the features suitable to this aging ascetic—the hollowed cheeks, and the crow's feet at the corner of the eye—form an integral part of the conception. Bearing in mind the comparison with Joachim in the Birth of the Virgin (1335–42) (Figs. 95 and 96), a dating in the later decades of Pietro's career would therefore seem appropriate.

The Fragmentary Inscription and Vasari's Date of 1335

The dating proposed here for the Way to Calvary and the "S. Egidio" bring us back to the question of how to interpret the fragmentary inscription (21.5 × 61 cm) (Fig. 97) that was among the pieces found in 1876. The few remaining letters of the inscription seem to defy interpretation.[95] The date, on the other hand, clearly supplies M C C C X X, with a further X partly extant but largely, it appears, due to restoration. If the artist was using his Roman numerals correctly, the year the inscription indicated cannot be later than 1339.[96] The small remaining piece of fictive molding visible on the inscription fragment could belong with the framing of the Genesis scenes (Figs. 63 and 64), as could the last surviving fragment (Fig. 98), a piece of decorative border (35 × 58.5 cm), which combines a red, black, and white geometric pattern identical to that of the Genesis scenes with a fictive grey stone molding (similar to that below the Joseph scene [Fig. 64], minus the dentils) and a band of rich foliate ornament painted in black, white and ocher on a red ground.[97]

93. Illustrated in Volpe, ed. Lucco, 138.

94. For an excellent color reproduction of the Centurion see Carli, 1981, 165, fig. 194.

95. QUIA S MA/M CCC XXX

96. If he was content to use XXXX for forty, the range of possible dates extends to 1349. Both Lorenzetti brothers used XL for forty on the inscriptions on their panel paintings.

97. The fall of light on the fictive stone moldings, when compared with those below the Joseph fragment (Fig. 64), suggest that the imaginary light source should be above the fragment and thus that the foliate band was originally above the geometric decoration, not below, as at present displayed in the Museo Diocesano.

In the absence of any further information as to where in the church the inscription was found, it can at least be observed that a date in the 1330s would agree with the visual evidence of the Way to Calvary and "S. Egidio" fragments. It is also conceivable that such a date could apply to the Genesis fragments. Their damaged state makes comparison with the Way to Calvary fragments, and any attempts at attribution, extremely difficult. Crowe and Cavalcaselle, with Vasari's attributions in mind, judged the fragments more like the works of Ambrogio Lorenzetti than of Barna, making no distinction of style between the Old and New Testament fragments.[98] Since then only Salmi,[99] Sinibaldi,[100] and Bellosi[101] have ventured opinions on the fragments. All were duly cautious. The Old Testament fragments were attributed by Salmi to a Florentine artist, by Sinibaldi to Antonio Veneziano, and by Bellosi to an artist similar to, but weaker than Barna.[102] The New Testament fragments were attributed by Salmi to an artist close to Barna, and by Bellosi, who saw the Way to Calvary after it had been restored, to Pietro Lorenzetti and his shop (as already discussed). All three seemed to be in agreement on only one point: that the Old and New Testament fragments are by different hands. Bellosi was ready to connect the Old Testament fragments with "Barna's" style; Salmi, however, made the same connection for the New Testament fragments. This suggests that the stylistic distance between the two cycles is not that great. Indeed, the firm musculature and carefully rendered fleshtones of the torso, arms, and legs of the good thief in the Way to Calvary (Fig. 72) may be compared with Eve's finely painted arms and legs, and the observation of her right hand delicately holding the thread above the spindle (Fig. 73).[103]

Vasari applied the date of 1335 to Ambrogio Lorenzetti's work in the church but, as already discussed, gave no indication of exactly which part of the decoration he believed was executed by that artist. His apportioning of large parts of the painting of the walls and vaults to both Ambrogio Lorenzetti and Barna could be taken to indicate that he had distinguished, on grounds of style or subject matter, between different sections of the church's decoration—either dividing the Genesis scenes from the New Testament one(s), or grouping those nave scenes together, in distinction to the Margherita scenes in the *cappella maggiore* and the south wall of the easternmost nave bay. Although ingenious argument can be devised to make Vasari's description fit with what can be reconstructed of the decoration of S. Margherita, there remains the strong possibility that Vasari simply used

98. Cavalcaselle and Crowe, 135 n. 2.

99. Salmi, 170 n. 4.

100. Opinion reported in M. Moriondo, "Le Opere d'arte dell'epoca Medioevale e Moderna nel Museo dell'Accademia Etrusca di Cortona," *Nuovo Annuario dell'Accademia Etrusca di Cortona*, n.s., 2 (1953), 37–38.

101. Bellosi, Cantelli, and Lenzini Moriondo, 10–11.

102. Reference to the attribution of the Old Testament fragments has also recently been made in passing in L. Speranza's catalogue entry for the Way to Calvary fragment in Maetzke, 1992, 51–53. She suggested that the two Old Testament fragments may be "d'ambito più o meno strettamente lorenzettiano." These two fragments

are not, however, discussed in the companion catalogue volume for the Museo dell'Accademia Etrusca, ed. P. Bocci Pacini and A. M. Maetzke, Florence, 1992.

103. The only head in the Joseph scene (Fig. 64) of which a part remains—that of Reuben—has in its sorrowful gaze and pouting lips something of the good thief's face, and the stocky figure bending over the goat may have something of the form and proportion of the figure holding the ladder in the small Calvary fragment. The arrangement of the figures around the well recalls, if distantly, the Carmelites gathered around the hexagonal well on the right of the central predella panel of Pietro Lorenzetti's Carmelite Altarpiece.

information concerning the church, gleaned from notes made in situ, in the composition of the *vite* of two separate artists. The use of the name "Berna" may have been based, as noted above, on Vasari's knowledge of Ghiberti's *Commentarii*. Ghiberti said that Barna painted many works in Cortona.[104] In the first half of the same sentence Ghiberti noted that Barna painted many Old Testament scenes in S. Gimignano, and in the first edition of the *Vite* Vasari repeated that information.[105] The existence of Genesis cycles in the naves of churches in both S. Gimignano and Cortona may well have prompted Vasari to use "Berna's" name for the decoration of the "maggior parte delle volte e delle facciate" of S. Margherita.[106] Vasari's use of Ambrogio Lorenzetti's name may, as discussed above, have been based on evidence he obtained either from an inscription or from a local written source. The majority of comparisons made in this chapter have, on the contrary, been made with Ambrogio's brother Pietro. Vasari was unaware of their relationship, and believed that Pietro's surname was Laurati. He would thus presumably have taken any reference to a Lorenzetti working in 1335 to mean Ambrogio.

Some attempt can now be made to answer the questions posed at the start of this section. There is clear evidence that an extended and ambitious program of mural decoration covered the walls and vaults of the nave of Margherita's burial church. Much, if not all, of that painting dated from the fourteenth century,[107] and there is evidence for a substantial campaign of decoration in the 1330s. Despite the uncertainties surrounding Vasari's evidence, detailed consideration of the surviving fragments, far from ruling out Vasari's dating, his enthusiastic assessment of the quality of the painting, and his attributions to two Sienese artists, gives them strong support. Questions that have not yet been addressed, concerning the precise location of the Margherita cycle within the church, its authorship, and date of execution, will be considered in Part IV.[108]

104. Ghiberti, ed. von Schlosser, 42.

105. Vasari, ed. Bettarini and Barocchi, text vol. 2, 255.

106. In the second edition of the *Vite*, acting on information supplied by Borghini and a probable visit to S. Gimignano in 1562, Vasari corrected the attribution of the Old Testament scenes to Bartolo di Fredi, and transferred Berna's name to the New Testament cycle on the other side of the nave (Williams, 19–20.) Since Vasari's stay in Cortona took place in 1554, well before the proposed date for his visit to S. Gimignano, he would still have linked the name of Berna with Old Testament cycles at that time.

107. Some evidence exists for other isolated murals, in the former Church of S. Basilio, probably known, in the fourteenth century, as the Cappella di S. Margherita. The visitors of 1634 were shown the former Church of S. Basilio, which was decorated with various pictures including, "in capite," above an altar (i.e., at the West End), an image of Beata Margherita with a halo, wearing the habit of the Third Order, which was described as "imaginem

antiquissimam." Below the image was the inscription, "Beata Margherita ora pro nobis" (*ASV*, *Riti*, Proc. 552, p. 514).

Bornstein has recently published excerpts from an account book that include (242) a payment for paintings of the Nativity and Adoration of the Magi, by a certain Giovanni di Ristoro, in the Cappella di S. Margherita in 1373. (Further payments to the same artist published by Bornstein, relating to work in the "Cappella Grande" of the church, and connected by Bornstein with the Margherita cycle recorded in the watercolor copies, will be discussed in the following chapter.)

108. Another Sienese painting in the Museo Diocesano, Cortona, a panel of the Virgin and Child (102 × 67 cm) (Fig. 99), is also said to have come from the Church of S. Margherita. See the catalogue entry by L. Speranza in Maetzke, 1992, 36–37, where the panel is attributed, with detailed argument, to Niccolò di Segna and dated to c. 1336. (No source is given for the provenance, which is presumably the unpublished *Inventario-Ricerca* of Monsignor Giovanni Basanieri, p. 41.)

Part IV

"Dipinti dall'istesso Ambrogio"?: The Watercolor Copies, the Margherita Mural Cycle, and Trecento Painting

In the preceding chapter we saw how Vasari's comments about the dating and authorship of the mural paintings in S. Margherita might be seen to apply to the fragments surviving from the nave. But might Vasari's testimony also refer to the lost murals of the Margherita cycle? The following chapters will consider the evidence of the watercolor copies, and the light they throw on the authorship and dating of the lost cycle, particularly Vasari's reference to Ambrogio Lorenzetti. The Lorenzetti brothers have already received a considerable amount of attention in the previous chapter. In the context of this book there are a number of reasons for continuing to pursue the issue of their possible activities in S. Margherita in detail. The first is the intrinsic potential interest of an extensive mural cycle, linked with these two major artists of the trecento, which has never previously received any serious analysis. Then there is the need to reconstruct the decoration of the church at this time, as far as possible, as a whole, in order to understand the aims and priorities of the patrons. Did they choose well-known (and well-paid) artists from out-side the town, whose abilities might add to the fame of their saint? Did they continue to turn to

Siena for practitioners (as they had done for the marble funerary monument) and if so, how did the artistic language of Siena affect the version of Margherita that was presented on the walls of her burial church? How accustomed were these artists to tackling the stories of saints, in a near contemporary setting, rather than the more standard iconographic repertoire of panels of the Virgin and Child, or scenes from the Passion of Christ? If these artists did indeed come to their task with a wealth of preexisting formulas in mind that might be put to use in the new commission, what were these formulas? And is the version of Margherita presented to us by the fresco paintings influenced largely, or almost entirely, by representations of other saints whose lives were painted in cycles before hers? Were these artists nevertheless able to be responsive to the particular requirements of their patrons and to use their initiative and inventiveness? Even if adopting or adapting compositions they had used before, could they refashion them so as to express, as closely as their artistic language permitted, the particular concerns of those paying, supervising, and advising them? These questions can only be addressed if we attempt to identify the artist or artists in question and to use any available information about their artistic careers to make some assessment of their skills and knowledge of the practice of painting hagiographical narratives. Moreover, if we can find in these artists' careers any support for applying Vasari's dating of 1335 to the Margherita cycle this will have a bearing on our interpretation, in Part V, of certain scenes, and their possible significance for contemporary Cortona; further it will throw light on Vasari's other piece of information: the name of a possible patron of the cycle.

7

Interpreting the Watercolor Copies

When the judges for the canonization process visited the Church of S. Margherita in 1634, one of their tasks was to consider the evidence provided by the mural cycle concerning the life and miracles of Beata Margherita. These scenes—described by the judges as *antiquissima*, a term that, as we have already seen, they seem to have reserved for works from the thirteenth and fourteenth centuries[1]—were regarded as a significant element in the canonization process.[2] In order to record and preserve this evidence, watercolor copies of each scene had been produced, and during the Visitation of 1634 the judges compared these copies with the original murals, and confirmed their accuracy. Each watercolor was then duly authenticated, on the reverse, with the seals and signatures of the provost (*prae-*

1. *ASV, Riti,* Proc. 552, p. 521. See Chapter 4, for the judges' terminology.

2. The consultation of visual evidence and the inclusion of drawings is not unknown in postmedieval canonization processes relating to other duecento and trecento figures but the extent and detail of such material, in Margherita's case, appears to be unique; see, for example, Umiltà of Faenza (copy of panel painting) in M. Carmi-

chael, "An Altarpiece of Saint Humility," *Ecclesiastical Review* (1913), 429–44. For two notarized copies made in 1653 of frescoes showing two miracles of Saint Francis, formerly in the cloister of S. Francesco, Gubbio, see E. Giovagnoli, *Gubbio nella storia e nell'arte*, Città di Castello, 1932, 94–99, figs. 33 and 34. I am grateful to Donal Cooper for bringing these drawings to my attention.

positus) and archdeacon of the Cathedral of Cortona, and of the notary, Reginaldo Sellari,[3] and a full set of watercolors was bound in with every copy of the canonization process that was produced (Pl. I). (These signatures are now visible, disfiguring some of the watercolors on the recto of the leaves [for example, Fig. 103]).

The Artist of the Watercolor Copies

We learn from the text of the process that the artist employed to record the murals was Adriano Zabarelli.[4] The standard reference works have little to say about Zabarelli—a follower of Pietro da Cortona.[5] Recently, Pacini has made the first careful study of the career of the artist, showing that he was born in Cortona in 1608 and died there in 1678.[6] By 1647 Zabarelli was, as we shall see, the official painter to the Commune of Cortona (*"pittore pubblico"*). At the request of Lodovico Serristori, bishop of Cortona from 1634 to 1656, Zabarelli made drawings recording four damaged frescoes of the life of S. Gilberto Pellegrino, in the Pieve di S. Cristoforo at Montecchio del Loto.[7] Pacini has assembled more than a dozen paintings by Zabarelli, all based on elements from existing works by other artists.[8] These paintings seem, at first sight, to be of higher quality than the watercolor copies, but it should be remembered that Zabarelli was in the early stages of his career at the time the murals were recorded. The report of the Visitation of 1634 shows that the copies had been made some years earlier, since two of the badly damaged scenes that they record (nos. xviii and xix) had disappeared completely about two years before the Visitation.[9] A likely date for their production would be c. 1629, the year in which the canonization process opened. Zabarelli would thus have been in his late teens or early twenties

3. The copies made from the original set were each certified, on the reverse, in the same words, recorded by the notary. See below, Appendix II, for further description of the production of the various sets of watercolor copies.

4. ASV, *Riti*, Proc. 552, pp. 1043–44.

5. See, for example, U. Thieme and F. Becker, *Allgemeines Lexikon der bildenden Künstler*, Leipzig, 1907ff., *s.v.* "Zabarelli."

6. P. Pacini, "Per Adriano Zabarelli detto 'il Paladino,' copista e divulgatore di Pietro da Cortona" in *Antichità viva* 35, iv (1996), 28–49. Pacini corrects the birth and death dates given in Thieme-Becker. Pacini also establishes the birth dates of Adriano's artist sons Antonio and Ascanio, and demonstrates that the one work mentioned in Thieme-Becker, a drawing of the Raising of Lazarus in the Uffizi, is in fact signed by Adriano's son Antonio.

7. Pacini (37) reports that after Zabarelli's death two sets of copies of these drawings were made for Francesco di Paolo Baldelli, a native of Cortona. One set was for his own use and the other was sent to Daniel Paperbroch for use in the supplement to the *Acta Sanctorum*. Pacini notes that drawings now in BC/AE MSS 530 and 630 may either be Zabarelli's original drawings or the posthumous copies.

8. Pacini, passim. To the paintings illustrated by Pacini may be added: a Pentecost for the refectory of the nuns of S. Michele Arcangelo (now suppressed) (see G. G. Sernini Cucciatti, *Quadri in chiese e luoghi pii di Cortona alla metà del settecento*, Accademia Etrusca, Cortona, Fonti e testi, 2, ed. P. J. Cardile, Cortona, 1982, 18); an altarpiece of the Immaculate Conception, signed and dated 1641, for the *Cappella della Santissima Concezione* in the Collegiata of S. Maria Nuova (ibid., 28, Tafi, 389); an altarpiece of the Holy Trinity for the High Altar of S. Marco (Tafi, 249); and an altarpiece of the *Madonna Addolorata*, which formerly stood on the High Altar of S. Antonio Abate (Della Cella, 152). Zabarelli is also known to have made a copy of an early image of Beato Guido of Cortona (d.1247) in 1647 (see *Bibliotheca Sanctorum*, vii, Rome, 1966, 507–8). Pacini does not include the watercolor copies of the Margherita cycle in his study.

9. ". . . erant duae antiquissimae picturae . . . quae ob iniuriam temporis a biennio circa perierunt." Their former existence and appearance was testified to by reliable witnesses. ASV, *Riti*, Proc. 552, p. 523.

when he made the copies. But the somewhat naive style of the watercolors ought not to be attributed to the artist's youth or mere incompetence. His task was to reproduce faithfully the (from his point of view) archaic style of the murals. We do have, in fact, further evidence from a few years later that Zabarelli was a copyist of notable skill and accuracy. In 1643 the artist was employed to paint a copy of Andrea del Sarto's *Assunta Passerini* when the original was moved from the High Altar of S. Antonio Abate, Cortona, to the Pitti Palace, by Cosimo III.[10] Zabarelli's painting was subsequently moved to the Cathedral in Cortona and is now placed high up on the south wall of the *cappella maggiore*. Despite its obscure position which, combined with its poor and grimy condition, makes it difficult to photograph satisfactorily, it is clear that the Zabarelli version (Figs. 101, 102) is an extremely careful replica of the del Sarto original (Fig. 100). Not only iconography, composition, and figure pose, but also small details of drapery and shading are imitated in the copy.[11] We can thus be confident in Zabarelli's abilities to reproduce carefully—albeit on a much smaller scale and in a different medium—the paintings that he was asked to record.[12]

Several versions of the watercolor copies were made, some in the seventeenth century, presumably by Zabarelli, to accompany further copies of the canonization process produced in Cortona, and others in the eighteenth century, partly from antiquarian interest, after the original murals had ceased to exist.[13] The relationship between the eight surviving sets of watercolors is discussed in Appendix II, where it is shown that the divergences between them are, on the whole, minor, and it is argued that the set now in MS 429 in the Biblioteca Comunale e dell'Accademia Etrusca of Cortona provides the most reliable and detailed copy of the cycle. It is that version that will be used to illustrate our discussion of the cycle.

Attributing the Mural Cycle

In the light of Vasari's description of the church, the murals recorded in the watercolor copies have, on several occasions, been attributed to Ambrogio Lorenzetti.[14] This connec-

10. See M. Campbell, *Pietro da Cortona at the Pitti Palace*, Princeton, 1977, 209 n. 111, who notes that the painting was formerly signed by Zabarelli, and dated 1643. See also Tafi, 305 and 308. The painting in Cortona has sometimes been attributed to Baccio Bonetti. For Zabarelli's training with Bonetti, see Pacini, 34–36. A second Assumption associated with Zabarelli, in S. Domenico, Cortona, principally follows del Sarto's *Assunta Panciatichi* rather than his *Assunta Passerini* (Pacini, figs. 1, 2, and 3).

11. Tafi (195) remarks that the Cortona version has been taken either for the original or for a replica made by Andrea del Sarto himself.

12. For his own opinion of his skills as a copyist of one of the mural scenes, given in a signed statement of 1647, see below. We should probably not put too much emphasis on a comparison of the work of the copyist with the two items that have survived—the marble tomb (Fig. 192)

and the Crucifix from S. Francesco (Fig. 191). This suggests a dogged fidelity to iconography, but more license in the treatment of drapery and details of pose, particularly in minor figures such as the two angels holding aside the curtains of B. Margherita's tomb. However, the low reliefs on the tomb, which are on a small scale, and difficult to see in poor light conditions, were probably the hardest works to copy. Moreover, the individual scenes on the tomb were not authenticated in separate drawings, as was the case for the murals, which seem to have been considered in more detail by both the judges and the artist.

13. See Appendix II. This proliferation of copies of the canonization process, together with their integral sets of watercolor copies, is unusual.

14. For example, G. Guerrieri, *Santa Margherita da Cortona nella pietà, nella letteratura e nell'arte*, Cortona, 1977, fig. e; illustration to Fra Giunta Bevegnati, *Leggenda della*

tion had already been made by the artist of the copies himself. Niccolò Catalano's book *Fiume de Terrestre Paradiso* concerning the origins of the Capuchin Order, which was printed in 1652, drew on many previous representations of Franciscans, as evidence for their early forms of dress. Among the paintings reproduced in engravings for the book was a detail showing the two Franciscans present at the Funeral of Beata Margherita, in Scene iv of the Margherita cycle.[15] The engraving, which although of higher quality than the watercolor copy (Pl. IX) reproduces almost exactly the same details, was formally authenticated by Adriano Zabarelli, "pittore pubblico," in 1647.[16] His evidence includes the statement that in the Church of S. Margherita:

> there are many paintings by Ambrogio Lorenzetti of Siena painted in the year 1335. And particularly in the choir on the right-hand side [i.e., liturgical north], is to be seen the funeral of the said S. Margherita, with many members of religious orders surrounding the body, such as Dominicans [and] Fathers of Saint Francis, with their habit and hood [*capuccio*], as is here shown above, and these were painted by that same Ambrogio Lorenzetti of Siena, and I have copied them accurately, as they are, and I, the above-mentioned, have signed with my own hand that this is the truth.[17]

Recently the connection between Ambrogio Lorenzetti and the cycle has been challenged. Daniel Bornstein has published excerpts from an account book kept for the *soprastanti* of the Church of S. Margherita (and for the related Churches of S. Marco, S. Giorgio, and S. Cristoforo).[18] These include payments, during 1370 and 1371, to a certain Giovanni di Ristoro, "perché depense e miracholi de Santa Margarita ella Capella grande dela deta ghiesa."[19] At first sight the link between this artist and the cycle may seem plausible, but there are two main difficulties in connecting the payments with those particular paintings. The payments only mention work in the *capella grande*, whereas the Margherita scenes recorded in the watercolors were in both the *cappella maggiore* and one bay of the south nave wall. The second difficulty concerns the quality of the paintings. The payments are

vita e dei miracoli di Santa Margherita da Cortona, trans E. Mariani, Vicenza, 1978, 231; A. Mezzetti, "Il sarcofago di Santa Margherita nell'omonima chiesa Cortonese," *Annuario dell'Accademia Etrusca di Cortona*, n.s., 11 (1979), 362. (Salmi, 170, restricts himself to calling the artist Sienese.) Most recently L. Speranza, in Maetzke, 1992, 51–53, mentions both Lorenzetti brothers; and Mori and Mori, 1996, 37, 39, suggest Pietro Lorenzetti and assistants.

15. Niccolò Catalano, *Fiume del Terrestre Paradiso . . .* , Florence, 1652, 440.

16. Ibid., 389 and 441.

17. ". . . sono molte pitture di Ambrogio Lorenzetti da Siena dipinte l'anno 1335. E particolarmente nel Choro à mano destra, vi si vedono l'essequie di detta S. Margarita, con molti Religiosi à torno al'corpo, come Domeni-

cani, Padri di S. Francesco, con l'habito, e Capuccio, come apparisce quì sopra, e questi sono dipinti dall'istesso Ambrogio Lorenzetti da Siena, & io gli hò ricopiati puntualmente, come stanno, e per esser' la verità, io sudetto, di mia mano propria hò sottoscritto."

18. ACC, Z 3, pezzo 3. D. Bornstein, "Pittori sconosciuti e pitture perdute nella Cortona tardo-medioevale," *Rivista d'Arte* 42 (1990), 227–40. I am most grateful to Daniel Bornstein for making the text of his article available to me in advance of publication. A full edition of the text of the account book will be published by him in a forthcoming article in the *Annuario dell'Accademia Etrusca di Cortona*.

19. "Because he painted the miracles of S. Margherita in the main chapel [*capella grande*] of the said church," Bornstein, 1990, 239. Further payments on 240–41.

low, as is the expenditure on pigments, which must have been of only modest quality, as Bornstein himself points out.[20] The overall payment for the work, including materials, was 25 florins and 4 lire (plus a further sum of 54 soldi 6 denarii—the equivalent of under a florin—for further pigments probably used in the same work).[21] One may compare this to the payment of 22½ florins to Jacopo di Mino del Pellicciaio and Bartolo di Fredi in 1367–68 for painting a single vault near the Cappella di S. Ansano in the Duomo of Siena.[22] The Cortona payments show the division of costs: 15 florins and 4 lire for wages, and something over 10 florins for materials. This can be compared with the payment of 43½ florins to Jacopo di Cione and Niccolò di Pietro Gerini in 1383 for painting one lunette with an Annunciation and four saints in the Palazzo dei Priori in Volterra: 33½ florins for wages and 10 florins for materials.[23] Comparing these types of payment across different times, places, and circumstances is notoriously difficult, but the implication would seem to be that Giovanni di Ristoro was not a well-paid artist. Bornstein draws a distinction between the local Cortonese painters named in the account book and more specialized artists, only visiting Cortona to execute a specific commission, who attracted higher rates of pay.[24] Giovanni does not seem to have had any assistants, apart from his father, who went to Arezzo to buy pigments for the enterprise, and sometimes he had to turn his hand to other work, such as the bricking-up of a window in S. Margherita.[25]

The attribution of the Margherita cycle to Giovanni di Ristoro thus depends, in large part, on an assessment of the quality of the original paintings.[26] Vasari was emphatic in his admiration for the decoration of S. Margherita, although we cannot be sure which parts he was describing, and Adriano Zabarelli, who must have looked at the paintings as carefully as anyone, accepted the attribution to Ambrogio Lorenzetti and the date of 1335. In the following analysis of the original paintings, as reconstructed by means of a study of the watercolor copies, it will be argued that the finest scenes in the cycle were indeed works of originality and imaginative quality, which employed a range of reference likely to have been beyond the reach of a modestly paid, local artist and occasional odd-job man.[27] As for the explanation of these payments to Giovanni di Ristoro, an alternative interpretation will be proposed below.

20. Ibid., 231 n. 9.

21. Ibid., 231 and 240. In 1361–62 the florin was valued at 87 soldi of Cortona. C. Harding, "Economic Dimensions in Art: Mosaics versus Wall Painting in Trecento Orvieto," *Florence and Italy: Renaissance Studies in Honour of Nicolai Rubinstein*, ed. P. Denley and C. Elam, London, 1988, 512; P. Spufford, *Handbook of Medieval Exchange*, London, 1986, 57.

22. G. Milanesi, *Document per la storia dell'arte senese*, I, Siena, 1854, 263–64.

23. The work was commissioned in March and finished by November. R. Offner and K. Steinweg, *A Critical and Historical Corpus of Florentine Painting*, IV, iii, New York, 1965, pp. 115–19, pl. XI.

24. Bornstein, 1990, 231 and 233–34.

25. Ibid., 234 and 241.

26. For a parallel case concerning the portico of the Chiesa del Santissimo Salvatore at Lecceto, in which murals apparently connected with documentation concerning a low payment to a minor artist—Paolo di Neri—have now been attributed in part to Ambrogio Lorenzetti, see N. Fargnoli, "La Chiesa di San Salvatore nel Trecento," in *Lecceto e gli eremi agostiniani in terra di Siena*, Milan, 1990, 196–98, figs. 10, 16, and 17; and C. Alessi, "I cicli monocromi di Lecceto: nuove proposte per vecchi problemi," ibid., 211–12.

27. As Bornstein, 1990, observes, "Essi [the Cortonese artists] furono pittori chiaramente meglio classificabili come artigiani che artisti" (233). This would not be the first time that a payment document concerning the church was mistakenly connected with a work of earlier date. See the discussion, in Chapter 4, of the document of 1362, previously used to date Margherita's marble tomb.

Before proceeding to an assessment of the artistic enterprise recorded in the watercolor copies, it is essential to address two issues: the extent to which the watercolors were copying a trecento paint surface, and the precise location of those paintings on the walls of S. Margherita.

The Condition of the Murals c. 1629

As we have seen, Vasari, writing in the sixteenth century, and Laparelli, writing in the seventeenth century, both emphasized the poor condition of the frescoes in S. Margherita.[28] Having established the fidelity of the artist of the watercolors as a copyist, we need to ask how much we can deduce from these watercolors about the condition of the original frescoes at the time when they were recorded by Zabarelli.

At many points in the copies of the murals the similarity to a trecento pose or setting shines through so strongly that we seem to be seeing the reproduction of a fourteenth-century work. Such instances will be discussed below, when considering the attribution of the cycle. On other, rarer, occasions, there is an equally strong impression that what was being copied was a later interpolation, made in order to "freshen up" an illegible passage in a scene, perhaps carried out at the time when Margherita's body was moved to its new position above the high altar in 1580. The most striking example is Scene xix, the Healing of the Man of Corciano (Fig. 103). The main scene has obvious medieval features, such as the repetition of the figure of the man of Corciano, once reclining in sickness, and once sitting up in health; a compositional device that would be most surprising in a later work. The painting was evidently damaged, lacking the face and upper arms of the cured man, the body of Margherita, and all the lower right-hand corner of the composition. At the top left corner is a view into a barrel-vaulted chamber drawn with a single vanishing-point—a construction not practiced in the trecento, even within the Lorenzetti's circle. Below, the figures holding candles appear to be wearing postmedieval, perhaps sixteenth- or early seventeenth-century dress. The lower left-hand corner of the scene is occupied by the representation of a door lintel, and this is presumably the record of an actual doorway within the church, which the copyist chose to include, to explain the irregular shape of the composition. Perhaps the repainting occurred after the fresco had been damaged by a postmedieval remodeling of the doorway. A further example of perspective with a single vanishing-point, at the center of Scene vi (The Revival and Healing of Bartoluccio of Cortona, Pl. XIX, Fig. 106), also appears to be due to repainting, as does the postmedieval style of the rusticated surrounds to the doorways and windows. There are also other instances of figures wearing dress that appears to be postmedieval, such as the woman at the extreme right of Scene x (The Resuscitation and Healing of Suppolino, Pl. XVI, Fig. 126).

28. See the introduction to Part III and Chapter 5.

(The probable condition of each mural, at the time when it was copied, is discussed in detail in Appendix III.)

These examples are warnings against accepting the copies unquestioningly as repetitions of trecento works, but they do not invalidate their usefulness as a source which increases our knowledge of trecento painting. While every hypothesis concerning attribution and style must be advanced with caution and argued with rigor, we should bear in mind the amount of information that surviving frescoes with later retouchings can still supply. For example, in the Ascent of the Evangelist, in the Peruzzi Chapel in S. Croce, Florence, it has been suggested that the acolytes on the right of the composition are later, probably quattrocento additions.[29] Evidence of the later modernizing of dress through, for example, the addition of hats, has also been found in the Peruzzi Chapel.[30] Such accretions do not invalidate, nor in any major way obscure the original composition. Before Tintori's restoration the murals of the Peruzzi Chapel were covered by extensive repainting. Comparison between prerestoration photographs, and the ghosts of Giotto's original compositions that emerged after cleaning, show that, in general, iconography, figure composition, and even the broader details of drapery, remained legible through the overpaintings.[31]

The Location of the Cycle Within the Church

Where were the scenes located within the church? The only indications given by the drawings are the order in which the watercolors were numbered,[32] which presumably represents some sort of sequence; and the outlines visible at the top of Scenes i, vi, and xii (Figs. 104, 106, and 107). In Scenes i and vi the outline, which takes the shape of a crude arc, presumably shows the limits of the picture field and indicates that these compositions fitted into the lunette-shaped spaces at the top of the walls directly beneath the rib-vaults of the church. This seems particularly appropriate for Scene i, since the normal sequence in fresco cycles is to start at the top. Scene xii (Pl. XXI; Fig. 107) is enclosed by a curved line that rises to the top of the page at approximately the center of the composition and then disappears into a blank area of loss that occupies the top right corner of the composition. The original height of the damaged figures on the right side of the scene makes it unlikely that the upper border could have curved down to complete the arc. It is more probable that Scene xii occupied the left section of the lunette at the top of a wall.

The situation is gradually clarified when we turn to the description of the Visitation of 1634.[33] This provides a gratifyingly detailed description, but one that is not without its peculiarities. Directions are given as left and right, but these appear to be consistently

29. L. Tintori and E. Borsook, *Giotto: The Peruzzi Chapel*, New York, 1965, 78, and pls. 101–4.

30. Ibid., 29–40, esp. 29.

31. Tintori and Borsook publish many reproductions comparing the murals before and after cleaning.

32. For the numbering of each watercolor see below, Appendix III.

33. ASV, *Riti*, Proc. 552, pp. 519–23.

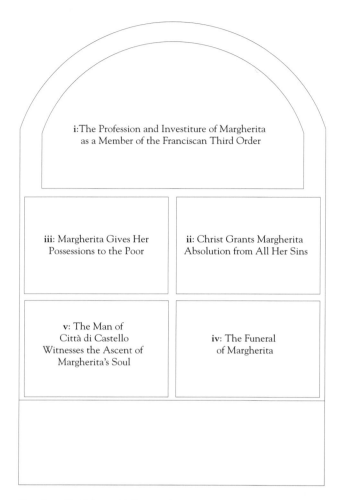

North wall of the *cappella maggiore*

reversed. Thus Margherita's funerary monument, which we know to have been on the left wall of the nave,[34] is described as being "in latere vero dextero dictae Ecclesiae,"[35] and the visitors go through the "right" (*dextero*) side of the choir into the sacristy, which we know to have been on the left side.[36] In the following discussions the terms will be replaced by liturgical north (for *dexter*) and south (for *sinister*).

The comparison (*collatio*) between the watercolor copies (which were already numbered) and the original frescoes began with the north side of the choir, at the top, below the vault. As expected, the cycle began there with Scene i. Next, below this, were Scenes ii and iii, and below them on the same wall, Scenes iv and v. The judges then turned to the south side of the choir and saw, at the top of it, beneath the vault, Scene vi. Next, below, they saw Scenes vii and viii, and below them on the same wall, Scenes ix and x.

The judges then left the choir by the south side and saw, next to the side door of the

34. See Chapter 4. 36. Ibid., 514.
35. ASV, *Riti*, Proc. 552, pp. 512 and 523.

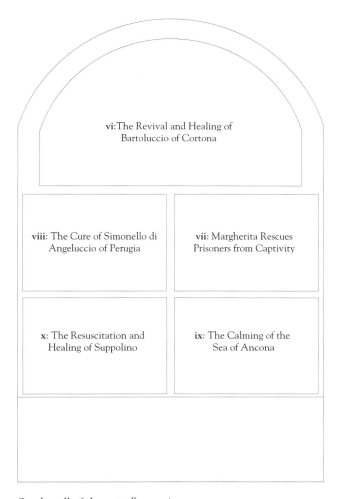

South wall of the *cappella maggiore*

church, marked on da Pelago's plan on the south wall (Fig. 13), various other scenes and miracles described as *picturae antiquissimae* on the south nave wall. At the top, beneath the vault, they saw Scenes xi and xii (Pls. XXIII and XXI; Fig. 107). The copies of these two scenes seem to have been numbered reading from right to left, since the curved border of Scene xii clearly shows, as discussed above, that it occupied the left side of a space directly below the vaults, while the scene numbered xi, although lacking a border, has a composition evidently designed to fit the right side of a lunette (Pl. XXIII; Fig. 107).[37] This apparent reversal of numbering might simply be a mistake, but it raises the possibility that all the adjacent pairs of scenes were numbered from right to left, rather than left to right as might have been expected. There is some evidence that this was indeed the case: the scenes in the middle tier of the north wall of the *cappella maggiore*, if numbered in that way, would

37. At the top of the scene a pointed arch has been tentatively penciled in, but if the line were continued it would cut through the cityscape on the left. The pencil line may therefore be a later addition and is not in any case included in any of the other copies of the scene.

show Margherita's Donation of Her Belongings to the Poor (Scene iii) on the left, followed by the Absolution of Margherita's Sins (Scene ii) on the right—the sequence that is also used in the panel painting of Margherita (Pl. II), and that makes better sense in the context of her spiritual development as described in her *legenda*.[38] On the bottom tier of the north wall of the *cappella maggiore* the same arrangement would place the Ascent of Margherita's soul (Scene v), occurring immediately after her death, on the left, and following that, on the right, Margherita's Funeral (Scene iv). This right to left reading of the numbering of scenes, which also seems appropriate—as discussed below—for Scenes xvii, xviii, and xix, is thus followed in the diagrams which accompany this chapter, in the descriptions provided in Appendix III, in the sketch-plan of the church (Fig. 204) and in the photomontage reconstructions (Figs. 201–203).

Below Scenes xi and xii on the south nave wall came Scenes xiii and xiv, and below these Scenes xv and xvi. Below all these, but apparently still on the same wall, was Scene xvii, the Visitation of Cardinal Napoleone Orsini. Next to this was a whitewashed wall on which, according to the evidence of two witnesses, there were previously the two damaged scenes shown in copies xviii (Aretino of Arezzo Saved Twice from Drowning in a Well) and xix (The Healing of the Man of Corciano). These, as mentioned above, had disappeared entirely within the previous few years.[39]

The description in the canonization process does not specify whether Scenes xviii and xix occupied the same bay of the nave as Scenes xi to xvii. This would have created an unusually crowded scheme, much fuller than the arrangement on the smaller walls of the *cappella maggiore*. But discussion of the Genesis scenes in the previous chapter has shown how the nave walls of the church could accommodate three or four tiers of scenes, with as many as three scenes in each tier. Rough calculations show that the dimensions of the rectangular scenes of both the *cappella maggiore* and the south nave wall may have been close to those already deduced for the Genesis scenes: approximately 240 × 300 cm. (The scenes in the *cappella maggiore* may have been slightly larger than this; the scenes in the nave slightly smaller.)[40]

A further clue to the location of scenes on the south nave wall may be found in the

38. For discussion of the relation between the panel and the *Legenda*, see Chapter 11. In the tomb reliefs, however, the Absolution of Sins now precedes the Donation of Goods to the Poor. The reliefs were in their present order when examined by the visitors of 1634. *ASV, Riti*, Proc. 552, p. 513.

39. *ASV, Riti*, Proc. 552, p. 523.

40. If the pairs of scenes recorded for the *cappella maggiore* extended the full width of the available wall space they would each have had a maximum width of 350 cm. The maximum width of the lunette scenes above them would presumably have been roughly twice that measurement: 700 cm; and the maximum height of the lunette would have been approximately 360 cm. (Measurements taken from Presenti's scale drawing of the longitudinal section of the church [Fig. 22]. See Chapter 3, note 58,

for discussion of the original height of the *cappella maggiore*.) The two rows of scenes below the lunettes were presumably not so tall. Their rectangular format and proportions, as seen in the watercolor copies, suggests a height somewhere in the region of 240 cm, which could easily have been accommodated on the remaining wall surface, between pavement-level and the base of the lunette, approximately 750 cm high.

The two lunette scenes at the top of the south nave bay would each have had maximum dimensions of approximately 630 × 450 cm. Further down the wall there would have been room for up to three scenes, each up to approximately 300 cm wide, (or two scenes of approximately that size in the parts of the wall interrupted by the window, for which see Chapter 3) and three tiers of scenes, each of a maximum height of approximately 230 cm.

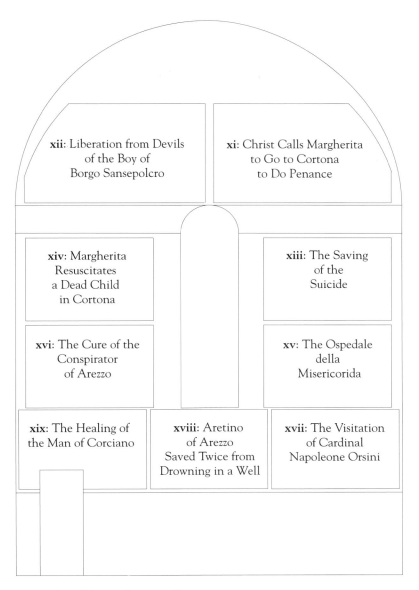

xii: Liberation from Devils
of the Boy of
Borgo Sansepolcro

xi: Christ Calls Margherita
to Go to Cortona
to Do Penance

xiv: Margherita
Resuscitates
a Dead Child
in Cortona

xiii: The Saving
of the
Suicide

xvi: The Cure of the
Conspirator
of Arezzo

xv: The Ospedale
della
Misericorida

xix: The Healing of
the Man of Corciano

xviii: Aretino
of Arezzo
Saved Twice from
Drowning in a Well

xvii: The Visitation
of Cardinal
Napoleone Orsini

Eastern bay of the south nave wall

bottom left corner of Scene xix (The Healing of the Man of Corciano) where, as mentioned above, some moldings that presumably represented part of the actual structure of the church are included in the watercolor (Fig. 103). If these moldings were part of a remodeling of the doorway that we know to have been at the east end of the south nave wall, Scene xix must have been situated immediately above and to the right of it. Scene xviii would presumably have occupied the available space to the right of Scene xix, suggesting again the curious right to left sequence for the numbering of the scenes.

8

Figure, Setting, and Narrative

It must be admitted, at the outset, that it is not easy to appreciate, through the intermediary of the copies, the qualities and characteristics of the artist—or artists—who painted the Margherita cycle. The information provided by the watercolors is insufficient to allow any attribution to a specific artist on the traditional grounds of drapery and figure-style. On the other hand, characteristics of figure pose, settings, and certain narrative techniques within various scenes can, after careful analysis, yield evidence concerning the artistic context of the cycle.[1] The following discussion starts by characterizing, in general terms, the treatment of figures, settings, and narrative within the cycle. This will be followed by more specific comparisons between individual scenes and various surviving fourteenth-century works. (It should be noted that not all the individual scenes of the lost mural cycle will be described, one by one, in the present chapter. Information about the subject, form, condition, and location of each individual scene is set out in Appendix III. A photomon-

1. For a discussion of the problems inherent in *Kopien-kritik*, see S. Waetzoldt, *Die Kopien des 17. Jahrhunderts nach Mosaiken und Wandmalereien in Rom*, Römische For-schungen der Bibliotheca Hertziana 18, Vienna, 1964, 20–22.

tage reconstruction of the cycle is provided in Figs. 201, 202, and 203, to help in visualizing the lost cycle during the discussion that follows.)

The events from Margherita's life and miracles chosen for inclusion in the cycle dictated to the artist a variety of settings. In addition to single and divided interiors, and mixed interior and exterior constructions, he was required to represent landscape, townscape, and, on one occasion, seascape. Only seven of the nineteen recorded scenes took place in a single setting. In all other cases figures were distributed among distinct spaces within a scene in order to articulate a narrative, or sequence or narratives, more clearly.

In his most successful compositions the artist blended narrative and setting so effectively that it is difficult to discuss them separately. An example is the Profession and Investiture of Margherita (Scene i; Pl. XVII; Fig. 104), in which the parapet and arcade construction representing the conventual buildings of S. Francesco, Cortona (presumably the cloister and chapterhouse), is of a type formulated by Giotto in the Bardi Chapel (Fig. 105).[2] This type was widely adapted by, among others, Maso di Banco, the Giotto-school artists of the Infancy cycle of the Lower Church of S. Francesco at Assisi, and Pietro and Ambrogio Lorenzetti (Figs. 109 and 110).[3] In the Cortona version the architectural setting was not placed parallel to the picture plane, as was normally the case. It was instead set obliquely, opening up a wedge of clear space in the foreground that contrasts with the restriction of the parapet and arcade behind which the male and female Tertiaries are enclosed. While a Franciscan (Fra Ranaldo, head of the Arezzo *custode*) prepares to cut Margherita's hair, signifying the moment of her entry into the religious life, she partly kneels within the open space, but is already at the entry to the *clausura* formed by the conventual buildings.

The artist appears to have enjoyed the opportunity to construct settings of varied depth and type, and to link these illusory spaces by the positioning, gesture, or glance of certain figures. Glance plays a pivotal role in, for example, Scene v (Fig. 187), in which the man of Città di Castello, shown kneeling at prayer enclosed within his own house, looks out through a window and catches sight of Margherita's soul being borne to heaven by two angels. Below her a landscape opens out, with foreground scene of lake, chapel, tree, man, and animals, and a background view of distant hills, which contrasts with the enclosure provided by the house, whose wall abuts the forward plane of the picture.[4]

The most complicated interaction of figure, setting, and space is probably that found in Scene x (Pl. XVI; Fig. 126), which tells the story of the revival of Suppolino, son of the

2. Apparition at Arles, Bardi Chapel, S. Croce, Florence. For consideration of the precise conventual buildings represented see J. Gardner, "Andrea di Bonaiuto and the Chapterhouse frescoes in Santa Maria Novella," *Art History* 2 (1979), 115–17.

3. Maso di Banco: Saint Sylvester cycle, Bardi di Vernio Chapel, S. Croce, Florence—Saint Sylvester Showing Pictures of the Apostles to the Emperor, The Miracle of the Bull; Lower Church Assisi Infancy Cycle: Christ Teaching in the Temple; Pietro Lorenzetti: Predella of Carmelite Altarpiece, now Pinacoteca, Siena (Fig. 110);

Ambrogio Lorenzetti: Saint Louis Before Boniface VIII (formerly Chapterhouse), S. Francesco, Siena (Fig. 109). For the relationship between the Bardi Chapel and the Lorenzetti brothers, see A. Péter, "Giotto and Ambrogio Lorenzetti," *Burlington Magazine* 76 (1940), 3–8.

4. Certain details of the landscape, in particular the reflection of the chapel in the lake, may constitute, in part, postmedieval repainting or copyist's license, but the overall design of the scene must always have combined the interior/exterior form of the house with the more open view on the left.

widow Donna Muccia, who had fallen from a high window of their house. The right half of the composition is occupied by a room with a coffered ceiling, which contains an ornate bed. The remaining area is divided into four, with two interconnecting lower spaces, probably representing a porch, and above these two small balconies, one of which contains the figures of two children, who were presumably playing with Suppolino when the accident occurred. One child raises his hand to his face in distress, while the other looks down, directing our attention to the figures below him, framed by the left section of the porch. An adult grasps Suppolino's wrist and others run to help, but they are too late, and can only lament, as blood is seen to pour from a wound on the child's head. In the right foreground the small body lies isolated on the large bed, as four women look on sorrowfully.[5] Behind the bed, however, the child is seen again, now standing, grasping the bed-end with his left hand and gesturing up toward Beata Margherita while his mother, not yet aware of the cure that has just taken place, prays for Margherita's intervention, and one of the members of her household touches her on the shoulder, to alert her to the miraculous revival of her son.

This complex composition, with several centers of narrative interest, is linked together, at the center, by the figure of the woman in black, presumably the widow Donna Muccia, whose arms are flung back in a sweeping, arrowhead gesture.[6] She leads the viewer's attention to the left section of the composition, while above her the diagonal formed by Margherita's figure directs attention toward the events at the right. These two key figures in the composition are further emphasised through their relation with the architectural setting. The piers dividing the three main areas in the scene are shown (according to the copies) on the foremost picture plane, contiguous with the edges of the scene. The woman in black with a white veil stands behind the left pier, confirming both the continuity of space beyond the pier, and the link between the left and central compartments of the scene. But the flying figure of Beata Margherita, arriving to resuscitate the child, appears in front of the left pier, apparently inhabiting the viewers' own space. Meanwhile Donna Muccia, who dominates the central compartment, looks behind the left pier to meet the gaze of the figure grasping Suppolino's arm, places her foot behind the right pier—another indication of spatial continuity—and extends her left arm in front of the same pier, again claiming the viewers' attention by appearing to enter their own space.

Moving from the individual scene to the section of the cycle of which it forms a part, we see similar signs of careful planning. The south wall of the *cappella maggiore* contained Scenes vi to x of the cycle probably arranged, as discussed above, with Scenes viii and x on the left, and Scenes vii and ix on the right, in the two main tiers (see the photomontage, Fig. 202). High up on the wall, the figure of Margherita appeared at the top center of the lunette field, coming to heal the young Bartoluccio who had fallen into the teeth of a mill wheel (Scene vi; Pl. XIX; Fig. 106). The scene was divided into three sections: on the

5. The woman on the far right, in postmedieval dress, had presumably been repainted, or may have been a post-medieval addition.

6. The gesture will be discussed again, in the next section of this chapter.

left the accident was shown; on the right was the mother's invocation and the cure; but at the center of the composition, below the figure of Margherita, was a surprising area of open space, presumably intended to represent the street or passageway that led from Bartoluccio's house to the mill. (This led back to a view into a courtyard, which appears to have been repainted at some later date.)[7] This unexpected device may be compared with the composition of the corresponding scene on the facing wall, the Profession and Investiture of Margherita (Scene i; Pl. XVII; Fig. 104). Here, as already discussed, a wedge of open space had been created in the foreground. In neither lunette scene is this peculiarity of setting required by the events as described in the text of the *Legenda*. Perhaps this emphatic use of space was a conscious technique to catch the eye and direct attention to the least visible part of the cycle, high up under the vaults. An analogous technique, in this case using a sharply projecting building, was employed by Giotto on the north wall of the Bardi Chapel, to break out of the confines imposed by the lunette-shaped field.[8]

In the tier beneath this lunette, Scenes vii and viii (Margherita Rescues Prisoners from Captivity, and The Cure of Simonello di Angeluccio) were both relatively simple compositions, with a small number of figures, while the scenes closer to the viewer, numbers ix and x (The Calming of the Sea of Ancona, and The Resuscitation and Healing of Suppolino) were more heavily populated (see the photomontage, Fig. 202). The four scenes were linked by the placing of Margherita at the outer upper section of each composition, in a manner reminiscent of the four scenes on Simone Martini's Beato Agostino Novello panel (Fig. 24). In each scene a contrast was drawn between the protagonists aware of Margherita's presence, and those absorbed in other events or concerns. The artist seems to have had the ability to turn potentially monotonous repetition of formulas to narrative and compositional advantage. Even the requisite inclusion of a bed, dominating the composition in Scenes vi, viii, and x (the cures of Bartoluccio, Simonello di Angeluccio, and Suppolino), was treated with variety, occupying a different proportion of the composition in each case, and decorated in each scene in a different and distinctive manner, which also seems to have given some indication of the social status of the protagonists.[9]

On the north wall of the *cappella maggiore* at Cortona the Funeral of Margherita (Scene iv; Pl. IX; Fig. 189) provided a densely populated scene, close to the spectator, analogous to the lowest scenes (ix and x—The Calming of the Sea of Ancona, and The Resuscitation and Healing of Suppolino) on the facing wall. Scene v (The Ascent of Margherita's Soul) was simpler, but, for narrative reasons, had to accompany the funeral scene by indicating

7. The possibility that the lacuna at the center of the scene was due to damage cannot entirely be excluded. The part of the wall closest to the vaults was presumably particularly vulnerable to damp, and it is clear that the upper-left section of the scene had been destroyed.

8. Illustrated G. Previtali, *Giotto e la sua bottega*, Milan, 1967, 328.

9. Bartoluccio's bed is simple, and he is attended only by his mother. Suppolino's bed is too large for all of it to

be seen. It has a carved foot and base, and Suppolino is surrounded by many members of the household. Similarly varied treatment of beds occurs in, for example, the Saint Francis Cycle in the Upper Church of S. Francesco at Assisi (illustrated in J. Poeschke, *Die Kirche San Francesco in Assisi und ihre Wandmalereien*, Munich, 1985, pl. 146, 151, 180, 181, 192, 193, and 196) and in Ambrogio Lorenzetti's Saint Nicholas scenes (Pl. XV; Figs. 125 and 131).

that Margherita's soul went directly to heaven (Fig. 187).[10] The two scenes of the central layer on the north wall of the *cappella maggiore* (ii and iii) are, however, striking for their brevity, and for the simplicity of their setting, in comparison with the scenes facing them, and with almost all the other scenes in the cycle (Pl. XX; Figs. 162 and 165). They represent Christ's remission of Margherita's sins, and Margherita's charity to the poor and needy, two subjects that (as will be discussed in Part V) had already appeared on the *Vita* panel and the marble funerary monument in similar compositions (Figs. 160, 161, 155, and 164). The plainness of the two murals may thus have been the result of conscious repetitions of familiar scenes. However, in the case of Scenes i and iv (The Profession and Investiture of Margherita, and the Funeral of Margherita) which had also been included in the marble reliefs, the artist of the murals was able to include many more figures than in the previous versions of the scenes, and to place them in adventurous architectural settings (Pls. XVII and IX; Figs. 104 and 189). (The implications of the amplifications of these two scenes will be discussed in Chapter 14.)

The lunette scenes of the south nave wall (Scenes xi and xii) provide a further example of individual compositions that also functioned as a group (Pls. XXI and XXIII; Figs. 107, 171, and 168). Both had landscape settings. Scene xii showed the boy from Sansepolcro who was delivered from demons when he came in sight of the Church of S. Basilio, one of four miracles accomplished by Margherita during her life. The boy is shown twice: on the left, at the moment of his liberation; and on the right, in a damaged section of the fresco, kneeling in thanks, with his family, before the figure of Margherita. The events are set in hilly countryside with the Church of S. Basilio in the background. The scene was balanced, both in form and content, by the representation in the other half of the lunette. Scene xi showed how Margherita came to Cortona to do penance. Again the direction of the narrative moves from the outer edge of the lunette toward the center. The standing figures of the two Franciscans before whom Margherita kneels, echo the standing figure of Margherita herself in the adjoining scene. Before them Margherita kneels in supplication, balancing the kneeling figures thanking Margherita in Scene xii. The devil, whose temptations Margherita ignores, provides a visual link with the three small demons whom Margherita herself casts out of the swooning figure of the boy in Scene xii. The composition of Scene xii accommodates the rising shape of the lunette by setting kneeling, crouching, and swooning figures to the left, and the standing figure of Margherita to the right. The shape is more thoroughly exploited in Scene xi where, despite the damage to the fresco, it is still possible to appreciate the ascent from Montepulciano, the walled town shown at the bottom right, toward Cortona, perched up on a hillside; a city to be entered, at Christ's bidding, by way of the Franciscans standing upright before its walls. The setting appears to have been completed, as in the adjoining scene, by a rocky terrain.

Consideration of the watercolor copies in general compositional terms, suggests that a

10. The remission of Margherita's sins, which ensured this direct passage to Paradise, was, of course, shown in the tier above.

considerable amount of thought and planning lay behind the design of the murals. The artist welcomed complexity and variety, and was also concerned to form groups of scenes into coherent units.

The Margherita Cycle and Other Central Italian Works

We can now start to approach the question of the relation between the Margherita compositions and other central Italian narratives by looking, first, at two scenes with related designs: the Funeral of Margherita (Scene iv) and the Visitation of Cardinal Napoleone Orsini (Scene xvii) (Pls. IX and XI; Figs. 189 and 23). Their architectural settings have clear affinities with certain surviving trecento works. Both are placed in tripartite structures that suggest a section through the nave and side aisles of a hall-church, with a view toward the East End. In both cases the dividing piers occupy the front plane of the picture space, with decorated spandrels above, and arches opening to views of rib-vaults, seen centrally in the *cappella maggiore* and obliquely in the two side aisles. The design of the two buildings is not identical: the rib vault of the *cappella maggiore* is carried on pilasters in Scene xvii, but seems to spring from the wall unsupported in Scene iv; there appear to be two vaulted chapels on each side of the *cappella maggiore* in Scene iv, but only one on each side in Scene xvii; the architecture in Scene xvii is obscured by festive red hangings suspended below the level of the pilaster capitals.

The compositions also vary substantially, but in both scenes the three main elements are the recumbent body of Margherita, a standing figure officiating to the left of the body, and a crowd of participants and onlookers. In the Funeral scene the symmetry of the architecture is complemented by the figures. Margherita's body, set low in the foreground, is framed by the two inner piers, and different groups of celebrants and mourners are divided between the three sections of the composition.[11] The Visitation of Napoleone Orsini shows (as discussed in Chapter 4) Margherita's body enclosed in its iron cage and raised, on a trestle, to the upper section of the scene. Unlike the Funeral scene the body is not centrally set, but passes behind the right pier into the side aisle. This allows room for two major figures to stand at the head of the bier within the central section of the composition: Napoleone Orsini (wearing the cardinal's red hat) and a bishop, who holds open the Bible on which the witnesses to miraculous events take their oaths.[12] The other groups of figures pass between the architectural divisions, instead of being framed within them, as in the Funeral scene.

The architecture in Scene iv may be compared with that found in the Presentation in the Temple, attributed to the school of Giotto, in the Infancy cycle in the right transept of the Lower Church of S. Francesco at Assisi (Pl. X; Fig. 120). In both cases the triple

11. See Chapter 14, for discussion of their identity.

12. See Chapter 14, for further discussion of these figures.

arches open to a view of rib-vaulted chapels and the east window is shown as a two-light design with an oculus. The only substantial variation is the change, at S. Margherita, to apse-ended side aisles. The spandrels above the forward arches are filled with fictive cut-stone decoration, both in the Assisi Presentation, and Cortona Scene iv. (The spandrels of Scene xvii appear to have a foliate, or marbled, patterning.) At Assisi the side aisle roofs are visible, and placed slightly lower than the nave roof, while the Cortona copies show the central arch depressed to fit the same upper border as the side aisles. At Assisi some figures stand within the arcade, but the majority occupy an open space in front of it. In the Cortona drawings the piers are shown to have been brought into the foremost picture plane, enclosing all the protagonists within the arcade.[13]

The conception of this tripartite design was thoroughly worked in the Lower Church Presentation but it did not originate there. The scene of Francis Preaching Before Honorius III in the Upper Church Saint Francis cycle is an earlier essay in a tripartite arrangement with obliquely seen rib-vaults.[14] Simone Martini adopted the tripartite arrangement in the Funeral of Saint Martin in the Lower Church Saint Martin Chapel.[15] The windows were modernized by the insertion of elegant cusped tracery, although the framing arches and vaulting ribs are round headed, probably to fit into the available space. The Saint Martin Chapel arrangement is closer to the Upper Church example than to the more complex Lower Church versions, with only a limited development of depth. It is, indeed, possible that Simone's composition was executed before the right transept frescoes, although he would certainly have been aware of them at the time when he himself was working in that part of the Lower Church.[16]

Pietro Lorenzetti, on the other hand, did not find the construction appropriate for any of the Passion scenes that he painted in the Left Transept of the Lower Church,[17] but was able to draw on the type, presumably with the aid of drawings, later in his career. Both he and Ambrogio Lorenzetti achieved a marriage of this tripartite format with the frame shapes of altarpiece design in their panels for the side altars of the Duomo of Siena, the Birth of the Virgin (contract 1335, completed 1342) (Pl. XII) and the Presentation in the Temple (under construction 1337, completed 1342) (Fig. 108).[18] Pietro's interest in linking

13. But note that two elements in the Funeral scene—the servicebook of the officiating priest, and a large candle held by a boy on the right, appear to have been placed on the spectator's side of the fictive architecture, as has the notary's parchment, in the Visitation scene. Compare the use made of this compositional device in Scene x (The Resuscitation and Healing of Suppolino) as discussed above.

14. Illustrated in Poeschke, pl. 172.

15. Ibid., pl. 291.

16. The Giotto-school frescoes in the right transept of the Lower Church are thought to have been executed after the completion of the Arena Chapel (c. 1305) and before the painting of the Passion Cycle in the left transept. (For the relative chronology of these paintings see the studies cited below, note 34.) For early dating of the

Saint Martin Chapel see F. Bologna, *I pittori alla corte angioina di Napoli 1266–1414*, Rome, 1969, 154 ("between 1315 and 1317"); and A. Martindale, *Simone Martini: Complete Edition*, Oxford, 1988, 20–23 ("before c. 1316"). For a summary of opinions and further bibliography see Borsook, 1980, 23.

17. Although the settings of the Last Supper, Washing of the Feet, and Flagellation all owe certain debts to the architecture of the right transept Presentation in the Temple and Christ Teaching in the Temple.

18. For the most complete publication of payments related to the Presentation in the Temple see H. B. J. Maginnis, "Chiaramenti documentari: Simone Martini, i Memmi e Ambrogio Lorenzetti," *Rivista d'arte* 41 (1989), 13–19.

the fictive world of a painting with the real world of the spectator led him to create trompe l'oeil effects in the Lower Church frescoes and, in the Annunciation that crowns the polyptych in the Pieve of Arezzo (commissioned 1320, completed 1323), to support the real framing moldings above the scene on a fictive pier that imitates the real framing pilasters of the altarpiece but also forms part of the architecture in the Annunciation scene.[19] By the time Pietro designed the Birth of the Virgin altarpiece he was able to carry this illusion further, so that it embraced the whole main field of the altarpiece. The forward faces of the painted architecture were brought right to the front of the scene, serving double duty as supports for the fictive vaults and the real frame, and creating the illusion that the spectator could pass beneath the framing arches, directly into the world of the painting.

The two Cortona versions of the tripartite design, especially the Funeral of Margherita, show a clear debt to the Lower Church, as already discussed. As in the Upper Church and Saint Martin Chapel versions, but unlike the Lower Church Presentation (or Ambrogio's related tripartite structure in the Massacre of the Franciscans at Ceuta fresco in S. Francesco, Siena) the nave piers are brought right to the forward plane of the composition.[20] If the copyist is to be trusted, the roof line at Cortona was also raised, so that no sky appeared above it, as it did in the Assisi version, thus taking a further step toward the contiguity of real and fictive worlds achieved in Pietro's Birth of the Virgin. The copies of the Margherita cycle may therefore add to our knowledge of the development of this architectural type, perhaps also to our knowledge of its development within the circles of the Lorenzetti.[21]

In both Cortona compositions a large number of figures is enclosed within the nave and aisles. In the Funeral of Margherita the recession of the figures on the right into the picture space is achieved by a diagonal setting reminiscent of the arrangement in the side fields of the Birth of the Virgin (and already explored in the oblique placing of Saint Nicholas and Elijah in the main panel of Pietro Lorenzetti's Carmelite altarpiece [completed 1329]).[22] The raked rows of figures standing behind the body of Margherita in the central compartment were presumably a satisfactory setting of numerous figures in a substantial interior space. The more subtle arrangement in Scene xvii (the Visitation of Napoleone Orsini)

19. See the illustrations in Volpe, ed. Lucco, 85, 88, 90, 91, and 122.

20. There is a slight variation in the treatment of the base of the piers in the different watercolor copies: in BC/AE 429 the piers in Scenes iv and xvii are cut by the lower frame of the scene, whereas in ACC H27 (and the related sets) the front faces of the piers in Scene xvii end just above the lower frame, and both this scene and Scene iv include a view of the pier bases receding into the picture space.

21. It is not possible to reconstruct in any detail the stage of this development that may formerly have been found in the lost facade frescoes of S. Maria della Scala. As pointed out in the detailed and thoughtful study by H. B. J. Maginnis, "The Lost Façade frescoes from Siena's Ospedale di S. Maria della Scala," *Zeitschrift für Kunstge-*

schichte 51 (1988), 180–94, the architecture in reflections of the Scala Birth of the Virgin (which Maginnis attributes to Pietro Lorenzetti) was probably often "contaminated" by consulting Pietro's later altarpiece of the same subject, in the Duomo of Siena. The architecture in Sano di Pietro's version of the Scala Birth of the Virgin (Fig. 140) has an asymmetrical tripartite setting that may indicate Pietro's original architecture, and that shows some resemblance to elements in Cortona Scenes x and xiii (Pls. X and XXIV; Figs. 126 and 134). For the complications surrounding the reconstruction of the Scala Presentation of the Virgin, which Maginnis thinks should probably be attributed to Ambrogio (and which may also have had a tripartite structure, set well back from the front plane), see Maginnis, 190.

22. Illustrated in Volpe, ed. Lucco, 138.

relies on a series of planes parallel to the picture surface, with a focal point to the left of center. In the copy this scheme is not entirely successful; the figures in the row behind the bier appear unnaturally high and large. But a comparison with Ambrogio Lorenzetti's Saint Louis of Toulouse Before Boniface VIII (S. Francesco, Siena) which also uses a series of parallel planes rising up the picture surface (and a focal point to the left) shows how convincing this method could be (Fig. 109).[23] A similar arrangement was used by Pietro Lorenzetti in the two closing scenes of the predella of the Carmelite Altarpiece, which are closely related to Ambrogio's Saint Louis composition (e.g. Fig. 110), but a more striking comparison for the Visitation scene from within Pietro's oeuvre is the Birth of the Virgin (Pl. XII). There the figures of the midwives and attendants in the central section form, together with the figure of Saint Anne, her bed, and the chest beneath it, a series of overlapping planes leading the eye up and back into the interior of the room. In both compositions a figure seated in the left compartment receives important information (in one case Joachim, hearing of the birth of his daughter, in the other the notary, recording the miracles described by the witnesses.) The left compartment of the Birth of the Virgin is, unlike that in the Cortona scene, separated from the other two sections, but in both compositions the central and right parts are linked by the figures who move between them. The position of Saint Anne on her checked blanket, which passes behind the right pilaster, recalls the space allowed to the grid containing Beata Margherita's body.

Both Cortona scenes thus use the device of the tripartite architectural setting, first found in Assisi, to set a large number of figures within a coherent space without sacrificing narrative clarity.

Gestures have so far been discussed for their use in linking separate parts of a composition, and directing the viewer's attention around a narrative, but not for their intrinsic emotional or descriptive value. The copyist's intervention has inevitably blunted the force of many gestures and poses, but certain examples still appear, through the copyist's veil, as authentic trecento devices that may be paralleled in existing works.

Two notable examples are gestures of grief and despair. The distraught mother at the center of the Resuscitation and Healing of Suppolino (Scene x) whose pose has already been discussed for its compositional significance, flings her arms behind her as she swoops forward, with her left leg extended backward, her flowing hair and cloak looped over her left arm, while her right arm, masked by her body, is visible only as a foreshortened hand (Pl. XVI; Fig. 115). The gesture is among the most familiar to students of trecento painting; it was the one adapted by Giotto from a Roman Meleager sarcophagus, possibly under the influence of Nicola Pisano, and given to Saint John the Evangelist in the Lamentation in the Arena Chapel (Fig. 114).[24] Giotto's Saint John is turned further away from the viewer, so that the far hand appears behind rather than in front of the head (and the swooping forward motion is not reinforced by a movement of the legs, as at Cortona). In the Lower

23. For the dating of this fresco, originally in the Chapterhouse of S. Francesco, see Chapter 6, note 73.

24. A. Bush-Brown, "Giotto: Two Problems in the Origin of His Style," *Art Bulletin* 34 (1952), 42–46.

Church at Assisi the gesture is given to a female, one of the Virgin's companions, in the Giotto-school Crucifixion in the right transept (Fig. 111). Here the looping of the cloak over the forward arm is explored, but the turn of the figure masks the far hand entirely and the long hair is hidden beneath a veil. In the Lower Church Massacre of the Innocents a briefer version of the same pose is used for a stocky woman who wears no cloak but whose long hair falls forward over her shoulder (Fig. 112). Working in the left transept of the Lower Church, Pietro Lorenzetti adapted the same pose for one of the grieving angels flying above the Crucifixion (Fig. 113). Here, as in the figure at Cortona, both hands are visible.

In Scene vi (Pl. XIX; Fig. 118) the mother of Bartoluccio, the child injured by the mill wheel, opens her mouth in horror and threads her hands through her long loose hair, to reach her face, perhaps to stanch the flow of tears but more likely to tear at her cheeks, in an ancient act of mourning.[25] Representations of tearing the cheeks or hair have a long art-historical pedigree.[26] The left transept of the Lower Church at Assisi may again be relevant for the particular combination of motifs found at Cortona. In the Death of the Boy of Suessa one open-mouthed female flings back her head and tears at her hair while another, beside her, also open-mouthed, scratches her cheeks (Fig. 117).[27]

These two gestures, appearing next to one another at Assisi, recur together in the works of two artists who would have had the opportunity to study and record them in situ. In the Orsini Polyptych Simone Martini used both poses on the left of the Entombment (Fig. 116). The open-mouthed figure tearing her cheeks is shown, as at Assisi, in profile. The figure throwing her head back as she tears her hair is a less successful version of the Suessa pose, but in the last scene of the predella of Simone's Saint Louis of Toulouse panel, the pose is tackled more effectively, with the woman's forehead foreshortened, and chin thrust into the air.[28] These two gestures were soon adopted into Pietro Lorenzetti's repertoire too, and formed the basis for the actions of two of the figures in the Entombment in the left transept of the Lower Church.[29] Since the two women in question were shown looking down at the body of Christ, the characteristic positions of their heads were not repeated,[30] but it seems that the original form of the Suessa poses was recorded for possible later use in Pietro Lorenzetti's shop: both recur in a work attributed to an assistant of the Lorenzetti, the Massacre of the Innocents in the Petroni Chapel of S. Maria dei Servi in Siena (Fig. 119).[31] Here a brave, if not entirely successful attempt was made to recapture the original effect. Toward the center of the composition both the head of the seated woman tearing

25. For ancient gestures of mourning, including the tearing of the hair and cheeks, and their continuing use, see M. Alexiou, *The Ritual Lament in Greek Tradition*, Cambridge, 1974, e.g., 6, 10, 33–35, and 41. For the use of such gestures in duecento and trecento art, see M. Barasch, *Gestures of Despair in Medieval and Early Renaissance Art*, New York, 1976, esp. chap. 6.

26. Barasch, 31–33 and chap. 6.

27. In the background of the Massacre of the Innocents in the right transept another open-mouthed woman scratches her cheeks (illustrated in Poeschke, pl. 233).

28. Clearly visible in G. Contini and M. Gozzoli, *L'op-* *era completa di Simone Martini*, Milan, 1970, pl. 6. In the panel of Beato Agostino Novello the type is used for the mother whose child falls from a balcony (Fig. 124). In this case the story dictates that she looks downward, and she is shown tearing her veil as well as her hair.

29. Illustrated in Volpe, ed. Lucco, 81.

30. The profile view of the woman tearing her cheeks in the Death of the Boy of Suessa does recur in one of the angels above Pietro's Lower Church Crucifixion (Fig. 113).

31. For discussion of the attribution of the painting, see Chapter 10.

her hair and of the standing woman scratching her cheeks are shown face-on, foreshortened, with chins thrust in the air and mouths open wide (emphasized by making the upper row of teeth visible).[32] The woman in Scene vi of the Margherita cycle (Fig. 118) may have combined the flowing hair and tearing of the cheeks seen in the two women in the Death of the Boy of Suessa. She may also have hurled her head back as she shouted out her grief, although the copyist, while giving her a prominent neck and chin, and receding forehead, is not clear on this point.

Certain details of architectural decoration that occur in the Margherita cycle are anticipated in the paintings of the right transept of the Lower Church. The structure of the balcony in Scene xiv (Margherita Resuscitates a Dead Child in Cortona; Pl. XXII; Fig. 122), supported on consoles and covered by a lean-to roof supported on colonettes may be compared with the structure in the Assisi Adoration of the Magi (Fig. 121). The tall, narrow, square-headed doorway with carved tympanum above, which appears behind the Virgin in the Assisi Adoration, and the smaller one to her right, recall the doorway of the Ospedale in Scene xv (Pl. XXV; Fig. 175), while the coffering set under the projecting balcony in the Adoration may hint at a more subtle original arrangement than that apparent in the drawing of Donna Muccia's house in Scene x (Pl. XVI; Fig. 126). The general interest in tall, narrow, darkened openings and a restrained decorative piercing of walls by windows cut in simple geometric shapes, found in several scenes in the Cortona cycle (for example nos. xiv and xvi; Pl. XXII; Figs. 122, 130) also recall architectural detailing of the type found in the right transept at Assisi (Fig. 120).

In total, these architectural details, like the gestures already discussed, are of the type that could easily have been noted in a sketch and repeated elsewhere by other artists. Indeed, several drawings after frescoes in the Lower Church transept survive, including two drawings of elements from the Visitation that is directly above the Adoration in the right transept (see Fig. 120). Both drawings are thought to date from the mid-fourteenth century; the one in the Uffizi is generally attributed to a Florentine artist, and the one in the Fogg Art Museum is generally attributed to a Sienese.[33] The similarities between the frescoes of the right transept of the Lower Church and the Margherita cycle need not be taken as evidence that the Cortona cycle was executed by the same Giottesque artist who had worked in the Lower Church at Assisi. But while an artist might have been able to work from such a sketch without ever having visited Assisi himself, it seems unlikely that the complex setting of the Lower Church Presentation (Pl. X; Fig. 120) could have been transmitted successfully in a drawing unless the person using that aide-mémoire had already studied the Assisi fresco carefully at first hand. We know that at least two Sienese artists had the opportunity to make just such a study. The frescoes of the right transept of the

32. Clearly seen in the illustrations in Barasch, figs. 43a and b.
33. Florence, Uffizi, 9E: B. Degenhart and A. Schmitt, *Corpus der italienischen Zeichnungen, 1300–1450*, Berlin, 1968, no. 47, i, 1, pp. 110–11; i, 3, pl. 79b. Cambridge, Mass., Fogg Art Museum, 1932.65: Degenhart and Schmitt, no. 52, i, 1, pp. 117–18; i, 3, pl. 82b.

Lower Church at Assisi constitute a crossroads: here Giottesque ideas arrived, were treated in a notably more anecdotal manner than in the Arena Chapel frescoes, and perhaps were also tinged with the earlier forms of the Upper Church cycle; here also two Sienese artists—Simone Martini and Pietro Lorenzetti—arrived to work and were able to note many Giottesque forms and ideas.[34]

34. For the order of execution in the transepts and crossing, which moved from right to left, so that the right transept and crossing vaults (*vele*) were completed before Pietro Lorenzetti started his work, and for Simone's work in the right transept (Fig. 120), which must also postdate the Giotto-school work there, see R. Simon, "Towards a Relative Chronology of the Frescoes in the Lower Church of S. Francesco at Assisi," *Burlington Magazine* 118 (1976), 361–66. See also H. B. J. Maginnis, "Assisi Revisited. Notes on Recent Observations," *Burlington Magazine* 117 (1975), 511–17; A. Tantillo Mignosi, "Osservazioni sul transetto della Basilica inferiore di Assisi," *Bolletino d'arte* 60 (1975), 129–42.

For a stimulating consideration of Pietro Lorenzetti's debt to the Giotto-school paintings in the right transept (as seen in his Passion cycle frescoes, and his S. Francesco, Siena, Crucifixion fresco), see M. Seidel, "Das Frühwerk von Pietro Lorenzetti," *Städel-Jahrbuch*, n.s., 8 (1981), 144–54.

9

The Margherita Cycle and Sienese Hagiographical Narrative

The decoration of the Upper and Lower Churches at Assisi provided opportunities for the creation of new cycles of saints' lives located, in the case of Saint Francis and Saint Martin (and the Saint Francis miracles in the Lower Church), in settings that included contemporary references. Domestic interiors, townscapes, and landscapes, and miraculous interventions in the lives of ordinary people, all features of the Margherita cycle, had already been tackled at Assisi and appear to have provided a fertile source of inspiration for many artists. A further stage of development of these themes, in which the lessons of Assisi were joined with those of Duccio's *Maestà*, occurred among a group of Sienese artists in the decade between the mid-1320s and the mid-1330s. Simone Martini's panel of Beato Agostino Novello, from S. Agostino, Siena (now dated to before 1329, probably by 1324), set sequences of miraculous events within architectural frameworks with clear contemporary reference (Pl. XIII; Fig. 24).[1] Ambrogio Lorenzetti's Saint Nicholas panels from the Church of S. Procolo in Florence (now Florence, Uffizi) probably painted c. 1332, developed this

1. For the context of the painting, and arguments for its date, see Chapter 4. For discussion of the contemporary reference in the scenes, see Seidel, 1985, 86–99.

theme in what may have been a conscious response to Simone's narratives.[2] The panel of Beata Umiltà, made for the Vallombrosan house of S. Giovanni Evangelista in Florence (now Florence, Uffizi, and Berlin, Gemäldegalerie) is often, but not universally, attributed to Pietro Lorenzetti, and has recently been dated to the years 1330–35.[3] It provides a more extensive cycle dealing with themes similar to those of the other two paintings. There appear to be close affinities between the Beato Agostino Novello and Saint Nicholas scenes, but the nature of the relation of the Beata Umiltà scenes to the other two works is less clear, and its place in the sequence of events has yet to be conclusively established. Nevertheless, its proximity to the art of Pietro Lorenzetti, and the possibility of a date close to the other two cycles, account for its inclusion in the present discussion.

How should the treatment of narrative and setting in the Margherita cycle be located in relation to these landmarks in the history of hagiographical narrative? Before making comparisons with the Cortona cycle, we should give some consideration to the treatment of narrative sequence and architectural setting in the three works in question. In the two scenes on the left side of the Agostino Novello panel Simone uses the technique of continuous narrative, part of an artist's armory at least since the Vienna Genesis, to underscore the plight of each child, the one already bleeding with eye dislodged as a result of the dog's savagery, the other moments from the terrible impact of the fall from balcony to street (Pl. XIII; Figs. 123 and 124). In each case the same child, now clearly restored to life and health, is shown in the right foreground, surrounded by grateful, prayerful adults. In these two narratives the detailed street scene gives immediacy and veracity to the event, opens up a space behind the foreground stage and gives compositional emphasis to the chief protagonists, but the setting is not used to separate the chronologically distinct events. In the scene showing the Miraculous Cure of an Infant Which Fell from Its Cradle (Fig. 123), on the other hand, the architecture assists a temporal separation, permitting the repetition of figures in a more "logical" manner. The moment of the accident, in which the nurse pushes the cradle and the rope snaps, is set in the upper room;[4] the baby's body and the grieving mother are set on a separate balcony, with the prayerful figure of the kneeling sister-in-law leading from one space to the other; and the figures are repeated, with the minimum incongruity, now in their street clothes, in the procession set in the lower foreground enclosure, with the resuscitated infant carried to Beato Agostino Novello's altar, dressed in the Augustinian habit in fulfillment of the sister-in-laws' vow.[5]

This lucid approach, in which the architectural divisions blunt the solecism of figure repetition in scenes of miraculous healing, is also used in the Beata Umiltà panels. In the scene of the Resuscitation of a Child within a Church, an archway opening to the interior

2. For a brief but illuminating discussion, see Borsook, 1966, 7–9, 29–30.

3. Dating proposed, with thorough argument (and extensive bibliography) in M. Boskovits, *Frühe italienische Malerei: Gemäldegalerie Berlin*, Katalog der Gemälde, I, ed. E. Schleier, Berlin, 1988, 84–91. For a later dating, after the completion of Pietro's Birth of the Virgin, see Volpe, ed. Lucco, 174–86 (with many illustrations).

4. A separation perhaps suggested by the Healing of the Boy of Suessa in the Lower Church at Assisi (see Fig. 120).

5. For a textual source for these events, see Seidel, 1985, 96–99.

reveals Umiltà kneeling in prayer before the altar, with the dead child laid on the altar step, while the standing figure of Umiltà, returning the living child to its grateful relatives, is framed in the portal of the church.[6] In the Cure of a Nun with a Nosebleed (Fig. 129) a subtler method is employed. The nun is shown on a bed—the location of her sickness—but sits upright, restored to health, in response to the benediction of Umiltà. Although the nun is not shown stricken by illness, the gravity of her former suffering (and thus the miracle of her cure) is implied by the figures in the adjacent room. A lay sister holds out a bowl full of blood to the physician who shrugs, indicating his inability to effect a cure. Here it is not the sequence of events but their contemporaneity that is shown: the physician indicates that cure is impossible at the precise moment when, through Umiltà's intervention, it is being achieved.

Ambrogio Lorenzetti's response to the possibilities opened up by Simone Martini's narratives was a different one. Rather than using the architectural settings of scenes of healing to achieve lucidity, or to show simultaneous events, Ambrogio explored the setting up of several centers of interest, increasing the number of moments in the story that might be represented. Thus the often-analyzed Resuscitation of the Merchant's Son[7] has four principal settings (Pl. XV; Fig. 125). The story unfurls from the top in a C-shape reminiscent of Simone's method (Fig. 123). But while Simone's C is a reversed one, in which the supernatural apparition of Beato Agostino Novello occuring (top right) in response to the sister-in-law's invocation, fits within the flow of the upper half of the composition, Ambrogio places the apparition of Saint Nicholas (top left) so that it creates a diagonal counter to the narrative flow, underlined by the two rays of healing running from Saint Nicholas to the child. The turn in the staircase provides separate fields for two stages in the boy's abduction, but the father's chamber on the ground floor encompasses at least three different events. The boy's corpse has been laid on his father's bed and on the far side a woman (his mother?) fingers intertwined, gazes sorrowfully at the body. In the foreground the kneeling father reproaches Saint Nicholas for permitting this disaster to occur and begs for his help. The figure in blue, standing in the right foreground, raises his forearms, palms facing outward, presumably in a gesture of surprise at the miraculous apparition. He can see, through the window, the figure of Saint Nicholas, and behind the bed a female figure looks up too. Aware of the child's revival, she stretches out her arms in astonishment, and perhaps also to catch the upright body of the child, who has suddenly risen to his feet upon the bed, extending his arms to Saint Nicholas. Even the intervention of Saint Nicholas is split into two events: the ray that issues from his mouth reaches the prostrate child; the ray emanating from his hand touches the risen child. The narrative device of the repeated figure of the boy illustrates in the clearest possible form the miracle of resuscitation.[8] Yet it breaks

6. Illustrated in Volpe, ed. Lucco, 182, fig. 150.

7. See, for example, G. Rowley, Ambrogio Lorenzetti, Princeton, 1958, I, 70–73.

8. The long-established technique of continuous narrative had already been used in Siena for scenes of miraculous healing, for example, in the Healing of the Blind Man from Duccio's Maestà, and Simone Martini's Agostino Novello panel, but the combination of prostrate and revived figures set beside each other on the same bed may have been a new variation on this formula, whose first surviving example appears to be that found in Ambrogio Lorenzetti's Saint Nicholas scene.

temporal logic in a way that cannot be remedied by apportioning events among different architectural settings. While the artists of the Beato Agostino Novello and Beata Umiltà scenes explored methods of avoiding such solecisms, Ambrogio Lorenzetti, with his highly developed skill in setting sequential narrative in architecture, nevertheless seems to have relished the anomalous complexity of this Saint Nicholas scene.

The artist of the Margherita cycle made repeated use of the device of the prostrate and resuscitated body in healing scenes: it occurs four times (Scenes viii, x, xiv, and xix; Pls. XIV, XVI, and XXII; Figs. 128, 126, 122, and 103) while in a further three examples a figure is repeated in different parts of the same composition, to indicate a transformation from sickness to health. Given the number of scenes of healing included within the cycle (and, indeed, in the last chapter of the *Legenda*) it is not surprising that the artist relied on the repetition of this convenient formula. But it is striking that in addition to the careful arrangement of sequential narrative within distinct architectural spaces, (for example, Scenes vi and xiv; Pls. XIX and XXII; Figs. 106, and 122) the artist seems to have seized the opportunity to manipulate the different moments in a story by different means. Thus while Scene vi, the Revival and Healing of Bartoluccio of Cortona who fell in the mill wheel (Pl. XIX; Fig. 106), makes a clear division and contrast between the mutilation of the child and despair of the mother in the left section, and the health of the child and prayerfulness of the mother in the right section; Scene viii, the Cure of Simonello di Angeluccio, is set in a single interior (Pl. XIV; Fig. 128). This encompasses both the dire prognosis of the doctor (the famous Maestro Tebaldo of Arezzo)[9] which he delivers to a woman (presumably Simonello's wife) and, at the same moment, the miraculous arrival of Beata Margherita, unseen by these two, to effect a cure. The relation between these two events is articulated by the central figure of a boy (presumably Simonello's son) who points urgently to the healed man, while touching the arm of the woman, who is turned away from him, to attract her attention. She is too immersed in her distressing discussion with the doctor to see Simonello rise up in health in his bed.

The contrast between sorrow and joy shown in Scene x, The Resuscitation and Healing of Suppolino, probably approaches the Saint Nicholas scene most closely (Pls. XV and XVI; Figs. 125 and 126). The left and central compartments are used to narrate the accident and the attendant horror. The single room that occupies the right side of the composition shows (as discussed in the previous chapter) not only the grieving females grouped around the bed on which the body has been laid, but also the woman in black, presumably a repetition of the figure in the central space (the child's widowed mother, Donna Muccia) looking up toward Beata Margherita, and the woman in green beside her, who places a protective hand on the head of the risen child while touching the mother's shoulder in an urgent desire to communicate the miraculous news. These distinctions, blurred by the copyist, but still capable of interpretation, recall the variety of reaction found in the closing section of Ambrogio Lorezetti's Saint Nicholas scene.[10]

9. *Legenda*, xii, 57; CM, 79.

10. A simpler version of this type, in Scene xix (The Healing of the Man of Corciano, Fig. 103), in which all the spectators seem unaware that the cure has occurred, at the same time as the offer of candles to the shrine is made, shares with the Saint Nicholas scene the pose of the disconsolate woman leaning, with arms bent, on the far side of the bed (Pl. XV; Fig. 125).

The copyist's mediation also obscures the interpretation of Scene xvi (The Cure of the Conspirator of Arezzo, Fig. 130), which may also have been extensively retouched; nonetheless, this ambitious composition appears to represent the protagonist, the conspirator of Arezzo, three times. A doctor inserts an instrument into the man's mouth in a vain attempt to dislodge the fishbone that stuck there as he ate a meal, having just prepared assassins to bring about the death of an enemy. To the left another doctor stands, looking outward, hands spread in a gesture of hopelessness, while one of the conspirator's associates listens in distress to the doctor's verdict.[11] To the right, in a separate room opening off the first one, the conspirator kneels in prayer to Margherita. She graciously extends her right hand to him to receive his vow that, if cured, he will forgive his enemy. Meanwhile she indicates, with her left hand, a second figure bending lower in penitence and gratitude.[12] This is the conspirator again, holding the fishbone in his hand, now cured, after having repented of his former misdeeds. This extended sequence is managed by the use of the two attendants, seen in three-quarter rearview, as visual dividers between events; by the setting of the cure in a separate room; and by the repetition of the kneeling figures, one partially concealed behind the other.

This analysis of narrative techniques highlights the similarities between the methods of the artists of the Beata Margherita and Saint Nicholas cycles. In this connection it is interesting to turn to Vasari's account of the decoration of S. Margherita which, as already discussed, has some claim to be taken seriously. The relevant passage in Ambrogio's *Vita* leads on from Vasari's description of how, in S. Procolo in Florence, the artist painted:

> the stories of Saint Nicholas in small figures in order to satisfy certain of his friends who wanted to see his way of working, and he completed this work in such a short time, being very practiced, that he very greatly increased his name and reputation. And this work, in the predella of which he painted his own portrait, was the reason that in the year 1335 he was summoned to Cortona by order of the Ubertini bishop, then lord of that city, where he worked in the Church of S. Margherita.[13]

The suggestion of a direct relationship between the two commissions may be nothing more than an elegant literary device for splicing information introduced into the second edition with material reused from the first.[14] But Vasari was clearly familiar with the Saint Nicholas panel, visible in Florence, and is also likely to have known the work in S. Margherita at firsthand. So his linking of the two groups of paintings, both of which he describes with

11. See *Legenda*, XII, 55; CM, 77, which specifies that several doctors attempted to remove the fishbone, but all failed.

12. These two gestures recall the two rays issuing from Saint Nicholas in Ambrogio Lorenzetti's Healing of the Merchant's son (Pl. XV; Fig. 125).

13. ". . . le storie di S. Nicolò in figure piccole per sodisfare a certi amici suoi desiderosi di veder il modo dell'operar suo, et in sì breve tempo condusse, come pratico, questo lavoro ch'e'gl'accrebbe nome e riputazione infinita. E questa opera nella predella della quale fece il suo ritratto fu causa che l'anno 1335 fu condotto a Cortona per ordine del vescovo degli Ubertini, allora signore di quella città, dove lavorò nella chiesa di S. Margherita"; Vasari, ed. Bettarini and Barocchi, text vol. 2, 181.

14. Ibid.

enthusiasm, is not without interest, and might even suggest that he saw some connection between the two groups of scenes.

The relation between the Margherita cycle and the three hagiographical narratives can be pursued a little further. The comparisons that follow are not clear-cut, but they deserve consideration because the cumulative effect of these examples is important in forming a view of the artist—or artists—of the Margherita cycle.

As already mentioned, the artist appears to have relished the opportunity to show a series of structures or spaces, often of differing depths, in a single scene. His preferred method seems to have been to place the forward edge of walls or piers on the foremost picture plane, to construct one wall parallel with the picture plane, and allow a steep oblique recession for other walls, leading rapidly into the middle ground of the picture. The construction in the domestic scene of the Saving of the Suicide (Scene xiii; Pl. XXIV; Fig. 134), clarifies the courtyard setting in which the main event takes place by showing, on the left, the exterior of the outer wall of the house receding to the edge of the picture, creating an empty alleyway into which a devil, come for the suicide's soul, escapes.[15] This narrow street is the descendant of the one in the background of the Healing of the Blind Man from Duccio's *Maestà*, where it appears behind the frieze of figures that occupy the forward plane.[16] In Simone Martini's scene of Beato Agostino Novello saving a boy falling from a balcony, the street is brought into the forward plane of the picture and figures are set within it (Fig. 124). It is used again, in this case receding more steeply, in Ambrogio Lorenzetti's Healing of the Merchant's Son and, to particular narrative effect, in his Miracle of the Dowry (Fig. 131), in which the construction most closely resembles that of the Cortona Saving of the Suicide (Fig. 134). Both examples use the device of situating the narrative heart of a scene passing through a window.[17] Margherita leans through an upper window in order to cut the rope, and bring the learned man so filled with despair to safety. It is clear that she has entered the house and climbed the stairs in great haste: the door, torn from its hinges, is seen to fall on the steps.[18] Two of her companions have meanwhile run to the courtyard below, to support the body of the learned man, until the cord is cut.[19]

15. This area in the watercolor is slightly confused by the white semicircular area in the top left. This is simply a piece of reinforcement on the paper, found in all the watercolors of Cortona MS 429.

16. Illustrated G. Cattaneo and E. Baccheschi, *L'opera completa di Duccio,* Milan, 1972, pl. 63.

17. See also the device of looking through a window, used in the Cortona scene of the Ascent of Margherita's Soul (Scene v, Fig. 187) and, as mentioned above, in Ambrogio Lorenzetti's Saint Nicholas Heals a Merchant's Son (Pl. XV; Fig. 125).

18. The emphatic shadow that the door casts on the steps may be due to later repainting, or copyist's licence, but it is interesting to note that Pietro Lorenzetti has been credited with an innovative use of sharply defined cast shadow in the Assisi Passion Cycle. See H. B. J. Maginnis,

"Cast Shadow in the Passion Cycle at San Francesco, Assisi: A Note," *Gazette des Beaux-Arts* 77 (1971), 63–64.

19. The figure of the hanged man, suspended from a beam set into an archway, recalls the figure of Judas in Pietro Lorenzetti's Passion cycle at Assisi (Fig. 133). The Assisi figure may, in turn, owe a debt to Giotto's figure of Despair in the dado of the Arena Chapel (Fig. 132). Perhaps a drawing of the Arena Chapel figure remained in the Lorenzetti workshop, since the motif of the devil waiting to claim the suicide's soul, used by Giotto but not used in the Judas mural, does recur to the left of the Cortona hanged man. Ambrogio Lorenzetti also painted a noteworthy figure of a hanged man, shortly after 1336, in the lost cloister murals of S. Francesco, Siena (for dating see Seidel, 1979, 10–20, esp. 16). Ghiberti described how: "Eui dipinto come essi ne inpiccano uno a uno albero,

The devil waiting to claim the suicide's soul flees from the scene, apparently toward the actual window to the left of this scene on the nave wall (see the photomontage reconstruction, Fig. 203).

The combination of interior and street view found, in different forms, in Scenes x, xiii, xiv, and xv of the Cortona cycle (Pls. XVI, XXIV, XXII, and XXV; Figs. 126, 134, 122, and 175),[20] is also found in the scenes of Beata Umiltà. In the scene of Umiltà reading in a refectory the link between street and interior is reinforced by the two steps of the threshold curving out into the street.[21] The use of steps as a pointer to action in the upper part of a composition in the Saving of the Suicide again recalls Duccio's *Maestà* (the Denial of Peter);[22] the Resuscitation of the Boy of Suessa in the Lower Church at Assisi;[23] the two lower Beato Agostino Novello scenes (Pl. XIII; Figs. 24, 123, and 124); Saint Nicholas Healing the Merchant's Son (Pl. XV; Fig. 125); and the steps on the left side of the Massacre of the Innocents, in the Servite church in Siena (Fig. 141). In this last example the steps protrude curiously out of the doorway in a form closest to the arrangement in the Cortona scene, where the curving steps seem to flow toward the front of the picture, forming a significant element of the composition.

Similarities between the Margherita and Umiltà cycles can also be observed in two scenes in which a doctor expresses his inability to effect a cure. In Scenes viii and xvi at Cortona, already described (The Cure of Simonello di Angeluccio and of the Conspirator of Arezzo, Pl. XIV; Figs. 128 and 130), the doctor holds his right arm by his side, hand with fingers extended and slightly spread, wrist bent and palm facing downward in a gesture that implies relinquishing responsibility. The left arm bends at the elbow, forearm extended toward the viewer and thus foreshortened, fingers curled and, in the case of Scene viii, thumb extended downward—often purely a gesture of indication, but in this case presumably expressing the bad prognosis being delivered. The origins of this type of scene may occur at Assisi, in this case in the Upper Church Saint Francis cycle, in the Healing of John of Lerida (Fig. 127). There the doctor's right hand is by his side, fingers extended and spread, implying resignation, but the left hand is obscured by a curtain so that the bad news is registered chiefly by the gesture of the woman to the right, who lifts her hand to her cheek and clasps her cloak to herself protectively. Closer to the Margherita cycle figures, and perhaps forming an intermediate step between Assisi and Cortona, is the doctor in the scene on the Umiltà panel of the Cure of the Nun with a Nosebleed (Fig. 129). He extends and spreads the fingers of both hands, palms turned outward, both elbows bent. His reaction is much more fully expressed than that of his counterpart at Assisi: he evi-

manifestamente tutto el popolo che v'è a vedere sente parlare et predicare el frate inpiccato all'albero" (. . . the people standing watching are listening to the hanged friar who continues to preach), L. Ghiberti, *I Commentarii*, ed. J. von Schlosser, Berlin, 1912, 40). A small-scale surviving example by Ambrogio is held by the figure of *Securitas* above the Landscape of Good Government in the Country. I am most grateful to my M.A. group of 1991 for

pointing out these similarities and discussing them with me.

20. Other types of combined interior and exterior are found in Scenes i, v, vi, vii (Pls. XVII and XIX; Figs. 104, 187, 106, and 170).

21. Illustrated in Volpe, ed. Lucco, 179, fig. 144.

22. Illustrated in Cattaneo and Baccheschi, pl. 47.

23. Illustrated in Poeschke, pl. 239 (and see Fig. 120).

dently shrugs his shoulders, and his downturned lips and the turn of his head show that he has no further advice to offer.[24] Again the copyist may have muted the original effect at Cortona, but it can still be seen that the doctor in Scene xvi has a wrinkled brow, as though raising his eyebrows in the facial equivalent of a despairing shrug.[25]

The "Calming of the Sea of Ancona" and Giotto's "Navicella"

One other scene in the Cortona cycle deserves extended consideration at this point. The scene of the calming of the *Mare Anconitanum*, which shows a wind-tossed ship on a stormy sea (Scene ix; Pl. XXVI; Fig. 137), is evidently based on Giotto's famous mosaic of the *Navicella*, made for the atrium of Old Saint Peter's.[26] Although that mosaic was extensively remade in the seventeenth century, its appearance has been preserved in numerous copies. When Paeseler analyzed these copies in his exhaustive study, he concluded that the most reliable source for the original appearance of the work was the facsimile made by Francesco Berretta in 1628 (Fig. 135).[27] Because of its fragmentary and damaged nature, the information given by Berretta's facsimile needed to be supplemented by other copies, such as the early fifteenth-century Florentine drawing now in the Metropolitan Museum, New York (No. 19.76.2) that is also reproduced here (Fig. 136).[28]

A comparison between the two *Navicella* compositions and the Cortona watercolor shows that the artist of the Margherita cycle concentrated on the image of the ship, surrounded by a sea covered with a regular pattern of waves. The setting of the ship parallel to the picture plane, its general form, the angle of the mast, and the shape of the sail, all correspond to the *Navicella* type. The apparition of Margherita at the top right of the composition echoes the setting and pose of the pair of prophets at the upper right of the *Navicella*. The figures on the ship are, in general, not closely related to Giotto's Apostles, but the striking figure of the man with his back turned to the viewer who strains to haul on the sheets and hold the sail against the force of the wind is clearly repeated at Cortona.

Giotto's *Navicella* must have made a vivid impression on many visitors to Rome. The earliest known reminiscence of it is found in a wall painting in St-Pierre le Jeune (Jung-

24. A connection with Assisi is also suggested by the use here of the motif of a figure sitting up in bed, found at Assisi in the adjacent scene of the Confession of the Temporarily Resuscitated Woman (illustrated in Poeschke, pl. 196). See also the similarity between the despairing gesture—hand raised to cheek—of the woman in the Saint Francis Heals John of Lerida at Assisi (Fig. 127), and a monk in the scene of the Monk Refusing to have his Foot Amputated by a Doctor, in the Beata Umiltà cycle (illustrated in Volpe, ed. Lucco, 179, fig. 145).

25. The architecture of Scene xvi also bears some resemblance to the central part of the setting of this Umiltà scene (Figs. 129, 130).

26. For a recent thorough discussion of possible datings, ranging from c. 1300 to c. 1320, see H. Köhren-Jansen, *Giottos Navicella: Bildtradition, Deutung, Rezeptionsgeschichte*, Worms, 1993, 32–46. Köhren-Jansen favors a date of c. 1300 for Giotto's work.

27. W. Paeseler, "Giottos Navicella und ihr spätantikes Vorbild," *Römisches Jahrbuch für Kunstgeschichte* 5 (1941), 49–162; esp. 93–111.

28. Paeseler, 102–4. The Metropolitan drawing has been attributed to Parri Spinelli. Degenhart and Schmitt, I, 2, 277–80, call it Florentine, first quarter of the fifteenth century.

St.-Peter), Strasbourg, painted in about 1320.[29] The first surviving Italian reflection has previously been thought to be the predella of Andrea Orcagna's Strozzi Altarpiece, painted between 1354 and 1357.[30] If the date proposed in the following chapter for the Margherita cycle is accepted, then the miracle on the sea of Ancona is an earlier reflection of Giotto's *Navicella* composition—although not, of course, a replica of *Navicella* iconography.[31]

How did the artist of the Cortona cycle come to know the *Navicella* composition? It is impossible to say whether he had seen the Saint Peter's mosaic himself or whether his knowledge came from consulting a modelbook of some kind. Although the earliest such drawings of Giotto's *Navicella* that survive date from the fifteenth century, *Navicella* compositions such as those at Strasbourg, and in the Strozzi Altarpiece and the Spanish Chapel at Santa Maria Novella, show that earlier drawings existed.[32] If the artist in Cortona was relying on another person's drawing rather than on direct study, then we can at least say that the copy that was available to him was a good one. The motif of the pulling figure with back turned, sometimes omitted from reflections of the *Navicella*, and often turned so that the figure faces forward,[33] was known to the artist.[34]

But however good the artist's knowledge of Giotto's *Navicella*, the composition was of only limited use for his purposes. Instead of a group of fearful apostles, the artist needed to show a ship filled with pilgrims calmed by the knowledge of the presence of Margherita's relics and her successful intervention, at the same time as the sailors struggled to control the storm-tossed vessel. The artist decided to dramatize the peril from which the travelers were just being delivered by showing the sail not simply filled with the wind, as in Giotto's *Navicella*, but also torn by its strength. Two of the ropes controlling the sail are shown to have snapped, curling uselessly from the spar as the tension is released. Meanwhile the sailors strain to make fast one of the remaining ropes, securing it to a ring near the steering oar at the stern of the ship. Beyond the ship some threatening rocks rise from the sea to

29. W. Körte, "Die früheste Wiederholung nach Giottos Navicella (in Jung-St-Peter in Straßburg)," *Oberrheinische Kunst* 10 (1942), 97–104, figs. 1 and 3.

30. R. Offner, *A Critical and Historical Corpus of Florentine Painting*, IV, i, New York, 1962, 8–10, 27–40 and pl. I, 21; L. Venturi, "La "Navicella" di Giotto," *L'Arte* 25 (1922), 49–69, esp. 67–68.

31. Another scene that deserves consideration in this context is a mural in the Saint Nicholas Chapel in the Lower Church of S. Francesco at Assisi, the Miracle of Saint Nicholas Saving a Storm-tossed Ship, attributed to Giotto's school and dated to the first years of the fourteenth century (illustrated in Poeschke, pl. 203a. For a summary of the arguments and the bibliography see ibid., 96.) It might be argued that this composition includes some elements from the *Navicella* but it cannot be called a repetition of that composition. On the other hand it may have had an influence on later Saint Nicholas scenes, and perhaps on Ambrogio Lorenzetti's work, discussed below.

32. For the Spanish Chapel, painted by Andrea Bonai-uti between 1366 and 1368, see Offner and Steinweg, IV, vi, New York, 1979, 61–63, pl. VII. For the popularity of Giotto's *Navicella* in fifteenth-century model books, see Degenhart and Schmitt, I, ii, 278–80. For the reception and repetition of *Navicella* iconography, see now also Köhren-Jansen, chap. 4. See Chapters 8 and 10, for further discussion of the probable use of motif books in the Margherita cycle.

33. For example, the predella of the Strozzi Altarpiece (in which the boat sails in the opposite direction); a sea miracle in the Saint Fina Altarpiece, by Lorenzo di Niccolò, dated 1402, now in the Pinacoteca Civica, S. Gimignano (Fig. 138).

34. Nor is there any evidence that the composition was copied from an intermediary painting, as appears to be the case in, for example, the later fourteenth-century *Navicella*-derived mural of the translation of Saint James Major, in the church of S. Domenico in S. Miniato al Tedesco, (Kaftal, 1952, col. 513 and fig. 596), which appears to depend directly on the version in the Spanish Chapel.

fill the central section of the background. Margherita's timely intervention has evidently prevented the vessel from being blown onto them.

These elements are not combined in any surviving fourteenth-century work,[35] but their use fits convincingly in the context of Sienese hagiographical narrative of the 1320s and 1330s. At a time when there was keen interest in representing the world as apprehended by the senses on a two-dimensional surface, the artist of the Margherita cycle may well have felt the challenge of extending Giotto's representation of the effects of an invisible force—the wind—on ship and water. In the Calming of the Sea of Ancona the artist has dispensed with the wind-gods that indicated the force and direction of the wind in Giotto's composition (Figs. 135 and 136). Instead, the standard in the stern of the ship, and the condition of the ship itself, conjure up the qualities of the storm.[36]

Ghiberti's laudatory description of Ambrogio Lorenzetti's lost fresco of a storm reveals the admiration one artist could feel for another's ability to represent this invisible, intangible element, "it really seems that the hail bounces from the shields as if driven by great winds. Trees are bent to the earth and split. . . . For a painted story it seems to me a marvelous thing."[37] Lorenzetti's cycle of scenes from the lives of four Franciscans martyred in 1321, painted in the cloister of S. Francesco in Siena, which Ghiberti was describing, has now been convincingly dated by Seidel to shortly after 1336.[38] The Cortona storm scene might thus be a near contemporary—perhaps a forerunner—of that more thorough-going exploration of extreme weather.

One particularly effective detail of the Cortona ship—the snaking curves of the snapped sheets—may have been suggested by another hagiographical narrative. The scene at the bottom right in Simone Martini's panel of Beato Agostino Novello shows an infant injured by a fall from his cradle. The poignancy of the moment is reinforced by the continued swing of the cradle toward the right, pushed by his nurse, whose arms are still extended. The cord from which the cradle was suspended has only just snapped, and the consequent release of tension has caused it to leap in the air in a series of elegant curves (Pl. XIII; Fig. 123).

Consideration of the apparent innovations in the Calming of the Sea of Ancona raises the question of whether the combination of these motifs was the artist's own invention. This

35. I have not found any earlier examples of torn sails or snapped rigging in scenes of storms—either in those deriving from Giotto's *Navicella,* or in unrelated sea scenes. (The Saint Nicholas miracle from the Saint Nicholas Chapel in Assisi [illustrated in Poeschke, pl. 203a] includes a broken mast.) Later fourteenth-century examples of rocks set behind, or to either side, of a storm-tossed boat, can occasionally be found: there are rocks in Orcagna's Strozzi Altarpiece version of the *Navicella* composition, but they are much less dominant than in the Cortona scene. (Another fourteenth-century example with rocks set to the side, in a sea scene related to Giotto's composition, is a predella by Lorenzo Veneziano, in the Gemäldegalerie Berlin, dated 1370). I have not found any

other examples of ropes being made fast in the stern of the boat.

36. The Saint Nicholas scene at Assisi, mentioned in the preceding note, also includes a standard in the stern, but it blows in the opposite direction from the sails.

37. ". . . pare veramente che lla grandine balçi in su palvesi con venti maraviglosi. Vedesi piegare gli alberi insino in terra et quale speccarsi. . . . Per una storia picta mi pare una maraviglosa cosa." Ghiberti, *I Commentarii,* ed. von Schlosser, 41.

38. Seidel, 1979, 10–20, esp. 16. See also Seidel, "Wiedergefundene Fragmente eines Hauptwerks von Ambrogio Lorenzetti," *Pantheon* 36 (1978), 119–27.

does not seem impossible: the discussion of the Way to Calvary composition, in Chapter 6, has already shown that the mural decoration of the church may have included innovations. On the other hand, it may be significant that these motifs made a reappearance in the early fifteenth century. The earliest example (and the only one using a ship clearly based on Giotto's *Navicella*) seems to be a sea-miracle on the Beata Fina panels painted by Lorenzo di Niccolò in 1402, now in the Pinacoteca Civica in San Gimignano (Fig. 138). There is no reason to suppose that this composition was copied directly from the Cortona scene, and it seems possible that the motif of the storm-damaged ship existed in other fourteenth-century paintings, more accessible and more widely known than the Cortona mural.[39]

A series of further examples by Florentine and Sienese artists use the motifs of damaged sails, torn rigging, and even, in some examples, broken masts.[40] It is tempting to speculate that a single seascape containing the motif of a damaged ship caught the imagination of a number of Florentine and Sienese artists in the first half of the fifteenth century. The evidence of the Margherita sea scene raises the possibility that such a prototype could have been a Sienese painting of the first half of the fourteenth century, also known to Florentine artists. This observation leads to the even more tentative speculation that such a scene once formed a part of the Saint Nicholas altarpiece by Ambrogio Lorenzetti admired by Florentine artists in S. Procolo. The repetition of the motifs in fifteenth-century Saint Nicholas scenes may lend a little weight to the hypothesis.

While the possibility of a lost Saint Nicholas scene of c. 1332, and the methods by which Ambrogio Lorenzetti conjured up a storm in the cloister of S. Francesco in Siena, in c. 1336, remain purely hypothetical, the salient features of the sea-storm painted at Cortona are still known to us. The watercolor copies have preserved valuable information about the achievements of a fourteenth-century artist in representing the invisible forces of nature.

39. The Lorenzo di Niccolò panel may be indirectly related to the Bernardo Daddi panel of 1338, now in the Muzeum Narodowe, Poznań, and thought to come from an altarpiece of 1338 for S. Maria Novella in Florence by Bernardo Daddi (see Offner, III, iii, 2d ed., rev. M. Boskovits and E. Neri Lusanna, Florence, 1989, 192–95, pl. VIII²⁻³) and to the Strozzi altarpiece predella, with which, in both cases, it shares certain figure poses, but not the condition of the ship.

40. The group includes Saint Nicholas of Bari scenes by Lorenzo Monaco (Florence, Accademia, c. 1420 [?]); Gentile da Fabriano (Predella of Quaratesi Altarpiece, Pinacoteca Vaticana, 1425); Bicci di Lorenzo (Oxford, Ash-molean Museum, 1435); and two sea miracles by Giovanni di Paolo: Saint Nicholas of Tolentino (Philadelphia, Museum, Johnson Coll., 1456 [?]); Saint Clare (Berlin, Gemäldegalerie, later 1450s). Some of these compositions are clearly related to one another: for example, the Bicci di Lorenzo derives from the Gentile; Van Os (*Sienese Altarpieces, 1215–1460*, II, Groningen, 1990, 50–51) has suggested that Giovanni di Paolo also looked at Gentile's scene. The Lorenzo di Niccolò, Gentile da Fabriano, and Bicci di Lorenzo scenes share the motif of a bale, neatly tied with rope, being dropped over the side of the ship to lighten its load.

10

The Artist or Artists of the Margherita Cycle and the Lorenzetti

Discussion of the copies of the Margherita cycle has drawn attention to numerous points of contact—some minor but others substantial—with central Italian painting of the early trecento. The artistic origins of both the artists whom Vasari named as working extensively in the church—Ambrogio Lorenzetti and "Berna"—were Sienese and, as we have seen, an attribution to a Sienese painter would fit comfortably with the evidence of the copies. The artistic identity of "Berna" (or, as he is more generally known, "Barna") is now agreed to be close to Simone Martini's circle and possibly identical with Simone Martini's brother-in-law, Lippo Memmi.[1] But while Simone's hagiographical narratives have been mentioned here for their relation to the cycle, a greater number of significant comparisons are to be found in the work of the Lorenzetti brothers.

The question remains, Which Lorenzetti? Vasari nominated Ambrogio; and the handling of narrative, as well as certain methods of showing pictorial depth in townscapes—

1. For a lucid summary of Barna's artistic identity, and further bibliography, see Borsook, 1980, 43–46. For a more recent account of the attribution of the San Gimig- nano New Testament cycle to Lippo Memmi, see Freuler, 1986.

perhaps also the seascape just discussed—are fundamental elements in the design of the Margherita scenes, and have been shown to resemble Ambrogio Lorenzetti's working methods. But other elements appear closer to Pietro Lorenzetti's conception of space. The comparison drawn between the Visitation of Napoleone Orsini (Scene xvii) and Pietro's Birth of the Virgin (Pls. XI and XII), is an example of a composition whose organization can, in its main lines, be compared with a signed work by Pietro. The various links between the Cortona compositions and the painting of the right transept of the Lower Church, discussed above, would also tend to point to Pietro, who executed the Passion cycle in the left transept at Assisi, and is hence more likely than his brother to have possessed a detailed knowledge, and sketches, of those Giotto-school works.[2] Moreover Pietro had already worked in Cortona, painting the Virgin and Child formerly in the Duomo (Fig. 66) which is placed early in his career, and two Crucifixes now in the Museo Diocesano (Figs. 70 and 71). The larger of these two Crucifixes came to the museum from S. Marco, a foundation that, at least by the second half of the fourteenth century, was administered by the same *soprastanti* as S. Margherita.[3]

The stylistic evidence deduced from the copies might suggest a collaborative venture such as that found in the S. Maria della Scala Facade, or the Chapterhouse of S. Francesco at Siena. At S. Francesco it is easy to distinguish the separate scenes for which the two brothers were responsible.[4] At S. Maria della Scala the two were both named in the inscription.[5] In his pioneering work, Péter sought to deduce the original form of these lost frescoes by studying later works related to them. He attributed the design of all four scenes to Ambrogio, with help from Pietro in their execution.[6] Since then, opinion concerning the attribution of scenes has varied, but all those studying the question have linked one individual artist—whether Ambrogio, Pietro, or, for the third and fourth scenes, Simone Martini—with each individual mural.[7] In the case of the Margherita cycle, however, the scenes cannot always be so conveniently apportioned. In Scene x—The Resuscitation and Healing of Suppolino—for example, it has been argued here that there is a clear parallel with the narrative methods used in the Saint Nicholas scenes attributed to Ambrogio (Pls. XV and XVI; Figs. 125 and 126). But the architecture is closer to Pietro Lorenzetti: the extensive use of coffering, in a series of interconnecting compartments, may be compared with the Dream of Sobac in Pietro's Carmelite Altarpiece of 1329 (Fig. 139); and the motif of a triple arcade opening onto a flat roof above a central horizontal beam recalls, in particular, Sano di Pietro's version of the lost Scala fresco of the Birth of the Virgin which Maginnis has recently attributed to Pietro (Fig.

2. For Pietro's study of the right transept frescoes, see Seidel, 1981, 144–54.

3. Bornstein, 1990, 229.

4. Enumerated in, for example, Seidel, 1978, 123–24.

5. HOC OPUS FECIT PETRUS LAURENTII ET AMBROSIUS EIUS FRATER M. CCC. XXX. V.

6. A. Péter, "Pietro és Ambrogio Lorenzetti egy elpusztult freskó-ciklusa," *Országos Magyar Szépmüvészeti Mú-*

zeum Evkönyvei 6 (1930), 52–81, 256–60, Budapest, 1931 (with German summary).

7. See, most recently and convincingly, Maginnis, 1988, 180–94, who gives a thorough account of the written sources; and D. Gallavotti Cavallero, "Pietro, Ambrogio e Simone, 1335, e una questione di affreschi perduti," *Prospettiva* 48 (1987), 69–74, who was the first to argue for a link between Simone Martini and the last two scenes.

140).[8] Moreover, the gesture of the central figure in Scene x drawn, as discussed above, from the Giottesque repertoire, had already been used in Pietro's work in the Lower Church at Assisi, in an angel on the upper left of the group above the crucified Christ (Figs. 115, 114, and 113). Even in the Visitation of Napoleone Orsini (Scene xvii), just cited as evidence of Pietro's intervention, there may be traces of the other brother too. As already noted, the row of standing figures beyond Margherita's body (and the group progressing from right to left in front of it) are reminiscent of the organization of the fresco of Saint Louis of Toulouse Before Boniface VIII, in the Chapterhouse at S. Francesco in Siena, attributed to Ambrogio (Pl. XI; Figs. 23 and 109).

The interchange of ideas between the two brothers has already been touched on, in the discussion of the Way to Calvary, in Chapter 6. Ambrogio's Saint Louis of Toulouse Before Boniface VIII is a particularly clear example of this, since it is generally agreed that it is closely related to the composition of the last two scenes of the predella of the Carmelite Altarpiece, completed by Pietro in 1329 (Figs. 109 and 110). Although opinions differ as to which of the two brothers should be credited with the initial conception,[9] it is accepted that the same basic setting was used by both, and could appear in either a small-scale panel painting, or a large-scale mural. The intertwining of elements from the works of both artists, detected in certain of the watercolor copies, might thus be interpreted as evidence that at the time when one brother devised these compositions, he had in mind certain paintings already executed by his sibling.[10]

This seems also to have been the case in at least one of the S. Maria della Scala frescoes: the Birth of the Virgin. Looking at the reflection of the scene provided by Sano di Pietro's predella panel now in the Museum of Art, University of Michigan—which Eisenberg, Gallavotti Cavallero, and Maginnis have shown to be, in many respects, the most reliable version[11]—the composition can be seen (as is always acknowledged) as a forerunner of Pietro's Birth of the Virgin altarpiece for the Duomo of Siena, commissioned in the year that the Scala fresco was completed (Pl. XII; Fig. 140). Péter, Rowley, and others attributed the design of the scene to Ambrogio, despite the similarities with Pietro's altarpiece, on the grounds that Ambrogio's superior skill in constructing three-dimensional space made him the likely source for these ideas, which were then transposed by his brother, with modifications, into the medium of panel painting.[12] Thanks to the redating of the Assisi frescoes, and several reassessments of Pietro's artistic career, he has emerged as a more

8. Maginnis, 1988, 181, fig. 1. For discussion of the fidelity of the various reflections of the S. Maria della Scala frescoes, see Maginnis, esp. 188–89.

9. For a summary of opinions see Borsook, 1980, 32–33, to which should be added the information, established in I. Hueck, "Le matricole dei pittori fiorentini prima e dopo il 1320," *Bolletino d'arte* 57 (1972), 114–16, that Ambrogio was in Florence, matriculating in the *Arte dei Medici e Speziali* at some time between 1328 and 1330, not in 1327, as previously thought.

10. See, in this connection, Volpe's observation of "un avvicinamento mentale fra i due fratelli," cited above, Chapter 6, note 73.

11. Gallavotti Cavallero, 71–72; Maginnis, 180. (In some respects Maginnis, 188–89, prefers the evidence of the Osservanza Master's Asciano Birth of the Virgin altarpiece when this diverges from Sano's much smaller work.)

12. Péter, 1931, 22, 34; Rowley, i, 85–86; Maginnis, 1988, 180–81, 188.

innovative artist than was previously thought,[13] and Maginnis has argued that his capacity to devise the Scala Birth of the Virgin should not be doubted.[14]

These differences of interpretation concerning the authorship of the S. Maria della Scala frescoes may be symptomatic of the growing closeness of the art of the two brothers in the years around 1335. Looking back in their work we may already see the forerunners of certain ideas found in the Birth of the Virgin, in the work of both artists. Ambrogio's Saint Nicholas panel Miracle of the Dowry, generally dated c. 1332 (Fig. 131),[15] contains not only the device of the foreshortened bed in the right third of the composition, and the wall receding to the left to mark the exterior setting of the left third of the composition, but also the kneeling figure placed in the central third. Pietro's Dream of Sobac in the predella of the Carmelite Altarpiece (completed 1329) (Fig. 139), contains the germ of the interior/exterior construction, contrasted with a two-part arched division, while his Last Supper in the Lower Church at Assisi (probably painted before 1320) already contains the device of the side room and, as Maginnis has noted, a fireplace.[16] In other words, the brothers might share an idea, and take turn and turn about in developing it and exploring its further possibilities.

Several scholars have pursued the links between the two artists further, proposing that they shared a workshop, either toward the end of their careers, or around the time when the Duomo altarpieces were painted (c. 1335–1342), or even earlier than this, at the start of the 1330s.[17] This suggestion of a shared workshop raises the possibility of an alternative explanation for the combination of ideas from the works of both brothers in certain of the

13. See, in particular, the brief comparison of Ambrogio and Pietro's work in M. Kemp, *The Science of Art*, New York, 1990, 10–11, in which Pietro's Birth of the Virgin altarpiece is called the tour de force of fourteenth-century perspective.

For a concise summary of the *fortuna critica* of Pietro Lorenzetti and the belated acceptance of Volpe's early dating of the Assisi cycle, see H. B. J. Maginnis, "The Literature of Sienese Trecento Painting, 1945–1975," *Zeitschrift für Kunstgeschichte* 40 (1977), 292–94, 306. For subsequent bibliography, including the further contributions of Maginnis, and those of Bellosi and Seidel, see Volpe, ed. Lucco, esp. 60–65.

14. Maginnis, 1988, 188–89. His arguments are also based on comparisons with Pietro's polyptych for the Pieve of Arezzo, his Carmelite Altarpiece, and the Passion cycle at Assisi.

15. For the date and possible provenance, see Borsook, 1966, 7–9, 29–30, and, for a detailed account of the dating arguments and extensive earlier bibliography, L. Marcucci, *I dipinti toscani del secolo XIV. Gallerie Nazionali di Firenze*, Rome, 1965, 161–63.

16. Maginnis, 189. Illustrated in Volpe, ed. Lucco, 68–69.

17. Meiss's suggestion that the two artists shared a workshop (M. Meiss, "Nuovi dipinti e vecchi problemi," *Rivista d'arte* 30 (1955), 118) was taken up by Zeri, in

relation to two small-scale diptychs (F. Zeri, *Diari di Lavoro*, I, Bergamo, 1971, 17–24). Zeri proposed that assistants would have had access to works by both brothers, toward the end of their careers. Frinta, studying one of the same diptychs, noted that punchmarks found separately in the works of each brother, appeared together in the same diptych, giving tangible evidence of a shared workshop (M. Frinta, "Note on the Punched Decoration of Two Early Painted Panels at the Fogg Art Museum: *St. Dominic* and the *Crucifixion*," Art Bulletin 53 [1971], 307–8). More recently Skaug has agreed that the brothers occasionally borrowed punches from one another, but concludes that there is no firm evidence for a shared workshop. (E. S. Skaug, *Punch Marks from Giotto to Fra Angelico. Attribution, Chronology, and Workshop Relationships in Tuscan Panel Painting c. 1330–1430*, Oslo, 1994, vol. I, 223–29; vol. II, charts 7.4 and 7.5.) Laclotte, discussing two further small-scale panels, agreed with Zeri's suggestion, and believed that this period of collaboration might have begun in the mid-1330s (M. Laclotte, "Quelques tableautins de Pietro Lorenzetti," in *"Il se rendit en Italie": Etudes offertes à André Chastel*, Rome, 1987, 31). Boskovits moved the start of this collaboration earlier, by proposing that Pietro shared Ambrogio's shop toward the end of the latter's time in Florence, at some time between 1332 and 1335, and that Pietro executed the Beata Umiltà narratives at that time (Boskovits, ed. Schleier, 89).

Margherita scenes: we need to consider whether an assistant employed in such a joint shop, and able to follow instructions and draw on models provided by both brothers, could have been responsible for the design and execution of the Margherita cycle.

A surviving group of frescoes associated with the Lorenzetti, in the Petroni and Spinelli Chapels in S. Maria dei Servi in Siena (Figs. 141 and 142), may help us in evaluating this hypothesis. These paintings have generally been attributed to Pietro Lorenzetti's shop, but Laclotte has recently attributed the works to an unidentified artist trained in the joint shop of the two brothers.[18] Analysis of the watercolor copies (made in Chapter 8) suggests that any assistant working on the Margherita cycle would have been provided with a stock of workshop sketches that included gestures and motifs culled from Assisi. As noted above, the gestures of grief used in the center of the Petroni Chapel Massacre of the Innocents also appear to have been taken from sketches made at Assisi (Figs. 117, 119, and 141), while the Feast of Herod in the Spinelli Chapel (Fig. 142) shows a similar use of sketches made, in this case, from Giotto's fresco of the same subject in the Peruzzi Chapel in S. Croce, and strangely combined with an un-Giottesque and structurally confused setting, presumably because the Peruzzi original was either beyond the artist's abilities, or had simply not been recorded in front of the original fresco in Florence.[19]

There is also evidence, in the Petroni Chapel Massacre of the Innocents, for the use of a drawing that might have been available in a shared Lorenzetti workshop. While the gestures of the two grieving women come, ultimately, from the Assisi fresco of the Death of the Boy of Suessa (Figs. 117 and 119) and one of the gestures can also be found in the Assisi Massacre of the Innocents, the soldier in red with back turned, arm raised, and head in profile, who occupies the space between them (Fig. 141), does not appear in the Assisi Massacre of the Innocents composition.[20] He is, instead, a distant relative of both the executioner on the left of the Massacre at Ceuta (attributed to Ambrogio Lorenzetti or his shop) (Fig. 88), and the soldier in yellow in the Cortona Way to Calvary (attributed to Pietro Lorenzetti or his shop) (Fig. 87).[21] The artist in the Petroni chapel used elements seen in both these figures, but worked at a much lower level of competence.

The combination of these motifs—grieving women and turned soldier—in the work of an artist in the circle of the Lorenzetti, provides a noteworthy link between motifs used in the nave and *cappella maggiore* murals of S. Margherita in Cortona. What should also be noted is that comparison between these three turned figures (Figs. 87, 88, and 141) marks

18. Entry by M. Laclotte in the exhibition catalogue *L'art gothique Siennois: Avignon, 1983*, Florence, 1983, 120. For a summary of previous attributions and further bibliography, see Volpe, ed. Lucco, 207–8.

19. See Tintori and Borsook, 26–28.

20. Illustrated in Poeschke, fig. 233. His predecessor in the Arena Chapel Massacre of the Innocents, at the right of the composition, is also seen from the back, but has a different pose, without the torsion, or the characteristic scooped neckline, and only the back of his head is shown.

21. He may also be compared with the flagellator on the right in the Assisi Lower church Passion Cycle (illus-

trated in Volpe, ed. Lucco, 74), but differences in hair, turn of head in relation to shoulder, foreshortened arm, and general arrangement of drapery, all suggest that the Petroni Chapel figure derives from a later stage in the development of this pose by the Lorenzetti. The pose used in the Petroni Chapel also seems to have been admired outside the circle of the Lorenzetti since it is repeated for the figure of the flagellator on the right in the Flagellation in the Collegiata at S. Gimignano (illustrated in Carli, 1981, 130) previously attributed to "Barna" but now to the circle of Simone Martini or, more specifically, to Lippo Memmi working in 1343.

an important distinction in the concept of an assistant following the master's style. Although the artist of the Massacre of the Innocents had access to, or copies of, Lorenzetti drawings, his own draftsmanship was much weaker than theirs, so that not only the execution, but also the design, lack conviction (Fig. 141). In the Ceuta executioner, on the contrary, the loss of most of the top layers of paint reveals the confident underdrawing—arguably that of the master—that may once have been covered by a layer painted a secco, perhaps executed by an assistant (Fig. 88).[22] This type of combination of efforts should be borne in mind both in evaluating the soldier in the Cortona Way to Calvary fragment (Pl. IV; Fig. 87), and the circumstances under which the Margherita cycle was produced.

Laclotte envisaged the artist of the Servite frescoes in Siena as an independent master, and it might be fair to say that although his vocabulary of motifs derives from the Lorenzetti, his compositional syntax shows no clear signs of their guiding hand. The careful design of the best scenes recorded in the Cortona copies suggest, in contrast, a more integrated conception than the simple stitching together of individual motifs. This raises the possibility (already touched on in the discussion of the Calming of the Sea of Ancona (Scene ix)) that the artist—or artists—painting the cycle had access to compositional ideas in hagiographical narratives, devised by one or both brothers, that have not survived. As it happens, we have some evidence for the previous existence of one such cycle. As discussed in Chapter 4, a series of scenes of the life and miracles of Beato Andrea Gallerani were painted on a panel said to have been made in 1327, by "Antonio Laurati fratello di Pietro sanese" who, as discussed above, is presumably to be identified as Ambrogio Lorenzetti.[23] The subject matter of seven of the scenes was recorded by Raimondo Barbi in his vita of Gallerani, composed in 1638.[24] They seem to have included events that could have provided useful models for adaptation and reuse in the Margherita cycle: a small girl who fell from a great height (compare Scene x; Pl. XVI; Fig. 126); a man possessed by demons, liberated by Gallerani (compare Scene xii; Pl. XXI; Fig. 168); the liberation of Ugoccione da Istia, who escaped from prison with his companions when the door was thrown open, through Gallerani's intervention (compare Scene vii; Fig. 170); the miracle of Baroncello, revived from death and healed (compare Scene viii; Pl. XIV; Fig. 128). (The list also includes the cure of a man whose eye had leaped from its socket, an affliction visible in the copy of Scene xix at Cortona (the Healing of the Man of Corciano) (Fig. 103)[25]; and a miracle at sea, in which piracy rather than tempests, necessitated Gallerani's intervention.)

If certain designs that existed in the workshop were, not surprisingly, adapted for use in the Margherita murals, it is still necessary to look for the artist (or artists) responsible for

22. See Borsook's discussion of the frescoes at Montesiepi, in which she considers whether Ambrogio executed some, or all, of the sinopie, for the guidance of the assistants responsible for the painting of the frescoes, and the possible role of drawings in this process. E. Borsook, Gli Affreschi di Montesiepi, Florence, 1969, 33–34.

23. It was previously thought that Ambrogio was in Florence, enrolling himself in the Arte dei Medici e Speziali

in 1327, but Hueck, 1972, 116, has shown that this did not occur until some time between 1328 and 1330. Ambrogio may thus have been moving between the two towns, during the later 1320s.

24. Enumerated in Bacci, 1939, 11–13.

25. For this distressing detail, see also the Healing of the Boy attacked by a Dog, on the Beato Agostino Novello panel.

the overall planning of this extended cycle. He (or they) would, at the very least, have needed to choose and adapt the most appropriate models, devise new compositions where no suitable examples existed, and supervise their execution. The designing of the two walls of the *cappella maggiore,* in particular, and the coherent presentation of Margherita's significance for her adopted town (discussed in detail in the following chapters), suggest a higher artistic enterprise than might be expected from a trusted and experienced assistant with a useful sketchbook to hand. It seems reasonable, therefore, to envisage the controlling hand of the master (or masters) of the workshop, guiding the planning and execution of the cycle.

Here we need to consider Vasari's date of 1335. As discussed in the preceding chapter, this date could convincingly be applied to the Way to Calvary fragments, but can it also, as the artist of the watercolor copies believed, be applied to the Beata Margherita cycle? The comparisons made in this chapter between the works of the Lorenzetti brothers and the compositions recorded in the copies, suggest a date following the innovative hagiographical narratives of Saint Nicholas (c. 1332) and preceding the completion of the two altarpieces for the Duomo of Siena, with their more developed use of tripartite architectural settings, in 1342. The year 1335 marked the brothers' collaboration in painting frescoes for the facade of S. Maria della Scala. In the same year Pietro obtained a specially commissioned vernacular translation of the *legenda* of Saint Sabinus, to aid him in his task of devising narratives for a painting for the altar of S. Savino, (generally thought to refer to the predella of the Birth of the Virgin altarpiece).[26] Around the same time, Ambrogio was engaged in planning and painting the murals of the stories of the four Franciscan Martyrs that decorated the cloister walls of S. Francesco in Siena.[27] Moreover, the iconographically innovative mural decoration of the Chapel of S. Galgano at Montesiepi, thought to have been executed by Ambrogio's assistants under his guidance, and connected by Borsook with the provisions of a will of 1340, has subsequently been dated by Luchs to the years 1334–36, on other documentary grounds.[28] Demand for Lorenzetti works must have put pressure on the workshop at this time, and may have encouraged a pooling of resources, as both brothers engaged in the production of a series of freshly devised hagiographical narratives.

At S. Margherita, the artists may have been commissioned to produce not only a hagiographical cycle, but also biblical scenes in the nave of the church. One possibility would have been to divide up responsibility for the task. In the Chapterhouse of S. Francesco, Siena, whose decoration probably began in the 1320s,[29] the divisions between the work of both brothers is, as already noted, easily distinguished. At Cortona there are signs, in both

26. Payment printed in Bacci, 91. For the relation between payment and altarpiece, see M. Davies, rev. D. Gordon, *The Early Italian Schools before 1400,* National Gallery Catalogues, London, 1988, 60–63.

27. Seidel, 1979, has dated them to shortly after 1336.

28. For the attribution, dating, and a full account of the chapel, see Borsook, 1969, passim. For the document establishing Ambrogio's presence at San Galgano in 1334, see A. Luchs, "Ambrogio Lorenzetti at Montesiepi," *Burlington Magazine* 119 (1977), 187–88. Borsook's connection of the chapel decoration with the will of 1340 has recently been upheld in D. Norman, "The Commission for the Frescoes of Montesiepi," *Zeitschrift für Kunstgeschichte* 56 (1993), 289–300.

29. For opinions on the dating, see above, Chapter 6, note 73.

the surviving fragments and the watercolor copies, that the art of the two brothers was moving closer together, and that they were presiding over assistants working in a more integrated style. Work may even have spread over several years, as seems to have been the case at S. Francesco, Siena.[30] Work on the decoration of the rather dark interior of S. Margherita would presumably have proceeded during the summer months; in the winter the artists are likely to have concentrated their efforts on the production of panel paintings including, at about this time, the planning of the two altarpieces for the Duomo.

As to the quality of the execution of the Margherita cycle, as distinct from the planning that preceded it, the copies do not permit any speculation. But the evidence of the surviving fragments from the north nave wall may be relevant here. Despite their damaged condition the best passages in these works, notably the thief with bound hands in the Way to Calvary (Pl. IV; Figs. 72 and 87) (and—if it does come from this church—the "S. Egidio" (Pl. VII; Figs. 92 and 95)), indicate the presence of the master, presumably, in this case, Pietro, painting in the Church of S. Margherita in the company of assistants. It is thus reasonable to propose that the master or masters responsible for planning the mural decoration of the church would also have executed parts of the Margherita cycle themselves. Whether that master was Ambrogio (as Vasari suggests) or Pietro (as the nave fragments imply) or both the Lorenzetti, cannot, in the present state of knowledge, be finally decided.

Despite these uncertainties, however, we can conclude this section on a positive note. If the various arguments that have been advanced here are accepted, and the major part of the mural decoration of S. Margherita was indeed a product of the Lorenzetti and their assistants in the mid-1330s, then a substantial new body of material has been added to the art history of the trecento. Whether the ideas and compositions seen here were used for the first time at Cortona, or whether they repeated compositions—now lost—first used elsewhere by the Lorenzetti and then adapted for use at S. Margherita, the evidence of the reconstructed fragments and of the watercolors provides new information concerning the development of Sienese hagiographical narrative, the role of the Lorenzetti brothers within this development, and their artistic relations at this time.

This new body of material may well, in the future, give rise to further art-historical interpretation.[31] But in the context of the present study we shall now use the evidence of the watercolor copies to shed light on a different group of fourteenth-century Tuscans: the inhabitants of Cortona and all those associated with the cult of Beata Margherita.

30. Pietro's Resurrected Christ from the Chapterhouse, for example, is generally dated later than his Crucifixion for the same place. See Volpe, ed. Lucco, 132–34. For Seidel's views on whether or not Ambrogio's work in the cloister was contemporary with, or later than, that in the chapter house, see above, Chapter 6, note 73.

31. Some further parallels between the watercolor copies and trecento painting are noted in Appendix III.

Part V

"Fama Laudabilis Beate Sororis Margherite": Art in the Service of the Cult of Margherita

Drawing together the threads of previous chapters, we can now focus on the central questions of this study: How did art work in the service of Margherita's cult? How does the view of Margherita presented in the *Legenda* compare with the three medieval visual versions of her story? What does the visual evidence tell us about Margherita's significance for the people of later medieval Cortona? In pursuing these issues we shall look at each of these visual cycles in turn, considering what prototypes may have seemed appropriate in devising Margherita's iconography, and how that iconography developed. In the case of the mural cycle we can see how the two earlier cycles may have produced certain visual expectations in those already familiar with the church and its decoration, and also provided exempla that could be used or, indeed, rejected by those planning and designing the murals.

The relation between the *Legenda* and these three cycles is intriguing. Although the medieval *Legenda* has come down to us as a single dated text, we should be aware that it represents, in one sense, a compilation of notes taken over a span of some twenty years, including Margherita's own

dictations; and, in another sense, only a snapshot of the knowledge and memories of Margherita that were still circulating in Cortona at the time when it was compiled. Thus all three visual cycles could draw on sources of knowledge other than the *Legenda* text as we have it, and the panel painting may well have been painted before compilation of the *Legenda* text was completed. In order to have a better understanding of the possible connections between text and images we therefore need first to consider what is known of the composition of that text, and of the relationship between its authors and those responsible for supervising Margherita's cult.

The declaration of authenticity appended to the *Legenda* (Fig. 1) tells us that the work was compiled at the request of the Franciscan inquisitor Fra Giovanni da Castiglione, who was, at one time, Margherita's principal spiritual director.[1] The text was not, however, composed as a single entity. This emerges from the fact that Fra Giovanni, and two of Margherita's other spiritual advisers, Fra Ubaldo and Fra Ranaldo, are named as having read and approved parts of the text, although their deaths are referred to within it.[2] The piecemeal nature of the composition is made clearer in a passage in which Fra Giunta seeks to comfort Margherita, at a time of spiritual affliction, by reading out to her some of the promises that God had previously revealed to her in their private conversations.[3] It seems that Margherita's confessor had kept a careful note of the visions she reported.[4] The practice probably continued during Fra Giunta Bevegnati's enforced seven-year absence from Cortona, which lasted from 1290 to shortly before Margherita's death.[5] During this time, when Margherita was living in her third cell, near the Rocca above Cortona, her confessor was no longer a Franciscan, but Ser Badia, rector of S. Basilio. Badia was a member of the secular clergy, and almost certainly also of the Franciscan Third Order.[6] The impression that Ser Badia recorded Margherita's visions[7] and then communicated them to Fra Giunta, would seem to be confirmed by Fra Giunta's reference to himself as an "unworthy *compiler*."[8]

We can deduce, therefore, that the material for the *Legenda* originally consisted of a series of working notes, only later to be reworked as a coherent account of the events and progress of Margherita's life. This would go some way to explaining the text's lack of narrative structure (already noted in Chapter 2). The first two chapters follow a roughly chronological form, and report some of the crucial points in Margherita's spiritual journey, but the remainder of the text seems to have no such pattern and consists, instead, of an accretion of separate visions and episodes. Da Pelago's painstaking study of the text clarified several points in the chronology of Margherita's life. We know that her years spent in relative reclusion (1288?–1297)[9] were preceded

1. Da Pelago, I, 340; 183 n.14, Iozzelli, 1997, 477–78.

2. *Legenda*, VII, 14 (Fra Giovanni, died c. 1289); IX, 36 (Fra Ubaldo, died c. 1289); I, 1 (Fra Ranaldo, died c. 1288). See da Pelago, I, 341.

3. *Legenda*, V, 19.

4. Fra Giunta was not her first confessor. Her spiritual supervision had previously been the responsibility of Fra Giovanni da Castiglione; other spiritual supervisors included Fra Ranaldo da Castiglione, and Fra Ubaldo da Colle. Da Pelago, II, 52–57.

5. The absence was presumably imposed on him by his superiors within the Order, who had already shown concern over his excessive contact with Margherita by limiting their meetings, under normal circumstances, to once in eight days. *Legenda*, V, 9. See also above, Chapter 2.

6. Da Pelago, II, p. 57. Da Pelago (51) believed that Ser

Badia, like all subsequent rectors of S. Basilio, was almost certainly a member of the Third Order.

7. *Legenda*, VII, 33.

8. ". . . ego infrascriptorum compilator indignus"; *Legenda*, VIII, 2. The declaration of authenticity also specifies, "hanc Legendam compilavit Fr. Juncta." Fra Giunta and Margherita certainly remained in contact during the time he spent away from Cortona, in the Siena convent: the contents of one of her letters to him there are alluded to in the *Legenda* text. *Legenda*, VIII, 8.

9. The reopening to the cult of S. Basilio, so near the site of her cell in 1290, at her request and insistence must, to some degree, have reduced her isolation. On the extent of her isolation see also the entry by Benvenuti-Papi, 1986, 180.

by busy years in two previous cells within Cortona, and by active participation within the religious and charitable life of the town. Yet, despite da Pelago's efforts, it is often impossible to know when or where an episode in the *Legenda* occurred. Although the *Legenda* is divided into chapters, each with a specific heading (for example, "De profunda ipsius humilitate, et contemptu sui"; "De timore indicibili circa omnia que gerebat, et desiderio finis sui")—implying that the material is arranged according to the different aspects of Margherita's spirituality (as discussed in Chapter 2)—in fact there is not always a clear distinction between the material included in different sections. This lack of order did not go unnoticed. Fra Giunta himself conceded in his introduction, "however, I respectfully urge the wise, that if they find something in this *Legenda* which is not in its right place, they should attach it to the chapters where it ought to be; for hampered, God knows, in many ways, I lacked the free time to put things in order."[10]

We learn from the declaration of authenticity, as discussed in Chapter 2, that the *Legenda* text was officially approved by the papal legate Napoleone Orsini in the Casali Palazzo in Cortona in 1308. By then parts of the text had already been revised by a number of people (some dead by 1308). The last chapter concerns Margherita's posthumous miracles, and it is clear from internal evidence that additions were made to this chapter after the approbation in 1308. Four miracles are said to have been reported, in front of witnesses, in 1310, and two in 1311.[11] No further dated miracles were added, and this may indicate that Fra Giunta died in that year when, according to da Pelago's calculations, he would have been at least seventy-two years old.[12]

The reports of the miracles give some insight into the shared supervision of Margherita's cult at this time. On 1 April 1304 a miracle was reported at Margherita's tomb in the presence of Ser Badia, Ser Costanzo, and suore Amata, Margherita, and Meliore (presumably Tertiaries).[13] On 19 and 27 May 1310, witnesses gathered in the cloister of S. Francesco in Cortona—not, it may be noted, in S. Basilio, the location of Margherita's shrine. They gave their testimony in the presence of several witnesses, of whom the first two to be named are Fra Giunta, and Ser Felice, the rector of S. Basilio after Ser Badia's death.[14] Presumably Fra Giunta kept a working copy of the *Legenda*

10. Prologue to the *Legenda:* "sapientibus tamen suadeo reverenter, ut quod invenerint in Legenda conforme non suo loco insertum, capitulis ubi ordinari debent, adiungant; cum multipliciter, Deus scit, impeditus, tempore libero carrerim ordinandi." The weakness of structure in the *Legenda* makes it unprofitable to compare the chapter divisions with the murals in S. Margherita as has been done, for example, in the case of the paintings of the life of Saint Francis in the Upper Church at Assisi and the arrangement of Bonaventura's description of Saint Francis's spiritual development in the *Legenda Major* in, for example, G. Ruf, *Franziskus und Bonaventura: Die heilsgeschichtliche Deutung der Fresken im Langhaus der Oberkirche von San Francesco in Assisi aus der Theologie des Heiligen Bonaventura*, Assisi, 1974, esp. 233–35.

11. *Legenda*, XII, 6, 33, 57, and 60; CM, 7, 34, 54, 55, 79, and 82.

12. Da Pelago (I, 333 n. 30; 337 n. 40) believed that the latest event included in the text of the chapter of miracles was the Calming of the Sea of Ancona which, although undated, he connected with the declaration of a tithe in support of a crusade at the Council of Vienne

in 1312. But, as argued below, the events described in connection with the miracle can plausibly be set in the years around 1307–8, and could thus belong with the main composition of the text. Da Pelago, (II, 54) believed that Fra Giunta's death should probably be dated soon after the last additions to the *Legenda*, but drew attention to a document of 1318 that mentioned a will, made previously, to which Fra Giunta was a witness. It is not known how much earlier the will in question was drawn up.

13. *Legenda*, XII, 37; CM, 38.

14. *Legenda*, XII, 33 and 6; CM, 34 and 7, 54. Ser Badia is last mentioned in 1304, Ser Felice is first mentioned in 1306. See da Pelago, I, 329, n. 24; II, 50. On unspecified dates in 1310 and 1311 three further miracles were reported, but the location is not given. Since all three cases included a promise to visit Margherita's shrine, they may have been witnessed in S. Basilio. One of the two miracles reported in 1311 was witnessed by Ser Felice, but Fra Giunta is not mentioned, which also implies that this report took place at S. Basilio. *Legenda*, XII, 57 and 60; CM, 55, 79 and 82.

text with him, adding items to the Chapter of Miracles as required, until his death (or disappearance) c. 1311. What happened to that working copy is not known. Of the three surviving fourteenth-century manuscripts of the text,[15] only one (Cortona, Archivio del Convento di S. Margherita, cod. 61) contains the Chapter of Miracles (although the table of contents of the other two manuscripts shows that they were intended to contain this chapter as well). Da Pelago reported that spaces were left in this manuscript (the smaller of the two still kept in the conventual library of S. Margherita) at the end of each section of the last chapter, to allow for further miracles to be added. But examination of the manuscript shows that this was not, in fact, the case: the manuscript is written in the same hand throughout, and shows no sign of a break in work.[16] This homogeneous production suggests that the manuscript is a fair copy of Giunta's working text, made at some time after 1311.[17] The declaration of authenticity, which is written on the same folio as the end of the index preceding the main text (Fig. 1), is written in a less formal hand, but does not appear to be substantially later in date.[18] There is no indication when this manuscript came into the possession of S. Margherita[19] but it is interesting to note that among the names of revisers listed in the declaration of authenticity, that of Ser Badia appears to have been added rather crudely to the list in a different hand (see Fig. 2).[20] This may simply have been the correction of a careless omission, but it may reflect the passing of this particular manuscript from the Franciscans of Cortona into the hands of the rector of S. Basilio, who wished to record the role his predecessor had played in the composition of the *Legenda*.

The conveniently portable format of codex 61 (c. 24 × 16.5 cm), and its inclusion of the Chapter of Miracles and of the declaration of authenticity, would have made such a book a suitable—indeed an indispensable—piece of baggage for a person traveling to Avignon in the hope of promoting a canonization process for Margherita. When in 1325 Ser Felice, rector of S. Basilio, was charged with this task, it was at the bidding of the Commune of Cortona.[21] By that date, therefore, the promotion of Margherita's cult—together, perhaps, with this very copy of the *Legenda*—had passed from the Franciscan friars of Cortona into the hands of the rector and owners of the Church of S. Basilio.

15. Two in the conventual archive of S. Margherita, one in the Biblioteca Comunale e dell'Accademia Etrusca, Cortona. I am most grateful to Padre Fortunato Iozzelli, who has prepared the new critical edition of the *Legenda*, for confirming that these appear to be the only fourteenth-century manuscripts of the text.

16. At the most there are erasures of a few lines at the end of a section. In most cases no space was left at all. I am most grateful to Padre Iozzelli for discussing and examining with me the script and codicology of the three medieval manuscripts of the *Legenda*.

17. Iozzelli, 1993, esp. 235, also concludes that cod. 61 in the conventual archive is an "apograph" (exact copy) of the original lost text of the *Legenda*.

18. Da Pelago (I, 341) argued that the declaration was written in Fra Giunta's own hand, possibly copied from a single leaf into a space in the manuscript of the *Legenda* text.

19. All three known fourteenth-century manuscripts of the *Legenda* were certainly in the convent library by the time of the Visitation of 1634. See ASV, *Riti*, Proc. 552, p. 516.

20. Da Pelago, I, 341, identified several other corrections to the text of the declaration, which he considered were made by the original hand. The addition of Ser Badia's name differs in appearance from those corrections.

21. See Chapter 2 and Appendix I.

11

The Panel Painting and the Funerary Monument

The Panel Painting

The large panel painting of Beata Margherita with scenes from her life (max. dimensions 197.5 × 131 cm) (Pl. II; Fig. 154), is of the type that has been termed either a "*vita*-icon" or "*vita*-retable." In other words it belongs with that design of panel painting, found in the early thirteenth century in Byzantium ("*vita*-icon") and shortly afterwards in the West, in which the large-scale standing figure of a saint is surrounded by small-scale narratives concerning his or her life and—in the West—miracles. The alternative terms for this type of painting reflect a continuing debate about its original function: when this type occurred in the West was it displayed on an altar (that is, as a retable), or did it only gradually assume that role?[1] To indicate the debts that the Margherita panel owes to such paintings without prejudging the issue, the term "*vita*-panel" will be used here.

1. For these terms see H. Hager, *Die Anfänge des italienischen Altarbildes*, Römische Forschungen der Bibliotheca Hertziana 17, Munich, 1962, chap. 5, esp. 94–100. Hager considers that such panels may have begun as pillar-paintings that subsequently became linked with side altars. He believes that such paintings were probably not connected with high altars until the end of the thirteenth century. Krüger, in his detailed study of Saint Francis panels and

Margherita's "*vita*-panel" is now displayed in the Museo Diocesano, Cortona. Although its original location is not recorded there is good reason to believe that it was made for the church of S. Basilio.[2] It is always cited as the earliest representation of the saint,[3] and is sometimes dated to the years immediately after Margherita's death in 1297,[4] although Garrison proposed a wider bracket: the first quarter of the fourteenth century.[5] The surface of the panel is severely abraded, with many areas of loss. At some time the panel evidently suffered fire damage, and the surface was then prepared for a thoroughgoing repainting (Fig. 143) which was only removed, revealing the medieval image beneath, during a restoration carried out by the Soprintendenza alle Gallerie di Firenze in 1946–47 (Figs. 144 and 145), before the painting was presented to the Museo Diocesano. The panel was restored again, with the supervision and financial support of the Soprintendenze per i beni ambientali, architettonici, artistici e storici di Arezzo, during the 1980s (Pl. II; Fig. 146). Despite the careful treatments it has received, the damage previously sustained by the painting makes it difficult to discuss the attribution of the work. Garrison's suggestion of "Tuscan (Cortonese[?])" for the artist, and Kaftal's "Sienizing master" are reasonable proposals, although made without supporting argument.[6] More recently Bellosi has linked the painting with the artist of two other existing works: a mural of the Crucifixion in the Forteguerri chapel of S. Maria Nuova in Viterbo (dated by inscription to 1288), and a panel of Saint

their role in the development of the form and function of Italian panel painting, has recently made the counterproposal that these works were always intended as altarpieces, but were only displayed—on the high altar of the church—on the feast day of the saint in question, and should therefore be regarded as "mobile" "feast-paintings." He argues that only subsequently did "*vita*"-panels influenced by the Saint Francis type (among which he numbers the Margherita panel) appear in use on side altars and in chapels. (K. Krüger, *Der frühe Bildkult des Franziskus in Italien*, Berlin, 1992, esp. chaps. 1 and 3.) For a consideration of the issues and a summary of Krüger's views, see H. Belting, *Bild und Kult*, Munich, 1990, 423–33, available in English as *Likeness and Presence*, trans. E. Jephcott, Chicago, 1994, chaps. 17 and 18, esp. 377–84. For stimulating proposals concerning an intercultural origin and purpose for *vita*-icons in the East, see the forthcoming paper by N. Ševčenko, provisionally entitled "The Vita Icon and the Painter as Hagiographer."

2. The earliest recorded provenance for the panel, found in the record of the Visitation of 1634 (ASV, *Riti*, Proc. 552, pp. 524–26) is the Monastery of S. Girolamo in Cortona, known as the Poverelle. This was a fifteenth-century foundation, for female Franciscan Tertiaries, closely connected with the Church of S. Margherita. Before the provision of a church, in 1570, the Tertiaries heard mass at S. Margherita, received their spiritual direction from there, and were buried there. Da Pelago regarded them as the direct descendants of Margherita and her first companions; the monastery was believed to oc-

cupy the site of Margherita's first cell in Cortona. It seems probable that the panel of Margherita passed directly from the Church of S. Margherita to the possession of the Tertiaries of S. Girolamo. See da Pelago, *Sommario*, "nota 3" and "nota 12." For the Poverelle see also the brief comments in A. Benvenuti Papi, "Le forme comunitarie della penitenza femminile francescana. Schede per un censimento toscano," in *Prime manifestazioni di vita comunitaria, maschile e femminile, nel movimento francescano della Penitenza (1215–1447): Atti del 4° Convegno di studi francescani, Assisi 1981*, ed. R. Pazzelli and L. Temperini, Rome, 1982, 410–12; reprinted as "Forme comunitarie," in Benevenuti Papi, 1990, 552–54.

3. For example, Nightlinger, 46; Guerrieri, 77–78.

4. See, for example, da Pelago, II, 39; Tafi, 478; G. Previtali, *Giotto e la sua bottega*, Milan, 1967, 133 n. 49; Maetzke, 1992, 27, "per evidenza di stile, di stesura pittorica e per le caratteristiche compositive non può varcare la soglia del nuovo secolo."

5. E. B. Garrison, *Italian Romanesque Panel Painting: An Illustrated Index*, Florence, 1949, no. 403, p. 154. This dating is repeated in the entry by A. Gianni in the exhibition catalogue *Sante e beate umbre tra il XIII e il XIV secolo*, Foligno, 1986, 109. Garrison listed the panel in the category "gabled dossal" and noted that it was one of the first examples of the indentation of the gable—a form that increased in popularity during the fourteenth century.

6. Garrison, 154; Kaftal, 1952, cols. 668–72. Kaftal, basing himself on a verbal attribution by Offner, dated the panel to the second quarter of the fourteenth century.

Francis, Saint Clare, and two archangels in the Galleria Nazionale dell'Umbria, Perugia.[7] Maetzke, in her entry for the recent catalogue of the Museo Diocesano, characterized the panel as the work of an unknown Aretine painter, possibly working at the end of the thirteenth century ("1298/99").[8]

Careful study of the surviving areas of the narrative scenes indicates that this was once a painting of considerable delicacy (for example, Fig. 152).[9] The lively treatment of the small-scale figures contrasts with the rather ponderous gravity of the main image, due in part to its function as the central figure of a "*vita*-panel," customarily shown facing directly forward.[10] It is hard now to appreciate the quality of the decorative detail of the incised gold ground of Margherita's halo, or the fluent patterning covering the red cloth before which she stands, but the panel was certainly of higher quality than its present state suggests.

The *Legenda* gives no direct help in dating the panel. Since we know that the text was compiled over a number of years, and begun even before Margherita's death, much of the material within it would have been available to the artist of the panel, long before the official approval of the text in 1308. Both Ser Badia and Fra Giunta would presumably have been able to instruct and advise the artist, if required. Moreover, the miraculous cures at Margherita's shrine, alluded to in the scene at the base of the panel (Fig. 166), had already received a general official recognition from the bishop of Chiusi in the year of Margherita's death,[11] and would therefore have been appropriate subject matter to include in a painting at any time from 1297 onward.

None of the individual miracles described in the last chapter of the *Legenda* and approved in, or after, 1308, is specifically represented in the panel. This may suggest that the panel was painted before that part of the *Legenda* was assembled. The omission of these posthumous miracles is noteworthy. Narratives emphasising thaumaturgic attributes—particularly miracles of healing—were staple fare in images of many saints and candidates for canonisation. The earliest *vita*-panels of Saint Francis, for example, all concentrate on his power to work miracles of healing, particularly in association with visits to his shrine.[12] Only after the initial growth of his cult was greater space devoted, in the Bardi Chapel Saint Francis panel, to other aspects of his life.[13]

The Margherita panel resembles the Bardi Chapel Saint Francis panel, rather than those

7. L. Bellosi, *La pecora di Giotto,* Turin, 1985, 193 n.15.

8. Maetzke, 1992, 27 and 35.

9. Maetzke, 1992, writing after the recent restoration, insists on the quality of the panel, and suggests the possibility of links between the formation of the artist in question and the circles of the S. Cecilia Master and Duccio. She also suggests a possible connection with manuscript illumination in Arezzo in the first half of the thirteenth century, and with the work of Ristoro di Arezzo.

10. Compare, for example, the contrast between the small-scale figures of the Beata Umiltà panel and the

large-scale central image. Illustrated in Volpe, ed. Lucco, 176–77.

11. Da Pelago, ii, 49.

12. For the development of the "*vita*-retable" in Italy see Hager, chap. 5. For discussion of the early Saint Francis panels, see W. B. Miller, "The Franciscan Legend in Italian Paintings in the Thirteenth Century," Ph.D. diss., Columbia University, 1961; and, recently, Krüger (whose disagreement with Hager's view of events is mentioned above, note 1); and C. Frugoni, *Francesco e l'invenzione delle stimmate,* Turin, 1993.

13. For two detailed interpretations of the Bardi Saint

earlier examples, in its choice of scenes. It gives a roughly chronological presentation of Margherita's religious life. Starting at the top left we see Margherita's arrival in Cortona, at Christ's bidding, to do penance (Fig. 147). Margherita kneels before the door of the convent of S. Francesco, while behind her stand two Franciscans in conversation. Margherita has her back turned to them, and looks up toward a figure, whose cross-nimbus shows him to be Christ, appearing in the top right corner of the scene. In the next scene this figure grouping is repeated (Fig. 147), but now the two Franciscans turn toward the kneeling Margherita, cutting her hair at the moment of her entry into the religious life, while before her stands another figure, probably also a Franciscan, emerging from the doorway of the Church of S. Francesco, to hand her a white object, presumably the veil of a member of the Third Order. The third stage in her conversion is shown in the next scene, where she embraces a life of poverty (Fig. 155). She has withdrawn to a humble cell, given her belongings to the poor and, with nothing left to wear, wrapped herself in the mat of reeds on which she slept.

The final scene on the left side, and the first scene on the right side, are difficult to interpret (Pl. II; Figs. 150 and 151). These scenes were evidently already badly damaged when the judges for the canonization process were shown the panel in 1634.[14] Kaftal identified the former as the Saving of the Suicide,[15] and the latter (tentatively) as Margherita preparing to wash the feet of some lepers.[16] Close study of the scene at the bottom left (Pl. II; Fig. 150) suggests that rather than representing the Saving of the Suicide, it forms a pair with the subsequent scene, illustrating different aspects of Margherita's struggles against temptation. Dressed, for the first time in the narratives, in the veil and cloak of a Tertiary and the checked dress of a Penitent,[17] Margherita kneels in prayer, looking toward her guardian angel, who gestures to her from the top right of the composition. A dragon—presumably the devil in one of the many forms in which he appeared to Margherita—attacks her by trying to climb up her knees. At the same time a layman, with white *cuffia*, fashionable red high-necked tunic and lavishly buttoned sleeves, holds up a round object to Margherita with his right hand, while gesturing with his left. It has been suggested this figure represents Margherita's guardian angel,[18] but in view of the worldly color and design of his clothes, he seems more likely to be another manifestation of the devil. Toward the end of the *Legenda* there is a lengthy description of a debate between Margherita, her guardian angel, and a devil dressed as a page from the "household" of the Inferno.[19] His

Francis panel see D. Blume, *Wandmalerei als Ordenspropaganda: Bildprogramme im Chorbereich franziskanischer Konvente Italiens bis zur mitte des 14.Jahrhunderts*, Worms, 1983, 13–17; and C. Frugoni, *Francesco: Un altra storia*, Genoa, 1988.

14. *ASV, Riti*, Proc. 552, p. 526.

15. Kaftal, 1952, col. 668. An identification accepted by Gianni, 109. The Visitation of 1634 identified the scene as the devil tempting Margherita with delicate foods. Nightlinger, 55, interpreted it as Margherita receiving gifts of food from the people of Cortona, to distribute to the poor. Maetzke, 1992, 27, follows Kaftal's identifications in this and all other cases.

16. Accepted by Gianni, 109. The visitors of 1634, and Nightlinger (55), considered it impossible to identify this scene.

17. For discussion of Margherita's clothing, see below, notes 34–35.

18. Unsigned and unpublished typescript notes supplied to E. B. Garrison, kept in the Garrison Collection, Courtauld Institute of Art, University of London.

19. *Legenda*, XI, 16; Iozzelli X, 16. Da Pelago, I, 311 n. 26, discusses the identification of this *domicellus*.

apparent attractions are set against Margherita's taunting of the devil for his ugliness, perhaps represented here by the dragon. The scene may also constitute a reference to the iconography of the much better established Saint Margaret of Antioch, who was frequently shown triumphing over the dragon of sin.[20] The object held by the figure in red has been interpreted as a piece of food.[21] The devil is said to have tempted Margherita from her austerities with the smell of delicate foods,[22] but this disc, painting in a dark tone and flecked with white, seems more likely to represent a mirror.[23] Margherita may be being shown her own beauty in order to distract her (her appearance was a source of pain to her, and she wished to mutilate her face).[24] Alternatively, this may refer to Margherita's epithet, mentioned in the *Legenda*, of "mirror of sinners."[25] When interpreting this and the following scene, it needs to be remembered that they may have been designed before the final composition of the *Legenda*. It may not, therefore, be possible to find a single or specific textual source. The visual narratives should be considered, rather, as a parallel to the text, reflecting the views and memories of Margherita that seemed, after her death in 1297, most crucial and vivid to those who who had known her and who tended her cult.

The first scene of temptation shows that Margherita had been fortified by her prayers, aided by the paternoster-cord looped over her joined hands. Having faced temptation and overcome it she is shown, in the scene at the top right, turning her head away from it, while holding up her hands to fend off the figures at the right (Pl. II; Fig. 151). The first of these, standing nearest to Margherita, has a white cap and white cuff buttons, and seems to have been dressed in red. This is presumably the same worldly figure as in the preceding scene, who appears to hold out his hands in a gesture of request that is answered in Margherita's gesture of rebuff. To the right are the remaining traces of a second figure, with two hooves, and perhaps even a third figure, representing the devil in yet another guise.[26]

Margherita's twofold rejection of the flesh and the devil leads, in the next scene, to Christ's absolution of her sins, through the merits of Saint Francis (Fig. 160). This absolution was, of course, a crucial stage in her spiritual journey. Margherita kneels before her cell, her head inclined, as Christ places his right hand on her head. To Christ's left, at the edge of the scene, kneels Saint Francis.

The following scene refers to Margherita's particular devotion to the Eucharist (Fig. 156). As she kneels before the entrance to her cell she is accompanied by two kneeling clerics, in liturgical dress, one holding a chalice and the other a pyx. Above them, in the top right corner, is a heavenly apparition. Kaftal identified this as the Eucharist brought to Margherita's cell during an illness by the parish priest of S. Marco or, alternatively, as the occasion on which Margherita was able to detect an unconsecrated host, brought to her cell by the parish priest of S. Giorgio, because of its lack of sweetness. After this disappoint-

20. See, for example, Katfal, 1952, cols. 661–66.

21. See above, note 15.

22. *Legenda*, v, 2.

23. This was suggested in the typescript notes referred to above (note 18) where it was thought to be intended to show the devil/dragon its own ugliness.

24. *Legenda*, ii, 15; Iozzelli, ii, 8.

25. For example, *Legenda*, v, 4. For further discussion of this epithet, see Chapter 2.

26. The devil was said to have appeared to Margherita in many forms. See, for example, *Legenda*, ii, 8; Iozzelli, ii, 2a.

ment she was comforted by Christ.[27] A further possibility would be the occasion when Margherita's guardian angel told her that Christ permitted her to receive the Eucharist every day in her own cell.[28]

Margherita's relation to Christ is also the theme of a third scene, which forms a suitable conclusion to the right side of the panel (Pl. II; Fig. 152). Kneeling before her cell, Margherita receives a vision of Christ and a female saint, with red tunic and blue robe (decorated with mordant gilding), wearing a pinkish veil and a circlet or crown on her head.[29] Christ holds the saint's right hand, and with their free hands they both indicate a throne, set between two seraphim, at the top of the scene. This appears to be a combination of three events recounted in the *Legenda*. In one vision, Christ showed Margherita the throne reserved for her in Paradise, flanked by two seraphim.[30] In another vision Margherita saw the Magdalene, wearing a crown and dressed in radiant garments, introduced by Christ with the words, "hec est filia mea dilecta."[31] In a third vision Christ told Margherita that the Magdalene is enthroned among the virgins in Paradise, second only to Mary and Saint Catherine of Alexandria, and that Margherita, too, will be enthroned among the virgins.[32] Thus the spiritual journey of penitence and absolution begun in the first scene at the top left of the panel, is concluded with Margherita's vision of a reunion with Christ, among the virgins, in Paradise.

At the centre of the base of the panel Margherita is shown on her bier, flanked to the left by a standing Dominican (Saint Dominic himself?) and probably originally to the right by a Franciscan (Saint Francis?) (Fig. 166). Below the bier can be seen two figures. The one to the left appears to be a cripple, making his way forward with the help of a wooden block held in each hand. The paint surface to the right is lost, but presumably this area showed one or more further figures coming to the shrine in search of a miraculous cure.

The "*vita*-panel" of St. Clare in the Church of S. Chiara in Assisi (Fig. 153) presents interesting comparisons with the panel of Beata Margherita (Fig. 154). The S. Chiara panel is a considerably earlier work, dated by its inscription to 1283, and attributed to an Umbrian painter (the "Maestro della S. Chiara" or a follower of the "Maestro di S. Francesco").[33]

The first impression is one of similarities between the two works. Both show, at the center of the panel, a full-length female figure facing forward, dressed in a religious habit.

27. Kaftal, 1952, cols. 668–72; *Legenda*, v, 26; vii, 26. No trace of the cross that would identify this figure as Christ is now visible in the halo.

28. *Legenda*, vi, 9.

29. This circlet is more clearly visible on photographs taken before the most recent restoration. This figure is identified, by Kaftal, as the Virgin, but is more likely to be the Magdalene, for the reasons set out below.

30. *Legenda*, iv, 13.

31. *Ibid.*, vi, 10.

32. *Ibid.*, iv, 15. For a discussion of the inclusion of the Magdalene among the virgins in Paradise in relation to the case of Beata Chiara of Rimini see Dalarun, 1994, 338 and n. 270.

33. Garrison, no. 393, p. 151; the exhibition catalogue *Francesco d'Assisi, Storia e Arte*, Comitato regionale umbro per le celebrazioni dell'VIII centenario della nascita di San Francesco di Assisi, Milan, 1982, 33; Bellosi, 1985, 34 n. 20, who explains that the indiction given in the inscription confirms the date of 1283. For excellent color reproductions see Bigaroni, Meier and Lunghi, 1994.

Margherita is dressed in the checked garment of a penitent,[34] with the white veil and long dark grey cloak of a female member of the Franciscan Third Order. She appears to wear the Franciscan knotted girdle of rope, only officially permitted to the Tertiaries in 1396.[35] The heads of both figures are flanked by flying angels. The left hand of both figures, placed across the stomach, with fingers curling inward, holds an object: for Saint Clare the staff of a cross, for Beata Margherita a string of paternoster-beads. The right hands of the two figures are also given identical gestures, with palms turned inward on the breast, and fingers extended toward the right. Corti has recently argued that this gesture signifies penitence, conversion, and acceptance of God's word; themes appropriate to both Clare and Margherita.[36]

In both panels four scenes are presented in columns to left and right, relating, in approximately chronological order, the religious life of the two women. (In the Saint Clare scenes the order of reading is from bottom to top in the left column, and from top to bottom in the right column.) In both paintings the second scene down in the left column shows the cutting of hair by a Franciscan (in Saint Clare's case by Saint Francis) as a sign of reception into the religious life (Figs. 147 and 148). The three figures in the Margherita panel derive from the equivalent figures on the Saint Clare panel.[37] Again the Margherita panel appears to be making a deliberate reference to the Saint Clare panel; even the order and direction of scenes may have been engineered so that the scene of Margherita's reception appears in the same position as the equivalent Saint Clare scene. But there is also a significant difference between the two scenes: the Margherita scene is sparsely populated. Only three friars are present, whereas the reception of Saint Clare is set inside the *Porziuncola*, and twelve friars (the first companions of Saint Francis) witness the event.

This marks a recurrent distinction between the two panels. In the Saint Clare panel the First and Second Orders of Saint Francis are represented by as many figures as possible in

34. For the use, in the *Legenda* text (VIII, 1) of the term *taculino* (italian: *taccolino*) for the checked tunic which Margherita wore, see da Pelago, II, 38–42, where a detailed consideration of all Margherita's clothing is supplied. A garment made of humble, undyed, black and white woven cloth, usually checked, but sometimes striped, was the dress of a penitent, and not, at that time, connected with any single order. (Compare, for example, the dress of Beata Chiara of Rimini, discussed in Davies, rev. Gordon, 71–72.) For Fabio Bisogni's detailed discussion of Margherita's clothing, with some corrections to da Pelago's interpretation, see Corti and Spinelli, forthcoming. For discussion of the significance and context of the checked cloth itself see the contribution by L. Gérard-Marchant in the same publication.

35. For the dress of a female Franciscan Tertiary, as specified in the Rule of 1289, see G. G. Meersseman, *Ordo Fraternitatis: Confraternite e pietà dei laici nel Medioevo*, Rome, 1977, 395. For a general discussion of the dress of Franciscan Tertiaries, drawing on wider textual sources,

see S. Gieben, "L'iconografia dei Penitenti e Niccolò IV," in *La 'Supra Montem' di Niccolò IV (1289): Genesi e diffusione di una regola. Atti del 5° Convegno di studi francescani, Ascoli Piceno, 1987,* ed. R. Pazzelli and L. Temperini, Rome, 1988, 289–304. For permission to wear the knotted cord, see J. Moorman, *A History of the Franciscan Order*, Oxford, 1968, 224. Da Pelago, II, 40, argues from the evidence of the *Legenda* that Margherita's belt did consist of a cord.

36. L. Corti, "Esercizio sulla mano destra: Gestualità e santi nel medioevo," *Annali della Scuola Normale Superiore di Pisa. Classe di lettere e filosofia* 26, forthcoming. I am grateful to Laura Corti for the opportunity to consult her paper in advance of publication.

37. Although Saint Francis gives Saint Clare her habit at the same time, while this action was performed by a separate figure on the Beata Margherita panel, perhaps to distinguish between acceptance by the Franciscans, and investiture in the Third Order, as discussed below, Chapter 14 in connection with the mural cycle.

the majority of scenes. When Saint Clare performs a miracle, it is a multiplication of loaves set in the monastery and witnessed by several sisters. When Saint Clare is on her deathbed she is granted a vision of the Virgin surrounded by female saints in Paradise, while two Clares look on. Another sister, Benvenuta, has a vision of Clare wrapped in a beautiful pall by the Virgin.[38] The *Legenda* of Margherita also described several visions granted to Margherita of the saints assembled in heaven. But in the Margherita panel we are shown instead a more austere apparition, including only Christ, the Magdalene, and Margherita's heavenly throne (Fig. 152). The scene of Margherita's prostrate body on her shrine also presents a contrast with the heavily populated funeral of Saint Clare, at which the pope officiates and numerous bishops and Franciscan friars participate (Figs. 153 and 154).

Saint Clare is constantly shown in her role as the founder of the Order of Clares, closely linked with the First Order of Franciscans. The significance of her life (like that of her sister, Agnes, related in the top right scene) resides most notably in her entry into and life within the Order, and the divine and ecclesiastical recognition granted to her, at the time of her death.[39] The contrasting sparseness of the Margherita panel does not appear to be simply the product of artistic incompetence or haste. The recurrent, dominant image of the later panel is that of the figure of Margherita, kneeling before her cell. Although the central image clearly presents Margherita as a Franciscan Tertiary, and she is accompanied both by Franciscans and, it seems, members of the secular clergy, it is not so much her relations with the Franciscan First or Third Order but her private spiritual journey, and her relation to Christ, on which the panel chose to focus.

This aspect of the Margherita panel is underlined by a comparison with another earlier "*vita*-panel," the Saint Mary Magdalene panel now in the Accademia in Florence, thought to have been painted around 1280 by a Florentine artist, the eponymous "Magdalen Master" (Fig. 163).[40] The comparison between Margherita and the Magdalene, both female sinners who repented, is drawn many times in the text of Margherita's *Legenda*.[41] It is the penitence of the Magdalene, and the importance of her example for sinners, which are stressed in the inscribed scroll held by the central figure on the Magdalene panel.[42] The eight flanking scenes relate her story from the anointing of Christ's feet, through episodes of her life in the wilderness (originally related to Saint Mary of Egypt), to her funeral. Two of the wilderness scenes present interesting precedents for the Margherita panel. Kneeling alone in the opening of her desert cave the Magdalene is brought the Eucharist, once by a

38. See Chapter 4 for the motif of a fine pall in the Beata Margherita panel.

39. For recent analysis of the content of the Saint Clare panel, not always sufficiently well informed, see J. Wood, "Perceptions of Holiness in Thirteenth-Century Italian Painting: Clare of Assisi," *Art History* 14 (1991), 301–28. Wood (314) sees two distinct themes in the panel: the voluntary nature of Clare's vocation and the Franciscan form of monasticism chosen by Clare and her nuns. Wood also notes that Clare is shown as an exemplar and intercessor (308), and that the panel focuses on her poverty and virginity (312).

40. Garrison, no. 404, p. 154. The panel was formerly in the Servite foundation of SS. Annunziata, Florence. For a concise discussion and further bibliography see the exhibition catalogue *La Maddalena tra sacro e profano*, ed. M. Mosco, Florence, 1986, 43–45.

41. See Chapter 2 and Chapter 14, note 39.

42. NE DESPERETIS. VOS QUI PECCARE SOLETIS.EXEMPLOQUE MEO.VOS REPARATE DEO (Do not despair, you who are accustomed to sin, and by my example, let yourselves be restored to God).

bishop, and once by an angel (Figs. 157 and 158). A further visual echo of the Magdalene in the wilderness, "clothed" only by her long hair, is to be found in the scene of Margherita, within her cell, wrapped only in her mat of reeds (Figs. 155 and 157).[43] A more oblique reference may be found in the scene of the Remission of Margherita's Sins (Fig. 160). Here Christ touches the penitent's head; but in the Magdalene's encounter with Christ in the garden, after the Resurrection (Fig. 159), the scene revolves around Christ's refusal to allow himself to be touched by the figure kneeling before Him: *Noli me tangere*. The closing scene on the Margherita panel draws a further parallel between the two women (Fig. 152). In this case Christ does hold the Magdalene's hand as He presents her to Margherita in a vision, assuring Margherita that she, like the Magdalene, will find a place in Paradise.

The original site of the Beata Margherita panel is not known, but the following observations may be made about possible settings and functions. There are two iron rings attached to the top cross-beam on the reverse of the panel. These rings, found on many other paintings in the period, formed attachment points for securing a panel to an architectural member or to an upright support on a rood beam, used to display paintings in a raised position.[44] A panel with such rings might thus have stood on or behind an altar, secured by ropes to a wall, pier, or post, but it could also have been designed to be independently supported on a wall, pier, beam, or screen. The physical evidence thus allows for the possibility that the Margherita panel may not have functioned initially as an altarpiece; although it may, like many other panels of the period, have come to serve as one. Krüger, in his recent detailed study of panel paintings of Saint Francis and their significance for the development of the form and function of other early Italian panel paintings, pointed to the Margherita painting as a key early example of the diffusion of the Saint Francis panel-types, in which the panel painting became directly connected with, and a permanent part of a *Reliquienaltar* (relic altar).[45] Krüger's use of this term implies that the Margherita panel functioned from the outset as an altarpiece but, as we have seen, Margherita's remains were not placed within a conventional altar structure.[46] The small Church of S. Basilio must have contained a main altar dedicated to Basilio (and the other saints mentioned in the foundation document) but it is by no means clear that there was room for a second altar, broad enough to support a panel 131 cm wide, contiguous with Margherita's resting place.[47]

43. Clothing in woven vegetation is also part of the iconography of the first hermit saint, Paul the Hermit, who is sometimes shown wearing a garment of woven palm leaves. See Kaftal, 1952, cols. 789–90; G. Kaftal, *Iconography of the Saints in Central and South Italian Schools of Painting,* Florence, 1965, cols. 861–62. The donation of clothing in this scene also echoes the iconography of well-established saints: Francis and, before him, Martin.

44. See Hager, chap. 8.

45. Krüger, chap. 3, esp. 69–70, 73, 96–99. For the differing views on the original function of "*vita*-panels" held by Hager, Krüger, and (following Krüger) Belting, see above, note 1.

46. Krüger (70) mistakenly believed that Margherita was buried from the outset in the new church the building of which, he stated, was completed in 1297.

47. As an uncanonized person Margherita was not, of course, entitled to have an altar dedicated to her, but, as discussed in Chapter 4, an altar was certainly in use below her tomb by 1343. It is not clear how much weight to give to the mention of Margherita's altar in a miracle that took place in 1304 and was subsequently reported in the *Legenda* "voveo, et tibi promicto, ipsum [the revived child] ad tuum deferre tumulum et cingere altare [*sic*] tuum"; *Legenda*, XII, 35; CM, 36.

Perhaps we should envisage the panel initially supported on a raised beam to aid visibility and access, or attached to the wall in the vicinity of the niche, but not necessarily forming a unit with it and not functioning, strictly speaking, as an altarpiece.[48] And it is possible that it was only after the translation of Margherita's remains that the panel took up a position on the main altar of the original church—which might have seemed appropriate at that point since, as we have seen, that building then became known as the Cappella di S. Margherita. Indeed, the panel may have been displayed in all three of these ways in the years following its production, depending on the location of the body, and the changing uses of the building.[49]

The possible connection between Margherita's painted image and her earthly remains has already been discussed in Chapter 4. There it was suggested that the panel may have formed a focal point for those visiting the shrine. The image, and its accompanying narratives, may also have had a particular significance for those using the church more regularly: the members of the Third Order living near to S. Basilio. As noted above, the earliest known mention of the painting, in the Visitation of 1634, shows that by that date it belonged to a group of female Tertiaries, closely linked with the Church of S. Margherita, who were considered to be descended from Margherita's first companions.[50] The spiritual journey toward heaven that the panel shows could serve as a pattern for members of the Third Order: conversion to the religious life; charity and austerity; prayer; rejection of temptation; penance and absolution—preconditions, as these Tertiaries would surely have known, to receiving the Eucharist, as shown in the following scene. These events in Margherita's life, which are related far from one another in the rather random arrangement of the *Legenda* text, are here presented in a sequence that gives them a clear value as a spiritual program. And the example proposed in these scenes from Margherita's life would seem to be emphasised by the inscription at the base of the panel: S͠A MARGARITA DEVOT[A] MULIER.[51] In the opening chapter of the *Legenda* Margherita herself prophesied to her female companions that after her death her sanctity would be acknowledged by the visits of pilgrims. Fra Giunta confirms that this sanctity has, indeed, been manifested in the visits made not only by men hastening from different places, but also by the many women who have come, with devotion (*devote*), to visit her body and her tomb.[52]

In considering the audience for the panel, one may thus envisage more than one type of viewer. The darkening of the paint surface at the base of the panel strongly suggests fire damage. This might be the legacy of the many candles lit beneath the image, perhaps by pilgrims in hope of—or gratitude for—a cure. But the paternoster-cord held by Margherita in the central image, and in at least three of the narratives, (Margherita Tempted by the

48. For a photomontage suggesting that the panel was displayed directly above the tomb niche, see Mori and Mori, 1996, 35, fig. 2.

49. The repeated image of Margherita's cell, shown six times in the panel, would be appropriate in a work made for the group of buildings that included the structure of the original cell.

50. See above, note 2.

51. MULIER has sometimes been read as MINORUM, but since the two restorations of the panel, the reading MULIER is clearer. Moreover, this was the inscription reported in the Visitation of 1634, ASV, *Riti*, Proc. 552, p. 525.

52. ". . . etiam in multitudine mulierum devote venientium ad suum corpus et tumulum visitandum"; *Legenda*, 1, 3; Iozzelli, 1, lc.

Devil; Margherita Receiving the Eucharist; Margherita's Vision of the Throne Reserved for her in Paradise (Figs. 150, 156, and 152)) may indicate one of the forms of prayer specifically encouraged in members of the Third Order who contemplated this image. Margherita herself repeated the Pater Noster many times during the day,[53] and the statutes of the Order of Penitence approved for the use of Franciscan Tertiaries by Nicholas IV in 1289 instructed those members of the order unable to recite the canonical hours daily to say the Pater Noster at the appropriate times instead.[54] The presence of a Dominican beside Margherita's bier reminds us that the statutes of the *Ordo poenitentia* were approved for the use not only of those attached to the Franciscan Third Order, but also served as the starting point for the rule of the Dominican Third Order, in the 1280s.[55] Those belonging to the order in Cortona may well have felt an allegiance to the spiritual direction of both main orders of friars within the town.[56]

Members of the Order of Penitence were probably also active in the development of the practice of singing *laude*. One of the earliest surviving compilations of *laude* comes from Cortona, and among these songs is one addressed to Margherita. The importance of Margherita's spiritual example, and in particular her rejection of temptation, aided by prayer and divine encouragement, shown in two scenes on the panel (Fig. 150 and 151), form the theme of one of the verses of this fourteenth-century *lauda*:

> Con umeltança a lei venne el nemico:
> sutilmente entrava ad engannare
> ed aparea a lei como romito
> le sue parole spirituale a conciare
> trovolla stare' ferma ad oratione
> chiamava el suo Signore che dicea posança.[57]

> (In humble guise the devil came to tempt her
> Cunningly he entered to deceive her

53. See, for example, *Legenda*, v, 8; vi, 12, 13, 14 (for extensive repetitions, in groups of one hundred).

54. Meersseman, 1977, 397. For the link between the paternoster-cord and the recitation of the Pater Noster and the Ave, see ibid., 1145 and n. 3.

55. For the texts of the three sets of statutes see Meersseman, 1977, 394–408.

56. The earliest reference to the Church of S. Domenico in Cortona dates from 1264. For this and further references see Inga, 52 n.13. The Dominican convent was only officially founded by the provincial chapter in 1298, but the official recognition of a new house normally occurred some years after the establishment of a locus. See Cannon, 1980, 354. Another example of the representation of both Saint Dominic and Saint Francis on a panel painting of a thirteenth-century lay *beato* is found on the late thirteenth-century painted shutters from the shrine of Beato Andrea Gallerani (d. 1251) (Fig. 174). In this case

the painting, which commemorated a lay penitent who was not a member of either a Dominican or a Franciscan Order, was located in the principal Dominican church in Siena. The significance of both mendicant orders for Gallerani's spirituality seems to be one of the points being alluded to on the shutters. For further discussion of this work see Cannon, 1980, 197–98 and 209–10; and Cannon, "Dominic *alter Christus?* Representations of the Founder in and after the *Arca di San Domenico*," in *Christ Among the Medieval Dominicans*, ed. K. Emergy Jr. and J. Wawrykow, Notre Dame, Ind., 1998, 26–28.

57. From the version of the lauda "Alegramente e del buon core" found in the Laudario cod. 180, Fraternità dei Laici, Biblioteca Comunale, Arezzo, principally compiled in the fourteenth century. See *Laude cortonesi dal secolo XIII al XV*, ed. G. Varanini, L. Banfi, A. Ceruti Burgio, 2, Florence, 1981, 255.

Dressed as a hermit he appeared to her
Spiritually her words to shape
He found her motionless in prayer
She called upon her Lord who bade her rest.)[58]

The Funerary Monument

In the case of Beata Margherita's funerary monument (Pl. III; Fig. 32) there is no doubt that image and narratives were connected with the site of Margherita's burial. Six scenes are included. Five of these are similar, although not identical, to images on the Margherita panel. But the use of fewer scenes, necessitating omissions, means that the marble reliefs differ in emphasis, in some respects, from the panel-painting narratives. Margherita's conversion is shown first by her Reception into the Order and then by her Donation of Clothing to the Poor. Between these two scenes is the Absolution of Margherita's Sins through the Merits of Saint Francis, and after this is the Death of Margherita and the Reception of her Soul into Heaven. Below the main chest, in two longer, lower, rectangular panels, are two scenes showing a variety of maladies being cured at her shrine.

The simplicity already noted in the panel scenes is even more marked here. The elegant figures of the funerary reliefs are, for the most part, set against undifferentiated backgrounds. This presumably improved the legibility of the scenes, set high on the wall, within a dark church interior. In the Profession and Investiture of Margherita, three figures are set against a flat ground (Fig. 149). The Franciscan presence is pared down to a single friar, cutting the hair of the kneeling Margherita, who crosses her arms on her chest in prayer.[59] She faces the taller, bulkier figure to the right, who holds her robe. He wears a close-fitting cap, and is not dressed as a Franciscan. His voluminous hooded cloak indicates that he is a *mantellato*: a male Franciscan Tertiary.[60] In this relief Margherita's robing as a member of the Third Order is given equal emphasis with her relation to the First Order.

The second scene shows Margherita before her cell; a structure built of ashlar masonry, with an arched entranceway and a tiled roof (Fig. 161). She stoops rather than kneels, as Christ places His hand on her head. His other hand rests on that of the kneeling Saint Francis, but Christ turns his back on him so that, as in the panel, it is the direct communication between Christ and Margherita, rather than the intercession of Saint Francis, that is emphasised. The same cell, seen from a slightly lower viewpoint, is repeated in the scene Margherita Gives her Possessions to the Poor (Fig. 164). Only two women, one young

58. The meaning of some of the words in this verse is obscure. In translating them I have generally followed the modern Italian editorial suggestions in Varanini et al. The meaning of the last word—*poscança*—is particularly unclear: the Varanini edition suggests "rest" or "peace." I am grateful to Giovanni Freni for his advice on this translation.

59. See *Legenda*, vi, 9, for a description of this gesture as one of prayer, suitable for use during the mass.

60. For the instructions in the statutes of 1289 concerning the dress of male Tertiaries, see Meersseman, 1977, 395, and for a discussion based on wider textual sources see Gieben, 289–304, esp. 300–302. For the term *mantellato*, see da Pelago, ii, 73.

and one old, are shown, rather than the three figures of the *vita*-panel. The treatment of Margherita's mat of reeds, however, is similar in both examples.

In the scene of the Death of Margherita, not shown on the panel, there is no setting beyond a simple bed set on a rocky ground (Fig. 188). The priest, with open book, standing at Margherita's head, has a cap and cloak like those worn by the man on the right in the opening scene. Presumably this is Ser Badia, the first rector of S. Basilio, almost certainly a member of the Third Order and, as we have seen, Margherita's confessor for the last seven years of her life.[61] At Margherita's feet stands a veiled female who is presumably also a Tertiary. In the upper part of the scene Margherita's soul is represented, carried in a cloth by angels, and crowned by Christ. The visions of future glory shown in the panel painting are here replaced by the ascension of Margherita's soul directly to Paradise, also reported in the *Legenda*.[62]

The two lower reliefs, which show scenes of healing at the shrine of Beata Margherita, are distinguished from the scenes on the chest above. They are longer and lower in shape, and set back in the more shadowy area between the consoles that support the tomb chest (Pl. III; Figs. 167 and 169). In a sense they appear subsidiary to the main cycle, providing a predella-like area. But, like a predella, their relatively low location means that they were well placed for reading by those close to the monument. Their position also brought the two scenes close to Margherita's remains, immured in the wall below, and placed them above the altar associated with monument and tomb.[63] The subject matter of these more accessible scenes also differs from those above: they present posthumous miracles at the site of Margherita's first shrine. Whereas the four upper reliefs each relate specific events, the lower relief on the left shows, simultaneously, three figures seeking cures at the shrine (Fig. 167). These supplicants cannot be identified, but their afflictions recall the section headings in the Chapter of Miracles of the *Legenda*: "Delivery of those with nervous contractions or lameness"; "Resuscitation of some and rescue of others from the jaws of death"; "Cures of the sick and suffering"; "Cures of fools and mutes." These figures thus represent categories of miracles that occurred at the shrine, offering a parallel to the repeated statement in the last chapter of the *Legenda* that those visiting the tomb of Beata Margherita, or vowing to do so, were cured. The scene on the right recalls the chapter heading "Liberation of people from devils," and again applies to a group of miracles (Fig. 169).

Comparison of the Narratives of the Panel Painting and Funerary Monument

The scenes chosen for the funerary monument, and the manner of their telling, present many visual similarities with the Margherita panel, but also certain shifts of emphasis. As

61. See above, Chapter 2 and the introduction to Part V.

62. *Legenda*, xi, 20; Iozzelli, x, 19.

63. For discussion of the altar, see Chapter 4.

discussed in Chapter 4, the type of funerary monument chosen for Margherita, and its position, presented her both as the focus of a cult and as an honored citizen. These two aspects are also taken up in the individual reliefs. The scenes of temptation, prayer, and devotion to the Eucharist, shown on the panel painting, are not included here. The scene of the donation of clothing to the poor demonstrates Margherita's charity to the needy, as much as her asceticism. Margherita's victories, not her struggles, are represented: she gains absolution for her sins, and at her death Christ receives her directly into Paradise.

In both the panel and the marble monument, the importance of Margherita's shrine as a place of miraculous cure is presented in a distinct area at the base (Pls. II and III; Figs. 32 and 56). The panel painting places the supplicants in a subsidiary position below the bier, with the flanking figures of the Dominican and Franciscan possibly referring to a funeral service (compare the funeral service in Scene iv of the fresco cycle, Figs. 186 and 189). But the sculpture devotes two scenes to the miracles, and gives more prominence to those visiting the tomb. A separate scene, on the chest above, was used to show Margherita's death, with male and female Tertiaries chosen, in this case, to flank the saint's body (Fig. 188). While the *Legenda* stressed that Margherita's Franciscan confessor, Fra Giunta, would be with her at the time of her death,[64] it is a *mantellato*—presumably Ser Badia—who administers the last rites in the marble relief. Reference is thus explicitly made to the church and personnel of S. Basilio. Margherita's cell, the structure of which was incorporated into the church to the west of the funerary monument, is shown twice,[65] and members of the Third Order appear in two of the reliefs (Figs. 149 and 188).

As discussed in Chapter 4, the funerary monument cannot be securely dated now that it has been dissociated from the previously accepted, but incorrect, dating of 1362. This opens up the question of the relative chronology of panel painting and funerary monument. The similarities between the two works indicate that one was produced with some knowledge of the other.[66]

Within the modest setting of the first Church of S. Basilio a relatively inexpensive panel painting could have served to present Margherita in the familiar, haloed, form of a saint;[67]

64. *Legenda*, v, 40.

65. The distinctive roof, covered with irregular slates, is identical in appearance to a small remaining portion of medieval roof on the north side of the *cappella maggiore* (Figs. 19, 161, and 164).

66. The more modest artistry of the panel, accentuated by its poor condition, might, at first sight, suggest that it borrowed ideas from the tomb. For example, the awkward setting of Saint Francis in the painted scene of the Absolution of Beata Margherita's Sins might be a weak version of the more explicit composition in the relief (Figs. 160 and 161). But a more plausible explanation would seem to be that the sculptor was improving on a significant, but poorly expressed motif in the panel painting.

67. The distinction between the halo of a saint and the rays used for an uncanonized *beatus/beata* developed during the course of the fourteenth century, after the time at

which this panel was produced. See Vauchez, 1981/1988, 101 n. 9. For further discussion of the representation of uncanonized persons see below. Later in the fourteenth century there is one representation of Margherita that attempts this distinction: the chalice commissioned on behalf of the *soprastanti* of S. Margherita from the Sienese goldsmith Michele, in the years 1372–73 (Bornstein, 1990, 241–43) includes a translucent enamel that shows Margherita with a polygonal halo (Fig. 190)—a form more often used for allegorical figures. (The figure of Margherita, and her unusual halo, are barely visible at the center of the base of the chalice in Figure 190. For a good reproduction see the exhibition catalogue *Arte aurea aretina: Tesori dalle chiese di Cortona*, ed. M. Collareta and D. Devoti, Florence, 1987, 23, fig. 18.) For a similar halo used in a frescoed image of Nicholas of Tolentino, see Bisogni, 1987, 268 n. 52.

to explain to pilgrims the story of the holy woman; and to act as a focus for pilgrims and Tertiaries alike. Da Pelago's belief that the panel was painted immediately, or soon after Margherita's death in 1297 cannot be confirmed,[68] but certainly gains support from our knowledge of the immediate recognition given to the cult, at the time of Margherita's death, by the people of Cortona and the bishop of Chiusi, and from the content of the narratives, discussed above. The panel may have been produced during Ser Badia's lifetime (he was still alive in 1304, and Ser Felice appears to have taken over from him in 1306)[69] and would thus reflect the earliest phase of the cult: a visual counterpart to the text being prepared by her other surviving confessor, Fra Giunta.

The funerary monument, in contrast, seems likely to belong to a later moment, when a much more costly work, longer in the planning and execution, could be paid for from the funds being amassed from a variety of sources for the new church.[70] The concentration on Margherita's private pilgrimage of penance and prayer, so vivid to her spiritual supervisors Giunta and Badia, is here overtaken by a vision of her relation to, and importance for others. Perhaps the conception of the tomb reflects a new emphasis in the cult in the years following the approval of the *Legenda* text and the deaths of Badia and Giunta, when—as discussed above—the goal of her canonization was to be vigorously pursued by the Commune and their emissary, Ser Felice.

A dating for the panel within the first decade after Margherita's death in 1297 seems appropriate. As for the funerary monument, a dating within the second or third decades after her death would fit the evidence. The nave of the new church was probably complete, and thus ready to receive her remains, at some time after 1308 and before 1318; as we have seen, however, the translation would not necessarily have taken place as soon as the new building was finished.[71] And we should bear in mind that since Margherita's remains were immured separately from the marble monument, the translation of the body and installation of the sculpture above it could have taken place at different times.

If Margherita's tomb was the work of the sculptor Gano di Fazio, as Bardotti Biasion argued, then it cannot have been carved after 1318 since Gano was certainly dead by some time in that year.[72] A lack of documentation concerning S. Basilio in the years leading up to 1318 means that it is not possible to assess this attributional dating in relation to any other facets of the development of Margherita's cult. But in the years immediately following Gano's death we find a number of indications that provide a plausible context for the commissioning of the tomb. The letter issued by twelve prelates at the Curia in 1318, favoring those visiting S. Basilio or contributing to its furnishing or embellishment, was more valuable and widely applicable than previous indulgences. It indicates a move from expenditure on construction to furnishing at S. Basilio, and marked a significant advance in the wider recognition of Margherita's cult.[73] In 1324 the commune voted an unspecified sum *pro ecclesia Sancti Basilii augmentanda*—the one recorded trace of what appears to have

68. Da Pelago, II, 39. He may be the unacknowledged source of the date of 1301 given for the panel by Mezzetti, 362, and Mariani, 264.

69. Da Pelago, II, 50.

70. See Chapter 3.

71. Ibid.

72. See Chapter 4, note 103.

73. See Chapters 2 and 3.

been a regular donation.[74] In the following year the commune made elaborate provision for the celebration of Margherita's feast day and resolved to send Ser Felice to Avignon to seek Margherita's canonization.[75] The provision of a marble funerary monument could have accompanied,[76] or even slightly preceded, these dated events, providing a focus for civic ceremonial and anticipating the opening and successful conclusion of a canonization *processus* which, in the event, did not materialize for several centuries.

74. See Chapter 3.

75. As discussed in Chapter 2 and the introduction to Part V. See Appendix I.

76. In which case the tomb might be attributed to a Sienese sculptor whose name is not known but who was also responsible for the Beato Gioacchino tomb reliefs (Figs. 30 and 31). For the dating of those reliefs in relation to the development of Gioacchino's cult, see Chapter 4, note 137.

12

The Mural Cycle: Overall Program and Arrangement

The view of Margherita's life and miracles presented to visitors to S. Margherita by the marble funerary monument was augmented, probably—as we have seen—in the fourth decade after her death, by the large-scale murals that covered the north and south walls of the *cappella maggiore* and one bay of the south nave wall.[1] This ambitious scheme appears to be the earliest known example of a fresco cycle devoted exclusively to the life and miracles of an uncanonized person covering the walls of the *cappella maggiore* of a central Italian church.[2] Although there was considerable latitude in the representation of uncanonized persons as saints in the thirteenth and early fourteenth centuries, and the distinction between the halo of a saint and the rays appropriate to an uncanonized person had yet to be formalized, criticisms of the tendency to "canonize by painting" were being

1. For the approximate size of the individual scenes, see Chapter 7. As discussed below, the decision to extend the cycle to the south nave wall may have been taken after the *cappella maggiore* had been decorated.

2. The decoration of the Cappella di S. Croce in the Church of S. Chiara in Montefalco, originally the *cappella maggiore* of the earlier church building, executed c. 1333, includes images of Beata Chiara of Montefalco, two of her visions (e.g., Fig. 180), one scene from her early life and the scene of her death, but these are interspersed among other images and scenes concerning various saints, the Virgin and Child, and the Crucifixion. For a full description of the decorative program, and a discussion of the date, see Gordon, 1979, 239–58.

voiced, showing that certain viewers were well aware of the distinction.[3] An early example is the Franciscan chronicler Salimbene, writing about late thirteenth-century Lombardy and Romagna. He deplored the role of the secular clergy in encouraging cults that had no papal recognition and considered paintings of such persons, on the walls of churches and public buildings, to be culpable encouragement of these cults.[4] At the Franciscan General Chapter of 1307 the minister general, Gonsalvo of Valboa, specifically tried to prevent—or remove—representations of uncanonized persons shown with haloes.[5] In Margherita's case the interests of the secular clergy may have overruled the qualms felt in certain Franciscan circles. On her "vita-panel" she was represented with a halo and called sancta, and the mural cycle was a highly conspicuous public statement of Cortonese confidence and pride in Margherita.

The subjects chosen for this extensive series of narratives built on the existing examples of the panel painting and, more closely, the marble reliefs, but various facets of Margherita's story hardly touched on in those works were given particular emphasis in the mural scenes. This chapter and the two that follow will consider both the choice and arrangement of the murals, and their relation to the Legenda text.

The reconstruction of the painted decoration of the walls of S. Margherita has already been discussed in Chapters 6 and 7, but it is necessary to consider briefly here the possibility that the watercolor copies may represent either less or more than the initial scheme. The condition of several scenes was very poor at the time that the watercolor copies were made, and two scenes disappeared completely between the execution of the copies and the Visitation of 1634. Other murals in the church could well have been lost before the copies were made. Paintings representing the miracles of Margherita could also have been added to the original sequence of scenes. It could be argued that the payments published by Bornstein (discussed in Chapter 7) relate to just such an addition, made either on the east wall of the cappella maggiore (for which no decoration is now recorded), or possibly at dado level on the north or south walls, in the years 1370–71.[6] The following discussion, however, relates only to those paintings recorded by the seventeenth-century copyist. Although this evidence may be incomplete, it will be argued below that, at least in the case of the cappella

3. For the gradual process of making such distinctions, both in general practice and specifically in images, and for the lack of doctrinal restraint on such images, see Vauchez, 1981/1988, 99–115 and 524–29. See also the remarks in Bisogni, 1987, 267–68.

4. Salimbene de Adam, Cronica, ed. G. Scalia, Bari, 1966, II, 733–34, discussed in Vauchez, 1981/1988, 100–101.

5. Cited in J. Gardner, "The Cult of a Fourteenth-Century Saint: The Iconography of Louis of Toulouse," in I Francescani nel Trecento. Atti del XIV Convegno, Società internazionale di studi francescani, Assisi, 1986, Perugia, 1988, 170 n. 4. For some further examples, and contemporary criticisms, see Krüger, 78–82.

6. If made at dado level, these paintings might have been hidden behind seating placed against the walls of the cappella maggiore in the post-Tridentine rearrangement of the high altar and choir. They would thus have been obscured from the artist of the watercolor copies and the Visitors of 1634. The subject matter, described in the payments as "e miracholi" and "la storia" (Bornstein, 1990, 239–41) may have taken the form of ex-voto images painted on behalf of individual visitors to the shrine. (Ex-voto panels certainly existed around the tomb. See ASV, Riti, Proc. 552, pp. 502–3.)

maggiore frescoes, we seem to have the record of a self-sufficient and coherent set of scenes. By using the copies we have at least some prospect of advancing the discussion. To go beyond noting the possibility, even the probability, of further lost scenes, to an attempt to guess what they might have looked like, would be to enter wholly the world of the imagination.

A basic distinction between the subjects chosen for the mural paintings on the three walls is immediately apparent from the copies (see the photomontage reconstruction, Figs. 201–203). The north wall of the *cappella maggiore* presented a summary of Margherita's life similar to that found in the nearby funerary reliefs. Her conversion to and perfection within the religious life, shown in the first three scenes, repeats the Profession and Investiture, Absolution from all Sins, and Donation of Possessions to the Poor found in the reliefs (Figs. 184, 185, 161, 162, 164, and 165). The Funeral of Margherita and her Ascension into Paradise are divided, in the fresco cycle, into two scenes, comprising a funeral with a large congregation (Pl. IX; Fig. 189), and the witnessing of the Ascent of Margherita's Soul by the Man of Città di Castello (Fig. 187). On the facing (south) wall of the *cappella maggiore* are presented six scenes not previously shown. These all represent miracles performed posthumously by Margherita.

In contrast to the clearly divided subjects of the two walls of the *cappella maggiore*, the frescoes of the south nave wall are a combination of events from during and after Margherita's life. They comprise her initial conversion to the religious life, three of the four miracles said to have been performed during her life, her association with the Confraternity and *Ospedale* of the Misericordia, three posthumous miracles and, most unusually, a scene showing the Visitation of Napoleone Orsini to investigate her life and miracles in 1308, as a step in her canonization process.

The frescoes of the south nave wall thus go over the same chronological ground as those of the *cappella maggiore*, from Margherita's conversion, through her life, to her posthumous miracles. This retracing raises the question of whether the frescoes all formed part of a single campaign. The analysis of the scenes given in Part IV indicated that, allowing for all the difficulties inherent in assessing the copies, the frescoes appear to have been artistically homogeneous. But this supposition need not imply that the frescoes were all executed at the same moment.

If we look again at the decoration of the *cappella maggiore* we see a coherent, carefully balanced program that presents, in a limited space, key elements from the story of Margherita. The scenes chosen for the north wall reflect the established iconography of Margherita's earthly career and its virtues; those on the south wall show her posthumous miraculous powers, represented at length for the first time, as a further proof of her sanctity. In the nave, as we have noted, the story goes back to the beginning again, to the theme of Margherita's conversion, but an earlier scene from that process, Margherita's decision to go to Cortona to do penance, is presented. Throughout the south nave wall there is no repetition of events used in the *cappella maggiore*. This makes the south nave wall a less satisfactorily self-sufficient account of Margherita. The choice seems, rather, to complement the account

of Margherita given in the *cappella maggiore*, and the selection of scenes seems to have been made in the light of those chosen in the *cappella maggiore*.

The following explanation may be proposed. Initially the decision was made to decorate the *cappella maggiore* with a fresco cycle concerning Margherita. This was a bold plan; as noted above, the dedication of the walls surrounding the high altar exclusively to scenes of a near contemporary figure, who was as yet uncanonized, may have been unprecedented. A program was carefully planned and the resulting cycle was considered a success. Encouraged by this achievement, funds were provided for further decorations planned soon, or even immediately after the completion of the *cappella maggiore* paintings.

The selection of scenes for the south nave wall needed to take into account not only the subjects already shown in the *cappella maggiore*, but also the difference in site. Situated on the wall opposite the tomb, they could be viewed in conjunction with the tomb reliefs (a further reason for omitting the scenes from Margherita's life shown there and in the *cappella maggiore*.) In the nave the paintings were not only more accessible to the laity,[7] but may also have provided a useful rallying point for pilgrims waiting, on busy days, to approach the tomb. (The sequence of the two lunette scenes on this wall (xi and xii) leads from right to left—that is, from west to east—perhaps indicating the direction from which the pilgrims approached.) The choice of scenes on this wall seems appropriate to a lay, local, and pilgrim audience, including several scenes making topographical reference to Cortona, and showing Napoleone Orsini confirming the miraculous benefits conferred through a visit to Margherita's shrine.[8] (These points will be discussed further.)

There is a further indication that these frescoes may primarily have been addressed to a specific audience. While the scenes in the *cappella maggiore* were accompanied by rather elaborate rhymed Latin inscriptions, those in the nave were provided with more direct, even exhortatory, captions, written in the vernacular. These inscriptions will be discussed in more detail below (and all the surviving inscriptions are transcribed in Appendix III). One example from each group will serve here to give the flavor of the contrast:

Cappella Maggiore, Scene i:
DIVINOS HABENS FERVORES / AD FRATRES MARGARITA RECURRENS MINORES SU[B]MICTENS RELIGIONI COLLUM / MARGARITA VITIA RENUNCIAT ET MUNDUM

South Nave Wall, Scene xiii:
COME UOMO DISPERATO S'IMPICO SE MEDESIMO SANCTA MARGARITA EL VIDE PER SPIRTO QUANDO ESSO S'EMPICAVA ACURSE LI CON DOI SUORE

7. There is, however, no evidence that a tall screen of the type used in the churches of the mendicant orders existed at this time in S. Margherita. If any formal structural division existed between nave and choir, we should probably envisage a low screen of the type represented in Saint Francis Praying before the Cross at S. Damiano in the Upper Church of S. Francesco at Assisi (illustrated in Poeschke, fig. 147).

8. Compare the choice of decoration in the burial chapel—*cappellone*—of S. Nicola da Tolentino (d. 1305). Bisogni (1987, 268 and 259) has argued that a division of content reflects a distinction of expected audience, with the scenes of Nicola's life directed primarily at the Augustinian friars, and the miracle scenes (more akin to ex-voto paintings than the Margherita miracle scenes) directed primarily at pilgrims. The choice of scenes in the Nicola cycle divides roughly equally between miracle scenes and scenes of Nicola's life.

Perhaps the change in the language and style of the inscriptions was also connected with the relative chronology of the two parts of the decorations. The carefully worked Latin of the *cappella maggiore* may have proved too difficult for many visitors to the church, as well as members of the Third Order, who may have preferred some more direct assistance in understanding, or explaining to others, the stories of Beata Margherita.

13

Margherita as Miracle Worker: The Choice of Scenes in the Mural Cycle and the Chapter of Miracles of the *Legenda*

One of the most obvious differences between the *Legenda* and the fresco cycle is the proportion of space devoted to Margherita's miracles. In the *Legenda* only the final chapter is concerned exclusively with her miraculous cures and interventions. Only one of these miracles (the Liberation from Devils of the Boy from Borgo San Sepolcro) is also mentioned in the main body of the *Legenda* text, and this event, which took place during Margherita's lifetime, is mentioned there as much for the light it cast on Margherita's humility as for its miraculous qualities.[1] The Chapter of Miracles has a character quite distinct from that of the rest of the *Legenda* text. It appears to have been written in accord with the *forma interrogatorii* used to gather evidence for a canonization process.[2] As discussed above, it also appears to be, at least in part, an addition to the original text, and is only included in one of the three existing fourteenth-century manuscript copies of the *Legenda*.[3]

In the murals, on the other hand, the miracles formed a major and integral part of the

1. *Legenda*, iv, 6.
2. See Vauchez, 1981/1988, 58–64, esp. 59 n. 70.

3. See the introduction to Part V.

program. The south wall of the *cappella maggiore* was devoted to five of Margherita's posthumous miracles. On the south wall of the nave three miracles attributed to Margherita during her life were shown together with two other events from her life and a selection of further posthumous miracles (see photomontage reconstruction, Figs. 202 and 203).[4]

The South Wall of the Cappella Maggiore

The last chapter of the *Legenda* is divided into ten sections, each dealing with a separate category of miracle.[5] The frescoes did not reflect this arrangement, choosing more than one example from some categories, and none from others, and departing from the sequence found in the *Legenda*. This is hardly surprising, since the text was required to be a methodical compilation of all reported cases, hardly suitable for direct translation into a visual cycle. But the choices made in the mural cycle nevertheless relate, in part, to those events that the compiler of the Chapter of Miracles seems to have regarded as of particular importance.

Miracles added to the text after it had been approved by the papal legate, Napoleone Orsini, in 1308, were supplied with a list of witnesses, but this was also the case for a few of the miracles reported before that date. In two cases Napoleone Orsini himself is named in the report of a miracle; he examined the miraculous healing of Bartoluccio of Cortona, who had been caught in a mill wheel, and he went to Monte Santa Maria in the diocese of Città di Castello to examine the miraculous revival of Suppolino the son of the widow Donna Muccia, which had occurred in 1304.[6] These two miracles were both included on the south wall of the *cappella maggiore* (Pls. XVI and XIX; Figs. 126 and 106), and the approval appears to have been referred to again in the scene of Napoleone Orsini's Visitation shown on the south nave wall (Pl. XI).

The kneeling female figure dressed in a voluminous black cloak, with one hand placed on the open Bible that the bishop holds, appears to be the widowed mother of Suppolino, Donna Muccia, accompanied by her kinswomen—or members of her household—dressed in very pale pink and in green, already shown in the miracle scene (Pl. XVI).[7] The woman in pale pink appears to hold a child dressed in red, presumably Suppolino (who wears this color in Scene x), up on her shoulder, apparently in fulfilment of the promise to carry him

4. An interesting contrast is provided by the case of S. Ranieri of Pisa (d. 1160). More than half of the text of his *vita*, written by his contemporary, Benincasa, concerns Ranieri's miracles, but the mural cycle of his life painted in the Camposanto in Pisa in the last quarter of the fourteenth century, which represents more than twenty-four separate events, includes only four examples of posthumous miracles. See L. Richards, "The Cult of San Ranieri and Its Importance in Pisa from the Twelfth to the Fourteenth Centuries: The Evidence of Text and

Image," M.A. thesis, Courtauld Institute of Art, University of London, 1991, esp. 24–52.

5. For a discussion of the narrative structure and types of miracle included in this chapter, and of their interest as a historical source, see Iozzelli, 1993, 236–60.

6. *Legenda*, xii, 38, CM, 39; *Legenda*, xii, 35; CM, 36. Da Pelago, i, 328, says that Orsini's chief visits to Cortona were made in September 1306 and June 1308.

7. *Legenda*, xii, 35; CM, 36. In the watercolor copy of Scene x the very pale pink is interpreted as white.

to—and perhaps also around—the tomb if he were resuscitated.[8] (Next in the line of those waiting to testify is a woman in red who may be identified as the mother of Bartoluccio, who wears that colour in the scene of his accident [Pl. XIX].) This apparent repetition of figures provides further evidence of continuity between the frescoes of the *cappella maggiore* and of the south nave wall, and of the relative chronology proposed here.

Another miracle included in the *cappella maggiore* was the cure of Simonello di Angeluccio, testified to on the Bible in May 1310, in the presence of Fra Giunta Bevegnati, Ser Felice (rector of S. Basilio after Ser Badia's death), and Ser Oddone, doctor of law.[9] These three miracles—the healing of Bartoluccio, revival of Suppolino, and cure of Simonello—with their impeccable credentials, were presumably also selected because they demonstrated Margherita's ability to revive those on the point of death.[10]

The motives for the choice of the remaining two miracles on this wall are less clear. Scene vii shows six men escaping from a prison (Fig. 170). Section 4 of the Chapter of Miracles gives four examples of the miraculous liberation of prisoners. Only one of these events, concerning thirty prisoners released from captivity in Città di Castello, involves more than one person, but this event is given no particular prominence in the text.[11] The inscription beneath the scene does not specify which liberation is represented, so it may be that the scene more generally represents the efficacy of the prayers of prisoners to Margherita,

ORATIO VESTRA FIDELIS / QUASI TUBA RESONAVIT IN CELIS
ET EDUXIT VOS DE CARCERE ISTO / ET REFERATIS GRATIAM CHRISTO

Your faithful prayer rang like a trumpet in heaven
And led you forth from your prison, and you render thanks to Christ)

It is interesting to note, in this context, that in 1322 and 1323, on Margherita's feast day, Christmas Day, or Good Friday, a ceremonial release of prisoners is known to have taken place in the Church of S. Basilio. These recorded examples probably represent the establishment of a regular custom of releases in S. Basilio on certain feast days.[12] The emphasis on the wrist irons the prisoners carry in the scene may also relate to one of the other cases of liberation reported in the Chapter of Miracles: the companion of Nerio Berardini, pris-

8. See Chapter 4, and esp. note 31, for discussion of the meaning of Donna Muccia's vow. The woman in pale pink may be a nurse, or household servant. Compare the figure carrying the baby in Simone Martini's Beato Agostino Novello Resuscitates a Baby fallen from its Cradle (Pl. XIII; Fig. 123). Seidel, 1985, 98, points out that the mother and aunt of the baby are the two figures following her in the procession. The figures of the woman and child constitute the only variation of any substance between the seventeenth-century versions of the watercolor copies. The differences are illustrated and discussed in detail, in Appendix II. Presumably this area of the mural was damaged and difficult to interpret when the copies were made;

the somewhat greater detail provided by the watercolor copies of MS 429 suggest (as discussed in Appendix II) that it is the most reliable version.

9. *Legenda*, XII, 57; CM, 79.

10. The chapter divisions to which they belong are vii: Resuscitates some, and rescues others from the jaws of death; x: Cures the sick and suffering.

11. *Legenda*, XII, 20; CM, 21.

12. G. Mancini, *Cortona nel Medio Evo*, Florence, 1897, 177. The vast majority of communal deliberations have not survived, so the recorded releases on 25 December 1322, and on the feast of S. Margherita and Good Friday, 1323, presumably represent the tip of the iceberg.

oner in Montepulciano, presented his chains to the tomb of Margherita as proof of his miraculous escape.[13] The content of the inscription is not taken directly from the *Legenda* text, and was apparently composed specifically for the image it accompanies. This observation raises the question of the relation among text, inscription, and mural cycle, to which we shall return below.

Another tangible item kept in the church, a relic of Margherita's hair, may help to explain the choice of the last miracle on this wall, which concerned a storm on the sea of Ancona (Pl. XXVI; Fig. 137). It was this relic, then being carried by Margherita's brother, Bartolo *Mantellato* (Tertiary),[14] which ensured that when Bartolo invoked his sister's name, the sea became calm. The link between relic and image was remarked on during the Visitation made in connection with the canonization process in 1634, when it was pointed out to the judges, as they examined the relic in the church, that Bartolo was shown holding the same relic in the frescoes in the *cappella maggiore*.[15]

Unfortunately the inscription beneath this scene is lost, but several other reasons for its choice may still be suggested. The event showed Margherita's efficacy beyond the Italian mainland, and her miraculous powers over natural phenomena. From the artist's point of view, sea miracles were a recognized ingredient in the cycles of several saints (notably Saint Nicholas and, in the Bardi Saint Francis panel, Saint Francis) deriving ultimately from Christ's own miraculous calming of the Sea of Galilee. Another theme is articulated in the text of the *Legenda*, although it was not possible to represent it in the image: the pilgrims prayed to many saints to calm the storm before successfully invoking Margherita.

The Calming of the Sea of Ancona and the Crusades

The significance of this scene may be pursued a little further. As discussed in Chapter 9, the composition echoes Giotto's *Navicella* in Old Saint Peter's (Figs. 135, 136, and 137). One of the distinctions between the Cortona scene and its *Navicella* prototype is the different nature of the people on board ship. In the *Navicella* they are, of course, the Apostles, but in the watercolor the figures are clearly divided into crew and passengers, and among the passengers two figures are singled out by the sobriety of their blackish-brown cloaks (in contrast with the bright reds and greens worn by the remaining passengers) and the crosses that two of them bear on each shoulder (Pl. XXVI). These figures are presumably intended to be, in some sense, crusaders. The paragraph recounting the miracle of the calming of the sea of Ancona, in the last chapter of the *Legenda*, is not specific on this point. The travelers are simply described as pilgrims, traveling toward Jerusalem.[16] Among them is traveling Bartolo *Mantellato* (Tertiary) of Laviano, who, as noted above, invokes the help of Margherita, knowing that he has with him relics of his departed sister. He is presumably the figure toward the prow of the ship, who holds a chalice-like container in his left hand, while pointing upward with his right hand. Later in the Chapter of Miracles we read that

13. *Legenda*, XII, 21; CM, 22.
14. See da Pelago, II, 73, for discussion of this term.

15. *ASV, Riti,* Proc. 552, p. 515.
16. *Legenda*, XII, 49; CM, 50.

Bartolo spent some time in Ragusa, while waiting for a ship to take him *cum aliis Crucesignatis* to the Holy Land.[17]

This specific reference to crusaders led da Pelago to date Bartolo's journey to 1312, the year in which the Council of Vienne decreed a tithe in support of a crusade.[18] But the references to Bartolo's journey seem to belong to the main body of the text of the Chapter of Miracles, completed by 1308, rather than forming one of the dated additions.[19] It is thus possible that Bartolo and his companions made their journey in the years before 1312. Although no crusade was formally declared within this period, there was plenty of interest and preparatory activity during the early years of Clement V's papacy.[20] During this preparatory activity, in 1307, Clement secured Angevin agreement to participation in the next general passage destined for the Holy Land. In this agreement, allowance was made for the possibility that the Tatars would by then have taken the Holy Land from the Saracens, and offered part or all of it back to the Christians.[21] In 1308 Clement turned directly to the *rex Tatarorum*, who promised help against the Saracens.[22] In these years there seems to have been a real hope that the Tatars would retake Jerusalem and hand it over to the Christians. This is presumably the situation that lies behind the remark, in the *Legenda* text, that Bartolo and the many people traveling with him had set out for Jerusalem, *"de victoria sperantium Tartarorum."* Rather than militant crusaders whose journey was attached to an official *passagium*, the travelers described in the Chapter of Miracles of the *Legenda* seem to have been pilgrims bound for the Holy Land, in the expectation that victory might already have been achieved.

There are few references to pilgrimage or crusade in Margherita's *Legenda*. Although Margherita's response to the fall of Acre, and the consequent end of the Christian presence in the Holy Land, is alluded to, Benvenuti Papi has shown that Margherita's interests lay closer to the concept of the pilgrimage undertaken at home, and the mental journeying of the *Via Crucis*.[23] The insistence on the crusading aspect of this sea-miracle in the mural cycle may thus seem unexpected. Another puzzling feature of the composition in the Margherita cycle is the inclusion, in the stern of the ship, of a figure dressed in red, wearing a headdress that seems to resemble a papal tiara. This might simply be dismissed as a seventeenth-century copyist's misunderstanding of medieval dress were it not for two points. The position of the figure recalls the isolated position of the apostle standing by the steering oar,

17. *Legenda*, xii, 54; CM, 76.

18. Da Pelago, i, 333 n. 30.

19. Additions made after Napoleone Orsini approved the text, in 1308, all seem to have been supplied with a date, and a list of witnesses. See the introduction to Part V.

20. E. Rotelli, "La politica crociata dei papi del primo Trecento e il disimpegno delle città toscane visti attraverso i registri pontifici," *Toscana e Terrasanta nel Medioevo*, ed. F. Cardini, Florence, 1982, 75–85. The most concrete expression of these ideas was the hospitaller *passagium* of 1309–10, led by the Master of the Hospitallers and a papal legate, which constituted the first crusade to the Eastern

Mediterranean since the fall of Acre. See N. Housley, *The Avignon Papacy and the Crusades, 1305–1378*, Oxford, 1986, 15–16.

21. N. Housley, *The Italian Crusades*, Oxford, 1982, 95–96. The Tatars had sent ambassadors to the Council of Lyons in 1274, seeking an alliance with the Christians against the Saracens (da Pelago, i, 333 n. 30) and had already offered Jerusalem to the Christians in 1299–1300 (Housley, 1982, 76).

22. Rotelli, 80.

23. Benvenuti Papi, 1982, 117–37; esp. 130–36; reprinted in Benvenuti Papi, 1990, 141–68; esp. 160–68.

and thus charged with the task of steering the ship of the church, in the original *Navicella* composition (Figs. 135 and 136). Moreover, the standard flying prominently on a staff at the stern of the ship, above the head of the figure in question, resembles, in form, design, and color, descriptions of the papal *vexillum* in use in the later Middle Ages.[24] The inclusion of the standard was a conscious choice. To judge by the copies, the *Navicella* itself did not include it, nor have I found any closely related composition that uses it.[25] The purpose of the standard may simply be to indicate, as discussed in Chapter 9, the direction of the strong wind afflicting the ship. But the prominent position of the figure in the stern, and the gesture of salutation (or prayer?) he seems to direct to Margherita's apparition, raise again the question of papal interests in a scene that uses, perhaps for the first time in Italy, the *Navicella* composition that was so closely identified with the papacy.[26] The seventeenth-century watercolor copy of Cortona appears to show that the ship in which Bartolo and his companions traveled was honored with a papal presence.

There was keen papal interest in a crusade to the Holy Land at the time when the Margherita cycle was probably executed. After a period of only modest enthusiasm in the earlier part of his papacy, John XXII (1316–34) gave his consent to the preaching of a crusade in December 1331, which was to set off before March 1334.[27] A preliminary *passagium* did indeed take place in 1334, although a more general and ambitious expedition, planned for the following year, failed to materialize.[28] The story of Bartolo's expedition may thus have been of topical interest in the mid-1330s, and the activities of the papacy in this connection—in this case in the person of John XXII—may have had contemporary relevance.[29]

The decision to include the figure of a pope, if such it was, remains a surprising piece of allegory in the midst of a purely narrative cycle.[30] But it may provide a hint of how events involving Margherita could be interpreted in the light of the interests of the 1330s; a theme to which we shall return in the following chapter.

24. D. L. Galbreath, *Papal Heraldry*, 2d ed., rev. G. Briggs, London, 1972, 3.

25. A similar standard, in this case including the accurate detail of the papal keys, appears on a ship with no connection to the *Navicella*, in the Miracle of the Grain from the Saint Nicholas panels attributed to Ambrogio Lorenzetti. An imperial standard flies (more appropriately, since the story concerns imperial grain) from the other galley. Examples of two-masted vessels with a flagstaff in the stern include: Giotto School, Saint Nicholas Chapel, Lower Church of S. Francesco at Assisi; Paolo Veneziano, Cover for Pala d'Oro (Venice, S. Marco, 1345); Circle of Paolo Veneziano, Scenes of Saint Ursula (Florence, Volterra Coll.); Antonio Veneziano, S. Ranieri cycle, (Pisa, Camposanto, 1384–86).

26. As Köhren-Jansen, 159, says, "Giotto's *Navicella* wurde als *die* Allegorie des römischen Papsttums schon bald weit über die Grenzen Roms und Italiens bekannt."

27. Housley, 1986, 24.

28. Ibid., 26.

29. Boskovits has recently pointed to what he believes to be the anachronistic inclusion of the figure of John XXII in a scene ostensibly recording a historical event. The scene in question is the fresco of Saint Louis of Toulouse before the Pope, from the Chapterhouse of S. Francesco, Siena, painted in the 1320s or 1330s (Fig. 109). Boskovits suggests that instead of Boniface VIII, the pope really present at this event, the artist represented John XXII in order to mark and to refer to a reconciliation between the Franciscans of Siena and the papacy that had taken place at the time of the laying of the foundation stone for the new Franciscan church in 1326. This anachronistic inclusion of John XXII in a mural that Boskovits characterizes as "a sort of church-political allegory in fresco . . . depicted by Ambrogio" appears to present an interesting parallel to the Calming of the Sea of Ancona. M. Boskovits, "Considerations on Pietro and Ambrogio Lorenzetti," *Paragone* 439 (1986), 8–9.

30. Köhren-Jansen, 159, emphasizes the importance of the allegorical nature of the iconography of the *Navicella*.

The South Nave Wall

The choice of the three miracles shown in the upper part of the south nave wall is easily explained, since they represent three of the four miracles accomplished by Margherita during her lifetime (see photomontage reconstruction, Fig. 203). (The fourth miracle of the group, the Liberation from Devils of the Girl from Borgo S. Sepolcro,[31] was presumably omitted because of its similarity to the Liberation from Devils of the Boy of Borgo S. Sepolcro.)

The three miracles shown lower down on the same wall form a less obviously coherent group. Two of them, the Healing of the Man of Corciano (Scene xix; Fig. 103), and Aretino of Arezzo Saved Twice from Drowning in the Well (Scene xviii; Fig. 172), were in such poor condition by the seventeenth century that they disappeared entirely a few years before the Visitation of 1634.[32] It is conceivable that they constituted additions to the original plan, but the copy of the inscription below the scene of Aretino of Arezzo is seen, in its imitation of fourteenth-century epigraphy, to be consistent with scenes higher up the wall for which inscriptions were also recorded.

The three miracles are not singled out in the *Legenda* text. The Healing of the Man of Corciano, one example among several of the restoration of sight by Margherita, is admittedly the first item recounted in the Chapter of Miracles, but this sort of consideration is not of any significance elsewhere in the cycle. Perhaps it was the promise that the man of Corciano made to carry ten candles, each worth twenty *soldi*, to Margherita's tomb if he was healed,[33] an episode clearly shown in the watercolor copy (Fig. 103), which prompted the inclusion of the scene directly across the nave from Margherita's tomb.

The choice of the Cure of the Conspirator of Arezzo (Scene xvi; Fig. 130) and the story of Aretino of Arezzo (Fig. 172) may have been influenced by a desire to emphasise Margherita's miraculous jurisdiction over those in a neighboring (and not always friendly) town. The inscription below the Healing of the Conspirator is recorded as "COME CHUSTUI PER LI MERTI DE SANCTA MARGARITA SPUTÒ LA SPINA E PERDONO A SUOI NEMICI E REDISSE PACE" (How this man through the merits of S. Margherita spat out the fishbone and forgave his enemies and returned to peace). The choice of this scene may thus have provided the opportunity for a reference to the importance Margherita attached to campaigns of peacemaking, both within Cortona and in external relations.[34] It may also be significant that, as the *Legenda* reports, the citizen of Arezzo had promised, if cured, to bring a candle *cingulum* to Margherita's tomb.[35]

The engaging story of Aretino of Arezzo (Fig. 172), who fell into a well and was saved through the merits of Margherita not once, but twice, is treated only briefly in the *Legenda*.[36] The reason for its inclusion among the murals is uncertain, but the appeal of the repetition of the miracle is made clear in the accompanying inscription, "COME UNO CADE

31. *Legenda*, xii, 27; CM, 28.
32. *ASV, Riti*, Proc. 552, p. 523.
33. *Legenda*, xii, 1; CM, 1.
34. See Chapter 2.

35. *Legenda*, xii, 55; CM, 77. For the meaning of *cingulum* see Chapter 4.
36. *Legenda*, xii, 50; CM, 51.

NEL POZZO DOI VOLTE L'UNA DOPPO L'ALTRA COME SE RACCOMANDO A SANCTA MARGARITA FONE[37] TRATO SENZA PERICOLO" (How someone fell into a well twice, one time after another [and] how he commended himself to S. Margherita and was pulled out without danger).

The Miracle Scenes, the *Legenda* Text and the Inscriptions

Although the choice and arrangement of miracles in the mural cycle was not closely related to the structure of the *Legenda*, the individual scenes generally contained elements very similar to those described in Fra Giunta's text. For example, when the Man of Corciano's eye is said to have hung out of its socket about a finger's length, a close look at the copy of Scene xix suggests that this detail also appeared in the fresco (Fig. 103).[38] The text tells us that the conspirator of Arezzo was visited by several doctors who all failed to extricate a fishbone from his throat,[39] and two doctors appear in the copy of Scene xvi (Fig. 130). In the Cure of Simonello di Angeluccio, Simonello's hands are joined in prayer as specified in the *Legenda* (Pl. XIV; Fig. 128).[40] The protagonists include the doctor, whom we learn from the *Legenda* was Maestro Tebaldo di Arezzo, and a woman and child who are presumably Simonello's wife and son. Although they are not named in the *Legenda*, they formed necessary parts of the composition, explaining (as discussed above, Chapter 9) the passage of time during which the miraculous healing occurred.

Thus although figures, details, or episodes occasionally appear in the copies of the miracle scenes that are not found in the text of the Chapter of Miracles, these may generally be explained by artistic license, compositional or narrative demands, or the repetition of artistic formulas. Should it therefore be supposed that the individual miracle scenes were based directly on the last chapter of Fra Giunta's text? The use of hagiographical texts by artists is often assumed,[41] and is occasionally recorded, as in the case of Pietro Lorenzetti's use of a vernacular translation of the life of S. Sabinus, mentioned above.[42]

37. The word *fone* occurs both here and in the inscription of the Joseph fragment (Fig. 174): [COME IO]SEP FONE VENDUTO DAI FRATELLI. It does not appear in the standard dictionaries, nor in the glossary to the *Laude cortonesi*, ed. Varanini, Banfi, and Ceruti Burgio, 4, Florence, 1985, which contains some of the other unusual forms found in the vernacular inscriptions. It would make sense in the context of both the Aretino of Arezzo and Joseph inscriptions if taken as a variant spelling of *fu + ne*. (In Varanini et al., 2:30 it is noted that the use of *fo* for *fu* is a clearly "aretino-Cortonese" form.) The repetition of this unusual word in both the Margherita and Genesis nave scenes is a further small indication of links between the two cycles, and it may also be noteworthy that both scenes included a polygonal well of similar design (Figs. 172 and 173).

38. *Legenda*, XXII, 1; CM, 1. This distressing detail had visual precedents. See above, Chapter 10, note 25.

39. *Legenda*, XII, 55; CM, 77.

40. "Tunc ipse Symonellus, humiliter et devote iunctis

manibus, rogavit beatam Margaritam de Cortona, quod intercederet" ; *Legenda*, XII, 57; CM, 79.

41. For example, J. Stein, "Dating the Bardi St. Francis Master Dossal: Text and Image," *Franciscan Studies* 36 (1976), 271–97, esp. 271. But see the entry by P. Scarpellini, "Iconografia francescana nei secoli XIII e XIV," in the exhibition catalogue *Francesco d'Assisi, Storia e Arte*, Comitato regionale umbro per le celebrazioni dell'VIII centenario della nascita di San Francesco di Assisi, Milan, 1982, esp. 96–97, who sounds a note of caution over assuming that artists followed texts directly and exclusively, or that the relationship between text and artist was always a one-way traffic.

42. For a discussion of Pietro Lorenzetti's formulation of visual narrative in relation to the contemporary composition of texts see J. Cannon, "Pietro Lorenzetti and the History of the Carmelite Order," *Journal of the Warburg and Courtauld Institutes* 50 (1987), 18–28.

The *Legenda* is not the only surviving textual equivalent for the miracle scenes. We have a record of many of the inscriptions that ran below the murals. The inscription below the Liberation of Prisoners has already been shown to have been composed for this specific scene. Another clear example of lines intended for this particular context can be found accompanying the Cure of Simonello di Angeluccio:

CESSET MEDICINA TERRENA / IBI GRATIA OPERATUR DIVINA
QUI ME NOVERUNT MORTI DONATUM / ME NOSCANT A MARGARITA SANATUM

When earthly medicine fails, then divine grace operates.
Those who recognized me as dead, recognize me as healed by Margherita.

The phrases "medicina terrena" and "gratia divina," while explaining in an appropriate contrast the point of Giunta's text, were not in fact employed by him. The inscription is written as though addressed directly by Simonello to the spectator and is thus entirely appropriate for its context, but it would make little sense in any other one.

In two cases the inscriptions below the scenes may, however, indicate the use of information from outside the *Legenda*. In Scene vi Bartolo, who was crushed in the mill wheel (Pl. XIX; Fig. 106), is identified as the son of a certain Restauro, and we are told that the mill in question was that of S. Vicenzo.[43] Neither of these details is given in the *Legenda*. In Scene xiv (Pl. XXII; Fig. 122), which concerns Margherita's prediction of the resuscitation of a child, the inscription says, "COME UNA DONNA AFFOGÒ IL FIGLIO EN LO LETTO E PER LI MERTI DE SANCTA MARGARITA RESUSCITÒ" (How a woman suffocated her son in bed and through the merits of S. Margherita [he was] revived). The *Legenda* text does not specify that the child was smothered by his mother, and the comparison it gives between this woman and the Shunamite woman of the Old Testament, whose son was resuscitated by Elisha, would not indicate suffocation, which has no part in the Shunamite's story.[44]

It would hardly be surprising if the planners of the cycle has access to an oral tradition, outside the *Legenda*, when writing the inscriptions and instructing the artist.[45] If the murals date to c. 1335, less than forty years after Margherita's death, they were planned and painted while some witnesses to her life, and more to her posthumous miracles, were still living in and around Cortona. This was certainly the case for one key figure, the rector of S. Basilio, Ser Felice, appointed as successor to Ser Badia by 1306, and certainly still in office in 1338[46] (his successor is first mentioned in 1343).[47] Ser Felice is listed among the witnesses to Simonello di Angeluccio's cure, reported in May 1310, and the subject of

43. . . . E BARTOLUS REDDITUR VITE RESTAURI FILIUS / QUEM NECAVIT MOLENDINUS
DE SANCTI VINCENTII IANUA / A MORTE REDDITUR PRAVA
44. *Legenda*, xii, 36; CM, 37. It is possible that there is a confusion here between two events. In a posthumous miracle Margherita revived Angelo, son of Donna Nuta of Lucignano, who had been unintentionally smothered in his sleep, by his uncle. *Legenda*, xii, 37; CM, 38.
45. For the proposal that oral tradition may have been the source for certain miracles—not found in the surviv-

ing written sources—represented in the mural cycle of S. Nicola at Tolentino, see Bisogni, 1987, 263–64, with discussion of specific scenes on 269–85, and a helpful tabulation of the material, 286–87.
46. Da Pelago, ii, 50, dates the last mention of Ser Felice to 1336, but he is also mentioned in the episcopal visitation of 1337–38. See N. Meoni, "Visite pastorali a Cortona nel Trecento," *Archivio storico italiano* 129 (1971), 197 and 254–56.
47. Da Pelago, ii, 50.

Scene viii on the south wall of the *cappella maggiore* (Pl. XIV; Fig. 128). There is no evidence that the fresco contained elements not available in the *Legenda* text, which might have been supplied by Ser Felice from his own memories, but it is worth noting that a possible candidate for the composition of the verses below the scene would be the rector of S. Basilio himself—a man whose role in the development of Margherita's cult has already been discussed.[48] He certainly had to hand the relevant materials, and perhaps also the relevant skills; we know that the statutes of 1325 charged him with the task of selecting the appropriate sermons, masses, and offices for use during Margherita's feast day.[49]

These crumbs of evidence serve to remind us that to look for a straightforward and complete dependence of the images on the *Legenda* text would be to distort the situation. The cycle of mural paintings were never simply "illustrations" of the *Legenda*, or of any other single text. The extent and nature of the divergences between the murals and the *Legenda* will become more apparent in the chapter that follows.

48. See Chapter 2 and the introduction to Part V. 49. See Appendix I.

14

The Margherita of the Mural Cycle and the Margherita of the *Legenda*

The last chapter of the *Legenda* was written in a style of concise narration that easily lent itself to visual translation. Although the proportion of scenes devoted to Margherita's miracles was much greater in the mural cycle than in the *Legenda*, the view of Margherita, and of her significance for her contemporaries and near contemporaries, given within those scenes did not differ substantially from that given by the Chapter of Miracles. But a comparison between the preceding chapters of the *Legenda* and the remaining scenes of the mural cycle produces very different results.

The precision and concision of the final chapter is in marked contrast to the amorphousness and prolixity of much that comes before. Large parts of the *Legenda* focus on Margherita's mental and spiritual life, and her conversations with Christ.[1] The figures of her confessors, and of other companions and inhabitants of Cortona, only occasionally come into view. A major contrast between the life of Margherita as presented by the text and the images is found in the number of protagonists involved. In the images we find a consid-

1. See Chapter 2, for further discussion of the contents of the *Legenda*.

erable number of participants, often intended to be clearly identifiable. This is in sharp contrast to the vagueness with which the inhabitants of Cortona are generally referred to in Fra Giunta's compilation.

One example will suffice here. Scene xv concerns the *Ospedale della Misericordia* and the *Fraternità di S. Maria della Misericordia*. The *Legenda* says only that Margherita's foundation of a *domus* or *hospitium misericordie*, with funds provided by a generous man, not named in the text, was begun in a house given to her by a certain Donna Diabella. The following paragraph of the *Legenda* records that each year, on the feast of Saint John the Baptist, Margherita distributed food to the poor.[2] This event is reported in chapter 2 of the *Legenda*, and the *Ospedale* is not mentioned again, but the scene in the mural cycle implies far more importance for this foundation.

The *Ospedale* was formed by the uniting of existing small hospices in Cortona, under the supervision of the *Fraternitas Sancte Marie de Misericordia de Cortona*, in 1286.[3] Margherita's name is not mentioned in the confraternity statutes, but a fifteenth-century account of the origins of the *Ospedale* attributed the foundation of the confraternity to her, and this has generally been accepted.[4] The activities of the *Fraternitas* presumably flourished in Cortona, and stone tablets inscribed with its monogram, F͡SM, are still visible in various parts of the town.[5] One such tablet, now immured near the entrance to Via Ghibellina (Fig. 177), bears the date 1334, confirming that the monogram was in use around the time that the mural was probably executed.[6]

The precise location of the original foundation is uncertain,[7] but the watercolor of Scene xv of the cycle may give some information about its appearance (Pl. XXV; Fig. 175). The monogram of the confraternity is prominently displayed above the figure of Margherita and appears again at both sides of the lintel of the doorway. The inclusion of two archways— one open and the other bricked up—is a curious detail that may also be a topographical reference, and the inclusion of the images of the Virgin and Child flanked by Saint John the Baptist and Saint Francis presumably reflects the original decoration of the *Ospedale* (although interpreted by the copyist with a rather quattrocento air).

The information provided in the *Legenda* and the confraternity statutes is supplemented by the events shown in Scene xv. Two laymen, presumably two of the rectors of the confraternity, are directed by Margherita to distribute food from special aprons that they wear. One appears to be holding a loaf of bread, the other a plate for the collection of money.[8] (The inclusion of Saint John the Baptist in the lunette above the entrance doorway suggests that this may be the annual distribution of food on his feast day mentioned so briefly

2. *Legenda*, ii, 2 and 3; Iozzelli, ii, 1b and 1c.
3. Mancini, 103–4.
4. For the history of the "Spedale," see da Pelago, ii, 112–15. The constitutions of the confraternity are printed in da Pelago, ii 150–54; the account of the foundation of the *Ospedale*, written in 1421, is printed in da Pelago, ii, 180–82. See also Chapter 2.
5. Tafi, 245.

6. The full inscription is: F͡.S.M. A.D. M.CCC.XXXIIII. MENSE. AUGUSTI. TEMPORE. DOMINI. RANERII. DOMINI. GENERALIS. CIVITATIS CORTONE.
7. Da Pelago thought it was probably on or near the site now occupied by the Convento delle Poverelle, opposite the Porta Berarda.
8. The statutes stipulated a weekly collection and distribution of bread and money.

in the *Legenda*.) One of the laymen (who wears fashionable shoes with interwoven thongs)[9] may be the anonymous benefactor of the *Ospedale*. The man standing beside Margherita is presumably the prior of the confraternity, whom the statutes required to be a member of either the regular or secular clergy. His manner of dress, with small, possibly fur-trimmed cap, indicates that he is not a member of the regular clergy. As a member of the secular clergy, the fullness of his cloak might suggest that he also belonged to the Franciscan Third Order, but the color of the garment, although contrasting in its pale neutrality with the scarlet and green worn by the two benefactors, is not of the dark grey worn by the *mantellati* in Scenes i and ix.[10] It is not thus possible, on the basis of the evidence of the watercolor, to confirm a link between the secular clergy related to the Tertiaries, and the running of the *Ospedale*.[11]

The mural tells us more about other activities of the *Ospedale* than the *Legenda* does. Two female assistants, dressed as penitents, and wearing the veils of Tertiaries, are shown at work in the hospital. A man who is presumably a leper is having his sores washed; pilgrims as well as paupers and those on crutches are welcomed within the *Ospedale*'s doors.[12] The inscription recognises Margherita's key role (shown by her pivotal position within the composition) in ensuring that the "bonomini" of Cortona assist the poor and sick: "COME SANCTA MARGARITA FECE LA MISERICORDIA E COME LA MANDAVA E I BONOMINI PER LO PANE PER GOVERNARE I POVERI ENFERMI" (How S. Margherita undertook works of mercy and how she sent good, upright men[13] for bread to provide for the poor and sick).

Besides the comparison between details of text and image in individual scenes, there is the question of the comparison between the overall content of the first ten chapters of the *Legenda* and the subjects from Margherita's life included in the mural cycle. Only a small number of scenes were used to represent this large body of material. While the miracles

9. Compare, for example, the shoes of the Magi in the triptych attributed to Bernardo Daddi, dated 1338, in the Princes Gate Collection, Courtauld Institute Galleries, or the shoes of several of the twenty-four prominent citizens in the foreground of Ambrogio Lorenzetti's Allegory of Good Government, 1338–39.

10. For the dress of male Tertiaries, see Chapter 11, notes 35 and 60.

11. A fifteenth-century source (cited in Chapter 2, note 4) named Ser Badia as the first prior of the *Fraternitas*. Tertiaries associated with S. Basilio may have had other connections with hospital work. The will of a certain Buongiovanni di Ranieri Villani, made in 1304, gave to the commune of Cortona a house built for the reception of paupers visiting the Church of S. Basilio. See da Pelago, *Sommario*, *ad annum* 1304. Da Pelago believed that the building was situated near the portico of the church. The cortonese statutes of 1325 designated ten *ospizi* as "casa del comune." These included the *ospizio* near S. Margherita, and that of the Misericordia, near Porta Berarda. (Mancini, 1897, 105 and 157–58.)

12. These details are not always easy to follow in the watercolor copy, since the fresco was presumably damaged before the copies were made. Comparison with the figures in the Andrea Gallerani shutters from S. Domenico, Siena, which show the activities of Gallerani and an assistant in the *Domus Misericordiae Pauperum* in Siena (Figs. 174 and 176), confirms the representation of, among others, pilgrims and lepers.

13. *Bonomini*, in this context, does not appear to mean, as it came to mean, peasants, or men who were good but simple. It seems rather to parallel the French medieval *bonhomme* which can mean a good and upright man. Compare the phrase "tres boni homine" in the Cortona statutes of 1325, Appendix I, p. 230, para. 13. For the use of the term in a broadly comparable fifteenth-century Florentine institution, see D. Kent, "The Buonomini di San Martino: Charity for the Glory of God, the Honour of the City, and the Commemoration of Myself," in *Cosimo 'il Vecchio' de' Medici, 1389–1464*, ed. F. Ames-Lewis, Oxford, 1992, 49–67.

included in the concluding chapter formed the subjects of eleven scenes, the preceding ten chapters of the *Legenda*[14] (the majority of which are substantially longer than the Chapter of Miracles) are represented by only seven scenes: five on the north wall of the *cappella maggiore*, and two on the south nave wall.

Even more significant than the selection of the subjects for these seven scenes are the omissions that were made, for these concern most of the major themes of the *Legenda*.

Magherita's Spiritual Progress

One of the *Legenda*'s principal functions was to act as a record of Margherita's experiences of conversations with Christ, which she then reported to her confessors.[15] These divine conversations and revelations often provided comfort and instruction for Margherita, and gave her knowledge of events that were to concern those around her. While Margherita's direct experience of Christ's word is shown in at least three of the narratives of the panel painting (Figs. 147, 152, and 160),[16] only one scene from these extended dialogues is taken into the mural cycle: the full remission of Margherita's sins, granted to her by Christ through the merits of Saint Francis (Fig. 179).[17] This is, of course, a key event in the *Legenda*, marking the full fruits of Margherita's harsh life of penitence, and acting as an example to all those seeking to confess and do penance, especially through the offices of the Franciscan Order. But the necessary presence of Saint Francis in the scene distinguishes the event from the majority of Margherita's conversations with Christ in the *Legenda*. Even in this case the *Legenda* mentions Saint Francis only briefly, at the start of the episode. It is the translation of his presence from text to image that diminishes the effect of an intimate dialogue between Margherita and Christ.

Margherita's conversations with Christ often occurred after the Eucharist, and there is much in the *Legenda* text concerning Margherita's devotion to the Host, the sweetness she found in it, and her eventual desire to partake of it daily. None of this aspect of Margherita's religious life is to be found in the mural cycle. This omission cannot be attributed to a difficulty in translating such events into satisfactory images. The panel painting of Margherita includes a scene in which the Host is brought to Margherita's cell and Christ (or her guardian angel) appears to her (Fig. 156). The *Legenda*'s frequent mentions of Margherita's participation in the Eucharist generally lack specific visual detail, but a few episodes might happily have formed the basis for illustration: on hearing a bell ring in a nearby church to signal the elevation of the Host, Margherita had a vision of a white child dressed in gold,

14. Or eleven chapters, if the division of chapter ten into two parts is allowed for. See above, Chapter 2, note 3, for this confusion in the chapter numbering.

15. See Chapter 2 and the introduction to Part V.

16. It is not clear whether the heavenly apparition in the scene of Margherita and the Eucharist is Christ or Margherita's guardian angel. There is no visible trace of a cross in the figure's halo.

17. Margherita is also shown responding directly to Christ's instructions in the scene of her arrival in Cortona to do penance.

held in the black hands of the priest; when the priest of S. Giorgio mistakenly brought an unconsecrated host to her cell, she detected its lack of sweetness.[18]

Attention has already been drawn to the connections between the "*vita*-panel" and the theme of Margherita at prayer. Margherita's frequent devotions, particularly her recitations of the Pater Noster and the Ave, are described in detail in the *Legenda*. Holy persons at prayer, either pursuing their regular devotions, or elevated in ecstatic contemplation, are images that can be found in some number in duecento and trecento painting, for example: in the Upper Church at Assisi the scenes of Saint Francis praying in S. Damiano, and Saint Francis seen by some of his companions to be raised in ecstasy;[19] Beato Andrea Gallerani at prayer with the rope of a penitent attached to his neck to prevent him from sleeping, on a panel by an artist related to Guido da Siena now in the Pinacoteca in Siena (Fig. 174); the scenes below each of the standing figures of five female *beate* of the Dominican Third Order on a panel painting by Andrea di Bartolo, from the Church of Corpus Christi in Venice.[20] Perhaps these precise records of the attitudes of prayer were more likely to be produced for audiences primarily comprising members of the regular clergy.[21] The watercolor copies give no indication that the Margherita cycle anticipated any of the rich inventions on the theme of a female Tertiary at prayer and in meditation to be found, in the next century, in Giovanni di Paolo's panels of Saint Catherine of Siena.[22]

Beyond the realm of formalized sacraments and prayer, Margherita's lengthy and agonized meditations on the sufferings of the crucified Christ led her to mystical experiences akin to those of Saint Francis. Most striking of all was her lengthy vision of the Passion, which she described as it took place (in words recorded by Fra Giunta) in the Church of S. Francesco in Cortona, before a large crowd of the faithful. At the end of the vision she collapsed insensible.[23] This prominent episode in the *Legenda*, witnessed by many inhabitants of Cortona, finds no echo in the recorded murals. It has been argued (Chapter 6) that there may once have been a large fresco of the Crucifixion on the north wall of the nave. If this image included the figure of Margherita, as a participant or devoted spectator, the theme of Margherita's meditations on the Passion may, in this form, have been included in the decoration of the church.[24]

A fresco of this type would also go some way to explaining the surprising omission of an

18. *Legenda*, VII, 17 and 26. The episode of the unconsecrated host may have been the scene shown on the panel painting (Fig. 156). For a discussion of similar episodes in the lives of other female saints, see C. Bynum, "Women Mystics and Eucharistic Devotion in the Thirteenth Century," *Women's Studies* 11 (1984), 179–214.

19. Illustrated in Poeschke, pls. 147, 149, 163, and 165.

20. Now in the Museo Civico Vetrario, Murano. See G. Freuler, "Andrea di Bartolo, Fra Tommaso d'Antonio Caffarini, and Sienese Dominicans in Venice," *Art Bulletin* 69 (1987), 570–86, esp. 570–77.

21. For a fifteenth-century example (building on a thirteenth-century text), see W. Hood, "Saint Dominic's Manners of Praying: Gestures in Fra Angelico's Cell Frescoes at S. Marco," *Art Bulletin* 68 (1986), 195–206.

22. For a lucid discussion of these panels, and superb color reproductions see the entry by C. Strehlke in the exhibition catalogue *Painting in Renaissance Siena, 1420–1500*, New York, 1988, 218–39.

23. *Legenda*, V, 1–4.

24. The combination of a standing figure of Margherita and other saints flanking a Crucifixion can still be seen in a fragmentary fourteenth-century mural on the west wall of S. Francesco, Cortona (Fig. 183). For the attribution of this mural see L. Bellosi, "Jacopo di Mino del Pelliccaio," *Bolletino d'arte* 57 (1972), 74.

event forcefully related at the very opening of the *Legenda*, immediately after Margherita's profession. As discussed in the introduction to this book, an image of Christ in S. Francesco, Cortona, is said to have spoken to Margherita.[25] But the opportunity that the text offered to paint a scene paralleling that of the Crucifix at S. Damiano addressing Saint Francis, does not seem to have been taken up by those planning the cycle. A carved and painted wooden crucifix from the Church of S. Francesco in Cortona has, as discussed in the Introduction, long been connected with the event described in the *Legenda*. The work in question (Figs. 3, 5, and 6) was only moved from the Church of S. Francesco to S. Margherita in 1602,[26] and it may thus, very tentatively, be proposed that those commissioning the fresco cycle did not wish to place undue emphasis on the importance of a relic connected with Margherita's life that was not in the possession of her burial church.[27] They may, instead, have preferred to concentrate the attention of those visiting the church on the carved wooden image of the Savior—presumably a crucifix—displayed in the Cappella del Salvatore which was the site of Margherita's last cell, and the place of her death.[28] (Potential tensions between the Franciscan First Order and the Church of S. Margherita will be discussed further.)

The austerity of Margherita's life, another clear link with the example of Saint Francis, is described in detail in Fra Giunta's text. The aspect of this asceticism represented in the cycle was Margherita's frequent gift of her possessions, including the clothes from her own back, to the poor (Pl. XX; Fig. 165). The main textual parallel is that given in chapter 3, paragraph 3, of the *Legenda* text, which concerns Margherita's austerity and love of poverty. She wished to give everything to the poor, and if she had nothing left to give, removed her tunic from her back, and wrapped herself in the mat on which she slept. To this scene, already shown on the panel painting and tomb (Figs. 155 and 164), there appear to have been added in Scene iii of the mural cycle further elements found elsewhere in Fra Giunta's text. If Margherita had nothing else to offer the poor she gave them various items including wood from her bed, and her paternoster beads,[29] which can clearly be seen in the hands of the central figure in the scene. Margherita was generous not only to the poor, but also to pilgrims.[30] This may explain the staffs that two of her visitors hold.[31] In the tomb relief Margherita is shown with two female visitors, one young and the other carefully characterized by her lined face as old (Fig. 164). In the fresco the figure closest to Margherita seems youthful, the age of the figure at the center is less certain, and the figure on the left has a

25. *Legenda*, I, 1.

26. Da Pelago, I, 18 n. 4.

27. And it can, even more tentatively, be asked whether the great emphasis placed on the image speaking to Margherita, right at the start of the *Legenda* text, was intended to draw attention to a tangible visual relic of Margherita's spirituality which, the text insists, "is now on the altar of the friars," in default of possession of that more prized relic: Margherita's body.

28. See Chapter 3.

29. *Legenda*, II, 3; Iozzelli, II, lc.

30. Ibid.

31. A staff is also held by a visitor in the "*vita*-panel" (Fig. 155). This may constitute a further reference to the *Legenda*: once, in her former life, reproved by her friends for dressing richly, Margherita prophesied that "adhuc tempus adveniet, in quo me nominabitis sanctam cum sancta fuero, et visitabitis me cum baculo peregrino, cum scarsellis pendentibus ab humeris vestris"; *Legenda*, I, 3; Iozzelli, I, lc.

lined face and stoops to support herself on a stick. Her body bends away from Margherita, although she twists round to look at her. It is difficult to say whether this pose has any particular significance, but it certainly contrasts with the uprightness of the other two figures and could perhaps indicate dissent. If that was the case, one further event may be alluded to in the scene: a certain woman doubted Margherita's humility and love of the poor. Margherita then gave the woman her tunic and veil and her food, and arranged, through the love of charity and humility, for all the woman's debts to be paid.[32]

Scene iii served to illustrate Margherita's charity, and perhaps also her humility in the face of those who doubted her, as much as her austerity. More rigorous mortifications of Margherita's flesh, through fasting and flagellation, mentioned in some detail in the *Legenda*,[33] were all omitted from the cycle.[34]

Various temptations of the devil stand, in the *Legenda* text, for the spiritual struggles that Margherita underwent. This aspect of Margherita's experiences, shown twice, in considerable detail, on the panel painting (Figs. 150 and 151), was illustrated succinctly in the first scene of the series on the south nave wall (Pl. XIII; Fig. 171). The devil is at Margherita's back, trying to draw her attention to the pleasures, and the potential companion (the man with the hawk), whom she is leaving behind in Montepulciano.[35] The event is described in the first chapter of the *Legenda,* which mentions the fig tree beneath which Margherita wept in her father's garden in Laviano. Fra Giunta indicates that, at the time of writing, the fig tree still existed. Perhaps the house to the right of Margherita, with its substantial dovecote, was an accurate portrait of Margherita's father's house.[36] The *serpens antiquus* is said to have seen her there, and the spiral of vine leaves winding up the trunk of the fig tree may either have been the copyist's misunderstanding of a serpent, or the original artist's allusion to one. The visual parallel with the temptation of Eve may once have been made clearer to the spectator. The Genesis cycle (reconstructed in Chapter 6) would probably have begun at the top of the nave bay next to this part of the Margherita cycle. A representation of the Fall may therefore have appeared not far from this mural of Margherita's victory over the temptation to sin again.

While the devil shows Margherita the life of ease and privilege that could be hers (with

32. *Legenda,* IV, 2. Unfortunately the fragmentary inscription that has survived beneath the scene does not clarify the various events which it represents: . . . AM / UT NON PALLIURUS SCINDAT ILLAM. This appears to refer to the division of a mantle (echoes of Saint Martin?) but does not seem to link with any event reported by Fra Giunta.

33. For example, *Legenda,* II, 3 and 4; Iozzelli, II, 1c; III. It should be noted that Margherita's mortification of the flesh through fasting, mentioned more than flagellation, mainly appears in chapters 2 and 3 of the *Legenda.* Fasting and flagellation both constitute a much smaller proportion of the subject matter of the *Legenda* than the lengthy descriptions of Margherita's conversations with Christ.

34. Large-scale images of women flagellants were rare, but not unknown, around this time in Italy. See, for ex-

ample, the mural in the nun's choir of S. Maria in Donna Regina, Naples, of Saint Elizabeth receiving the discipline from her maid, illustrated in Kaftal, 1965, cols. 385–86, fig. 435. For detailed consideration of the social structures that may have militated against such representations of women see J. Bennett, "Framing the Subject: Representation and the Body in Late-Medieval Italy, Ph.D diss., University of London, 1993, esp. chaps. 3 and 4.

35. *Legenda,* I, 2; Iozzelli, I, 1b. The devil tried to tempt her to take a new "protector".

36. Alternatively, it may have indicated the house that Margherita could have enjoyed, had she taken a new "protector." (The house in Laviano now called Margherita's birthplace has no dovecot but may owe its identification to a dubious later tradition. See Mariani, xxxvi.)

the walled town of Montepulciano reminiscent of the cities in the Temptation of Christ from the predella of Duccio's *Maestà*.[37] Christ calls her to come to Cortona and place herself under the obedience of the friars. The symmetry of the composition reflects the balance in the *Legenda* text. The form of the devil at Margherita's back also suggests familiarity with the next chapter in the *Legenda*, in which the devil appears to Margherita in various forms: as a woman, a man, a serpent, and a four-legged animal.[38] Some of these forms—the devil as woman, clawed beast, and serpent—seem to be present in the copy of the painting.

Margherita's identification with the Magdalene is a theme that recurs throughout the *Legenda* in different forms.[39] It was, of course, at the heart of Margherita's desire to be an example of Christ's love for penitents. As we have seen, Christ even showed Margherita in a vision that, like the Magdalene, a place was reserved for her among the virgins in Paradise.[40]

It has already been noted that the Magdalene appears on the panel painting of Margherita (Fig. 152), and that visual parallels with Magdalene iconography seem to have been intended in that work and in the funerary reliefs (Figs. 155–61). The Magdalene was also shown, at the foot of the cross, on the painted wooden shutters of Margherita's tomb niche. No specific reference to the parallel between these two female penitents is found in the watercolor copies but, as in the two earlier versions of the Absolution of Margherita's Sins, the standing figure of Christ in Scene ii (Fig. 179) clearly touches the head of the kneeling female figure—perhaps a reference, with one major significant alteration, to a representation of the *Noli Me Tangere* such as that found in the Magdalene Chapel in the Lower Church of S. Francesco at Assisi (Fig. 178).[41]

As we have seen, the panel painting of Margherita described her spiritual progress in some detail. The reliefs of the funerary monument gave a more restricted account, shifting the emphasis away from Margherita's private spirituality. The decision to commission an extended mural cycle could have provided the opportunity to return to such themes, but the extra space available in the *cappella maggiore* was devoted instead to Margherita's posthumous miraculous powers, with the subjects of the marble reliefs repeated (with a few significant modifications, discussed below) on the north wall of the *cappella maggiore*. Only the scene of Margherita's arrival at Cortona, on the south nave wall, returned to the themes of temptation and penance found in the panel painting.

This choice was not simply dictated by artistic imperatives; it was artistically possible

37. Illustrated in Cattaneo and Baccheschi, pls. 59 and 60.

38. *Legenda*, ii, 8; Iozzelli, ii, 2a.

39. For example, *Legenda*, ii, i; iii, i; v, 5; vi, 10; xi, 20.

40. *Legenda*, iv, 15.

41. The next scene in the cycle, in which the unclothed Margherita stands in the doorway of her cell wrapped in a mat (Pl. XX; Fig. 165), recalls, as in the two earlier versions, the figure of Saint Mary Magdalene standing in the entrance to her desert cave, covered only by the luxuriant growth of her hair. Connections between the Margherita cycle and the art of the Lower Church at Assisi have already been noted. But the Magdalene Chapel, which could have provided convenient schemata for the representation of a solitary female in prayerful ecstasy or for the receiving of the Eucharist, only shows passing resemblances in the donation of a mantle to Saint Mary Magdalene by Zosimas, as she appears in the shelter of her isolated cave (compare Scene iii of the Margherita cycle); and in her elevation between angels over an open landscape (compare Scene v)—although in Margherita's case this is a posthumous event. (Poeschke, pl. 220.)

and also, it appears, acceptable, to represent the spirituality of certain female penitents and mystics in murals and on panel paintings. The examples of Chiara of Montefalco (Fig. 180), Elizabeth of Hungary,[42] and five Dominican *beate* of the Third Order, have already been touched on. Chiara of Rimini provides another example of art taking personal spirituality, in this case a vision that manifested intense devotion to the body and blood of Christ, as its subject matter. In a Riminese panel painting of the first half of the fourteenth century (Fig. 181), now in the National Gallery in London, Chiara, dressed in the checked robe of a Penitent, kneels at the bottom left of the composition. Saint John the Evangelist, acting as intercessor, shown on a slightly larger scale, stands to Chiara's left. He holds out to her a book, given by Christ, on which was inscribed (as her *vita* describes): "Pacem meam do vobis. Pacem meam relinquo vobis" (based on John 14:27; part of Christ's discourse at the Last Supper).[43] The Evangelist gestures to the considerably larger figure of Christ, on his left, surrounded by other apostles (shown on the same scale as Saint John, and thus emphasising Christ's greater dimensions).[44] These apostles crowd into the top right corner of the composition. This simple, diagonally organized, composition, set against an inscribed gold ground, conveys something of the path to be traveled between the mortal mystic and the substance of her vision. Christ reveals the copiously bleeding wounds in his hands and side to Chiara. Margherita also had a vision in which she saw Christ's heart through the wound in his side,[45] but those planning the mural cycle in S. Margherita do not seem to have chosen to represent it. The only one of Margherita's visions that was chosen for inclusion, Christ Grants Margherita Absolution from All Her Sins (Scene ii; Fig. 179), gave a much simpler account of an apparition, in which the different realms inhabited by the protagonists were not described, and in which Margherita's visions of the sufferings of Christ were not alluded to.

Three themes of the *Legenda* have yet to be discussed: Margherita's relations with the Franciscan Friars, her membership of the Third Order, and her relation to her adopted city, Cortona. These three themes can be discerned both in the *Legenda* and in the copies of the cycle, but once again there are differences, sometimes sharp divergences, between the two versions of Beata Margherita which are presented in them.

Margherita and the Franciscans

In the *Legenda* the Franciscan presence is very strong. The author was, of course, a friar, who as Margherita's confessor discussed her spiritual path and recorded her visions. As we

42. See above, note 34.

43. This connection was first noticed by Zeri. For a meticulous account of the panel see Davies, rev. Gordon, 69–73. For discussion of the vision itself, see Dalarun, 1994, esp. 137–40.

44. The technique of painting in a blue glaze over a ground of silver leaf, used for Christ's robe, and seen against the inscribed gold ground of the painting, produces an ethereal effect not easily achieved in fresco.

45. *Legenda*, vi, 17.

have seen, during his absence from Cortona he corresponded with Margherita and received news of her from her non-Franciscan confessor, Ser Badia, which he combined with his firsthand experience when compiling the *Legenda*.[46] Before Margherita's move to her third cell, beside the Church of S. Basilio, and her increasing isolation and spiritual retreat, she seems to have spent a great deal of time in the Franciscan church in Cortona, consulting the friars and attending services that sometimes led to mystical experiences evident, in some cases, to the rest of the congregation.

The *Legenda* makes it clear that Christ entrusted Margherita to the spiritual care of the Franciscans, and her decision to retreat to a cell near the Rocca was greeted by them with displeasure. Fra Giunta emphasises at this point in the *Legenda* that Margherita made her profession in the hands of Fra Ranaldo da Castiglione, and also freely promised that her body would, after her death, belong to the Franciscans of Cortona.[47] The question of the burial place of a potential saint was evidently a crucial one. One has only to remember the armed guard that accompanied the dying Saint Francis from Cortona to Assisi, taking care to avoid Perugia on the way.[48] Fra Giunta reports Christ's prediction to Margherita that she would be buried in a Franciscan church.[49] But Margherita was not, in the event, buried in S. Francesco, Cortona, and the prophecy was only fulfilled in 1392, long after Giunta's death, when the Church of S. Margherita was transferred to a group of Franciscan Observants. The *Legenda* may be described, in part, as an attempt to reclaim Margherita's soul for the Franciscan domain, even if her body rested outside it.

The *Legenda* seems to have been compiled not only with an eye to Margherita's fame outside the Franciscan Order, but also to her place within it. The *Legenda* indicates that Margherita had certain detractors and had to undergo many trials and tribulations. Some of these veiled statements may relate to the situation in the Franciscan Provincial Chapter held in Siena in 1288, in which there was a faction that doubted the veracity of Margherita's visions. After the Chapter the new head of the Arezzo custode, Fra Giovanni da Castiglione, came to Cortona to instruct Fra Giunta to visit Margherita no more than once every eight days.[50] A year or two later, Giunta was moved from the Cortona house to Siena, where he remained for the next seven years, only returning to Cortona shortly before Margherita's death.[51] It was essential for Giunta to portray the Margherita of the *Legenda* as orthodox, her visions as genuine, and the harshness of her austerities and the ecstasies of her visions as unconnected with the excesses of the most extreme on the Spiritual wing of the Order.[52]

At several points in the *Legenda* Margherita passed on to Giunta advice and rules of conduct for the Franciscans as a whole, or as individuals, as revealed to her by Christ. In a few instances this advice relates specifically to the conduct and fortunes of the Cortona house: the rebuilding of the oratory of the Fraternità delle laudi in S. Francesco; the neces-

46. As discussed above, Chapter 2 and the introduction to Part V.
47. *Legenda*, ii, 9; Iozzelli, ii, 2b.
48. Moorman, 77.
49. *Legenda*, ii, 9; Iozzelli, ii, 2b.

50. *Legenda*, v, 9.
51. *Legenda*, xi, 20; Iozzelli, x, 19. Da Pelago, i, 314 n. 29.
52. For further consideration of this issue, see Chapter 2 and the Afterword.

sity for the friars to retain the church building; the spiritual benefits for those in purgatory that would be gained if their living relatives contributed to the construction of the convent; Margherita's direction to Ser Badia, inspired by divine guidance, to give one-third of the income of S. Basilio to the church and convent of the Franciscan friars in Cortona.[53] Margherita also reported many confirmations of Christ's love for the Franciscan Order, and warnings of troubles to come within the Order.[54]

In sharp contrast to the *Legenda,* few Franciscans appeared in the murals. Only three of the nineteen recorded scenes included members of the First Order. In Scene xi two Franciscans prepare to welcome Margherita to Cortona, when she decides to do penance (Pl. XXIII; Fig. 171). They form a prominent part of the foreground, but damage to the fresco makes it impossible to know whether the figure of Christ hovering above them was gesturing with his right hand directly at the Franciscans, or to the city of Cortona on the hill behind them. The recorded inscription, which makes no mention of Franciscans, may indicate the latter, "COME SANCTA MARGARITA VENNE A CORTONA A FAR PENITENÇA" (How S. Margherita came to Cortona to do penance).

Scene i, at the top of the north wall of the *cappella maggiore,* showed Margherita's religious profession (Pl. XVII; Fig. 185). The text tells us only that in 1277[55] Margherita, having already given herself to Christ with purity of soul and fervor of heart, knelt before Fra Ranaldo, head of the Arezzo *custode,* and with joined hands and many tears humbly offered herself of her own free will, body and soul, to the Order of Blessed Francis, having also obtained, after much insistence, the habit of the Third Order of the same Blessed Francis.[56]

In the copy of the fresco Margherita does indeed kneel with hands joined, as the text specifies, while a Franciscan, presumably Fra Ranaldo, cuts her hair. This action is not mentioned in the text, nor was it stipulated as an official part of the profession of a Tertiary in this period,[57] but Meersseman notes that in thirteenth-century Italy female Penitents received a tonsure and the imposition of a veil from a priest—often a friar.[58] As a recognizable part of the admission of a postulant into a religious order, already shown on the panel

53. *Legenda,* IX, 32, 45.

54. *Legenda,* V, 32, and many others. On this issue, see Chapter 2.

55. De Pelago, I, 17 n. 1, suggests, after lengthy discussion, that this date should be corrected to 1275.

56. *Legenda,* I, 1.

57. The statutes given to those members of the Order of Penitents who were reconstituted as the Franciscan Third Order in 1289 mention only a simple promise to observe the divine precepts; Meersseman, 1977, 394–95. Da Pelago, II, 74, raises the question of whether, in the later thirteenth century, some Tertiaries were taking solemn vows, and following a regular religious life. D'Alatri, 1982, 70–71, citing *Legenda,* I, considers that Margherita was both a Penitent and an Oblate, and sees the cutting of Margherita's hair as a sign of becoming an Oblate. This

view was recently supported by Servus Gieben in a paper delivered to the conference *Santa Margherita da Cortona tra spiritualità ed arte dal XI al XX secolo,* Villa I Tatti, Florence, 1997.

For further discussion of the ceremonies accompanying entry into the Third Order, see F. Casolini, "I Penitenti francescani in "Leggende" e Cronache del Trecento," in *I Frati penitenti di San Francesco nella società del due e trecento. Atti del 2° Convegno di studi francescani, Rome, 1976,* ed. M. d'Alatri, Rome, 1977, 75–76; A. Matanić, "I Penitenti francescani dal 1221 (Memoriale) al 1289 (Regola bollata) principalmente attraverso i loro statuti e le regole," in *L'Ordine della Penitenza di San Francesco d'Assisi nel secolo XIII: Atti del Convegno di studi francescani, Assisi, 1972,* ed. O. Schmucki, Rome, 1973, 53–56.

58. Meersseman, 375–76.

painting and funerary reliefs (Figs. 182 and 184), the motif of the tonsure may have entered
Margherita's iconography, in the panel painting, through emulation of the scene of Saint
Clare's profession, shown in the panel painting in S. Chiara, Assisi (Fig. 148).[59] Or it may
record an actual ceremony, more prevalent among laywomen than is now generally real-
ized, stressing, like Margherita's checked dress, her status as a Penitent. To the right of
Margherita stands a figure that was already difficult to interpret when the copy was made,
apparently wearing the checked tunic of a Penitent. Presumably this is a representative of
the Third Order, supervising Margherita's robing as a member of the Order. Profession and
investiture, described in the *Legenda* as separate events, are here combined, while retaining
the distinction implied in the *Legenda* between Margherita's offering of herself to the Order
of Blessed Francis and her earlier robing in the habit of the Third Order. The text hints at a
direct compact between Margherita and the Order—presumably the First Order—of Saint
Francis, distinct from her membership of the Third Order.

The scene may also illustrate more generally the dual jurisdiction over Margherita's
spiritual life, characterised by the change from a Franciscan confessor to a member of the
secular clergy, whose links were with the Tertiaries. As discussed above, this combination
had already been shown succinctly in the marble relief of the same subject, by setting
Margherita between a friar and a Tertiary (Fig. 184). Since the fresco was damaged by the
time the copy was made, it is not possible to identify the figure who either wears, or hands
to Margherita, the garment of a Penitent. But the fresco definitely emphasizes the impor-
tance of the Tertiaries at the time of Margherita's profession. Two female Tertiaries, wearing
broad cloaks and the distinctive white veil, and three *Mantellati*—male Tertiaries—with
capacious cloaks joined at the neck,[60] are the witnesses to the ceremony, with no other
friars present.

The inscription beneath the scene is recorded as,

DIVINOS HABENS FERVORES / AD FRATRES MARGARITA RECURRENS MINORES
SU[B]MICTENS RELIGIONI COLLUM / MARGARITA VITIA RENUNCIAT ET MUNDUM

With divine fervor Margherita hastens to the Friars Minor.
Bending her neck to the religious life, Margherita renounces vices and the world.

These words underline the profound nature of Margherita's submission to the religious life,
although she was only a member of the Third Order who lived, initially, in the world, and
never entirely relinquished contact with the people of Cortona.[61]

59. For a discussion of the relation between the two
"*vita*-panels," see Chapter 11.

60. For the dress of Tertiaries see Chapter 11, notes 35
and 60. The statutes of 1289 make no reference to the
specific hat to be worn by a male Tertiary. Gieben, 298,
has found one mention of a Tertiary wearing a *caliendrum*,
which he believes was a flat-topped, rather deep biretta,
but the figures on the right of Scene i appear to be wearing

broad-brimmed traveling hats, perhaps comparable to that
worn by the poor man in the Miracle of the Spring in
the Upper Church of S. Francesco, Assisi (illustrated in
Poeschke, fig. 169). See Appendix III, Scene ix, for the
hat worn by Bartolo *Mantellato*.

61. Although the chronology of events within the *Leg-
enda* is often impossible to establish, it appears that people
other than her spiritual advisers continued to visit Margh-

In the mural of Margherita's funeral (Pl. IX; Fig. 189) two Franciscans, holding lighted candles, stood beside her body. But two Dominicans with lighted candles also stood beside her. They had the same compositional weight as the Franciscans and, the picture seems to imply, a similar importance at the funeral as representatives of the friars of Cortona. A similar balance has already been noted in the scene of Margherita's shrine on the panel painting (Fig. 186), while the scene of Margherita's death in the marble reliefs appears to be attended by the rector of S. Basilio in the presence of a female Tertiary (Fig. 188).

Margherita and Saint Francis

Margherita's relations with Saint Francis must be considered separately. As a Franciscan Tertiary she had a direct relation with Francis, held to be the founder of her Order, that could be said to "bypass" the mediation of the First Order, despite the spiritual guidance it offered members of the Third Order.

In the *Legenda* Christ calls Francis Margherita's father.[62] Margherita is granted visions of Francis among the company of saints, and is assured by Christ of his special love for Francis and of the special place that Francis should occupy in her prayers.[63] As we have seen, Margherita is granted plenary absolution from her sins through the merits of Francis.[64] On the other hand Margherita is never described as conversing directly with Francis[65] and it could be said that the *Legenda* is more concerned with parallels between Margherita and Francis than with contact between them. Christ tells Margherita that He wishes her to confirm the faith with her life, as Francis did.[66] Later Christ tells her that just as Saint Francis is the light of the First Order, and Saint Clare of the Second Order, so she will be the light of the Third Order.[67]

Unlike the disparity between the picture of the Franciscan First Order given in the *Legenda* text and in the mural cycle, the single appearance of Saint Francis in the murals seems to have been similar in spirit to the version given in the *Legenda*. The compositional similarity between the three versions of the Absolution of Margherita's Sins through the Merits of Saint Francis—in the panel painting, funerary reliefs, and mural cyle—has already been noted (Figs. 160–62). Francis is shown as an intercessor, but it is the parallel between the figures of Francis and Margherita, not their direct contact, that is illustrated. Christ's direct relation with Margherita takes precedence over the relation of either figure with Francis.[68]

erita in her third cell. A group of companions appear to have lived nearby, and in 1290 the Church of S. Basilio, close to Margherita's cell, was reopened to the cult. For the contact possible from her first two cells see da Pelago, I, 30 n. 7.

62. *Legenda*, II, 11; Iozzelli, II, 4; *Legenda*, IV, 8; X, 11; Iozzelli, IX, 63.

63. See, for example, *Legenda*, IV, 12; VI, 7. On this issue, see also Chapter 2.

64. *Legenda*, II, 18; Iozzelli, II, 11.

65. Apart from her one prayer to him to intercede for her with Christ (*Legenda*, II, 18; Iozzelli, II, 11.).

66. *Legenda*, V, 15.

67. *Legenda*, XI, 9; Iozzelli, X, 9.

68. Compare the intercessory role and position of Saint John the Evangelist, shown in an intermediary scale, in the Beata Chiara of Rimini panel in the National Gallery, London, discussed above (Figs. 179 and 181).

Margherita and the Franciscan Third Order

The situation for the Third Order is virtually the reverse of that for the First Order. Few references are made to the Tertiaries in the *Legenda*,[69] but a substantial number are to be found in the cycle.

The *Legenda* speaks once of Margherita as the light of the Third Order, but shows little interest in reporting its activities. It relates the bare fact that Margherita took the habit of the Third Order. On one occasion Margherita passes on to Fra Giunta some advice about the suitability of entrants to the Third Order: only those willing to submit themselves to the governance of the friars should be accepted.[70] On another occasion the devil makes a comparison between the rigors of Margherita's life and the conduct of those simply following the rule of the Order of Penitence.[71] Apart from these passing references, occasional mention is made of Margherita's companions, without specifying that they were Tertiaries. The *Ospedale* is not mentioned as an enterprise connected with the Tertiaries, nor is it specifically stated that Margherita's third cell and the Church of S. Basilio became a center for the religious and charitable activities of members of the Third Order.[72]

In the copies of the murals the distinctive checked tunic of the penitent, adopted by Margherita and her companions, seems ubiquitous (see the photomontage reconstruction, Figs. 201, 202, and 203). Worn by Margherita, it was visible in virtually every scene in the cycle. On the north wall of the *cappella maggiore* it was also seen being given to Margherita (Scene i) and then being given away by her in charity (Scene iii). It was worn by her female companions (mentioned, but not described as members of any specific order or group, in Fra Giunta's text)[73] in the Saving of the Suicide (Scene xiii), and by her helpers (perhaps the same two companions) in the scene of the *Ospedale* (Scene xv). Male and female members of the Third Order appeared in Scene i, and the capacious cloaks of the male Tertiaries (*mantellati*) were found again in Scene ix, where Bartolo *Mantellato*, journeying with his companions, was caught in the storm on the sea of Ancona.

The choice and treatment of scenes in the cycle illustrate certain of the characteristics and activities of the Third Order. We see their involvement with charitable work in Cortona, their association with Margherita, the interest felt by some of their members in journeying to the Holy Land and (only in Scene i) their association with the Franciscan First Order. In addition to these overt references, the choice of scenes illustrating Margherita's life seems to refer to the interests of the Order. The importance of confession and penance are illustrated by Margherita's arrival in Cortona, and in the remission of her sins. Entry into the Order is celebrated in the scene of her profession, and the virtue of charity is shown in both the gift of clothing to the poor and the *Ospedale* scene. The significance

69. Although for a discussion of what can be gleaned about the Third Order from the *Legenda*, see Chapter 2, and d'Alatri, 1982, esp. 73–76.

70. *Legenda*, v, 14.

71. ". . . regulam generalem tuorum Fratrum de penitentia"; *Legenda*, iii, 5.

72. See Chapter 2.

73. *Legenda*, xii, 56; CM, 78, where they are simply called *devote sociari* [*sic*].

of S. Basilio as a center for the Tertiaries after Margherita's death may have encouraged its representation as a structure of some grandeur in the scene of the Funeral of Margherita (Pl. IX; Fig. 189). The real church was presumably more modest. The priest officiating at the funeral service (Scene iv)—who appears to be wearing a close-fitting cap that covers his ears—is presumably Ser Badia, rector of S. Basilio.[74]

The members of the Third Order may have been particularly eager to stress the importance and orthodoxy of their prospective saint around the time when the mural cycle was probably planned and executed. Responding to Pope John XXII's charges of heresy against groups suspected of sympathy with the Spiritual element of the Franciscan Order, the rectors of Cortona (together with other civil authorities in Tuscany) wrote to the Curia in support of their local Tertiaries in 1322, defending them against such accusations.[75] The official approval that canonization would have bestowed so abundantly on Margherita may thus have been seen, both by the Third Order and the Commune, as a potential safeguard for the Tertiaries of Cortona.

Margherita and Cortona

Mention of the activities of the rectors of Cortona leads us to look beyond specific sections of the population of Cortona to the entire town. We find a certain number of references to Cortona in the *Legenda*. It was, of course, the unspecified setting for most of the *Legenda*. As an entity it is mentioned in connection with the campaigns of peacemaking that Margherita and Fra Giunta undertook within the town, and in Margherita's hopes for peace with external enemies, notably Bishop Guglielmino degli Ubertini of Arezzo.[76] Margherita prayed for the salvation of Cortona, and Christ told her that the kindness the Cortonese had shown to Margherita would bring blessings to them and that, despite rumors to the contrary, Margherita would die in Cortona.[77]

Margherita's significance for the people of Cortona cannot be summarized in a single sentence. Besides the example of penance and absolution, meditation and devotion, charity and peacemaking, that she provided to the Cortonese during her lifetime, her shrine

74. Compare the cap worn by the *mantellato* in the scenes of Margherita's entry into the Order (Fig. 184) and her death (Fig. 188) on the funerary monument. (For a similar close-fitting cap worn by a figure who is presumably a member of the secular clergy, see the Confession of a Woman Temporarily Revived from Death in the Upper Church of S. Francesco at Assisi, illustrated in Poeschke, fig. 196.)

In Scene iv of the mural cycle Ser Badia appears to be looking at the Franciscan nearer to him, who appears to turn toward Ser Badia and to be engaged in speech (this detail is clearer in Zabarelli's engraving of the Franciscan, Catalano, 440). The Franciscan may have been intended

to represent Fra Giunta, so that the mural recorded the primacy of Ser Badia at the funeral, but also the links between these two men.

75. See Ini, 324 and C. Schmitt, "La position du Tiers-Ordre dans le conflict des Spirituels et de Fraticelles en Italie," in *I Frati penitenti di San Francesco nella società del due e trecento: Atti del 2° Convegno di studi francescani, Rome, 1976*, ed. M. d'Alatri, Rome, 1977, 184–85.

76. For the preaching of peace within Cortona, see, for example, *Legenda*, viii, 12–15. For a prayer for peace with Arezzo, see *Legenda*, iv, 4. See also Chapter 2.

77. *Legenda*, ix, 16.

became a focus of pilgrimage and healing, immediately after her death. Margherita's political significance, her support of certain alliances and the cause of peace, were liable to reinterpretation after her death, as the political and ecclesiastical situation in Cortona evolved. While the *Legenda* presents a picture of Margherita's significance, from the point of view of her Franciscan confessor, during and shortly after her life, the murals present a later stage in her importance for her adopted town.

Two key scenes in this presentation of Margherita are the related compositions of her Funeral and the Visitation of Napoleone Orsini (Pls. IX and XI; Figs. 189 and 23). The Visitation forms a visual equivalent to two sections of the *Legenda*, Cardinal Napoleone Orsini's approbation of two items in the Chapter of Miracles (discussed above) and the declaration of authenticity appended to the *Legenda* text (Figs. 1 and 2). In addition to listing all those, both living and dead, who had read and revised sections of the *Legenda*, the declaration states that Napoleone Orsini approved the text after many months perusal. As we have seen, Orsini's approval was given at a ceremony on 15 February 1308, in the Palazzo of Uguccio dei Casali, in Cortona.

The fresco conflates these events by bringing together Napoleone Orsini and a group of those testifying to miraculous cures, beside Margherita's body resting in the iron cage of the first shrine, supported on a trestle. Several points are emphasized. The witnesses swear to the veracity of the miracles on an open Bible held by the bishop, in the presence of the cardinal legate, and recorded by the notary seated prominently on the left foreground, in the presence of numerous lay representatives.[78] The notarizing of miracles, authorized by the local bishop, formed a preliminary to the application for the opening of a canonization process.[79] The Visitation scene appears to be virtually unprecedented among surviving images. Only the scene of Saint Francis's Canonization in the Upper Church at Assisi offers certain parallels.[80] The representation of witnesses apparently gathering to testify to miracles before the assembled prelates may have influenced the choice of scene in the Margherita cycle, but at Assisi neither the body of the saint nor the figure of the notary is included, the act of testifying on oath is not made so explicit, and the overall composition is quite different.[81]

The Visitation mural was set low down on the wall, in a position analogous to those scenes on the panel painting and funerary monument concerning miraculous cures at Margherita's shrine (Pls. II and III). One of the witnesses turns to encourage the other group of foreground figures—those who have come to the shrine in search of a cure for lameness, twisted limbs, or demonic possession. The message of encouragement to them, and to the pilgrim visitors to the church seeing the painting, is clear. The stories of the miraculous cures were visible in the *cappella maggiore*, and the key to those miracles was not only the invocation of Margherita, but also the promise of a visit to her shrine, shown at the center

78. The declaration of authenticity lists, among those who had approved the *Legenda*, elected priors and judges of Cortona.

79. See Vauchez, 1981/1988, 49–50 and 106.

80. Illustrated in Poschke, fig. 189.

81. The canonization of Saint Francis in the Bardi Saint Francis panel (illustrated in Frugoni, 1988, fig. 17) does not include any reference to the workings of a *processus*.

of the painting, and existing, in reality, on the opposite wall of the nave. With the single exception of Aretino of Arezzo, all the recorded miracle scenes used in the mural cycle were associated specifically with Margherita's remains: with a promise to visit it at least once a year (Scene viii); to carry a child to the tomb (Scene x); to present a wax *cingulum* to the tomb (Scene xvi); to present ten candles, each worth twenty soldi, to the tomb (Scene xix); to encircle the tomb with a silver thread (Scene vi).[82] Scene ix relates, as discussed in the preceding chapter, to a relic of Margherita's hair in the possession of the church, and Scene vii relates to the presentation of a prisoner's chains to the tomb, and probably also to the release of prisoners that took place in the church on Margherita's feast day during the second quarter of the fourteenth century.[83] Only one of the scenes, the Healing of the Man of Corciano (Fig. 103), showed the presentation of candles (in a section that was probably repainted), but the scene of the Visitation at the Shrine makes clear the connection between pilgrimage and cure, a theme that a guide could easily have elaborated for those visiting the church. (All this is, of course, in direct contrast to the *Legenda*, which sets out to prove that Margherita's body would be buried in S. Francesco in Cortona.)

The efficacy of a visit to Beata Margherita's tomb was important not only for the sick and suffering but also to all those in Cortona who were seeking her canonization. The statutes of 1325 clearly show her importance for the city of Cortona.[84] Anyone speaking against Margherita was liable to a heavy punishment. More positively, elaborate arrangements were made for the celebration of her feast day and funds were set aside to assist Ser Felice and a companion to travel to Avignon and seek her canonization. The commune of Cortona had a particular reason to be interested in Margherita's cult: they had contributed substantially to the building costs of the new church, and were its owners.

This official lay interest is seen in the murals of the Funeral and the Visitation. The scene of Margherita's Funeral (Pl. IX; Fig. 189), which presented a far more detailed composition than the representation of her death on the marble reliefs, was concerned with including and differentiating certain groups within the society of Cortona. In the left aisle are representatives of the secular clergy, presumably led by Ser Badia, conducting the funeral service. In the right aisle are figures whose scarlet robes and fur-trimmed hats mark them out as men of importance. In the foreground stands a man wearing a full-length scarlet robe with a white collar that was probably miniver trimming, his hand resting on the pommel of his sword (a clear indication of secular power and authority), who may have been intended as a signorial figure. In the central section, behind the body of Beata Margherita, and the friars, are men in more modest dress. At the center is another man with a broad miniver collar, who is placed conspicuously beneath the two-light lancet of the apse. His wide, biretta-like hat would seem to be an indication of learning or status.[85]

82. See Chapter 4 for further discussion of votive acts and offerings to the tomb. For references to these individual examples in the *Legenda*, see Appendix III.

83. Mancini, 1897, 177.

84. See Chapter 2 and Appendix I.

85. Compare the hat worn by Luccio de' Liuzzi (d. 1318) on his tomb, illustrated in R. Grandi, *I monumenti dei dottori e la scultura a Bologna (1267–1348)*, Bologna, 1982, figs. 52 (printed in reverse) and 55.

Perhaps he is the current rector of Cortona.[86] If the men at the right may be—in some sense—signorial, then perhaps those at the centre are civic officials and guild representatives.

This variety is reminiscent of the description in the *Legenda* of the convening of a general council at the news of Margherita's death, and the information that she was embalmed in the presence of members of both the secular and regular clergy.[87] But this grouping also recalls, more precisely, the categories named in the statutes of 1325, in which the celebration of the feast of Beata Margherita is prescribed in detail. The groups required to participate, and to carry to the church lighted candles, included all friars, parish priests, guild officials, judges, and notaries and, of course, the vicar or rector of the commune who had the responsibility of organizing the procession.[88] It may tentatively be suggested that this scene represents not so much the reconstruction of Margherita's funeral in 1297 as an impression of the celebration of her feast, as enacted in the years after 1325.

The possibility that there was an element of anachronism in the Funeral scene, may also be considered in relation to two figures in the Visitation scene (Pl. XI; Fig. 23). We have already seen that Cardinal Napoleone Orsini's presence there records more than one event: the investigation of two separate miracles, and the approbation of the main text of the *Legenda*. Orsini's efforts in support of Margherita's cult, however, did not end with these activities. While in Cortona in September 1306 he had already issued two bulls in favor of those visiting S. Basilio, and the letter issued from Avignon in favor of S. Basilio by twelve prelates in 1318 was organized through the efforts of a Cortonese physician at the Curia, Maestro Accursio Cambi, doctor to Napoleone Orsini.[89] Orsini, who had originally been charged by the papacy with investigations into the cults of Angela of Foligno, Chiara of Montefalco, and Margherita, during his time as papal legate in central Italy (1306–9),[90] continued to support the cause of Chiara's canonization during the protracted stages of the *processus*, in the years between 1318 and 1331.[91] In Cortona, too, he was apparently still considered a key player in 1324 when the commune, eager for Margherita's canonization, decided to offer gifts to his nephews.[92] And more than a decade later, at the time when the Visitation scene (Pl. XI; Fig. 23) was probably painted, Orsini was still alive. He finally

86. His forked beard may appear, at first sight, to be due to postmedieval repainting, but taken together with the shape of his hat makes an interesting comparison with the figure of *Bene Comune* in Ambrogio Lorenzetti's Allegory of Good Government, and on the related Biccherna cover (illustrated in Frugoni, 1988, figs. 83 and 84.) Whether overtones from Sienese political iconography were intended to be seen in this Margherita fresco must remain an open question.

87. *Legenda*, xi, 20; Iozzelli, x, 19.

88. See Appendix I.

89. Da Pelago, ii, 167–68. The long-lived Napoleone's special feeling for his physicians is demonstrated by the curious story of the portrait of the cardinal executed by Simone Martini. The image (which no longer exists), inscribed with certain verses, is said to have been presented to Pope Clement VI in 1342, the year of Napoleone's death. The intention of these verses was apparently to commend Napoleone's last physician, Giovanni of Arezzo, to the pope—as if from the Cardinal's own mouth. See A. Martindale, *Simone Martini: Complete Edition*, Oxford, 1988, 184 (where the year of death is incorrectly given as 1343).

90. C. Willemsen, *Kardinal Napoleon Orsini, 1263–1342*, Berlin, 1927, 143 and 196; Vauchez, 1981/1988, 89–90.

91. See Vauchez, 1981/1988, 563 and 592.

92. ACC, Q.1, f. 90v. See Chapter 2.

died in Avignon, at about eighty years of age, in 1342.[93] The representation of the cardinal can thus be seen as both the record of a number of historical events, and as an appeal to the influence he might still be able to exercise in securing the wider recognition of the miraculous powers of Margherita's body. His interest in contemporary Italian painting, which can be demonstrated in several instances,[94] may have been thought to render him more susceptible to such flattery.

The bishop who stands beside Orsini, holding the Bible for the witnesses, is not named in Fra Giunta's declaration of authenticity. In fact neither the last chapter of the *Legenda* nor the declaration of authenticity mentions the presence of a bishop, only noting in passing that "many bishops" read the text. The bishop with authority over Cortona at the time of Margherita's death was Ildebrandino, bishop of Arezzo, so the figure should, logically, represent him. But it may be that the relatively prominent inclusion of this figure was intended to prompt anachronistic associations, in the spectator's mind, with the first bishop of the Cortona diocese, Ranieri degli Ubertini.

Cardini, in his account of the establishment of the *signoria cittadina* in Cortona, has shown the close links between Ranieri degli Ubertini's installation as first bishop of Cortona, in 1325, and the establishment of the Casali *signoria* around the same time.[95] Fra Giunta says that Napoleone Orsini's approval of the *Legenda* took place in Uguccio Casali's Cortona Palazzo. The planners of the cycle seem to have passed up this opportunity for topographical realism, preferring instead to set the event within the church, beside the shrine, emphasizing the efficacy of that site. But a reference to the Casali may still have been intended in the mural. The most prominent lay spectator is the figure on the left, dressed in scarlet, fur-trimmed garments, standing behind the seated notary, to the left of the cardinal and the bishop. Perhaps he represents Uguccio Casali, witnessing the Visitation.

By the time that the mural cycle was painted, the Casali were firmly established as lords

93. Willemsen, 133. Willemsen notes (2) that Napoleone's birth date is not known, but he deduces (164 n. 13) that it must have been c. 1263, the date he uses in the title of his book.

94. In addition to the portrait of himself that he is said to have commissioned from Simone Martini (mentioned above, note 89) he is now generally agreed to be the supplicant shown on the portable folding altarpiece signed by Simone Martini, known as the Orsini Polyptych (asserted most vehemently by J. Brink, "Simone Martini's Orsini Polyptych," *Jaarboek van het Koninklijk Museum voor Schone Kunsten, Antwerpen*, 1976, 16–18 [with inaccurate reference to Willemsen]). His portrait also appears in one of the stained-glass windows and in the Giotto-school frescoes of the Saint Nicholas Chapel in the Lower Church of S. Francesco at Assisi whose patronage he seems to have assumed around 1300 (I. Hueck, "Die Kapellen der Basilika San Francesco in Assisi: die Auftrag-geber und die Franziskaner," in *Patronage and Public in the Trecento: Proceedings of the St. Lambrecht Symposium, Abtei St. Lambrecht, Styria, 16–19 July 1984*, ed. V. Moleta, Florence, 1986, 88–91 and fig. 5). Hueck (91) suggested that Napoleone at one time intended the chapel dedicated to Saint John the Baptist at the opposite end of the Lower Church transepts (which has a fictive altarpiece attributed to Pietro Lorenzetti) to be his burial chapel. Schönau has gone so far as to propose that he was the patron of all the fresco decoration (attributed to the school of Giotto and to Pietro Lorenzetti) in the transepts and crossing of the Lower Church at Assisi; D.-W. Schönau, "A New Hypothesis on the Vele in the Lower Church of San Francesco, Assisi," *Franziskanische Studien* 3–4 (1985), 326–47.

95. F. Cardini, "Una signoria cittadina "minore" in Toscana: i Casali di Cortona," *Archivio storico italiano* 131 (1973), 241–55, esp. 250–52.

of Cortona. Cardini has shown how anxious the family was to strengthen their association with Margherita's cult, emphasising links between the *beata* and their family (whether real or imaginary) during her lifetime.[96] S. Margherita became their family burial place.[97] Vasari's account of the calling of Ambrogio Lorenzetti to Cortona implies, as already discussed, that either the Ubertini or the Casali were responsible for commissioning mural paintings for the church. Some reflection of Casali interest might, for all these reasons, therefore be expected in the murals.

The signorial figure with the sword on the right of the Funeral scene (Pl. IX; Fig. 189), could be seen as an anachronistic reference to Ranieri Casali, lord of Cortona from about 1323 to 1351(?). But this figure may simply be intended as a generalized reference to one of the sections of Cortonese society. The inclusion of the *Ospedale* scene (Pl. XXV; Fig. 175) could be an opportunity to show the munificence of Uguccio Casali, identified by da Pelago as the anonymous benefactor of the foundation.[98] But da Pelago's identification is unsupported, and this scene may also be a more general celebration, in this case of the achievements of the *buonomini* of Cortona.

In the scene of Margherita's decision to go to Cortona the city is shown in a manner reminiscent of the heavenly Jerusalem (Pl. XXIII; Fig. 171).[99] This idea finds a parallel in the remark attributed to Margherita in Boncìtolo's chronicle of Cortona (begun in the thirteenth century, and continued by others in the fourteenth century). When talking to Guglielmino Casali, (Uguccio's son and Ranieri's father) she is said to have predicted that Cortona would become a new Jerusalem.[100] Once again the Casali connection seems secondary to the point being made about Cortona as a whole. The scene shown in the other half of the lunette, the Liberation from Devils of the Boy of Borgo Sansepolcro (Pl. XXI; Fig. 168), may also refer, more indirectly, to the holiness of Cortona. The boy was freed from devils near Castel Gherardo (modern-day Castel Gilardi), as soon as he

96. F. Cardini, "Allegrezza Casali, devota di S. Margherita, figura poco nota nella spiritualità cortonese," *Studi francescani* 72 (1975), 335–44; Cardini, "Agiografia e politica: Margherita da Cortona e le vicende di una città inquieta," *Studi francescani* 76 (1979), 129.

97. The anonymous antiquarian of Cortona Biblioteca Comunale Cod. 501 (*L'Antiquario Sacro . . .*) recorded, on f. 2v., that when, in about 1770, a new pavement was laid in the sacristy (that is, the original S. Basilio, subsequently Cappella di S. Margherita) a number of tombs of the Casali family were removed from between the altar and the south(?) wall of the church. In his history of Cortona published in 1700 (130) Tartaglini reported that a member of the Casali family (not specified) left 3,000–4,000 scudi for the building of the church. Tartaglini gave no indication of his sources, and I have not found any other reference to this donation. Tartaglini's information may be a confused account of the annual donation of 30 florins made to the Cappella di S. Margherita by Francesco Casali in his will of 1375. I am indebted to Céline

Perol for knowledge of the provisions of this will. For further discussion of the will and of subsequent Casali links with the church see the contribution by Céline Perol to the Italian-language version of this book.

98. Da Pelago, i, 28 n. 3. The name of another Casali, Ranieri, was mentioned in 1334 on an inscribed tablet bearing the monogram of the confraternity that administered the *ospedale* (Fig. 177).

99. For the concept of the medieval Italian town as a heavenly Jerusalem in relation to Ambrogio Lorenzetti's paintings see U. Feldges-Henning, "The Pictorial Programme of the Sala della Pace: A New Interpretation," *Journal of the Warburg and Courtauld Institutes* 35 (1972), 159–62, with further bibliography. For recent wider discussion of the concept of the heavenly Jerusalem in relation to the image of the medieval town, see C. Frugoni, *A Distant City: Images of Urban Experience in the Medieval World*, Princeton, 1991.

100. *Cronache cortonesi di Boncìtolo e d'altri cronisti*, ed. G. Mancini, Cortona, 1896, 19.

came in sight of the Rocca of Cortona. (S. Basilio is presumably the church visible on the skyline in the fresco.) The devil was heard to say that he could not tolerate being any closer to Cortona, because of the prayers of Margherita, and her presence there.[101] Da Pelago reports that Castel Gherardo, where the miracle occurred, was a *signorie* of the Casali family at that time.[102] It is impossible to say whether this fact influenced the choice of scene in any way.

One further, and even more tenuous connection with Casali interests may be proposed. Cardini has argued that the twin births of the new diocese, under Ranieri Ubertini, and the Casali *signoria,* formed the fulcrum of papal policy in the area.[103] The inclusion of a *navicella*-like composition for Scene ix (Pl. XXVI; Fig. 137), a favorite piece of papal iconography, could perhaps have been a salute to this alliance of interests.[104] It was proposed in Chapter 13 that this scene might include an allusion to the papacy of John XXII. If this is correct, it might be further tentatively proposed that Scene ix also constituted a gesture of homage to the memory of Pope John XXII from the representatives of Cortona in thanks for his establishment of the independent diocese, and the rescinding of the annual tax of one thousand florins previously due to the bishop of Arezzo.[105] Yet again, the interests of Cortona in general seem more predominant than those of the Casali in particular.

The south nave wall provides several pictures of the buildings of Cortona, in an appeal to local pride. At the top of the wall, Cortona is approached from the directions of Borgo Sansepolcro and Montepulciano (Pls. XXI and XXIII; Figs. 107, 168, and 171). The next two scenes on this wall (xiii and xiv) concern miracles that took place in the streets and houses of Cortona, while Margherita lived in a cell within the town (Pls. XXIV and XXII; Figs. 134 and 122), and these are followed by the representation of the *Ospedale* (Pl. XXV; Fig. 175).[106] The Visitation of Napoleone Orsini (Pl. XI; Fig. 23) makes a rousing end to this section of the cycle, in which many citizens of Cortona are represented, gathered around Margherita's shrine.

Consideration of the S. Margherita murals, particularly those of the south nave wall, serve to remind us that "Cortona" was not a single entity in the trecento any more than it is today. When considering how the interests of Cortona might be reflected in the mural

101. *Legenda*, iv, 6.

102. Da Pelago, i, 70 n. 11. Da Pelago confirms that this was the first place from which the Rocca above Cortona was visible to those approaching from Borgo Sansepolcro.

103. Cardini, 1973, 251. A certain Rinaldo [*sic*] di Guglielmo dei Casali, knight of Cortona, was honored by the Curia of John XXII on 6 October 1334 and his son was received as a *familiares* on 29 December 1331; B. Guillemain, *La Cour pontificale d'Avignon (1309–1376),* Bibliothèque de l'Ecole française d'Athènes et de Rome 201, Paris, 1962, 493 n. 63.

104. Köhren-Jansen, 170–74, has shown how the choice of the *Navicella* by the canons of St.-Pierre le Jeune in Strasbourg for the decoration of their church c. 1320 seems to have been a deliberate statement of support for John XXII in his conflict with Louis IV of Bavaria.

105. Bull of 18 May 1325. See Chapter 2.

106. For the location of Margherita's first and second cells, see da Pelago, ii, 34–38. For discussion of the use of scenes set in appropriate townscapes to help the promotion of the cult of Beato Agostino Novello, see Seidel, 1985, 86–99.

cycle, it is essential to be aware of the wide variety of interested groups, all with their own aims and preoccupations, who may have found it convenient, even inspiring, to gather together under the banner of Cortona's new prospective patron saint. In the Margherita of the frescoes we have the active rather than the contemplative. Margherita's life may serve as a pattern, but while the *Legenda* provides a guide to the inner life of asceticism, penance, mysticism, and reclusion, the frescoes propose the outward life of a good citizen and member of the Third Order, assisting members of many parts of the community in life—and after death. The people of Cortona are seen to come to her cell for help, or are supported by Margherita as she and her companions run to their homes to save them. Margherita is shown as the vital link that ensures the feeding and help of the sick and poor by those among the citizens who were well provided for. The Margherita of the *Legenda* is assailed by doubts and racked by remorse. She flinches from the evidence of her miraculous powers, as in the case of the Liberation of the Boy from Sansepolcro, where Margherita is horrified by her unworthiness. The Margherita of the frescoes has already turned her back on the devil. She receives full absolution from Christ and, at her death, is carried directly to heaven. Her triumph, and her miraculous powers, are seen to be a source of joy and comfort for all those in Cortona.

The Mural Cycle and the Legenda

Although the text of the *Legenda* and the images of the fresco cycle both take as their starting point the character, spirituality, deeds, death, and miracles of Beata Margherita, they do not have a great deal in common. Fra Giunta's text presents a lengthy record of Margherita's spiritual development, in which precise information about events and chronology are alluded to elliptically, ignored, or perhaps even consciously obscured. In contrast the murals illustrate a progression of events and are filled with circumstantial detail.

This contrast springs in part from the obvious broad differences in method and presentation inherent in the forms of text and image. While the narrative text has to reveal itself to its audience one step at a time, the visual—in the form of a series of mural paintings—can be apprehended in a variety of sequences and combinations. On the other hand, while a text can attempt the description of a spiritual state, or the contents of a meditation or conversation, a fourteenth-century mural painting must search for techniques and equivalents for expressing feelings, thoughts, ideas, and speech. But the two forms are capable of coming close to one another, as the discussion of the representations of the miracles has shown.

It is necessary to look beyond the basic differences between text and image to consider the differences between the production and function of the two works. The *Legenda* was not a unified composition. It probably began as a series of working notes together with information supplied by others, that Fra Giunta compiled and added to as time allowed. Analysis of the watercolor copies has suggested, on the other hand, that the mural cycle

was planned as a coherent scheme, executed in one or two campaigns. The *Legenda* needed to be acceptable as evidence in a canonization process, and also as a defense of Margherita's orthodoxy and the veracity of her experiences. The text was indeed approved by a large number of readers, and by the papal legate, Napoleone Orsini, as the declaration of authenticity shows, but despite the crisply written account in the last chapter of the *Legenda,* in which Margherita's miracles were set out, approval of the cult was not forthcoming. The text also seems to have been intended to urge the right of the Franciscans of Cortona to the body and cult of Margherita. But it did not succeed in this aim either.

The full text did not enjoy a wide diffusion. Only three medieval copies of the text are known to exist, all now in Cortona. This Latin text no doubt served as the basis for extracts and summaries in the vernacular, available to the people of Cortona through sermons and other teaching, perhaps also written down in forms that have not survived.[107] But in fourteenth-century Cortona the oral tradition concerning Margherita was presumably also strong. This vernacular version of events, stemming from eyewitness reports and shared memories, would have been known by a far greater number of people than the lengthy contents of one of the three copies of Fra Giunta's *Legenda.*[108] It was not until the *Legenda* (without the Chapter of Miracles, and somewhat abridged) was printed in the *Acta Sanctorum* that Fra Giunta's text was available to a wide public. In the centuries following its composition, Fra Giunta's version of Margherita was probably only fitfully and indirectly influential.[109] The printing of the *Legenda* in the *Acta Sanctorum* may now give us a false impression of its medieval status.[110]

The reverse is true of the murals. Now little known or studied, these would once have been accessible to every pilgrim visiting the church. These images, in conjunction with the oral tradition, formed a basis for the general view of Margherita and probably preserve elements of that oral tradition for us. It is only through careful study of the copies of the

107. For the "preaching" of Margherita's *Legenda*—in abbreviated form—soon after its composition, see Chapter 2.

108. For an indication of the durability of the oral tradition, see the depositions to the *processus* of 1629–40 printed by Montenovesi.

109. For an example of the vernacular use of snippets of information from the *Legenda,* mixed with elements from the oral tradition, in the early sixteenth century, see Mariano da Firenze, *Il Trattato del Terz'Ordine o vero 'Libro come Santo Francesco istituì et ordinò el Tertio Ordine de Frati et Sore di Penitentia et della dignità et perfectione o vero Sanctità sua',* edited with introduction by M. D. Papi, Rome, 1985, 353, 355–56, and 447 (extract from *Analecta Tertii Ordinis Regularis Sancti Francisci* 18, 1985).

For a highly abbreviated version of the *Legenda* in Italian, see the life of Margherita in S. Razzi, *Vite de' Santi e Beati Toscani . . . ,* Florence, 1593–1601, 417–33. In the absence of a published text of the *Legenda* Razzi based himself on the information given in a Franciscan chronicle written in Spanish, which he translated and further

abbreviated. Giacomo Lauro, writing in 1639, observed that the *Legenda* remained unpublished, but noted that shorter prose and verse versions (not specified) had been written in Spanish, Catalan, Portuguese, Latin, and Italian (Lauro, part II, gathering F).

110. As, for example, in Bell, 87, where it is claimed that "we do know that [the *Legenda*] was read eagerly and widely retold, indicating at least that the struggles and longings presented in it variously fascinated or inspired medieval people." Bell draws on the *Legenda* (and, it seems, on postmedieval embellishments of the story) for his portrait of Margherita. He envisages both the text and its contents enjoying a wide dissemination through public readings (87 and 152) but it is impossible to know which parts of the story were retold for the edification of the faithful, and whether these correspond to passages that Bell found especially significant. We can, on the other hand, be more confident about the aspects of Margherita chosen for presentation in the panel, tomb, and mural cycle.

cycle and its content that we can recover this aspect of Beata Margherita, with its significance for the people of Cortona, the members of the Third Order, and the guardians of her tomb. Where Fra Giunta's text had initially failed, the mural cycle eventually helped lead to success: its evidence was carefully examined during the *processi* of 1629–40 and again in 1719.[111] These deliberations finally led, in 1728, to the canonization of Margherita.

111. *ASV, Riti*, Proc. 549.

Conclusion
Art, Cult, and Canonization: The Case of Margherita of Cortona

The reconstruction of the art and architecture associated with the cult of Margherita, and with the search for her canonization, in the decades following her death, has been pains-taking but also rewarding. A rich source of art-historical material has been revealed. If the arguments advanced here are accepted, then the lost mural decoration of S. Margherita provides us with substantial new insights into the art of Pietro and Ambrogio Lorenzetti. Examination of the architectural context of, and visual forerunners for that decoration has brought together a valuable series of visual commemorations associated with the different stages in the early development of Margherita's cult. Despite the loss of much of this material, we know more about the narrative art connected with Margherita than with virtually any other central Italian saint or would-be saint of the thirteenth or fourteenth centuries apart from Francis of Assisi. Only the mural cycles of the stories of Elizabeth of Hungary (d. 1231) in the nun's choir of S. Maria in Donna Regina, Naples,[1] and Nicholas

1. For illustration of the cycle, see Kaftal, 1965, cols. 380–97. For discussion of authorship, and proposal of a date of c. 1335, see F. Bologna, *I pittori alla corte angioina di Napoli, 1266–1414*, Rome, 1969, 136–38; pl. III-50, fig. 63. Subsequently, a date of c. 1320 has been proposed in M. Boskovits, "Proposte (e conferme) per Pietro Caval-lini," in *Roma Anno 1300*, ed. A. M. Romanini, Rome, 1983, 308–11, and a dating in the 1320s to 1330s in P.

of Tolentino (d. 1305) in the Cappellone of S. Nicola, Tolentino,[2] approach the number of scenes telling Margherita's story in a single monumental cycle,[3] and neither provides the sequence of narrative cycles that permit, in Margherita's case, a comparison of three related versions of her story and significance. Only the numerous representations of the story of Saint Francis offer many more monumental versions of the depiction of the life of a near contemporary saint in late medieval central Italy.

This series of works has made it possible to consider the initial choices made in the panel painting and its relation to the models provided by certain earlier saints; to see the repetitions and changes made to the examples provided by the panel painting in the marble reliefs; and to trace the use of that iconographic nucleus, with many significant additions, in the mural cycle. These paintings and carvings were chosen and designed with knowledge of existing forms, and a number of sources or parallels within the art of central Italy have been indicated in the course of this study. But I would certainly not maintain that this series of visual commemorations followed a preordained pattern. On the contrary, the sequence seems more notable for its unpredictability.

The Margherita panel did not concentrate on her thaumaturgic powers, as might have been expected in a painting of this format; the requirements for the presentation of a candidate for canonization do not seem to have made themselves visible in art at this early stage in the cult. Instead Margherita's local status is amply demonstrated on the panel (Pl. II; Fig. 154): she is shown with a halo and called *sancta*. Only the examples of the Clare of Assisi and Magdalene *vita*-panels (Figs. 153 and 163) seem to have provided visual precedents that accorded to some degree with the concerns of the earliest guardians of Margherita's cult: Fra Giunta Bevegnati, Ser Badia, and the members of the Franciscan Third Order associated with S. Basilio.

Margherita's marble funerary monument, with its effigy, was of a type associated at that time with the burials of prelates and prominent laymen rather than with venerated remains. This monument seems to mark the increasingly civic aspect of Margherita's cult and, through the choice and treatment of subjects in the narrative reliefs, the growing

Leone de Castris, *Arte di corte nella Napoli angioina*, Florence, 1986, 286–90. For the proposal that Mary of Hungary (d. 1323), patron of the rebuilding of the church, was also associated with the mural cycle, see A. S. Hoch, "*Beata Stirps*, Royal Patronage and the Identification of the Sainted Rulers in the Saint Elizabeth Chapel at Assisi," *Art History* 15 (1992), 288, 293 n. 32, and 294 n. 44–46, with further bibliography.

2. For a valuable collection of studies, including F. Bisogni's illuminating discussion of the iconography of the mural program, see *San Nicola, Tolentino, le Marche: Contributi e ricerche sul processo (a. 1325) per la canonizzazione di San Nicola da Tolentino: Convegno internazionale di studi, Tolentino 4–7 Sett. 1985*, Tolentino, 1987. For a summary of suggested datings, reaching from 1310 to 1348, see M. Boskovits, "La decorazione pittorica del Cappellone di S. Nicola a Tolentino," in ibid., 254. Bisogni, 289–96, argues

for an early dating, possibly even before 1310. See also J. Gardner, "The Cappellone di San Nicola at Tolentino: Some Functions of a Fourteenth-Century Fresco Cycle," *Italian Church Decoration of the Middle Ages and Early Renaissance: Functions, Forms and Regional Traditions*, Villa Spelman Colloquia 1, ed. W. Tronzo, Bologna, 1989, 101–17. Gardner supports a dating of between c. 1326 and 1348, and considers that the cycle was undertaken after the *processus* of 1325 in the expectation of a forthcoming canonization.

3. As Gardner (1989, 116–17) observes about Tolentino, "The creation of a new cult centre with an imposing fresco decoration was less common [in fourteenth-century Italy], and in this the *Cappellone* is one of the major exceptions. It is redolent of the previous century."

importance of the personnel of S. Basilio, and marginalizing of the Franciscans of Cortona, in the promotion of her veneration. It may also seem surprising that Margherita's remains were not placed within the marble tomb but in a niche below it, guarded by wooden shutters. Here we may be witnessing the effect of the continuing importance of the complete and incorrupt body, the desire to maintain the possibility of access to it, and the strength of the local devotions and of the pilgrimage that centered around Margherita's remains.

The mural cycle also presents its share of unexpected elements. While parallels can be drawn between the construction and overall decorative scheme of S. Margherita and the burial churches of Saint Francis and Saint Clare in Assisi, individual scenes within the Margherita cycle show few points of contact with these predecessors.[4] Even when parallels might easily have been drawn between the Margherita scenes and the cycle in the Upper Church of S. Francesco (and there is reason to suppose that the artists who designed the Margherita cycle were well acquainted with the murals at Assisi) the opportunity appears to have been passed by.[5] There seems to be no simple explanation for this divergence, but it may be significant that other prototypes for hagiographical narrative appeared in central Italy between the initial planning and construction of the church and its eventual decoration. The developments in this field made by Sienese artists, most notably Simone Martini, and Pietro and Ambrogio Lorenzetti, provided more recent and perhaps more appealing and appropriate schemata to apply to the armature of Margherita's story. Both the mural cycle and the tomb-type move Margherita within the orbit of Sienese celebrations of civic cults and away from Umbrian commemorations of venerated figures.

The introduction of so many miracle scenes into the canon of Margherita's iconography may have been one factor that made these Sienese cycles a more suitable source of inspiration than the Upper Church cycle. This delayed adoption of the miracles that might have been expected on the panel painting or tomb reliefs, suggests a further shift in Margherita's cult toward an increasing interest in official canonization.[6] As we have seen, in 1325 the

4. For the evidence concerning the Saint Francis cycle, see Chapter 14. Loss of all but two of the Saint Clare scenes complicates the discussion, but the two surviving fresco scenes do not seem to have exercised a direct influence on the planners or artists of the Cortona cycle.

5. For example the Assisi composition of Saint Francis Praying before the Crucifix at San Damiano: both Francis and Margherita helped to restore a ruined church, and both were addressed by a crucifix. Saint Francis's vision of the throne prepared for him in heaven may have influenced the equivalent scene on Margherita's "vita-panel," but no scene of this subject appears among the recorded scenes of her mural cycle. The Assisi scene of Saint Francis liberating the city of Arezzo from the demons of strife could have provided a model for a representation of Margherita's activities as a peacemaker, another facet of Margherita's story not apparently represented in a separate scene in the cycle. The scenes of Margherita's Funeral and the Ascent of her soul to heaven, which do resemble

compositions in the Saint Francis cycle, use motifs that were quite widely diffused by that time.

6. An interesting contrast is presented by the fresco cycle of S. Ranieri in the Campo Santo in Pisa (painted by Andrea Bonaiuti and Antonio Veneziano in the years following 1377). The local cult of Ranieri (d. 1160) was established before the need for papal canonization was universally recognized, and the Pisans do not appear to have pursued this goal (Vauchez, 1981/1988, 102 and 234–35). In the extensive mural cycle (six "fields" containing a total of approximately twenty-four separate events) only the last two fields contain any miracles of healing. The inscription below the final field specifies only one miracle from each of the three categories "miracles accomplished at sea," "miracles accomplished on land," and "miracles around the saint's tomb." In the penultimate field, the inscription beneath the representation of Ranieri's funeral procession mentions only one miracle that happened at that time; the viewer wishing to find out

commune appointed Ser Felice, Ser Badia's successor as rector of S. Basilio from c. 1306–c. 1338, to travel to Avignon at the commune's expense in an attempt to expedite the canonization and the granting of further indulgences to the church. We do not know whether this journey was ever undertaken, but it seems likely that it was not, for no new indulgences were issued from the Curia and in 1328 Ser Felice was busy urging the bishop of the newly created diocese of Cortona, Ranieri degli Ubertini, to confirm all the privileges previously granted to the church.[7] Perhaps Ser Felice turned his immediate attention instead to using communal funds for the painting of the Margherita cycle. In the near contemporary case of Chiara of Montefalco expenditure on a canonization process certainly went hand-in-hand with the organization of mural decoration in the burial church. Béranger de Saint-Affrique, Chiara's biographer, was a major contributor to the costs of her *processus*, which began in 1318 and came to a halt in its curial phase in 1331.[8] A few years later he was probably closely involved in planning the program of decoration in the *cappella maggiore* of S. Chiara, Montefalco.[9] In the absence of precise documentation it has not been possible to establish the identity of the patron—in the narrow sense of the person responsible for payment or for the mechanism of commission—of Margherita's mural cycle or tomb.[10] But this does not rule out the possibility of making certain suppositions on the basis of the wider situation in Cortona and a consideration of the works themselves. In later medieval Italy the commune often seems to have paid for the tomb of a person attracting a cult of civic dimensions.[11] The documentation in Appendix I demonstrates the commune's financial commitment to the furtherance of Margherita's cult by various means, and the deliberation of 1324 to vote money "pro ecclesia Sancti Basilii augmentanda," although disappointingly imprecise, shows that improvement and embellishment of the church were seen as legitimate items of expenditure on the part of the commune—who, after all, owned the church at this time.

If it seems reasonable to see the commune as the major financial guarantor behind these works, and Ser Felice as an organizing force, how should we view the contributions of Ranieri degli Ubertini and Ranieri Casali, whose identities Vasari conflated when naming a patron? As we have seen, despite extended Casali interest in Margherita's cult and burial church, there is no strong evidence for the preeminence of their interests within the mural cycle. Indeed, the Casali use of the Cappella di S. Margherita as a family burial chapel may

more about such miracles is invited to consult the *Legenda* text, "E molti altri miracoli li quali appariscono nella sua leggenda, Amen." For an illuminating analysis of this cycle in relation to Ranieri's cult and the text of his *legenda* see Richards, passim, esp. 24-52.

7. De Pelago, II, 171.

8. See Vauchez, 1981/1988, 77, 563, and 592.

9. See Gordon, 1979, 248–55. Gordon notes that the murals of Chiara adhere closely to the text of her *vita* that Béranger himself composed. The Crucifixion mural on the east wall of the *cappella maggiore*, dated 1333, was paid for by Jean d'Amiel but Gordon considers that the chapel decoration was executed in two phases, the second of

which, including the images of Chiara, was supervised by Béranger. I am grateful to Dillian Gordon for discussing with me Béranger's activities.

10. Recent study of commission documents for Sassetta's altarpiece for S. Francesco in Borgo San Sepolcro makes it abundantly clear that the person or persons paying for a painting might sometimes have little or no say in its appearance. See J. R. Banker, "The Program for the Sassetta Altarpiece in the Church of S. Francesco in Borgo San Sepolcro," *I Tatti Studies: Essays in the Renaissance* 4 (1991), 11–58, esp. 21–22.

11. See Vauchez, 1981/1988, 274 n. 289, 277; see also Chapter 4.

only have been established later in the century.[12] But the close association of both Ranieri Casali and Ranieri degli Ubertini with the commune's interest in the Church of S. Basilio is clearly demonstrated in the document of 1332 concerning the Cappella del Salvatore. A new chaplaincy was instituted, "to the honor of God, and the Blessed Virgin Mary, the Blessed Basilio, and Blessed Margherita, and all God's saints, and to the honor of the Venerable Father Lord Ranieri, by God's grace bishop of Cortona, and the lord provost, and to the honor and reverence of the magnificent Lord Ranieri, son of Lord Guglielmo, lord general of the city of Cortona, and count of the same."[13] Thus to speak of the activities of the commune may be to assume, in the context of Margherita's cult, the support and advice of both the bishop and the lord of Cortona.[14]

Both men could have had an opinion to offer on the choice of artist for the murals in S. Margherita. Guido Tarlati, who combined the roles of bishop and lord of Arezzo, had commissioned from Pietro Lorenzetti an altarpiece (Figs. 84, 93, and 94) and—according to Vasari—a fresco cycle of the life of the Virgin, in 1320 for the *cappella maggiore* of his favored church, the Pieve di S. Maria in Arezzo.[15] Ranieri Ubertini, whose younger brother succeeded Tarlati as bishop of Arezzo in 1326, and Ranieri Casali, lord of a city newly independent from Arezzo, might both have considered the choice of the same artist fitting for a major church in the newly created diocese.

Informed advice may also have guided those negotiating with the artists in their choice

12. The earliest recorded Casali burial in the church is that of Ranieri himself, who died in 1351. (For Casali connections with the church, see the contribution of Céline Perol in the Italian-language version of this book.) A silver-gilt and enamel chalice from S. Margherita, now in the Museo Diocesano, Cortona (Fig. 190), is a reminder of the possibility of a distinction between those paying for an object and those celebrated by it. The chalice bears the Casali arms on one of the knop enamels, and one of the enamels on the foot shows the diminutive figure of an unidentified layman kneeling before Margherita. (For a description of the chalice and detailed illustrations see Collareta and Devoti, 11–25. See also the entry by Daniela Galoppi Nappini in Maetzke, 1992, 194–96. These authors were not aware of the payments published by Bornstein and did not therefore realize that the chalice could be dated precisely). The inscription on the knop says that the chalice was made in the time of *Domini Francisci* (Casali), but it goes on to name the two *soprastanti* of the church who were responsible for the commission. Bornstein (1990, 241–43) has published documents that make it clear that the payments (totaling 39 florins), made in installments during 1372 and 1373 to a Sienese goldsmith Michele di Tommaso, were handled on behalf of the *soprastanti*. The payments call the chalice "Lo challaci de Sancta Margarita" and da Pelago (*Sommario*) noted that in 1781 the chalice was still used when celebrating mass on Margherita's feast day. An inventory of the church made in 1447 ("Quaternus piissimi loci Beate

Margherite," ACC, Z3, ff.2r and 4r) mentions two objects decorated with the arms of the Casali: the chalice and an altar frontal. Presumably the two were used in conjunction, presenting a clear visual link between the Casali family and Margherita, on her feast day, although no Casali money can be shown to have gone into the making of the chalice. (Two years later, in 1375, Francesco Casali made the will that was so favorable to the church.)

13. ". . . ad honorem Dei, et B. Marie Virginis, B. Basilii, et B. Margarite, et omnium Sanctorum Dei, et ad honorem Venerabilis Patris Domini Ranerii Dei gratia Episcopi Cortonensis, et Domini Prepositi, et ad honorem et reverentiam Magnifici Domini Ranerii Domini Guielmi Domini Generalis Civitatis Cortone, et Comitatus eiusdem"; da Pelago, II, 172.

14. For the shared involvement of bishop and commune in the arrangements for the burial and cult of Enrico da Bolzano (d. 1315), see Vauchez, 1981/1988, 278–79. For an example of "divided authority" over an altarpiece, and the processes of deciding the subject matter of a painting between an artist and several interested parties see Banker's study of Sassetta's altarpiece for San Francesco, Borgo San Sepolcro, esp. 18 and 21–28.

15. For the patronage of Tarlati, and thorough consideration of the relevant documents, see A. Guerrini, "Intorno al polittico di Pietro Lorenzetti per la Pieve di Arezzo," *Rivista d'arte* 40 (1988), 3–29. The contract shows that Tarlati reserved to himself the right to decide the subject matter of the altarpiece.

of subject matter. Among the unexpected features of the murals we have noted a lack of reference to Margherita's spiritual life, meditations, ascetic privations, and mystical experiences within the reconstructed cycle. The apparent omission of certain features of Margherita's story might simply be the result of a loss of evidence, or of difficulties in translating this material into visual form, but it is striking that the comparisons that have been made here with visual narratives of other female thirteenth- and fourteenth-century saints have drawn attention to differences rather than similarities. Those female mystics with whom Margherita is most often considered do not provide a satisfactory artistic context for her tomb or fresco cycle.[16] This raises the question of whether it might have seemed prudent to emphasise Margherita's orthodoxy rather than the mystical and ascetic aspects of her spirituality, or her links with certain parts of the Franciscan Order, when presenting in visual terms the case for her canonization in the 1330s. Here we may speculate on the possible value of advice on curial politics from Bishop Ranieri degli Ubertini, himself a former papal chaplain.[17]

It seems that in the half-century following Margherita's death the desire to have her sanctity officially recognized by the papacy grew, and had a growing influence on the art in which she was celebrated. But it would be misguided to look for a single explanation of that art. This study has sought to emphasize the multiplicity and diversity of relations between Margherita's cult and its visual commemorations. The unpredictability of much of the art studied in this book in itself constitutes a strong argument for subjecting it to close analysis. The resulting picture is inevitably incomplete, but nonetheless richly detailed, unexpected, and informative.

16. In addition to the examples given in the preceding chapter see the exhibition catalogue *Sante e beate umbre tra il XIII e il XIV secolo. Mostra iconografica*, Foligno, 1986. For Chiara of Montefalco see also Nessi, 1986. Chiara was buried in a wooden coffin under the pavement of the church (Nessi, 1963, 3–4) and no stone tomb was provided until Chiara's translation behind the high altar of a new church, in 1430 (Nessi, 1986, 317–18). Even then the chief decoration consisted not of carving but of

painted decoration on the chest itself (Nessi, 1986, figs. 8–11).

17. Cardini, 1973, 250, sees Ranieri degli Ubertini as a possible conduit between the Curia and the Casali—and perhaps also between the Curia and Cortona as a whole. Ubertini might conceivably have been a source of information on Napoleone Orsini's interest in art, or the significance of the *Navicella* composition, both discussed in the preceding chapter.

Afterword

André Vauchez

The story of the cult of Saint Margherita of Cortona in the late Middle Ages might seem, in several respects, to be one of failure. It was not until the early sixteenth century that her sanctity was officially recognized by the papacy, and only in the seventeenth did her liturgical cult spread beyond the narrow confines of the diocese of Cortona. It almost seems as if the two diverging interpretations of her person, brought to light in this study, had acted against one another: in the one corner the strongly Franciscan and spiritual view promoted by Fra Giunta in the *Legenda,* and in the other the more worldly and "civic" view that emerges from the lost frescoes of the Church of SS. Basilio e Margherita.

Despite the efforts of her biographer, Margherita did not, in fact, become the figurehead of the Franciscan Third Order at this time, even in Italy. She was not able to supplant Saint Elizabeth of Hungary, in whose favor were her royal birth and her canonization by Gregory IX in 1235. Even though Saint Elizabeth's membership of the Franciscan penitential movement is very doubtful, it was she, and not Margherita, who came to be regarded by posterity as "the third light of the order of Saint Francis," as Fra Giunta put it. This is well exemplified by Italian art of the fourteenth and fifteenth centuries, from the Neapolitan frescoes of S. Maria in Donna Regina to the famous altarpiece by Piero della Francesca

in Perugia. Images of Margherita in the same period, like the manuscripts of her *Legenda*, achieved no wider circulation than Cortona and its *contado*. This restricted popularity of the holy penitent clearly demonstrates the limitations of Franciscan activity in operating and administering local sanctity. In the case of Margherita, it is true, they were to some extent justified in claiming as one of the glories of their spiritual family a penitent who, in her life, had placed herself under their direction, and had given them so many signs of respect and devotion. But their claim came into conflict with that of the civic authorities and populace of Cortona, who were no less attached to Margherita, but for different reasons. This double "reading" of her sanctity was even inscribed in her devotional space: for centuries the crucifix said to have addressed Margherita remained in the Church of S. Francesco, while her body rested in the church up the hill, rebuilt and enlarged to protect her tomb.

It is not impossible that the efforts made to have S. Margherita canonized—pursued for how long and with what vigor we cannot know—were destroyed or at the least confounded by those conflicts that set the papacy against a good part of the Franciscan Order between 1310 and 1340. The orthodoxy of the mystic was not in doubt, to be sure, but can one imagine that during the papacy of John XXII a saint should be raised to the altars when the names of Ubertino of Casale and Conrad of Offida appear in her *Legenda*, and God's special predilection for the Order of Friars Minor is affirmed unreservedly on its every page? It was no doubt for similar reasons that the canonization process of her contemporary from neighboring Umbria, Chiara of Montefalco, became bogged down around 1330, even though it had already reached a very advanced stage. In any event it is significant that both these parallel figures only began to enjoy real celebrity in the church in the early nineteenth century.

Nonetheless, and this is of interest to the historian, the cult rendered to Margherita at Cortona remained vigorous throughout the later Middle Ages despite the lack of any papal approval. One reflection of this is the art that decorated the Church of SS. Basilio e Margherita. The conception of sanctity that was manifested in the sanctuary is quite different from that propounded in the *Legenda*, not only because the Franciscanism of Margherita is less marked, and her local connections underlined, but above all because of the considerable space given over in the images to miracles and supernatural phenomena in the estimation of her sanctity. On this level the contrast is especially clear: the *Legenda* eschewed thaumaturgic events in the first version, and the addition of the final chapter, which is devoted to miracles, seems to have been dictated by "strategic" considerations linked to the pursuit of her canonization. For Fra Giunta, Margherita was a saint because she had communicated directly with God, and through penitence and tears had come to experience Christ's Passion, which she never ceased to contemplate and meditate upon, in her own body. Furthermore, her life exemplified the divine mission assigned to the Franciscans, whose vocation was to recall souls to the road to salvation through preaching and example. The miraculous is not absent from the *Legenda*, but it takes a mystic or sacramental form—Margherita sees the Christ Child in the Eucharist. When implored to undertake healings, the saint draws back, even saying that contact with her will only aggravate the

malady (*Legenda,* IV, 2). But scarcely has she closed her eyes when the first miracles are produced. From that time onward her tomb seems to have been visited without a break by numerous pilgrims, sometimes coming from afar to find a cure or to give thanks for the release that they have enjoyed due to her intercession. From this point of view the message of the lost frescoes is simple: they express a very traditional view of sanctity, defined by its utility and effectiveness. They also draw attention to Margherita's action in support of the poor at the *domus misericordiae,* as well as her function as protectress of the city and of its populace when faced by the difficulties of daily life and its temptations, such as suicide. One can scarcely conceive of a more all-purpose saint!

Only the appropriation of the Church of SS. Basilio e Margherita by the Observant Friars Minor in 1392, and the disappearance of the frescoes beneath whitewash in the seventeenth century, have allowed this somewhat too pragmatic aspect of Margherita's sanctity to be reabsorbed. These actions put an end to the duality (in all senses of the word) of the images of the Penitent of Cortona, making her an "order saint," that is to say, a lay woman following in the furrow of a religious order and conforming to a tried and trusted Christian model of perfection. But the loss of autonomy suffered by the major focus of her cult, her sanctuary, is not only linked to a development in ecclesiastical contingency: when the Casali finally called on the First Order of Franciscans, and for a short while the Second, to take over from the Tertiaries, it was also because the very notion of civic religion was in crisis. At the end of the fourteenth century, in this period of "Signori," the commune was no more than a fiction and the independence of Cortona would soon be no more than a memory.

In conclusion, one final aspect of this vast iconographic and monumental programme deserves our attention. In the first decades of the fourteenth century a church in Cortona was decorated on an important part of its wall surface with frescoes honoring an uncanonized lay female saint. To some extent we can fit this into a developing pattern within Italian religious imagery. At Assisi for the first time in the course of the thirteenth century, a basilica was constructed and decorated in honor of a recent saint, Francis, who stands at the origins of an order in the full flood of expansion: the Friars Minor. This example was soon followed elsewhere. But a further boundary was crossed in the frescoes at Cortona, because they celebrate the merits and holy powers of a laywoman on whose sanctity the Roman Church had not yet officialy pronounced, even if the fresco showing Cardinal Napoleone Orsini might seem to indicate approval of the cult (he was merely ratifying the text of the *Legenda*). Later and in other places there was no hesitation in exalting through images the stirring deeds of persons of the same type, whether we think of Beata Giovanna at Signa, near Florence, or Beata Fina at S. Gimignano. But it seems to me no exaggeration to affirm that the Cortona frescoes, in their ambition to imitate those of the church at Assisi and to attract pilgrims toward the "New Jerusalem" exalted by Margherita, began a movement of the celebration of lay sanctity that certainly recurs in other Italian city communes at the same period, but not to the same degree. This change in devotional inflection, well attested to by communal statutes and artworks, was overshadowed from the early fif-

teenth century by that process within the church by which the religious orders took in hand the cult of saints. But at Cortona the bond between the city and its heroine was so close that the cult of Margherita, unlike most local cults, was able to survive and continue to our own time despite all efforts expended over the centuries to normalize it. It remains an echo of that civic and lay religiosity that constituted one of the most original features of the civilization of the Italian commune at its apogee.

Appendixes

Appendix I

Extracts from the *Statuti Comunali di Cortona*, 1325, Florence, Archivio di Stato, Statuti comunità soggette, 279, ff. 95, 140v–141v, 123

Selected and transcribed by André Vauchez

De feriis et diebus feriatis. Rubrica (III, 34)

1. Item statuimus et ordinamus quod ad laudem omnipotentis dei et sanctorum et sanctarum dei quod in causis civilibus coram omnibus et singulis offitialibus comunis Civitatis Cortone qui pro tempore fuerint, sint et esse. debeant ferie omnibus et singulis diebus festivitatis, videlicet diebus dominicis et omnibus et singulis diebus veneris pasqualibus et nativitatis domini, .viii. diebus ante dictum festum et post usque ad festum epefanie domini, et die pascatis resuretionis domini et .viii diebus post dictum pascatum.

2. Item die ascensionis domini, die sabati pentecostes et duobus diebus post ipsum festum.

3. Item diebus festivitatum Beate Marie Virginis, videlicet anumptiationis, assumptionis, nativitatis et purificationis ipsius.

4. Item diebus festivitatum omnium et singulorum appostollorum dei et omnium Evangelistarum.

5. Item festi Sancti Marci et . . . siliani (?)

6. Item diebus festi S. Marie Magdalene, S. Laurenti, S. Blaxii, S. Martini, S. Georgii, S. Christofori, S. Vicentii, S. Nicholai, S. Ludovici, S. Petri Martiris, S. Alo, sanctorum Cosmatis et Damiani, S. Silvestri et S. Tome de Aquino, S. Benedicti, S. Francisci, S. Dominici, S. Agustini, S. Clare, S. Guidonis, S. Lucie, S. Chactarine, S. Margarite, S. Cicilie, festum omnium sanctorum.

7. Item quod quando festum Beate Marie Virginis esset vel celebraretur aliqua die sabati vel alia die, non apperiantur apotecie vel alique res vendantur, exceptis rebus comestibilibus.

8. Item quod sint ferie pro messibus in estate recolligendis a medietate mensis junii usque ad festum Sancte Marie de mense agusti.

*My warm thanks to Céline Pérol, of the University of Clermont-Ferrand, for her help in preparing the edition of this text.

9. Item pro vendemiis .viii. diebus ante festum Beati Michaelis Archangeli de mense setembris usque ad .xvi. dies mense ottobris.

10. Item die carnisprivii una die ante et una die post carnisprivium.

11. Item dies in qua obiit soror Margarita, que migravit in diem Chatrede[1] Sancti Petri et dies festivitatis Sancti Basilii et dies conversationis[2] Sancti Pauli et dies festivitatis Sancti Apoliti sint feriati et debeant custodiri. Omnes vero alii dies sint et esse debeant in dictis causis civilibus utiles et non feriati, exceptis diebus in quibus inponerentur ferie [et] per consilium generalem et specialem comunis Cortone. In causis vero malleficiorum omnes et singuli dies sunt et intelligantur utiles et non feriati, nisi reformaretur contrarium et stantiaretur per consilium generalem comunis Cortone, salvo et reservato quod ferie non fierent nec dies feriati in promissionibus sine carta in[3]. . . . et censibus et laboreris . . . et terrarum et vinearum et . . . et incisionibus arborum et dampnis datis et . . . domorum, de quibus omni tempore possit cognosci feriato et non feriato, exceptis diebus supradictis in quibus ferie indicte sunt in honorem dei sanctorum et sanctarum ejus.

12. Item quod[4] . . . debitor possit capi vel detineri pro debito.

13. Item quod in die festivitatis Sancti Michaelis Archangeli .iiii[or]. diebus proxime precedentibus et aliis .iiii[or]. proxime sequentibus diem ipsius festivitatis [quibus], debitores habeant libertatem standi in Cortona et eius districtu, et quod nulla possit vel debeat capi ad petitionem alicuius spetialis persone vel detineri vel aliquorum specialium personarum debito vel occasione debiti sive debitum sit cum carta vel sine carta. Et quod nullus offitialis comunis Cortone infra dictum tempus aliquos debitores faciat detineri vel capi neque cogiere tamquam suspectos ad petitionem alicuius de stando in judicio vel solvendo si debitum probaretur, non obstante aliquo statuto comunis et populi.

14. Item quod ferie ordinari non possint vel fieri super aliqua vel aliquibus questionibus criminalibus, nisi ordinaretur et fieret per ordinem trium consiliariorum secundum formam statuti tractantis de novis ordinamentis faciendis et facere et ordinare aliter non valeant ; et offitialis qui contrafecerit vel passus fieri fuerit, puniatur per fucturum successorem in . xxv. libris denariorum comunis Cortone applicandis.

15. Item quod super civilibus questionibus non possint fieri ferie praeter formam superius denotatam in una vel pluribus questionibus specialibus, nisi in genere fierent super omnibus questionibus et omnes questiones generaliter conprehenderent . . . et aliter . . . ut supradictum est.

16. Item quod notarii possint rogare contractum et facere instrumenta quolibet die sabbati, salvo quod si in die sabbati esset festum . . . Beate Marie Virginis in . . . diem sabbati . . .[5]

Quod nullus proferat in detratum laudabilis sororis Margarite. Rubrica (IV, 31)

1. Item quod nulla persona cuiuscumque condictionis existat, acttentet dicere vel proferre publice et privatim in predicatione vel alibi verba inhonesta seu inlicita in detractionem fame laudabilis Beate sororis Margarite vel que pertineat ad aliquam injuriam dicti Beate sororis Margarite. Et quicumque dixerit vel contrafecerit sit extra protectionem comunis Cortone et ab omnibus benefeciis et offitiis comunis Cortone sit exclusus in totum.

1. *Sic* (for *cathedre*). The feast of *Cathedra Petri* is celebrated on 22 February.

2. *Sic* in ms (for *conversionis*).

3. Text partially cancelled.

4. One and a half lines at the foot of the page are illegible.

5. Two lines at the foot of the page are illegible.

De honore faciendo festivitatis Beate Margarite. Rubrica (IV, 75)

1. Item statuimus et ordinamus quod per comunem Cortone et homines de Cortona et suo districtu fiat honor festivitatis Beate Margarite sub hac forma, videlicet quod in hora vesperi vigilie dicti festi congregentur in platea comunis omnes fratres de Cortona et omnis clerus plebatus de Cortona, qui rogentur ex parte domini vicarii sive rectoris, ut accedant ad honorandum dictum festum, et ipsis congregatis cuilibet detur candelum conveniens de cera expensis comunis, cum quibus candelis accensis omnes predicti cantando alta voce divinum offitium, ad dictum festum accedant.

2. Item quod expensis dicti comunis fiant duo cerei valoris .iiiiᵒʳ. librarum et tot cerei de media libra quot sunt omnes offitiales forenses comunis Cortone, et omnes rectores artium et eorum consiliarum et consiliarii cuiuslibet consilii de Cortona, qui cerei dentur in dicta hora predictis offitialibus, consiliariis consiliarum, rectoribus et consiliariis ipsorum. Cum quibus cereis et candelis dominus vicarius sive rector et consiliarii ire ad dictum festum in dicta hora vesperi teneantur, et quilibet predictorum teneatur tunc offerre et demictere in ecclesia Sancti Basilii cereum et candelum suum et ipsum assignare positis personis ad recipiendum introitus dicte ecclesie. Et qui predicta non fecerit, solvat de facto dicte ecclesie .xx. solidos denariorum, quas penas dominus vicarius sive rector teneatur exigere.

3. Item quod mane dicti festi judices et notarii per se simul, cancelarii per se, Magistri lapidum per se, spetiarii, medici et barberii simul per se et eorum expensis teneantur offerre unum cereum sicut honori suo videbitur convenire. In alio vero anno fabri per se tantum, Magistri lignaminum per se tantum, lanaioli et merciarii per se tantum, Tabernarii et Albergatores, Banbacarii et Piliciarii per se tantum teneantur offerre mane dicti festi unum cereum dicte Ecclesie, in alio uno anno carnifices, pessciali et lardaioli simul per se tantum, Mercatores bestiarum per se tantum, Mugniarii et Fornarii per se tantum, Mercatores pannorum, campsores et sartores per se tantum teneantur offerre mane dicti festi unum cereum dicte Ecclesie, ita quod quolibet anno ad minus .iiiiᵒʳ. cerei laborati dicte ecclesie offerantur ut supradictum est. Alie vero artes singulariter et per se sine alia unione faciant duplerios et cereos sicut eis videbitur convenire ; et ille artes incipiant facere cereos laboratos quibus brevia venerint, sicut dominus vicarius ordinabit inter eos. Expense vero dictorum cereorum fiant per capita magistrorum et discipuli eorum solvant sicut per eorum rectores et consiliares fuerit ordinatum, ita tantum quod nullus artifex cogatur solvere ipsas expensas nisi in una arte et in ea videlicet quam magis exercet.

4. Item quod omnes homines artium teneantur sequi suum cereum cum candelis anccensis⁶, ut supradictum est.

5. Item quod quilibet Sindicus cuiuslibet ville districtus Cortone offerat ad dictam ecclesiam mane dicti festi expensis hominum sue ville unum cereum, ita quod quelibet massaritia offerrat minus .vi. denarios.

6. Item quod per vicarium sive rectorem elligantur . .iiiiᵒʳ. armegiatores pro qualibet terra quibus dentur bigordi banderie tantum expensis comunis Cortone cum quibus ludant in dicto festo et circa ipsum festum et, finito ludo, dictas banderias offerant dicte Ecclesie.

7. Item quod quelibet Ecclesia de Cortona sita a fonte porcielli supra stet tota nocte vigilie dicti festi aperta cum lampadibus accensis et paleis sufficientibus in quibus receptantur mulieres forenses tantum.

8. Item quod quilibet alia persona teneatur hospitari forenses venientes ad dictum festum secundum mandatum eis faciendum per vicarium.

9. Item quod unus notarius domini vicarii sive rectoris de die et de nocte in vigilia dicti festi

6. *Sic* in ms.

moretur in podio Cortone ad custodiam dicte terre et dicti festi, qui non sinat aliquem hominem de Cortona vel eius districtu morari in dicta noctte a secundo sono canpane populi in aria ab ecclesia de Marçano supra, ad penam .xx. solidorum denariorum auferendam a quolibet qui contra dictam formam stare repertus fuerit, exceptis custodibus terre Cortone et dicti festi et hospitantibus in domibus comunis Cortone que sunt in sumitate terre Cortone et vendentibus vitualia et res alias qui sine pena stare possint; qui si aliquod maleficium commiserint, solvant duplum bannum.

10. Item quod camerarius comunis Cortone octto diebus ante dictum festum teneatur de pecunia comunis Cortone emere .xx. salmas palearum mictendas in dictis ecclesis et in domibus in quibus noctte dicte festivitatis receptabantur forenses.

11. Item quod dictus camerarius teneatur emere .xxv. salmas lignorum que assignentur conburenda de noctte dicti festi, prout illis quibus assignabuntur videbitur convenire.

12. Item quod dominus vicarius sive rector teneatur facere et curare ita et taliter quod forenses venientes ad dictum festum inveniant panem ad sufficientiam, et quod nulla persona vendat panem vel vinum vel aliquam victialiam cariora solito ad penam suo arbitrio auferendam.

13. Item quod die kalendarum februarii fiat consilium generale in quo proponatur de custodia terre Cortone et dicti festi et de honorando dictum festum iuxta formam in presenti capitulo denotatam, et quidquid in dicto consilio fuerit ordinatum de predictis vel aliquo predictorum plenam habeat firmitatem, dum modo nichil possit ordinari in derogationem contentorum in presenti capitulo vel alicuius eorum ; in quo predicto consilio ad brevia eligantur tres boni homine, unus per terziero, qui electi approbentur ad bussolas et paloctas per duas partes dicti consilii ad manus quorum perveniant omnes introitus dicte ecclesie.

14. Item quod dominus vicarius, sive rector possit mandatum suum spernentes circa honorem dicti festi, ubi pena non est determinata in statuto, punire pro qualibet vice et qualibet persona a .xx. solidis denariorum usque ad .x. libris, considerata qualitate personarum et delicti.

15. Item quod quicumque in vigilia dicti festi et die festi predicti et una die post ipsum festum commiserit adulterium vel aliquod mallefitium personalem vel furtum vel aliud mallefitium in Cortona vel eius districtu, solvat duplum bannum in statuto contentum, et ipsa mallefitia puniantur et puniri debeant per potestatem, vicarium sive rectorem et judicem mallefitiorum et quemlibet eorum, procedendo super hiis per inquisitionem et accusationem et aliter, sicut eis videbitur convenire, non obstante aliquo statuto comunis et populi, et predictum festum debeat omni tempore predicto modo celebrari.

16. Item quod dominus vicarius sive rector teneatur ad petitionem rectoris cuiuslibet artis cogere de facto omnem personam de qualibet arte ad solvendum partem sibi contingentem de cereis supradictis.

17. Item quod predicationes, misse et alia divina offitia dicenda in vigilia et festo predictis ordinentur per rectorem ecclesie Sancti Basilii tantum.

18. Item quod rector dicte ecclesie Santi Basilii cum uno sotio quem voluerit semel et pluries ad petitionem ipsius rectoris per dominum vicarium sive rectorem, expensis comunis Cortone, ad summum pontificem mictatur ad procurandum et impetrandum modis omnibus quibus poterit quod corpus Beate Margarite canoniccetur et indulgentia aliqua concedatur ecclesie memorate.

Appendix II

The Eight Sets of Watercolor Copies of the Margherita Mural Cycle

The purpose of this appendix is to enumerate and evaluate all the sets of watercolor copies that the authors have been able to trace, and to explain the choice of one particular set—Biblioteca Comunale e dell'Accademia Etrusca, Cortona, cod. 429—as the main basis for study and illustration in this book.

The following abbreviations will be used for the watercolors:

ACC H27 *Processus extractus a Processu originali . . . in causa Cortonensis canonizationis Beatae Margaritae de Cortona . . .*, Archivio Storico del Comune di Cortona, MS H 27, 1001–1042.

ACC H28 *Copia collata processus remissorialis auctoritate Apostolica in Civitate Cortona facti . . .*, Archivio Storico del Comune di Cortona, MS H 28, 1001–1042.

ACC H29 *Copia collata processus remissorialis auctoritate Apostolica in Civitate Cortona facti . . .*, Archivio Storico del Comune di Cortona, MS H 29, 1001–1042.

BC/AE 390 Biblioteca Comunale e dell'Accademia Etrusca, Cortona, cod. 390, section iv, ff.185–96 (bound in with unrelated eighteenth-century material concerning the history of Cortona).

BC/AE 429 Biblioteca Comunale e dell'Accademia Etrusca, Cortona, cod. 429, section i, pp. 445–448 (bound in with material used in Margherita's eighteenth-century canonization process).

BML 318 Biblioteca Medicea Laurenziana, Florence, Acquisti e Doni, MS 318.

MF Museo Francescano, Istituto Storico dei Cappucini, Rome; Gabinetto dei disegni e delle stampe, disegni: cartella I C1–I C20 (unbound and unnumbered, housed with other unrelated material).

ASV 552 *Copia collata processus remissorialis auctoritate Apostolica in Civitate Cortona facti . . .*, Archivio Segreto Vaticano, *Riti*, Proc. 552, pp. 1001–1042.

Eight sets of watercolor copies are now known to exist: three in the Archivio Storico del Comune di Cortona; two in the Biblioteca Comunale e dell'Accademia Etrusca, Cortona; one in the Biblioteca Laurenziana, Florence; one in the Archivio Segreto Vaticano; and one in the Museo Francescano in Rome. Kaftal listed a set of watercolors in the Brera, Milan, that the present authors have been unable to trace.[1] One further manuscript, MS 80 in the Biblioteca Comunale in Arezzo, formerly in the collection of the Fraternità dei laici, may once have included a set of watercolors. This seventeenth-century manuscript, which has been rebound and is now only sixty-six leaves long, records part of the evidence used in the canonization process. It refers (ff. 55–60) to the watercolor copies but does not include them.[2] All eight surviving sets contain copies of nineteen scenes accompanied, when known, but their inscriptions, written in a manner that imitates fourteenth-century epigraphy.[3] The scenes are preceded by a watercolor of the crucifix from S. Francesco, Cortona that was moved to S. Margherita in 1602 (Fig. 191), and they are followed by a watercolor of Margherita's funerary monument (Fig. 192).[4] The variations between the sets are small, but not insignificant. By analyzing them it is possible to deduce the relationship between the sets and to establish their relative reliability in recording the cycle.

Two of the sets, those in the Museo Francescano and BC/AE 390, can be set aside immediately, since they appear to have been executed long after the obliteration of the murals, which took place in 1653.[5] Under the watercolor of the tomb in MF is written, in the same hand as the inscriptions accompanying the other watercolors, "Antico sepolcro di S. Margherita trasferito dopo la fabrica della croce della chiesa in sagrestia l'anno 173. [sic] ove presentamente ritrovasi." A note above the watercolor of the tomb in BC/AE 390 indicates that this set was also made during the eighteenth century, "Disegno del antico sepolcro di S. Margherita quale in questo anno 1769 esiste nella sagrestia della chiesa di detta santa." Moreover these watercolors are preceded by a note, also dated 1769, recording that the drawings were based on paintings that formerly existed in the Church of S. Margherita.[6]

Of the remaining six sets, four (ACC H27, ACC H28, ACC H29, ASV 552) are bound in with copies of the text of the canonization process of 1629–40, having always formed an integral part of those volumes. The Laurenziana set, now bound as an independent volume, was presumably extracted from a copy of the process, and shares with the four sets just listed the identical page numbering (1001–1042). The watercolors in BC/AE 429, which are now bound with eighteenth-century materials from Margherita's canonization process, do not have the same page numbers. These watercolors were trimmed and pasted onto guards when they were bound, so the original page numbering may have been cut off. Each watercolor of these six sets bears, on the reverse, a copy of the verification signed by the notary and two judges during the Visitation of 1634. As discussed in Chapter 7, the text

1. For previous publication of watercolors from some of these sets, see the Introduction, note 23.

2. I am most grateful to Giovanni Freni for having brought this manuscript, and its contents, to my attention.

3. In MF alone the inscriptions are repeated, beneath this, in a cursive hand. ASV omits the inscriptions below Scenes xii–xvi. Although there are only a few minor variations in spellings or abbreviations between the different versions of the inscriptions, the way in which the inscription was broken into lines varies. There seems to have been no interest in reproducing the precise layout of the

original inscriptions, and it may be that the inscriptions were originally recorded separately from the murals.

4. With the exception of BC/AE 390, which has the same contents bound in a random sequence.

5. See the introduction to Part III.

6. The two notes in BC/AE 390 could have been added, in the eighteenth century, to a set of watercolors made in the seventeenth century, but this seems unlikely, since the watercolors have none of the numbering or authentification present on all the seventeenth-century versions, and appear to have been executed by an entirely different artist.

of the *processus* shows that when the judges visited the Church of S. Margherita they took with them a set of watercolor copies in order to confirm their fidelity to the original murals. These watercolors were probably made c. 1629, at the time when the canonization process began, in anticipation of the judges' visit (see Chapter 7). The bound sets of watercolors are also preceded, on page 1001, by a declaration of the accuracy of the preceding text, signed by two judges in the *processus*, Girolamo Sernini, provost, and Giorgio Nucciarelli, archdeacon of the Cathedral of Cortona, and by the notary Reginaldo Sellari, A similar declaration occurs after the copies. As Bornstein has pointed out, ACC H27 bears the original signatures and paper seals of the two judges, appended when this record of the *processus* was made in 1640.[7] In the equivalent place in ACC H28, H29, L, and ASV there is, instead, a note of where these signatures and seals occurred: the notary copied the names of the two judges, and noted *loco + sigilli* where each of the paper seals was placed in the originals. The same procedure occurs on the back of each watercolor. The fidelity of the copy is confirmed, and the wording of the judges' signatures and the presence of their seals is noted down by the notary.[8] The procedure is the same throughout each of the six sets in question. In other words, none of these sets is the original group of watercolors that the judges consulted, signed, and sealed in 1634. Perhaps they were of a larger format, unsuitable for binding into a portable volume. Or they may have been damaged by the signing and stamping on the reverse. Presumably they were sent for examination in Rome at some stage of the *processus*, but it has not been possible to establish whether they still exist.[9]

When the record of the *processus* was made in final form, in 1640, this original set was presumably returned to the artist, so that copies could be prepared for that volume. In 1653–54, six further copies of the *processus* were commissioned, each including a full set of watercolors.[10] This must have been a tedious job. Although the artist took care, in almost every case, to repeat everything found in the murals, some sets of watercolors were evidently painted more hastily than others. Comparing, for example, Scene viii, in ACC H27, H28, and H29 (Figs. 196, 198, and 200), we see, as might be expected, that the watercolors from ACC H27, the codex in which the declaration preceding the watercolors has original signatures and seals, was more carefully produced than its two companions. A decline in quality is noticeable in every aspect: not only the care with which the scene was drawn, painted, and shaded (most obviously in the bedspread—checked in H27, but only striped in H28 and H29), but also in the lettering of the inscription, and even the pen decoration occupying the space beneath the declaration on the reverse of each watercolor (see Pl. I). To speed production the main

7. Bornstein, 1990, 228.

8. For example, on page 1004, the reverse of Scene i: "Exemplum historiae Beatae Margaritae de Cortona in ecclesia eiusdem Sanctae Margaritae in Civitate Cortonae antiquitus depictae in actis productum, et repetitum, et cum suo originali collationatum in dicta Ecclesia ut supra sub numero primo. Die vigesima secunda Decembris 1634.

Ita est Reginaldus Sellarius Notarius Actuarius deputatus manu propria.

Hieronymus Serninius Praepositus Judex subdelegatus manu propria: Loco + sigilli.

Georgius Nucciarellius Archidiaconus Judex subdelegatus manu propria: Loco + sigilli."

9. In discussing the *Legenda* texts contained in these records of the canonization process Iozzelli (1993, 228) also considered that the orginal "atti del processo" had not survived.

The approximate dimensions of the sheets used for the watercolors (probably trimmed in some cases) are as follows:

ACC H27	20.5 × 31 cm	(p. 1001)
ACC H28	23 × 33 cm	(p. 1001)
ACC H29	23 × 33 cm	(p. 1001)
BC/AE 429	21 × 31 cm	(p. 445)
L	23 × 32.5 cm	(p. 1001)

One watercolor in BC/AE 429, the representation of the funerary monument (Fig. 192), occupies a sheet of paper double the size used for all the rest. Presumably it was difficult to compress an image of those proportions onto a single sheet, but the double-sheet format may have been cumbersome to bind. In ACC H27, 28, 29, L, and ASV the watercolor of the monument is squeezed onto a single sheet. (In L the drawing ends halfway down the wooden doors of the tomb niche, confirming the awkwardness of the format.)

10. See M. Belardini in Corti and Spinelli, 52, 156. The total cost was 370 scudi.

features of the scenes may have been transferred by tracing from one set to another.[11] The equivalent scenes in L and ASV (Figs. 197 and 199) are also less carefully painted than ACC H27 (although the bedspread in L is checked rather than striped), with ASV being the crudest and hastiest of all. The differences visible between these sets could indicate the work of different hands, with an assistant taking over the laborious work of copying, but are more likely to be the result of rapid repetitions all made by the same artist.

Only one of the seventeenth-century versions, BC/AE 429, is more carefully drawn than ACC H27. Here the artist relied more on penwork, supplying, for example, indications of folds on the bedcover and on the doctor's tunic, and indicating the inner face of the doorway beside him. The dark-brown background found in the five other versions, is replaced here by some light shading, with much of the paper left uncovered. In general the painting of scenes in BC/AE 429 is more careful, relying more on pen-drawing, and on a lighter use of thinner colored washes, while the lettering in the inscriptions is less neat and regular than that in ACC H27, perhaps in imitation of the looser epigraphy of the original murals. The different proportion of brushwork to pen-drawing probably accounts for the difference in appearance between the two sets. Here again, there is no pressing reason to attribute the work to different artists.

BC/AE 429 and ACC H27 vary slightly, but significantly. For example in Scene v, A Man of Città di Castello Witnesses the Ascent of Margherita's Soul, ACC H27 does not show the man's nightcap hanging on the wall above his bed, and it also omits the two diminutive animals (mules?) and the man in the landscape on the left. These details are also omitted in the other versions under consideration: ACC H28, ACC H29, L, and ASV. Several other minor differences occur between BC/AE 429 and ACC H27, and in each case the more rapidly made copies—ACC H28, ACC H29, L, and ASV—all follow ACC H27. Most of the differences consist of details that are included only in BC/AE 429; the paternoster beads held by the central figure in Scene iii (Pl. XX; Fig. 165);[12] the front of the arch enclosing Bartoluccio's mother on the left of Scene vi (Pl. XIX; Fig. 106); the garments of Margherita and her companions shown as checked, rather than striped, in Scene xiii (Pl. XXIV; Fig. 134).[13] Since all the details of each scene were normally repeated conscientiously, and the watercolors were each confirmed, on the reverse, as accurate records, it seems most unlikely that the artist would have added elements such as the paternoster beads (Scene iii) or the nightcap (Scene v) to the watercolors of BC/AE 429 if they were not visible in the murals. The omission of these details from ACC H27 were presumably small errors that were then copied in ACC H28, ACC H29, L, and ASV, which all appear to have followed ACC H27 rather than being taken directly from either the murals or the original set of watercolors made c. 1629.[14]

11. Another sign of increased haste and standardization is the method of writing in the number of each scene. In H27 it was generally carefully placed in a pale area for legibility (and it was even more carefully placed in BC/ AE 429). But in ACC H28 and H29 the numbers were simply written in the top right corner of each sheet, where they were sometimes covered by the painting, and had to be rewritten elsewhere.

12. And a different manner of drawing the weave of the mat of reeds.

13. ACC H27 and the sets related to it often have backgrounds that are of a different color from, and more heavily painted than those in BC/AE 429 (e.g., Scenes ii, iii, viii, xiv). One further difference concerns the bases of the door jambs in Scene xv and the bases of the two central piers in Scene xvii. In BC/AE 429 the jambs and piers continue to the bottom of the scene, so that their bases are not visible. In ACC H27 and its related sets the bottom of the jambs and piers are shown, just above the baseline of the watercolor. The latter arrangement seems more logical (especially in Scene xv) and may be a more accurate reflection of the original composition.

14. Belardini has shown that six copies, presumably including ACC H28, ACC H29, L, and ASV, were made between December 1653 and August 1654 (Corti and Spinelli, 52, 156). The watercolors they contain, made at the same time, could not have been made with reference to the murals since they had been obliterated in the previous year (see introduction to Part III). I am most grateful to Bruno Gialluca and Donal Cooper for providing transcriptions of the records consulted by Belardini, ACC H1, fols. 61v–63r.

In one case the difference between BC/AE 429 and ACC H27 (and its related sets) appears to be of a different nature. In Scene xvii, the Visitation of Napoleone Orsini, there is a variation in one of the figures approaching Napoleone Orsini and the bishop to swear on the open Bible (Figs. 193 and 194). The figure, or figures, in question stand directly behind the kneeling woman in black (presumably the widow Donna Muccia of Monte Santa Maria, see Chapter 13). In BC/AE 429 (Pl. XI) two figures are shown: a woman, dressed in pale pink, appears to hold up a small boy, dressed in red, who reaches out toward the Bible that the bishop holds. As discussed in Chapter 13, this could identify the boy as Suppolino, who wears red in Scene x (Pl. XVI), the miracle of his resuscitation, and would represent the fulfillment of his mother's vow that he was to be carried to Margherita's altar if cured.[15] The hand drawn directly behind Donna Muccia's head would presumably belong to the woman in pink (perhaps a kinswoman, nurse, or household servant)[16] showing how she supports the child. Between this hand and the woman's face is an unexplained area of red that appears to be some part of the child's clothing. In ACC H27 and its followers only one figure is shown here (Fig. 194). It is a standing figure with a childlike head who appears to be of approximately the same height as the adults standing behind him. As in BC/AE 429 he extends his right hand toward the Bible held by the bishop. He wears a red tunic but over this he has a pale pink garment that forms a curious shape, apparently wrapped diagonally across his chest. This pale garment occupies a space equivalent to the head and body of the woman in pale pink in BC/AE 429. The hand visible above Donna Muccia's head in BC/AE 429 does not appear in ACC H27. The face of the woman in pink, and the puzzling area of red beside it are interpreted, in ACC H27, as a fur-trimmed sleeve, or a fur-trimmed hat held by the figure with the childlike head.

Neither version of this area makes perfect sense, and it is probable that this part of the mural was damaged, and difficult to interpret, at the time when the original watercolor copy was made. In this case the variations between BC/AE 429 and ACC H27 do not necessarily indicate that one version is more reliable than the other. They appear, rather, to be two separate attempts by the artist to make sense of a puzzling passage in the original watercolor—perhaps one that could not be verified, due to deterioration of the murals by the time these copies were made.

Thus the most likely relation between the copies would be as follows. BC/AE 429 and ACC H27 were both made following the original certified set of watercolors, prepared c. 1629. It would have made sense for them to follow this, rather than to return directly to the originals, not only because of the awkwardness of working in a dim church interior,[17] but also because the watercolors themselves were a record that had been legally approved as an official part of the *processus* and therefore needed to be reproduced in the *processus* report. Moreover, two of the scenes had disappeared between the production of the original set of watercolors and the Visitation of 1634, as recorded on the reverse of the watercolor copies of Scenes xviii and xix,[18] and could not possibly have been copies from the original. The two sets may be been made at different times. For example, ACC H27 was presumably made at the end of the *processus,* when the record was prepared, c.1640, whereas BC/AE 429 could perhaps have been made earlier, as an extra set to be consulted while the *processus* was in progress, and to be kept by those promoting the process in Cortona, if the originals were required in Rome, or

15. Compare the figure holding a baby in Simone Martini's Beato Agostino Novello Resuscitates a Baby fallen from its Cradle (Pl. XIII).

16. See above, Chapter 13, note 7.

17. The description of the Visitation of 1634 reports that all the doors and windows of the church were opened to admit light (ASV, *Riti,* Proc. 552, p. 523).

18. The phrase, "in ecclesia eiusdem Sanctae Margari-

tae in Civitate Cortonae antiquitus depictae in actis productum, et repetitum, et cum suo originali collationatum in dicta Ecclesia ut supra," used on the reverse of the other scenes is replaced, in these two cases, by "in ecclesia eiusdem Sanctae Margaritae in Civitate Cortonae olim depicti, in actis productum, et repetitum, et per testes fide dignos in dicta ecclesia, ut super recognitum."

elsewhere. Although this is pure hypothesis, there may be evidence that BC/AE 429 was kept, at some point in its history, in a temporary binding, and subsequently bound, with other material, in a more permanent form.[19] BC/AE 429 seems to have been made slightly more conscientiously, and with more pen-drawn details than ACC H27, making it the most useful set on which to base discussion in this study.[20] ACC H27, which was more heavily painted and neatly produced, provided the direct source for the production of ACC H28, ACC H29, L, and ASV.

This most unusual multiplication of copies of the watercolors may have complicated the art historian's task, but it also serves to underline the importance attached to this set of images, both in the legal context of the canonization process and, later, as objects of local pride and antiquarian interest.[21]

19. An approximately semicircular area of loss occurs at the top left corner of each scene in the watercolors (see e.g., Pls. XXII and XXIV; Figs. 122 and 134). Through this area of loss is now visible, in each case, the unpainted surface of the paper used to repair the damage. In other words, the watercolors that now form part of BC/AE 429 may once have been held together by some type of semicircular clip, from which they were subsequently cut away, causing a small, regular area of damage to each sheet, when it became necessary to place them in a more permanent binding. (The watercolor of Margherita's funerary monument, executed—as discussed above, note 9—on a sheet twice as large as the others, was evidently folded in half. In this case the area of damage is a rough circle, occurring half way down the left side of the sheet.)

20. Bornstein (1990, 228) in drawing attention to the importance of the watercolors in ACC H27, proposed that they were the models not only for ACC H28 and H29 but also for the other copies existing in Cortona. It has been argued here that BC/AE 429 contains details that are independent of ACC H27. BC/AE 390 follows the version in BC/AE 429, not that in ACC H27. The only significant departure from BC/AE 429 is the inclusion, in Scene xix, of Margherita's body, and the face of the healed man of Corciano. These additions occur only here and in the version in the Museo Francescano. It is interesting to note that, apart from this exception in Scene xix, both these post–seventeenth-century sets follow BC/AE 429 in all the variations. MF even gives the relevant page number in BC/AE 429 below each scene. This may be because BC/AE 429 was regarded as the most reliable set. On the other hand it may simply have been the most easily available exemplar to copy on both occasions. (The only known provenance for BC/AE 429 is that given on page 445 of the manuscript: in 1852 the codex passed from Giovanni Battista Mori to the painter Ferdinando Cavalleri who then presented it to the Accademia Etrusca.)

21. A note beneath the MF version of Scene xvii also indicates the presence of family interests. A reference to Rinaldo Baldelli's book on the families of Cortona notes that a painting once existed in the Church of S. Margherita, opposite the saint's altar, which included a representation of the chancellor of the Signoria of Cortona, a certain Ser Nino, who gave his name to the Sernini family. It appears that the person writing this note, who also transcribed the inscriptions below the other watercolors, believed Ser Nino to be the notary seated on the left in Scene xvii (The Visitation of Napoleone Orsini). The Sernini family had long been important in Cortona. One of the two judges examining the watercolors in 1634 was a certain Girolamo Sernini and a later member of the family who seems a likely candidate for instigator of the MF copies is Giovanni Girolamo Sernini Cucciatti (1705–85) who was an ardent antiquarian who, among many activities, collected and transcribed information on local churches and wrote about famous paintings in Cortona. (For further information about his life, see G. G. Sernini Cucciatti, *Quadri in chiese e luoghi pii di Cortona all metà del settecento*, Accademia Etrusca, Cortona, Fonti e testi, 2, ed. P.J. Cardile, Cortona, 1982, esp. 5–6.)

Summary Description and Reconstruction of the Original Location, Appearance, and Content of the Nineteen Recorded Scenes of the Margherita Mural Cycle

This appendix is intended as a brief guide to the original appearance and content of the nineteen murals recorded in the watercolor copies made c. 1629. (Many individual scenes are discussed in greater detail in the main text.) The scope and arrangement of the entries is as follows. First, the *number* given to each scene refers to the numbering of the watercolor copies and of the Visitation of 1634. The approximate position of each mural is given at the head of each scene. For the probable sequence of scenes within the church see Figures 201, 202, and 203, and Chapter 7.

Second, a brief summary is given of the *events* shown in each scene, and reference is given to corresponding passages in the *Legenda* text. This is intended to help the reader to follow the content of the murals and to pursue the relations between mural image and *Legenda* text, but it should not be taken to imply that the murals derived directly, in all cases, from the cited texts. (See the introduction to Part V; Chapters 13 and 14, where the relation between text and image is discussed at some length.)

Third, the *inscriptions* provided with the watercolors (an incomplete set, due to losses) are transcribed here. Abbreviations have generally been expanded. (See also the transcriptions given in O. Montenovesi, "I Fioretti di Santa Margherita da Cortona," *Miscellanea francescana* 46 [1946], 292–93, from which the present text differs on a few points.)

Fourth, an attempt is made to reconstruct the *condition* of the murals at the time when the watercolor copies were made. The interpretation by the seventeenth-century artist of paintings that had already suffered damage and repair creates difficulties in envisaging the original form of the trecento murals. (For a general discussion of these problems see Chapter 7.) These problems are tackled in three different ways in the following descriptions.

(A) Substantial areas of loss in the original murals, reflected by lacunae in the watercolors (or, in three instances, areas of a uniform sandy-brown tone) are noted.

(B) Apparent anachronisms in dress or settings are noted and evaluated as possible evidence of postmedieval repainting of the trecento murals. Here it is necessary to try to distinguish between, on the one hand, changes to the appearance of certain figures or settings in the murals that the seven-

teenth-century copyist faithfully reflected and, on the other hand, reinterpretations by the copyist, in a seventeenth-century idiom, of trecento forms that may have been unfamiliar to him or difficult to see because of their poor state of preservation.

(C) In attempting to establish which parts of the watercolors reproduce original trecento areas of the murals it is, of course, essential to point to parallels in exisiting trecento paintings. This method is explored at some length in Chapters 8 and 9, and is pursued in the discussion concerning the possible authorship of the original murals in Chapter 10. In order to provide a survey of a complementary nature, the comparisons made here concern the dress of figures that may be compared with existing examples in trecento art. In a few instances, setting is also discussed, and textual evidence is also cited where appropriate. Italian dress of the fourteenth century can often be distinguished from that of the following centuries. Even within the fourteenth century there was a distinctive change in fashion from c. 1340 onward that can assist in the approximate dating of paintings. For a summary of these changes see S. M. Newton, *Fashion in the Age of the Black Prince*, Bury St. Edmunds, 1980, 6–8. For the use of dress in dating trecento paintings see L. Bellosi, "Moda e cronologia. a) Gli affreschi della Basilica inferiore di Assisi," *Prospettiva* 10 (1977) 21–30; "Moda e cronologia. b) Per la pittura del primo Trecento," *Prospettiva* 11 (1977), 12–26; Bellosi, 1985, 3–17. Even when the dress of figures in the watercolor copies appears postmedieval—or simply curious—careful scrutiny, and comparison with existing works, often suggests that the copyist was attempting to reproduce the appearance of trecento garments with which he was unfamiliar. Taken together, this evidence (generally included under the separate heading "*Dress*") increases the likelihood that extensive areas of the mural were still in reasonably original condition in c. 1629. (I should like to thank Jane Bridgeman for discussing the dress in the watercolors and offering much helpful advice.)

Cappella Maggiore, North Wall, Lunette

I. *The Profession and Investiture of Margherita as a Member of the Franciscan Third Order* (Pl. XVII; Figs. 104 and 185)

The *Legenda* text (*Legenda*, I, 1) gives the date of profession as 1277, corrected by da Pelago to 1275 (see above, Chapter 14, note 55). Margherita's hair is cut by a Franciscan (probably Fra Ranaldo, head of the Arezzo *custode*) in the Chapterhouse of the Franciscan convent at Cortona, in the presence of female and male members of the Franciscan Third Order. To the right of Margherita is the checked garment of a Penitent. For further discussion of the content of the scene, and comparison with representations on the panel painting and funerary monument, see Chapter 14, and Figures 182 and 184.

Inscription. DIVINOS HABENS FERVORES/ AD FRATRES MARGARITA RECURRENS MINORES/ SU[B]MICTENS RELIGIONI COLLUM/ MARGARITA VITIA RENUNCIAT ET MUNDUM.

Condition of mural c. 1629. The outline framing the watercolor indicates the lunette shape which the mural occupied (see Chapter 7). This position directly beneath the vaults may have been particularly vulnerable to damage; a considerable area of loss occurs at the apex of the composition, including the upper parts of the architectural framing, and extending down to affect the figure to the right of Margherita. It is unclear whether this figure wore, or held, the checked garment of a Penitent. The light brown area below the checked garment may indicate another area of loss (compare Scene xix).

The rest of the mural does not appear to have suffered serious damage, and the open area in the foreground is more likely to be a deliberate compositional element than a further area of extensive loss (see Chapter 8).

Dress. For the dress of female Tertiaries see Chapter 11, note 35; for male tertiaries see Chapter 11, note 60; and Chapter 14, note 60.

Cappella Maggiore, North Wall, Middle Row

II. *Christ Grants Margherita Absolution from All Her Sins* (Figs. 162 and 179)

Margherita prayed to Saint Francis to obtain for her, through his merits, full absolution from her sins. Saint Francis then asked Christ to announce this indulgence, and Margherita heard, within her soul, Christ absolving her from all her sins. (See *Legenda,* II, 18; Iozzelli, II, 11.) For a comparison of the relationship between the three protagonists in text and image, see Chapter 14.

Inscription. PER CONFESSIONEM HOSTIUM TUI CORDIS APERUISTI / ABSOLVO TE MERITIS BE[A]TI FRAN-CISCI.

Condition of mural c. 1629. Condition appears to have been good. The blank area behind Saint Francis might indicate loss, but comparison with the equivalent scenes in the panel painting (Fig. 160) and the funerary monument (Fig. 161) suggest that this area may always have been an undifferentiated backdrop. Irregular white patches on the wall above the entrance to Margherita's cell are due to flaking of the watercolor pigment.

Dress. For Margherita's dress see Chapter 11, note 34. In the panel painting one end of Margherita's veil is wrapped round her neck, while the free end, caught beneath it, hangs down in a point. (A similar arrangement is seen in the representation of another Franciscan Tertiary, Saint Elizabeth of Hungary, in a pinnacle panel attributed to Ambrogio Lorenzetti now in the Isabella Stewart Gardner Museum, Boston). (See da Pelago, II, 40–41, for further discussion of Margherita's veil as represented in different paintings and sculpture). In most of the watercolor copies, and in the mural representation of Margherita in S. Francesco, Cortona (Fig. 183) a white wimple encloses Margherita's neck, but the outer white veil hangs open, framing her face. (However, in Scenes XIII, XIV, and XV the outer veil may have been wrapped round Margherita's neck as in the panel painting.)

Cappella Maggiore, North Wall, Middle Row

III. *Margherita Gives Her Possessions to the Poor* (Pl. XX; Fig. 165)

On several occasions Margherita gave her possessions to the poor. If she had nothing else to give, she gave her own tunic from her back, and wrapped herself in the mat of woven reeds on which she slept.

(See *Legenda*, ii, 3; Iozzelli, ii, 1c; *Legenda* iii, 3; possibly also i, 3; Iozzelli, i, 1c; *Legenda* iv, 2; viii, 1). For further discussion of which events from the *Legenda* are shown here, see Chapter 14.

Inscription. . . . am / ut non palliurus scindat illam.

Condition of mural c. 1629. The condition appears to have been good, although the inscription was substantially damaged, with only the last part surviving. As in Scene ii, the undifferentiated background might seem to suggest areas of loss but may, alternatively, indicate the simplicity of a composition influenced by the existing images on the panel painting (Fig. 155) and the funerary monument (Fig. 164).

Dress. The limited, muted colors and simple forms of the garments of the three female figures may have been intended to indicate their poverty.

Cappella Maggiore, North Wall, Bottom Row

IV. *The Funeral of Margherita* (Pl. IX; Fig. 189)

The funeral, which followed her death on 22 February 1297, was attended by lay and ecclesiastical dignitaries of Cortona (see *Legenda*, xi, 20; Iozzelli, x, 19). In the watercolor two Franciscans and two Dominicans stand behind Margherita's body. For further discussion of the identities of the figures shown here and their significance see Chapter 14. (For related scenes see panel painting, Fig. 186, funerary monument, Fig. 188).

Inscription. Lost.

Condition of mural c. 1629. There appear to have been several areas of loss, notably in the background above the figures on the left and in the lower parts of all three sections of the scene. (The wavy line at the base of the central section, above the area of loss, presumably indicates the undulating hem of the drapery that covered Margherita's bier: compare Funeral of St. Francis, Upper Church, S. Francesco, Assisi (Poeschke, fig. 184); Funeral of Saint Martin, St. Martin Chapel, Lower Church, S. Francesco, Assisi (Poeschke, fig. 291). The Funeral of Margherita evidently owed a substantial debt to the composition established in the Upper Church at Assisi. It also suggests an awareness of later versions of the composition such as that in the Saint Martin Chapel: the motif of a diminutive figure supporting a large candle to the right of Margherita's bier finds a parallel in the Funeral of Saint Martin.) The band of geometric patterning on the wall to the right of the *cappella maggiore* was presumably all that remained of an architectural decoration similar to that in, for example, The Presentation in the right transept of the Lower Church of S. Francesco, Assisi (Pl. X), or on the rear wall in Pietro Lorenzetti's Last Supper in the left transept of the Lower Church (Poeschke, fig. 261). The irregular area of white on the cloak of the central Dominican is a loss in the watercolor copy, caused by flaking of the black pigment. Certain curiosities in dress and appearance may indicate some areas of repainting: e.g. the dress, hats, and beards of the figure on the extreme left, and of the two men between the pairs of Franciscans and Dominicans, may have been postmedieval.

Dress. See Chapter 14, notes 74, for cap of the priest on the left, and 85 and 86, for the figure below the central window, and for the figures on the right.

Cappella Maggiore, North Wall, Bottom Row

V. *The Man of Città di Castello Witnesses the Ascent of Margherita's Soul* (Pl. XVIII, Fig. 187).

On 22 February 1297 a certain pious man of Città di Castello, while at prayer, saw Margherita's soul assumed into heaven, accompanied by a large number of souls freed from purgatory. (The mural does not show these liberated souls.) (See *Legenda*, XI, 20; Iozzelli, X, 19). This mural, like the adjacent Scene V, belonged to a compositional tradition for the representation of the death and funerals of saints formulated in the Saint Francis cycle in the Upper Church at Assisi (Poeschke, figs. 180, 181). The ascent of Margherita's soul is also shown in the funerary monument (Fig. 188).

Inscription. Lost.

Condition of mural c. 1629. Apart from the disappearance of the inscription there are no obvious areas of loss. Certain elements may appear to be the result of postmedieval repainting but some of these can be paralleled in existing trecento works. For example, the full-length angels carrying Margherita to heaven on a cloud may be compared with representations of the ascent of Saint Francis witnessed by Fra Agostino, especially that in the Upper Church of S. Francesco at Assisi (Poeschke, figs. 180 and 181). Certain details of the landscape, in particular the reflection of the chapel in the lake, may constitute areas of postmedieval repainting or the copyist's interpretation/improvement of what he saw, but an open landscape viewed from above, and populated with small-scale figures and buildings, can be found in Ambrogio Lorenzetti's Good Government in the Country (see the examples given below, Scene VII.) The leafless tree in the left foreground may also be an original element, and would be appropriate since Margherita's death occurred in the month of February. The overall design of Scene V must always have combined the interior/exterior form of the house with a more open view on the left. For an existing trecento example of a figure suspended over open countryside see The Magdalene in Ecstasy, Magdalene Chapel, Lower Church, S. Francesco, Assisi (Poeschke, fig. 220a). The pious man's beard is an unexpected, although not unprecedented, feature in an Italian who was neither a soldier, nor a hermit, a member of a religious order, pilgrim, pauper, or captive. It has been shown that beards probably only came into fashion among the noncombatant urban laity in Italy in the 1340s (See S. M. Newton, *Fashion in the Age of the Black Prince*, Bury St. Edmunds, 1980, 6–8). The pious man's beard may thus have been part of a later retouching of the figure.

Dress and furnishings. For the hat on the peg above the bed, presumably a nightcap, see below, Scenes VIII and XIX. For the bed, with the edge of the mattress shown, supported on a trestle base with splayed legs, see The Confession of the Temporarily Resuscitated Woman in the Saint Francis Cycle, Upper Church, S. Francesco, Assisi, (Poeschke, fig. 196).

Cappella Maggiore, South Wall, Lunette

VI. *The Revival and Healing of Bartoluccio of Cortona*. Posthumous miracle (Pl. XIX; Figs. 106 and 118 [detail])

Five-year-old Bartoluccio of Cortona, left alone in the house by his mother, was trapped in the teeth of a mill wheel and was horribly injured. He was extracted from the mill wheel with great difficulty by several men (shown at the left in the mural) and people thought only of his burial. But his mother, who was full of faith (shown in grief-stricken state in the left section) returned home and invoked Margherita's help (right section) promising to encircle her tomb with a silver thread, whereupon Bartoluccio was revived and healed. (See *Legenda*, XII, 38; CM, 39.)

Inscription (opening words lost by c. 1629). . . . E BARTOLUS REDDITUR VITE RESTAURI FILIUS / QUEM NECAVIT MOLENDINUS / DE SANCTI VINCENTII IANUA / A MORTE REDDITUR PRAVA.
 (For the relation between inscription, mural, and *Legenda* text see Chapter 13.)

Condition of mural c. 1629. The double outline on the watercolor copy indicates the lunette shape that the mural occupied (see Chapter 7). This position directly beneath the vaults may have been vulnerable to damage, for there are losses at the upper left side of the mural. (Compare the areas of loss in Scene i, which occupied the equivalent position on the north wall of the *cappella maggiore*.) Postmedieval repainting, perhaps following damage, may explain the use of single-point perspective for the floor-tiles of the central section of the scene, and the rusticated door- and windowframes. The basic composition of the central section may, however, be medieval, since the use of a view into a distant courtyard may be paralleled in Lorenzetti works: for example, the left section of Pietro's Birth of the Virgin (Pl. XII; Fig. 96), and the hypothetical form of the mural of the Birth of the Virgin from the facade of S. Maria della Scala, Siena, particularly as reflected in the version by the Osservanza Master in Asciano (Maginnis, 1988, 187, fig. 8). The puffy clouds surrounding Margherita may indicate a further area of repainting, but they may, on the other hand, be a seventeenth-century interpretation of the more restricted clouds found supporting duecento and trecento saints in ecstasy or appearing posthumously, particularly in exterior scenes, for example, Saint Francis in Ecstasy, Upper Church, S. Francesco, Assisi (Poeschke, figs. 163 and 165).

Cappella Maggiore, South Wall, Middle Row

VII. *Margherita Rescues Prisoners from Captivity*. Posthumous miracle (Fig. 170)

See *Legenda*, XII, 19–22; CM 20–23, and see Chapter 13, for the relation between the image and specific miracles reported in the *Legenda* text.

Inscription. ORATIO VESTRA FIDELIS / QUASI TUBA RESONAVIT IN CELIS / ET EDUXIT VOS DE CARCERE ISTO / ET REFERATIS GRATIAM CHRISTO.

Condition of mural c. 1629. At first sight this mural appears to have been largely postmedieval, but a combination of some repainting with misunderstandings by the copyist probably obscure what remained of a basically medieval composition. The curious dress of the prisoners, resembling post-medieval breeches, is probably the copyist's anachronistic interpretation of medieval undergarments—

camicia/camisia (undershirt) and *brache/braghe* (loose, long drawers)—indicating the captives' disarray and the suddenness of their release. The hanged man held by *Securitas* in Ambrogio Lorenzetti's Good Government in the Country (Rowley, II, fig. 173) wears similar loose knee-length drawers and long undershirt, and the drawers may also be compared with those worn by the Good Thief in the Cortona Way to Calvary Fragment (Pl. IV; Figs. 65 and 87). Long, loose *brache* seem to have gone out of fashion in the second half of the century, to be replaced by shorter, tighter *mutande;* see R. Levi-Pisetsky, *Storia del costume in Italia,* II, Milan, 1967, 22–23. The captives' disarray is also indicated by bare feet and beards (compare the feet, beard, hair, and shackles of the captive—wearing a shift rather than shirt and drawers—in the Release of Peter the Heretic in the Saint Francis Cycle, Upper Church, S. Francesco, Assisi, illustrated in Poeschke, figs. 196 and 197). The hat of the prisoner on the right may be the copyist's misunderstanding of a linen coif that prisoners might have continued to wear indoors. (For the copyist's difficulty in understanding the form of a medieval coif see below, Scene viii. For another type of hat that covered the ears see Chapter 14, note 74.) The headgear of the central prisoner may have been a *cappuccio* (chaperon) worn over a linen coif (for trecento comparisons see below, Scenes ix and x). The figure shown climbing out of the prison window wears a ragged tunic, perhaps indicating his lower social status. Wrist-irons and a leg-iron, shown in the foreground, may be compared with those in fourteenth-century representations of Saint Leonard (compare, for example, Seidel, 1985, color plate and figs. 50, 53, 56, and 58). The rustication of the prison walls may be compared with frescoes at S. Francesco, Assisi (Saint Francis Cycle, Upper Church, city walls of Arezzo, Poeschke, fig. 161; Crossing Vault, Lower Church, castle wall in Allegory of Chastity, Poeschke, fig. 256) and in the Bardi Chapel at S. Croce, Saint Francis Renounces his Worldly Goods, palazzo walls (illustrated in Previtali, 1967, 328). The landscape background of the right side of the composition was given a seventeenth-century interpretation by the copyist, but an open landscape with architectural features, and a similar group of a man driving an ass, can be found in Ambrogio Lorenzetti's Good Government in the Country (E. Carli, *I Pittori senesi,* 1971, 113, fig. 91; Carli, 1981, fig. 233) (see also Fig. 69). For the puffy clouds surrounding Margherita see above, Scene vi.

Cappella Maggiore, South Wall, Middle Row

VIII. *The Cure of Simonello di Angeluccio of Perugia.* Posthumous miracle (Pl. XIV; Figs. 128 and 195–200)

Simonello di Angeluccio of Perugia was suffering from a severely ulcerated tumor below the chin, that no doctor, not even Maestro Tebaldo of Arezzo, had been able to cure. Simonello prayed to Margherita, vowing to visit her church annually on her feast day, or at some other time during the year, and was cured of his life-threatening tumor. (See *Legenda,* XII, 57; CM, 79.) In Scene viii the doctor gives a woman—presumably Simonello's wife—the bad prognosis while, at the same moment, her child tries to tell her of Simonello's miraculous cure.

Inscription. CESSET MEDICINA TERRENA / IBI GRATIA OPERATUR DIVINA / QUI ME NOVERUNT MORTI DONATUM / ME NOSCANT A MARGARITA SANATUM.

Condition of mural c. 1629. A slight loss appears to have occurred at the lower right edge of the mural. The left edge of the scene, which also appears to have been damaged, may have represented an

architectural feature on the exterior of Simonello's house. There are no obvious signs of repainting to be deduced from the watercolor.

Dress. Simonello appears to have been wearing a nightshirt (*camicia*) and a nightcap (See the hat and nightshirt in the Healing of John of Lerida, Saint Francis Cycle, Upper Church, S. Francesco, Assisi (Fig. 127) and Poeschke, figs. 193 and 195, and see the hat on a peg above the bed in Scene v.) In the Assisi fresco the nightcap covers a close-fitting linen coif, whose laces hang loose. In the watercolor Simonello's ears are not covered by a coif, but a triangular area between ear and cap-brim, and some lines on the pillow beside Simonello's neck, indicate that the copyist was attempting to record an item of headwear that was no longer clear in the original mural, or that he did not properly understand. The woman at the center of the composition—presumably Simonello's wife—appears to have worn a wimple under her veil (cf. The Confession of the Temporarily Resuscitated Woman, Saint Francis Cycle, Upper Church, S. Francesco, Assisi, Poeschke, fig. 196). It is difficult to comment conclusively on the physician's clothing since ideas concerning the appropriate dress for a doctor of medicine appear to have been formulated gradually during the fourteenth century. Textual evidence indicates that physicians above a certain level of accomplishment dressed like doctors of civil law, wearing a long *supertunica* over their usual tunic. This tunic, and the biretta, which covered the head, could be trimmed with miniver, and the *supertunica* could be made of scarlet cloth (see W. N. Hargreaves-Mawdsley, *A History of Academical Dress in Europe until the End of the Eighteenth Century*, Oxford, 1963, 16–17). The visual evidence discussed in A. Corsini, *Il costume del medico nelle pitture Fiorentine del Rinascimento*, Florence, 1912, suggests that by the fifteenth century there was a certain degree of uniformity, at least in Florence, in the dress of doctors, including the scarlet, miniver-trimmed *supertunica,* and broad, soft, scarlet biretta, gathered into a close-fitting, miniver-trimmed band. But visual evidence from the fourteenth century suggests that while doctors of medicine wore the clothing of wealthy and important citizens, there was no uniformity in the form and color of dress (compare, for example, The Healing of John of Lerida, Saint Francis Cycle, Upper Church, S. Francesco, Assisi (fig. 127; color plate Poeschke, fig. 193); Cure of a Nun with a Nosebleed, Beata Umiltà panel, (Fig. 129; color illustration, Boskovits, ed. Schleier, 1988, pl. 5); Monk Refusing to have his Foot Amputated by a Doctor (Volpe, ed. Lucco, 179, fig. 145). The doctor in Scene viii has a scarlet hat and *supertunica.* The hat, which appears to have been trimmed with miniver, seems to be of a broad type similar to fifteenth-century examples (compare, for example, Corsini, pls ii, 2; iv, 1; v, 1; vi, 2) suggesting either postmedieval repainting or misunderstanding of a medieval hat by the copyist. The sleeves, which have been given an anachronistic leg-of-mutton shape, presumably consisted of an outer, broad, short sleeve for the *supertunica,* with a tighter, longer, inner sleeve for the undertunic (cf. Beata Umiltà scene, Fig. 129). The slit at the neck of the *supertunica,* with reveres folded back, can be paralleled in many examples (e.g., one of the group of twenty-four citizens in Ambrogio Lorenzetti, Allegory of Good Government (illustrated in Frugoni, 1988, 71, fig. 85), medical students on the tomb of physicians Lucio and Mondino de'Liuzzi, 1318, Bologna, SS. Vitale e Agricola, illustrated in R. Grandi, *I monumenti dei dottori e la scultura a Bologna (1267–1348)*, Bologna, 1982, figs. 52, 53, 56, pp. 138–39).

Cappella Maggiore, South Wall, Bottom Row

IX. *The Calming of the Sea of Ancona.* Posthumous miracle (Pl. XXVI; Fig. 137)

Pilgrims journeying toward Jerusalem encountered a storm in the Sea of Ancona that continued for several days. They invoked several saints unsuccessfully. Bartolo *Mantellato* (member of the Franciscan

Third Order) of Laviano, Margherita's brother, who was among their number, was carrying with him some relics of Margherita. When they invoked her help the storm instantly abated and they had a safe and speedy journey to port (see *Legenda*, xii, 49; CM, 50).

The figure second from right in Scene ix, holding a chalice-shaped object, is presumably Bartolo, holding the relic. The man to the left of him, with similar clothing, is presumably another *mantellato*. For further discussion of the significance of this scene, and of the possible identity of the figure in red in the stern of the boat, see Chapter 13.

Inscription. Lost.

Condition of mural c. 1629. The condition appears to have been good, apart from the loss of the inscription. For the form of the cloud surrounding Margherita, which might be due to overpainting, see above, Scene vi.

Dress. Certain curiosities in various hats in the scene are probably the result of the copyist's misunderstanding or reinterpretation of medieval forms. The figure in red in the prow of the boat, the figure in brown beside him, and the standing figure in brown, four from the right, were presumably all wearing a chaperon (*cappuccio*) (see Levi Pisetzky, ii, 65-68). This type of headwear, made with or without a fur lining, could be arranged and wrapped round the head to form a variety of shapes (see, for example, the procession of citizens in Ambrogio Lorenzetti's Allegory of Good Government (illustrated in Frugoni, 1988, 71, fig. 85).) The chaperon was often, but not exclusively, worn over a linen coif (see the scenes of the Death and Resuscitation of the Boy of Suessa, Lower Church, S. Francesco, Assisi (Poeschke, figs. 238 and 239) for a variety of styles and combinations.) The figures in Scene ix (and elsewhere in the watercolors) are not shown wearing coifs, but this may be because, as discussed above (Scene viii), the copyist appears to have been puzzled by this piece of headwear, and probably tended to omit it. The dress of a Franciscan Tertiary has already been discussed (see Chapter 11, note 60; Chapter 14, note 60). The shape of chaperon worn by Bartolo, which appears to be similar to that of the man in red on the right, was evidently not exclusively worn by *mantellati*, but a similarly shaped chaperon, which may indicate the original form of Bartolo's headwear, is worn by a representative of the Franciscan Third Order in the Allegory of Chastity in the crossing vault of the Lower Church of S. Francesco, Assisi (Poeschke, figs. 252 and 253). The figure in red in the center foreground of the boat may have worn either a coif, or a cap covering the ears (see above, Scenes iv and vii). The man in profile, third from the right, appears to have worn a broad-brimmed traveling hat (see the hat of the poor man in the Miracle of the Spring, Upper Church, S. Francesco, Assisi, Poeschke, figs 167 and 169, or the hats worn by several figures in Ambrogio Lorenzetti, Good Government in the Country, e.g. Carli, 1981, 203, fig. 233). For the crosses on the cloaks of Bartolo and his companion, and for the headgear and possible identity of the figure in red in the stern of the boat, see Chapter 13.

Cappella Maggiore, South Wall, Bottom Row

X. *The Resuscitation and Healing of Suppolino*. Posthumous miracle (Pl. XVI; Figs. 115 [detail] and 126)

Five-year-old Suppolino, son of the widow Donna Muccia of Monte Santa Maria (diocese of Città di Castello), fell from a high window and damaged his head severely on a rock. Donna Muccia prayed to

Margherita, promising to bring Suppolino to her tomb and to encircle (*cingere*) her altar if the boy were saved. Immediately the child breathed again, and his wounds were healed (see *Legenda*, xii, 35; CM, 36). (For discussion of the meaning of *cingere* see Chapter 4.) For a description of the protagonists, and of the succession of events shown in the mural, see Chapters 8 and 9.

Inscription. Lost.

Condition of mural c. 1629. Appears to have been good, apart from the loss of the inscription. The dress of figures appears to have been medieval (compare, for example, Simone Martini, Beato Agostino Novello scenes, Pl. XIII, Figs. 123 and 124; Ambrogio Lorenzetti, Saint Nicholas Resuscitates a Child, Pl. XV, Fig. 125) and, with one exception, gives no indication of repainting. This exception is the female figure on the extreme right, whose low bodice indicates that she was either an addition, or was repainted, probably in the early seventeenth century. The ornate bed may appear postmedieval in detail but some trecento parallels can be suggested for its general form: the trestle legs may be compared with those in The Confession of the Temporarily Resuscitated Woman, Saint Francis Cycle, Upper Church, S. Francesco, Assisi, (Poeschke, fig. 196); the ornate central bed-leg may be the copyist's misunderstanding of a central bench support of the type seen in the Upper Church, in the Healing of John of Lerida (Fig. 127; Poeschke, fig. 193).

South Nave Wall, Eastern Bay, Right Half of Lunette

XI. *Christ Calls Margherita to Go to Cortona to do Penance* (Pl. XXIII; Figs. 107 and 171)

After the death of her lover, Margherita returned from Montepulciano to her father's house in Laviano, but her stepmother persuaded him to reject her. While praying under a fig tree in the garden of her father's house, at Laviano, Margherita resisted the temptation to take some important man as her new protector. Christ urged her to go instead to Cortona and put herself under the supervision of the Franciscans (see *Legenda*, i, 2 and 3; Iozzelli, i, ib and ic; also *Legenda* ii, 8; Iozzelli, ii, 2a). (The identification of the town in which she had lived as Montepulciano is found in *Legenda*, ii, 14; Iozzelli, ii, 7.) For further discussion of the contents of this scene see Chapter 14.

Inscription. COME SANCTA MARGARITA VENNE A CORTONA A FAR PENITENÇA.

For the relative positions of Scenes xi and xii within the lunette see Chapter 7 and Figure 107. The curved pencil line at the top of the watercolor is a later—and misleading—addition.

Condition of mural c. 1629. It is clear that, as in Scenes i and vi, lunette scenes were particularly vulnerable. The left part of the figure of Christ, the heads of the two Franciscans on the left, and part of the city of Cortona on the far left, are all lost. The male figure on the right, holding a bird (falcon?), appears to be wearing postmedieval doublet and breeches, either because of repainting of this section of the mural or through the copyist's misunderstanding of medieval dress (see, e.g., the short and relatively fitted tunic worn by the hawking figure in Ambrogio Lorenzetti's Good Government in the Country, Carli, 1981, fig. 234). Margherita is dressed in black, as specified in the *Legenda* text.

South Nave Wall, Eastern Bay, Left Half of Lunette

XII. *Liberation from Devils of the Boy of Borgo Sansepolcro* (Pl. XXI; Figs. 107 and 168)

A young boy of Borgo Sansepolcro was so troubled by devils that three strong men could barely restrain him. Asked which saint could help to liberate him, he always replied that only Suor Margherita, who lived in Cortona, could expel this demon. He was thus taken toward Cortona. Once in sight of the Rocca of Cortona, and of the Church of S. Basilio, the devil left the boy, unable to tolerate the proximity to Margherita's prayers. The boy and his companions then continued on to Cortona and went to Margherita to report the miracle (see *Legenda*, IV, 6).

Inscription. COME I SPIRITI MALIGNI SE PARTIERO DA CUSTUI PER LI MERTI DI SANCTA MARGARITA.

Condition of mural c. 1629. The lunette-shaped field that the mural occupied is indicated by a pen outline. The right half of the mural had suffered severe losses. Only the figure of the boy, kneeling before Margherita, the lower part of the standing figure of Margherita, and part of the kneeling figure of one of the adults accompanying the boy, were still visible to the copyist. There is no indication of repainting, and the dress of the figures on the left (with the exception of the buttons on the boy's garment) is similar to that seen in the relief of A Child Liberated from Devils on the funerary monument (Fig. 169).

South Nave Wall, Eastern Bay, Second Tier from Top

XIII. *The Saving of the Suicide* (Pl. XXIV; Fig. 134)

Margherita, with the help of two companions, saved a learned man from death after receiving a vision of his intended suicide. The man had already placed a rope round a beam, and a stool beneath his feet, when Margherita arrived (see *Legenda*, XII, 56; CM, 78).

The watercolor shows the door to the man's house torn from its hinges, by Margherita, in her haste to save him. Having climbed the stairs to an upper window, overlooking the courtyard, Margherita cuts the rope, as her companions take the man's weight, and the demon waiting to claim his soul disappears from the house into an alleyway. The *Legenda* text simply describes the man as *quidam litteratus*, but his dress, discussed below, suggests that he may have been a doctor of canon law. It is possible that this clear visual statment of Margherita's support for a man of ecclesiastical learning was intended to dispel any association that may have been made between her and the tendency, in Franciscan Spiritual circles, to value revelation far above the authority of book-learning.

Inscription. COME UOMO DISPERATO S'IMPICO SE MEDESIMO SANCTA MARGARITA EL VIDE PER SPIRTO QUANDO ESSO S'EMPICAVA ACURSE LI CON DOI SUORE.

Condition of mural c. 1629. Condition appears to have been good, with no indication of losses. (The white semicircular area in the top left corner of the watercolor, which might be interpreted as a loss, and confuses the appearance of the empty alley beside the house of the learned man, is simply a piece of reinforcement to the watercolor paper, found in the same position in all the watercolors of Cortona

MS 429, but not generally so conspicuous.) The distinctive shadow cast by the door, torn from its hinges, on the steps leading into the house of the learned man, might indicate postmedieval repainting, but see Chapter 9, note 18, for the possibility that this was an original feature of the mural.

Dress. The learned man was dressed in blue. If his learning was such that he had obtained a doctorate, this color of dress, in place of the customary scarlet, would signify that he was a doctor of canon law. See Hargreaves-Mawdsley, 1963, 14. (For the dress of Margherita and her companions see Chapter 11, notes 34 and 35.)

South Nave Wall, Eastern Bay, Second Tier from Top

XIV. *Margherita Resuscitates a Dead Child in Cortona* (Pl. XXII; Fig. 122)

A certain woman of Cortona had left her small son for dead in bed (shown on the upper right) and, fearing her husband's anger, planned to run away from Cortona. She went to visit Margherita in her cell, who urged her to return to her house rather than taking refuge in her native village. On the mother's return to the house she found her son alive (also shown on upper right) (see *Legenda*, XII, 36; CM, 37).

Inscription. COME UNA DONNA AFFOGÒ IL FIGLIO EN LO LETTO E PER LI MERTI DE SANCTA MARGARITA RESUSCITÒ. (For the relation among the inscription, mural, and *Legenda* text see Chapter 13.)

Condition of mural c. 1629. There appears to have been an area of loss on the right side of Margherita's body and in the entrance to her cell. (For the white semicircular patch on the top left of the watercolor see above, Scene xiii.) The curious shape of the architectural frame surrounding the bedroom on the right may be the result either of repainting or copyist's license. There are trecento parallels for the rest of the architecture (see Chapter 8 and Fig. 121). For panelled wooden doors set in arched openings at street level see, for example, Simone Martini: Beato Agostino Novello Saves a Child Falling from a Balcony (Fig. 124); Ambrogio Lorenzetti: Saint Nicholas Resuscitates the Merchant's Son (Pl. XV; Fig. 125).

Dress. For the short veil worn by the mother see the kneeling women in the scene Saint Francis Resuscitates a Boy who had Fallen from a Window, Lower Church, S. Francesco, Assisi (Poeschke, fig. 237).

South Nave Wall, Eastern Bay, Third Tier from Top

XV. *The Ospedale della Misericordia* (Pl. XXV; Fig. 175).

Margherita supervises the collection and distribution of bread and money by members of the Fraternità di S. Maria della Misericordia while her companions welcome pilgrims and assist the poor and sick

inside the Ospedale (see *Legenda*, ii, 2, 3). (For further discussion of the events shown here see Chapter 14.)

Inscription. COME SANCTA MARGARITA FECE LA MISERICORDIA E COME LA MANDAVA E I BONOMINI PER LO PANE PER GOVERNARE I POVERI ENFERMI.

Condition of mural c. 1629. The right half of the mural appears to have been in good condition, but there were considerable areas of loss in the central section (notably the body of the pilgrim and the ground on which he stood or knelt) and on the left (the area surrounding the basin in which the leper's leg is being washed). The abrupt transition at the left from exterior view of figures arriving on crutches to the interior view of the Ospedale may originally have been more convincingly handled. Damage, repainting, or copyist's misinterpretation may account for the present form of this area in the watercolor. The base of the *Ospedale* door jambs are more logically drawn in the version in the ACC H27 set. Possible areas of postmedieval repainting include the full beard of the figure on the far right (see above, Scene v, concerning beards) and possibly also the figures in the lunette over the Ospedale entrance, which have a quattrocento air.

Dress. For the two benefactors in green and red at the right (carrying donations of bread or money in their aprons) compare the citizens leading the procession in Ambrogio Lorenzetti's Allegory of Good Government (illustrated in Frugoni, 1988, fig. 85). (For discussion of the absence of coifs see above, Scenes viii and ix.) The benefactor in red, with fur-trimmed capuchon (*cappuccio*) and fashionable openwork shoes, is clearly intended to be a man of high status (for discussion of his identity see Chapter 14). For the dress of the figure in white to the right of Margherita, who may represent the prior of the Fraternità di S. Maria della Misericordia, see Chapter 14.

South Nave Wall, Eastern Bay, Third Tier from Top

XVI. *The Cure of the Conspirator of Arezzo*. Posthumous miracle. (Fig. 130).

A certain man of Arezzo who had just prepared assassins to murder an enemy, and who was himself already armed, was eating a meal. A fishbone lodged in his throat and several doctors were unable to remove it. Having vowed to make peace with his enemies and surround Margherita's tomb with candles if cured, Margherita appeared to him, the bone immediately came out, and he fulfilled his vow (see *Legenda*, xii, 55; CM, 77). (For further description of the events shown here see Chapters 9 and 13.)

Inscription. COME CHUSTUI PER LI MERTI DE SANCTA MARGARITA SPUTÒ LA SPINA E PERDONO A SUOI NEMICI E REDISSE PACE.

Condition of mural c. 1629. Although there are no obvious areas of loss in the mural, apart from the blank area at the lower right corner, oddities in the dress of certain figures suggest that this scene may have been considerably repainted. Scenes xviii and xix, which were probably directly below Scene xvi, were in such poor condition that they had disappeared completely by 1634. Scene xvi may thus also have been in a condition that necessitated postmedieval repainting. The two attendants at the table have remarkably short tunics, not worn in the fourteenth century. (For a short belted tunic

[*ciopetta*] illustrated c. 1380, see Levi Pisetzky, II, 45, fig. 21.) The conspirator of Arezzo is shown three times: seated behind the table in the main scene, and kneeling twice, once in supplication and once after cure, with the fishbone in his hand, on the right.) His clothing, including the turbanlike hat that was presumably a capuchon (*cappuccio*) (see above, Scene ix), could belong to the first half of the fourteenth century but his prominent pointed beard would be surprising at this date for a man who was neither a soldier, nor a hermit, nor a foreigner (see above, Scene v). The dress of the doctor standing on the far left may be compared with the doctor in Scene viii, although the hat is smaller and the beard is surprising. (The doctor standing behind the seated conspirator, attempting to extract the bone, appears to have been dressed similarly.) The dog in the foreground may be an addition, but would not be unique in the context of a fourteenth-century dining scene. See, for example, Pietro Lorenzetti: The Last Supper, Lower Church, S. Francesco, Assisi (Poeschke, fig. 261); School of Giotto: Saint Nicholas Returns Adeodatus to his Parents, Lower Church, S. Francesco, Assisi (Poeschke, fig. 207).

South Nave Wall, Eastern Bay, Bottom Tier

XVII. *The Visitation of Cardinal Napoleone Orsini* (Pls. I and XI; Figs. 23 and 193–94 [details]).

In the presence of Margherita's body, protected within the iron *arca* (for which see Chapter 4), witnesses testify on the Bible (held by a bishop) to miracles achieved through Margherita's intervention. Cardinal Napoleone Orsini (on the left of the central section) listens to the evidence, which is recorded by a notary, seated in the left foreground. Behind the notary and beyond Margherita's body stand a group of civic and ecclesiastical dignitaries. In front of the body, to the right, the sick approach in hope of a cure. (See declaration of authenticity of 1308, appended to the *Legenda*, Fig. 1, Iozzelli, 1997, 477–78.) For a more detailed discussion of the events shown here, and the possible identity of certain figures, see Chapters 13 and 14. For a variation in the watercolor copies of this scene see Appendix II.

Condition of mural c. 1629. Apart from possible losses in the middle ground of the right section, represented in the watercolor by an area of even brown tone, the mural appears to have been in reasonable condition. The shape of the beards of some of the figures standing behind Margherita's body, notably the man visible above the bishop's miter, may indicate some repainting of these figures. The curious appearance of some of their hats may be due to the copyist's misunderstanding of the *cappuccio* (see above, Scene ix). The mutilated figures in the right foreground are not simply a copyist's error; they represent, at least in part, the deformities Margherita was to be asked to cure. (At the back of this group a demon, such as those found in Scenes xii and xiii, escapes from a man's mouth.) The boy in blue walking on crutches, at the right of the central section, appears to have worn a short, close-fitting buttoned doublet of the type only becoming popular in Italy for everyday urban wear around 1340 (see Newton, 6–8) and probably not represented in Italian paintings until the middle of the century. This may simply be the copyist's misunderstanding of a child's short tunic, but it may be worth noting that the boy's clothing in the watercolor resembles that of the prisoners in the foreground to the right of the figure of *Bene Comune* in the Allegory of Good Government in the Palazzo Pubblico in Siena. These figures form part of the area thought to have been repainted a decade or two after the original campaign of c. 1338–39, to repair areas of damage in Ambrogio Lorenzetti's murals,

and probably adhering to the original composition; see C. Brandi, "Chiaramenti sul "Buon Governo" di Ambrogio Lorenzetti," *Bolletino d'arte* 40 (1955), 119–23; Borsook, 1980, 37 and 38 n. 31. If the boy on crutches had been repainted, it may have been in similar circumstances.

It is conceivable that Sassetta's figure of a seated notary in Saint Francis and the Wolf of Gubbio from the Borgo Sansepolcro altarpiece (now National Gallery, London) was derived from the notary in Scene xvii. Van Os has recently demonstrated Sassetta's careful following of a Lorenzetti prototype elsewhere in the altarpiece (Van Os, 1990, 95–96). Sassetta would have had ample opportunity to study the mural since he was himself born in Cortona.

South Nave Wall, Eastern Bay, Bottom Tier

XVIII. *Aretino of Arezzo Saved Twice from Drowning in a Well.* Posthumous miracle (Fig. 172)

Aretino of Arezzo, having invoked Margherita while falling into a well, was saved from drowning. Friends came to his rescue, but as he reached the mouth of the well the rope that he was holding snapped. He fell into the water a second time, but was finally rescued unharmed (see *Legenda*, xii, 50; CM, 51).

Inscription. COME UNO CADE NEL POZZO DOI VOLTE L'UNA DOPPO L'ALTRA COME SE RACCOMANDO A SANCTA MARGARITA FONE TRATO SEÇÇA [= SENZA] PERICOLO. (For the possible meaning of FONE see Chapter 13, note 37.)

Condition of mural c. 1629. The mural was in very poor condition, with almost complete loss of the upper section and areas of further loss in the left part of the remaining section. This mural, together with that recorded in Scene xix, had disappeared entirely by 1634 (see Chapter 7). The scene was presumably divided into two episodes: on the left Aretino was shown reaching up within the well, grasping the rope held by his friends; on the right he and his friends celebrated his rescue. The figures appear to have been dressed in the short tunics worn by peasants in, for example, Ambrogio Lorenzetti's Good Government in the Town and Good Government in the Country (e.g., Fig. 69; Carli, 1981, fig. 230). The boots with rolled tops worn by the figure to the right of the well may have resembled those worn by the soldier in yellow and the man carrying the ladder in the Cortona Way to Calvary fragments (Pl. V; Fig. 67). The shape of the well is comparable to that in the surviving fresco fragment of Joseph Sold by his Brothers (Fig. 173).

South Nave Wall, Eastern Bay, Bottom Tier

XIX. *The Healing of the Man of Corciano.* Posthumous miracle (Fig. 103)

A man of Corciano (diocese of Perugia) was suffering from a fever so severe that one of his eyes fell from its socket. Doctors despaired of a cure but, although unable to speak, the man vowed in his heart to visit Margherita's tomb with ten candles, each worth twenty soldi, if he was cured. Immediately he was cured, his eye returned to its normal position, and leaping from his bed he went, with his brother, to Margherita's tomb, to carry out his vow and report the miracle (see *Legenda*, xii, 1, CM, 1).

Inscription. Lost.

Condition of mural c. 1629. Like the mural in Scene xviii, this scene had disappeared by the time of the Visitation of 1634. It was evidently badly damaged when the copy was made, with extensive losses in the upper section of the central scene, including the face and lower arms of the figure of the cured man, and loss of everything apart from Margherita's head framed by an arch, at the right end of the mural. The sandy yellow area in the center foreground may also indicate an area of loss between the striped blanket covering the bed, and the brown *cassone* below the bed, on which the grieving seated figure rests his feet. At the bottom right corner of the watercolor there is an architectural feature that appears to be a postmedieval door-surround. As discussed above (Chapter 7) this appears to be the representation of an actual doorway in the church, probably an enlargement and remodeling of a medieval doorway whose alteration caused damage to the mural. Areas of loss are visible above and to the right of the doorway. The basic core of Scene xix was probably medieval (see Chapter 7) but there appear to have been substantial areas of repainting. Although the figures in the main scene generally seem to have worn trecento dress (see above, Scene viii, for the nightcap and nightshirt worn by the man of Corciano) the broad beards of the two men on the left of the main scene may have been postmedieval. One of these two men, dressed in red, may be intended to represent a doctor, in which case it is surprising that he does not wear a hat. In the lefthand section of the composition the figures carrying large candles, especially the female with low-cut bodice, appear to wear postmedieval dress. The architectural detail above them, with single vanishing point, also appears to have been postmedieval in detail (compare the central section of Scene vi).

The care with which the copyist could record the contents of the original mural is seen in the inclusion of the detail of the eye of the man of Corciano, shown hanging from its socket (see Chapter 10, note 25, and Chapter 13).

Bibliography of Cited Works

Manuscript Sources

Cortona, Archivio Storico del Comune, MS H 27: *Processus extractus a Processu originali . . . in causa Cortonensis canonizationis Beatae Margaritae de Cortona . . .*

———, MS H 28: *Copia collata processus remissorialis auctoritate Apostolica in Civitate Cortona facti. . . .*

———, MS H 29: *Copia collata processus remissorialis auctoritate Apostolica in Civitate Cortona facti. . . .*

Cortona, Archivio del Convento di S. Margherita, MS 61.

———, *Sommario della storia della chiesa e del convento di S. Margherita di Cortona, compilato e disposto per ordine cronologico dal P. Fra Lodovico da Pelago . . .* , 1781.

Cortona, Biblioteca Comunale e dell'Accademia Etrusca, MS 390.

———, MS 429.

———, MS 501: *L'Antiquario Sacro che conduce alcuni suoi amici forestieri a vedere, e visitare le Chiese, e pitture che sono tanto negli Altari, che nei Conventi della Città di Cortona . . . fatto l'anno 1774 da un dilettante.*

Florence, Archivio Provinciale dei Frati Minori, *Sommario della storia della chiesa e del convento di S. Margherita di Cortona, compilato e disposto per ordine cronologico dal P. Fra Lodovico da Pelago . . .*

Florence, Archivio di Stato, Statuti comunità soggette, 279.

Florence, Biblioteca Medicea-Laurenziana, MS Acquisti e Doni 318.

Rome, Istituto Storico dei Cappucini, Museo Francescano, Gabinetto dei disegni e delle stampe, Disegni, cart. I C.

Vatican City, Archivio Segreto Vaticano, Riti, Proc. 549.

———, Riti, Proc. 552: *Copia collata processus remissorialis auctoritate Apostolica in Civitate Cortona facti. . . .*

Printed Sources

Acta Sanctorum. Antwerp, 1643 ff.

Acta Sanctorum. 3d ed., Paris and Rome, 1863–65.

Alessi, C. "I cicli monocromi di Lecceto: nuove proposte per vecchi problemi." In *Lecceto e gli eremi agostiniani in terra di Siena,* 211–46. Milan, 1990.

Alexiou, M. *The Ritual Lament in Greek Tradition.* Cambridge, 1974.

Argenziano, R. "Iconografia della beata Colomba a Perugia." In *Una santa, una città,* ed. G. Casagrande and E. Menestò, 253–89. Perugia and Florence, 1990.

L'art gothique Siennois. Exhibition catalogue, Avignon, 1983. Florence, 1983.

Avanzati, E. "Beato Andrea Gallerani." In *Simone Martini e "chompagni."* Exhibition catalogue, Siena, 1985, 78–81. Florence, 1985.

Bacci, D. *Il Santuario di S. Margherita in Cortona.* Arezzo, 1921.

Bacci, P. *Dipinti inediti e sconosciuti di Pietro Lorenzetti, Bernardo Daddi, ecc. in Siena e nel contado*, Siena, 1939.

———. *Fonti e commenti per la storia dell'arte senese.* Siena, 1944.

Bagnoli, A., and M. Seidel. "Il Beato Agostino Novello e quattro suoi miracoli." In *Simone Martini e "chompagni."* Exhibition catalogue, Siena, 1985, 56–72. Forence, 1985.

Banker, J. R. "The Program for the Sassetta Altarpiece in the Church of S. Francesco in Borgo San Sepolcro." *I Tatti Studies: Essays in the Renaissance* 4 (1991), 11–58.

Barasch, M. *Gestures of Despair in Medieval and Early Renaissance Art.* New York, 1976.

Barbi, R. *Vita del B. Andrea Gallerani.* Siena, 1638.

Bardotti Biasion, G. "Gano di Fazio e la tomba-altare di Santa Margherita da Cortona." *Prospettiva* 37 (1984), 2–19.

———. "Il monumento di Gregorio X ad Arezzo." In *Skulptur und Grabmal des spätmittelalters in Rom und Italien: Akten des Kongress, "Scultura e Monumento Sepolcrale del tardo medioevo a Roma e in Italia"* (Rome 1985), ed. J. Garms and A. M. Romanini, 265–73. Vienna, 1990.

Barsotti, R. *Gli antichi inventari della Cattedrale di Pisa.* Pisa, 1959.

Bartalini, R. "Goro di Gregorio e la tomba del giurista Guglielmo di Ciliano." *Prospettiva* 41 (1985), 21–38.

Bartoli, M. *Chiara d'Assisi*, Bibliotheca Seraphico-Capuccina 37. Rome, 1989.

Belamarić, J. "Un intagliatore gotico ignoto sulla sponda orientale dell'Adriatico." In *Gotika v Sloveniji. Nastajanje kulturnega prostora med Alpami, Panonijo, in Jadranom. Akti mednarodnega simpozija Ljubljana, Narodna galerija, 1994*, ed. J. Höfler, 147–57. Ljubljana, 1995.

Bell, R. M. *Holy Anorexia.* Chicago, 1985.

Bellosi, L. "Jacopo di Mino del Pellicciaio." *Bolletino d'arte* 57 (1972), 73–77.

———. "Moda e cronologia. a) Gli affreschi della Basilica inferiore di Assisi." *Prospettiva* 10 (1977), 21–30.

———. "Moda e cronologia. b) Per la pittura del primo Trecento." *Prospettiva* 11 (1977), 12–26

———. "Gano a Massa Marittima." *Prospettiva* 37 (1984), 19–22.

———. *La pecora di Giotto.* Turin, 1985.

———. "Per l'attività giovanile di Bartolo di Fredi." *Antichità viva* 24 (1985), 21–26.

———, ed. *Simone Martini: Atti del convegno (Siena, 1985).* Florence, 1988.

Bellosi, L., G. Cantelli, and M. Lenzini Moriondo. *Arte in Valdichiana.* Exhibition catalogue. Cortona, 1970.

Belting, H. *Bild und Kult.* Munich, 1990.

———. *Likeness and Presence.* trans. E. Jephcott, Chicago, 1994.

Belting, H., and D. Blume, eds. *Malerei und Stadtkultur in der Dantezeit. Die Argumentation der Bilder.* Munich, 1989.

Bennett, J. "Framing the Subject: Representation and the Body in Late-Medieval Italy." Ph.D. diss., University of London, 1993.

Benvenuti Papi, A. "Umiliana dei Cerchi: Nascita di un culto nella Firenze del Duecento." *Studi francescani* 77 (1980), 87–117. Reprinted in Benvenuti Papi, 1990, 59–98.

———. "Margarita filia Jerusalem. Santa Margherita da Cortona e il superamento mistico della crociata." In *Toscana e Terrasanta nel Medioevo*, ed. F. Cardini, 117–57. Florence, 1982. Reprinted as "Cristomimesi al femminile," in Benvenuti Papi, 1990, 141–68.

———. "Le forme comunitarie della penitenza femminile francescana. Schede per un censimento toscano." In *Prime manifestazioni di vita comunitaria, maschile e femminile, nel movimento francescano della Penitenza (1215–1447). Atti del 4° Convegno di studi francescani, Assisi 1981*, ed. R. Pazzelli and L. Temperini, 389–449. Rome, 1982. Reprinted in Benvenuti Papi, 1990, 531–92.

———. "Velut in sepulchro: Cellane e recluse nella tradizione agiografica italiana." In *Culto dei santi, istituzioni e classi sociali in età preindustriale*, ed. S. Boesch-Gajano and L. Sebastiani, 367–455. Rome-L'Aquila, 1984. Reprinted in Benvenuti Papi, 1990, 305–402.

———. "Marguerite de Cortone." In *Une Eglise éclatée, 1275–1545*, Histoire des saints et de la sainteté chrétienne 7, ed. A. Vauchez, 178–83. Paris, 1986.

———. *"In Castro Poenitentiae": Santità e società femminile nell'Italia medievale*, Italia sacra 45. Rome, 1990.

Bertagna, M. "Intorno all'origine del convento di Santa Margherita in Cortona." *Studi francescani* 72 (1975), 125–32.

———. "Sviluppo edilizio del convento di S. Margherita a Cortona nel sec.XV." *Annuario dell'Accademia Etrusca di Cortona* 18, n.s. 11, (1979), 63–72.

Bianchi, L., and D. Giunta, *Iconografia di Santa Caterina da Siena*, I. Rome, 1988.

Bibliotheca Sanctorum. 12 vols. Rome, 1965–87

Biebrach, K. *Die Holzgedeckten Franziskaner- und Dominikanerkirchen in Umbrien und Toskana.* Berlin, 1908.

Bigaroni, M., H.-R. Meier, and E. Lunghi. *La basilica di S. Chiara in Assisi.* Perugia, 1994.

Bisogni, F. "Gli inizi dell'iconografia di Nicola da To-
lentino e gli affreschi del Cappellone." In *San Ni-
cola, Tolentino, le Marche: Contributi e ricerche sul
processo (a. 1325) per la canonizzazione di San Ni-
cola da Tolentino. Convegno internazionale di studi,
Tolentino 4–7 Sett. 1985*, 255–321. Tolentino,
1987.

———. "Pietà come immagine ovvero l'immagine
della pietà. Osservazioni in margine alla «Vita»
della beata Colomba da Rieti." In *Una santa, una
città*, ed. G. Casagrande and E. Menestò, 239–52.
Perugia and Florence, 1990.

Blume, D. *Wandmalerei als Ordenspropaganda: Bildpro-
gramme im Chorbereich franziskanischer Konvente
Italiens bis zur Mitte des 14.Jahrhunderts.* Worms,
1983.

Bober, P., and R. Rubinstein. *Renaissance Artists and
Antique Sculpture.* London, 1986.

Boesch Gajano, S., and L. Scaraffia, eds. *Luoghi sacri e
spazi della santità.* Turin, 1990.

Bologna, F. *I pittori alla corte angioina di Napoli, 1266–
1414.* Rome, 1969.

Bologna, P. "Aneddoti artistici cortonesi." *Archivio st-
orico italiano* 5th ser., 17 (1896), 117–35.

Bornstein, D. "Pittori sconosciuti e pitture perdute
nella Cortona tardo-medioevale." *Rivista d'arte* 42
(1990), 227–44.

———. "The Uses of the Body: The Church and the
Cult of Santa Margherita da Cortona." *Church
History* 62 (1993), 163–77.

———. "Parish Priests in Late Medieval Cortona: The
Urban and Rural Clergy." In *Preti nel Medioevo*,
Quaderni di storia religiosa 4, 165–93. Verona,
1997.

Bornstein, D., and R. Rusconi, eds. *Women and Religion
in Medieval and Renaissance Italy*, trans. M. J.
Schneider. Chicago, 1996. (Revised version of
Mistiche e devote nell'Italia tardomedievale, Naples,
1992.)

Borsook, E. *Ambrogio Lorenzetti.* Florence, 1966.

———. *Gli Affreschi di Montesiepi.* Florence, 1969.

———. *The Mural Painters of Tuscany.* 2d ed. Oxford,
1980.

Boskovits, M. *Pittura Fiorentina alla vigilia del Rinasci-
mento, 1370-1400.* Florence, 1975.

———. "Proposte (e conferme) per Pietro Cavallini."
In *Roma Anno 1300*, ed. A. M. Romanini, 297–
329. Rome, 1983.

———. "Considerations on Pietro and Ambrogio Lor-
enzetti." *Paragone* 439 (1986), 3–16.

———. "La decorazione pittorica del Cappellone di S.
Nicola a Tolentino." In *San Nicola, Tolentino, le
Marche: Contributi e ricerche sul processo (a. 1325)
per la canonizzazione di San Nicola da Tolentino.*

*Convegno internazionale di studi, Tolentino 4–7 Sett.
1985*, 245–52. Tolentino, 1987.

———. *Frühe italienische Malerei: Gemäldegalerie Ber-
lin*, Katalog der Gemälde, I, ed. E. Schleier. Ber-
lin, 1988.

———. "Un libro su Pietro Lorenzetti." *Arte cristiana*
79 (1991), 387–88.

Brancia Apricena, M. "La chiesa di S. Margherita a
Cortona." In *Giovanni V di Portogallo (1707–
1750) e la cultura romana del suo tempo*, ed. S.
Vasco Rocca and G. Borghini, 197–99. Rome,
1995.

Brandi, C. "Chiaramenti sul "Buon Governo" di Am-
brogio Lorenzetti." *Bolletino d'arte* 40 (1955),
119–23.

Brink, J. "Simone Martini's Orsini Polyptych." *Jaarboek
van het Koninklijk Museum voor Schone Kunsten,
Antwerpen* (1976), 7–23.

Büll, R. "Wachs und Kerzen im Brauch, Recht und
Kult. Zur Typologie der Kerzen." In *Vom Wachs,
Hoechster Beiträge zur Kentnis der Wachse*, I, 10–11.
Frankfurt, 1970.

Bullarium Franciscanum, V, ed. C. Eubel, Rome, 1898.

Bush-Brown, A. "Giotto: Two Problems in the Origin
of His Style." *Art Bulletin* 34 (1952), 42–46.

Butzek, M. "Altar des sel. Augustinus Novellus." In *Die
Kirchen von Siena*, ed. P. A. Riedl and M. Seidel,
I, i, 210–12. Munich, 1985.

Bynum, C. Walker. "Women Mystics and Eucharistic
Devotion in the Thirteenth Century." *Women's
Studies* 11 (1984), 179–214. (Reprinted in
Bynum, 1991, 119–50.)

———. *Holy Feast and Holy Fast: The Religious Signifi-
cance of Food to Medieval Women.* Berkeley and
Los Angeles, 1987.

———. *Fragmentation and Redemption: Essays on Gen-
der and the Human Body in Medieval Religion.* New
York, 1991.

Campbell, M. *Pietro da Cortona at the Pitti Palace.*
Princeton, 1977.

Cannon, J. "Dominican Patronage of the Arts in Cen-
tral Italy: The *Provincia Romana*, c. 1220–c.
1320." Ph.D diss., University of London, 1980.

———. "Pietro Lorenzetti and the History of the Car-
melite Order." *Journal of the Warburg and Cour-
tauld Institutes* 50 (1987), 18–28.

———. "Marguerite et les Cortonais: Iconographie
d'un «culte civique» au XIVe siècle." In *La religion
civique à l'époque médiévale et moderne (Chrétienté
et Islam)*, Collection de l'École française de Rome
213, ed. A. Vauchez, 403–13. Paris, 1995.

———. "Dominic *alter Christus*? Representations of
the Founder in and after the *Arca di San Domen-
ico*." In *Christ Among the Medieval Dominicans*, ed.

K. Emery Jr. and J. Wawrykow, 26–48. Notre Dame, Ind., 1998.

Cardini, F. "Una signoria cittadina "minore" in Toscana: i Casali di Cortona." *Archivio storico italiano* 131 (1973), 241–55.

———. "Allegrezza Casali, devota di S. Margherita, figura poco nota nella spiritualità cortonese." *Studi francescani* 72 (1975), 335–344.

———. "Agiografia e politica: Margherita da Cortona e le vicende di una città inquieta." *Studi francescani* 76 (1979), 127–36.

Carli, E. *La Pittura senese del Trecento.* Milan, 1981.

———. "Sculture senesi nel Trecento tra Gano, Tino e Goro." *Antichità viva* 29, ii–iii (1990), 26–39.

Carmichael, M. "An Altarpiece of Saint Humility." *The Ecclesiastical Review* (1913), 429–44.

Casagrande, G. "Un tentativo d'indagine sullo 'status' economico e sociale dei 'Frati della Penitenza' a Perugia." In *I Frati penitenti di San Francesco nella società del due e trecento. Atti del 2° Convegno di studi francescani, Rome 1976,* ed. M. d'Alatri, 325–45. Rome, 1977.

Casolini, F. "I Penitenti francescani in "Leggende" e Cronache del Trecento." In *I Frati penitenti di San Francesco nella società del due e trecento. Atti del 2° Convegno di studi francescani, Rome 1976,* ed. M. d'Alatri, 69–86. Rome, 1977.

Catalano, N. *Fiume del Terrestre Paradiso. . . .* Florence, 1652.

Cattaneo, G., and E. Baccheschi. *L'opera completa di Duccio.* Milan, 1972.

Cavalcaselle, G.-B., and J.-A. Crowe. *Storia della Pittura in Italia,* 11 vols., Florence, 1875–1908.

Christiansen, K. *Gentile da Fabriano.* London, 1982.

Collijn, I. *Acta et processus beate Birgitte.* Stockholm, 1931.

Collareta, M., and D. Devoti. *Arte aurea aretina: Tesori dalle chiese di Cortona.* Exhibition catalogue. Florence, 1987.

Contini, G., and M. Gozzoli. *L'opera completa di Simone Martini.* Milan, 1970.

Corsini, A. *Il costume del medico nelle pitture Fiorentine del Rinascimento.* Florence, 1912.

Corti, L. "Esercizio sulla mano destra: Gestualità e santi nel medioevo." *Annali della Scuola Normale Superiore di Pisa. Classe di lettere e filosofia,* 3d series, 26, forthcoming.

Corti, L., and R. Spinelli, eds. *Margherita da Cortona: Una storia emblematica di devozione narrata per testi e immagini.* Milan, 1998.

Cortona a Santa Margherita nel settimo centenario della "conversione" (1272–1972). Cortona, 1973.

Cristiani Testi, M. L. "The Frescoes at the Sacro Speco." In *The Benedictine Monastery of Subiaco,* ed. C. Giumelli, 95–202. Milan, 1982.

Crivelli, E. *Leggenda di S. Margherita di Cortona del P. G. Bevegnati.* Siena, 1897.

Dalarun, J. "*Lapsus linguae.*" *La Légende de Claire de Rimini.* S.I.S.M.E.L., Biblioteca di Medioevo Latino 6. Spoleto, 1994.

D'Alatri, M., ed. *I Frati penitenti di San Francesco nella società del due e trecento. Atti del 2° Convegno di studi francescani, Roma 1976.* Rome, 1977.

———, ed. *Il Movimento francescano della Penitenza nella società medioevale. Atti del 3° Convegno di studi francescani, Padova, 1979.* Rome, 1980.

———. "L'ordine della Penitenza nella Leggenda di Margherita da Cortona." *Prime manifestazioni di vita comunitaria, maschile e femminile, nel movimento francescano della Penitenza (1215–1447). Atti del 4° Convegno di studi francescani, Assisi 1981,* ed. R. Pazzelli and L. Temperini, 67–80. Rome, 1982.

Dal Pino. A. L. "Note iconografiche sul B. Giovacchino da Siena e la sua 'legenda.'" *Studi storici dell'Ordine dei Servi di Maria* 8 (1957–58), 156–61.

Dal Poggetto, P. *Ugolino di Vieri: Gli smalti di Orvieto.* Florence, 1965.

Da Pelago, L. *Antica leggenda della vita e dei miracoli di S. Margherita da Cortona,* 2 vols. Lucca, 1793.

Davies, M. *The Early Italian Schools Before 1400,* rev. D. Gordon. National Gallery Catalogues. London, 1988.

Davis, C., and J. Kliemann. "Lettera di Giorgio Vasari da Firenze a Angelo Niccolini a Siena." In *Giorgio Vasari.* Exhibition catalogue, Arezzo, 1981, ed. L. Corti and M. Daly Davis, 233–34. Florence, 1981.

De Francovich, G. "L'Origine e la diffusione del crocifisso gotico doloroso." *Römisches Jahrbuch für Kunstgeschichte* 2 (1938), 143–261.

Degenhart, B., and A. Schmitt. *Corpus der italienischen Zeichnungen 1300–1450,* i, i–iv. Berlin, 1968.

Della Cella, A. *Cortona antica.* Cortona, 1900.

Delumeau, J.-P. *Arezzo, espace et sociétés, 715–1230.* Rome, 1996.

Demus, O. *The Mosaics of Norman Sicily.* London, 1950.

Dendy, D. R. *The Use of Lights in Christian Worship.* London, 1959.

Derbes, A. *Picturing the Passion in Late Medieval Italy: Narrative Painting, Franciscan Ideologies, and the Levant.* Cambridge, 1996.

Ditchfield, S. "How Not to Be a Counter-Reformation Saint: The Attempted Canonization of Pope

Gregory." *Papers of the British School at Rome* 60 (1992), 379–422.

Dictionnaire de Spiritualité. Paris, 1937–95.

Dizionario biografico degli Italiani (in progress). Rome, 1960–.

Esser, C., ed. *Opuscula sancti Patris Francisci Assisiensis.* Bibliotheca franciscana ascetica medii aevi 12. Grottaferrata, 1978.

Faison, S., Jr. "Barna and Bartolo di Fredi." *Art Bulletin* 14 (1932), 285–315.

Fargnoli, N. "La Chiesa di San Salvatore nel Trecento." In *Lecceto e gli eremi agostiniani in terra di Siena,* 181–209. Milan, 1990.

Feldges-Henning, U. "The Pictorial Programme of the Sala della Pace: A New Interpretation." *Journal of the Warburg and Courtauld Institutes* 35 (1972), 145–62.

———. *Landschaft als topographisches Porträt.* Bern, 1980.

Francesco d'Assisi. Chiese e Conventi. Comitato regionale umbro per le celebrazioni dell'VIII centenario della nascita di San Francesco di Assisi. Exhibition catalogue, Narni, 1982. Milan, 1982.

Francesco d'Assisi. Storia e Arte. Comitato regionale umbro per le celebrazioni dell'VIII centenario della nascita di San Francesco di Assisi. Exhibition catalogue, Assisi, 1982. Milan, 1982.

Frescucci, B. "Attività sociale di S. Margherita." In *Cortona a Santa Margherita,* 51–59.

———. "L'eremo delle Celle." In *Le Celle di Cortona eremo francescano del 1211, aa.vv.,* 20–30. Cortona, 1977.

Freuler, G. "Lippo Memmi's New Testament Cycle in the Collegiata of San Gimignano." *Arte cristiana* 74 (1986), 93–102.

———. "Andrea di Bartolo, Fra Tommaso d'Antonio Caffarini, and Sienese Dominicans in Venice." *Art Bulletin* 69 (1987), 570–86.

———. *Bartolo di Fredi Cini.* Disentis, 1994.

Frey, K., and H.-W. Frey. *Der literarische Nachlass Giorgio Vasaris.* 2 vols., Munich, 1923, 1930.

Frinta, M. "Note on the Punched Decoration of Two Early Painted Panels at the Fogg Art Museum: *St. Dominic* and the *Crucifixion.*" *Art Bulletin* 53 (1971), 306–9.

Frugoni, C. "Le mistiche, le visioni e l'iconografia: rapporti ed influssi." In *Temi e problemi nella mistica femminile trecentesca. Convegni del Centro di studi sulla spiritualità medievale, 20, Todi, 1979,* 139–79. Todi, 1983.

———. *Francesco: un altra storia.* Genoa, 1988.

———. *Pietro and Ambrogio Lorenzetti.* Florence, 1988.

———. *A Distant City: Images of Urban Experience in the Medieval World.* Princeton, 1991.

———. *Francesco e l'invenzione delle stimmate.* Turin, 1993.

Galbreath, D. L. *Papal Heraldry.* 2d. ed., rev. G. Briggs. London, 1972.

Gallavotti Cavallero, D. "Pietro, Ambrogio e Simone, 1335, e una questione di affreschi perduti." *Prospettiva* 48 (1987), 69–74.

Galletti, A. I. "I francescani e il culto dei santi nell'Italia centrale." In *Francescanesimo e vita religiosa dei laici nel 200,* 353-59. Assisi, 1981.

Gardner, J. "Andrea di Bonaiuto and the Chapterhouse frescoes in Santa Maria Novella." *Art History* 2 (1979), 107–38.

———. "The Cult of a Fourteenth-Century Saint: The Iconography of Louis of Toulouse." In *I Francescani nel Trecento. Atti del XIV Convegno, Società internazionale di studi francescani, Assisi, 1986,* 167–93. Perugia, 1988.

———. "The Cappellone di San Nicola at Tolentino: Some Functions of a Fourteenth-Century Fresco Cycle." In *Italian Church Decoration of the Middle Ages and Early Renaissance: Functions, Forms, and Regional Traditions,* Villa Spelman Colloquia 1, ed. W. Tronzo, 101–17. Bologna, 1989.

———. *The Tomb and the Tiara: Curial Tomb Sculpture in Rome and Avignon in the Later Middle Ages.* Oxford, 1992.

Garms, J. "Gräber von Heiligen und Seligen." *Skulptur und Grabmal des spätmittelalters in Rom und Italien: Akten des Kongress, "Scultura e Monumento Sepolcrale del tardo medioevo a Roma e in Italia" (Rome 1985),* ed. J. Garms and A. M. Romanini, 83–105. Vienna, 1990.

Garrison, E. B. *Italian Romanesque Panel Painting: An Illustrated Index.* Florence, 1949.

Gatti, I. *La Tomba di S. Francesco nei secoli.* Assisi, 1983.

Ghiberti, L. *I Commentarii,* ed. J. von Schlosser. Berlin, 1912.

Gialluca, B. "La formazione del comune medioevale di Cortona." In *Cortona: Struttura e storia. Materiali per una conoscenza operante della città e del territorio, aa.vv.,* 239–73. Cortona, 1987.

Gianni, A. "Iconografia delle sante e beate umbre fra il XIII e gli inizi del XIV secolo." In *Sante e beate umbre tra il XIII e il XIV secolo. Mostra iconografica,* 91–139. Foligno, 1986.

Gieben, S. "L'iconografia dei penitenti e Niccolò IV", in *La 'Supra Montem' di Niccolò IV (1289): Genesi e diffusione di una regola. Atti del 5° Convegno di studi francescani, Ascoli Piceno, 1987,* ed. R. Pazzelli and L. Temperini, 289–304. Rome, 1988.

Giovagnoli, E. *Gubbio nella storia e nell'arte.* Città di Castello, 1932.

Goodich, M. *Vita Perfecta: The Ideal of Sainthood in the Thirteenth Century*, Monographien zur Geschichte des Mittelalters 25. Stuttgart, 1982.

Gordon, D. "Art in Umbria c. 1250–c. 1350." Ph.D. diss., University of London, 1979.

Gougaud, L. "Circumambulation." In *Dictionnaire de Spiritualité*.

Il gotico a Siena. Exhibition catalogue, Siena, 1982. Florence, 1982.

Grandi, R. *I monumenti dei dottori e la scultura a Bologna (1267–1348)*. Bologna, 1982.

Guerrieri, G. *Santa Margherita da Cortona nella pietà, nella letteratura e nell'arte*. Cortona, 1977.

Guerrini, A. "Intorno al polittico di Pietro Lorenzetti per la Pieve di Arezzo." *Rivista d'arte* 40 (1988), 3–29.

Giusti, M., and P. Guidi. *Rationes decimarum Italiae nei secoli XIII e XIV: Tuscia*, II, Studi e testi, Biblioteca Apostolica Vaticana 98. Vatican City, 1942.

Guillaume, M. *Catalogue raisonné du Musée des Beaux-Arts de Dijon: Peintures italiennes*, Dijon, 1980.

Guillemain, B. *La Cour pontificale d'Avignon (1309–1376)*. Bibliothèque de l'Ecole française d'Athènes et de Rome 201. Paris, 1962.

Guillou, A. *Recueil des inscriptions grecques médiévales d'Italie*. Rome, 1996.

Hager, H. *Die Anfänge des italienischen Altarbildes*. Römische Forschungen der Bibliotheca Hertziana 17. Munich, 1962.

Hamburger, J. "The Visual and the Visionary: the Image in Late Medieval Monastic Devotions." *Viator* 20 (1989), 161–82.

———. *The Rothschild Canticles: Art and Mysticism in Flanders and the Rhineland circa 1300*. New Haven, 1990.

Harding, C. "Economic Dimensions in Art: Mosaics versus Wall Painting in Trecento Orvieto." In *Florence and Italy: Renaissance Studies in Honour of Nicolai Rubinstein*, ed. P. Denley and C. Elam, 503–14. London, 1988.

Hargreaves-Mawdsley, W. N. *A History of Academical Dress in Europe Until the End of the Eighteenth Century*. Oxford, 1963.

Herklotz, I. *"Sepulcra" e "Monumenta" del Medioevo. Studi sull'arte sepolcrale in Italia*. Rome, 1985.

Hoch, A. S. "*Beata Stirps*, Royal Patronage and the Identification of the Sainted Rulers in the St. Elizabeth Chapel in Assisi." *Art History* 15 (1992), 279–95.

Hood, W. "Saint Dominic's Manners of Praying: Gestures in Fra Angelico's Cell Frescoes at S. Marco." *Art Bulletin* 68 (1986), 195–206.

Housely, N. *The Italian Crusades*. Oxford, 1982.

———. *The Avignon Papacy and the Crusades, 1305–1378*. Oxford, 1986.

Hueck, I. "Le matricole dei pittori fiorentini prima e dopo il 1320." *Bolletino d'arte* 57 (1972). 114–21.

———. "Die Kapellen der Basilika San Francesco in Assisi: die Auftraggeber und die Franziskaner." In *Patronage and Public in the Trecento: Proceedings of the St. Lambrecht Symposium, Abtei St. Lambrecht, Styria, 16–19 July, 1984*, ed. V. Moleta, 81–104. Florence, 1986.

Inga, G. "Gli insediamenti mendicanti a Cortona." *Storia della città* 9 (1978), 42–52.

Ini, A. M. "Nuovi documenti sugli spirituali in Toscana." *Archivum Franciscanum Historicum* 66 (1973), 305–77.

Iozzelli, F. "I Francescani ad Arezzo e a Cortona nel Duecento." In *Quaderni di vita e di cultura francescana*, 121–42. Florence, 1991.

———. "I miracoli nella "legenda" di Santa Margherita da Cortona." *Archivum Franciscanum Historicum* 86 (1993), 217–76.

———, ed. *Iunctae Bevegnatis. Legenda de Vita et Miraculis Beatae Margaritae de Cortona*, Biblioteca franciscana ascetica medii aevi 13. Grottaferrata, 1997.

Kaftal, G. *Iconography of the Saints in Tuscan Painting*. Florence, 1952.

———. *Iconography of the Saints in Central and South Italian Schools of Painting*. Florence, 1965.

Kallab, W. *Vasaristudien*. Vienna and Leipzig, 1908.

Kemp, M. *The Science of Art*. New York and London, 1990.

Kent, D. "The Buonomini di San Martino: Charity for the Glory of God, the Honour of the City, and the Commemoration of Myself." In *Cosimo "il Vecchio" de' Medici 1389–1464*, ed. F. Ames-Lewis, 49–67. Oxford, 1992.

Köhren-Jansen, H. *Giottos Navicella: Bildtradition. Deutung. Rezeptionsgeschichte*. Worms, 1993.

Körte, W. "Die früheste Wiederholung nach Giottos Navicella (in Jung-St-Peter in Straßburg)." *Oberrheinische Kunst* 10 (1942), 97–104.

Kosegarten, A. "Einige sienesische Darstellungen der Muttergottes aus dem frühen Trecento." *Jahrbuch der Berliner Museen* n.s. 8 (1966), 96–118.

Kretzenbacher, L. "Die Ketten um die Leonhardskirchen im Ostalpenraume. Kulturhistorische Beiträge zur Frage der Gürtung von Kult-objekten in der religiösen Volkskultur Europas." In *Kultur und Volk: Festschrift für Gustav Gugitz*, ed. L. Schmidt, 163–202. Vienna, 1954.

Kreytenberg, G. "Zum gotischen Grabmal des heiligen Bartolus von Tino di Camaino in der Augustinerkirche von San Gimignano." *Pantheon* 46 (1988), 13–25.

———. "Drei gotische Grabmonumente von Heiligen in Volterra." *Mitteilungen des Kunsthistorischen Institutes in Florenz* 34 (1990), 69–100.

Kriss-Rettenbeck, L. *Ex Voto*. Zurich, 1972.

Krönig, W. "Caratteri dell'architettura degli Ordini Mendicanti in Umbria." In *Storia e Arte nell'età communale. Atti del sesto convegno di studi umbri*, I, 165–98. Perugia, 1971.

Krüger, K. *Der frühe Bildkult des Franziskus in Italien*. Berlin, 1992.

Laclotte, M. "Peintre Siennois de l'entourage des frères Lorenzetti vers 1345–50." In *L'art gothique Siennois*, 120–23.

———. "Quelques tableautins de Pietro Lorenzetti." In *"Il se rendit en Italie." Etudes offertes à André Chastel*, 29–38. Rome, 1987.

Laparelli, A. *Memorie cortonesi dal 1642 al 1670*, Accademia Etrusca, Cortona, Fonti e Testi 1, ed. N. Fruscoloni. Cortona, 1982.

Lauro, G. *Dell'Origine della Città di Cortona in Toscana e sue Antichità*. Rome, 1639. Reprinted in the series Historiae Urbium et Regionum Italiae Rariores, n.s. 79. Sala Bolognese, 1981.

Leone de Castris, P. *Arte di corte nella Napoli angioina*. Florence, 1986.

Levi-Pisetsky, R. *Storia del costume in Italia*, II. Milan, 1967.

Luchs, A. "Ambrogio Lorenzetti at Montesiepi." *Burlington Magazine* 119 (1977), 187–88.

Ludovico da Pietralunga. *Descrizione della Basilica di S. Francesco e di altri santuari di Assisi*, ed. P. Scarpellini. Treviso, 1982.

Maetzke, A. M., ed. *Arte nell'Aretino, seconda mostra di restauri dal 1975 al 1979*. Exhibition catalogue, Arezzo, 1979. Florence, 1979.

———, ed. *Il Museo diocesano Cortona*. Florence, 1992.

Maginnis, H. B. J. "Cast Shadow in the Passion Cycle at San Francesco, Assissi: A Note." *Gazette des Beaux-Arts* 77 (1971), 63–64.

———. "Assisi Revisited: Notes on Recent Observations." *Burlington Magazine* 117 (1975), 511–17.

———. "The Literature of Sienese Trecento Painting, 1945–1975." *Zeitschrift für Kunstgeschichte* 40 (1977), 276–309.

———. "Pietro Lorenzetti: A Chronology." *Art Bulletin* 66 (1984), 183–211.

———. "The Lost Façade Frescoes from Siena's Ospedale di S. Maria della Scala." *Zeitschrift für Kunstgeschichte* 51 (1988), 180–94.

———. "Chiaramenti documentari: Simone Martini, i Memmi e Ambrogio Lorenzetti." *Rivista d'arte* 41 (1989), 3–23.

Magrini, E. "Margherita in ambiente francescano." In *Cortona a Santa Margherita*, 77–85.

Mancini, G., ed. *Cronache cortonesi di Boncìtolo e d'altri cronisti*. Cortona, 1896.

———. *Cortona nel Medio Evo*. Florence, 1897.

———. *Vita di Luca Signorelli*. Florence, 1903.

Marcucci, L. *I dipinti toscani del secolo XIV. Gallerie Nazionali di Firenze*. Rome, 1965.

Mariani, E., trans. *Leggenda della vita e dei miracoli di Santa Margherita da Cortona*, by Fra Giunta Bevegnati. Vicenza, 1978.

Mariano da Firenze. *Il Trattato del Terz'Ordine o vero 'Libro come Santo Francesco istituì et ordinò el Tertio Ordine de Frati et Sore di Penitentia e della dignità et perfectione o vero Sanctità sua'*, ed., with introduction, by M. D. Papi. Rome 1985. (Extract from *Analecta Tertii Ordinis Regularis Sancti Francisci* 18 (1985).)

Martindale, A. *Simone Martini: Complete Edition*. Oxford, 1988.

Matanić, A. "I Penitenti francescani dal 1221 (Memoriale) al 1289 (Regola bollata) principalmente attraverso i loro statuti e le regole." In *L'Ordine della Penitenza di San Francesco d'Assisi nel secolo XIII: Atti del Convegno di studi francescani, Assisi 1972*, ed. O. Schmucki, 41–63. Rome, 1973.

Meersseman, G. G. "Les confréries de Saint-Dominique." *Archivum Fratrum Praedicatorum* 20 (1950), 5–113.

———. "Nota sull'origine delle compagnie dei Laudesi, (Siena 1267)." *Rivista di storia della chiesa in Italia* 17 (1963), 395–405.

———. *Ordo Fraternitatis: Confraternite e pietà dei laici nel Medioevo*, Italia sacra, 24–26. Rome, 1977.

———. *Dossier de l'Ordre de la pénitence au XIIIe siècle*. Fribourg, 1961; 2d ed. Fribourg, 1982.

Meier, H.-R. "Santa Chiara in Assisi. Architektur und Funktion im Schatten von San Francesco." *Arte medievale* 2d ser., 4, ii (1990), 151–78.

Meiss, M. "Nuovi dipinti e vecchi problemi." *Rivista d'arte* 30 (1955), 107–45.

———, " "Highlands" in the Lowlands: Jan Van Eyck, the Master of Flemalle and the Franco-Italian Tradition." *Gazette des Beaux-Arts* 57 (1961), 273–314.

Mencherini, S. "Le Clarisse in Cortona. Documenti inediti del sec.XIII." *La Verna* 10 (1912–13), 330ff.

Menestò, E. "La mistica di Margherita di Cortona." In *Temi e problemi nella mistica femminile trecentesca. Convegni del Centro di studi sulla spiritualità medievale, 20, Todi, 1979*, 181–206. Todi, 1983.

Meoni, N. "Visite pastorali a Cortona nel Trecento." *Archivio storico italiano* 129 (1971), 181–256.

Mezzetti, A. "Il sarcofago di Santa Margherita nell'omonima Chiesa cortonese." *Annuario dell'Accademia Etrusca di Cortona* n.s. 11 (1979), 355–68.

Micheli, M. E. "Aneddoti sul sarcofago del Museo Diocesano di Cortona." *Xenia* 5 (1983), 93–96.

Middeldorf Kosegarten, A. *Sienesische Bildhauer am Duomo Vecchio. Studien zur Skulptur in Siena 1250–1330.* Italienische Forschungen herausgegeben vom Kunsthistorischen Institut in Florenz, 3d ser., 13. Munich, 1984.

Milanesi, G. *Documenti per la storia dell'arte senese,* 3 vols. Siena, 1854.

———, ed. *Le Vite de' più eccellenti Pittori Scultori ed Architettori scritte da Giorgio Vasari . . . ,* 9 vols. Florence, 1878–85.

Miller, W. B. "The Franciscan Legend in Italian Paintings in the Thirteenth Century." Ph.D. diss., Columbia University, 1961.

Minto, A. "Il sarcofago romano del Duomo di Cortona." *Rivista d'arte* 26 (1950), 1–22.

Mirri, D. *Cronaca dei lavori edilizi della nuova chiesa di S. Margherita in Cortona,* rev. E. Mori. Cortona, 1989.

Montenovesi, O. "I Fioretti di Santa Margherita da Cortona." *Miscellanea francescana* 46 (1946), 234–93.

Moorman, J. *A History of the Franciscan Order.* Oxford, 1968.

Mori, E., and P. Mori. *Guida storico artistica al Museo diocesano di Cortona.* Cortona, 1995.

———. *Guida storico artistica al Santuario di Santa Margherita in Cortona,* Cortona, 1996

Moriondo, M. "Le Opere d'arte dell'epoca Medioevale e Moderna nel Museo dell'Accademia Etrusca di Cortona." *Nuovo Annuario dell'Accademia Etrusca di Cortona* n.s. 2 (1953), 35–48.

Mosco, M. *La Maddalena tra sacro e profano.* Exhibition catalogue. Florence, 1986.

Moskowitz, A. F. *The Sculpture of Andrea and Nino Pisano.* Cambridge, 1986.

Nessi, S. "Un raro cimelio nel monastero di S. Chiara a Montefalco." *Commentari* 14 (1963), 3–7.

———. "Primi appunti sull'iconografia clariana dei secoli XIV e XV." In *La Spiritualità di S. Chiara da Montefalco: Atti del primo Convegno di studio, Centro di spiritualità agostiniana e clariana, Montefalco, 1985,* ed. S. Nessi, 313–40. Montefalco, 1986.

Newton, S. M. *Fashion in the Age of the Black Prince.* Bury St. Edmunds, 1980.

Nightlinger, E. B. "The Iconography of Saint Margaret of Cortona." Ph.D. diss., George Washington University, 1982.

Norman, D. "The Commission for the Frescoes of Montesiepi." *Zeitschrift für Kunstgeschichte* 56 (1993), 289–300.

Nyberg, T. *Birgittinische Klostergründungen des Mittelalters.* Lund, 1965.

———. "Brigidini-Brigidine." In *Dizionario degli Istituti di Perfezione,* ed. G. Pelliccia and G. Rocca, I, cols. 1578–93. Rome, 1974.

Odoardi, G. "Guido da Cortona, beato." *Bibliotheca Sanctorum,* VII, cols. 505–8. Rome, 1966.

Offner, R. *A Critical and Historical Corpus of Florentine Painting,* IV, i. New York, 1962.

———. *A Critical and Historical Corpus of Florentine Painting,* III, iii, 2d ed., rev. M. Boskovits and E. Neri Lusanna. Florence, 1989.

Offner, R., and K. Steinweg. *A Critical and Historial Corpus of Florentine Painting,* IV, iii. New York, 1965.

———. *A Critical and Historical Corpus of Florentine Painting,* IV, vi. New York, 1979.

Oliger, L. "Documenta inedita ad historiam fraticellorum spectantia." *Archivum Franciscanum Historicum* 6 (1913), 721–30.

Osborne, J. "Lost Roman Images of Urban V (1362–1370)." *Zeitschrift für Kunstgeschichte* 57 (1991), 20–32.

Pacini, P. "Per Adriano Zabarelli detto 'Il Paladino,' copista e divulgatore di Pietro da Cortona." *Antichità viva* 35, iv (1996), 28–49.

Padoa Rizzo, A. *Benozzo Gozzoli pittore fiorentino.* Florence, 1972.

Paeseler, W. "Giottos Navicella und ihr spätantikes Vorbild." *Römisches Jahrbuch für Kunstgeschichte* 5 (1941), 49–162.

Pagnotti, S. *Margherita, 1247–1297.* Turin, 1993.

Pasztor, E. "Pietà e devozione popolare nel processo di canonizzazione di S. Nicola da Tolentino." In *San Nicola, Tolentino, le Marche: Contributi e ricerche sul processo (a.1325) per la canonizzazione di San Nicola da Tolentino. Convegno internazionale di studi, Tolentino 4–7 Sett. 1985,* 219-41. Tolentino, 1987.

Pazzelli, R., ed. *Il B. Tomasuccio da Foligno terziario francescano ed i movimenti religiosi popolari umbri nel Trecento.* Rome, 1979.

Pazzelli, R., and L. Temperini, eds. *La "Supra montem" di Niccolò IV (1289). Genesi e diffusione di una regola. Atti del 5° Convegno di studi francescani, Ascoli Piceno, 1987.* Rome, 1988.

Péter, A. "Pietro és Ambrogio Lorenzetti egy elpusztult freskó-ciklusa." *Országos Magyar Szépmüvészeti Múzeum Evkönyvei* 6 (1930), 52–81, 256–60 (with German summary).

———. "Giotto and Ambrogio Lorenzetti." *Burlington Magazine* 76 (1940), 3–8.

Petrocchi, G. "Correnti e linee della spiritualità umbra ed italiana nel Duecento." In *Atti del IV Convegno di studi umbri (Gubbio 1966),* 133–76. Perugia, 1967.

Poeschke, J. *Die Kirche San Francesco in Assisi und ihre Wandmalereien.* Munich, 1985.

Pompei, A. M. "Concetto e pratica della penitenza in Margherita da Cortona e Angela da Foligno." In La "Supra montem" di Niccolò IV (1289). Genesi e diffusione di una regola. Atti del 5° Convegno di studi francescani, Ascoli Piceno, 1987, ed. R. Pazzelli and L. Temperini, 381–423. Rome, 1988.

Pope-Hennessy, J., and L. B. Kanter. The Robert Lehman Collection. Vol. 1: Italian paintings. The Metropolitan Museum of Art, New York, 1987.

Poulenc, J. "Saint François dans le "vitrail des anges" de l'église supérieure de la basilique d'Assise." Archivum Franciscanum Historicum 76 (1983), 701–13.

Previtali, G. Giotto e la sua bottega. Milan, 1967.

———. "Alcune opere 'fuori constesto': il caso di Marco Romano." In Studi sulla scultura gotica in Italia, 115–36. Turin, 1991.

Ragusa, I., and R. Green, trans. and ed. Meditations on the Life of Christ. Princeton, 1961.

Razzi, S. Vite de' Santi e Beati Toscani. . . . Florence, 1593–1601.

Richards, L. "The Cult of San Ranieri and Its Importance in Pisa from the Twelfth to the Fourteenth Centuries: The Evidence of Text and Image." M.A. thesis, Courtauld Institute of Art, University of London, 1991.

Riess, J. Political Ideals in Medieval Italian Art: The Frescoes in the Palazzo dei Priori, Perugia. Ann Arbor, 1981.

Rigaux, D. "The Franciscan Tertiaries at the Convent of Sant'Anna at Foligno." Gesta 31 (1992), 92–98.

Rock, D. The Church of our Fathers as Seen in St. Osmund's Rite for the Cathedral of Salisbury, new ed. G. W. Hart and W. H. Frere, 4 vols. London, 1905.

Romano, S. Eclissi di Roma: Pittura murale a Roma e nel Lazio da Bonifacio VIII a Martino V (1295–1431). Rome, 1992.

Ronan, H. A. "The Tuscan Wall Tomb, 1250–1400." Ph.D diss., Indiana University, 1982.

Rotelli, E. "La politica crociata dei papi del primo Trecento e il disimpegno delle città toscane visti attraverso i registri pontifici." In Toscana e Terrasanta nel Medioevo, ed. F. Cardini, 75–85. Florence, 1982.

Rowley, G. Ambrogio Lorenzetti. 2 vols. Princeton, 1958.

Rubin, P. Giorgio Vasari: Art and History. London, 1995.

Ruf, G. Franziskus und Bonaventura, Die heilsgeschichtliche Deutung der Fresken im Langhaus der Oberkirche von San Francesco in Assisi aus der Theologie des Heiligen Bonaventura. Assisi, 1974.

Rusconi, R. "Margherita da Cortona, Peccatrice redenta e patrona cittadina." In Umbria sacra e civile, E. Menestò and R. Rusconi, 89–104. Turin, 1989. (Subsequently republished as Umbria. La strada delle sante medievali, 56–73, 200–201. Rome, 1991.)

Russo, D. "Jeanne de Signa ou l'iconographie au féminin, étude sur les fresques de l'église paroissiale de Signa." Mélanges de l'Ecole française de Rome, Moyen Age-Temps Modernes 98 (1986), 201–18.

Saintyves, P. Essais de Folklore biblique. Paris, 1922.

———. "Le tour et la ceinture de l'église." Revue archéologique, 5th ser. 15 (1922), 79–113.

Salimbene de Adam. Cronica, ed. G. Scalia. 2 vols. Bari, 1966.

Salmi, M. "Postille alla Mostra di Arezzo." Commentari 2 (1951), 93–97, 169–95.

Sansedoni, G. Vita del Beato Ambrogio Sansedoni da Siena. Rome, 1611.

Sante e beate umbre tra il XIII e il XIV secolo. Mostra iconografica. Exhibition catalogue. Foligno, 1986.

Santuario di Santa Margherita, Cortona. Breve guida illustrata a cura dei Padri Minori del Santuario. Cortona, n.d.

Scarpellini, P. "Iconografia francescana nei secoli XIII e XIV." In Francesco d'Assisi, Storia e Arte, Comitato regionale umbro per le celebrazioni dell'VIII centenario della nascita di San Francesco di Assisi. Exhibition catalogue, Assisi, 1982, 91–106. Milan, 1982.

Schmitt, C. "La position du Tiers-Ordre dans le conflit des Spirituels et de Fraticelles en Italie." In I Frati penitenti di San Francesco nella società del due e trecento. Atti del 2° Convegno di studi francescani. Rome 1976, ed. M. d'Alatri, 179–90. Rome, 1977.

Schönau, D.-W. "A new hypothesis on the Vele in the Lower Church of San Francesco, Assisi." Franziskanische Studien 3/4 (1985), 326–47.

Seidel, M. "Studien zu Giovanni di Balduccio und Tino di Camaino." Städel Jahrbuch n.s. 5 (1975), 37–84.

———. "Wiedergefundene Fragmente eines Hauptwerks von Ambrogio Lorenzetti." Pantheon 36 (1978), 119–51.

———. "Gli affreschi di Ambrogio Lorenzetti nel chiostro di San Francesco: ricostruzione e datazione." Prospettiva 18 (1979), 10–20.

———. "Das Frühwerk von Pietro Lorenzetti." Städel Jahrbuch, n.s. 8 (1981), 79–158.

———. "Ikonographie und Historiographie." Städel Jahrbuch, n.s. 10 (1985), 77–142.

———. "Condizionamento iconografico e scelta semantica: Simone Martini e la tavola del Beato Agostino Novello." In Simone Martini: Atti del convegno (Siena, 1985), ed. L. Bellosi, 75–80. Florence, 1988.

———. "Das Grabmal der Kaiserin Margarethe von Giovanni Pisano." In *Skulptur und Grabmal des spätmittelalters in Rom und Italien: Akten des Kongress, "Scultura e Monumento Sepolcrale del tardo medioevo a Roma e in Italia (Rome 1985)*, ed. J. Garms and A. M. Romanini, 275–316. Vienna, 1990.

Sernini Cucciatti, G. G. *Quadri in chiese e luoghi pii di Cortona alla metà del settecento*. Accademia Etrusca, Cortona, Fonti e testi 2, ed. P.J. Cardile. Cortona, 1982.

Silva, R. "Una cintura trecentesca di argento dorato con smalti." *Arte medievale*, 2d series, 5, ii (1991), 149–55.

Simon, R. "Towards a Relative Chronology of the Frescoes in the Lower Church of S. Francesco at Assisi." *Burlington Magazine* 118 (1976), 361–66.

Simone Martini e "chompagni." Exhibition catalogue, Siena, 1985. Florence, 1985.

Skaug, E. S. *Punch Marks from Giotto to Fra Angelico. Attribution, Chronology, and Workshop Relationships in Tuscan Panel Painting, c. 1330–1430*, 2 vols. Oslo. 1994.

Spufford, P. *Handbook of Medieval Exchange*. London, 1986.

Stein, J. "Dating the Bardi St. Francis Master Dossal: Text and Image." *Franciscan Studies* 36 (1976), 271–97.

Strehlke, C. B. "Giovanni di Paolo: The Saint Catherine of Siena Series." In *Painting in Renaissance Siena, 1420–1500*, ed. K. Christiansen, L. B. Kanter, and C. B. Strehlke, 218–39. New York, 1988.

Stubblebine, J. H. *Guido da Siena* Princeton, 1964.

Tafi, A. *Immagine di Cortona*. Cortona, 1989.

Tanfani Centofanti, L. *Notizie di artisti tratte dai documenti pisani*. Pisa, 1897.

Tantillo Mignosi, A. "Osservazioni sul transetto della Basilica inferiore di Assisi." *Bolletino d'arte* 60 (1975), 129–42.

Tartaglini, Domenico. *Nuova Descrizione dell'antichissima città di Cortona*. Perugia, 1700. Reprinted in the series Historiae Urbium et Regionum Italiae Rariores, n.s. 86. Sala Bolognese, 1986.

Terni, C., ed. *Laudario di Cortona. Temi musicali e poetici contenuti nel cod.91 della Biblioteca comunale di Cortona*. Spoleto, 1992.

Thieme, U., and F. Becker. *Allgemeines Lexikon der bildenden Künstler*. Leipzig, 1907–50.

Tintori, L., and E. Borsook. *Giotto: The Peruzzi Chapel*. New York, 1965.

Toesca, P. *Il Trecento*. Storia dell'Arte italiana 2. Turin, 1951.

Van Os, H. W. *Vecchietta and the Sacristy of the Siena Hospital Church*. The Hague, 1974.

———. "Due divagazioni intorno alla pala di Simone Martini per il Beato Agostino Novello." In *Simone Martini: Atti del convegno (Siena, 1985)*, ed. L. Bellosi, 81–86. Florence, 1988.

———. *Sienese Altarpieces, 1215–1460*, ii. Groningen, 1990.

Varanini, G., L. Banfi, and A. Ceruti Burgio. *Laude cortonesi dal secolo XIII al XV*. 4 vols. Florence, 1981–85.

Vasari, Giorgio. *Le Vite de' più eccellenti Pittori, Scultori e Architettori*, ed. R. Bettarini and P. Barocchi, 6 vols. Florence, 1966–87.

Vauchez, A. "La commune de Sienne, les Ordres Mendiants et le culte des saints. Histoire et enseignements d'une crise (novembre 1328–avril 1329)." *Mélanges de l'Ecole française de Rome, Moyen Age-Temps Modernes* 89 (1977), 757–67.

———. *La sainteté en Occident aux derniers siècles du Moyen Age*. Bibliothèques des Écoles françaises d'Athènes et de Rome, 241. Rome, 1981/88.

———. "Pénitents au Moyen Age." In *Dictionnaire de Spiritualité*, XII, cols. 1010–1023. Paris, 1984.

———. "Patronages des saints et religion civique dans l'Italie communale à la fin du Moyen Age." In *Patronage and Public in the Trecento: Proceedings of the St. Lambrecht Symposium, Abtei St. Lambrecht, Styria, 16–19 July 1984*, ed. V. Moleta, 59–80. Florence, 1986. Translated in Vauchez, 1993, 153–68.

———. *Les laïcs au Moyen Age. Pratiques et expériences religieuses*. Paris, 1987.

———. *Ordini Mendicanti e società italiana, XIII–XV secolo*. Milan, 1990.

———. *The Laity in the Middle Ages: Religious Beliefs and Devotional Practices*, trans. M. J. Schneider, ed. and introduced by D. Bornstein, Notre Dame, Ind., 1993.

———. *Sainthood in the Later Middle Ages*, trans. J. Birrell. Cambridge, 1997.

Venturi, L. "La "Navicella" di Giotto." *L'Arte* 25 (1922), 49–69.

Vigni, G. *Lorenzo di Pietro detto il Vecchietta*. Florence, 1937.

Villani, Giovanni. *Nuova Cronica*, ed. G. Porta. 3 vols. Parma, 1990.

Volbach, W. F. *Catalogo della Pinacoteca Vaticana, vol. 2, Il Trecento: Firenze e Siena*. Vatican City, 1987.

Volpe, C. *Pietro Lorenzetti*, ed. M. Lucco. Milan, 1989.

Waetzoldt, S. *Die Kopien des 17. Jahrhunderts nach Mosaiken und Wandmalereien in Rom*, Römische Forschungen der Bibliotheca Hertziana 18. Vienna, 1964.

Weinstein, D., and R. M. Bell. *Saints and Society: The Two Worlds of Western Christendom, 1000–1700*, Chicago, 1982.

Wilk, B. *Die Darstellung der Kreuztragung Christi und verwandter Szenen bis um 1300*, Ph.D. diss., Tübingen, 1969.

Willemsen, C. *Kardinal Napoleon Orsini, 1263–1342.* Berlin, 1927.

Williams, R. "Notes by Vincenzo Borghini on Works of Art in San Gimignano and Volterra: A Source for Vasari's 'Lives.' " *Burlington Magazine* 127 (1985), 17–21.

Wolters, W. *La Scultura veneziana gotica (1300–1460).* 2 vols. Venice, 1976.

Wood, J. "Perceptions of Holiness in Thirteenth-Century Italian Painting: Clare of Assisi." *Art History* 14 (1991), 301–28.

Zeri, F. *Diari di Lavoro*, I. Bergamo, 1971.

Zocca, E. *Assisi*, Catalogo delle cose d'Arte e di Antichità d'Italia 8. Rome, 1936.

A Bibliographical Note on Margherita of Cortona

For further bibliography on Margherita of Cortona, much of it of a devotional nature, the reader could consult the following (in date order):

Mancini, G. "Note bibliografiche sugli scritti relativi a S. Margherita da Cortona." *Miscellanea francescana* 4 (1889), 135–40.

Bibliographia francescana 11 (1964–65), 1191.

Mennini, S. "Bibliografia sopra S. Margherita." In *Cortona a S. Margherita nel VII cenetenario della «conversione» (1272–1972)*, 105–114. Cortona, 1973. (Revised and updated version of notes made by Mancini in 1912.)

Jacobelli, M. C. *Una Donna senza volto. Lineamenti antropologico culturali della santità di Margherita da Cortona*, 205–213. Rome, 1992.

Photo Credits

COLOR PLATES

Author: I, III, V–VII, IX, XI, XIV, XVI–XXVI; Cortona, Fotomaster di G. Poccetti: II, IV, VIII; New York, Scala/Art Resource: X, XV; Siena, Lensini: XII, XIII.

BLACK-AND-WHITE PHOTOGRAPHS

Ann Arbor, University of Michigan Museum of Art: 140; Arezzo, Soprintendenza per i beni ambientali, architettonici, artistici e storici: 3, 5, 6, 15, 44, 56, 59, 60, 66, 70, 71, 83, 84, 89–91, 93, 94, 99, 101, 102, 146, 155, 156, 160, 166, 182, 183, 186, 190; Assisi, Archivio Fotografico Sacro Convento: 86, 111–13, 117, 121, 127, 133, 148; Berlin, Staatliche Museen, Preußischer Kulturbesitz, Gemäldegalerie, Photo: Jörg P. Anders: 116, 129; Cortona, Celestino Bruschetti: 10; Cortona, Lamentini: 7, 8; Dijon, Musée des Beaux-Arts: 79; Florence, Biblioteca Medicea Laurenziana (with permission of the Ministero per i Beni Culturali e Ambientali): 197; Florence, Brogi/Fratelli Alinari: 11, 57, 149, 161, 164, 167, 169, 184, 188; Florence, Fratelli Alinari: 12, 32, 58, 76, 77, 157, 159; Florence, Kunsthistorisches Institut: 28, 74, 85, 105, 120, 178; Florence, Kunsthistorisches Institut/Artini: 82; Florence, Soprintendenza per i beni artistici e storici: 100, 108, 125, 131, 143–45, 147, 150, 151, 154, 158, 163; London, Author/Courtauld Institute of Art, Conway Library: 1, 2, 9, 13, 14, 17–23, 27, 30, 31, 33–43, 45–54, 62–65, 67, 68, 72, 73, 78, 87, 92, 95, 97, 98, 103, 104, 106, 107, 115, 118, 122, 126, 128, 130, 134, 137, 162, 165, 168, 170–73, 175, 176, 179, 185, 187, 189, 191–96, 198, 200, 201; London, Dillian Gordon: 180; London, National Gallery: 181; Munich, Zentralinstitut für Kunstgeschichte: 25, 26; New York, Metropolitan Museum of Art: 136; Oslo, Universitetets Oldsaksamling: 4; Padua, Musei Civici–Cappella degli Scrovegni: 114, 132; Rome, Istituto centrale per il Catalogo e la Documentazione: 29, 75; Rome, Istituto centrale per il Restauro, Archivio fotografico; 153; Siena, Fotografia Lensini: 88, 109; Siena, Soprintendenza per i beni artistici e storici (with permission of the Ministero per i Beni Culturali e Ambientali): 24, 55, 69, 80, 81, 96, 110, 119, 123, 124, 138, 139, 141, 142, 174; Vatican City, Archivio Segreto Vaticano: 61, 119; Vatican City, Musei Vaticani, Archivio fotografico: 135.

Index

Illustrations

Fig. 1. Cortona, Archivio del Convento di S. Margherita, cod. 61, declaration of authenticity appended to the list of contents at the start of the text of Margherita's *Legenda*.

Fig. 2. Cortona, Archivio del Convento di S. Margherita, cod. 61, declaration of authenticity appended to the list of contents at the start of the text of Margherita's *Legenda*, detail showing addition of Ser Badia's name to the list of witnesses.

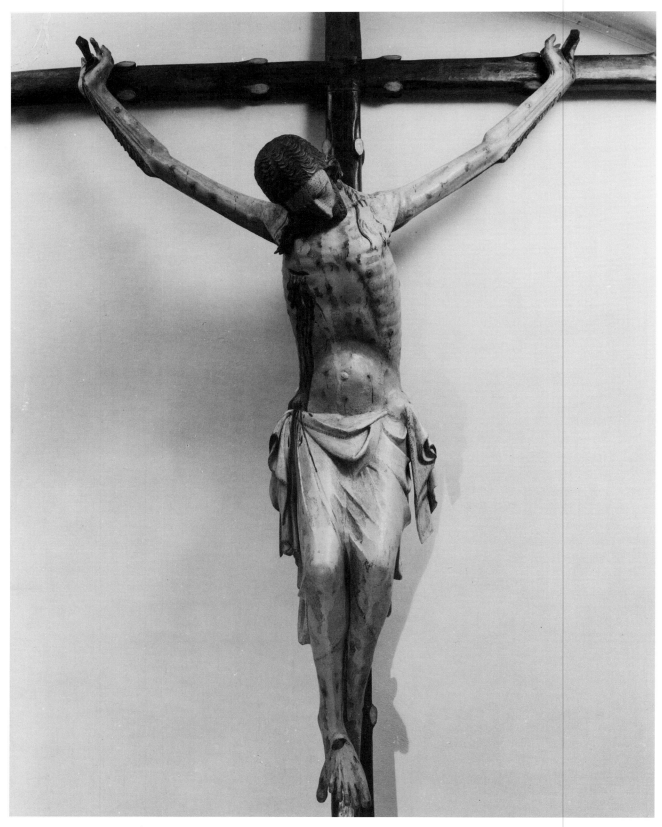

Fig. 3. Cortona, S. Margherita, Crucifix, wood and polychrome, after restoration (dimensions of cross: 259 x 175 cm; dimensions of *corpus*: 147 x 117 cm) transferred from S. Francesco, Cortona, in 1602, attributed to an itinerant sculptor (Spanish or Scandinavian?), late thirteenth century.

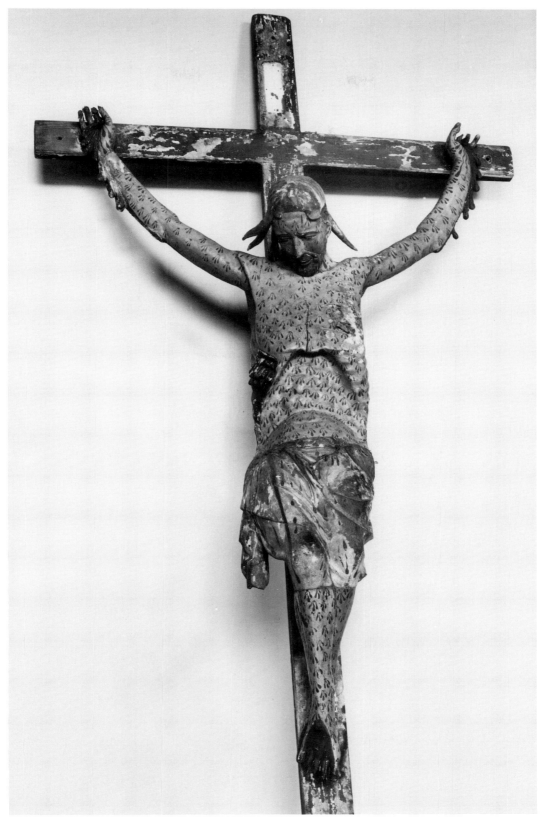

Fig. 4. Oslo, Universitetets Oldsaksamling, Crucifix, wood and polychrome (dimensions of cross: 265 x 133 cm; dimensions of *corpus*: 220 x 123 cm), from Tretten, Crucifix no. I, Scandinavian, late thirteenth century (?).

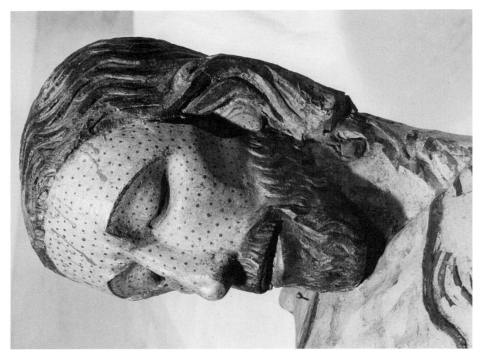

Fig. 5. Cortona, S. Margherita, Crucifix, wood and polychrome, after restoration, detail of Christ's head.

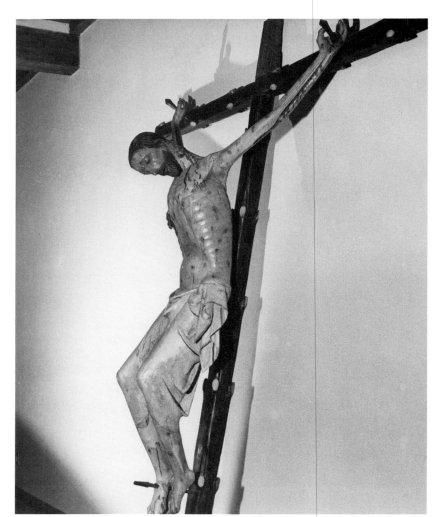

Fig. 6. Cortona, S. Margherita, Crucifix, wood and polychrome, after restoration.

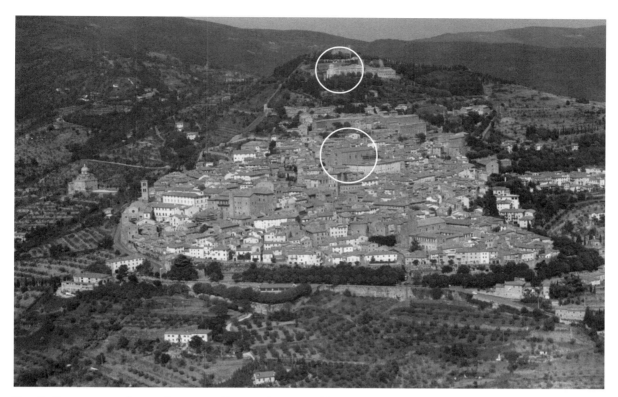

Fig. 7. Cortona, aerial view from west (S. Margherita visible, just below *Rocca* [fortress], above the town; S. Francesco at center of town).

Fig. 8. Cortona, S. Margherita, aerial view of church and convent (*Rocca* just visible at top of photograph).

Fig. 9. Cortona, Biblioteca dell'Accademia Etrusca, watercolor of the facade and south nave wall of S. Margherita, Enrico Presenti, 1856.

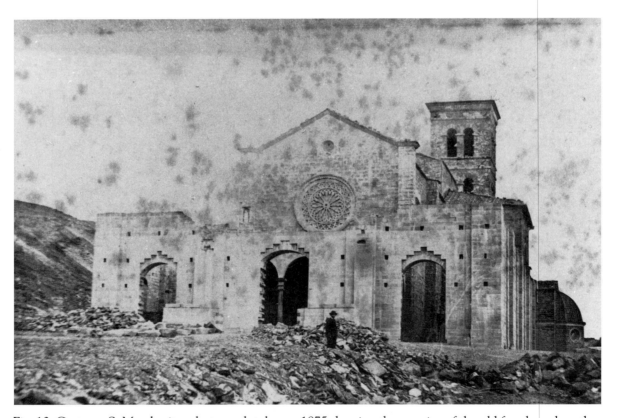

Fig. 10. Cortona, S. Margherita, photograph taken c. 1875 showing the remains of the old facade and south nave wall surrounded by the new facade and nave walls in the course of construction. (Photograph courtesy of the late dott. Celestino Bruschetti).

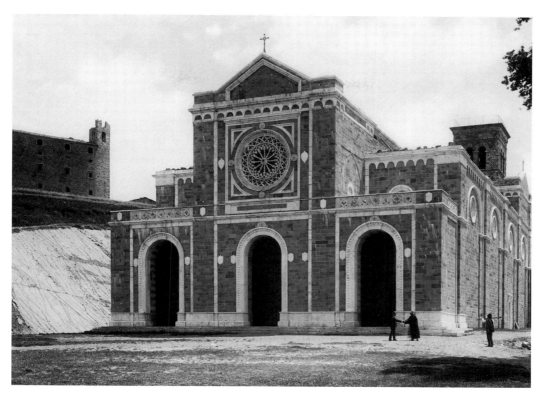

Fig. 11. Cortona, S. Margherita, facade designed by Mariano Falcini, 1878.

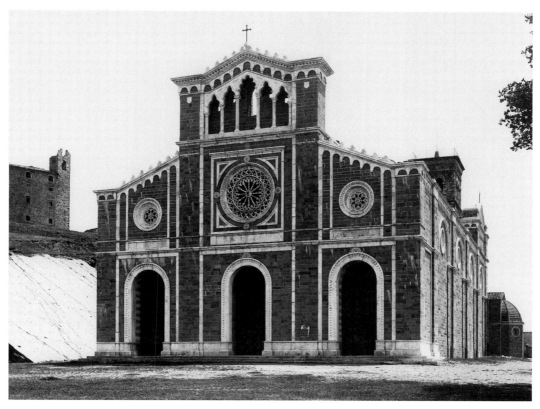

Fig. 12. Cortona, S. Margherita, facade, present state (designed by Giuseppe Castellucci, completed 1897).

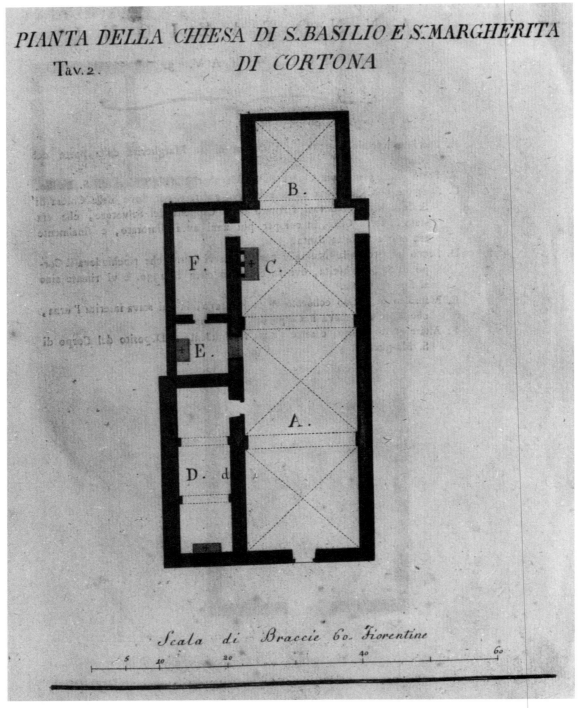

Fig. 13. Cortona, S. Basilio and S. Margherita, da Pelago's reconstruction of the ground plan of the medieval church and associated buildings (published 1793). The reconstruction shows the church of S. Margherita (A) begun in 1297, the year of Margherita's death; the choir of that church (B); the site of Margherita's burial in the new church (C) (translation from S. Basilio dated by da Pelago to 1330); the original church of S. Basilio, restored by Margherita in 1290 (D); the location of a niche that da Pelago believes was Margherita's original burial place in S. Basilio (d); the *Cappella del SS. Salvatore* (E), which da Pelago argues was the precise site of Margherita's third cell, in which she died; and the sacristy of S. Margherita (F), which da Pelago says was used until the original church of S. Basilio was turned into a sacristy in about 1450.

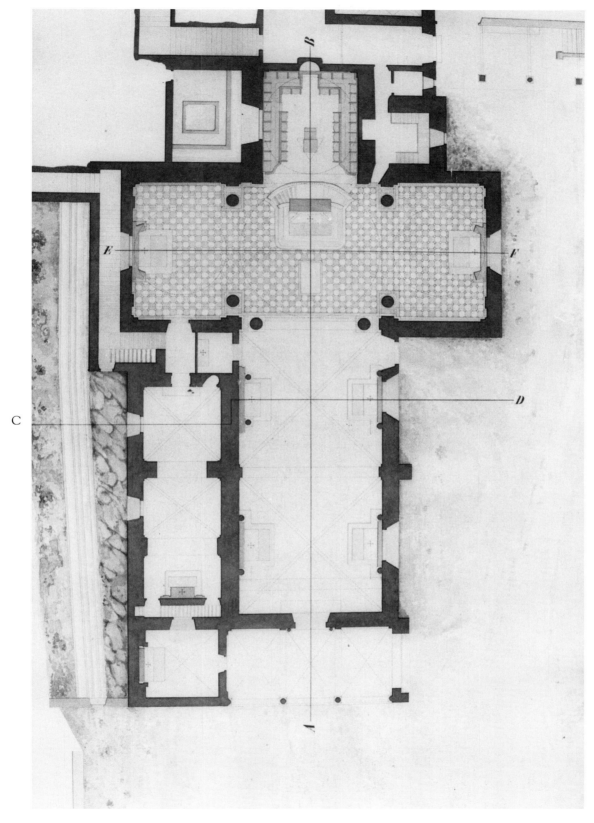

Fig. 14. Cortona, Biblioteca dell'Accademia Etrusca, ground plan of S. Margherita and associated buildings, Enrico Presenti, 1856. (This plan indicates the actual state of the church when da Pelago was making the reconstruction shown in Figure 13).

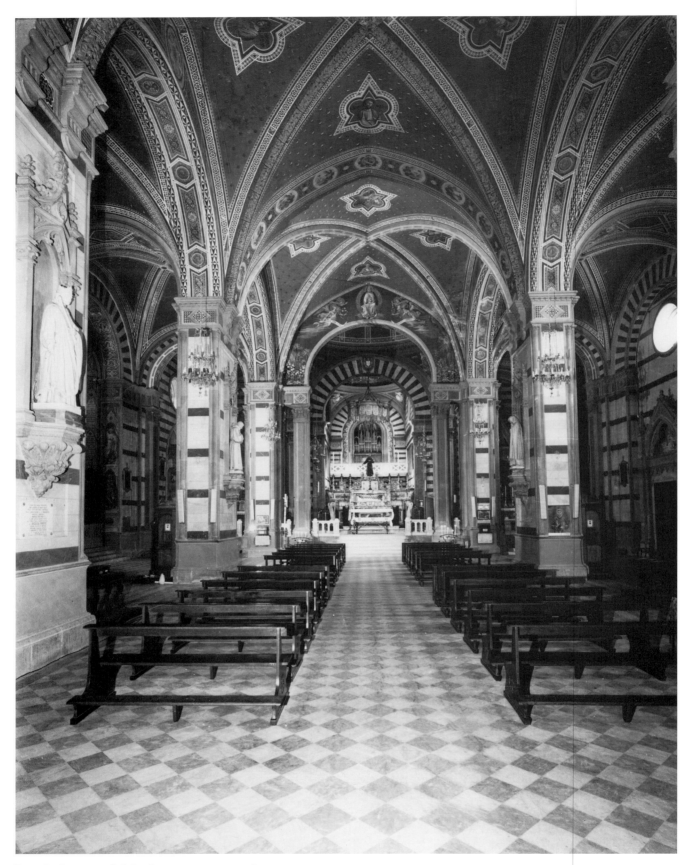

Fig. 15. Cortona, S. Margherita, interior to the east.

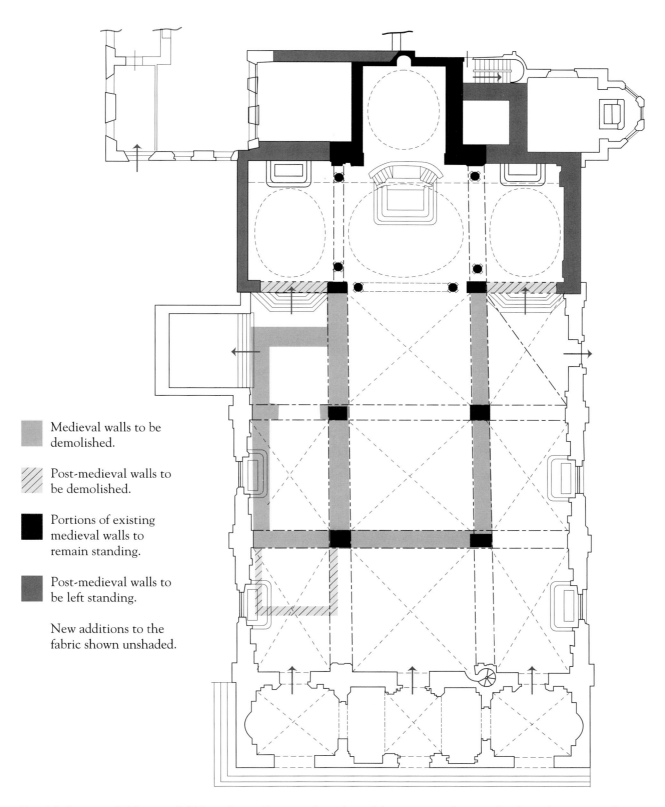

Medieval walls to be demolished.

Post-medieval walls to be demolished.

Portions of existing medieval walls to remain standing.

Post-medieval walls to be left standing.

New additions to the fabric shown unshaded.

Fig. 16. Cortona, Biblioteca dell'Accademia Etrusca, plan adapted from project drawing for the enlargement of S. Margherita, Enrico Presenti, 1856.

Fig. 17. Cortona, S. Margherita, exterior of the *cappella maggiore* from the east, showing remains of masonry of original gable end.

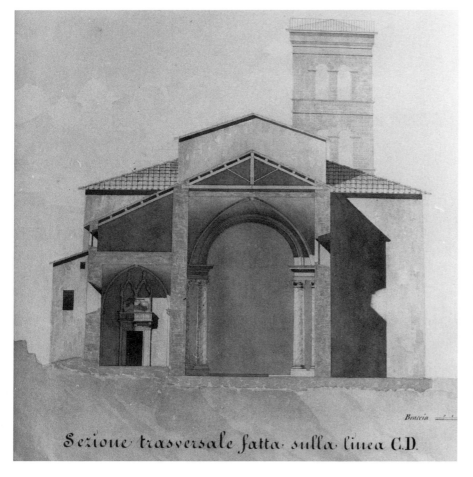

Sezione trasversale fatta sulla linea C.D.

Braccia

Fig. 18. Cortona, Biblioteca dell'Accademia Etrusca, transverse section of S. Margherita and associated buildings (taken on the line CD indicated on Figure 14), Enrico Presenti, 1856. (Funerary monument of Margherita visible above doorway of building to left of main nave. This building was presumably the original church of S. Basilio, probably called the *Cappella di S. Margherita* after the construction of the new fourteenth-century church. By da Pelago's day, having functioned as a sacristy, it was returned to use as a chapel dedicated to S. Basilio.)

Fig. 19. Cortona, S. Margherita, exterior from the northeast showing the original masonry of the north wall of the *cappella maggiore* and the original buttress with slate roofing at the junction of the *cappella maggiore* and nave.

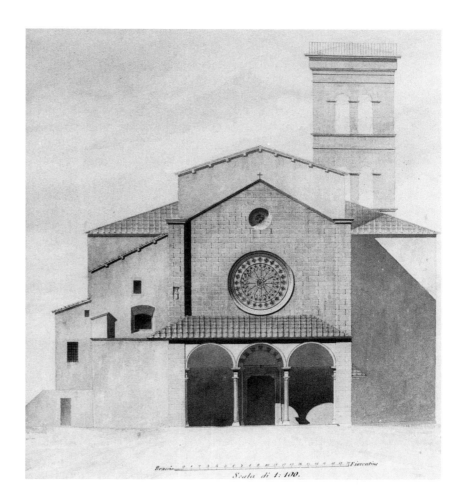

Fig. 20. Cortona, Biblioteca dell'Accademia Etrusca, watercolor of the facade of S. Margherita, Enrico Presenti, 1856.

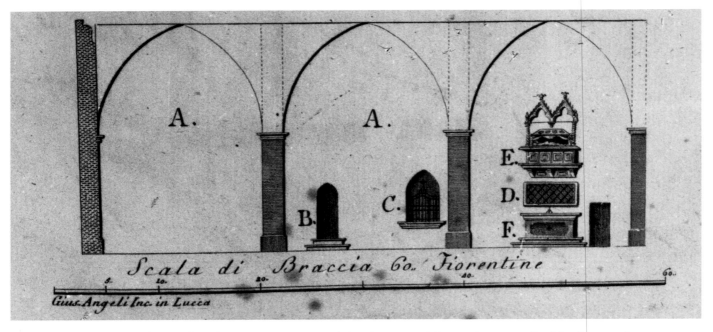

Fig. 21. Cortona, S. Margherita, da Pelago's reconstruction of the elevation of the north nave wall of the fourteenth-century church, with an indication of entry to the structure of old S. Basilio (B), window joining nave to site of Margherita's original cell (C), and reconstruction of appearance and arrangement of funerary monument (E), burial niche (D), and altar (F).

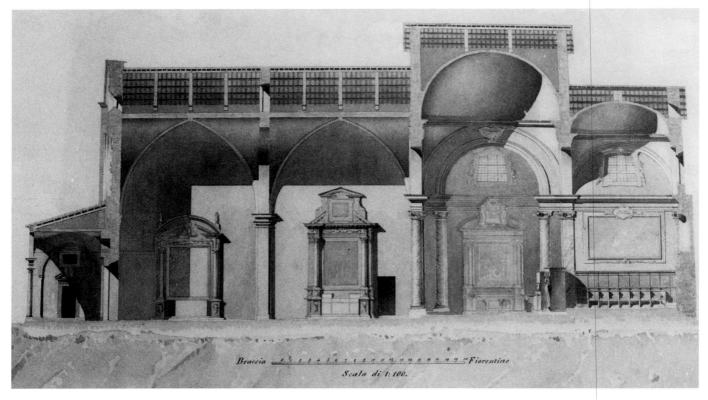

Fig. 22. Cortona, Biblioteca dell'Accademia Etrusca, longitudinal section of S. Margherita (taken on the line AB indicated on Figure 14), Enrico Presenti, 1856.

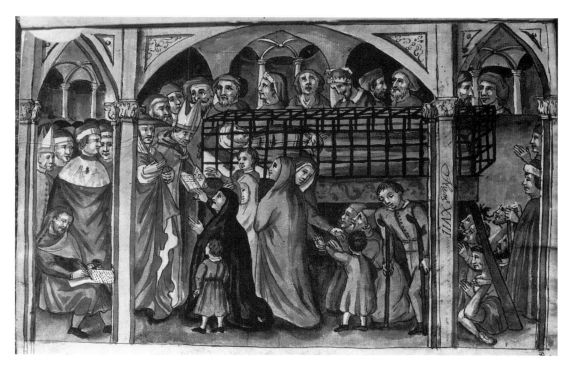

Fig. 23. Cortona, Biblioteca Communale e dell'Accademia Etrusca, cod. 429, watercolor no. xvii, Adriano Zabarelli, c. 1629, copy of the mural *Visitation of Cardinal Napoleone Orsini* formerly on the south nave wall of S. Margherita.

Fig. 24. Siena, Pinacoteca Nazionale (on deposit), *Beato Agostino Novello and Four Miracles*, panel (200 x 256 cm), from S. Agostino, Siena, Simone Martini (attrib.), before 1329.

Fig. 25. Munich, Saint Wolfgang in Pipping, High Altarpiece, follower of Gabriel Mälesskircher, c. 1480, left wing.

Fig. 26. Munich, Saint Wolfgang in Pipping, High Altarpiece, follower of Gabriel Mälesskircher, c. 1480, right wing.

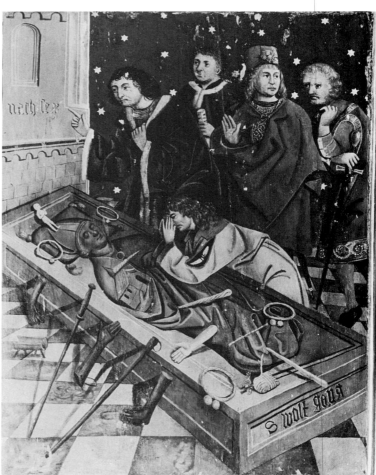

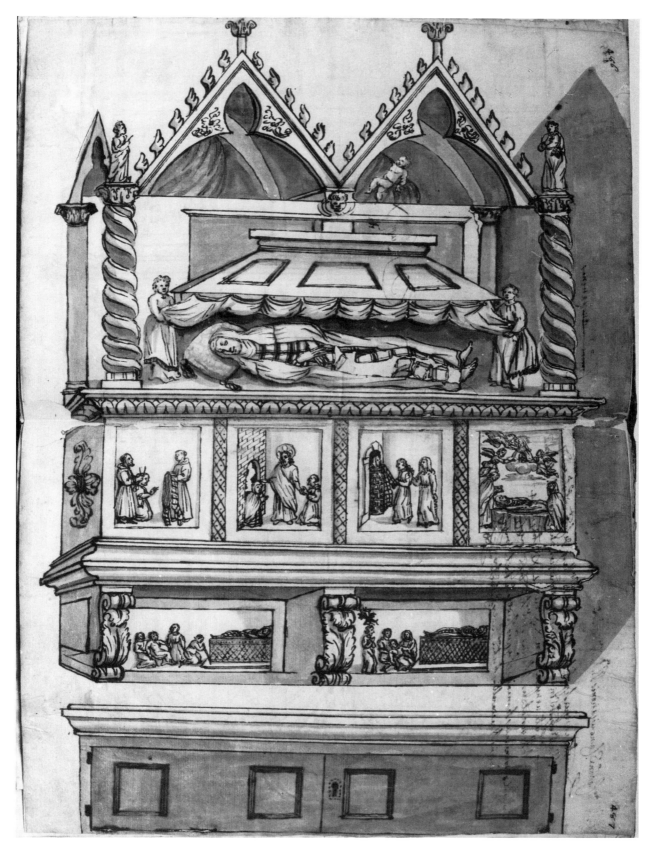

Fig. 27. Cortona, Biblioteca Comunale e dell'Accademia Etrusca, cod. 429, watercolor of the funerary monument and burial niche on the north nave wall of S. Margherita.

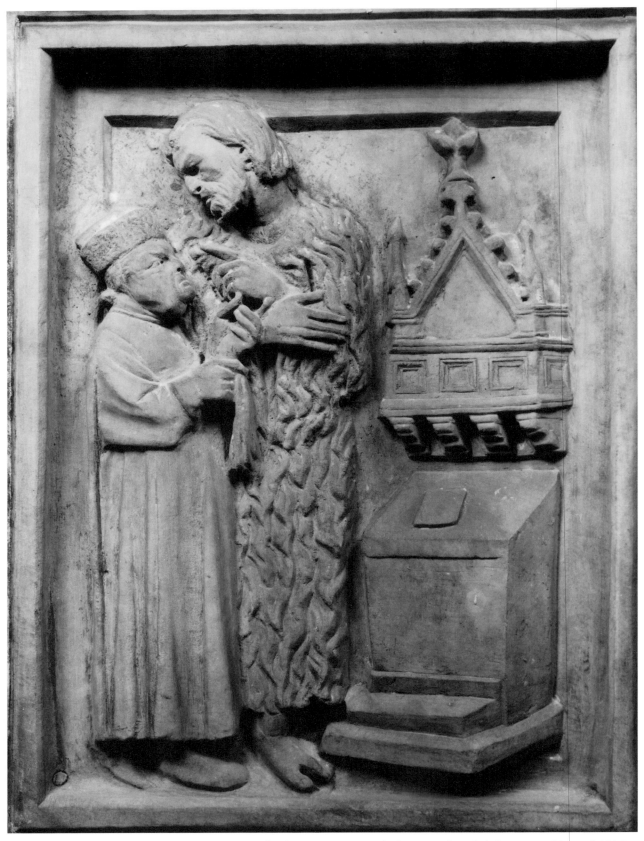

Fig. 28. Pisa, Museo dell'Opera del Duomo, tomb of S. Ranieri, Tino di Camaino (attrib.), between 1291 and 1306, relief from tomb chest, *S. Ranieri and a Donor, Marco Sicchi, Stand Before the Tomb and Altar of the Saint.*

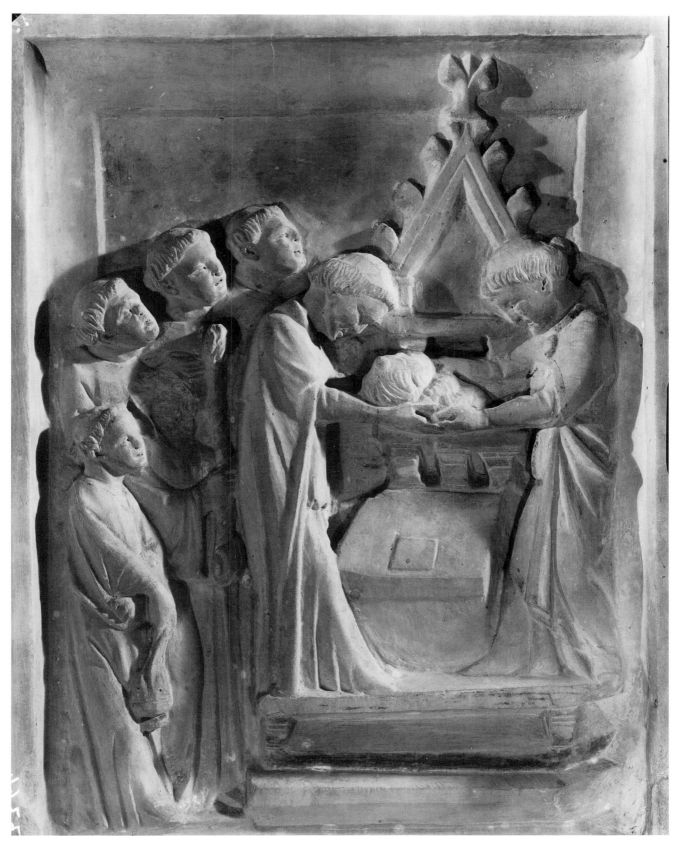

Fig. 29. Pisa, Museo dell'Opera del Duomo, tomb of S. Ranieri, Tino di Camaino (attrib.), between 1291 and 1306, relief from tomb chest, *The Body of S. Ranieri Is Placed Within the Tomb Chest*.

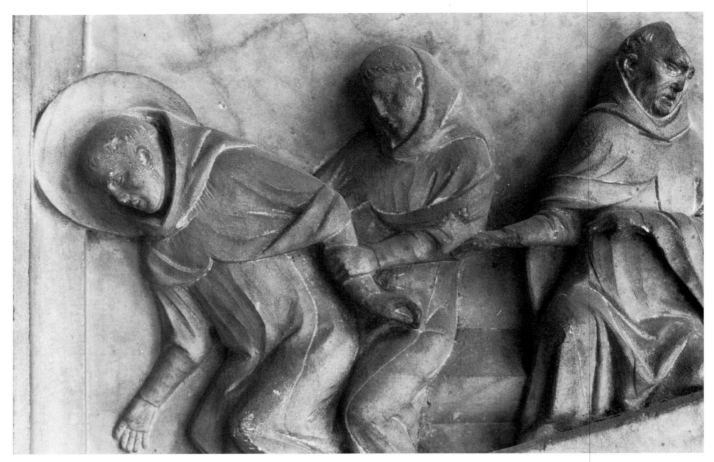

Fig. 30. Siena, Pinacoteca Nazionale, relief from the tomb chest of Beato Gioacchino, Sienese sculptor (Gano di Fazio?), second or third decade of the fourteenth century, detail.

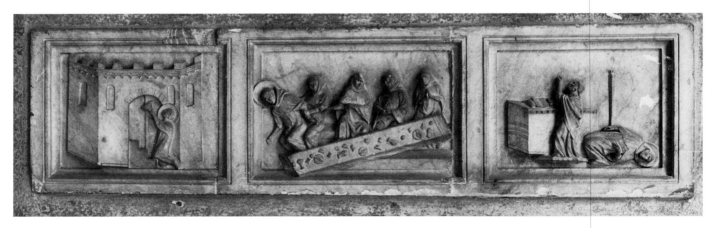

Fig. 31. Siena, Pinacoteca Nazionale, reliefs from the tomb chest of Beato Gioacchino, *Three Scenes from the Life of Beato Gioacchino* (overall dimensions: 45 x 170 cm), from S. Maria dei Servi, Siena, Sienese sculptor (Gano di Fazio?), second or third decade of the fourteenth century.

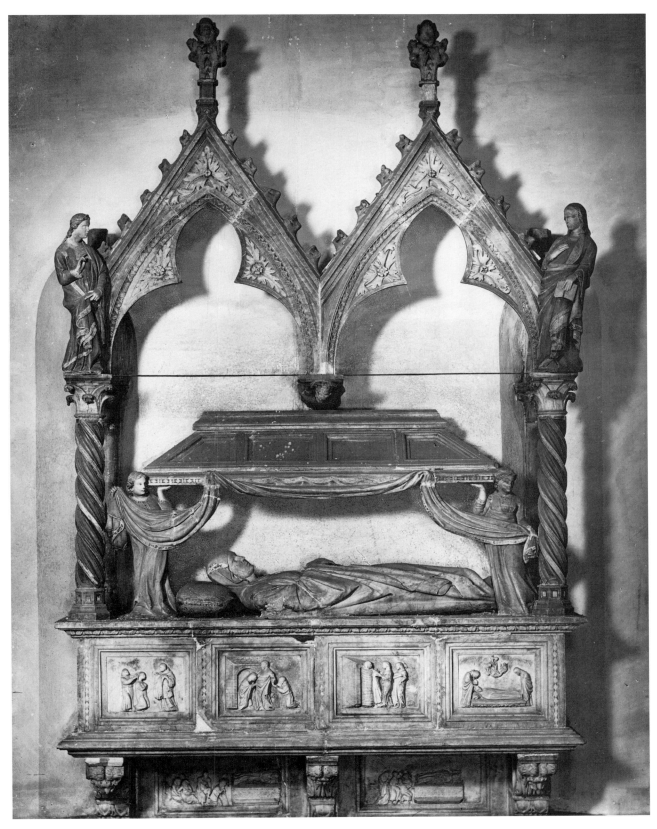

Fig. 32. Cortona, S. Margherita, funerary monument of Beata Margherita (maximum width of base of monument: 229 cm), nineteenth-century photograph showing remains of original polychrome, Sienese sculptor (Gano di Fazio?), second or third decade of the fourteenth century.

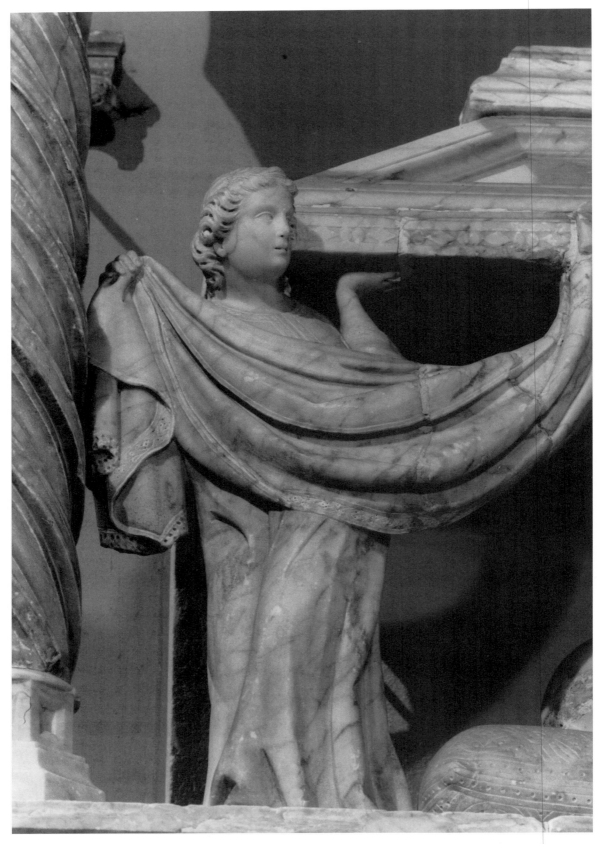

Fig. 33. Cortona, S. Margherita, funerary monument of Beata Margherita, detail showing the angel to the left of the effigy.

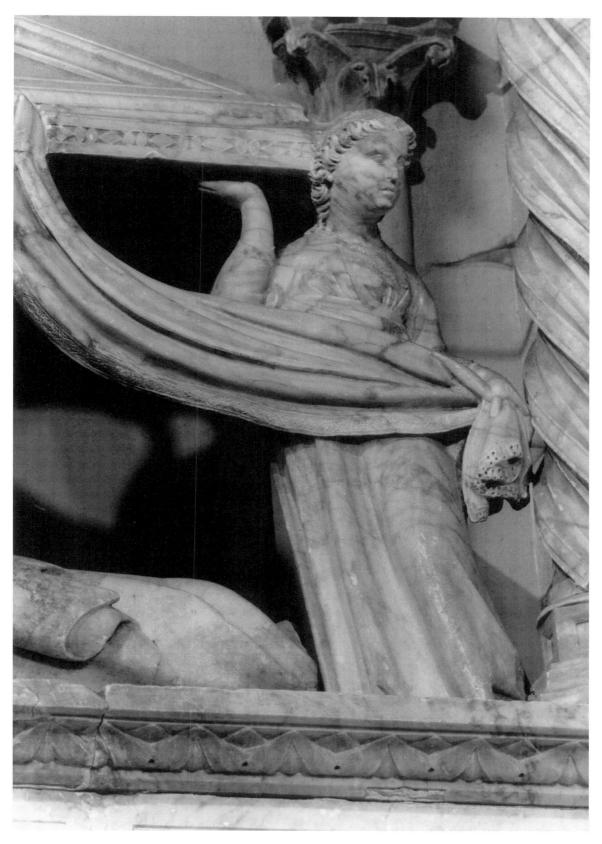

Fig. 34. Cortona, S. Margherita, funerary monument of Beata Margherita, detail showing the angel to the right of the effigy.

Fig. 35. Cortona, S. Margherita, funerary monument of Beata Margherita, detail showing the figure (the Redeemer, a prophet, or an apostle?) above the sarcophagus lid.

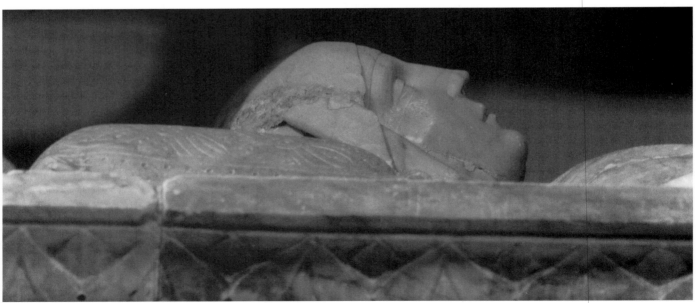

Fig. 36. Cortona, S. Margherita, funerary monument of Beata Margherita, detail showing the head of Margherita's effigy with signs of damage and repair.

Fig. 37. Cortona, S. Margherita, funerary monument of Beata Margherita, detail showing foliate decoration on the return panel at the right end of tomb chest.

Fig. 38. Cortona, S. Margherita, marble relief with foliate decoration (appox. 34 x 66 cm) Sienese, fourteenth century; one of five slabs from the high altar (see Figures 55 and 61) now immured below a sculpture of Santa Margherita by Vincenzo Pacetti (1781) in the south transept of S. Margherita, and which may originally have decorated the altar beneath Margherita's funerary monument.

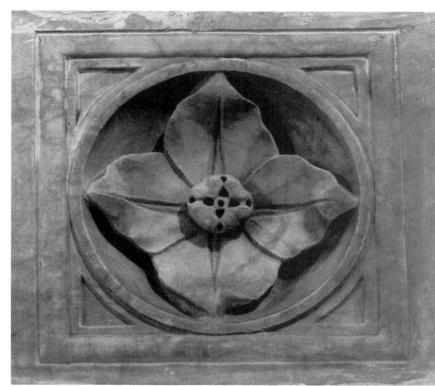

Fig. 39. Cortona, S. Margherita, funerary monument of Beata Margherita, detail showing the Archangel Gabriel.

Fig. 40. Cortona, S. Margherita, funerary monument of Beata Margherita, detail showing the rear and base of the figure of the Archangel Gabriel.

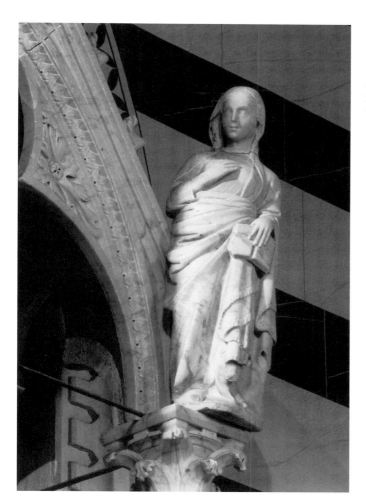

Fig. 41. Cortona, S. Margherita, funerary monument of Beata Margherita, detail showing the Annunciate Virgin.

Fig. 42. Cortona, S. Margherita, funerary monument of Beata Margherita, detail showing the side and base of the figure of the Annuciate Virgin.

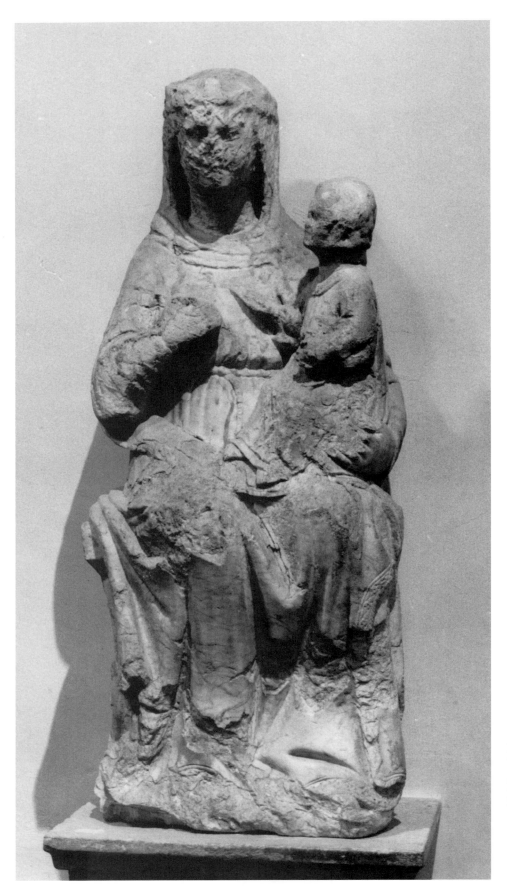

Fig. 43. Cortona, Museo Diocesano, Virgin and Child, marble (approx. 86 cm high), from the facade of S. Margherita (see Figure 20), Sienese, before c. 1320.

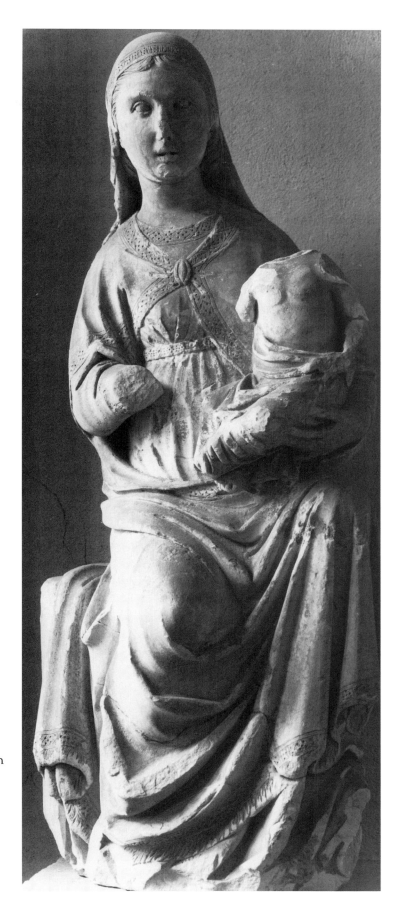

Fig. 44. Cortona, Museo Diocesano, Virgin
and Child, marble (approx. 94 cm high),
from S. Margherita, Sienese, c. 1310–20.

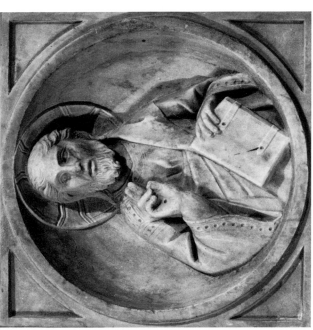

Fig. 45. Cortona, S. Margherita, marble relief slab, detail, *The Redeemer*, Sienese, fourteenth century; part of one of five slabs from the high altar (see Figure 54).

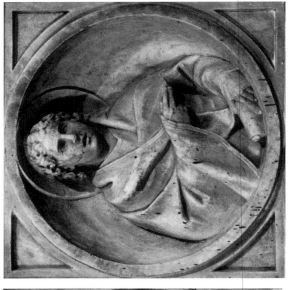

Fig. 48. Cortona, S. Margherita, marble relief slab, detail, *Saint John the Evangelist*, Sienese, fourteenth century; part of one of five slabs from the high altar.

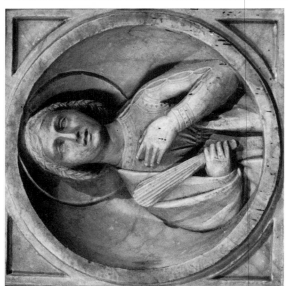

Fig. 47. Cortona, S. Margherita, marble relief slab, detail, *Saint Catherine of Alexandria*, Sienese, fourteenth century; part of one of five slabs from the high altar.

Fig. 46. Cortona, S. Margherita, marble relief slab, detail, *Beata Margherita*, Sienese, fourteenth century; part of one of five slabs from the high altar.

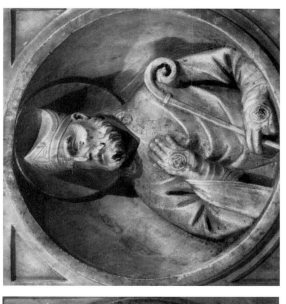

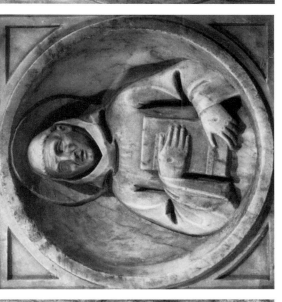

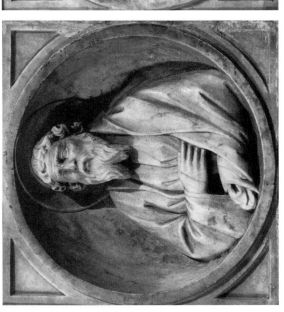

Fig. 49. Cortona, S. Margherita, marble relief slab, detail, *Saint Egidio (Giles)* (Egidio), Sienese, fourteenth century; part of one of five slabs from the high altar.

Fig. 50. Cortona, S. Margherita, marble relief slab, detail, *Saint Francis*, Sienese, fourteenth century; part of one of five slabs from the high altar.

Fig. 51. Cortona, S. Margherita, marble relief slab, detail, *Saint Basilio (Basil)*, Sienese, fourteenth century; part of one of five slabs from the high altar.

Fig. 52. Cortona, S. Margherita, marble relief slab with foliate decoration, Sienese, fourteenth century; one of five slabs from the high altar.

Fig. 53. Cortona, S. Margherita, marble relief slab with foliate decoration, Sienese, fourteenth century; one of five slabs from the high altar.

Fig. 54. Photomontage of relief slabs from the former high altar of S. Margherita, Cortona, incorporating part of a drawing of the altar made c. 1719 by Francesco Fabbrucci, bound into Archivio Segreto Vaticano, *Riti*, proc. 549 (see Figure 61).

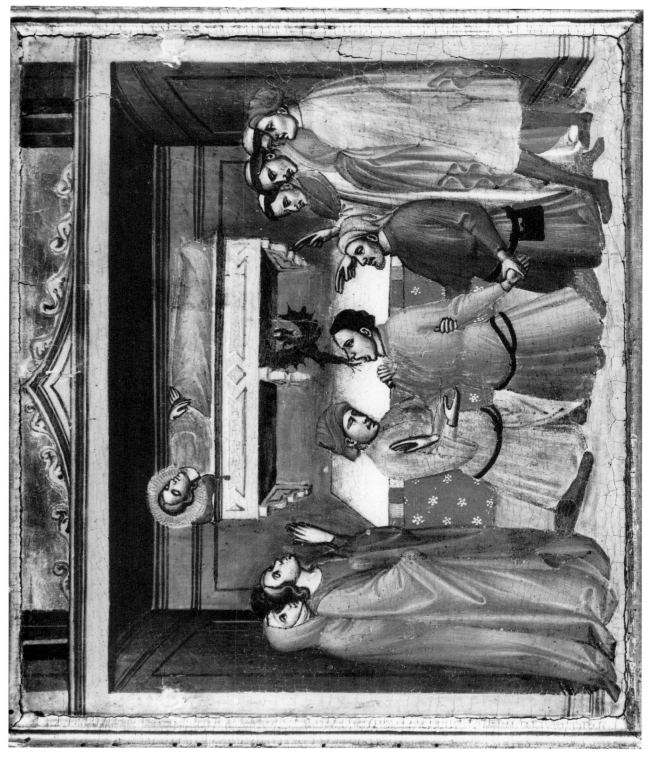

Fig. 55. San Gimignano, Pinacoteca Civica, shutters from the brain-reliquary of Beata Fina; Saint Gregory, Beata Fina, and Scenes from the Life and Miracles of Beata Fina, Lorenzo di Niccolò (attrib.), 1402, formerly Collegiata, San Gimignano, detail, *A Man Is Freed from Devils at Beata Fina's Tomb.*

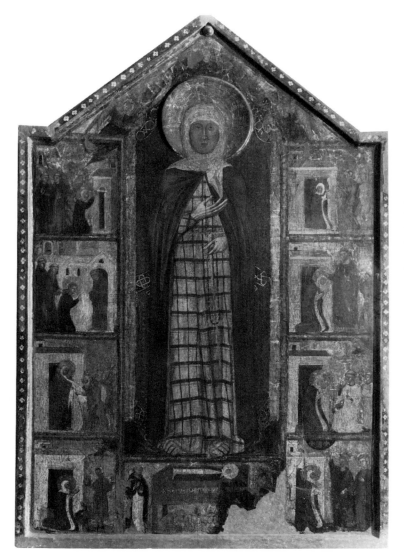

Fig. 56. Cortona, Museo Diocesano, *Beata Margherita with Eight Scenes from Her Life*, panel (maximum dimensions: 197.5 x 131 cm), Tuscan (or Umbrian), within the decade following 1297.

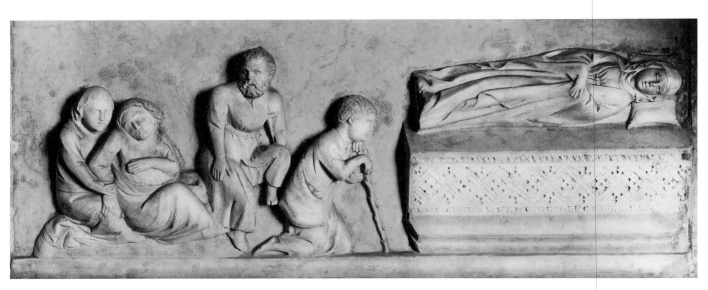

Fig. 57. Cortona, S. Margherita, funerary monument of Beata Margherita, detail showing relief of sick and lame seeking cures at Margherita's tomb.

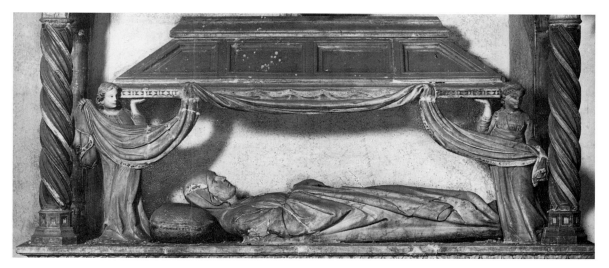

Fig. 58. Cortona, S. Margherita, funerary monument of Beata Margherita, detail showing the lid of the sarcophagus being raised by angels, and curtains parted to reveal the effigy.

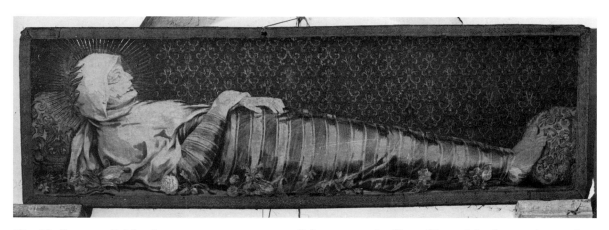

Fig. 59. Cortona, S. Margherita, convent museum, silk hanging with effigy of Beata Margherita, designed by Pietro Berettini "da Cortona," executed by a Flemish master, 1652.

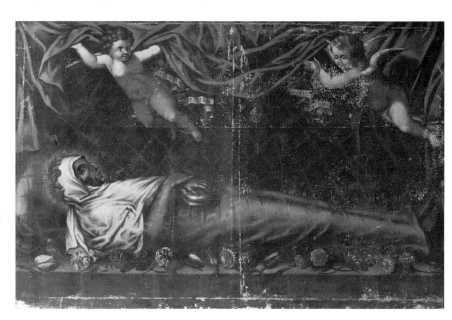

Fig. 60. Pergo, near Cortona, S. Bartolomeo, painting of S. Margherita "*nell'urna,*" seventeenth- or eighteenth-century artist.

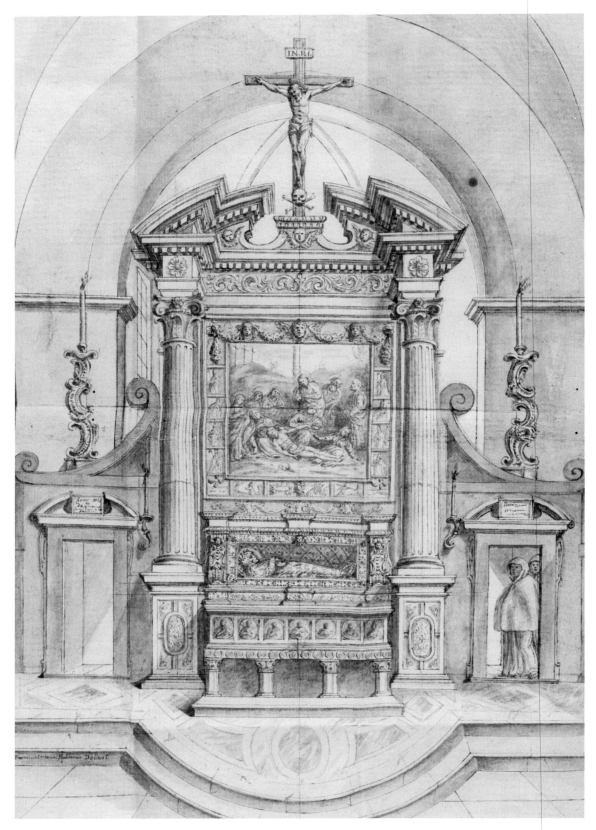

Fig. 61. Cortona, S. Margherita, high altar with shrine of Beata Margherita (casket and silk effigy designed by Pietro Berettini "da Cortona," 1651–52) and *Deposition* by Luca Signorelli, 1502. Drawing of c. 1719 by Francesco Fabbrucci, bound into Archivio Segreto Vaticano, *Riti*, proc. 549.

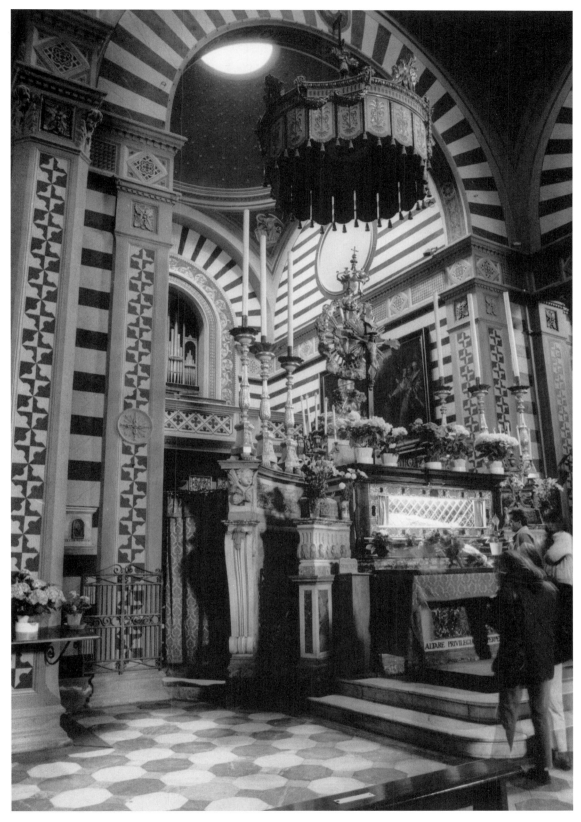

Fig. 62. Cortona, S. Margherita, the *cappella maggiore* and high altar with the shrine of Beata Margherita, current state.

Fig. 63. Cortona, Museo dell'Accademia Etrusca, *Eve Spinning* (approx. maximum dimensions of painted surface: 200 x 161 cm), fragment of fresco of *Labor of Adam and Eve*, formerly nave of S. Margherita, Tuscan (Sienese?) artist, first half of the fourteenth century (c. 1335?).

Fig. 64. Cortona, Museo dell'Accademia Etrusca, *Joseph Sold by His Brothers* (approx. maximum dimensions of painted surface: 186 x 200 cm), fragment of fresco, formerly nave of S. Margherita, Tuscan (Sienese?) artist, first half of the fourteenth century (c. 1335?).

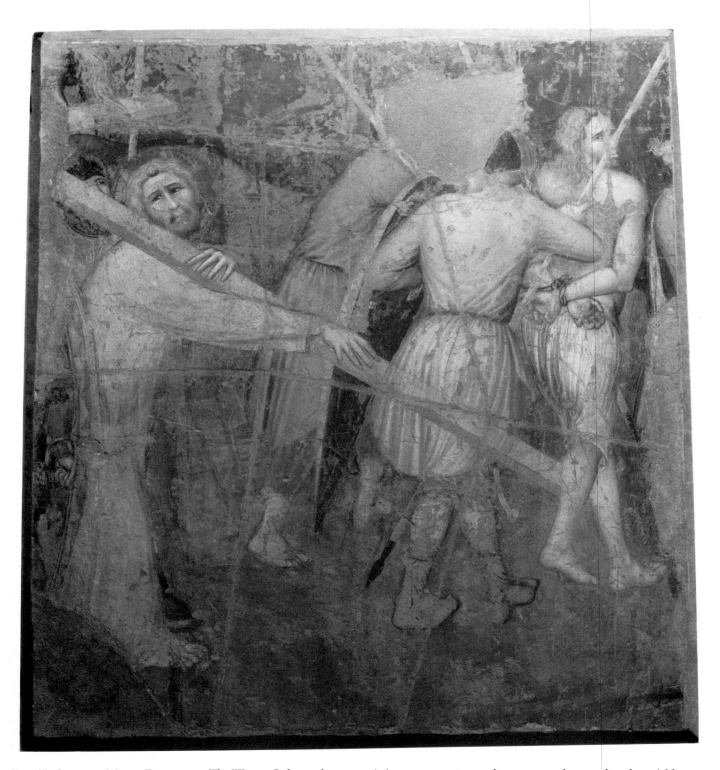

Fig. 65. Cortona, Museo Diocesano, *The Way to Calvary*, fragment A (approx. maximum dimensions of painted surface: 166 x 146 cm), fragment of fresco, formerly nave of S. Margherita, here attributed to Pietro Lorenzetti working with a member of the Lorenzetti workshop who may also have worked with Ambrogio Lorenzetti, c. 1335.

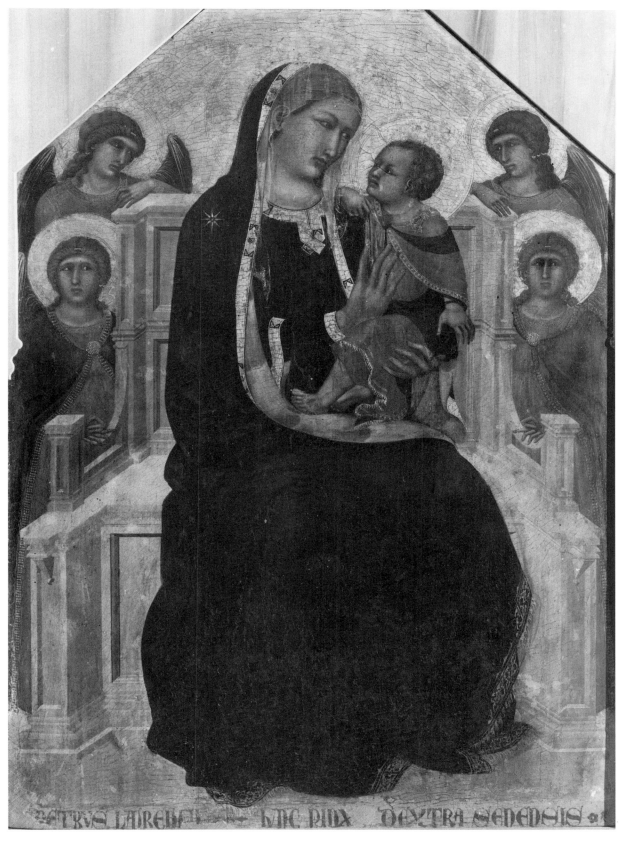

Fig. 66. Cortona, Museo Diocesano, *Virgin and Child with Angels*, panel (126 x 83 cm), from Duomo, Cortona, Pietro Lorenzetti (signed).

Fig. 67. Cortona, Museo Diocesano, *The Way to Calvary*, fragment B (77 x 84.5 cm), fragment of fresco, formerly nave of S. Margherita, here attributed to Pietro Lorenzetti and a member of the Lorenzetti workshop who may also have worked with Ambrogio Lorenzetti, c. 1335.

Fig. 68. Cortona, Museo Diocesano, *The Way to Calvary*, fragment C (32 x 30.5 cm), fragment of fresco, formerly nave of S. Margherita, here attributed to Pietro Lorenzetti and a member of the Lorenzetti workshop who may also have worked with Ambrogio Lorenzetti, c. 1335.

Fig. 69. Siena, Palazzo Pubblico, *Effects of Good Government in the Countryside*, Ambrogio Lorenzetti, c. 1338–39, detail.

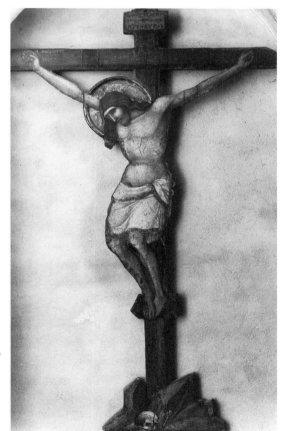

Fig. 70. Cortona, Museo Diocesano, *"Cut-away" Crucifix* (125 cm high), from the crypt of the Gesù, Cortona, Pietro Lorenzetti (attrib.).

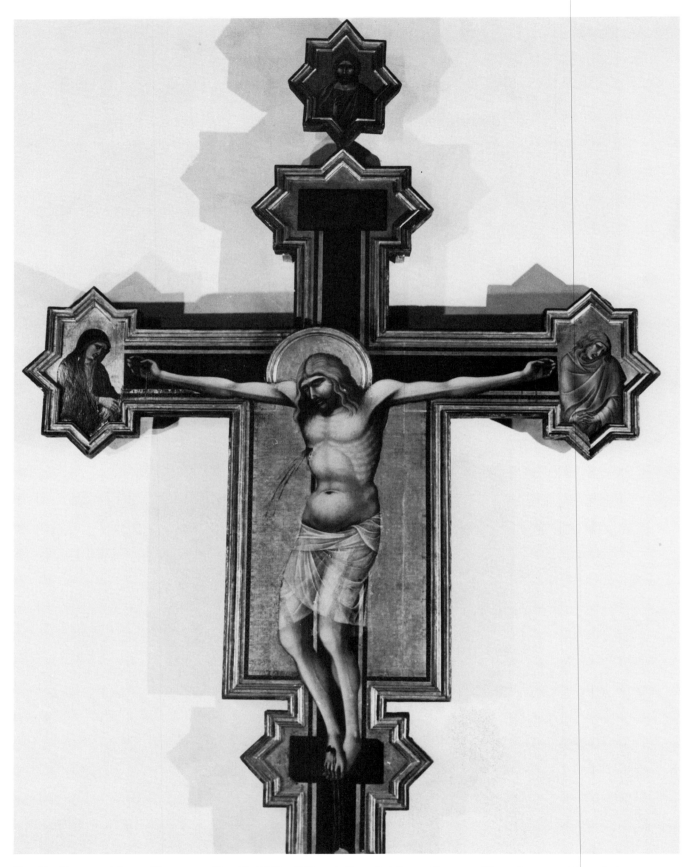

Fig. 71. Cortona, Museo Diocesano, *Crucifix* (380 x 274 cm), from S. Marco, Cortona, Pietro Lorenzetti (attrib.).

Fig. 72. Cortona, Museo Diocesano, *The Way to Calvary*, detail of soldier and hands of the good thief.

Fig. 73. Cortona, Museo dell'Accademia Etrusca, *Eve Spinning*, detail of Eve.

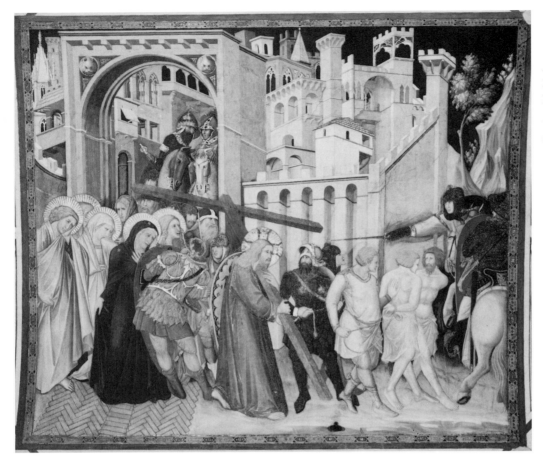

Fig. 74. Assisi, S. Francesco, Lower Church, left transept, *The Way to Calvary*, attributed to Pietro Lorenzetti and assistants.

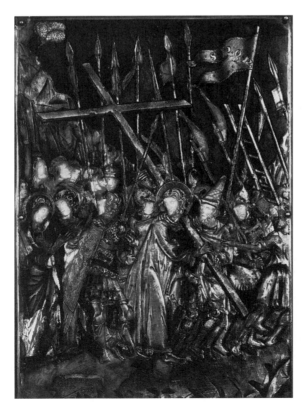

Fig. 75. Orvieto, Duomo, Reliquary of the Holy Corporal, translucent enamel, plaque of *The Way to Calvary*, Ugolino di Vieri and associates, 1337–38.

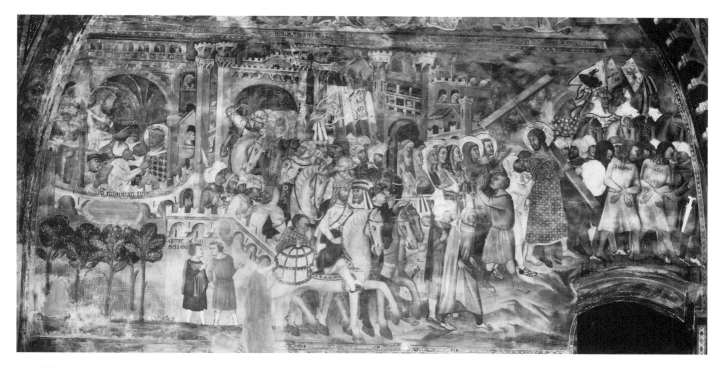

Fig. 76. Subiaco, Sacro Speco, Upper Church, *The Way to Calvary*, fresco, follower of Meo da Siena, end of the fourth decade of the fourteenth century.

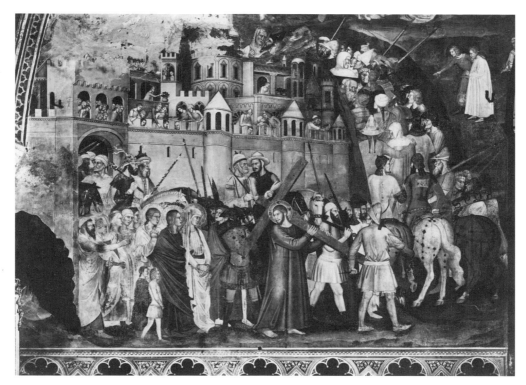

Fig. 77. Florence, S. Maria Novella, Chapter House ("Spanish Chapel"), *The Way to Calvary*, Andrea Bonaiuti, 1366–c. 1368.

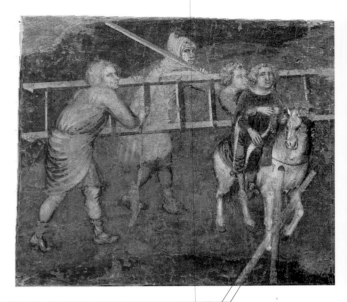

Fig. 78. Photomontage of fresco fragments A, B, and C of *The Way to Calvary*, now in the Museo Diocesano, Cortona, and formerly in the nave of S. Margherita, Cortona.

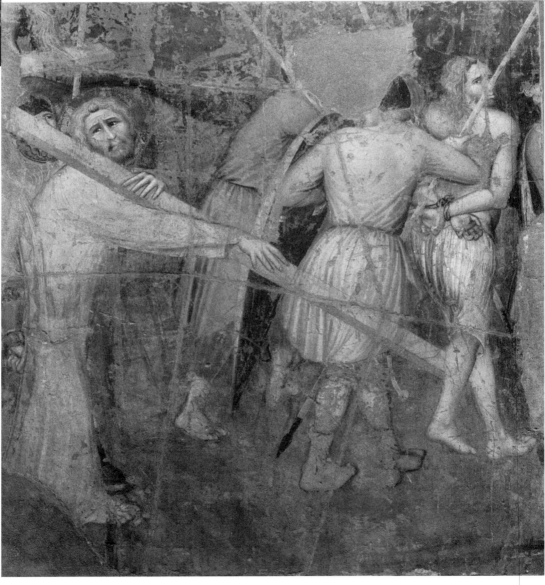

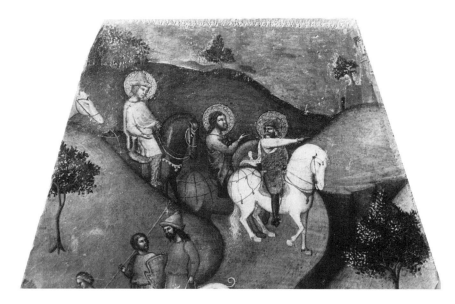

Fig. 79. Dijon, Musée des Beaux-Arts, *Journey of the Magi* (maximum dimensions: 27 x 38 cm), pinnacle of panel of *Adoration of the Magi* (Lehman Collection, Metropolitan Museum of Art, New York), Bartolo di Fredi (attrib.).

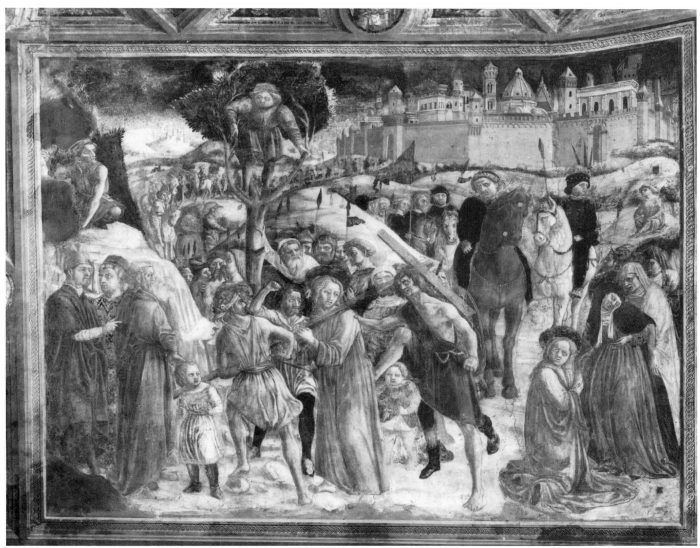

Fig. 80. Siena, Cathedral Baptistry, *The Way to Calvary*, fresco, Vecchietta, 1450.

Fig. 81. Siena, Pinacoteca Nazionale,
No. 104, *Adoration of the Magi*, panel
(195 x 163 cm), Bartolo di Fredi (attrib.).

Fig. 82. San Gimignano, Collegiata,
*Parting of Abraham and Lot in the Land of
Canaan*, fresco, Bartolo di Fredi, 1367.

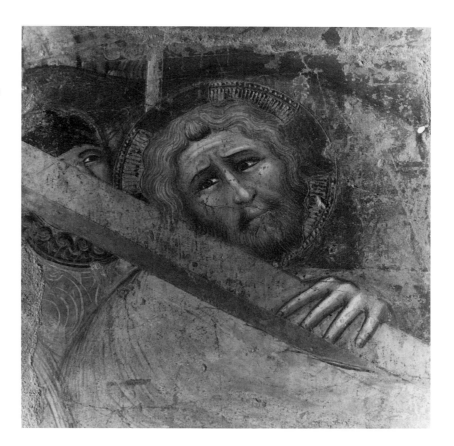

Fig. 83. Cortona, Museo Diocesano, *The Way to Calvary*, detail of the figure of Christ.

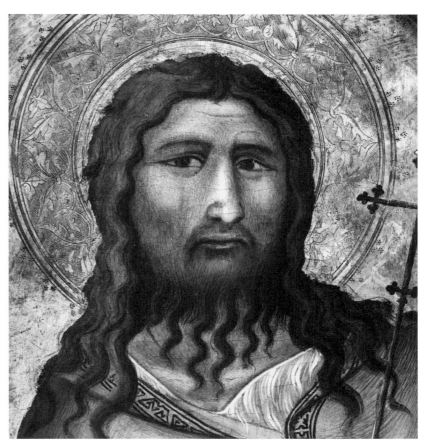

Fig. 84. Arezzo, Pieve di S. Maria, Polytych (maximum present dimensions: 298 x 309 cm), Pietro Lorenzetti, 1320–24, detail of John the Baptist

Fig. 85. Assisi, S. Francesco, Lower Church, left transept, *The Way to Calvary*, fresco, Pietro Lorenzetti and assistants (attrib.), detail, the two thieves and a soldier.

Fig. 86. Assisi, S. Francesco, Lower Church, left transept, *The Betrayal*, fresco, Pietro Lorenzetti and assistants (attrib.), detail, Saint Peter, a soldier, Malchus, and an apostle.

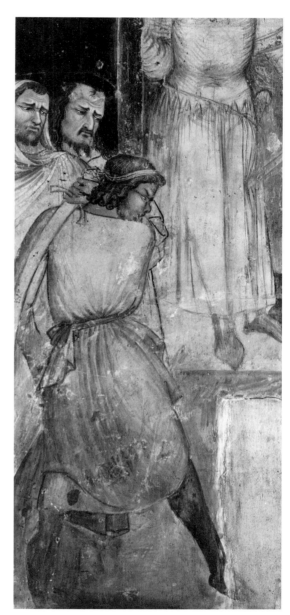

Fig. 87. Cortona, Museo Diocesano, *The Way to Calvary*, detail, the good thief and the soldier in yellow.

Fig. 88. Siena, S. Francesco, Cappella Bandini Piccolomini, formerly Chapter House, *Massacre of the Franciscans at Ceuta*, Ambrogio Lorenzetti or assistant (attrib.), detail of executioner and onlookers.

Fig. 89. Cortona, Museo Diocesano, Sarcophagus of the *Battle of Bacchus and His Retinue with Indians and an Amazon*, Roman, c. A.D. 160, later used for the burial of Beato Guido of Cortona (d. 1247), front face.

Fig. 90. Cortona, Museo Diocesano, Sarcophagus of the *Battle of Bacchus and His Retinue with Indians and an Amazon*, detail, left end of lid.

Fig. 91. Cortona, Museo Diocesano, Sarcophagus of the *Battle of Bacchus and His Retinue with Indians and an Amazon*, detail, right end of lid.

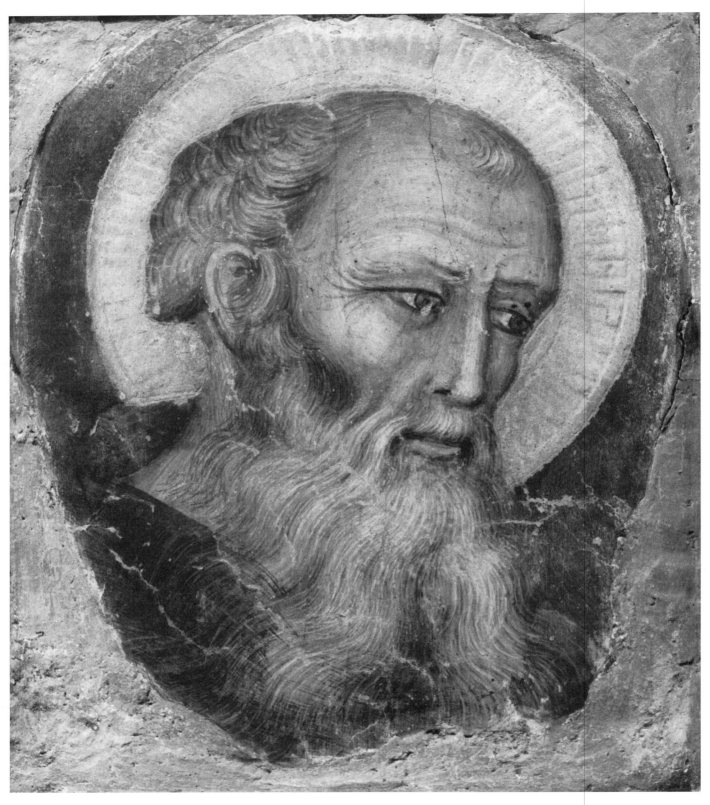

Fig. 92. Cortona, Museo Diocesano, *Head of a Hermit Saint (Egidio?)*, fresco fragment (maximum dimensions: 39 x 33.5 cm), here attributed to Pietro Lorenzetti.

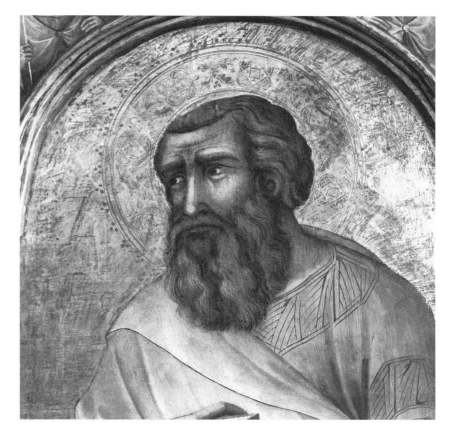

Fig. 93. Arezzo, Pieve di S. Maria, Polytych (maximum present dimensions: 298 x 309 cm), Pietro Lorenzetti, 1320–24, detail of Saint Matthew.

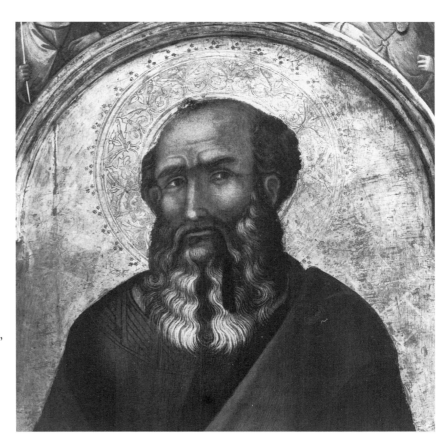

Fig. 94. Arezzo, Pieve di S. Maria, Polytych, Pietro Lorenzetti, 1320–24, detail of Saint John the Evangelist.

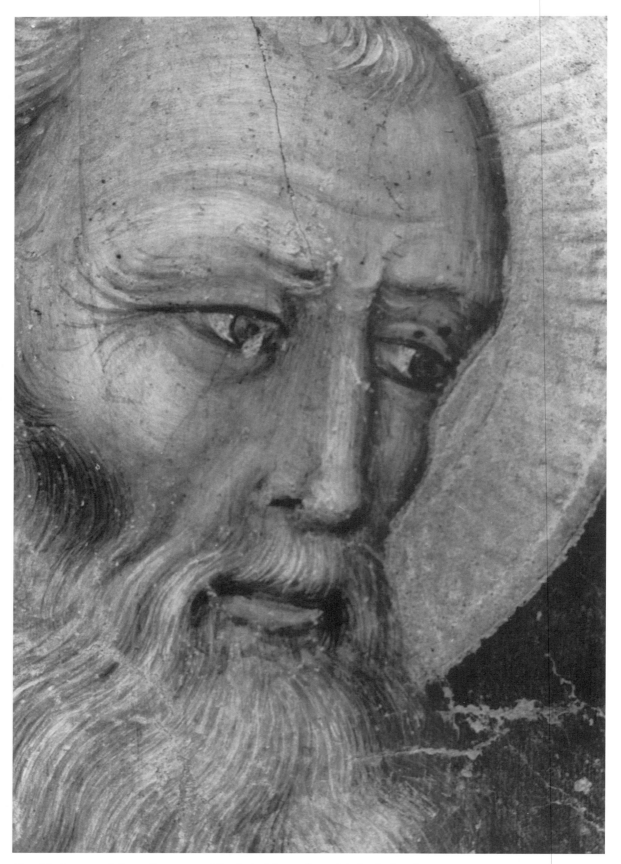

Fig. 95. Cortona, Museo Diocesano, *Head of a Hermit Saint (Egidio?)*, detail.

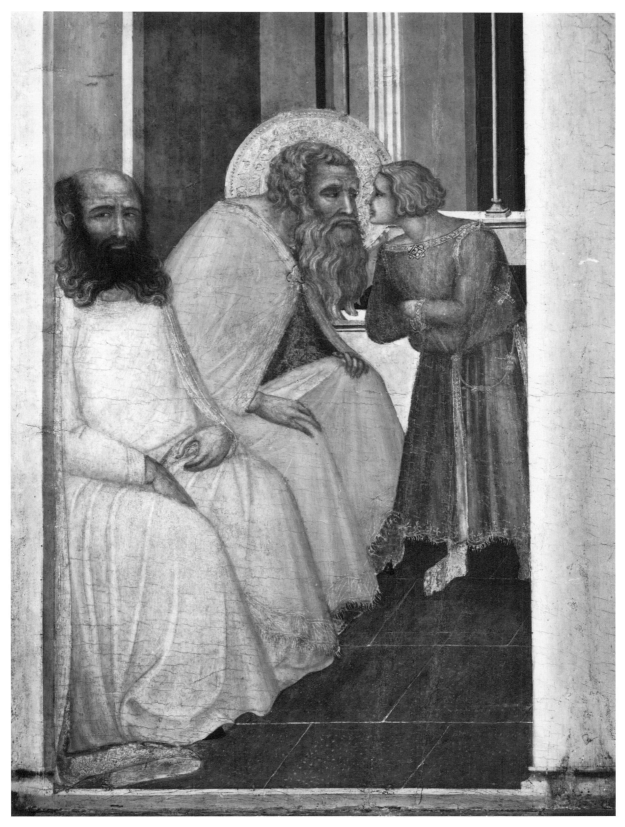

Fig. 96. Siena, Museo dell'Opera del Duomo, *Birth of the Virgin*, panel (187 x 182 cm), formerly *Cappella di S. Savino*, Duomo, Siena, Pietro Lorenzetti, 1335–42, detail of Joachim and a companion hearing the news of the Virgin's birth.

Fig. 97. Cortona, Museo Diocesano, fragmentary inscription with the date 133– (?), fresco (21.5 x 61 cm), from S. Margherita.

Fig. 98. Cortona, Museo Diocesano, fragment of decorative border with foliate and geometrical decoration and fictive stone molding, fresco (35 x 58.5 cm), from S. Margherita.

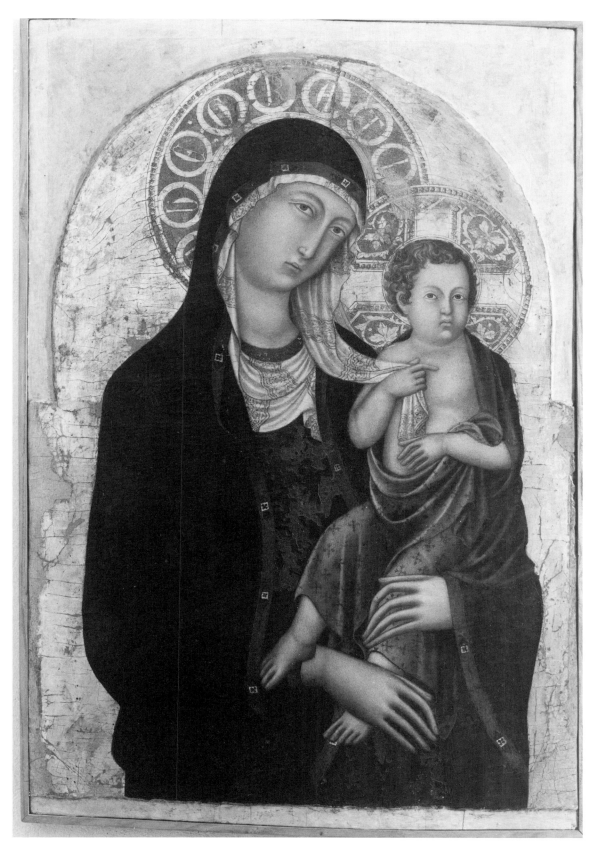

Fig. 99. Cortona, Museo Diocesano, *Virgin and Child*, panel (102 x 67 cm), from S. Margherita, Cortona, Niccolò di Segna (attrib.).

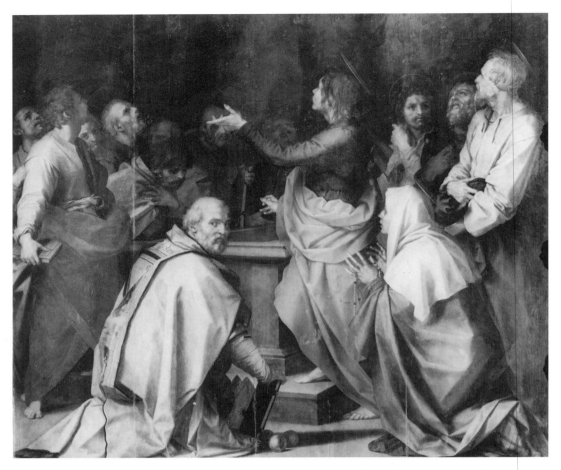

Fig. 100. Florence, Galleria Palatina, Palazzo Pitti, Assumption of the Virgin: "*Assunta Passerini*" (379 x 222 cm), from S. Antonio dei Servi, Cortona, Andrea del Sarto, 1526–28(?), detail of Saint Nicholas and Beata Margherita.

Fig. 101. Cortona, Duomo, Assumption of the Virgin, copy of the "*Assunta Passerini*," from S. Antonio dei Servi, Cortona, Adriano Zabarelli, 1643, detail of Saint Nicholas and Beata Margherita.

Fig. 102. Cortona, Duomo, Assumption of the Virgin, copy of the "*Assunta Passerini,*" from S. Antonio dei Servi, Cortona, Adriano Zabarelli, 1643, detail of Beata Margherita.

Fig. 103. Cortona, Biblioteca Comunale e dell'Accademia Etrusca, cod. 429, watercolor no. xix, Adriano Zabarelli. c. 1629, copy of the mural *The Healing of the Man of Corciano*, formerly on the south nave wall of S. Margherita.

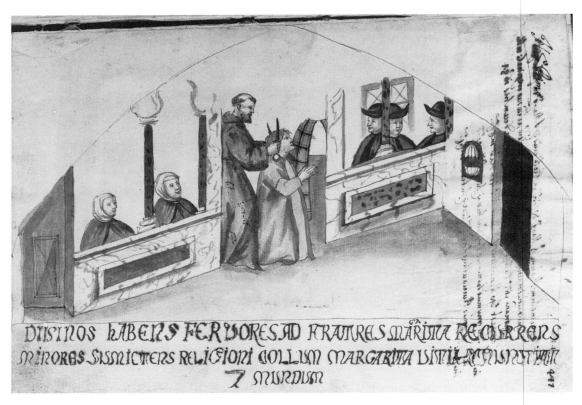

Fig. 104. Cortona, Biblioteca Comunale e dell'Accademia Etrusca, cod. 429, watercolor no. i, copy of the mural *The Profession and Investiture of Margherita as a Member of the Franciscan Third Order*, formerly in the lunette of the north wall of the *cappella maggiore* of S. Margherita.

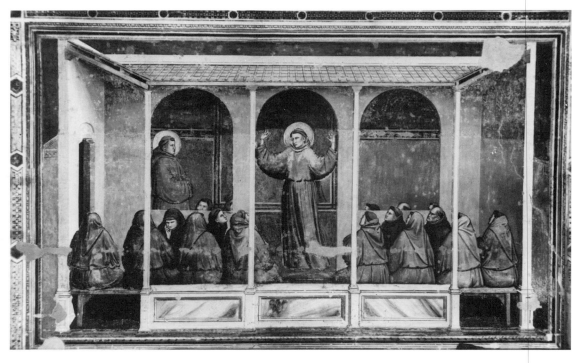

Fig. 105. Florence, S. Croce, Bardi Chapel, *The Apparition at Arles*, fresco, Giotto (attrib.).

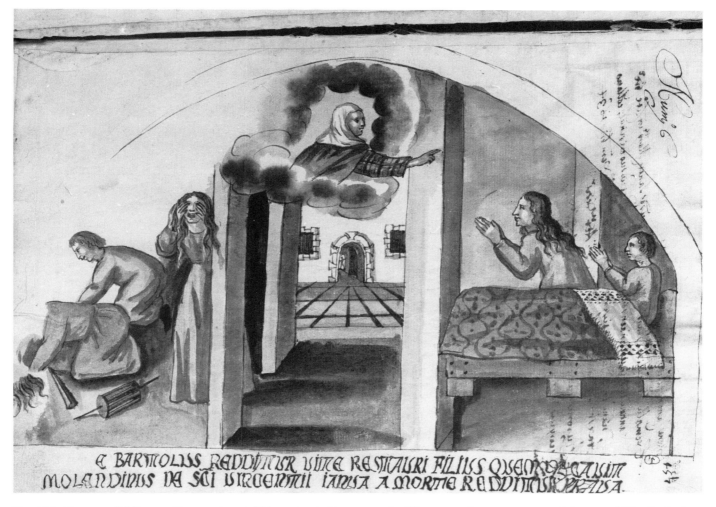

E BARTIOLISS REDDITISR VIITE RESITAISRI FILISS QSEM&CALSIM
MOLANDINIS DA SCI VIRCENTII IANSA A MORTIE REDDITISR.PRAISA.

Fig. 106. Cortona, Biblioteca Comunale e dell'Accademia Etrusca, cod. 429, watercolor no. vi, copy of the mural *The Revival and Healing of Bartoluccio of Cortona*, formerly in the lunette of the south wall of the *cappella maggiore* of S. Margherita.

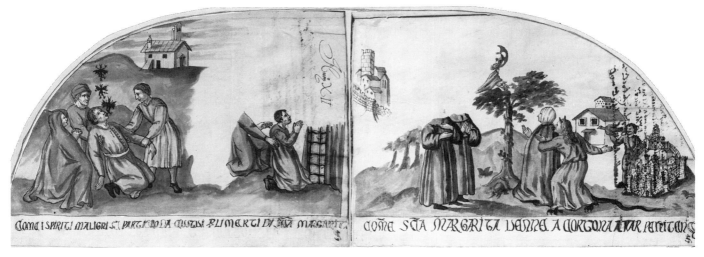

COME I SPIRITI MALIGRI SI PARTIRODA CRISTIS PLI MERTI DI SCA MARGARIT. COME SCA MARGARITA VENIRE A CORTONA A FAR PENITENTI

Fig. 107. Cortona, Biblioteca Comunale e dell'Accademia Etrusca, cod. 429, watercolors nos. xii and xi, copies of the murals of *Liberation from Devils of the Boy of Borgo Sansepolcro* and *Christ Calls Margherita to Go to Cortona to Do Penance*, formerly in the lunette of the eastern bay of the south nave wall of S. Margherita.

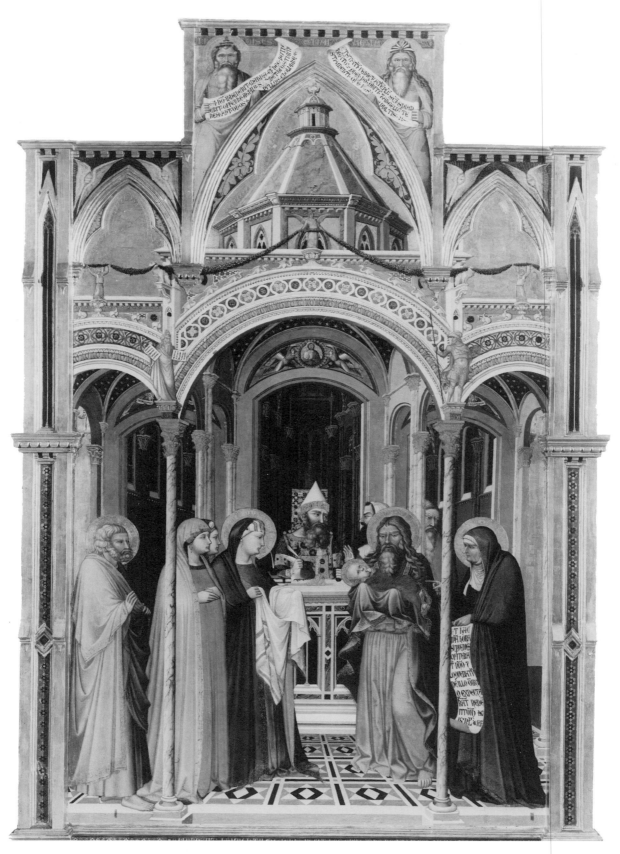

Fig. 108. Florence, Galleria degli Uffizi, *Presentation in the Temple*, panel (dimensions excluding frame: 252 x 142 cm), formerly *Cappella di S. Crescenzio*, Duomo, Siena, Ambrogio Lorenzetti, 1337–42.

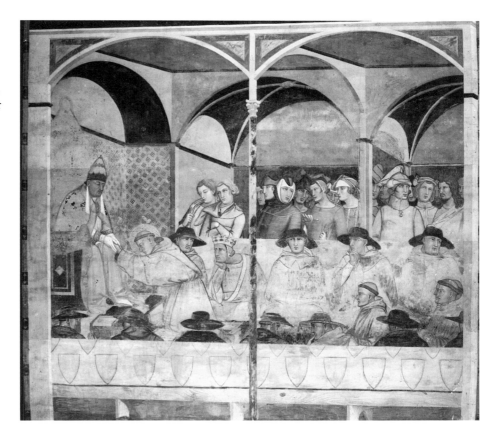

Fig. 109. Siena, S. Francesco, Cappella Bandini Piccolomini, formerly Chapter House, *Saint Louis of Toulouse Before Boniface VIII*, fresco, Ambrogio Lorenzetti (attrib.).

Fig. 110. Siena, Pinacoteca Nazionale, *Carmelite Altarpiece*, formerly S. Niccolò del Carmine, Siena, Pietro Lorenzetti, completed 1329, predella panel (37 x 46 cm), *Honorius IV Approves the Change from the Striped to the White Habit.*

Fig. 111. Assisi, S. Francesco, Lower Church, right transept, *Crucifixion*, fresco, attributed to the school of Giotto, detail, grieving women standing to the left of the cross.

Fig. 112. Assisi, S. Francesco, Lower Church, right transept, *Massacre of the Innocents*, fresco, attributed to the school of Giotto, detail, grieving mother in foreground, at right.

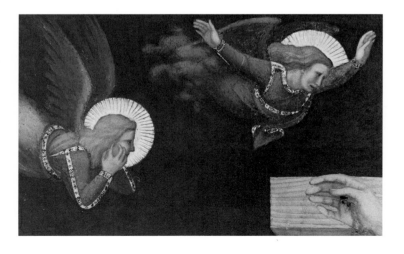

Fig. 113. Assisi, S. Francesco, Lower Church, left transept, *Crucifixion*, fresco, Pietro Lorenzetti (attrib.), detail, angels above Christ's right hand.

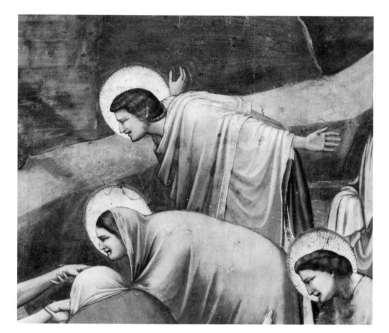

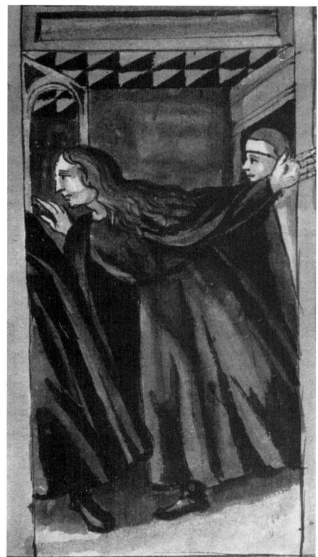

Fig. 114. Padua, Arena Chapel, *Lamentation*, fresco, Giotto (attrib.), detail, Saint John the Evangelist.

Fig. 115. Cortona, Biblioteca Comunale e dell'Accademia Etrusca, cod. 429, watercolor no. x, copy of the mural *The Resuscitation and Healing of Suppolino*, detail, Donna Muccia, the mother of Suppolino.

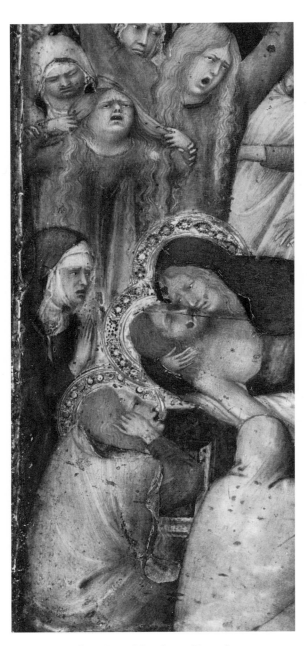

Fig. 116. Berlin, Gemäldegalerie, *Entombment*, panel (23.5 x 16.5 cm), from Orsini polyptych, Simone Martini, detail, grieving women to the left of the tomb.

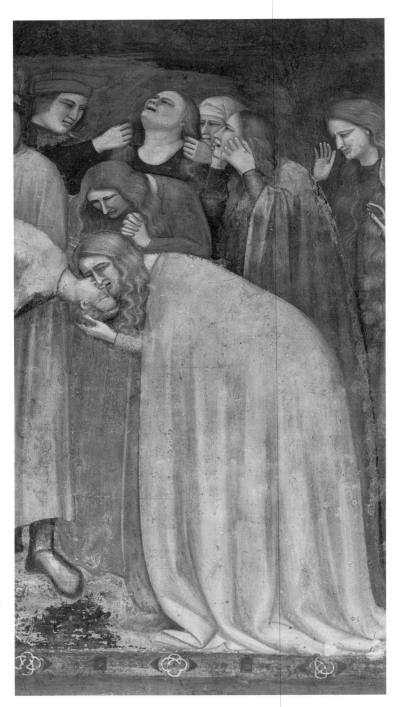

Fig. 117. Assisi, S. Francesco, Lower Church, right transept, *Death of the Boy of Suessa*, fresco, attributed to the school of Giotto, detail, grieving women at center of the composition.

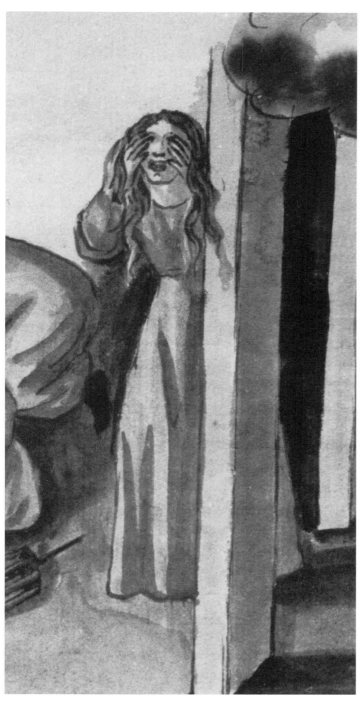

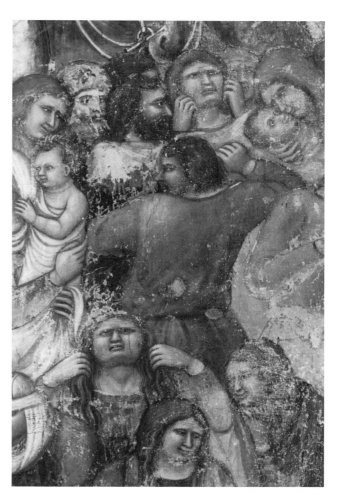

Fig. 119. Siena, S. Maria dei Servi, Petroni Chapel, *Massacre of the Innocents*, fresco, here attributed to an anonymous master who worked for Pietro and Ambrogio Lorenzetti, detail, grieving women in center foreground.

Fig. 118. Cortona, Biblioteca Comunale e dell'Accademia Etrusca, cod. 429, watercolor no. vi, copy of the mural *The Revival and Healing of Bartoluccio of Cortona*, detail, Bartoluccio's mother grieves.

Fig. 120. Assisi, S. Francesco, Lower Church, right transept, view to (liturgical) west, showing Giotto school frescoes of the *Infancy Cycle*, *Crucifixion*, and *Posthmous Miracles of Saint Francis*, and, below *Virgin and Child Enthroned with Angels and Saint Francis* (attrib. Cimabue), shrine of five companions of Saint Francis, protected by an iron grille, and fresco of these five Franciscan *beati*, attributed to Pietro Lorenzetti's workshop.

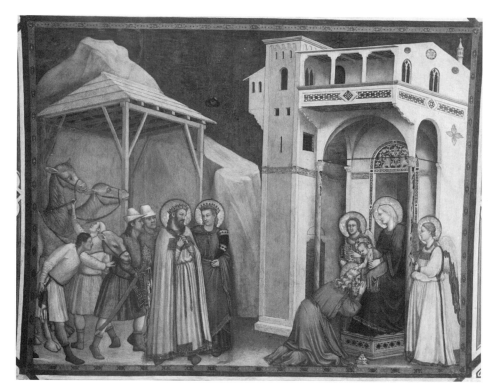

Fig. 121. Assisi, S. Francesco, Lower Church, right transept, *Adoration of the Magi*, fresco, attributed to the school of Giotto.

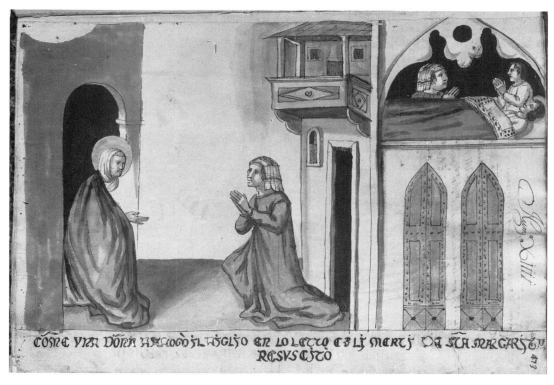

CŌME VIEN DŌNA À(?)GO̅GO̅ IL T-̅GLIO EN LO LECTO E E LI MERT̅ DA STA MARGARITA RESVSCITO

Fig. 122. Cortona, Biblioteca Communale e dell'Accademia Etrusca, cod. 429, watercolor no. xiv, copy of the mural *Margherita Resuscitates a Dead Child in Cortona*, formerly on the south nave wall of S. Margherita.

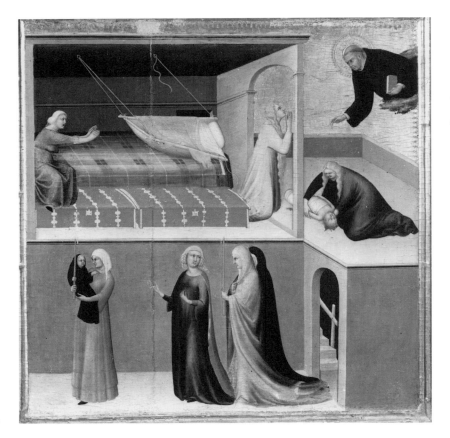

Fig. 123. Siena, Pinacoteca Nazionale (on deposit), *Beato Agostino Novello and Four Miracles*, panel (200 x 256 cm), from S. Agostino, Siena, Simone Martini (attrib.), before 1329, detail, *Miraculous Cure of an Infant Which Fell from Its Cradle.*

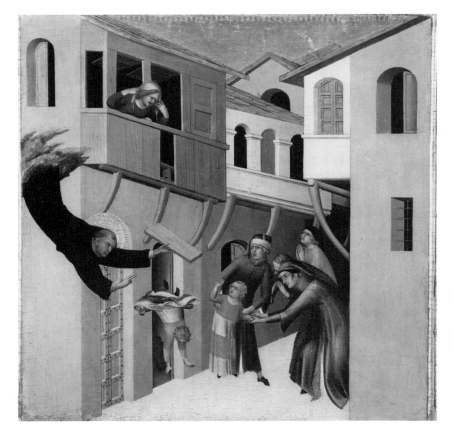

Fig. 124. Siena, Pinacoteca Nazionale (on deposit), *Beato Agostino Novello and Four Miracles*, detail, *Miraculous Rescue of a Child Who Fell from a Balcony.*

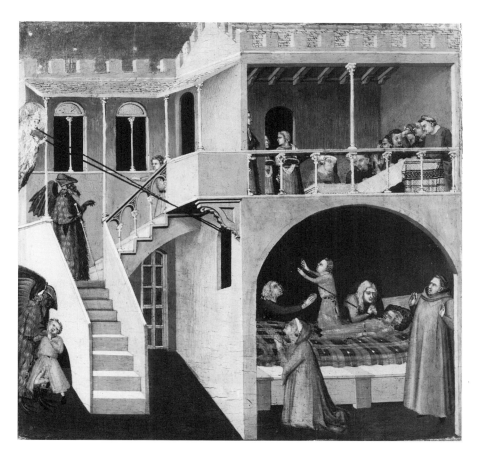

Fig. 125. Florence, Galleria degli Uffizi, *Four Scenes from the Life and Miracles of Saint Nicholas*, panel, from S. Procolo, Florence, Ambrogio Lorenzetti (attrib.), c.1332, detail, *Resuscitation of the Merchant's Son* (width, including frame, 52.5 cm).

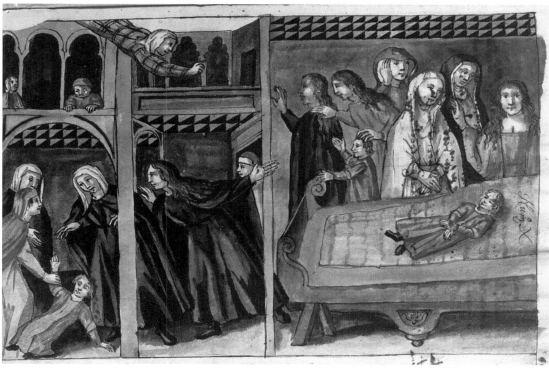

Fig. 126. Cortona, Biblioteca Comunale e dell'Accademia Etrusca, cod. 429, watercolor no. x, copy of the mural *The Resuscitation and Healing of Suppolino*, formerly on the south wall of the *cappella maggiore* of S. Margherita.

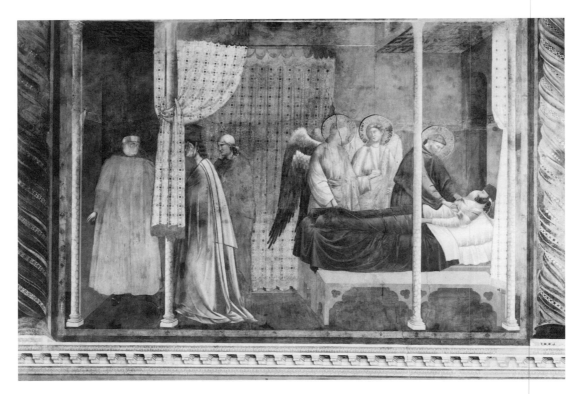

Fig. 127. Assisi, S. Francesco, Upper Church, nave, *Saint Francis Heals John of Lerida*, disputed attribution to the Saint Cecilia Master, detail.

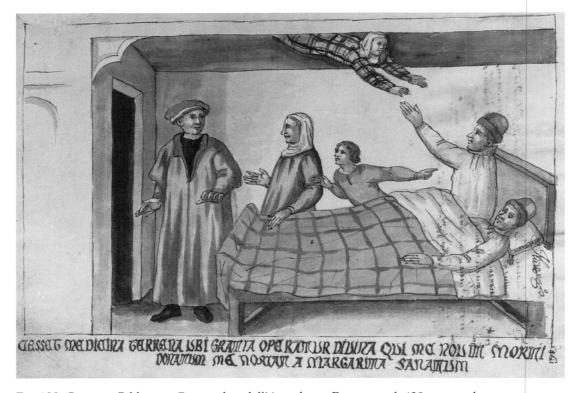

CESSET MEDICINA TERRENA ISBI GRATIA OPERATUR DIVINA QUI ME NON IN MORTII
DORATUM ME NOVAT A MARGARITA SANAMIM

Fig. 128. Cortona, Biblioteca Comunale e dell'Accademia Etrusca, cod. 429, watercolor no. viii, copy of the mural *The Cure of Simonello di Angeluccio of Perugia*, formerly on the south wall of the *cappella maggiore* of S. Margherita.

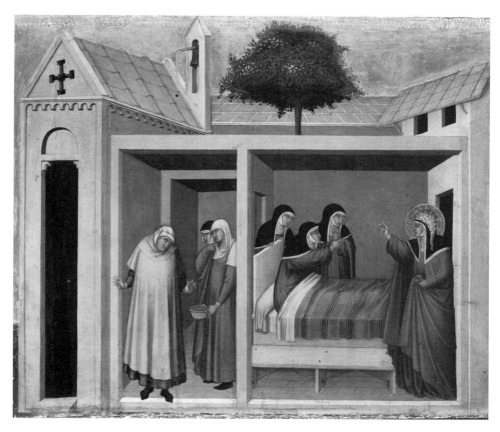

Fig. 129. Berlin, Gemäldegalerie, *Cure of a Nun with a Nosebleed* (46 x 56 cm), panel from *Beata Umiltà with Scenes from Her Life*, Gemäldegalerie, Berlin and Galleria degli Uffizi, Florence, from S. Giovanni Evangelista, Florence, disputed attribution to Pietro Lorenzetti, c. 1330–35 (?).

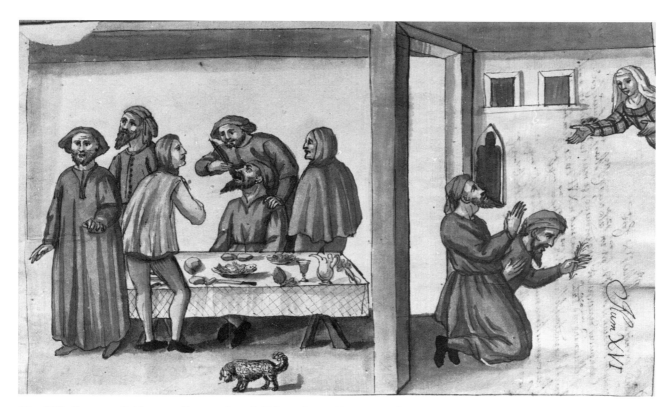

Fig. 130. Cortona, Biblioteca Comunale e dell'Accademia Etrusca, cod. 429, watercolor no. xvi, copy of the mural *The Cure of the Conspirator of Arezzo*, formerly on the south nave wall of S. Margherita.

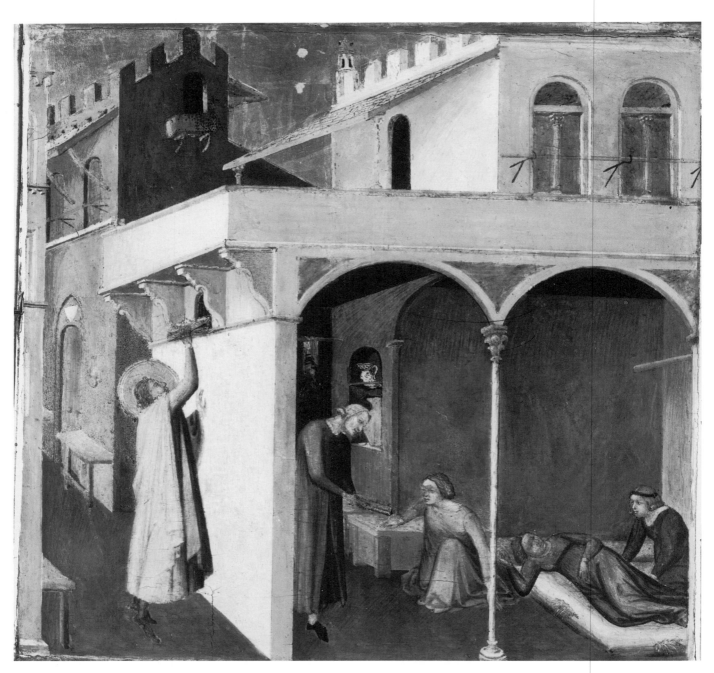

Fig. 131. Florence, Galleria degli Uffizi, *Four Scenes from the Life and Miracles of Saint Nicholas*, panel, from S. Procolo, Florence, Ambrogio Lorenzetti (attrib.), c. 1332, detail, *Miracle of the Dowry* (width, including frame, 49 cm).

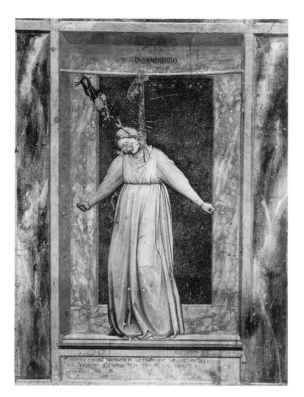

Fig. 132. Padua, Arena Chapel, *Allegorical Figure of Despair*, fresco, Giotto (attrib.).

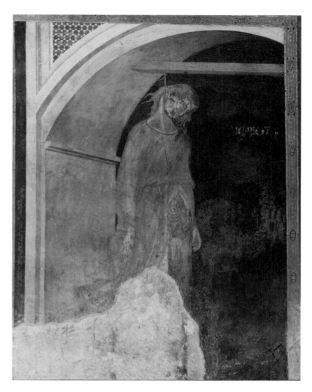

Fig. 133. Assisi, S. Francesco, Lower Church, left transept, *The Hanged Judas*, fresco, Pietro Lorenzetti (attrib.).

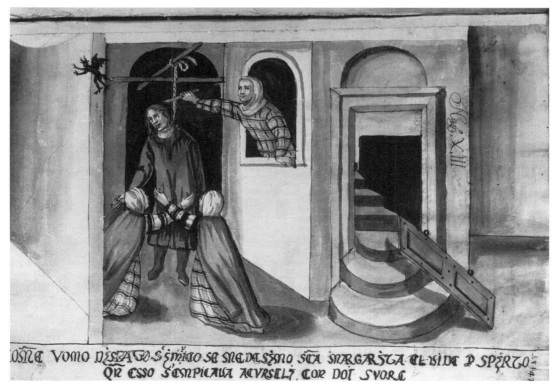

Fig. 134. Cortona, Biblioteca Comunale e dell'Accademia Etrusca, cod. 429, watercolor no. xiii, copy of the mural *The Saving of the Suicide*, formerly on the south nave wall of S. Margherita.

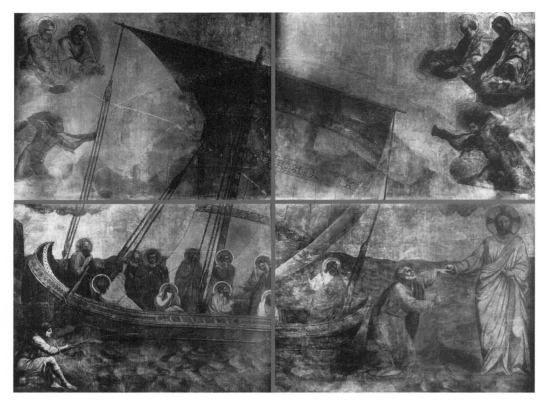

Fig. 135. Vatican City, Fabbrica di S. Pietro, facsimile of the *Navicella* mosaic from the atrium of Old Saint Peter's, Francesco Berretta, 1628.

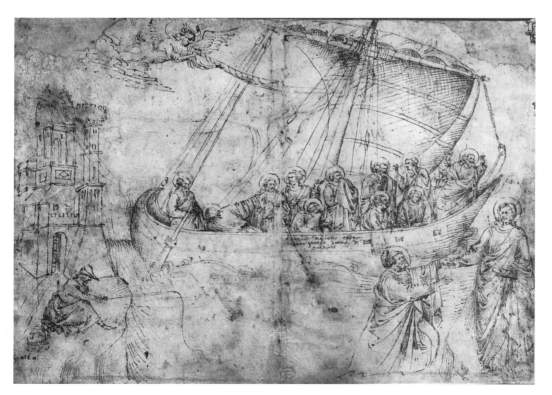

Fig. 136. New York, Metropolitan Museum of Art, drawing no. 19.76.2 (Hewitt Fund, 1917), ink on paper (27.4 x 38.6 cm), drawing after the *Navicella* mosaic from the atrium of Old Saint Peter's, Florentine, first quarter of the fifteenth century.

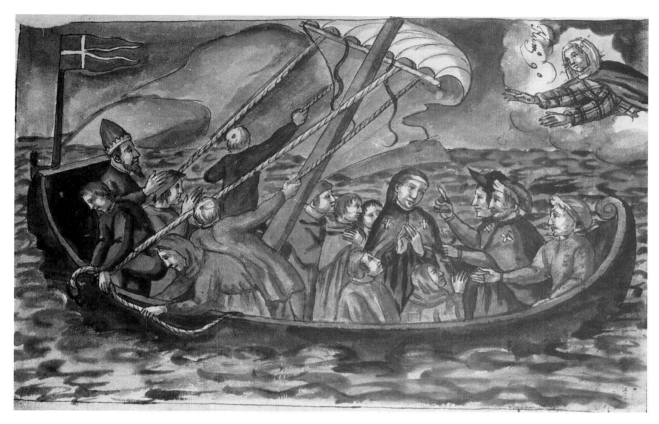

Fig. 137. Cortona, Biblioteca Comunale e dell'Academia Etrusca, cod. 429, watercolor no. ix, copy of the mural *The Calming of the Sea of Ancona*, formerly on the south wall of the *cappella maggiore* of S. Margherita.

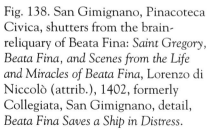

Fig. 138. San Gimignano, Pinacoteca Civica, shutters from the brain-reliquary of Beata Fina: *Saint Gregory, Beata Fina, and Scenes from the Life and Miracles of Beata Fina*, Lorenzo di Niccolò (attrib.), 1402, formerly Collegiata, San Gimignano, detail, *Beata Fina Saves a Ship in Distress*.

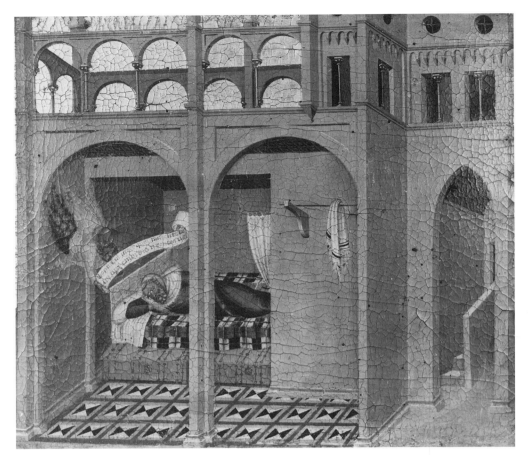

Fig. 139. Siena, Pinacoteca Nazionale, *Carmelite Altarpiece*, formerly S. Niccolò del Carmine, Siena, Pietro Lorenzetti, completed 1329, predella panel (37.3 x 45.2 cm), *Dream of Sobac*.

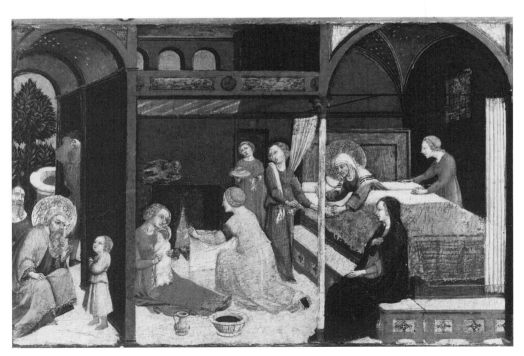

Fig. 140. Ann Arbor, University of Michigan, Museum of Art, *Birth of the Virgin*, panel (31.8 x 47.2 cm) from the predella added to Simone Martini's altarpiece for the *Cappella de'Signori*, Palazzo Pubblico, Siena, Sano di Pietro, 1449.

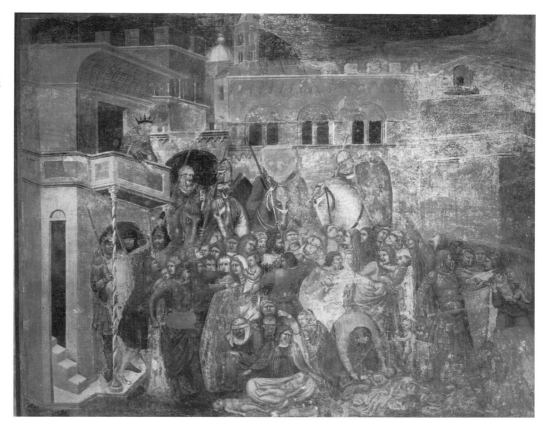

Fig. 141. Siena, S. Maria dei Servi, Petroni Chapel, *Massacre of the Innocents*, fresco, here attributed to an anonymous master who worked for Pietro and Ambrogio Lorenzetti.

Fig. 142. Siena, S. Maria dei Servi, Spinelli Chapel, *Feast of Herod*, fresco, here attributed to an anonymous master who worked for Pietro and Ambrogio Lorenzetti.

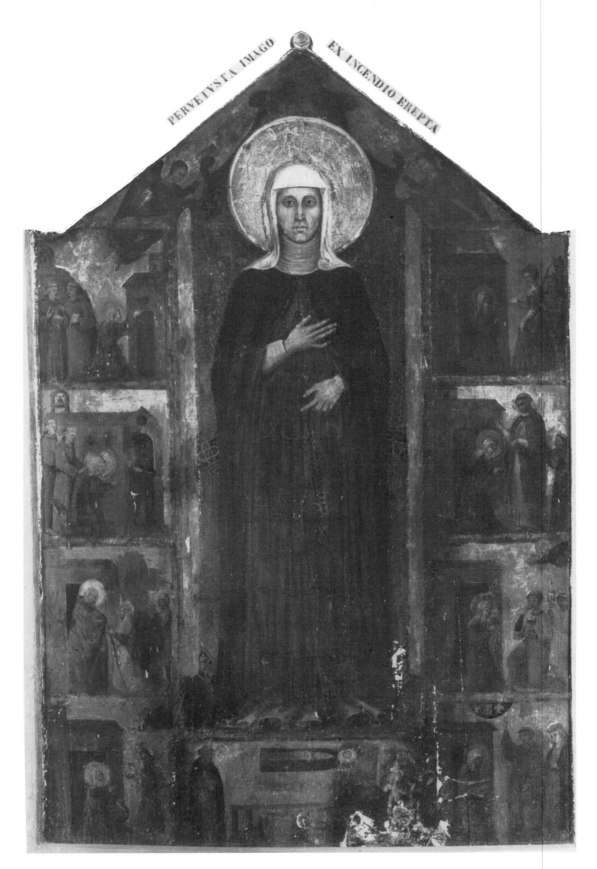

Fig. 143. Cortona, Museo Diocesano, *Beata Margherita with Eight Scenes from Her Life*, panel
(maximum dimensions: 197.5 x 131 cm), before restoration.

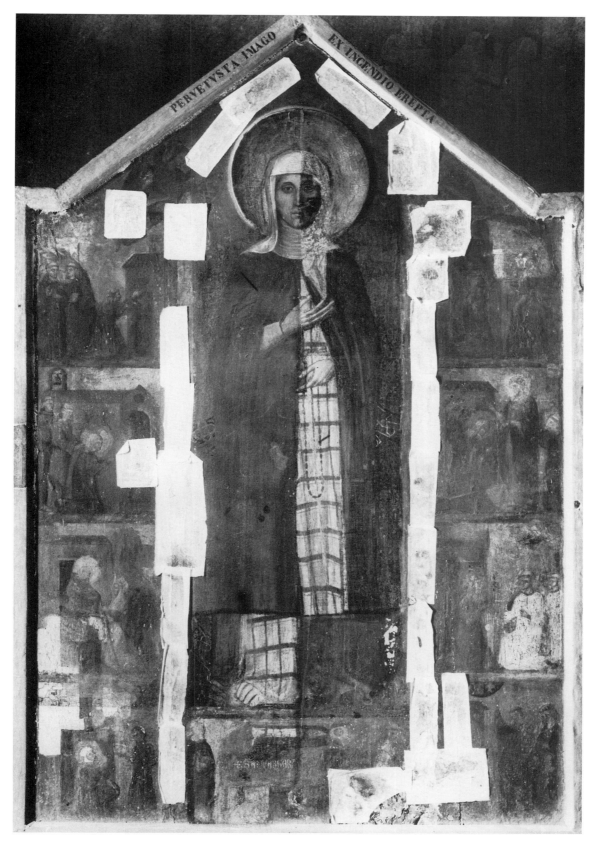

Fig. 144. Cortona, Museo Diocesano, *Beata Margherita with Eight Scenes from Her Life*, panel, during restoration of 1946–47.

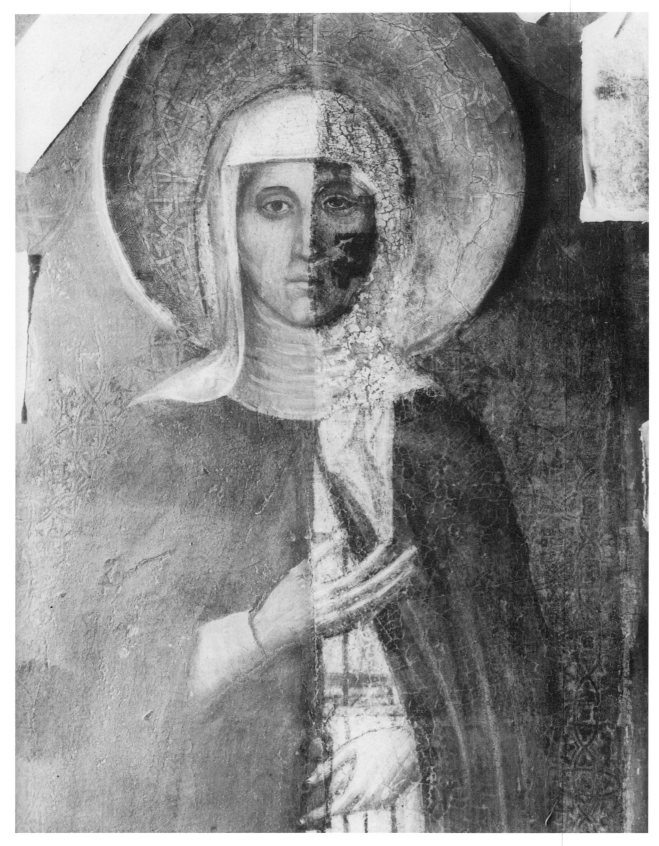

Fig. 145. Cortona, Museo Diocesano, *Beata Margherita with Eight Scenes from Her Life*, panel, during restoration of 1946–47, detail.

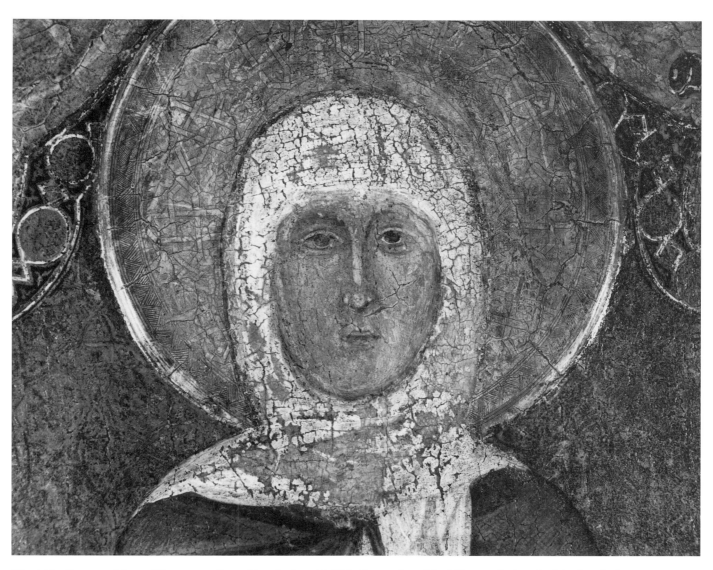

Fig. 146. Cortona, Museo Diocesano, *Beata Margherita with Eight Scenes from Her Life*, panel, detail of the head after restoration in the 1980s.

Fig. 147. Cortona, Museo Diocesano, *Beata Margherita with Eight Scenes from Her Life*, panel, detail, *Margherita Comes to Cortona to Do Penance* and *The Profession and Investiture of Margherita as a Member of the Franciscan Third Order*.

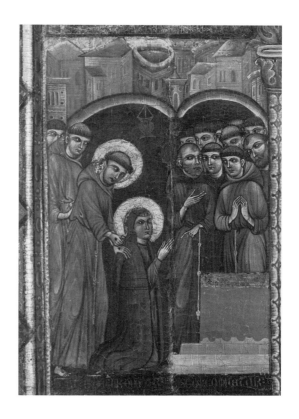

Fig. 148. Assisi, S. Chiara, *Saint Clare with Eight Scenes from Her Life*, panel (281 x 166 cm), Umbrian artist (Maestro della S. Chiara), 1283, detail, *Profession and Investiture of Saint Clare as a Member of the Franciscan Second Order*.

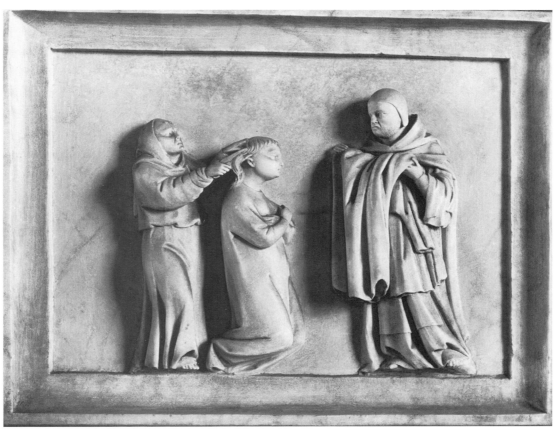

Fig. 149. Cortona, S. Margherita, funerary monument of Beata Margherita, detail, *Profession and Investiture of Margherita as a Member of the Franciscan Third Order*.

Fig. 150. Cortona, Museo Diocesano, *Beata Margherita with Eight Scenes from Her Life*, panel, detail, *Margherita Suffers the Temptations of the Devil.*

Fig. 151. Cortona, Museo Diocesano, *Beata Margherita with Eight Scenes from Her Life*, panel, detail, *Margherita Resists the Temptations of the Devil.*

Fig. 152. Cortona, Museo Diocesano, *Beata Margherita with Eight Scenes from Her Life*, panel, detail, *Christ Presents Saint Mary Magdalene to Margherita and Shows Margherita the Throne Reserved for Her in Paradise.*

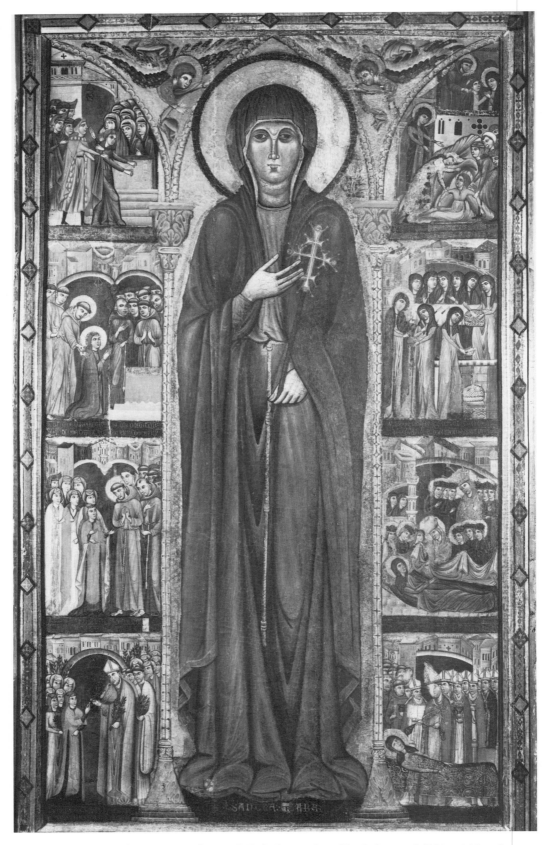

Fig. 153. Assisi, S. Chiara, *Saint Clare with Eight Scenes from Her Life*, panel (281 x 166 cm), Umbrian artist (Maestro della S. Chiara), 1283, after restoration.

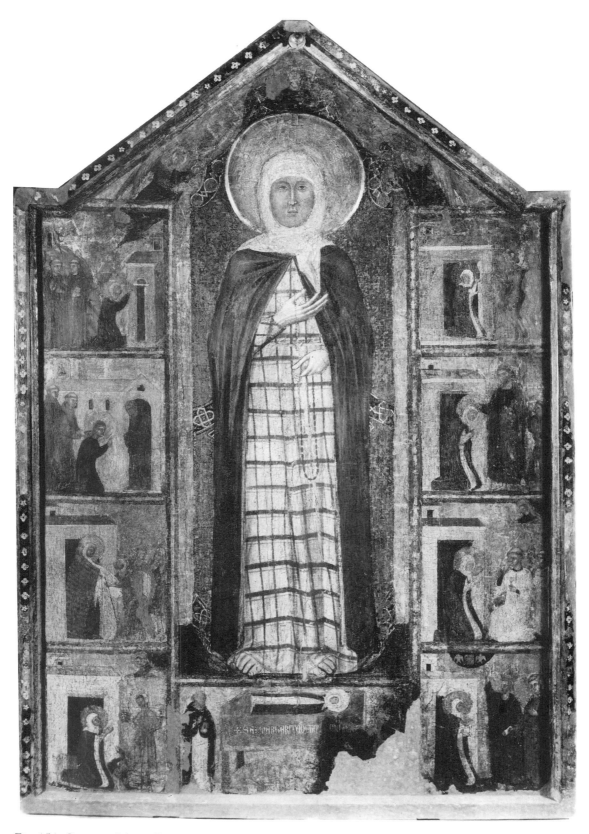

Fig. 154. Cortona, Museo Diocesano, *Beata Margherita with Eight Scenes from Her Life*, panel (maximum dimensions: 197.5 x 131 cm), Tuscan (or Umbrian), within the decade following 1297, after restoration of 1946–47.

Fig. 155. Cortona, Museo Diocesano, *Beata Margherita with Eight Scenes from Her Life*, panel, detail (after 1980s restoration), *Margherita Gives Her Possessions to the Poor and Wraps Herself in the Mat of Woven Reeds on Which She Slept.*

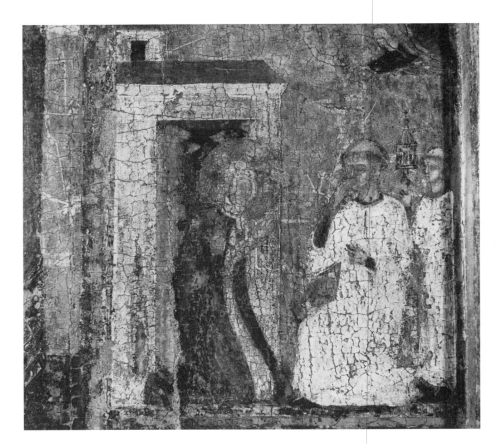

Fig. 156. Cortona, Museo Diocesano, *Beata Margherita with Eight Scenes from Her Life*, panel, detail (after 1980s restoration), *Margherita Receives the Eucharist in Her Cell.*

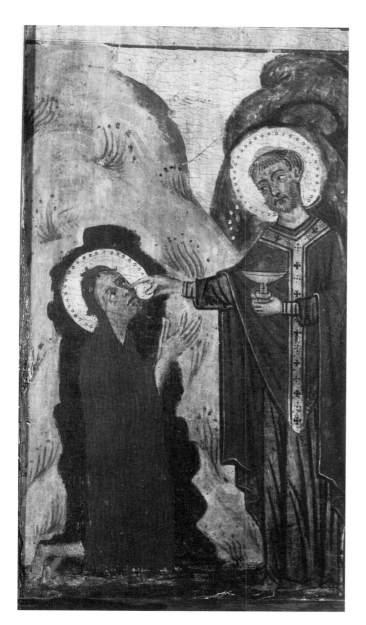

Fig. 157. Florence, Galleria dell'Accademia, *Saint Mary Magdalene with Eight Scenes from Her Life*, detail, *The Eucharist Is Brought to the Magdalene in Her Desert Cave by Bishop Maximinus*.

Fig. 158. Florence, Galleria dell'Accademia, *Saint Mary Magdalene with Eight Scenes from Her Life*, detail, *The Eucharist Is Brought to the Magdalene in Her Desert Cave by an Angel*.

Fig. 159. Florence, Galleria dell'Accademia, *Saint Mary Magdalene with Eight Scenes from Her Life*, detail, *Noli Me Tangere*.

Fig. 160. Cortona, Museo Diocesano, *Beata Margherita with Eight Scenes from Her Life*, panel, detail (after 1980s restoration), *Christ Grants Margherita Absolution from All Her Sins Through the Intercession of Saint Francis*.

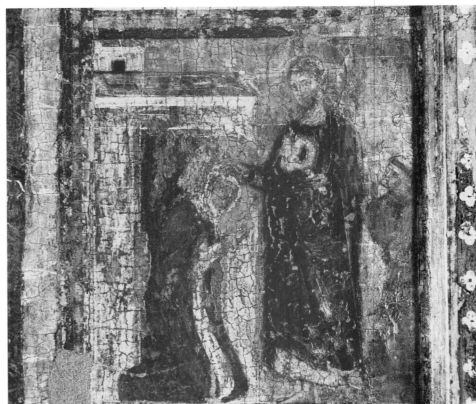

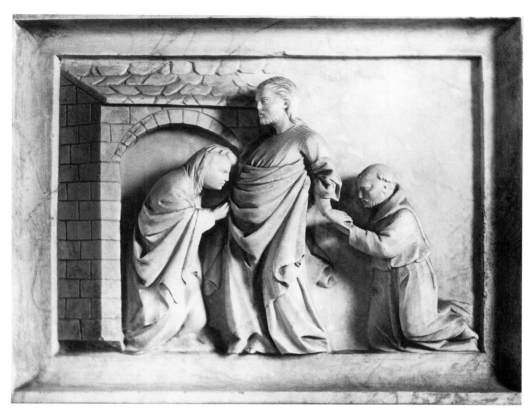

Fig. 161. Cortona, S. Margherita, funerary monument of Beata Margherita, detail, *Christ Grants Margherita Absolution from All Her Sins Through the Intercession of Saint Francis.*

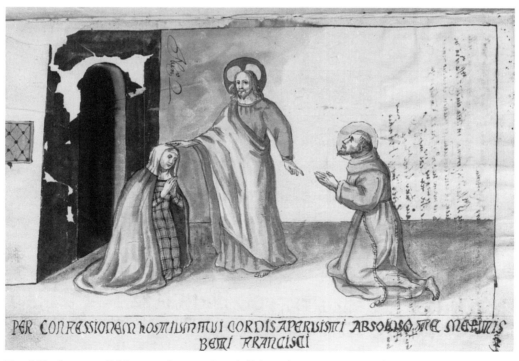

PER CONFESSIONEM hoSTIUM TUI CORDIS APERUISTI ABSOLUSO ME MERITIS BETI FRANCISCI

Fig. 162. Cortona, Biblioteca Comunale e dell'Accademia Etrusca, cod. 429, watercolor no. ii, copy of the mural *Christ Grants Margherita Absolution from All Her Sins Through the Intercession of Saint Francis,* formerly on the north wall of *cappella maggiore* of S. Margherita.

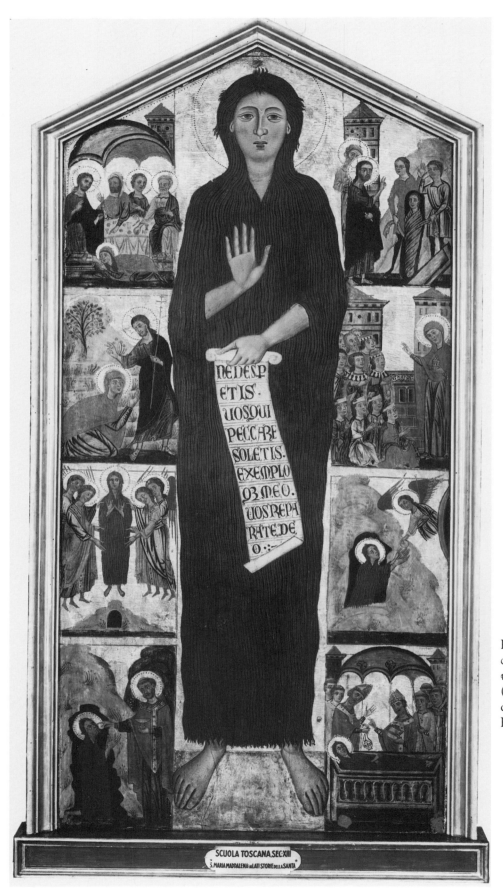

Fig. 163. Florence, Galleria
dell'Accademia, *Saint Mary Magdalene
with Eight Scenes from Her Life*, panel
(164 x 76 cm), Magdalen Master,
c. 1280, formerly SS. Annunziata,
Florence.

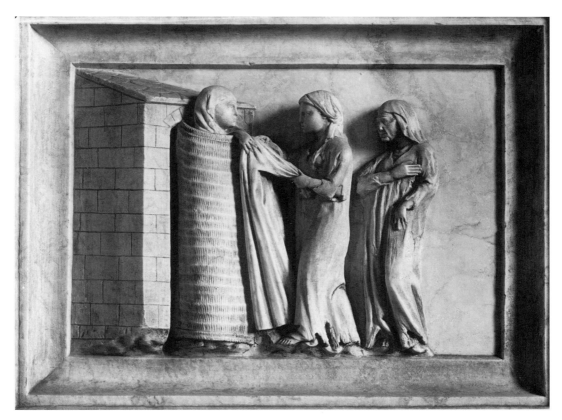

Fig. 164. Cortona, S. Margherita, funerary monument of Beata Margherita, detail, *Margherita Gives Her Possessions to the Poor and Wraps Herself in the Mat of Woven Reeds on Which She Slept.*

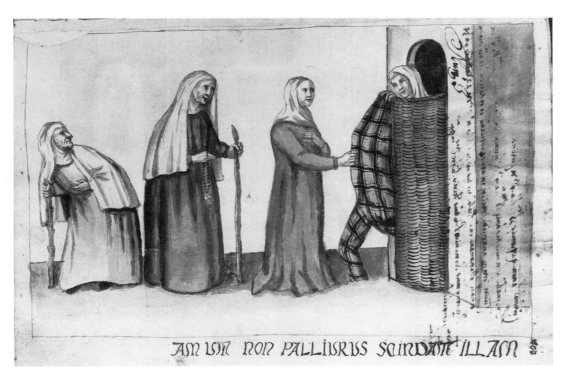

Fig. 165. Cortona, Bibloteca Comunale e dell'Accademia Etrusca, cod. 429, watercolor no. iii, copy of the mural *Margherita Gives Her Possessions to the Poor and Wraps Herself in the Mat of Woven Reeds on Which She Slept*, formerly on the north wall of the *cappella maggiore* of S. Margherita.

Fig. 166. Cortona, Museo Diocesano, *Beata Margherita with Eight Scenes from Her Life*, panel, detail, *The Sick Come to Be Cured at Margherita's Shrine*.

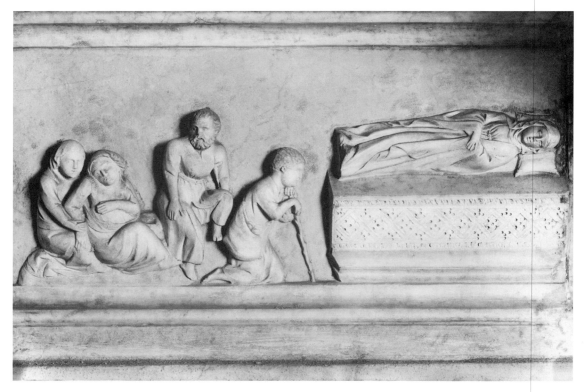

Fig. 167. Cortona, S. Margherita, funerary monument of Beata Margherita, detail, *The Sick Come to Be Cured at Margherita's Shrine*.

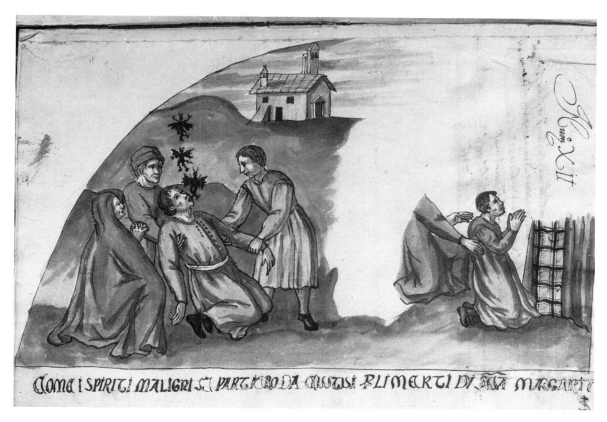

COME I SPIRITI MALIGNI SI PARTIRONO DA COLUI PLI MERTI DI STA MARGARIT

Fig. 168. Cortona, Biblioteca Comunale e dell'Accademia Etrusca, cod. 429, watercolor no. xii, copy of the mural *Liberation from Devils of the Boy of Borgo Sansepolcro*, formerly in the lunette of the south nave wall of S. Margherita.

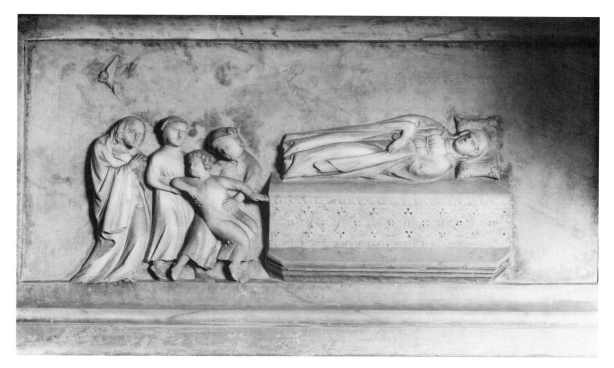

Fig. 169. Cortona, S. Margherita, funerary monument of Beata Margherita, detail, *A Child Possessed by Devils Comes to Be Cured at Margherita's Shrine*.

Fig. 170. Cortona, Biblioteca Comunale e dell'Accademia Etrusca, cod. 429, watercolor no. vii, copy of the mural *Margherita Rescues Prisoners from Captivity*, formerly on the south wall of the *cappella maggiore* of S. Margherita.

Fig. 171. Cortona, Biblioteca Comunale e dell'Accademia Etrusca, cod. 429, watercolor no. xi, copy of the mural *Christ Calls Margherita to Go to Cortona to Do Penance*, formerly in the lunette of the south nave wall of S. Margherita.